W9-BUI-960

PHOTO LAB INDEX
M & M
COMPACT EDITION

The Cumulative Formulary
of Standard Recommended
Photographic Procedures

Stephen J. Brennan, *Editor.*

Morgan & Morgan, Inc., *Publishers*
145 Palisade Street
Dobbs Ferry, N.Y. 10522

The Compact Photo-Lab-Index

BASIC SET PUBLISHED: JUNE 1939
THIRTY—EIGHTH EDITION: 1981
THIRD COMPACT EDITION: 1983

THE COMPACT PHOTO-LAB-INDEX
© Copyright 1983
MORGAN & MORGAN, INC.

International Standard Book Number:

0-87100-185-3 (softbound)
o-87100-189-6 (hardbound)

Library of Congress Card Number: 77-79076

All rights reserved in all countries.
No part of this book may be reproduced or translated in any form,
including microfilming, without permission in writing
from the publisher.

MORGAN & MORGAN, INC.
145 Palisade Street
Dobs Ferry, New York 10522
Tel.: (914) 693-9303

ACKNOWLEDGEMENTS

THE EDITOR and THE PUBLISHERS EXTEND THEIR APPRECIATION
and thanks on behalf of photographers and users of photographic
materials, to the manufacturers of photographic materials that appear
in this book.

Printed in U.S.A.

AGFA-GEVAERT

EASTMAN KODAK

BLACK AND WHITE FILM

ILFORD

POLAROID

MISCELLANEOUS MFG.

BY MANUFACTURER

BY CATEGORY

BW FILM DEVELOPERS

BW PRINT DEVELOPERS

FORMULARY

GLOSSARY

DIRECTORY OF MANUFACTURERS

ACUFINE, INC.
439-447 E. Illinois St.
Chicago, Ill. 60611
(312) 321-0240

AGFA-GEVAERT, INC.
275 North St.
Teterboro, N.J. 07608
(201) 288-4100

AMERICAN NATIONAL STANDARDS INSTITUTE
1430 Broadway
New York, N.Y. 10018
(212) 868-1220

BERKEY MARKETING COMPANIES, INC.
25-20 Brooklyn-Queens Expressway W.
Woodside, New York 11377
(212) 932-4040

BESELER PHOTO MARKETING COMPANY, INC.
8 Fernwood Road
Florham Park, New Jersey 07392
(201) 822-1000

BEST PHOTO INDUSTRIES, INC.
Bowman Field
Louisville, Ky. 40205

BERG COLOR-TONE, INC.
P.O. Box 16
East Amherst
New York 14051

BRAUN NORTH AMERICA
PHOTO PRODUCTS DIVISION
55 Cambridge Parkway
Cambridge, Mass. 02142
(617) 492-2100

duPONT de NEMOURS & CO., E. I.
General Services Dept.
Product Inquiry Ref. Sec.
1007 Market St.
Wilmington, Del. 19898
(302) 774-2421

DURACELL PRODUCTS COMPANY
Div. of P. R. Mallory & Co., Inc.
S. Broadway
Tarrytown, N.Y. 10591
(914) 591-7000

EASTMAN KODAK CO.
343 State St.
Rochester, N.Y. 14650
(716) 325-2000

EDWAL SCIENTIFIC PRODUCTS CORP.
12120 S. Peoria St.
Chicago, Ill. 60643
(312) 264-8484

ETHOL CHEMICALS INC.
1808 North Damen Ave.
Chicago, Ill. 60647
(312) 278-1586

FISHER SCIENTIFIC CO.
52 Faden Road
Springfield, N.J. 07081
(201) 379-1400

FR, DIV. of PHOTOMAGNETICS, INC.
Chemical Div.
16 Gordon Pl.
Yonkers, N.Y. 10703
(914) 375-0600

FUJI PHOTO FILM, U.S.A.
350 Fifth Ave.
New York, N.Y. 10001
(212) 736-3335

GENERAL ELECTRIC CO., LAMP DIV.
Nela Park
Cleveland, Ohio 44112
(216) 266-2258

GTE SYLVANIA
100 Endicott St.
Danvers, Mass. 01923
(617) 777-1900

HARRISON & HARRISON
6363 Santa Monica Blvd.
Hollywood, Calif. 90038
(213) 464-8263

HEICO, INC.
Delaware Water Gap
Pennsylvania 18327
(717) 476-0353

THE H&W CO.
Box 332
St Johnsbury, Vt. 05819
(802) 748-8743

HOYA CORPORATION
Uniphot-Levit Corp.
61-10 34th Ave.
Woodside, N.Y. 11377
(212) 779-5700

HUSTLER PHOTO PRODUCTS, INC.
P.O. Box 14
St. Joseph, Mo., 64502
(816) 233-1237

ILFORD, INC.
West 70 Century Road
P.O. Box 288
Paramus, New Jersey 07652
(201) 265-6000

LIGHT IMPRESSIONS CORPORATION
Box 3012
Rochester, New York 14614
(716) 271-8960

LUMINOS PHOTO CORP.
25 Wolffe St.
Yonkers, N.Y. 10705
(914) 965-5254
Telex 13-1575

MALLORY BATTERY CO. INC.
South Broadway
Tarrytown, N.Y. 10591
(914) 591-7000

3M COMPANY, PHOTOGRAPHIC PRODUCT DIV.
3M Center 220-3E
St. Paul. Minn. 55101
(612) 733-1110

MINMAX
5739¾ Tujunga Ave.
North Hollywood, California 91601
(213) 762-3659

MORGAN & MORGAN, INC.
145 Palisade St.
Dobbs Ferry, N.Y. 10522
(914) 693-9303

PHOTOCOLOR (See Satter, Inc.)

POLAROID CORPORATION
Cambridge, Mass. 02139
(617) 864-6000

POLAROID HOT LINE
1-800-225-1384
Mon.-Fri., 9 a.m.-4:30 p.m.
Eastern Time

ROCKLAND COLLOID CORP.
599 River Road
Piermont, N.Y. 10968
(914) 359-5559

SATTER DISTRIBUTING CO., INC.
4100 Dahlia St.
Denver, CO 80207
(303) 399-4535

SEAL, INC.
550 Spring St.
Naugatuck, Conn. 06770
(203) 729-5201

SPIRATONE, INC.
135-06 Northern Boulevard
Flushing, N.Y. 11354
(212) 886-2000

SPRINT SYSTEMS OF PHOTOGRAPHY, INC.
100 Dexter St.
Pawtucket, R.I. 02860
(401) 728-0913

SYLVANIA (See
GTE SYLVANIA)

TIFFEN MANUFACTURING CORP.
90 Oser Ave.
Hauppauge, N.Y. 11787
(516) 273-2500

TKO CHEMICAL CO.
303 South 5th St.
St. Joseph, Mo. 64501
(816) 232-7194

UNICOLOR DIV. PHOTO SYSTEMS, INC.
P.O. Box 306
Dexter, Mich. 48130
(313) 426-4646

WESTINGHOUSE LAMP DIV.
Westinghouse Plaza
Bloomfield, New Jersey 07003
(201) 465-0222

INTRODUCTION

This Third Compact Photo Lab Index, like its predecessors, is a compilation of over seven hundred pages of information drawn from the 1700 page Photo Lab Index Lifetime Edition. The editor has attempted to select the most used, most useful information on photographic materials and processes.

Unlike earlier Compact Editions, this one varies somewhat in format from the Lifetime Edition. For the first time, photograhic formulas are gathered into one place, rather than entered under individual manufacturer headings. (Exception: formulas for D-76 and D-72 are in the Kodak Section.) The formulary is reprinted from The Morgan and Morgan Darkroom Book, by Algis Balsys and Liliane DeCock-Morgan. A useful glossery is also drawn from the same source. The formulas represented are those of greatest general interest and usefulness to the advanced darkroom worker. It is interesting to note that these formulas were in turn taken from earlier editions of The Photo Lab Index, and are thus returning to their source.

A departure from alphabetical sequence has been made in placing Eastman Kodak in front of Agfa Gevaert. This is to alleviate the problem of Kodaks 200+ pages hiding Agfa's 20.

In order to allow for expanded coverage of standard Photographic materials, certain types of non-standard films and papers have been deleted or their listings have been condensed. The growth in the number and variety of graphic arts films has exceeded even that of photographic films, to the extent that full coverage is impossible in a book this size. We have therefore included only representative graphic arts products.

Similarly, the dye-transfer section has been deleted because it is a rather specialized process and because Kodak's own publications cover it well.

In keeping with PLI's long-standing practice, the information included is that supplied by the manufacturer. We have not undertaken to test materials and formulas, except in rare cases where specific missing information needed to be filled in. It is most unusual today for a manufacturer to exaggerate the performance of a product. (Which was by no means true

in the earlier years of the PLI.) We therefore take manufacturers at their word, and have encountered no serious trouble because of it.

Throughout this book you will encounter phrases like "The film speed listed are to serve as starting points", "Individual developing requirements may vary", or "Guide numbers should be taken as points of departure," etc. These are not just disclaimers made to avoid responsibility, but rather statements of photographic facts of life. We have known photographers who routinely rated 400 speed films at EI 50, and others who use them at 3000, and each got results which suited their purposes. (Or they may have just been indulging their needs to be different.) Ultimately the test of any material is the way it serves your purpose.

So take that as a large and a small warning. The information is this book will get you through most darkroom problems. But don't be afraid to adjust and adapt procedures as you find necessary.

KODAK COLOR FILMS

EASTMAN KODAK

KODAK COLOR FILM (Code) / ROLL FILMS	Balanced For	FILM SPEED AND KODAK WRATTEN FILTER NUMBER									PROCESSING
		Daylight		Flash		Photolamps (3400 K)		Tungsten (3200 K)		Electronic Flash	Kodak Chemicals ◉
		Speed	Filter	Bulb	Filter	Speed	Filter	Speed	Filter	Filter	
Kodachrome 25 (Daylight) (KM) For color slides①	Daylight, Electronic Flash, Blue Flash	25	None	Blue	None	8	80B	6	80A	None①	By Kodak labs and photofinishers. Sent to Kodak by dealers or direct by users with Kodak Mailers. *Not for user processing*
Kodachrome 40, 5070 (Type A) (KPA) For color slides① 135-36 only	Photolamps (3400 K)	25	85	Blue	85	40	None	32	82A	85	
Kodachrome 64 (Daylight) (KR) For color slides①	Daylight, Electronic Flash, Blue Flash	64	None	Blue	None	20	80B	16	80A	None①	
Kodacolor II (C) For color prints②	Daylight, Electronic Flash, Blue Flash	100	None	Blue	None	32	80B	25	80A	None	By Kodak, other labs, or users. Sent to Kodak by dealers or direct by users with Kodak Mailers. *Flexicolor, Process C-41*
Kodacolor 400 (CG) For color prints②	Daylight, Electronic Flash, Blue Flash	400	None	Blue	None	125	80B	100	80A	None	
Ektachrome 64 (Daylight) (ER) For color slides①	Daylight, Electronic Flash, Blue Flash	64	None	Blue	None	20	80B	16	80A	None③	By Kodak, other labs, or users. Sent to Kodak by dealers or direct by users with Kodak Mailers. *Process E-6*
Ektachrome 200 (Daylight) (ED) For color slides①	Daylight, Electronic Flash, Blue Flash	200	None	Blue	None	64	80B	50	80A	None③	
Ektachrome 400 (Daylight) (EL) For color slides①	Daylight, Electronic Flash, Blue Flash	400	None	Blue	None	125	80B	100	80A	None	

19

KODAK COLOR FILMS (Continued)

KODAK COLOR FILM (Code) ROLL FILMS	Balanced For	Daylight		Flash Bulb		Photoflood (3400 K)		Tungsten (3200 K)		Electronic Flash	Processing
		Speed	Filter		Filter	Speed	Filter	Speed	Filter	Filter	
Ektachrome 160 (Tungsten) (ET) For color slides①	Tungsten	100	85B	Blue	85B	125	81A	160	None	85B	Process E-6 — By Kodak, other labs, or users. Sent to Kodak by dealers or direct by users with Kodak Mailers.
Ektachrome 64 Professional (Daylight) (EPR)① 120, 135-36, long rolls—5017	Daylight, Electronic Flash, Blue Flash	64③	None	Blue	None	20	80B	16	80A	None⑤	
Ektachrome 50 Professional (Tungsten) (EPY)① 120, 135-36, long rolls—5018	3200 K Tungsten	32 at 1/60 sec	85B	Blue	85B	40 at 1/10 sec	81A	50③ at 1/10 sec	None	85B	
Ektachrome 200 Professional (Daylight) (EPD)① 120, 135-36, long rolls—5036	Daylight, Electronic Flash, Blue Flash	200③	None	Blue	None	64	80B	50	80A	None⑤	
Ektachrome 160 Professional (Tungsten) (EPT)① 120, 135-36, long rolls—5037	Tungsten	100 at 1/60 sec	85B	Blue	85B	125 at 1/30 sec	81A	160③ at 1/30 sec	None	85B	
Vericolor II Professional, Type S (VPS)②120, 135, 220 Expose 1/10 sec or less	Electronic Flash, Daylight, or Blue Flash	125	None	Blue	None	40	80B	32	80A	80C	Flexicolor, Process C-41 — By Kodak, user labs, or professional finishers. Sent to Kodak by dealers or direct by users with Kodak Mailers. Type L film is not printed by Kodak.
Vericolor II Professional, Type L (VPL)②120 only Expose 1/50 to 60 sec	3200 K Tungsten	64 at 1/50 sec	85B	Not recom.		64 at 1 sec	81A	80 at 1 sec③	None	85C	
Vericolor II Commercial, Type S (VCS)② (120 only) Expose 1/10 sec or less	Electronic Flash, Daylight, or Blue Flash	100	None	Blue	None	32	80B	25	80A	None	

KODAK COLOR FILMS (Continued)

SHEET FILMS

KODAK COLOR FILM (Code)	Balanced For	Daylight Speed	Daylight Filter	Flash Bulb	Flash Filter	Photolamps (3400 K) Speed	Photolamps (3400 K) Filter	Tungsten (3200 K) Speed	Tungsten (3200 K) Filter	Electronic Flash Filter	PROCESSING
Ektachrome 64 Professional① 6117 (Daylight)	Daylight, or Electronic Flash, Blue Flash	64③	None	Blue	None	20	80B	16	80A	None⑤	By user labs or professional finishers, not by Kodak. *Process E-6*
Ektachrome Professional① 6118 (Tungsten)	3200 K Tungsten	20③	85B+ CC10G at 1/10 sec	—	—	25③ at 5 sec	81A	32③ at 5 sec	None	—	By user labs or professional finishers, not by Kodak. *Process E-6*
Vericolor II Professional, 4107, Type S② Expose 1/10 sec or less	Electronic Flash, Daylight, Blue Flash	125	None	Blue	None	40	80B	32	80A	80C	By user labs or professional finishers, not by Kodak. *Flexicolor, Process C-41*
Vericolor II Professional, 4108, Type L② Expose 1/50 to 60 sec	3200 K Tungsten	64 at 1/50 sec	85B	Not recom.		64 at 1 sec	81A	80 at 1 sec	None③	85	*Flexicolor, Process C-41*

LONG ROLLS (Wider than 16mm)

KODAK COLOR FILM (Code)	Balanced For	Daylight Speed	Daylight Filter	Photolamps (3400 K) Speed	Photolamps (3400 K) Filter	Tungsten (3200 K) Speed	Tungsten (3200 K) Filter	Electronic Flash Filter	PROCESSING
Ektachrome MS 5256 (EMS)	Daylight	64	None	20	80B	16	80A	80A	By Kodak (35mm only), other labs, or users. Sent to Kodak by dealers. *Process ME-4*
Ektachrome EF 5241, Daylight (EF)	Daylight	160	None	50	80B	40	80A	80A	*Process ME-4*
Ektachrome EF 5242, Tungsten (EFB)	3200 K Tungsten	80	85B	100	81A	125	None	None	*Process ME-4*
Vericolor II Professional, Type S (VPS), 2107 (on Estar Base), 5025 (on Acetate Base), Expose 1/10 sec or less	Electronic Flash, Daylight, or Blue Flash	125	None	40	80B	32	80A	80A	By Kodak, other labs, or users. Sent to Kodak by dealers. *Flexicolor, Process C-41*

EASTMAN KODAK

EASTMAN KODAK

KODAK BLACK-AND-WHITE FILMS

KODAK FILM (Code) ROLL FILMS	PROPERTIES & PURPOSE	SPEEDS Daylight	SPEEDS Tungsten
VERICHROME PAN (VP) rolls and for Cirkut cameras	All-round use.	125	125
PLUS-X PAN (PX)–135①	General-purpose film.	125	125
TRI-X PAN (TX)①	Very fast. For limited light, action.	400	400
PANATOMIC-X (FX)–135① / PANATOMIC-X PROFESSIONAL (FXP)–120	Extremely fine grain, very high resolving power.	32	32
PLUS-X PAN PROFESSIONAL (PXP)– 120 and 220 in pro-pack (5 rolls)	General-purpose film, retouching surface on emulsion side.	125	125
TRI-X PAN PROFESSIONAL (TXP)– 120 and 220 in pro-pack (5 rolls); film packs	Superior highlight brilliance, good contrast control, retouching surface on both sides.	320	320
ROYAL-X PAN (RX)–120 only	Ultra-fast. For existing light.	1250②	1250②
RECORDING 2475 (Estar-AH Base) (RE)–135-36①	Ultra-fast panchromatic. For adverse light conditions.	–	1000-3200③
TECHNICAL PAN (Estar-AH Base) SO-115①	Panchromatic. For line copying.	–	100
HIGH SPEED INFRARED (HIE)–135-20 only	Haze penetration, special effects and purposes.	–③	–③
SHEET FILMS	**PROPERTIES & PURPOSE**	**Daylight**	**Tungsten**
EKTAPAN 162 (Estar Thick Base)⑧	For portraits by electronic flash and general use.	100	100
PLUS-X PAN PROFESSIONAL 4147 (Estar Thick Base)⑧	Excellent definition. For portrait and commercial work.	125	125
SUPER-XX PAN 4142 (Estar Thick Base)	Long tonal gradation. Color-separation negatives.	200	200
TRI-X PAN PROFESSIONAL 4164 (Estar Thick Base)⑧	Superior highlight brilliance, good contrast control.	320	320

Notes ① to ⑧: See bottom of next page 13.

KODAK BLACK-AND-WHITE FILMS (Continued)

	PROPERTIES & PURPOSE	Tungsten	Daylight
TRI-X ORTHO 4163 (*Estar* Thick Base)	Superior highlight brilliance. For portraits and commercial subjects.	320	200
ROYAL PAN 4141 (*Estar*) Thick Base⑥	High speed. General purpose.	400	400
ROYAL-X PAN 4166 (*Estar* Thick Base)	Ultra-fast. For available-light exposure.	1250③	1250③
COMMERCIAL 6127 and *4127* (*Estar* Thick Base)	Blue-sensitive. For continuous-tone copying, transparencies.	50 (20)⑨	8
CONTRAST PROCESS ORTHO 4154 (*Estar* Thick Base)	Extremely high contrast. For line copies.	100⑨	50
CONTRAST PROCESS PAN 4155 (*Estar* Thick Base)	Extremely high contrast. For copies of colored line originals.	100⑨	80
PROFESSIONAL COPY 4125 (*Estar* Thick Base)	Retains highlight gradation in copies.	25⑨	12
HIGH-SPEED INFRARED 4143 (*Estar* Thick Base)	Haze penetration, special effects. Document copying.	–③	–③

LONG ROLLS (Wider than 16mm)

	PROPERTIES & PURPOSE	Tungsten	Daylight
PLUS-X PAN PROFESSIONAL 2147 (*Estar* Base)	Good definition and excellent latitude.	125	125
PLUS-X PORTRAIT 5068	For portrait and school work. Retouching surface.	125	125
DIRECT POSITIVE PANCHROMATIC 5246	For reversal processing to slides.	80	64

Notes
① Must be processed into slides or transparencies before prints can be made.
② Must be developed to negatives before prints or slides can be made.
③ See film instructions.
④ If results are consistently bluish, use a No. 81B filter and increase exposure ⅓ stop.
⑤ If results are consistently bluish, use a CC10Y or CC20Y filter and increase exposure ⅓ stop. (If CC filters are not available, substitute a No. 81B filter.)
⑥ Chemicals other than the *Kodak* Chemicals listed may be available.
⑦ Also available in long rolls, 35mm perforated.
⑧ Also available in long rolls, 3½ in. wide.
⑨ Speed to white-flame arc.

EASTMAN KODAK

23

The Compact Photo-Lab-Index

EASTMAN KODAK

SHEET FILMS

Film	Properties & Purpose	Daylight	Tungsten
EKTAPAN 4162 (ESTAR Thick Base)	For portraits by electronic flash and general use.	100	100
PLUS-X PAN PROFESSIONAL 4147 (ESTAR Thick Base)¶	Excellent definition. For commercial work.	125	125
SUPER-XX PAN 4142 (ESTAR Thick Base)	Long tonal gradation. Color-separation negatives.	200	200
SUPER PANCHRO-PRESS 6146, TYPE B	General purpose. Good contrast control.	250	250
TRI-X PAN PROFESSIONAL 4164 (ESTAR Thick Base)¶	Superior highlight brilliance, good contrast control, excellent retouching surface.	320	320
TRI-X ORTHO 4163 (ESTAR Thick Base)	Superior highlight brilliance. For men's portraits and commercial subjects.	320	200
ROYAL PAN 4141 (ESTAR Thick Base)	High speed. General purpose.	400	400
ROYAL-X PAN 4166 (ESTAR Thick Base)	Ultra-fast. For available-light exposure.	1250	1250
COMMERCIAL 6127 and 4127 (ESTAR Thick Base)	Blue-sensitive. For continuous-tone copying.	50 (20‡)	8
CONTRAST PROCESS ORTHO 4154 (ESTAR Thick Base)	Extremely high contrast. For line copies.	100‡	50
CONTRAST PROCESS PAN 4155 (ESTAR Thick Base)	Extremely high contrast. For colored line copies.	100‡	80
PROFESSIONAL COPY FILM 4125 (ESTAR Thick Base)	Retains highlight gradation in copies.	25‡	12
PROFESSIONAL LINE COPY 6573	Orthochromatic. Extremely high contrast. For highlight masking.	—	3
HIGH SPEED INFRARED FILM 4143 (ESTAR Thick Base)	Haze penetration, special effects. Document copying.	—	—

LONG ROLLS

Film	Properties & Purpose	Daylight	Tungsten
PLUS-X PAN PROFESSIONAL 2147 (ESTAR Base)	Good definition and excellent latitude.	125	125
PLUS-X PORTRAIT 5067	For portrait and school work. Retouching surface.	125	125

•Also available in long rolls, 35mm perforated and 70mm perforated.
¶Also available in long rolls, 3½ in. wide.
‡Speed to white-flame arc.

The Compact Photo-Lab-Index

EASTMAN KODAK

BLACK-AND-WHITE PRODUCTS

Texture	Smooth	Smooth	Smooth	Smooth	Fine Grained	Fine Grained	Tweed	Silk	Tapestry
Brilliance	Glossy	Lustre	High Lustre	Matte	Lustre	High Lustre	Lustre	High Lustre	Lustre
Kodak Black-and-White Materials									
Ad-Type		A WH, LW 2,3							
Azo	F WH, SW 1-5 DW 2				E WH, SW 2-3 DW 2, 3				
Dye Transfer	F WH, DW				G CR, DW				
Ektalure					G CR, DW	K WM-WH DW	R CR, DW	Y WM-WH DW	X CR, DW
Ektamatic SC	F WH SW, DW	N WH, SW A WH, LW							
Kodabrome II RC	F WH, MW S-ÜH°	N WH, MW S-ÜH°							
Kodabromide	F WH, SW 1-5 DW 1-5	A WH LW 2-3			E WH, SW 2-4 DW 2-4				
Medalist	F WH, SW 1-4 DW 2,3				G CR, DW 2-3			Y CR, DW 2, 3	
Mural							R, WRM CR, SW 2-3		

25

EASTMAN KODAK

BLACK-AND-WHITE PRODUCTS (Continued)

Texture	Smooth	Smooth	Smooth	Smooth	Fine Grained	Fine Grained	Tweed	Silk	Tapestry
Brilliance	Glossy	Lustre	High Lustre	Matte	Lustre	High Lustre	Lustre	High Lustre	Lustre
Panalure	F WH, SW								
Panalure Portrait					E WH, DW				
Polycontrast	F WH SW, DW	N WH SW, DW A WH, LW	J WH SW, DW		G CR, DW				
Polycontrast Rapid	F WH SW, DW	N WH, SW			G CR, DW			Y CR, DW	
Polycontrast Rapid RC	F WH, MW	N WH, MW							
Polycontrast Rapid II RC	F WH, MW	N WH, MW							
Portrait Proof							R CR, SW		
Resisto		N WH SW 2-3							
Studio Proof	F WH, SW								
Velox	F WH SW 1-4								
Velox Premier RC	F WH, MW				E WH, MW				
Velox Unicontrast	F WH, SW								

WH—White paper stock; CR—Cream-white paper stock; WM-WH—Warm-white paper stock.
*Available in soft, medium, hard, extra hard and ultra hard grades.

EASTMAN AND KODAK COLOR CAMERA FILMS—MOTION PICTURE

Name of Film	Film Code No. (35mm)	Film Code No. (16mm)	General Description	Exposure Index Daylight	Exposure Index Tungsten (3200K)	Code Letter Ident. **(Prec. Footage Number)	End Mark. (on 16mm 100-ft. and 200-ft. spools)	Footage Numbered•	Frame-line Marked (35mm only)	Magnetic Pre-striping (16mm only)
EASTMAN Color Negative II	5247	7247	A high speed color film designed for camera use in tungsten light.	64 (with KODAK No. 85 Filter)	100			YES	NO	NO
EASTMAN EKTACHROME Commercial		7252	A low-contrast, reversal-type, multi-layer color film for general 16mm color production work both outdoors and in the studio. Recommended for originals from which it is desired to make one or more color release prints.	16 (with KODAK No. 85 Filter)	25		EKT-C	YES	NO	NO
5256 7256 KODAK EKTACHROME MS (Daylight)	5256	7256	A medium-speed, daylight-balanced color film processed by reversal to give a positive intended primarily for direct projection. It finds useful application in data and engineering analysis, high-speed camera use and sports photography under low daylight illumination conditions.	64	†See note at bottom of this page.		EMS	YES	NO	YES
KODAK EKTACHROME EF (Daylight)	5241	7241	A high-speed, color reversal film for daylight exposure, designed for use under very low illumination conditions or high-speed photography applications where sufficient exposure cannot be obtained with slower-speed color reversal films.	160	40 (with KODAK No. 80A Filter)		EF	YES	NO	YES
KODAK EKTACHROME EF (Tungsten)	5242	7242	This film, for exposure at 3200 K, serves as a companion to EKTACHROME EF Film Daylight Type, and is useful for making industrial pictures under existing plant illumination, for nighttime sports photography and newsreel work.	80 (with KODAK No. 85B Filter)	125		EFB	YES	NO	YES

†Exposure to tungsten light not recommended except under emergency conditions. For 3200 K tungsten lamps and with KODAK Filter No. 80A, index is 16.

EASTMAN KODAK

27

EASTMAN AND KODAK COLOR CAMERA FILMS—MOTION PICTURE (Continued)

Film	Number	Description	Speed
EASTMAN EKTACHROME Video News Film High Speed (Tungsten)	7250	Very high speed reversal color camera film. Balanced for 5400 K projection, suitable for telecasting.	
EASTMAN EKTACHROME Video News Film (Daylight)	5239 / 7239	A high-speed color reversal film for low-level daylight. Balanced for projection at 5400 K, suitable for TV telecasting.	160 — 40 (with KODAK 80A Filter)
EASTMAN EKTACHROME Video News Film (Tungsten)	5240 / 7240	A high-speed color reversal film for tungsten. Balanced for projection at 5400 K, suitable for TV telecasting.	80 (with KODAK 85B Filter) — 125
KODAK EKTACHROME SM Film (Type A)	7244	A high-speed super 8 reversal color camera film for low-level illumination. Balanced for 5400 K projection for TV telecasting.	100 (with KODAK No. 85 Filter) — 125 (with KODAK 82A Filter)

KODAK MOTION PICTURE FILMS (Color)

KODAK FILM (code) COLOR FILMS	Balanced For	FILM SPEED AND KODAK WRATTEN FILTER NUMBER						PROCESSING
		Daylight		Photolamps (3400 K)		Tungsten (3200 K)		
		Speed	Filter	Speed	Filter	Speed	Filter	
KODACHROME 25 Daylight (KM) (Daylight) 8mm and 16mm	Daylight	25	None	Not recommended		Not recommended		Not for user processing — By Kodak labs and photofinishers. Sent to Kodak by dealers or direct by users with Kodak Mailers.
KODACHROME 40 Type A (KMA) (Type A) 8mm, super 8 silent & sound, & 16mm	Movie Light (3400 K)	25	85	40	None	32†	82A	
EKTACHROME 160 Type A (ELA) For use in limited light. Super 8 & super 8 sound only	Tungsten	100	85*	160	None	160	None†	Ektachrome Movie
EKTACHROME 160 Type G (EG) For use in limited light. Super 8 only	Use in any type of light	160	None	160	None	160	None	
EKTACHROME MS 7256 (EMS) 16mm	Daylight	64	None	20	80B	16	80A	Process ME-4 — By Kodak and other labs. Sent to Kodak by dealers.
EKTACHROME EF Super 8 and 16mm — 7241, EF Daylight (16mm only)	Daylight	160	None	50	80B	40	80A	
EKTACHROME EF Super 8 and 16mm — 7242, EFB Tungsten (Super 8 and 16mm)	3200 K Tungsten	80	85B	100	81A	125	None	

Kodak Chemicals §

29

EASTMAN KODAK

The Compact Photo-Lab-Index

KODAK COLOR & B & W CAMERA FILMS—MOTION PICTURE

MOVIE FILMS	Balanced For	Speed	Daylight Filter	Daylight Speed	Photoflood Filter	Photoflood Speed	3200 K Tungsten Filter	3200 K Tungsten Speed	Processing
KODACHROME For color movies 8, super 8 (Type A only), & 16mm — Daylight Type (KM)	Daylight	25	None		Not recom.		Not recom.		Processed by Kodak and other labs. Sent to Kodak by dealers or direct by users with KODAK Mailers. — Process K-14
Type A (KMA)	Movie Light (3400 K)	25	85	40	None		Not recom.		
EKTACHROME 40 EMA — Super 8 only	Movie Light (3400 K)	25	85	40	None		Not recom.		
EKTACHROME 160 ELA — For use in limited light. Super 8 and Sound Super 8 only.	Tungsten	100	85°	160	None	160	None†		
EKTACHROME TYPE G — For all kinds of light.									
EKTACHROME MS 7256 (EMS) — For color movies in limited light. 16mm	Daylight	64	None	20	80B	16	80A		Processed by Kodak and other lab. Sent to Kodak by dealers. — ME-4

EASTMAN KODAK B & W MOTION PICTURE CAMERA FILMS

Name of Film	Film Code No. (35mm)	Film Code No. (16mm)	General Description	Exposure Index Daylight	Exposure Index Tungsten (3200K)	Code Letter Ident. **(Prec. Footage Number)	End Markings (on 16mm 100-ft. and 200-ft. spools)	Footage Numbered*	Frame-line Marked (35mm only)	Magnetic Pre-striping (16mm only)
EASTMAN PLUS-X Negative	4231	7231	High-speed, fine-grain negative film for general production use both outdoors and in the studio.	80	64	H	PXN	YES	YES	YES
EASTMAN DOUBLE-X Negative	5222	7222	A high-speed negative film representing the latest advances in speed-granularity ratio. Suitable for exterior and interior photography under difficult lighting conditions.	250	200	C	DXN	YES	YES	YES
EASTMAN 4-X Negative	5224	7224	An extremely highspeed negative film of medium graininess. It has an exceptional ability to reproduce shadow detail. It is well suited for newsreel work and all photography where the lighting conditions are adverse.	500	400	G	4XN	YES	YES	YES
KODAK PLUS-X Reversal		7276	Fine-grain, medium-speed reversal film for general motion picture production use where reversal films are indicated.	50	40		PXR	YES		YES

*All 35mm films are ink-footage numbered except 5254, 5256, 5241 and 5242, which are latent-image footage numbered; all 16mm films are latent-image footage numbered.

**35mm films only.

EASTMAN KODAK

31

EASTMAN KODAK B & W MOTION PICTURE CAMERA FILMS (Continued)

Name of Film	Film Code No. (35mm) (16mm)	General Description	Exposure Index Daylight	Exposure Index Tungsten (3200K)	Code Letter Ident. °° (Prec. Footage Number)	End Markings (on 16mm 100-ft. and 200-ft. spools)	Footage Numbered°	Frame-line Marked (35mm only)	Magnetic Pre-striping (16mm only)
KODAK TRI-X Reversal	7278	High-speed reversal film of medium granularity provides excellent halation control. It is useful for photography under difficult lighting conditions both outdoors and in the studio. Especially suitable for television newsreel work and sports photography.	200	160		TRX	YES	YES	YES
KODAK 4-X Reversal	7277	A high-speed reversal film having twice the speed of TRI-X Reversal Film. Especially suitable for photographing news and sports under limited available light and for high-speed photography. Excellent halation control.	400	320		4RX	YES	YES	YES

°All 35mm films are ink-footage numbered except 5254, 5256, 5241 and 5242, which are latent-image footage numbered; all 16mm films are latent-image footage numbered.
°°35mm films only.

EASTMAN SOUND RECORDING AND TELEVISION RECORDING FILMS

Name of Film	Film Code No. (35mm) (16mm)	General Description	Code Letter Identification (35mm only) (Precedes Footage Number)	Footage Numbered°	Frame-line Marked (35mm only)
Fine Grain Sound Recording	5375 7375	A film designed for variable area sound recording using a tungsten light source. May also be used for direct playback purposes.	S	YES	YES
Television Recording	5374 7374	This material is intended for making kinescope recordings of television programs using monitor tubes having either blue (P-11) or ultraviolet (P-16) phosphors.	S	YES	YES

°All these 35mm films are ink-footage numbered; all 16mm films are latent-image footage numbered.

EASTMAN DUPLICATING FILMS

	35mm	16mm				
Color Reversal Intermediate	5249	7249	Designed for making duplicate negatives from negative originals in one printing stage instead of the two stages usually required for duplication.	D	YES	NO
Fine Grain Panchromatic Duplicating Negative	5234	7234	A low-speed, extremely fine-grain duplicating negative film. May be used to make duplicate negatives from master positives or internegatives from reversal originals.	D	YES	YES
Fine Grain Duplicating Positive	5366	7366	A blue-sensitive film with extremely fine grain and very high resolution. Intended for making positives from camera negatives. Used as a companion to 5234 and 7234.	D	YES(35) NO(16)	YES
Panchromatic Separation	5235		An extremely fine-grain film intended for making black-and-white separation positives from color negatives.	D	YES	YES
Color Intermediate	5253	7253	A multilayer color film suitable for use in preparing both color master positives and color duplicate negatives from originals on Color Negative Film.	M	YES	NO
Color Internegative	5271	7271†	A multilayer color film designed for making color internegatives from color reversal originals. The film is designed for printing onto Color Print Film.		YES	NO
Direct MP	5360	7360	A low-speed, black-and-white, orthochromatic duplicating film with extremely fine grain, high resolving power, and medium contrast. Used for making a black-and-white duplicate of any black-and-white negative, black-and-white positive, or color print film.			NO

•All 35mm films are ink-footage numbered except 5253 and 5271, which are latent-image footage numbered; most 16mm films are latent-image footage numbered.

†Also supplied perforated for certain super 8 formats.

EASTMAN KODAK

33

CODE NOTCHES FOR KODAK SHEET FILMS

When the notch is at the right hand side of the top edge of the sheet, the emulsion sides faces you.

KODAK Black-and-White Films

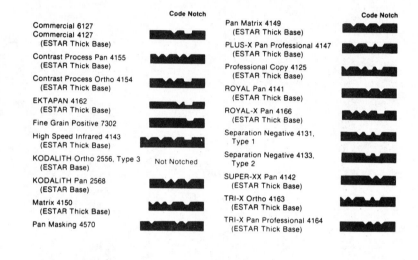

Code Notch

Commercial 6127
Commercial 4127
 (ESTAR Thick Base)

Contrast Process Pan 4155
 (ESTAR Thick Base)

Contrast Process Ortho 4154
 (ESTAR Thick Base)

EKTAPAN 4162
 (ESTAR Thick Base)

Fine Grain Positive 7302

High Speed Infrared 4143
 (ESTAR Thick Base)

KODALITH Ortho 2556, Type 3 Not Notched
 (ESTAR Base)

KODALITH Pan 2568
 (ESTAR Base)

Matrix 4150
 (ESTAR Thick Base)

Pan Masking 4570

Code Notch

Pan Matrix 4149
 (ESTAR Thick Base)

PLUS-X Pan Professional 4147
 (ESTAR Thick Base)

Professional Copy 4125
 (ESTAR Thick Base)

ROYAL Pan 4141
 (ESTAR Thick Base)

ROYAL-X Pan 4166
 (ESTAR Thick Base)

Separation Negative 4131,
 Type 1

Separation Negative 4133,
 Type 2

SUPER-XX Pan 4142
 (ESTAR Thick Base)

TRI-X Ortho 4163
 (ESTAR Thick Base)

TRI-X Pan Professional 4164
 (ESTAR Thick Base)

KODAK Color Films

Code Notch

(For Process C-41)

VERICOLOR II Professional
 4107, Type S

VERICOLOR II Professional
 4108, Type L

VERICOLOR Internegative
 4112 (ESTAR Thick Base)

VERICOLOR Print 4111
 (ESTAR Thick Base)

Code Notch

(For Process E-6)

EKTACHROME 64 Pro-
 fessional 6117 (Daylight)

EKTACHROME Pro-
 fessional 6118 (Tungsten)

EKTACHROME Duplicating
 6121 (Process E-6)

(For Process C-22; discontinued)

EKTACOLOR Internegative 6110

EKTACOLOR Print 4109
 (ESTAR Thick Base)

EKTACOLOR ID/Copy 5022

EASTMAN KODAK

34

CHARACTERISTICS OF NEGATIVE QUALITY

A good-quality negative can be defined as one that will make a high-quality print when printed on the paper you choose with your enlarger or contact printer.

The shadow densities, as determined primarily by exposure, are great enough to reproduce the tones just lighter than black (0.10 to 0.15 above the base plus fog density).

The density range of the negative, as achieved by development, matches the scale of the paper when exposed by your printing equipment, or is made to match by dodging (holding back or burning in).

TONE REPRODUCTION

Tone reproduction is one of the most important factors in technical print quality. The black-and-white photographic process converts the neutral and colored tones of the subject into whites, grays, and blacks in the print. How well these tones represent the visual aspects of the subject is a prime measure of the photographic quality.

The brightness range (technically, the luminance ratio) of the typical, outdoor, 45° frontlit subject greatly exceeds 1000/1 if you include the deepest shadow and the specular highlights. The black-and-white paper can reproduce a brightness range of only slightly over 100/1, at best (glossy paper). You must do two things to fit the subject range to the paper range:

1. Compress the tonal scale.

2. Let all specular highlights print as white, and let all the deepest tones print as black. The deepest tones are usually dark subjects in shadow and relatively unimportant to the picture.

Graphic Representation of Typical Photographic Tone Reproduction

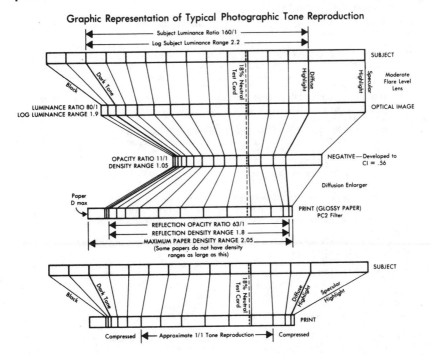

The Compact Photo-Lab-Index

EASTMAN KODAK

When you eliminate the specular highlights and deepest blacks from the subject tonal range, you are left with about a 160/1 brightness range from the *diffuse* highlight tone to the dark tone to be reproduced just lighter than black in the print. The print range from the diffuse highlight tones, which are printed with a density of about 0.04 greater than that of the paper base, to the dark tones, just lighter than black, which are printed about .90 × the D-max, is about 60/1 for glossy paper. This means that the subject range is compressed to make the tonal range fit the scale of the paper.

The film, however, compresses the tonal range even more than this—so that the tonal range is actually expanded when the negative is printed.

While this compression and expansion of the brightness ratio is occurring in the typical black-and-white photographic process, all parts of the tonal scale are not compressed and expanded evenly. As indicated earlier, the darkest tones in the shadow areas are dropped from the reproduction—they are reproduced as *black* with no detail. The tones just lighter than black are compressed considerably. Dark tones are compressed somewhat. *The middle tones are usually reproduced in the print with no compression at all.* This means that the brightness ratio between adjacent tones in the middle of the tonal scale is nearly the same in the print as it is in the subject. In the highlight region, the tones are compressed, but not so much as they are in the shadows. This occurs because in properly exposed and developed negatives there is the same compression in the highlight region as in the midtones, while the shadow region *is compressed* in the negatives by being recorded in the toe of the characteristic curve. This type of tone reproduction, with relative values, is shown in the series of diagrams.

The quality negative, then, is one that will make a high-quality print on your printing equipment, and a high-quality print will have the type of tonal reproduction just described.

JUDGING NEGATIVE QUALITY VISUALLY

Not all photographers have equipment to measure negative densities, but experienced photographers can usually tell by a visual examination whether or not a negative has the quality for a particular purpose. Those with less experience may have some difficulty in choosing the best negative from among several. One method is to place the negative, emulsion side down, on a sheet of good black-and-white printed matter.

If the negative is to be printed on a diffusion-type enlarger, it should be just possible to read the large type through the diffuse highlight areas of the negative. The deepest shadow areas should be clear, while detailed shadow areas (lighter tones in shade) should show varying light densities. A negative that passes this test should print well on a medium grade of paper on a diffusion enlarger.

A negative to be printed on a condenser enlarger will have similar characteristics in the shadow areas, but the diffuse highlight areas will be less dense, and the printing should also be readily distinguishable through these areas.

Other characteristics of a good-quality negative are usually:

Every part of the negative that is intended to be sharp should be sharp when viewed with a magnifying glass.

The overall density should allow reasonably short printing exposures.

The density range of the negative should be such that the negatives will print on grade 2 or medium-grade paper on your printing equipment to give good highlight and shadow reproduction.

The deepest shadow areas should be clear in the negatives, while the shadowed light tones should show adequate detail.

The diffuse highlights should have gradation and should have noticeably less density than the specular highlights.

The image should not print with more effective graininess than can be expected from the type of film emulsion at the magnification used.

The negative should be free from physical imperfections: scratches, static markings, scum, water spots or water marks, pinholes caused by dust or improper film developer, or dried-on dust particles.

The negative should be free from mottle or uneven densities caused by improper agitation during development or a very short development time.

The Compact Photo-Lab-Index

MEASURING NEGATIVE QUALITY

A precise method of judging negative printing quality is to measure certain negative densities with a densitometer. Using such measurements, you can:

Evaluate the film exposure. Measure the density of a shadow area that you want to print just lighter than black. Its density should be 0.10 to 0.15 above the gross fog density of the film (base + fog density).

Evaluate the film development. Measure a diffuse highlight area that you want to print just darker than white. Subtract the density of the shadow area from that of the diffuse highlight to find the *density* difference. If a subject has a normal brightness ratio of 160:1, the density difference (negative density range) should be about 1.05 for negatives to be printed with diffusion enlargers or 0.80 for negatives made for condenser enlarger printing. For example:

	Diffusion Enlarger	Condenser Enlarger
Lightest Diffuse Highlight Density	1.20	0.90
Detailed Shadow Density	−0.15	−0.10
Density Range	1.05	0.80

The aim density ranges of 0.80 for condenser enlargers and 1.05 for diffusion enlargers are average figures derived from measurements made on a number of modern enlargers with clean lenses. Your enlarger may be slightly different—in other words, prints made on grade 2 or medium-grade paper (or on a selective-contrast paper with a *Kodak Polycontrast Filter PC2*) may consistently have too little or too much contrast. When the contrast is too low, increase the developing time and find a higher density difference that produces the contrast you want on grade 2 paper with your enlarger. If the contrast is too high, reduce the development time and find a lower density range figure that gives the contrast you want. A useful tool in finding the correct density range is the 8-step gray scale in *KODAK Professional Photoguide,* Publication No. R-28, available at your photo dealer.

The actual density difference of many negatives will be higher or lower than your aim, due to subject contrast variation. Various paper grades are available to compensate for these differences.

THE CHARACTERISTIC CURVE

The way a photographic emulsion responds to exposure and development is seen most clearly by plotting a graph called the characteristic curve.

To obtain the characteristic curve of a film, a section of the material is given a carefully controlled exposure through a step tablet in an instrument called a sensitometer. The step tablet produces a series of exposure steps in the film, each one of which differs from the preceding step by a constant factor, such as 2 or the square root of 2 (1.41). The exposed sample film is developed under very carefully controlled conditions to yield a test film with a series of steps that differ in *density*.

Density is a measure of the light-stopping attribute of an area in a photographic image, and is largely dependent on the amount of metallic silver developed in the image. The diffuse highlight density in a well-exposed and processed film will be in the 0.90 to 1.40 range. While higher densities may be encountered, in a practical sense, continuous-tone negatives that have densities over 2.50 can be very difficult to print.

Transmittance is the ratio, in decimal form, of transmitted light divided by incident light. When half the incident light goes through a piece of film, the transmittance of the film is 0.5. *Opacity* is the reciprocal of the transmittance ($\frac{1}{0.5} = 2$). *Density* is the logarithm of the opacity. ($\log_{10} 2 = .301$). A film density of .3 lets half the light go through.

When a film is given a sensitometric exposure, the amount of exposure that is given to each step is specified in terms of light intensity multiplied by the length of the exposure time. As indicated in the drawing, the exposure units are meter-candle-seconds. Because it results in a curve that is easy to interpret, the density is plotted versus the *logarithm* of exposure. In the illustration, the equivalent transmittance and opacity values are shown opposite the density values, and the equivalent meter-candle-second values are shown opposite the log exposure values.

EASTMAN KODAK

37

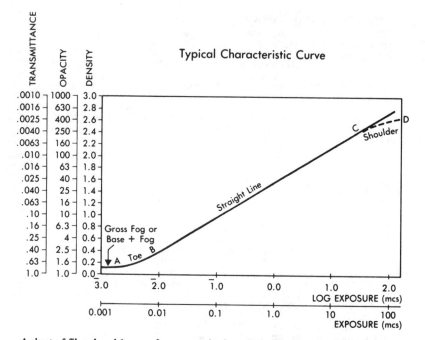

A sheet of film placed 1 meter from a standard candle is illuminated by light of an intensity of 1 meter-candle. If it is exposed to light of 1 meter-candle intensity for 1 second, it has received an exposure of 1 meter-candle-second.

The characteristics curve made from readings taken from a test film exposed and processed as above is an absolute or real characteristic curve of a particular emulsion processed in a particular developer in a particular manner, etc.

You can make *relative* characteristic curves yourself. If you photograph a transilluminated film step scale or an illuminated paper gray scale, and plot the densities of the test film versus the transmission densities of the original film step scale or the reflection densities of the original paper gray scale, you have a *relative* characteristic curve. These are useful curves but provide only relative speed information.

Representation characteristic curves are those that are typical of a product, and are made by averaging the results from a number of tests made on a number of production batches of films.

Curve Shape: Because of its shape, the characteristic curve is generally divided into three distinct regions. In the illustration of the typical curve, you will see that section AB is called the toe, BC is called the straight line, and CD, the shoulder.

The shape of the characteristic curve varies with different emulsions. The toe may be short or long. The straight line may be long, or it may be straight line in name only. With some films the curve may continue upward, like an extended toe, throughout the entire useful range of the film. The meaning of curve shape in practical negative making is explained in the following sections.

The Toe: The section to the left of A is a horizontal straight line. This represents the region of exposure in which the film gives no response. The unexposed edge of a processed film has this density. It is sometimes called the gross fog or base plus fog density.

From A to B is the toe, the crescent-shaped lower part of the characteristic curve. In this

region the tones are compressed, and the density change for a given log-exposure change increases continuously. As a practical matter, this means that the separation of thin shadow densities in the negative becomes progressively less as the lower end of the toe is approached, and densities less than about 0.10 density units greater than the gross fog level usually print as black. The toe region varies in length and shape with different films. Toe shape is an important factor in the choice of a film for a particular use.

The Straight Line: In films that have a straight line in the characteristic curve, the midsection of the curve (B to C) has a constant gradient for a given log exposure change. The relationship between density and the log exposure is constant. The tonal scale is compressed *evenly.*

Some films have a long straight line like that shown in the illustration, whereas other have little or no straight line. When the direction of the line changes only a few degrees, this usually does not change the tone reproduction to a visible extent. In other words, the line may be considered straight even though it has a slight bend or curve in it. The differences in curve shape affect choice of a film, exposure, and development latitude, and can be used to advantage in various picture-taking situations. The slope of the straight line (a measure of the angle it makes with the horizontal axis) is an important measure of contrast, and is determined both by emulsion characteristics and the development.

CHARACTERISTIC CURVE OF LONG TOED *KODAK* FILM DEVELOPED TO A CONTRAST INDEX = .53

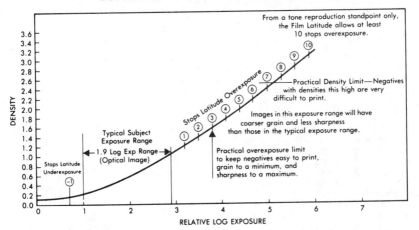

The Shoulder: As shown by the dotted line in the upper part of the curve (C to D), the shoulder is the region where the slope of the characteristic curve decreases, and the curve finally becomes a horizontal line again. With *most films, the shoulder is never reached* in practical picture making. Negatives would have to be 10-15 stops overexposed before the shoulder would be reached. With some films, such as *Kodak* High Speed Infrared Film 4143 (Estar Thick Base), the shoulder is reached within the highlight region of the exposure. For best results, such films must be exactly exposed, because when highlights are exposed on the shoulder of a film, tone separation is lost, and the highlights are "blocked." This means poor highlight tone separation. However, most *Kodak* film emulsions for general use are designed with extremely long straight lines, which result in excellent tone separation in the highlights, even in grossly overexposed negatives.

The illustration shows the characteristic curve of a long toe film. Note that the straight line portion might be considered an extension of the toe, and that there is no tendency to shoulder off even at 10 stops overexposure.

EASTMAN KODAK

Other factors harmful to photographic reproduction become evident with gross overexposure—negatives become difficult to print because of the high density levels, and the graininess is increased while the sharpness is decreased. For these reasons, **three stops of overexposure should be considered a practical limit. If the same care is applied to correct exposure in black-and-white photography as is necessary in color photography, then maximum quality due to correct exposure can be achieved.**

CHOOSING A FILM

There are a number of factors that determine the choice of a black-and-white film:

1. Availability in format to fit camera
2. Contrast
3. Color Sensitivity
4. Speed
5. Characteristic Curve Shape
6. Other Emulsion Characteristics
 a. Graininess
 b. Resolving Power
 c. Degree of Enlargement

FORMAT AVAILABILITY AND FILM USAGE

Some subjects can be photographed with nearly any type of camera and with any of a number of films. Other subject may require a certain type of camera, for which a limited number of films are available.

SHEET FILMS

The widest variety of film emulsion types is available in sheet film. Because sheet film cameras are generally first choice for copying, architectural photography, and photography where large film format size is required for maximum image definition, films for a wide variety of uses are made in sheet form. Some suggestions for various purposes are listed below:

ROLL FILMS

For many years roll films, including 35 mm magazines, were considered amateur products. In recent times, with the improvement of film emulsions, the availability of professional quality roll-film cameras, and the availability of roll-film backs for sheet-film cameras, roll films have been increasingly used by professional photographers. Once the film emulsions were advanced to where they would stand reasonable enlargement without obvious graininess and without much sacrifice in definition, the smaller formats became practical. For the professional, the chief advantages over the sheet-film camera are the ease in changing film and in processing resulting from the roll format, increased portability and flexibility of the camera position due to smaller camera size, availability of faster lenses, increased precision resulting from the type of small camera construction, the compositional advantages of reflex finding, and the lower cost of the smaller film area. The chief disadvantages are the loss in camera flexibility (no swings or tilts for perspective correction), a lessening of potential definition in print quality, and an increased difficulty in negative retouching. Some suggestions for various purposes are listed below:

LONG ROLL FILMS

Where the type of photography involves many similar exposures, and where other factors permit, cameras that use long rolls of film are often used. Some types of portraiture, school photography, mass-production copying and duplicating, and some types of 35 mm sports photography are examples. While the long rolls (15, 27½, 50, 75, 100 feet long in 35 mm, 46 mm, 70 mm, and 3½-inch widths perforated and unperforated) are designed to fit long roll cameras or camera backs, some types are cut into shorter lengths and loaded into magazines or cassettes. Some suggestions for various purposes and long roll film types are listed below:

EASTMAN KODAK

The Compact Photo-Lab-Index

The photographer thinks in terms of a camera-film combination that will best fulfill the requirements of his photographic task. In the purchase of new cameras for specific purposes, it is wise to survey the availability of films that will fit the camera, which are also best suited to the type of photographic work expected to be done with the camera. With already available equipment, some film that comes close to meeting the photographic needs can usually be found. In rare cases when no suitable film may be found available to fit the camera, another suitable film type can often be special-ordered from *Kodak* cut to size, provided minimum order quantity requirements are met.

Film Use	*KODAK Films, Sheets*
Line Copy—extreme contrast	*Kodalith* Ortho, 2556, Type 3 (*Estar* Base) *Kodalith* Pan, 2568 (*Estar* Base)
Line Copy—very high contrast	Contrast Process Pan, 4155 (*Estar* Thick Base) Contrast Process Ortho, 4154 (*Estar* Thick Base)
Continuous Tone Copy	Commercial, 6127 Commercial, 4127 (*Estar* Thick Base) Professional Copy, 4125 (*Estar* Thick Base)
Direct Duplicate Negatives	Professional Direct Duplicating (*Estar* Thick Base) SO-015
Positive Transparencies	*Translite*, 5561 Commercial, 6127 Commercial, 4127 (*Estar* Thick Base) Fine Grain Positive, 7302
Continuous Tone—medium speed	*Ektapan*, 4162 (*Estar* Thick Base) *Plus-X* Pan Professional, 4147 (*Estar* Thick Base)
Continuous Tone—high speed	*Super-XX* Pan, 4142 (*Estar* Thick Base) *Tri-X* Pan Professional, 4164 (*Estar* Thick Base) *Tri-X* Ortho, 4163 (*Estar* Thick Base) *Royal* Pan, 4141 (*Estar* Thick Base)
Continuous Tone—extremely high speed	*Royal-X* Pan, 4166 (*Estar* Thick Base)
Special Sensitivity—aerial	High Speed Infrared, 4143 (*Estar* Thick Base)

In addition to these sheet films used commonly by professional photographers, there are more specialized sheet films available that are used in fields such as graphic arts, radiography, and engineering drawing reproduction.

ROLL FILMS

Film Use	*KODAK Films, Rolls and/or 35mm*
Line Copy—high contrast	*Technical* Pan (*Estar*-AH Base) SO-115
Continuous Tone—low speed	*Panatomic-X* *Panatomic-X* Professional
Continuous Tone—medium speed	*Plus-X* Pan *Plus-X* Pan Professional *Verichrome* Pan
Continuous Tone—high speed	*Tri-X* Pan *Tri-X* Pan Professional
Continous Tone—extremely high speed	*Royal-X* Pan Recording 2475, (*Estar*-AH Base)

The Compact Photo-Lab-Index

LONG ROLL FILMS

Film Use	KODAK Films, Long Rolls
Line Copy—extreme contrast	*Kodalith* Ortho, 6556, Type 3
Line Copy—very high contrast	*Technical* Pan (*Estar*-AH Base) SO-115
Continuous Tone Copy	Ortho Copy, 5125
Direct Camera Positives	Direct Positive Panchromatic, 5246
Transparency Prints from Negatives	*Eastman* Fine Grain Release Positive, 5302
Continuous Tone—slow speed	*Panatomic-X*
Continuous Tone—medium speed	*Plus-X* Pan *Plus-X* Pan Professional, 2147 (*Estar* Base) *Plus-X* Portrait, 5068 *Ektapan,* 4162 (*Estar* Thick Base)
Continuous Tone—high speed	*Tri-X* Pan *Tri-X* Pan Professional, 4146 (*Estar* Thick Base) *Royal* Pan, 4141 (*Estar* Thick Base)
Continuous Tone—extremely high speed	Recording 2475, (*Estar*-AH Base)

CHARACTERISTICS OF *KODAK* BLACK-AND-WHITE FILMS

Extremely High Contrast Films: When the photographer must copy a line drawing, printed text material, or other high-contrast subject, extremely high contrast films such as *Kodalith* Ortho Film 6556, Type 3, or 2556, Type 3 (*Estar* Base), might well be his first choice. Developed in *Kodalith* developer (or one of the other *Kodak* developers for *Kodalith* films), they essentially produce two tones, an extremely high density black, and a low density base-plus-fog clear tone. While exposure of extremely high contrast films is critical to avoid the low background densities that result from underexposure, or the filling in of copy that occurs with overexposure, some development latitude is obtained when the film is developed by inspection. *Kodalith* Ortho Film, Type 3, can be developed under a red safelight. Because the film speed changes with development time with little change in contrast, development can be stopped when the right balance between black and white has been achieved.

Where extremely high contrast copies of colored originals are needed, *Kodalith* Pan Film 2568 (*Estar* Base) can be used. Filters can be used to control the colors to be left in (held) or dropped out—reproduced as black or white in final reproduction. These extremely high contrast films can also be used for contact printing and enlarging to make high-contrast transparencies.

Kodalith Ortho and *Kodalith* Pan Films can also be used to make block-out masks in a camera, by contact with the negative or on a pin-registration easel with an enlarger. Photographic derivation processes such as tone-line, posterization, and block-effect nearly always make use of extremely high contrast films.

Very High Contrast Films: *Kodak* High Contrast Copy Film 5069, while it does not have as high an emulsion contrast as the *Kodalith* films, is also used primarily to copy text materials. There is a difference, however, because *Kodak* High Contrast Copy Film 5069 has extremely fine graininess and ultra high resolving power. Because of this, it can be used to make greatly reduced size copies of originals. Developed in *Kodak* Developer *D-19*, it produces microimages that can be read (with magnification) in negative form, or enlarged

EASTMAN KODAK

EASTMAN KODAK

to make duplicate copies. Its speed is greater than that of the *Kodalith* films, which makes it suitable for the rapid photography of multiple documents. The emulsion is panchromatic so that it reproduces subject colors in a reasonable gray-tone rendering, and it can be used with filters to lighten or darken subject hues. Additional information about this film can be found in Publication No. M-1, *Copying*, available from Eastman Kodak Co., or your dealer.

High-Contrast Films: Copying photographic prints and making positive transparencies from negatives require a high-contrast film. For years *Kodak* Commercial Films 6127 and 4127 (*Estar* Thick Base) have served these purposes as well as others where a high-contrast film is required. Both are blue-sensitive films, and can be developed under relatively bright safelight conditions.

Where somewhat more contrast is needed, and where ortho- and pan-sensitization is of value, *Kodak* Contrast Process Ortho Film 4154 (*Estar* Thick Base) and *Kodak* Contrast Process Pan Film 4155 (*Estar* Thick Base) are available. The panchromatic version is particularly useful in copying photographs with colored stains through filters, which eliminates or minimizes the stain on the copy.

Kodak Professional Copy Film 4125 (*Estar* Thick Base) is designed for the exact purpose of copying black-and-white photographic prints. It has a special curve shape that enhances highlight separation. A long roll version is *Kodak* Ortho Copy Film 5125.

Kodak Fine Grain Positive Film 7302 is another film useful for making positive transparencies from negatives. For 35mm positive transparencies, *Eastman* Fine Grain Release Positive Film 5302 is available.

Kodak Direct Positive Panchromatic Film 5246 is designed to make copy positives directly from prints. It is process by reversal. It can also be used to make transparencies of normal subjects under daylight or tungsten illumination.

Duplicate negatives are often made by using commercial film. An intermediate positive is made first, and the duplicate negative printed from the positive. This extra step is eliminated when *Kodak* Professional Direct Duplicating Film (*Estar* Thick Base) SO-015 is used. This film does not require reversal process. A 35mm version of this film, with a slightly bluer color, is *Kodak* Rapid Processing Copy Film SO-185.

Medium-Contrast Films: There is a wide range of speeds available in different medium-contrast film emulsions, and one of the major factors in the choice of a medium-contrast film is speed. The decision cannot be made on the basis of speed alone, because there is an inverse ratio of speed to graininess that often requires a compromise. It is almost invariably true that the faster the film the grainier it is and vice versa. The usual choice made is that the slowest film, hence the finest grain, will be used that will permit adequately short exposure times and small enough apertures for the lighting conditions that prevail.

Kodak Panatomic-X Film, available in 35mm magazines, and *Kodak Panatomic-X* Professional Film in the 120 roll-film size, are the slowest, finest grain *Kodak* films available with medium-contrast characteristics for general-purpose photography. They are generally chosen for outdoor work where fast subject motion is not involved, and when a high degree of enlargement is anticipated. They are also used in studio-type work where subjects at relatively close distances are to be illuminated with flash.

The medium-speed films are chosen for general-purpose photography outdoors, and for much studio work where a reasonable lighting level can be maintained by either incandescent lights or electronic flash. *Kodak Plus-X* Pan, *Plus-X* Portrait 5068, and *Plus-X* Pan Professional Films have very similar emulsion characteristics. While the graininess is in the same category as that of the *Panatomic-X* films, the resolving power and degree of enlargement are one category less. These films have short toe and long straight line characteristics, making their use ideal in high-flare conditions such as are usually encountered outdoors, as well as giving them unusually good tone reproduction characteristics.

Kodak Plus-X Pan Professional Film 2147 (*Estar* Base) and 4147 (*Estar* Thick Base) have emulsion characteristics different from those of the films listed above. Even though the grain is not as fine as in the other *Plus-X* films, the degree of enlargement is listed in the same category. The characteristic curve shape of *Kodak Plus-X* Pan Professional Film 2147 (*Estar* Base) and *Kodak Plus-X* Pan Professional Film 4147 (*Estar* Thick Base) can be

EASTMAN KODAK

described as "all toe" in the exposure range normally used. This makes these films suitable for low-flare (studio) conditions and provides unusually good highlight tone separation.

Kodak Verichrome Pan Film is often considered a film for amateur use only, but it is sometimes used by professional photographers. It has emulsion characteristics similar to those of *Kodak Plus-X* Pan Film. It could be considered as an alternative to *Kodak Plus-X* Pan Professional Film, without the retouching surface, and it is the only *Kodak* black-and-white film available in some roll-film sizes. It is capable of recording very professional pictures.

Kodak Ektapan Film 4162 (*Estar* Thick Base) is made the same speed as *Kodak Vericolor II* Professional Film, Type S, so the photographer can use the two films interchangeably without having to change exposure. It is often used as a test film for professional color exposures; when the quickly processed *Ektapan* film negative shows proper exposure, light balance, and subject arrangement, the photographer can expose his color negative film with more assurance that he will get a good negative. With its long toe and retouching characteristics, *Ektapan* film is used frequently to make portraits with electronic flash.

The speed of *Kodak Super-XX* Pan Film 4142 (*Estar* Thick Base) places it midway between medium- and high-speed films. Because of its short toe and long straight line curve characteristics, *Super-XX* film has long been used in such special applications as making separation negatives from still setups or from transparencies when dye transfer prints are to be made. Because of its moderately high speed and fine curve shape, it also serves well as a general-purpose sheet film for both outdoor and studio usage. Both surfaces are suitable for retouching.

Both *Tri-X* Pan Professional Film (rolls) and *Tri-X* Pan Professional Film 4164 (sheets) are fast permitting a moderate degree of enlargement. Both have extended toe curve characteristic that make them especially suitable for low flare level studio use, with the expected gain in highlight separation so useful for commercial and professional photographic subjects. These desirable characteristics, combined with both-side retouching surfaces, make these films popular for outdoor informal portraiture under the low-contrast and backlit lighting conditions usually used for this type of photography.

Kodak Tri-X Pan Film (35mm and rolls) is a different type of film from the *Tri-X* Pan Professional Films just discussed. Its speed is higher, its surfaces are not specially treated for retouching, and its characteristic curve is shaped differently. It is used widely as a general-purpose film—it is fast enough so that it can be used for much available light photography, yet slow enough that it can be exposed in daylight with most cameras. Its special curve shape gives *Kodak Tri-X* Pan Film a wider exposure latitude than almost any other. Its high speed permits reasonable exposure times with filters having relatively large filter factors.

Another fast sheet film primarily for studio use is *Kodak Royal* Pan Film 4141 (*Estar* Thick Base). Its speed, its long toe curve characteristics, and its two-side retouching feature make it widely used for interior commercial, industrial, and professional purposes. Its high speed permits the small apertures often required for industrial and commercial pictures without excessively long exposure times. This film is the favorite studio view-camera film of the *Kodak* professional photographers.

Kodak Tri-X Ortho Film 4163 (*Estar* Thick Base) is a fast ortho film used when red sensitivity is not a requirement. Some photographers prefer the tonal rendition of landscapes made with an ortho film and a yellow filter. The lack of red sensitivity in ortho film records the warm shadows in portraits darker than they appear visually, thus accentuating facial wrinkles. Hence ortho film adds "character" or "ruggedness" that can be effective in portraits of elderly men, outdoorsmen or athletes. Both sides of this film are suitable for retouching.

When an extremely fast film is required, as for low light level or fast-action photography, *Kodak Royal-X* Pan Film and *Royal-X* Pan Film 4166 (*Estar* Thick Base) are strongly recommended. With these films the degree of enlargment is moderately low due to medium graininess and medium resolving power; however, when the extra film speed means the difference between usable pictures or no pictures at all, the choice is obvious. These two films have the short toe, long straight line characteristic curve that results in excellent tone reproduction. The exposure latitude is excellent, a desirable feature in available-light photography.

EASTMAN KODAK

Another extremely fast film for 35mm photography is *Kodak* Recording Film 2475 (*Estar*-AH Base). With faster lenses available on 35mm cameras than on larger cameras, the use of Recording Film 2475 with an ultra-fast lens on a 35mm camera gives the fastest combination for extremely low light level photography currently available.

EXPOSURE WITH FLASH

Both flashbulbs and electronic flash provide light at a relatively high illumination level for a relatively short period of time. Because it is important for the camera shutter to be open for this brief period, the flash and the shutter are usually synchronized. Open flash, an acceptable alternative when there is no motion to be stopped and when the ambient illumination is very low, is accomplished by the manual opening of the shutter, and the firing of the flash when the shutter is open.

FLASH SYNCHRONIZATION

There are various types of flash synchroniztion. Those that are in current use are M, X and FP. M synchronization times the flashing of most bulbs and flashcubes with the opening of blade-type shutters. Electronic flash requires the use of X synchronization when used with both blade and focal-plane shutters. FP or M is the type of synchronization used to synchronize focal-plane shutters with FP flashbulbs (No. 6 and No. 26). The flash terminal provided on many current focal-plane-shutter cameras in addition to the X terminal is the FP terminal. It may be identified with the symbol of a flashbulb.

DIRECT FLASH

Flash exposure is usually computed by the use of guide number. A guide number depends on the film speed, shutter speed, the light output of the bulb or electronic flash unit, and in the case of flashbulbs, the type of reflector. Flashcubes and electronic flash units have built-in reflectors that provide a standard reflector condition. The guide numbers for various film-speed, flashbulb, and reflector combination can be found in the *Flash Exposure Guide Number Table.*

In using flashbulbs for picture-taking, the guide number should be adjusted to the type of room or other surrounding conditions. The flash guide numbers in the table are based on exposures made in a room of average size and average reflection level. Actual exposure depends both on light that reaches the subject directly from the flash and reflector and on light that reaches the subject by reflection from surfaces in the room, primarily from the ceiling and walls. When making flash exposures in rooms smaller than normal, or with lighter-than-normal surfaces, use an exposure ½ to 1 stop less than that given by the guide number. For larger rooms or rooms with surfaces darker than normal, use ½ to 1 more exposure than that found by the use of the guide number. This is especially important either in very large rooms, such as auditoriums, or outdoors at night. Such exposure corrections are not usually necessary with electronic flash because of the reflector design.

Electronic-flash guide numbers are based on the reflected-light output of the unit as measured in beam-candlepower-seconds (BCPS), or effective-candlepower-seconds (ECPS). The guide numbers for different film speeds and various output electronic flash units are given in the *Electronic Flash Guide Number Table.*

The guide numbers are used to find the *f*-number at which the exposure should be made by the following formula:

The guide number divided by the flash-to-subject distance in feet gives the f-*number.*

Some electronic flash units are automatic. With such units, the camera lens aperture is set at a single *f*-number for all distances within a range, dependent on the film speed, and the unit automatically controls the duration of the flash to give the correct exposure. Guide numbers are *not* used with this type of unit, unless it is set in a nonautomatic mode. (See the sheet that is packaged with the unit for specific instructions.)

The Compact Photo-Lab-Index

FLASH EXPOSURE GUIDE NUMBER TABLE

Shutter Type				Blade (Between-the-Lens)										X		FP or M	
Type of Synch				M										X		FP or M	
		Flash-cube	Shallow Cylin-drical Reflec-tor	Intermediate-Shaped Reflector				Polished Bowl-Shaped Reflector									
Film Speed	Shutter Speed	Flash-cube	AG-1B	AG-1B	M3B 5B 25B	11 40	2B 22B	AG-1B	M3B 5B 25B	11 40	2B 22B	3 50	M2B	M2B	6B 26B	6B 26B	
---	---	---	---	---	---	---	---	---	---	---	---	---	---	---	---	---	
32	1/25-1/30	34	26	36	65	85	110	50	90	120	160	240	50	70	70	100	
	1/50-1/60	34	26	36	65	85	110	50	90	120	150	—	40	60	50	75	
	1/100-1/125	28	22	30	55	70	90	45	25	100	130	—	—	—	34	50	
	1/200-1/250	22	18	26	42	55	70	36	60	75	100	—	—	—	24	34	
	1/400-1/500	18	14	20	32	42	55	28	45	60	75	—	—	—	17	24	
40	1/25-1/30	38	28	40	75	100	100	60	110	140	130	260	55	75	80	110	
	1/50-1/60	38	28	40	70	90	90	55	100	130	130	—	45	65	60	80	
	1/100-1/125	32	24	34	60	80	75	50	85	110	110	—	—	—	38	55	
	1/200-1/250	24	20	28	45	60	55	40	65	85	80	—	—	—	28	38	
	1/400-1/500	20	16	22	36	45	42	32	50	65	60	—	—	—	20	28	
80	1/25-1/30	55	40	60	110	140	130	80	150	200	200	380	25	110	110	160	
	1/50-1/60	55	40	55	100	130	130	80	140	180	180	—	65	90	80	120	
	1/100-1/125	45	34	50	85	115	110	70	120	160	150	—	—	—	55	75	
	1/200-1/250	34	28	40	65	85	80	55	90	120	110	—	—	—	38	55	
	1/400-1/500	28	22	32	50	65	60	45	70	90	85	—	—	—	28	38	
100	1/25-1/30	60	45	65	120	150	150	90	170	220	220	420	85	120	130	180	
	1/50-1/60	60	45	65	110	140	140	90	160	200	200	—	70	100	90	130	
	1/100-1/125	50	38	55	90	130	120	75	130	180	170	—	—	—	60	85	
	1/200-1/250	38	32	45	75	90	90	65	110	130	130	—	—	—	42	60	
	1/400-1/500	32	24	34	55	70	70	50	80	100	100	—	—	—	30	44	
125	1/25-1/30	70	50	70	130	170	170	100	180	240	240	450	100	130	140	200	
	1/50-1/60	65	50	70	120	160	160	100	180	220	220	—	80	110	100	140	
	1/100-1/125	55	42	60	100	140	140	85	150	200	200	—	—	—	70	100	
	1/200-1/250	44	36	50	85	110	100	70	120	150	140	—	—	—	50	70	
	1/400-1/500	36	28	38	65	85	75	55	90	120	110	—	—	—	34	50	
160	1/25-1/30	75	60	80	150	200	200	120	220	280	260	550	110	150	160	220	
	1/50-1/60	75	55	80	140	180	180	110	200	260	260	—	90	130	120	160	
	1/100-1/125	65	50	70	120	150	150	100	170	220	220	—	—	—	75	110	
	1/200-1/250	50	40	55	90	120	110	80	130	170	160	—	—	—	55	75	
	1/400-1/500	40	32	45	70	90	85	60	100	130	120	—	—	—	38	55	
200	1/25-1/30	85	65	90	170	220	220	130	240	300	300	600	120	170	180	260	
	1/50-1/60	85	65	90	160	200	200	130	220	280	280	—	100	140	130	180	
	1/100-1/125	70	55	75	130	180	170	110	180	260	240	—	—	—	85	120	
	1/200-1/250	55	45	65	110	140	130	90	150	200	180	—	—	—	60	85	
	1/400-1/500	45	34	50	80	110	100	70	110	150	140	—	—	—	44	60	
250	1/25-1/30	100	70	100	180	240	240	140	260	340	340	650	130	200	200	280	
	1/50-1/60	100	70	100	180	230	220	140	240	320	320	—	110	160	140	200	
	1/100-1/125	80	60	85	150	200	200	120	200	280	280	—	—	—	100	140	
	1/200-1/250	60	50	70	120	150	140	100	170	220	200	—	—	—	70	100	
	1/400-1/500	50	38	55	90	120	110	80	130	160	150	—	—	—	45	70	
320	1/25-1/30	110	80	120	220	280	260	160	300	400	380	750	150	220	220	320	
	1/50-1/60	110	80	110	200	260	260	160	280	360	360	—	130	180	160	240	
	1/100-1/125	90	70	100	170	230	220	140	240	320	300	—	—	—	110	150	
	1/200-1/250	70	55	80	130	170	160	110	180	240	220	—	—	—	75	110	
	1/400-1/500	60	45	60	100	130	120	90	140	180	170	—	—	—	55	75	
400	1/25-1/30	120	90	130	240	320	300	180	340	450	420	850	170	240	260	360	
	1/50-1/60	120	90	130	220	280	280	180	320	400	400	—	140	200	180	260	
	1/100-1/125	100	75	110	180	260	240	150	260	360	340	—	—	—	120	170	
	1/200-1/250	75	65	90	150	180	180	130	220	260	260	—	—	—	85	120	
	1/400-1/500	65	50	70	110	140	140	100	160	200	200	—	—	—	60	85	
500	1/25-1/30	140	100	140	260	360	340	200	380	500	500	900	200	260	280	400	
	1/50-1/60	130	100	140	240	320	320	200	360	450	450	—	160	220	200	280	
	1/100-1/125	110	85	120	200	280	280	170	300	400	380	—	—	—	140	200	
	1/200-1/250	85	70	100	170	220	200	140	240	300	280	—	—	—	100	140	
	1/400-1/500	70	55	80	130	170	150	110	180	240	220	—	—	—	70	100	

Shallow to intermediate or fan-type reflector.

Deep polished bowl: AG-1B, 2-inch; M2B, 3-inch; M3B, M5B, 25B, 4- to 5-inch; 11, 40, 3, 50, studio-type reflector.

Clear Bulbs: 11, 40, 3 and 50 are clear bulbs; the others listed are blue. To find the approximate guide number of the clear version of a blue bulb listed in the table, multiply the blue bulb guide number by 1.3; and to find the blue bulb guide number version of a clear bulb listed in the table, divide the clear bulb guide number by 1.3.

Caution: Bulbs may shatter when flashed. Use a flashguard over the reflector. Do not flash bulbs in an explosive atmosphere.

EASTMAN KODAK

The Compact Photo-Lab-Index

EASTMAN KODAK

ELECTRONIC FLASH GUIDE NUMBER TABLE

Film Speed	Output of Unit (BCPS or ECPS)									
	350	500	700	1000	1400	2000	2800	4000	5600	8000
32	24	28	32	40	50	55	65	80	95	110
40	26	32	35	45	55	65	75	90	110	130
50	30	35	40	50	60	70	85	100	120	140
64	32	40	45	55	65	80	95	110	130	160
80	35	45	55	65	75	90	110	130	150	180
100	40	50	60	70	85	100	120	140	170	200
125	45	55	65	80	95	110	130	160	190	220
160	55	65	75	90	110	130	150	180	210	250
200	60	70	85	100	120	140	170	200	240	280
250	65	80	95	110	130	160	190	220	260	320
320	75	90	110	130	150	180	210	250	300	360
400	85	100	120	140	170	200	240	280	340	400
500	95	110	130	160	190	220	260	320	370	450
650	110	130	150	180	210	260	300	360	430	510
800	120	140	170	200	240	280	330	400	470	560
1000	130	160	190	220	260	320	380	450	530	630
1250	150	180	210	250	300	350	420	500	600	700
1600	170	200	240	280	340	400	480	560	670	800

MULTIPLE FLASH

Large area scenes are sometimes lighted with multiple flash. In some cases the light from several flash units is overlapped on the subject to permit the use of a smaller lens opening. The following two formulas show how to calculate the f-numbers when two or four flash units are used in this manner.

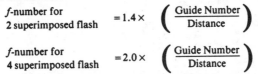

$$f\text{-number for 2 superimposed flash} = 1.4 \times \left(\frac{\text{Guide Number}}{\text{Distance}} \right)$$

$$f\text{-number for 4 superimposed flash} = 2.0 \times \left(\frac{\text{Guide Number}}{\text{Distance}} \right)$$

If two flash units are used with a film that gives a guide number of 400, and the distance is 36 feet, the calculation becomes:

$$f\text{-number} = 1.4 \times \frac{400}{36} = 1.4 \times 11 = f/15.4 \text{ or } f/16$$

Another multiple flash method used is to light separate sections of a large scene with several flash units in such a way that there is little or no overlap of the light beams. The key to exposure when using this method is to *have the same flash-to-subject distance for each flash*. The f-number is computed by using the distance and the guide number in the same manner as if it were single, direct flash. The area near the camera is usually illuminated by one flash synchronized to the shutter, with other units being fired by electronic switches triggered by the light of the synchronized flash (slave units). The units are hidden from the camera lens by placing them behind various objects in the scene.

An alternative method is to use open flash. This method can only be used when it is dark. The camera is placed on a tripod facing the scene with the shutter set at Time. The f-number is computed by using the guide number and a convenient flash-to-subject distance. The open flash guide number is usually the same as the 1/25-1/30-second guide number. The shutter is opened, and the photographer walks around in the scene, flashing to illuminate various scene objects, keeping behind scene objects so that the flashes will avoid recording his silhouette, and being sure that each section is illuminated from approximately the same distance. When all areas have been illuminated by individual flashes, the shutter is closed.

BOUNCE FLASH

All the above instructions for finding f-numbers by using guide numbers refer to direct flash illumination, in which the light from the flash shines directly on the subject. A more

natural appearing lighting effect can be achieved in average- and small-sized rooms by bouncing the light of the flash off a light-colored or wall.

The exposure for bounce flash is difficult to compute exactly, but may be approximately found by the formula given below the diagram.

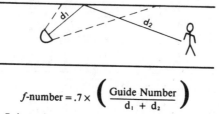

$$f\text{-number} = .7 \times \left(\frac{\text{Guide Number}}{d_1 + d_2} \right)$$

The f-number equals .7 times the guide number divided by the sum of the flash-to-ceiling distance and the ceiling-to-subject distance measured along the center light beam from the flash.

If d_1 is 4 feet, and d_2 is 8 feet, and the guide number is 100, the aperture is $f/5.6$.

$$f\text{-number} = .7 \times \frac{100}{4+8} = .7 \times \frac{100}{12} = .7 \times 8 = 5.6$$

This formula is for a relatively clean, white ceiling. For off-white or light-colored ceilings or walls, give ½ to 1 stop more exposure.

In using bounce flash, it is important that a deep reflector is used, and that the flash unit is aimed in such a direction that *no direct light falls on the subject*. This is shown in the diagram by the dashed lines.

UMBRELLA FLASH

A modified type of bounce flash is provided, usually for electronic flash, by silver, white, light blue, or amber-colored umbrellas made especially for photography. The flash unit is mounted on the handle of the umbrella, aimed at its inside center. The inside of the umbrella is then aimed toward the subject.

A guide number can be found for the flash-umbrella combination; with a clean, silver umbrella, the guide is typically about .7 times the guide number for the flash unit used directly. Umbrella lighting is softer than direct flash lighting, but is more directional than bounce flash lighting. Because umbrellas size is relatively large compared to light-to-subject distance, guide numbers do not work well with them. Virtually the same exposure is used over the normal range of distances used with umbrella flash.

EASTMAN KODAK

TECHNICAL INFORMATION
KODAK PROFESSIONAL BLACK-AND-WHITE FILMS

The following pages contain technical information for the *Kodak* black-and-white films listed below. Each page also contains a brief description of the principal use of the materials.

The sensitometric curves and data represent current product under normal conditions of exposure and processing. They are averages of a number of production coatings and, therefore, do not apply directly to a particular box or roll of film. They do not represent standards or specifications which must be met by *Eastman Kodak Company*. The company reserves the right to change and improve product characteristics at any time.

ISO and DIN film speeds for continuous-tone, in camera films (not copy films) are listed in addition to the ANSI speeds (ASA). DIN speeds are used mostly outside the United States. The ISO (International Standards Organization) figures are new and represent a trend toward internationally accepted speeds. For black-and-white films, the ISO speeds are identical to the ANSI speeds.

KODAK FILM

Commercial, 6127 and Commercial, 4127 (Estar Thick Base)
Contrast Process Ortho, 4154 (Estar Thick Base)
Contrast Process Pan, 4155 (Estar Thick Base)
Ektapan, 4162 (Estar Thick Base)
High Speed Infrared, 4143 (Estar Thick Base)
 (Calculated Small-Tank Contrast Index Curves)
Kodalith Ortho, 6556, Type 3 and Kodalith Ortho, 2556, Type 3 (Estar Base)
Kodalith Pan, 2568 (Estar Base)
Panatomic-X and *Panatomic-X* Professional
Plus-X Pan, *Plus-X* Portrait and *Plus-X* Pan Professional
Plus-X Pan Professional, 2147 (Estar Base) and *Plus-X* Pan Professional,
 4147 (Estar Thick Base)
Professional Copy Film, 4125 (Estar Thick Base)
Recording, 2475 (Estar-AH Base)
Royal-X Pan, 4166 (Estar Thick Base)
Royal Pan, 4141 (Estar Thick Base)
Super-XX Pan, 4142 (Estar Thick Base)
Tri-X Pan
Tri-X Pan Professional
Tri-X Pan Professional, 4164 (Estar Thick Base)
Tri-X Ortho, 4163 (Estar Thick Base)
Verichrome Pan
Direct Positive Panchromatic, 5246
 (Modulation Transfer Function Curves)

EASTMAN KODAK

KODAK COMMERCIAL FILM 6127 AND 4127 (*Estar* Thick Base)

These medium-speed, blue-sensitive films yield moderately high contrast and are for copying continuous-tone black-and-white originals, as well as for making positive transparencies or similar applications where red and green sensitivity is unnecessary or undesirable.

Kodak Commercial Film 6127 has an acetate base. *Kodak* Commercial Film 4127 (*Estar* Thick Base) has a .007-inch *Estar* Base.

FORM AVAILABLE
Sheets only.

SPEED
White-Flame Arc: 20. Daylight: 50. Tungsten and Quartz Iodine: 8.

These speeds are for use with meters marked for ANSI film speeds; they are recommended for trial exposures in copying. To obtain a trial exposure, take a reflected-light meter reading from the gray (18% reflectance) side of the *Kodak* Neutral Test Card at the copyboard. If the white (90% reflectance) side of the card is used, multiply the indicated exposure by 5.

In copying, extra expsoure is needed to compensate for a long bellows extension.

SAFELIGHT
Kodak Safelight Filter No. 1 (red), or equivalent.

EMULSION CHARACTERISTICS

GRAIN
Very fine

RESOLVING POWER
High Contrast: 100 lines/mm (High)
Low Contrast: 40 lines/mm

COLOR SENSITIVITY
Blue

DEVELOPMENT FOR PHOTOGRAPHIC COPYING OR GENERAL APPLICATIONS

	Developing Time in Minutes with Continuous Agitation (tray)				
Kodak Developer	18 °C (65 °F)	20 °C (68 °F)	21 °C (70 °F)	22 °C (72 °F)	24 °C (75 °F)
DK-50	2½	2	2	1¾	1¾
HC-110 (Dilution B)	2¾	2¼	2¼	2	1¾
HC-110 (Dilution D)	4¾	4½	4¼	4	3¾
Polydol	4½	4	3¾	3½	3¼
D-11	9	8	7	6½	5½

EASTMAN KODAK

The Compact Photo-Lab-Index

RECIPROCITY EFFECT ADJUSTMENTS

If Indicated Exposure Time Is (Seconds)	Use Either		In Either Case Use This Development Adjustment	
	This Lens Aperture Adjustment	Or	This Adjusted Exposure Time (Seconds)	
1/100	none	no adjustment	10% more	
1/25	none	no adjustment	none	
1/10	none	no adjustment	10% less	
1	none	no adjustment	20% less	
10	½ stop more	15	30% less	
100	1 stop more	300	40% less	

CHARACTERISTIC CURVES

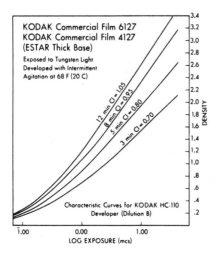

KODAK Commercial Film 6127
KODAK Commercial Film 4127
(ESTAR Thick Base)

Exposed to Tungsten Light
Developed with Intermittent
Agitation at 68 F (20 C)

12 min CI = 1.05
8 min CI = 0.95
5 min CI = 0.80
3 min CI = 0.70

Characteristic Curves for KODAK HC-110
Developer (Dilution B)

CONTRAST INDEX CURVES

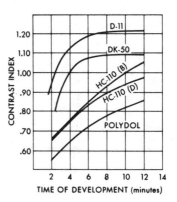

D-11
DK-50
HC-110 (B)
HC-110 (D)
POLYDOL

51

KODAK CONTRAST PROCESS ORTHO FILM 4154 (*Estar* Thick Base)

A high-contrast, orthochromatic film for copying black-and-white originals and those with black printed or written matter on blue, green, or yellow paper. When developed to a moderately high contrast, this film records the intermediate tones in the lines of etchings, handwriting, and similar originals.

FORM AVAILABLE
Sheets only.

SPEED
White-Flame Arc: 100. Tungsten and Quartz Iodine: 50. Pulsed-Xenon Arc: 100.

The speeds for white-flame arc, tungsten and quartz are for use with meters marked for ANSI film speeds; they are recommended for trial exposures in copying. The pulsed-xenon arc speed is for a light-integrating meter. To obtain a trial exposure, take a reflected-light meter reading from the gray (18% reflectance) side of the *Kodak* Neutral Test Card at the copyboard. If the white (90% reflectance) side of the card is used, multiply the indicated exposure by 5.

In copying, extra exposure is needed to compensate for a long bellows extension.

SAFELIGHT
Use a *Kodak* Safelight Filter No. 1 (red), or equivalent, in a suitable safelight lamp with a 15-watt bulb at not less than 4 feet from the film.

FILTER FACTORS
Multiply the normal exposure by the filter factor given below.

Kodak *Wratten* Filter	No.6	No.8	No.9	No.15	No.58	No.47	No.47B	Polarizing Screen
Tungsten	1.5	1.5	2	3	3	10	16	2.5
White-Flame Arc*	2	2.5	3	5	6	6	8	2.5
Quartz Iodine	1.2	1.5	2	2.5	3	10	16	2.5
Pulsed-Xenon Arc	2.5	3	4	6	5	6	10	2.5

*With the positive carbon in the lower position for direct-current arc lamps.

EMULSION CHARACTERISTICS

GRAIN
Fine

RESOLVING POWER
High Contrast: 200 lines/mm (Very High). Low Contrast: 50 lines/mm.

COLOR SENSITIVITY
Orthochromatic.

DEVELOPMENT
Develop at approximate times and temperatures given below.

EASTMAN KODAK

The Compact Photo-Lab-Index

Kodak Developer	Developing Time (Minutes)									
	Continuous Agitation (Tray)					Intermittent Agitation* (Tank)				
	18°C (65°F)	20°C (68°F)	21°C (70°F)	22°C (72°F)	24°C (75°F)	18°C (65°F)	20°C (68°F)	21°C (70°F)	22°C (72°F)	24°C (75°F)
D-11 (High Contrast)	4¾	4	3½	3	2½	6	5	4½†	3¾†	3†
D-8 (Maximum Contrast) (2:1)	—	2	—	—	—	—	—	—	—	—
HC-110 (High Contrast) (Dilution B)	—	5	—	—	—	—	—	—	—	—

*Agitation at 1-minute intervals during development.
†Development times of less than 5 minutes in a tank may produce poor uniformity and should be avoided.

CHARACTERISTIC CURVES

CONTRAST INDEX CURVES

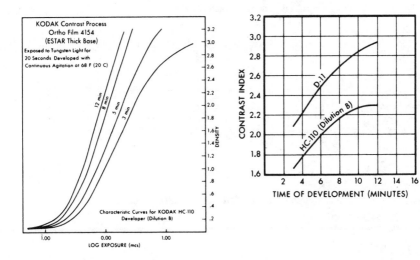

KODAK CONTRAST PROCESS PAN FILM 4155 (*Estar* Thick Base)

A high-contrast, panchromatic film on .007-inch *Estar* Base for copying originals containing colored lines or printed matter on either white or colored paper. Various filters can be used to increase separation between colors that photograph in similar tones of gray or to eliminate a color if desired.

FORM AVAILABLE
Sheets only.

SPEED
White-Flame Arc: 100. Tungsten and Quartz Iodine: 80. Pulsed-Xenon Arc: 100.

The speeds are for use with meters marked for ANSI film speeds; they are recommended for trial exposures in copying. The pulsed-xenon arc speed is for light-integrating meters. To obtain a trial exposure, take a reflected-light meter reading from the gray (18% reflectance) side of the *Kodak* Neutral Test Card at the copyboard. If the white (90% reflectance) side of the card is used, multiply the indicated exposure by 5.

In copying, extra exposure is needed to compensate for a long bellows extension.

SAFELIGHT
Handle the film in total darkness. After development is half completed, a *Kodak* Safelight Filter No. 3 (dark green) in a suitable safelight lamp with a 15-watt bulb can be used at 4 feet from the film *for a few seconds only*.

FILTER FACTORS
Multiply the normal exposure by the filter factor given below.

Kodak Wratten Filter	No.8	No.9	No.15	No.29	No.25	No.58	No.47	No.47B	Polarizing Screen
Tungsten	1.2	1.5	1.5	6	3	4	12	20	2.5
White-Flame Arc	2	2.5	2.5	25	10	8	6	8	2.5
Quartz Iodine	1.2	1.5	1.5	10	5	6	20	25	2.5
Pulsed-Xenon Arc	1.5	2	2	16	6	6	8	12	2.5

EMULSION CHARACTERISTICS

GRAIN
Very Fine.

RESOLVING POWER
High Contrast: 160 lines/mm (Very High). Low Contrast: 50 lines/mm.

COLOR SENSITIVITY
Panchromatic.

DEVELOPMENT
Develop at approximate times and temperatures given below.

EASTMAN KODAK

	Developing Time (Minutes)									
	Continuous Agitation (Tray)					Intermittent Agitation* (Tank)				
Kodak **Developer**	18°C (65°F)	20°C (68°F)	21°C (70°F)	22°C (72°F)	24°C (75°F)	18°C (65°F)	20°C (68°F)	21°C (70°F)	22°C (72°F)	24°C (75°F)
D-11 (High Contrast)	4¾	4	3½	3	2½	6	5	4½†	3¾†	3†
D-8 (Maximum Contrast) (2:1)	—	2	—	—	—	—	—	—	—	—

*Agitation at 1-minute intervals during development.
†Development times of less than 5 minutes in a tank may produce poor uniformity and should be avoided.

CHARACTERISTIC CURVES

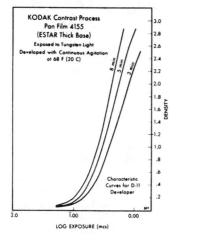

CONTRAST INDEX CURVE

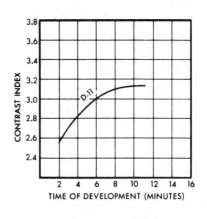

TIME OF DEVELOPMENT (MINUTES)

KODAK EKTAPAN FILM 4162 (*Estar* Thick Base)

This is a long toe, panchromatic, antihalation film of medium speed on *Estar* Thick Base. It is particularly suitable for portraiture and other close-up work with electronic flash illumination. However, the film yields excellent results with all normal lighting. Because its speed is similar to that of *Kodak Vericolor II* Professional Film, Type S, it is valuable in situations where color and black-and-white negatives are needed from the same subject.

Both base and emulsion sides of the film are suitable for retouching.

FORMS AVAILABLE
Sheets, 3½-inch and 70mm long rolls.

SPEED
ISO 100/21° ASA 100/21 DIN.

SAFELIGHT
Handle in total darkness.

EMULSION CHARACTERISTICS

GRAIN
Fine.

RESOLVING POWER
High Contrast: 80 lines/mm (Medium). Low Contrast: 40 lines/mm.

COLOR SENSITIVITY
Panchromatic

DEVELOPMENT
Develop at approximate time and temperatures given below. The amount of development is the major control of negative contrast. The figures given below are to be considered average starting times.

| Kodak Developer | Developing Time (Minutes) | | | | | | | | | |
|---|---|---|---|---|---|---|---|---|---|
| | Continuous Agitation (Tray) | | | | | Intermittent Agitation* (Tank) | | | | |
| | 18°C (65°F) | 20°C (68°F) | 21°C (70°) | 22°C (72°F) | 24°C (75°F) | 18°C (65°F) | 20°C (68°F) | 21°C (70°) | 22°C (72°F) | 24°C (75°F) |
| HC-110 (Dilution A) | 3¼ | 3 | 2¾ | 2½ | 2¼ | 4* | 3¾* | 3¼* | 3* | 2¾* |
| HC-110 (Dilution B) | 5 | 4½ | 4¼ | 4 | 3½ | 7 | 6 | 5½ | 5 | 4¼* |
| Polydol | 9½ | 8 | 7 | 6 | 5 | 12 | 10 | 9 | 8 | 7 |
| DK-50 (1:1) | 5 | 4½ | 4¼ | 4 | 3½ | 7 | 6 | 5½ | 5 | 4¼* |
| D-76 | 9 | 8 | 7 | 6½ | 5½ | 11 | 10 | 9 | 8½ | 7½ |
| Microdol-X | 12 | 10 | 9½ | 8 | 7 | 16 | 13 | 12 | 10 | 9 |

*Not recommended because development times of less than 5 minutes in a tank may produce poor uniformity.

CHARACTERISTIC CURVES

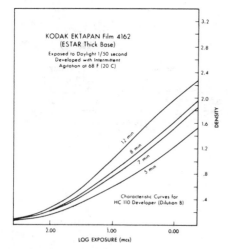

KODAK EKTAPAN Film 4162
(ESTAR Thick Base)
Exposed to Daylight 1/50 second
Developed with Intermittent
Agitation at 68 F (20 C)

Characteristic Curves for
HC 110 Developer (Dilution B)

LOG EXPOSURE (mcs)

CONTRAST INDEX CURVES

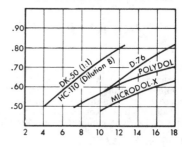

KODAK HIGH SPEED INFRARED FILM 4143 (Estar Thick Base)

A high-speed, moderately high contrast, infrared-sensitive film for haze penetration in landscape photography and for special effects in commercial and architectural work. With variations in development and with the use of different filters, the film has applications in scientific, medical, and document photography, as well as in photomechanical work and photomicrography.

FORM AVAILABLE

Sheets. (A film with similar characteristics, *Kodak* High Speed Infrared Film, is available in 35mm magazines and in 50-ft rolls).

SAFELIGHT

None. Handle and process the film in total darkness.

SPEED

Exact speed numbers cannot be given for infrared film because the ratio of infrared radiation to light is variable, and most exposure meters are calibrated only for light. Since light levels that appear similar may be very different in the amount of infrared radiation they contain, correct exposure should be determined by trial exposures made under the conditions in which the photographs are to be taken.

FILTERS FOR INFRARED PHOTOGRAPHY

A filter must be used over the camera lens (or over the light source) to absorb the blue light to which the film is sensitive. For general photography, a *Kodak Wratten* Filter No. 25, or equivalent, is recommended.

The meter settings in the table below are intended for trial exposures with different filters. They are for use with meters for ANSI film speeds and are based on development in *Kodak* Developer *D-76*.

METER SETTINGS FOR TRIAL EXPOSURES

Conditions	Daylight	Tungsten
Without a filter	80	200
Through *Kodak Wratten* Filters:		
—No. 25, No. 29, No. 70, or No. 89B	50	125
—No. 87 or No. 88A	25	64
—No. 87C	10	25

FOCUSING FOR INFRARED

Lenses do not focus infrared radiation in the same plane as visible rays. Therefore, stop the lens down to the smallest aperture that conditions permit. If large lens apertures must be used and the lens has no infrared focusing mark, establish a correction by making a practical photographic test.

FLASH EXPOSURE GUIDE NUMBERS

To obtain the lens aperture for flashbulbs or electonic flash, divide the appropriate guide number by the flash-to-subject distance in feet, taken to a point midway between the nearest and farthest details of interest.

FLASHBULB GUIDE NUMBERS

The following numbers apply for the clear flashbulbs indicated when a *Kodak Wratten* Filter No. 25, No. 29, No. 70, or No. 89B is used over the camera lens.

EASTMAN KODAK

The Compact Photo-Lab-Index

Between Lens Shutter Speed	Syn-chroni-zation	AG-1*	M2†	M3† 5‡, 25‡	11§ 40§	2§ 22§	Focal-Plane Shutter Speed	6 26‡
Open, 1/30	X or F	180	180	280	NR	NR	1/30	NR
1/30	M	120	NR	240	240	320	1/60	180
1/60	M	120	NR	240	220	300	1/125	130
1/125	M	100	NR	200	200	260	1/250	90
1/250	M	80	NR	160	150	200	1/500	65
1/500	M	65	NR	120	NR	NR	1/1000	45

Bowl-Shaped Polished Reflectors: *2-inch; †3-inch; ‡4- to 5-inch; §6- to 7-inch. If shallow cylindrical reflectors are used, divide these guide numbers by 2. For intermediate-shaped reflector, divide the numbers by 1.4. NR = Not Recommended.

CAUTION: Since bulbs may shatter when flashed, use a flashguard over the reflector. **Do not flash bulbs in an explosive atmosphere.**

ELECTRONIC FLASH

Use with a *Kodak Wratten* Filter No. 87, or equivalent, over the camera lens.

Output of Unit (BCPS or ECPS)	500	700	1000	1400	2000	2800	4000	5600
Guide Number for Trial	24	30	35	40	50	60	70	85

EMULSION CHARACTERISTICS

RESOLVING POWER

High Contrast: 80 lines/mm (Medium). Low Contrast: 32 lines/mm.

GRAIN

Fine.

SPECTRAL SENSITIVITY

Infrared with recommended filtration.

DEVELOPMENT

Develop at approximate times and temperatures given below.

	Developing Time (Minutes)										
	TRAY (Continuous Agitation)					LARGE TANK (Agitation at 1-Minute Intervals)					CI
Kodak Developer	18°C (65°F)	20°C (68°F)	21°C (70°F)	22°C (72°F)	24°C (75°F)	18°C (65°F)	20°C (68°F)	21°C (70°F)	22°C (72°F)	24°C (75°F)	
D-76 (Pictorial)	11	9½	8½	7½	6½	14	12	11	10	9	.70
HC-110 (Dil. B) (Scientific Use)	5	4½	4½	4¼	4	7	6½	6	5½	5	.80
D-19 (for Maximum Contrast)	5½	5	5	4½	4	8½	7½	6½	6	5	1.65

EASTMAN KODAK

The Compact Photo-Lab-Index

	SMALL TANK—(Agitation at 30-Second Intervals)					
D-76 (Pictorial)	13	11	10	9½	8	.70
HC-110 (Dil. B) (Scientific Use)	7	6	6	5½	5	.80
D-19 (for Maximum Contrast)	7	6	5½	5	4	1.65

Characteristic Curves

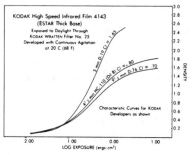

KODAK High Speed Infrared Film 4143 (ESTAR Thick Base)
Exposed to Daylight Through KODAK WRATTEN Filter No. 25
Developed with Continuous Agitation at 20 C (68 F)

Characteristic Curves for KODAK Developers as shown

TENTATIVE DATA
Calculated Small-Tank, Contrast Index Curves for Three KODAK 35 mm and Roll Films

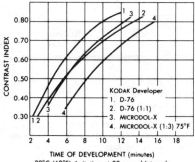

KODAK TRI-X Pan Film

KODAK Developer
1. HC-110 (Dil. B)
2. MICRODOL-X (1:3) 75°F
3. D-76
4. D-76 (1:1) and MICRODOL-X
5. POLYDOL

TIME OF DEVELOPMENT (minutes)
20°C (68°F) Agitation at 30-second Intervals

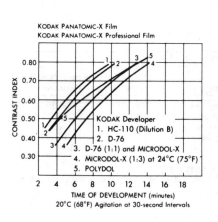

KODAK PANATOMIC-X Film
KODAK PANATOMIC-X Professional Film

KODAK Developer
1. HC-110 (Dilution B)
2. D-76
3. D-76 (1:1) and MICRODOL-X
4. MICRODOL-X (1:3) at 24°C (75°F)
5. POLYDOL

TIME OF DEVELOPMENT (minutes)
20°C (68°F) Agitation at 30-second Intervals

KODAK PLUS-X Pan Film
KODAK PLUS-X Portrait Film
KODAK PLUS-X Pan Professional Film

KODAK Developer
1. D-76
2. D-76 (1:1)
3. MICRODOL-X
4. MICRODOL-X (1:3) 75°F

TIME OF DEVELOPMENT (minutes)
20°C (68°F) Agitation at 30-second Intervals

KODALITH ORTHO FILM 2556, TYPE 3 (*Estar* Base)
KODALITH ORTHO FILM 6556, TYPE 3

(no notch)

Extremely high contrast, orthochromatic films designed primarily for making line and halftone negatives and positives for photomechanical reproduction. These films have wide development latitude and will produce sharp halftone dots suitable for dot etching. They are available in both sheets and rolls. *Kodalith* Ortho Film 2556 is on a .0053-inch base, while 6556 is on a .004-inch base. These are very useful films for copying line drawings and text material.

FORM AVAILABLE

Sheets, 35mm long rolls (Other forms available at graphic arts dealers).

SPEED

For meters marked with ANSI film speeds.

	Kodalith Developer	*Kodak* Developer D-11
White—Flame Arc—	12	—
Tungsten —	8	25

To obtain a trial exposure, take a reflected-light reading from the gray (18% reflectance) side of the *Kodak* Neutral Test Card at the copyboard. If the white (90% reflectance) side is used, multiply the exposure by 5.

SAFELIGHT

Use a *Kodak* Safelight Filter No. 1A (light red), or equivalent, in a suitable safelight lamp with a 15-watt bulb not less than 4 feet from the film.

FILTER FACTORS

Multiply the normal exposure by the filter factors given below.

Light Source	No. 8	No. 15	No. 47B	No. 58
White Arc (ac or dc)	2.5	8	12	5
Photolamp (3400 K) or Other High-Efficiency Tungsten	1.5	3.5	20	3

DEVELOPMENT

Develop at 20 °C (68 °F) for approximate times given below:

Kodak Developer	Developing Time (Minutes)			Development Range (Minutes)
	Halftone Negative	Agitation	Line Negatives	
Kodalith Super RT	2¾	Continuous	2¾	2¼ to 3¼
Kodalith	2¾	Continuous	2¾	2¼ to 3¼
Kodalith Fine-Line	—	†See note below	2¾	—
Kodalith Liquid (1:3)	2¾	Continuous	2¾	2¼ to 3¼
Kodak Developer *D-11*	NR	Continuous	2½	2 to 3

*Available in convenient ready-to-mix form in several sizes.
†2¾ minutes' total time (about 45 seconds' continuous agitation plus 2 minutes with no agitation). Full instructions come with developer.

KODALITH PAN FILM 2568 (*Estar* Base)

This is an extremely high contrast, fast panchromatic film on *Estar* Base primarily designed for making line and direct color separation negatives and positives for photomechnical reproduction. It is also a very useful film for making line copies of colored originals where stains on the original or the need to drop out copy of certain colors makes the use of filters a requirement. It is also used for the making of highlight masks for color duplicating.

FORM AVAILABLE
Sheets.

SAFELIGHT
Use a *Kodak* Safelight Filter No. 3 (dark green), or equivalent, in a suitable safelight lamp with a 15-watt bulb at not less than 4 feet.

METER SETTINGS
For meters marked with ANSI speeds.

METER SETTINGS
For meters marked with ANSI speeds. White-Flame Arc—40. Tungsten—32.

These speeds are recommended for first trial exposures in copying. To obtain a trial exposure, take a reflected-card reading from the gray (18% reflectance) side of a *Kodak* Neutral Test Card at the copyboard. If the white (90% reflectance) side of the card is used, multiply the indicated exposure by 5. Allow for the extra exposure required for the lens extension usually necessary in copying. These speeds are based on development in *Kodalith* Developer.

FILTER FACTORS
When a filter is used, multiply the unfiltered exposure time by the factor for that particular *Kodak Wratten* Filter shown in the table below. Since conditions vary, these factors are only approximate.

Kodak Wratten Filter	No. 8	No. 25	No. 58	No. 47B
White-Flame Arc	2.5	5	15	15
Tungsten (3400 K)	1.8	3	12	36

DEVELOPMENT
Tray develop at 20 °C (68 °F) for approximate times given below.

Kodak Developer	Developing Time (minutes)	Range (minutes)
Kodalith Super RT	2¾	2¼ to 3¼
Kodalith	2½	2 to 3

NOTES
1. *Kodalith* Liquid Developer is not recommended for this film.

2. *Kodak* Developer *D-11* is recommended for developing when this film is used to make highlight pre-masks. Expose and develop to obtain a density of .30 to .50 in areas corresponding to the transparency diffuse highlights. Use 2 minutes at 20 °C (68 °F) as a starting time for tray development.

EASTMAN KODAK

EASTMAN KODAK

CHARACTERISTIC CURVES

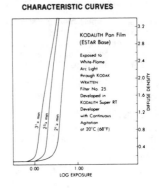

COLOR SENSITIVITY
Panchromatic

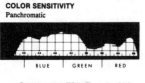

Spectrogram to White-Flame Arc Light

KODAK PANATOMIC-X FILM
KODAK PANATOMIC-X PROFESSIONAL FILM

These are slow speed, panchromatic films that yield negatives with extremely fine grain and excellent definition. These qualities make *Kodak Panatomic-X* and *Panatomic-X* Professional Films particularly suitable for small camera work and any similar purpose when the negatives must be enlarged to high magnifications. With their slow speed and medium-toe curve shape, these films are especially suitable for daylight use and for interior use with bulb and electronic flash. *Panatomic-X* Film can be processed by reversal to produce black-and-white transparencies.

FORMS AVAILABLE
Kodak Panatomic-X Film, 135 magazines, 35mm and 70mm long rolls.
Kodak Panatomic-X Film, 120 rolls.

SPEED
ISO 32/16° ASA 32/16 DIN.

SAFELIGHT
Handle in total darkness.

EMULSION CHARACTERISTICS

GRAIN
Extremely Fine.

DEGREE OF ENLARGEMENT
Very High.

RESOLVING POWER
High Contrast: 200 lines/mm (Very High). Low Contrast: 80 lines/mm.

COLOR SENSITIVITY
Panchromatic.

The Compact Photo-Lab-Index

DEVELOPMENT

Develop at approximate times and temperatures given below. The amount of development is the major control of negative contrast. The figures given below are to be considered average starting times.

	Developing Times (Minutes)									
	Small Tank*					Large Tank‡				
Kodak Developer	18°C (65°F)	20°C (68°F)	21°C (70°F)	22°C (72°F)	24°C (75°F)	18°C (65°F)	20°C (68°F)	21°C (70°F)	22°C (72°F)	24°C (75°F)
HC-110 (Dilution B)	4¾	4¼	4	3¾	3¼	5½	4¾	4¼	4	3½
D-76	6	5	4½	4¼	3¾	6½	5½	5	4¾	4
D-76 (1:1)	8	7	6½	6	5	9	7½	7	6½	5½
Microdol-X	8	7	6½	6	5	9	7½	7	6½	5½
Microdol-X (1:3)‡	—	—	11	10	8½	—	—	12	11	9½
Polydol	6½	5½	5	4½	3½	7	6	5½	5	4

*Agitation at 30-second intervals throughout development.
†Agitation at 1-minute intervals throughout development.
‡Gives greater sharpness than other developers shown in table.

Development times of less than 5 minutes may produce poor uniformity and should be avoided.

Note: Do not use developers containing silver halide solvents, such as thiocyanates or thiosulfates.

CHARACTERISTIC CURVES

CONTRAST INDEX CURVES

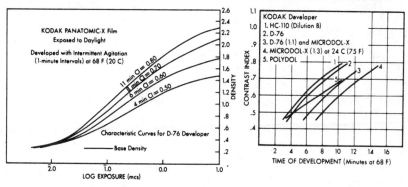

Note: These curves represent 35mm and 70mm films with gray antihalation base. For the roll film with clear base, all densities are 0.15 lower.

EASTMAN KODAK

KODAK PLUS-X PAN FILM
KODAK PLUS-X PORTRAIT FILM 5068
KODAK PLUS-X PAN PROFESSIONAL FILM

These are extremely fine grain, panchromatic films of medium speed and excellent sharpness. Although they have similar sensitometric characteristics, the films are available in various forms to suit different applications. *Plus-X* Pan has a gray dye incorporated in the base material for improved antihalation and to prevent edge fog. *Plus-X* Portrait Film 5068 and *Plus-X* Pan Professional Film have a clear acetate base and a retouching surface on the emulsion side. These are short-toed, long-straight-line-curve films especially suitable for daylight use.

FORMS AVAILABLE

Plus-X Pan Film—135 magazines, 35mm and 70mm long rolls.
Plus-X Portrait Film—35mm and 70 mm long rolls.
Plus-X Pan Professional Film—120 and 220 rolls and 4 × 5-inch packs.

SPEED

ISO 125/22° ASA 125/22 DIN.

SAFELIGHT

Handle in total darkness.

EMULSION CHARACTERISTICS

GRAIN

Extremely Fine.

DEGREE OF ENLARGEMENT

(High).

COLOR SENSITIVITY

Panchromatic.

RESOLVING POWER

High Contrast: 125 lines/mm High. Low Contrast: 50 lines/mm.

DEVELOPMENT

Develop at approximate times and temperature given below. The amount of development is the major control of negative contrast. The figures given below are to be considered average starting times.

The Compact Photo-Lab-Index

Kodak Developer	Developing Time (Minutes)*									
	SMALL TANK—(Agitation at 30-Second Intervals)					LARGE TANK—(Agitation at 1-Minute Intervals)				
	18°C (65°F)	20°C (68°F)	21°C (70°F)	22°C (72°F)	24°C (75°F)	18°C (65°F)	20°C (68°F)	21°C (70°F)	22°C (72°F)	24°C (75°F)
HC-110 (Dilution B)	6	5	4½	4	3½	6½	5½	5	4¾	4
Polydol	6½	5½	4¾	4¼	3¼	7½	6	5½	4¾	3¾
D-76	6½	5½	5	4½	3¾	7½	6½	6	5½	4½
D-76 (1:1)	8	7	6½	6	5	10	9	8	7½	7
Microdol-X	8	7	6½	6	5½	10	69	8	7½	7
Microdol-X (1:3†)	—	—	11	10	9½	—	—	14	13	11

*Avoid development times of less than 5 minutes if possible, because poor uniformity may result.

†Gives greater sharpness than other developers shown in table.

CHARACTERISTIC CURVES CONTRAST INDEX CURVES

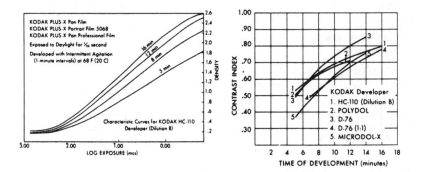

Note: The characteristic curves above are for films with gray antihalation base; for those with clear base, all densities are 0.15 lower.

EASTMAN KODAK

KODAK PLUS-X PAN PROFESSIONAL FILM
2147 (*Estar* Base) 4147 (*Estar* Thick Base) ▗▚▟▚

These are medium-speed, panchromatic films with very fine grain and high sharpness. They have the long toe and excellent highlight separation recommended for studio use. The emulsions are coated on *Estar* Base for greater resistance to mechanical damage and better dimensional stability. They are excellent materials for general studio negative-making, particularly when a high degree of enlargement is needed. Both sides are suitable for retouching.

FORMS AVAILABLE

Kodak Plus-X Pan Professional Film 2147 (*Estar* Base)—35mm, 46mm, and 70mm long rolls. 4147 (*Estar* Thick Base)—Sheets and 3½-inch long rolls.

SPEED

ISO 125/22° ASA 125/22 DIN.

SAFELIGHT

Handle in total darkness.

EMULSION CHARACTERISTICS

GRAIN

Very Fine.

COLOR SENSITIVITY

Panchromatic.

RESOLVING POWER

High Contrast: 125 lines/mm (High). Low Contrast: 50 lines/mm.

DEVELOPMENT

Develop at approximate times and temperatures given below. The amount of development is the major control of negative contrast. The figures given below are to be considered average starting times.

	Developing Times (Minutes)									
	Continuous Agitation (Tray)					Intermittent Agitation* (Tank)				
Kodak *Developer*	18°C (65°F)	20°C (68°F)	21°C (70°F)	22°C (72°F)	24°C (75°F)	18°C (65°F)	20°C (68°F)	21°C (70°F)	22°C (72°F)	24°C (75°F)
Polydol	7	6	5½	5	4½	9	8	7½	7	6
HC-110 (Dilution B)	6	5	4¾	4½	4	8	7	6½	6	5½
DK-50 (1:1)	5	4½	4¼	4	3½	6½	6	5¾	5½	5
D-76	7	6	5½	5	4½	9	8	7½	7	6
Microdol-X	9	8	7½	7	6	11	10	9½	9	8

*Agitation at 1-minute intervals during development.
 Developing long rolls in special reels: See instruction sheet that accompanies the film.

CHARACTERISTIC CURVES

CONTRAST INDEX CURVES

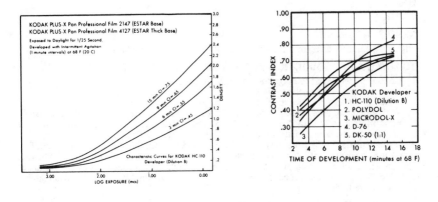

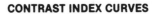

EASTMAN KODAK

KODAK PROFESSIONAL COPY FILM 4125 (*Estar* Thick Base)

An orthochromatic copy film designed to yield the increased highlight contrast needed in continuous-tone copy negatives and in photogravure reproduction. The highlight contrast can be controlled by exposure and development to give a fairly accurate reproduction of most black-and-white originals or to maintain clean backgrounds in copies of combined line and continuous-tone originals.

FORM AVAILABLE

Sheets only (*Kodak* Ortho Copy Film 5125 is available in 70mm, not perforated, long rolls).

SPEED

White-Flame Arc: 25. Tungsten and Quartz Iodine: 12. Pulsed-Xenon: 25.

These speeds are for use with meters marked for ANSI film speeds; they are recommended for trial exposures in copying. To obtain a trial exposure, take a reflected-light meter reading from the gray (18% reflectance) side of the *Kodak* Neutral Test Card at the copyboard. If the white (90% reflectance) side of the card is used, multiply the indicated exposure by 5.

In copying, extra exposure is needed to compensate for a long bellows extension.

SAFELIGHT

Use a *Kodak* Safelight Filter No. 2 (dark red), or equivalent, in a suitable safelight lamp at not less than 4 feet from the film. For short periods of time, a *Kodak* Safelight Filter No. 1 (red) can be used.

67

EMULSION CHARACTERISTICS

GRAIN
Coarse.

RESOLVING POWER
High Contrast: 63 lines/mm (Medium). Low Contrast: 32 lines/mm.

TO MAKE A REPRODUCTION FROM A CONTINUOUS-TONE ORIGINAL:
1. Copy a paper gray scale together with the original.
2. Choose a paper from the table below.
3. Make a series of test negatives at different exposures.
4. With a densitometer, read the density of the steps in the negative gray scale that correspond most closely with those marked 0.00 and 1.60 in the paper gray scale. Select the negative whose aim densities are closest to those indicated by the table.
6. If the densities in the negative gray scale fail to read within the indicated tolerances, first adjust exposure until the shadow density matches that given in the table. Then, if necessary, adjust developing time until the highlight density also matches that in the table. Then, if necessary, adjust developing time until the highlight density also matches that in the table.

DEVELOPING COPY NEGATIVES FOR REPRODUCTION OF PHOTOGRAPHS:

When Your Use This *Kodak* Paper	Develop *Kodak* Professional Copy Film in This *Kodak* Developer at 20°C (68°F)	For These Development Times		To Obtain These Densities Negative Gray Scale	
		Tray— Continuous Agitation	Tank— Intermittent Agitation	Shadow	Highlight
Ektamatic SC*	*HC-110* (Dilution E)	4¾ min	6½ min	0.37 ± .02	1.48 ± .05
Polycontrast F*	*HC-110* (Dilution E)	4½ min	6 min	0.30 ± .02	1.30 ± .05
Ektalure G	*HC-110* (Dilution E)	3¾ min	4¾ min‡	0.24 ± .02	1.12 ± .05
Azo F†	*HC-110* (Dilution B)	3½ min	4 min‡	0.38 ± .02	1.52 ± .05

**Kodak* Polycontrast Filter PC2.
†Contrast grade 1.
‡Development times of less than 5 minutes in a tank may produce poor uniformity and should be avoided.

DEVELOPING COPY NEGATIVES FOR LESS CRITICAL APPLICATIONS:
With sufficient exposure to yield a highlight density of 1.52 (± .05), the developing times given below yield negatives suitable for contact printing on *Kodak Azo* Paper, Grade 1, or on papers with similar contrast.

Kodak Developer	Developing Times in Minutes at 20°C (68°F)	
	Tray (Continuous Agitation)	Tank Agitation at 1-Minute Intervals)
HC-110 (Dilution B)	3½	4*
DK-50 (1:1)	6	8
Polydol	4¼	5½

*Development times of less than 5 minutes in a tank may produced poor uniformity and should be avoided.

EASTMAN KODAK

KODAK RECORDING FILM 2475 (Estar-AH Base)

An extremely fast, coarse-grain panchromatic film with extended red sensitivity for use in 35mm cameras. It is recommended for photography in low levels of existing light, or where very fast shutter speeds coupled with small apertures must be used. This film is especially useful for indoor sports photography, available-light press photography, surveillance photography, and in other situations where flash illumination cannot be used.

FORMS AVAILABLE

EI 1000 to 4000, for exposure meters marked for ANSI film speeds. For low-contrast scenes, and exposure index of 1600 can be used with normal development, and up to EI 4000 can be used if the extended development shown below is given.

SAFELIGHT

Total darkness is required.

FILTER FACTORS

Because of the extended red sensitivity, some factors are different for this film, and tests should be made to determine the modification of exposure necessary for good results.

Light Source	No. 6	No. 8	No. 11	No. 15	No. 25	No. 47	No. 58	Polarizing Screen
Daylight	1.5	2*	6	2	3	6	10	2.5
Tungsten	1.2	1.2	6*	1.5	2	16	12	3

Kodak Wratten Filters

*For a gray-tone rendering of colors approximating their visual brightnesses.

EMULSION CHARACTERISTICS

GRAIN
Coarse.

DEGREE OF ENLARGEMENT
Low.

RESOLVING POWER
High Contrast: 63 lines/mm (Medium). Low Contrast: 32 lines/mm.

COLOR SENSITIVITY
Panchromatic with extended red sensitivity.

RECIPROCITY EFFECT ADJUSTMENTS:

If Indicated Exposure Time Is (Seconds)	Use Either		Contrast Change*
	This Lens Aperture Adjustment	Or This Adjusted Exposure Time (Seconds)	
1/10 and faster	None	no adjustment	None
1	+⅔	1.6	+10%
10	+1⅓	25	+20%
100	+2⅓	500	+30%

*Developing time can be reduced to compensate for increased contrast.

The Compact Photo-Lab-Index

DEVELOPMENT

Develop at approximate times and temperatures given below. Times are for small tanks with agitation at 30-second intervals. Times given in the lower half of the table are the extended times. Use fresh developer only; partially exhausted developer may produce a deposit of dichroic fog.

Kodak **Developer**	18°C (65°F)	20°C (68°F)	21°C (70°F)	22°C (72°F)	24°C (75°F)	29°C (85°F)
			Developing Time (Minutes)			
Average Subjects						
DK-50	7	6	5	4¾*	4*	2½*
HC-110 (Dil. A)	5½	4½*	4*	3½*	3*	2*
HC-110 (Dil. B)	11	9	8	7	6	3*
Low Contrast Subjects						
DK-50	10½	9	8½	7½	6½	3¾*
HC-110 (Dil. A)	9½	8	7½	6½	5	2¾*
HC-110 (Dil. B)	17	15	12	11	10	2

*Not recommended because development times of less than 5 minutes may produce poor uniformity.

KODAK ROYAL-X PAN FILM 4166 (*Estar* Thick Base)

An extremely fast, medium-grain, panchromatic film recommended for photography in low levels of existing light, or when very fast shutter speeds coupled with small lens apertures must be used. The film is particularly useful for indoor sports photography and in situations where flash illumination cannot be used.

FORMS AVAILABLE

Sheets and 3½-inch long rolls. A similar film, *Kodak Royal-X* Pan Film, is available in 120-size rolls. See the instruction sheet packaged with the film.

SPEED

ISO 1250/32° ASA 1250/32 DIN.

This number is for use with meters marked for ANSI film speeds. In flat lighting, good negatives can be obtained with meter settings up to ASA 2000 and normal development. A meter setting of AS 4000 can be used if the recommended developing times are increased by about 50 percent.

SAFELIGHT

None. Handle and process the film in total darkness.

EMULSION CHARACTERISTICS

GRAIN
Fine.

DEGREE OF ENLARGEMENT
Moderately Low.

RESOLVING POWER
High Contrast: 100 lines/mm (Medium). Low Contrast: 40 lines/mm.

EASTMAN KODAK

The Compact Photo-Lab-Index

COLOR SENSITIVITY
Panchromatic.

DEVELOPMENT
Develop at approximate times and temperatures given below. Note that a slight fog density is normal. Do not use developers containing silver-halide solvents, such as thiocyanates or thiosulfates. Also, do not use an exhausted developer because this may produce dichroic fog on the negative. The amount of development is major control of negative contrast. The figures given below are to be considered average starting times.

| | Developing Time (Minutes) | | | | | | | | | |
| | TRAY (Continuous Agitation) | | | | | SMALL TANK—(Agitation at 30-Second Intervals) | | | | |
Kodak Developer	18°C (65°F)	20°C (68°F)	21°C (70°F)	22°C (72°F)	24°C (75°F)	18°C (65°F)	20°C (68°F)	21°C (70°F)	22°C (72°F)	24°C (75°F)
HC-110 (Dil. B)	8½	8	7½	7	6½	10	9	8	7½	6½
Polydol	7½	6½	6	5½	4½	8	7	6½	6	5
DK-60a	4½	4	3¾	3½	3	5	4½*	4½*	—	—
DK-50	4¾	4½	4¼	4¼	4	5½	5	4¾*	4¾	4½*
HC-110 (Dil. A)	5	4½	4¼	4	3½	6	5	4¾*	4½*	4¼*

	LARGE TANK—(Agitation at 1-Minute Intervals)				
HC-110 (Dil. B)	11	9	9	8½	7½
Polydol	9½	7	8	7½	6½
DK-60a	6	5	4½*	4*	3½*
DK-50	6½	5	5½	5½	5
HC-110 (Dil. A)	7	6	5½	5½	4½*

*Not recommended because development times of less than 5 minutes in a tank may produce poor uniformity.

CHARACTERISTIC CURVES

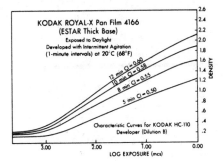

KODAK ROYAL-X Pan Film 4166
(ESTAR Thick Base)
Exposed to Daylight
Developed with Intermittent Agitation
(1-minute intervals) at 20°C (68°F)

12 min CI = 0.60
10 min CI = 0.58
8 min CI = 0.55
5 min CI = 0.50

Characteristic Curves for KODAK HC-110
Developer (Dilution B)

LOG EXPOSURE (mcs)

CONTRAST INDEX CURVES

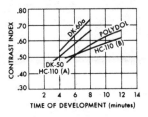

DK-60a
POLYDOL
HC-110 (B)
DK-50
HC-110 (A)

TIME OF DEVELOPMENT (minutes)

71

KODAK ROYAL PAN FILM 4141 (*Estar* Thick Base)

This fast, fine-grain, panchromatic film is suitable for many purposes in commercial and industrial photography. Its long-toed curve makes it especially suitable for studio use and provides brilliant highlight separation. It is particularly useful when a sheet film is needed in candid wedding photography, in which flash illumination is generally used. Both sides of the film are suitable for retouching.

FORMS AVAILABLE
Sheets and 3½-inch long rolls.

SPEED
ISO 400/27° ASA 400/27 DIN.

SAFELIGHT
Handle in total darkness.

EMULSION CHARACTERISTICS

GRAIN
Fine.

RESOLVING POWER
High Contrast: 80 lines/mm (Medium). Low Contrast: 40 lines/mm.

DEGREE OF ENLARGEMENT
Moderately Low.

DEVELOPMENT
Develop at approximate times and temperatures given below. The amount of development is the major control of negative contrast. The figures given below are to be considered average starting times.

	Developing Times (Minutes)									
	Continuous Agitation (Tray)					Intermittent Agitation* (Tank)				
Kodak Developer	18°C (65°F)	20°C (68°F)	21°C (70°F)	22°C (72°F)	24°C (75°F)	18°C (65°F)	20°C (68°F)	21°C (70°F)	22°C (72°F)	24°C (75°F)
Polydol	7	6	5½	5	4½	9	8	7½	7	6
HC-110 (Dilution A)	3½	3	2¾	2½	2¼	4†	3¾†	3¼†	3†	2¾†
HC-110 (Dilution B)	7	6	5½	5	4½	9	8	7½	7	6
DK-50	4½	4	4	3¾	3½	5½	5	4¾†	4½†	4¼†
DK-50 (1:1)	7	6	5½	5	4½	9	8	7½	7	6
D-76	9	8	7½	7	6	11	10	9½	9	8
Microdol-X	10	9	8½	8	7	12	11	10½	10	9

*Agitation at 1-minute intervals during development.
†Development times of less than 5 minutes in a tank may produce poor uniformity and should be avoided.

CHARACTERISTIC CURVES

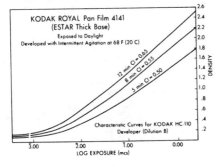

CONTRAST INDEX CURVES

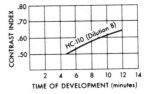

KODAK SUPER-XX PAN FILM 4142 (*Estar* Thick Base)

A moderately high speed, panchromatic film for general purposes in portrait, commercial, and industrial photography. It is an excellent material for making color-separation negatives and for black-and-white negatives from color transparencies.

FORM AVAILABLE
Sheets only.

SPEED
ISO 200/24° ASA 200/24 DIN.

SAFELIGHT
Handle in total darkness

EMULSION CHARACTERISTICS

GRAIN
Fine.

RESOLVING POWER
High Contrast: 100 lines/mm (High). Low Contrast: 40 lines/mm.

COLOR SENSITIVITY
Panchromatic.

EASTMAN KODAK

73

The Compact Photo-Lab-Index

DEVELOPMENT

Develop at approximate times and temperatures given below. The amount of development is the major control of negative contrast. The figures given below are to be considered average starting times.

Kodak Developer	Developing Time (Minutes)									
	Continuous Agitation (Tray)					Intermittent Agitation* (Tank)				
	18°C (65°F)	20°C (68°F)	21°C (70°F)	22°C (72°F)	24°C (75°F)	18°C (65°F)	20°C (68°F)	21°C (70°F)	22°C (72°F)	24°C (75°F)
Polydol	11	9	8	7	6	13	11	10	9	8
HC-110 (Dilution A)	4½	4	3¾	3½	3	6	5	4½†	4¼†	3½†
HC-110 (Dilution B)	8	7	6½	6	5	11	9	8	7	6
DK-50	5½	5	4¾	4½	4	8	7	6½	6	5
DK-50 (1:1)	9	8	7½	7	6	11	10	9½	9	8

*Agitation at 1-minute intervals during development.
†Development times of less than 5 minutes in a tank may produce poor uniformity and should be avoided.

CHARACTERISTIC CURVES

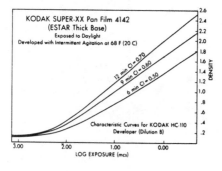

CONTRAST INDEX CURVES

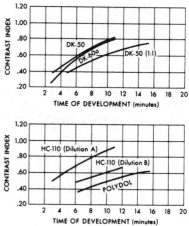

KODAK TRI-X PAN FILM

A fast, wide-latitude panchromatic film with a medium-toed curve. It can be used with all types of lighting and yields excellent gradation. It is very responsive to contrast control with a wide variety of developers. This film has remarkably fine grain, considering its fast speed. Many photographers choose *Kodak Tri-X* Pan Film as an all-purpose film.

FORMS AVAILABLE
Standard-size roll films, 135 magazines, and 35mm long rolls.

SPEED
ISO 400/27° ASA 400/27 DIN.

SAFELIGHT
Handle in total darkness.

EMULSION CHARACTERISTICS

GRAIN
Fine.

RESOLVING POWER
High Contrast: 100 lines/mm (High). Low Contrast: 50 lines/mm.

SENSITIVITY
Panchromatic.

DEVELOPMENT
Develop at approximate times and temperatures given below. The amount of development is the major control of negative contrast. The figures given below are to be considered average starting times.

	Developing Time (Minutes)*									
	Small Tank—(Agitation at 30-Second Intervals)					Large Tank—(Agitation at 1-Minute Intervals)				
Kodak Developer	18°C (65°F)	20°C (68°F)	21°C (70°F)	22°C (72°F)	24°C (75°F)	18°C (65°F)	20°C (68°F)	21°C (70°F)	22°C (72°F)	24°C (75°F)
HC-110 (Dilution B)	8½	7½	6½	6	5	9½	8½	8	7½	6½
Polydol	8	7	6½	6	5	9	8	7½	7	6
D-76	9	8	7½	6½	5½	10	9	8	7	6
D-76 (1:1)	11	10	9½	9	8	13	12	11	10	9
Microdol-X	11	10	9½	9	8	13	12	11	10	9
Microdol-X (1:3)*	—	—	15	14	13	—	—	17	16	15
DK-50 (1:1)	7	6	5½	5	4½†	7½	6½	6	5½	5
HC-100 (Dilution A)	4¼†	3¾†	3¼†	3†	2½†	4¾†	4¼†	4†	3¾†	3¼†

*Gives greater sharpness than other developers shown in table.
†Avoid development times of less than 5 minutes if possible, because poor uniformity may result.
Note: Do not use developers containing silver halide solvents.

EASTMAN KODAK

CHARACTERISTIC CURVES

CONTRAST INDEX CURVES

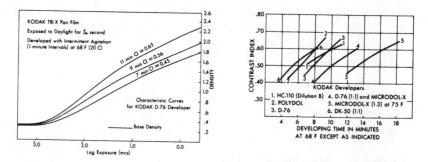

NOTE: These curves represent 35mm and 70mm films with gray antihalation base. For the roll film with clear base, all densities are 0.15 lower.

KODAK TRI-X PAN PROFESSIONAL FILM

This fast, long-toed curve panchromatic film yields negatives with excellent gradation and brilliant highlights. While it can be used with all types of lighting, it is especially suited to low-flare interior tungsten or flash conditions. The emulsion gives good control of contrast in development. *Kodak Tri-X* Pan Professional Films in rolls and film packs have retouching surfaces on both sides of the film.

FORMS AVAILABLE
120- and 220-size roll films and film packs.

SPEED
ISO 320/26° ASA 320/26 DIN.

SAFELIGHT
Handle in total darkness.

EMULSION CHARACTERISTICS

GRAIN
Fine.

RESOLVING POWER
High Contrast: 100 lines/mm (High). Low Contrast: 32 lines/mm.

COLOR SENSITIVITY
Panchromatic.

DEVELOPMENT
Develop at approximate times and temperatures given below. The amount of development is the major control of negative contrast. The figures given below are to be considered average starting times. For tray development times of pack film, see the instruction sheet packaged with the film.

The Compact Photo-Lab-Index

Kodak Developer	Developing Time (Minutes)*									
	Small Tank—(Agitation at 30-Second Intervals)					Large Tank—(Agitation at 1-Minute Intervals)				
	18°C (65°F)	20°C (68°F)	21°C (70°F)	22°C (72°F)	24°C (75°F)	18°C (65°F)	20°C (68°F)	21°C (70°F)	22°C (72°F)	24°C (75°F)
Polydol	10	9	8	7½	6½	11	10	9	8	7
HC-110 (Dilution B)	10	9	8	7	6	11	10	9	8	7
DK-50 (1:1)	9	8	7½	7	6	10	9	8½	8	7
D-76	9	8	7½	7	6	10	9	8½	8	7
*Microdol-X**	11	10	9	8½	7½	12	11	10	9	8

*Gives greater sharpness than other developers shown in table.
Note: Do not use developers containing silver halide solvents.

EASTMAN KODAK

CHARACTERISTIC CURVES

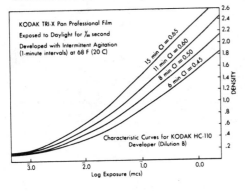

KODAK TRI-X Pan Professional Film
Exposed to Daylight for 1/50 second
Developed with Intermittent Agitation (1-minute intervals) at 68 F (20 C)

15 min CI = 0.65
11 min CI = 0.60
8 min CI = 0.50
6 min CI = 0.45

Characteristic Curves for KODAK HC-110 Developer (Dilution B)

CONTRAST INDEX CURVES

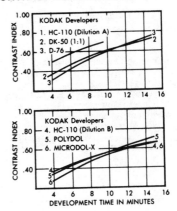

KODAK Developers
1. HC-110 (Dilution A)
2. DK-50 (1:1)
3. D-76

KODAK Developers
4. HC-110 (Dilution B)
5. POLYDOL
6. MICRODOL-X

DEVELOPMENT TIME IN MINUTES

77

KODAK TRI-X PAN PROFESSIONAL FILM 4164 (*Estar* Thick Base)

This fast panchromatic film has sensitometric characteristics similar to the *Kodak Tri-X Pan Professional Films*, except that the emulsion is coated on the more dimensionally stable and durable *Estar* Thick Base. Both sides of the film have surfaces suitable for retouching.

FORMS AVAILABLE
Sheets and 3½-inch long rolls.

SPEED
ISO 320/26° ASA 320/26 DIN.

SAFELIGHT
Handle in total darkness.

EMULSION CHARACTERISTICS

GRAIN
Fine.

RESOLVING POWER
High Contrast: 100 lines/mm (High). Low Contrast: 32 lines/mm.

COLOR SENSITIVITY
Panchromatic.

DEVELOPMENT
Develop at approximate times and temperatures given below. The amount of development is the major control of negative contrast. The figures given below are to be considered average starting times. Do not use developers containing silver halide solvents. The developing times and contrast-index curves on this page and following page are new. The changes result from a larger testing of product and keeping data, an improved correlation between our sensitometric process and actual tank processes, and not from a change in product. It is believed that use of these developing times will provide improved results. If however, you feel that satisfactory results are being obtained with other developing times you are now using, do not change.

	Developing Time (Minutes)									
	Tray (Continuous Agitation)					Tank (Agitation at 1-minute Intervals†)				
Kodak Developer	18°C (65°F)	20°C (68°F)	21°C (70°F)	22°C (72°F)	24°C (75°F)	18°C (65°F)	20°C (68°F)	21°C (70°F)	22°C (72°F)	24°C (75°F)
HC-110 (Dilution B)	6	5½	5	4½	4	8	7½	7	6	5
D-76	6	5½	5	5	4½	7½	7	6½	6	5½
Polydol	7	6	5	5	4½	9	8	7	6½	5½
Microdol-X*	8	7	6	5½	5	10	9	8	7½	6½
DK-50 (1:1)	5	5	4½	4½	4	7	6½	6	5½	5

*Gives greater sharpness than other developers shown in table.

EASTMAN KODAK

The Compact Photo-Lab-Index

CHARACTERISTIC CURVES

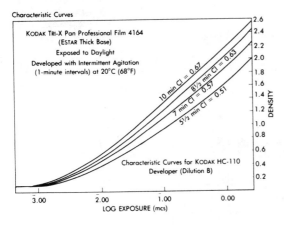

Characteristic Curves

KODAK TRI-X Pan Professional Film 4164
(ESTAR Thick Base)
Exposed to Daylight
Developed with Intermittent Agitation
(1-minute intervals) at 20°C (68°F)

10 min CI = 0.67
8½ min CI = 0.63
7 min CI = 0.57
5½ min CI = 0.51

Characteristic Curves for KODAK HC-110
Developer (Dilution B)

DENSITY

2.6
2.4
2.2
2.0
1.8
1.6
1.4
1.2
1.0
0.8
0.6
0.4
0.2

3.00 2.00 1.00 0.00
LOG EXPOSURE (mcs)

CONTRAST INDEX CURVES

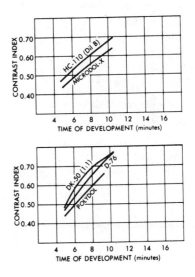

CONTRAST INDEX
0.70
0.60
0.50
0.40

HC-110 (Dil B)
MICRODOL-X

4 6 8 10 12 14 16
TIME OF DEVELOPMENT (minutes)

CONTRAST INDEX
0.70
0.60
0.50
0.40

DK-50 (1:1)
D-76
POLYDOL

4 6 8 10 12 14 16
TIME OF DEVELOPMENT (minutes)

KODAK TRI-X ORTHO FILM 4163 (*Estar* Thick Base)

A fast orthochromatic film with fine grain and moderate contrast. It yields negatives with good shadow detail and brilliant highlights. The film is suitable for press, commercial, and industrial photography and any purpose where red sensitivity is unnecessary or undesirable. In portraiture it can be used for character studies, particularly those of elderly men. Both side of the film are suitable for retouching.

FORM AVAILABLE
Sheets only.

SPEED
Daylight: ISO 320/26° ASA 320/26 DIN.
Tungsten: ISO 200/24° ASA 200/24 DIN.

SAFELIGHT
Use a *Kodak* Safelight Filter No. 2 (dark red), or equivalent, in a suitable safelight lamp with a 15-watt bulb at not less than 4 feet from the film.

EMULSION CHARACTERISTICS

GRAIN
Fine.

RESOLVING POWER
High Contrast: 100 lines/mm (High). Low Contrast: 40 lines/mm.

COLOR SENSITIVITY
Orthochromatic.

FILTER FACTORS
Multiply the normal exposure by the filter factor given below.

Kodak Wratten Filter	No. 6	No. 8	No. 15	No. 58	No. 47	Polarizing Screen
Daylight	2	2	3	6	5	2.5
Tungsten	1.5	2	3	5	8	2.5

DEVELOPMENT
Develop at approximate times and temperatures given below. The amount of development is the major control of negative contrast. The figures given below are to be considered average starting times. Do not use developers containing silver halide solvents.

80

EASTMAN KODAK

The Compact Photo-Lab-Index

Kodak Developer	Developing Time (Minutes)*									
	Tray (Continuous Agitation)					Tank (Agitation at 1-minute Intervals)				
	18°C (65°F)	20°C (68°F)	21°C (70°F)	22°C (72°F)	24°C (75°F)	18°C (65°F)	20°C (68°F)	21°C (70°F)	22°C (72°F)	24°C (75°F)
HC-110 (Dilution B)	6½	5½	5	4½	4	8½	7½	7	6½	5
D-76	6½	6	5½	5	4½	8	7½	6½	6	5½
Polydol	7½	6½	5½	5	4½	9	8	7	6½	5½
Microdol-X	9	7½	7	6	5	11	9½	9	8	7
DK-50 (1:1)	5½	5	4½	4½	4	7½	6½	6	5½	5

CHARACTERISTIC CURVES

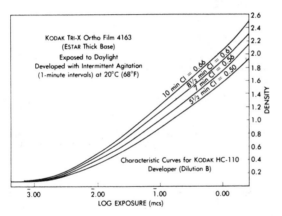

KODAK TRI-X Ortho Film 4163 (ESTAR Thick Base) Exposed to Daylight Developed with Intermittent Agitation (1-minute intervals) at 20°C (68°F)

10 min CI = 0.66
8½ min CI = 0.61
7 min CI = 0.56
5½ min CI = 0.50

Characteristic Curves for KODAK HC-110 Developer (Dilution B)

CONTRAST INDEX CURVES

KODAK VERICHROME PAN FILM

A medium-speed, panchromatic film with extremely fine grain, its excellent gradation and wide exposure latitude, combined with a medium-toed characteristic curve shape, make it an excellent general purpose roll film. It has similar characteristics to *Kodak Plus-X* Pan Professional Film, but does not have retouching surfaces. *Kodak Verichrome* Pan Film comes in several roll-film sizes and is the only *Kodak* black-and-white film available in size 110 and 126 cartridges.

SIZES AVAILABLE
110—12 exposures; 126—12 exposures; 120; 620; 127; 616.

SPEED
ISO 125/22° ASA 125/22 DIN.

SAFELIGHT
Handle in total darkness.

EMULSION CHARACTERISTICS

GRAIN
Extremely Fine.

RESOLVING POWER
High Contrast: 100 lines/mm (High). Low Contrast: 50 lines/mm.

COLOR SENSITIVITY
Panchromatic.

DEVELOPMENT
Develop at approximate times and temperatures given below. The amount of development is the major control of negative contrast. The figures given below are to be considered average starting times.

	Developing Time (Minutes)*									
	Small Tank*					Large Tank†				
Kodak Developer	18°C (65°F)	20°C (68°F)	21°C (70°F)	22°C (72°F)	24°C (75°F)	18°C (65°F)	20°C (68°F)	21°C (70°F)	22°C (72°F)	24°C (75°F)
HC-110 (Dilution B)	6	5	4½	4	2	8	6½	6	5½	4½
D-76	8	7	5½	5	4½	9	8	7	6	5
D-76 (1:1)	11	9	8	7	6	12½	10	9	8	7
Microdol-X	10	9	8	7	6	11	10	9	8	7
Microdol-X (1:3)‡	15	14	13	12	11	20	15	14	13	12
Polydol	8	6	5	4½	5	9	7½	6	5	4½

*Agitation at 30-second intervals throughout development.
†Agitation at 1-minute intervals throughout development.
‡Gives greater sharpness than other developers shown in table.

Note: Tank development times of less than 5 minutes may produce poor uniformity and should be avoided.

EASTMAN KODAK

The Compact Photo-Lab-Index

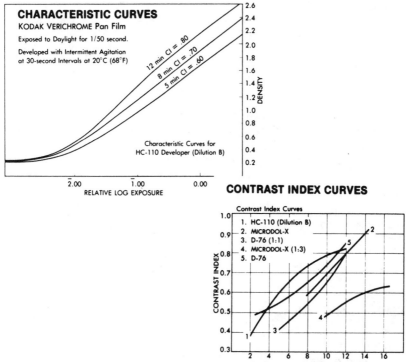

CHARACTERISTIC CURVES

KODAK VERICHROME Pan Film

Exposed to Daylight for 1/50 second.

Developed with Intermittent Agitation
at 30-second Intervals at 20°C (68°F)

12 min CI = .80
8 min CI = .70
5 min CI = .60

DENSITY

2.6
2.4
2.2
2.0
1.8
1.6
1.4
1.2
1.0
0.8
0.6
0.4
0.2

Characteristic Curves for
HC-110 Developer (Dilution B)

2.00 1.00 0.00

RELATIVE LOG EXPOSURE

CONTRAST INDEX CURVES

Contrast Index Curves

1. HC-110 (Dilution B)
2. MICRODOL-X
3. D-76 (1:1)
4. MICRODOL-X (1:3)
5. D-76

CONTRAST INDEX

1.0
0.9
0.8
0.7
0.6
0.5
0.4
0.3

2 4 6 8 10 12 14 16

DEVELOPMENT TIME (minutes) at 68°F
AGITATION AT 30-SECOND INTERVALS

KODAK DIRECT POSITIVE PANCHROMATIC FILM 5246

This extremely fine grain panchromatic film is for making 35mm black-and-white transparencies directly from the camera exposure. The positive image is obtained by reversal processing; thus the intermediate negative is unnecessry. The film is suitable for producing 35mm slide from most general subject matter, as well from photographs, prepared artwork, and similar continuous-tone material.

FORM AVAILABLE

Rolls 35mm × 100 feet—perforated.

SPEED

Daylight: ISO 80/20° ASA 80/20 DIN.
Tungsten: ISO 64/19° ASA 64/19 DIN.

SAFELIGHT

Total darkness (see processing instructions below).

FILTER FACTORS

Increase normal exposure by the filter factor given below.

83

The Compact Photo-Lab-Index

Kodak Wratten Filter	No.8	No.15	No.11	No.13	No.25	No.58	No.47	No.47B	Polarizing Screen
Daylight	2*	2.5	4	4	10	5	8	10	2.5
Tungsten	1.5	2	3*	5	5	5	16	20	2.5

*For a gray-tone rendering of colors approximating their visual brightnesses.

PHOTOFLOOD EXPOSURE TABLE

Two No. R2 reflector floodlamps, or two No. 2 photofloods in 12-inch average reflectors, giving comparable light output.

Side Light-to-Subject Distance	3½ ft	4½ ft	6 ft	9 ft	10 ft	13 ft
Camera Light-to-Subject Distance	4½ ft	6 ft	9 ft	13 ft	14 ft	18 ft
Lens Opening at 1/25 sec	f/11	f/8	f/5.6	f/4	f/3.5	f/2.8

EMULSION CHARACTERISTICS

GRAIN
Extremely Fine.

RESOLVING POWER
High Contrast: 125 lines/mm (High). Low Contrast: 50 lines/mm.

COLOR SENSITIVITY
Panchromatic.

PROCESSING
Chemicals for reversal processing of this film may be purchased in the *KODAK Direct Positive Film Developing Outfit,* or separately. They may also be mixed from formulas given in Publication No. J-6, *Small-Batch Reversal Processing of KODAK B/W Films.* The film must be processed in total darkness until the bleaching step is completed; thereafter, a *Kodak* Safelight Filter 0A (greenish yellow) can be used with a 15-watt bulb 4 feet from the film. Do not inspect the film with white light until it is completely fixed. Keep the temperature of all processing solutions at 20 °C (68 °F), if possible.

Note: Drain the film 10 to 15 seconds after each bath.

Follow the special processing steps given below:

1. First Developer6 to 9 minutes*
2. Rinse2 to 5 minutes†
3. Bleach1 minute
4. Clearing Bath2 minutes
5. Redeveloper 8 minutes
6. Water Rinse 1 minute
7. Fixing Bath 5 minutes
8. Wash20 minutes

*Adjust the time in the first developer for your developing equipment agitation technique.
†A 2-minute rinse is sufficient with a running-water wash and thorough agitation.

EASTMAN KODAK

MODULATION TRANSFER FUNCTION CURVES FOR SOME KODAK FILMS

KODAK EKTAPAN Film 4162 (ESTAR Thick Base)
POLYDOL Developer, 10 min, 20°C (68°F)

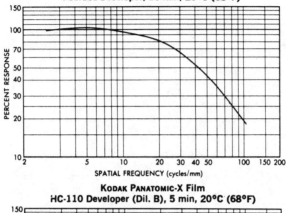

KODAK PANATOMIC-X Film
HC-110 Developer (Dil. B), 5 min, 20°C (68°F)

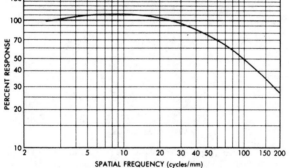

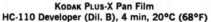

KODAK PLUS-X Pan Film
HC-110 Developer (Dil. B), 4 min, 20°C (68°F)

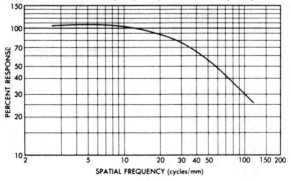

EASTMAN KODAK

85

The Compact Photo-Lab-Index

EASTMAN KODAK

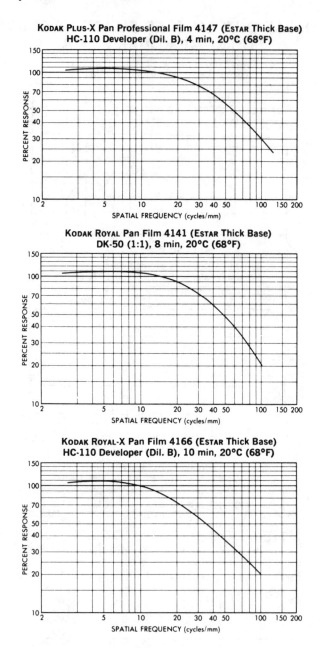

KODAK PLUS-X Pan Professional Film 4147 (ESTAR Thick Base)
HC-110 Developer (Dil. B), 4 min, 20°C (68°F)

KODAK ROYAL Pan Film 4141 (ESTAR Thick Base)
DK-50 (1:1), 8 min, 20°C (68°F)

KODAK ROYAL-X Pan Film 4166 (ESTAR Thick Base)
HC-110 Developer (Dil. B), 10 min, 20°C (68°F)

The Compact Photo-Lab-Index

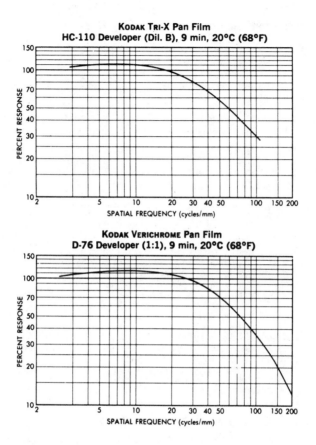

Note: Development for all films except Verichrome Pan Film is in large tank with agitation at 1-minute intervals. Development of Verichrome Pan Film is in small tank with agitation at 30-second intervals.

EASTMAN KODAK

KODAK TECHNICAL PAN FILM (*Estar-AH* BASE) SO-115

DESCRIPTION

Kodak Technical Pan Film (*Estar-AH* Base) SO-115 is a black-and-white negative film with extended red panchromatic sensitivity. It has extremely fine grain and extremely high resolving power. This film replaces two films used in a wide range of scientific and technical applications—*Kodak* Solar Flare Patrol Film (*Estar-AH* Base) SO-392 and *Kodak* Photomicrography Monochrome Film (*Estar-AH* Base) SO-410. SO-115 Film provides several advantages over the SO-392 and SO-410 Films. These include higher green sensitivity, higher resolving power and modulation transfer function (MTF), and better handling in sheet formats.

The SO-115 emulsion accommodates flexible processing to a wide range of contrasts. Gammas from 1 to 4 are achievable with conventional developers. *Kodak* Technical Pan Film can be processed to higher contrast and density than *Kodak* High Contrast Copy film 5069. This contrast control is of special benefit, for example, in photomicrography of low-contrast specimens.

The dyed-gel backing layer suppresses curl as well as halation. The *Estar-AH* Base (with a 0.1 base density) permits handling of magazine-loaded film in subdued light.

APPLICATIONS

This film provides contrast enhancement of photomicrography specimens which are colorless, faintly stained, or intended for phase contrast or Nomarski illumination (such as chromosomal or karyotyping studies). It requires reduced exposure times with green filtration in photomicrography compared with SO-410 Film.

In solor recording it replaces *Kodak* Solar Flare Patrol Film SO-392 for solar disk recording and provides information on solar phenomena occurring throughout the green wavelengths as well as at the H-alpha line.

It is excellent for photographing the images reconstructed from holograms where the playback illuminant is a helium-neon laser (633 nm). It may also be used to record the output of light-emitting diodes (LEDs), which peak at 640 to 660 nm, and plasma displays.

Because it can provide very high contrast and maximum density when processed in selected conventional developers, this film is very useful for making black-and-white slides.

This film will find other applications where speed/grain ratio is important, where both high resolution and camera speed are important, or where a range of contrast control is necessary.

SPECTRAL SENSITIVITY

The spectral sensitivity of SO-115 Film reflects an extensive effort to provide reasonably uniform sensitivity at all visible wavelengths while retaining the exceptional red sensitivity (and other valuable properties) of SO-392 and SO-410 Films. To achieve a closer approximation to flat response, some users may wish to make exposures through a color compensating filter which selectively attenuates red and blue-UV radiation, e.g., *Kodak* Color Compensating Filter CC40C or CC50C (Cyan). The effect of using such a filter will be to yield reasonably flat response out to 655 nm. Note, in comparison, that films having conventional panchromatic sensitivity are designed to provide flat response only out to 625 nm. Thus, even with a CC50C Filter in place, SO-115 Film will record red portions of a scene relatively more efficiently then materials such a *Kodak Panatomic-X* Film or *Kodak Plus-X* Pan Film.

EASTMAN KODAK

The Compact Photo-Lab-Index

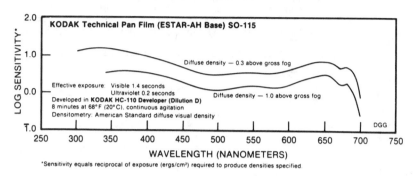

SPECTRAL SENSITIVITY

KODAK Technical Pan Film (ESTAR-AH Base) SO-115

Diffuse density — 0.3 above gross fog

Effective exposure: Visible 1.4 seconds
Ultraviolet 0.2 seconds
Developed in **KODAK HC-110 Developer (Dilution D)**
8 minutes at 68°F (20°C). continuous agitation
Densitometry: American Standard diffuse visual density

Diffuse density — 1.0 above gross fog

DGG

LOG SENSITIVITY*

WAVELENGTH (NANOMETERS)

*Sensitivity equals reciprocal of exposure (ergs/cm²) required to produce densities specified.

IMAGE STRUCTURE CHARACTERISTICS

All data given in this section is based on development in *Kodak HC-110* Developer (Dilution D) at 68°F (20°C) for 8 minutes.

RESOLVING POWER

Test-Object Contrast	Resolving Power (lines/mm)
1000:1	320
1.6:1	125

MODULATION TRANSFER FUNCTION

These photographic modulation transfer values were determined using a method similar to that of ANSI Standard PH 2.39-1977. The film was exposed with the specified illuminant to spatially varying sinusoidal test patterns having an aerial image modulation of a nominal 35 percent at the image plane, with processing as indicated. In most cases, the photographic modulation transfer values are influenced by development adjacency effects, and are not equivalent to the true optical modulation transfer curve of the emulsion layer in the particular photographic product.

DIFFUSE RMS GRANULARITY

8 (extremely fine)

This value represents 1000 times the standard deviation in density produced by the granular structure of the material when a uniformly exposed and developed sample is scanned with a microdensitometer calibrated to read American National Standard *diffuse* visual density and having a 48 m circular aperture. Granularity is an objective measurement of the spatia variation of sample density that generally correlates with graininess, which is the subjective effect of the image nonuniformity upon an observer.

Broadly speaking, granularity measurements with the 48 μ m aperture will indicate the magnitude of the graininess sensation produced by viewing the *diffusely* illuminated sample with 12X monocular magnification. If the viewing conditions are changed from the specified 12X condition, the published rms values may no longer correctly indicate the relative sensations of graininess produced by various samples.

EXPOSURE, FILM SPEED AND CONTRAST

The following are suggested starting exposure conditions. Since there are a wide range of unique exposure situations in which this film may be used, we give recommendations only for the most common applications. Note that the exposure index is closely related to the

The Compact Photo-Lab-Index

processing conditions and the resulting contrast. Compare the tables presented with the characteristic curves in choosing the appropriate contrast and exposure index. Values given are for use with meters marked for ASA speeds or exposure indexes and are suggested starting points for trial exposures. Bracketing exposures by full-stop intervals will usually be required for initial tests.

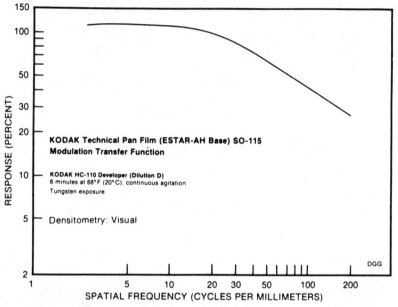

KODAK Technical Pan Film (ESTAR-AH Base) SO-115
Modulation Transfer Function

KODAK HC-110 Developer (Dilution D)
8 minutes at 68°F (20°C), continuous agitation
Tungsten exposure

Densitometry: Visual

EXPOSURE INDEXES FOR PHOTOMICROGRAPHY

The following exposure index (EI) values are intended as starting points for trial exposures to give satisfactory results with photomicrography equipment having through-the-lens meters. The indexes are based on the formula $EI = 10/E$, where E is the 1-second exposure in meter-candle-seconds required to produce a density of 0.6 above minimum density with the indicated development.

TUNGSTEN EXPOSURE INDEX

In Kodak Developer*	Development Time (minutes) at 68°F (20°C)	Contrast Index	Gamma	Exposure Index
D-19	4	2.9 maximum	4.0	100
HC-110 (Dilution D)	8	1.7	1.9	100
HC-100 (Dilution F)	8	1.4	1.8	50

*Processed in a small tank with agitation at 30-second intervals.

The Compact Photo-Lab-Index

FILTER FACTORS FOR PHOTOMICROGRAPHY

The following values are based on 1-second tungsten exposure with development for 8 minutes at 68 °F (20 °C) in *Kodak HC-110* Developer, Dilution D:

Kodak *Wratten* Filter		Filter Factor†
No. 11	(yellowish green)	5
No. 12	(deep yellow)	1.25
No. 13	(dark yellowish green)	6.4
No. 47	(blue tricolor)	25
No. 58	(green tricolor)	12.5

†When using through-the-lens exposure meters, read the exposure *without* the filter in place. Then use the filter factor to compute the correct exposure. Depending upon the actual response of the meter, reading exposures through the filter may give erroneous results.

PICTORIAL (FULL-RANGE) PHOTOGRAPHY

Conventional developers used with this film will generally produce contrast too high for normal pictorial photography. In addition, the extended red sensitivity of this material will generally cause poor rendition of skin tones when photographing people. However, it may still be desirable in specialized applications to take advantage of the extremely fine grain and high power of SO-115 Film when photographing scenes or subjects having a wide range of brightnesses. In such cases, the user may find it rewarding to experiment with specialized low-contrast developers. Most such developers are relatively unstable and must be prepared shortly before use. An example is POTA Developer, see "Wide Latitude Photography" by Marilyn Levy in *Photographic Science and Engineering*, Volume 11, No. 1, January-February, 1967, pages 46-53. For additional information on this topic, write to Scientific and Technical Photography, Dept. 757, Eastman Kodak Company, Rochester, N.Y. 14650. Suggested meter setting for trial exposure on film to be processed with this developer in a small tank for 15 minutes at 68 °F (20 °C) is developer in a small tank for 15 minutes at 68 °F (20 °C) is

<center>EI 25 (Daylight)</center>

This exposure index is based on the formula $EI = 0.8/E$, where E is the exposure (at 1/25 second) in meter-candle-seconds required to produce a density of 0.1 above minimum density with the indicated development.

SPEED AND CONTRAST WITH MACHINE PROCESSING

Processing in a *Kodak Versamat* Film Processer, Model 11, will yield these speed and contrast results:

Kodak Developer	Developer Temperature	Machine Speed (ft/min)	Developer Racks	Contrast Index	Gamma	Exposure Index
Versamat 641	85 °F (29.4 °C)	7.5	1	2.25	2.8	160 (Daylight)§
Versaflo	80 °F (26.7 °C)	10.0	2	1.5	1.8	80 (Tungsten)

§Based on 1/25-second exposure time.

RECIPROCITY FAILURE

When tungsten exposures are made at times appreciabley more or less than 1 second, changes in speed or contrast may be noted. The following corrections will be necessary:

Changes in Speed and Contrast Due to Reciprocity Effect

	Exposure Time (seconds)							
	100	100	10	1	1/10	1/100	1/1000	1/10000
Contrast Index Change	− 10%	None	None	None	− 5%	− 5%	− 10%	− 10%
Speed Change	− 70%	− 50%	− 20%	None	+ 20%	+ 20%	None	None
Exposure Change Required (camera stops)	+ 1⅔	+ 1	+ ⅓	None	− ⅓	− ⅓	None	None
Adjusted Ex-Index	32	50	80	100	125	125	100	100

Based on development in *Kodak HC-110* Developer (Dilution D) for 8 minutes at 68 °F (20 °C) in a sensitometric processing machine with agitation at 8-second intervals to give a contrast index of 1.9.

PROCESSING
SMALL TANK PROCESSING

For processing in small tanks with spiral reels, agitation at 30-second intervals, use the following sequence:

Develop to the desired contrast index based on information in the exposure section and on the characteristic curves. The contrast index obtained depends primarily upon the developer, temperature, dilution, and development time chosen. It is affected to a lesser extent by exposure time (see Reciprocity Failure), specific processing techniques, and normal product variability. Therefore, the times given should be considered as starting points only.

Rinse in *Kodak* Stop Bath SB-1a for 15 to 30 seconds at 65 to 70 °F (18 to 21 °C).

Fix as follows with frequent agitation at 65 to 70 °F (18 to 21 °C):

In *Kodak* Fixer or *Kodak* Fixing Bath F-5	2 to 4 minutes
In *Kodak* Rapid Fixer	1½ to 3 minutes

Wash in running water for 5 to 15 minutes at 65 to 70 °F (18 to 21 °C), depending upon reduction of residual hypo needed. For faster washing and less water consumption, rinse the fixed film in running water for 15 seconds to remove excess hypo. Bathe the film in *Kodak* Hypo Clearing Agent for 30 seconds with agitation. Then wash the film for 1 minute in running water at 65 to 70 °F (18 to 21 °C), allowing at least one change of water during this time.

Dry the film in a dust-free place. Heated forced-air drying at 120 to 140 °F (49 to 60 °C) may be used to reduce drying time.

MACHINE PROCESSING

Using the *Kodak Versamat* Film Processor, Model 11, and the listed chemicals, follow one of the processing sequences described below. For both processing sequences, fixing and drying are adequate at the recommended machine speeds. The user should run tests to determine that washing quality is adequate for his needs.

Kodak Versamat 641 Developer Replenisher
Kodak Versamat 641 Developer Starter
Kodak Versamat 641 Fixer and Replenisher

EASTMAN KODAK

The Compact Photo-Lab-Index

Processing Sequence

Step	No. of Racks	Path Length	Temperature
Develop	1	4ft (1.2 m)	85 ± ½ °F (29.4 ± 0.3 °C)
Fix	3	12 ft (3.8 m)	85 °F (30 °C) *nominal*
Wash	2	8 ft (2.4 m)	75 to 80 °F (24 to 27 °C)
Dry	—	8 ft (2.4 m)	135 to 140 °F (57 to 60 °C)

To produce a gamma of about 2.8, start with a machine speed of 7.5 feet per minute (2.3 m/min).

Kodak Versaflo Developer Replenisher
Kodak Versaflo Developer Starter
Kodak Rapid Fixer

Processing Sequence

Step	No. of Racks	Path Length	Temperature
Develop	2	8ft (2.4 m)	80 ± ½ °F (26.7 ± 0.3 °C)
Fix	3	12 ft (3.8 m)	80 °F (27 °C) *nominal*
Wash	2	8 ft (2.4 m)	70 to 75 °F (21 to 24 °C)
Dry	—	8 ft (2.4 m)	135 to 140 °F (57 to 60 °C)

To produce a contrast index of about 1.5, start with a machine speed of 10 feet per minute (3 m/min). Washing is not sufficient to provide archival quality but should be adequate for many scientific recording applications. The 4 × 5-inch sheet film may cause transport difficulties when processing with *Versaflo* Developer.

CHARACTERISTIC CURVES

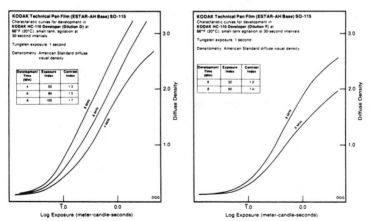

The Compact Photo-Lab-Index

EASTMAN KODAK

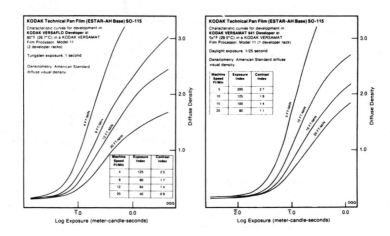

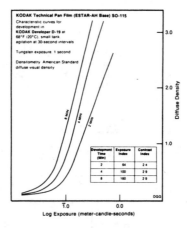

94

The Compact Photo-Lab-Index

HANDLING AND STORAGE

Keep unopened boxes of film at 70°F (21°C) or below. Allow cold film to reach room temperature before opening the package (2 hours if refrigerated, 3 hours if frozen). Load and unload the camera in subdued light, and rewind the film completely into the magazine before unloading the camera. For best results, process the film as soon as possible after exposure.

Total darkness is required when removing the film from the magazine and in processing. However, after development is half completed, a suitable safelight lamp with a 15-watt bulb and a *Kodak* Safelight Filter No. 3 (dark green), or equivalent conditions, can be used for a few seconds if the safelight is kept at least 4 feet (1.2 meters) from the film.

FILM SIZES AND ORDERING INFORMATION

Three sizes are listed and are available in single units through dealers who serve the professional photographer. Because this film is a special-order product, your dealer may not have it in stock. He can order the film in the listed sizes for you. The 150-foot rolls are wound on small diameter cores so that the outside diameter of the rolls will be compatible with 35mm bulk-film loaders. The 4×5-inch sheet film package contains two 25-sheet hermetically sealed envelopes.

Size & Specification	Catalog Number
135-36 magazine	129 7563
35 mm × 150 ft Sp 651 (Type AA core, KS perf)	129 9916
4 × 5-inch, 50 sheets per pkg	152 4594

Other sizes may be made available subject to minimum order quantities. Minimum order quantities for special-order sizes correspond generally to 750 square feet of film.

The sensitometric curves and data shown represent product tested under the conditions of exposure and processing specified. They are representative of production coatings and, therefore, do not apply directly to a particular box or roll of photographic material. They do not represent standards or specifications which must be met by *Eastman Kodak Company*. The Company reserves the right to change and improve product characteristics at any time.

EASTMAN KODAK

The Compact Photo-Lab-Index

EASTMAN KODAK

TYPES OF COLOR FILMS

The Kodak color films discussed here are conventional films used in professional and advanced amateur still-camera photography. Other Kodak sensitized products used in the making of color prints and duplicate transparencies from camera films, as well as color films for specialized scientific photography are available as is *Kodak* Instant Print Film used in Kodak instant cameras.

Kodak professional color films should be stored under refrigeration. Kodak general-purpose (consumer) films may be stored at normal room temperatures, away from heat.

There are two general types of conventional color films: reversal and negative. Reversal films yield positive color transparencies, while negative films yield color negatives that must be printed onto paper or film to obtain a positive image. Frequently, color reversal films in roll sizes are called slide films because the resulting transparencies are usually mounted for slide projection. Likewise, color negative films in roll sizes are frequently called print films because the resulting color negatives are printed to make reflection prints. Both types of color films are described briefly below.

REVERSAL FILMS

Kodak reversal-type color films are designated by use of the suffix "-chrome" in the product name, as in *Ektachrome* and *Kodachrome*. The transparencies obtained from color reversal films are viewed on an illuminator or by projection. Then transparencies can be duplicated by several methods. Color prints of the transparencies can be made directly on *Kodak Ektachrome* RC Paper, Type 2203. The transparencies can also be printed by the *Kodak* Dye Transfer Process and on *Kodak Ektacolor* 74 RC and 78 Papers from color internegatives made from the color transparencies.

Kodak Ektachrome Films contain chemical couplers that are put into the emulsion layers during manufacture. These couplers form dye images during the film processing. Only one color developer (compared to three required in the processing of Kodachrome Films) is needed to produce simultaneously the three dye images in the emulsion layers, and the process does not require elaborate chemical controls. The films can be processed by a large number of color processing laboratories, or you can process them yourself. Prepared chemicals are supplied as *Kodak Ektachrome* Film Processing Kits or as separate units in several sizes. Current *Kodak Ektachrome* and *Ektachrome* Professional Films use Process E-6 chemicals.

Kodak maintains processing services for all *Ektachrome* Roll Films intended for Process E-6 and Process E-4. Films can be sent to a Kodak processing laboratory—either through a dealer or directly—in the appropriate *Kodak* Mailer. An exceptional feature of *Ektachrome* Professional 160 and 200 Films and *Ektachrome* 160 and 200 Films is their ability to be exposed at twice the normal speed (at 320 and 400 respectively) when the first development time is increased. To obtain the special process from a Kodak laboratory, purchase a *Kodak* Special Processing Envelope, ESP-1, for each roll of 135- or 120-size film. Follow the instructions accompanying the ESP-1 Envelope. The film can also be processed in your own darkroom.

Kodachrome Films do not contain dye-forming particles in the emulsion layers. These are introduced during processing from three separate color-developer solutions. Processing is, therefore, much more complex and requires elaborate equipment with precise sensitometric, chemical, and mechanical controls. Processing can be obtained through a dealer, who will send the film to a Kodak or other

97

processing laboratory equipped to process it. *Kodachrome* Films can also be sent directly to a Kodak processing laboratory if the appropriate *Kodak* Mailers are used.

NEGATIVE FILMS

Kodak negative-positive color films are designated by use of the suffix "-color" in the product name, as in *Vericolor* and *Kodacolor.*

Colored couplers are incorporated in the emulsion layers at the time of manufacture, and the unused couplers remaining in the film after development provide automatic masking for color correction. Since the colored couplers in these films correct for the unwanted absorptions of the dyes in the negative, color prints and transparencies of excellent quality can be made without the supplementary masking procedures usually required for best results in reproductions from positive color transparencies. Negative color films yield color negatives from which positive pictures can be made in a variety of ways. Not only can color prints be made directly on *Kodak* 74 RC and 78 Papers, but the color negatives can also be used to produce color transparencies in any desired size and quantity. *Kodak* Print Film (*Estar* Thick Base) is used for producing large transparencies, and Kodak Vericolor Slide Film is used for producing 35mm and smaller transparencies for projection. Color prints can also be made by the Kodak Dye Transfer Process. Black-and-white prints from color negatives can be made on *Kodak Panalure II* RC Papers, which are expressly designed for this purpose.

Kodak Vericolor II Professional Films are sheet and roll films designed for portrait, commercial, and industrial use. They have exceptional granularity and sharpness characteristics. Excellent sensitometric relationships produce flesh tones that are very pleasing, neutral gray tones, and colors that are close to original subject colors.

Vericolor II Professional and Commercial Films can be processed in a variety of equipment, ranging from small tanks (sink line) to the large automatic processors. *Kodak Flexicolor* Chemicals for Process C-41 are available. At the recommended temperature of 37.8°C (100°F), the wet process time is approximately 24 minutes in most processors. Many color laboratories offer processing services.

Kodacolor Films are consumer roll films for general use. Like *Vericolor II* Professional Films, these films contain colored couplers to improve the quality of color reproduction. *Kodacolor II* Film has a film speed of ASA 100 and is balanced for daylight, blue flashbulb, or electronic flash illumination. *Kodacolor* 400 Film has a film speed of ASA 400, is balanced for the same illumination, but has special sensitizing characteristics that minimize the photographic differences among other light sources so that conversion filters are not necessary to produce pleasing and acceptable color prints. (Correction filters can be used for critical use if desired. The resulting negatives usually require less correction in the printing stage.) The high speed of this film makes it ideal for dimly lighted subjects, for fast action, for extending the distance range for flash pictures, and for subjects requiring good depth of field or high shutter speeds.

You can develop *Kodacolor* Films yourself in the same Process C-41 chemicals used for processing the *Vericolor II* Professional Films, or you can send them to a Kodak or other laboratory for processing.

Kodak Internegative Films are designed for making color internegatives from color transparencies, and for making copy negatives of reflection print originals in photographic laboratories. Since these films are not for general camera use, they will not be discussed here.

GUIDELINES FOR THE SELECTION OF COLOR FILMS

Your choice of a color film depends upon many factors. Here are some guidelines:

98

The Compact Photo-Lab-Index

1. If you want slides or transparencies primarily, use one of the reversal films.
2. If you want color prints primarily, use one of the color negative films.
3. Your camera size may limit your choice of films.
4. If you want to process the film yourself, use any of the films except the Kodachrome Films.

(Continued on following page)

PATHWAYS TO COLOR

With KODAK Reversal Materials

Camera Films	KODAK Chemicals*
Sheets	
EKTACHROME 64 Professional 6117 (Daylight)	
EKTACHROME Professional 6118 (Tungsten)	
Rolls	
EKTACHROME 64 Professional (Daylight)	
EKTACHROME 200 Professional (Daylight)	Process E-6
EKTACHROME 50 Professional (Tungsten)	
EKTACHROME 160 Professional (Tungsten)	
EKTACHROME 64 (Daylight)	
EKTACHROME 200 (Daylight)	
EKTACHROME 400 (Daylight)	
EKTACHROME 160 (Tungsten)	
KODACHROME 25 (Daylight)	
KODACHROME 64 (Daylight)	†
KODACHROME 40, 5070 (Type A)	

With KODAK Negative-Positive Materials

Camera Films	KODAK Chemicals*
Sheets	
VERICOLOR II Professional 4107, Type S	
VERICOLOR II Professional 4108, Type L	
Rolls	
VERICOLOR II Professional, Type S	FLEXICOLOR* (Process C-41)
VERICOLOR II Professional, Type L	
VERICOLOR II Commercial, Type S, SO-172	
KODACOLOR II	
KODACOLOR 400	

KODAK Internegative Films

	KODAK Chemicals*
VERICOLOR Internegative 4112 (ESTAR Thick Base) (sheet) and 6011 (roll)	Process C-41

Reflection Prints

	KODAK Chemicals*
EKTACHROME 2203 Paper	EKTAPRINT R-100 and R-1000
Dye Transfer Paper‡	Dye Transfer

Reflection Prints

	KODAK Chemicals*
EKTACOLOR 74 RC Paper	EKTAPRINT 2 and EKTAPRINT 300 Developer
EKTACOLOR 78 Paper	
Dye Transfer Paper‡	Dye Transfer
PANALURE II RC Papers (for black-and-white prints)	Normal Black-and-White

Transparency Dupes

	KODAK Chemicals*
EKTACHROME Slide Duplicating Film 5071	Process E-6
EKTACHROME Duplicating Film 6121 (sheet)	Process E-6

Transparencies

	KODAK Chemicals*
VERICOLOR Slide Film 5072	Process C-41
VERICOLOR Print Film 4111 (ESTAR Thick Base) (sheet)	Process C-41

Day-Night Prints

	KODAK Chemicals*
Dye Transfer Film 4151 (ESTAR Thick Base) (sheet)‡	Dye Transfer

Day-Night Prints

	KODAK Chemicals*
Dye Transfer Film 4151 (ESTAR Thick Base) (sheet)‡	Dye Transfer
EKTACOLOR 74 DURATRANS Print Material SO-103	EKTAPRINT 2

*Chemicals other than those supplied by Kodak may be available.
†Not for processing by the user: Kodak laboratories and photofinishers offer processing services.
‡Printing from transparencies may involve color-separation negatives on KODAK SUPER-XX Pan Film 4142 (ESTAR Thick Base) and matrices on KODAK Matrix Film 4150 (ESTAR Thick Base). Printing from color negatives requires matrices on KODAK Pan Matrix Film 4149 (ESTAR Thick Base) or equivalent. Prints on KODAK Dye Transfer Film 4151 (ESTAR Thick Base) can be viewed by either reflected light or a combination of reflected and transmitted light.

EASTMAN KODAK

5. If you want slides with extremely fine grain, use one of the *Kodachrome* Films. *Ektachrome 50* Professional Film (Tungsten) is almost equivalent to the *Kodachrome* Films in this respect. The other E-6 *Ektachrome* Films produce slides with very fine grain. The *Kodachrome* Films and the E-6 *Ektachrome* Films all have high resolving power classifications.

6. If you want to stop action or take scenes under low levels of existing light on slide film, use one of the 200-speed daylight or 160-speed tungsten *Ektachrome* Films. These films can also be exposed at twice these speeds if they are processed in a pushed-process. If you want prints of similar scenes, use *Kodacolor* 400 Film.

KODAK COLOR FILMS FOR STILL CAMERAS

Type	Rolls														Sheets (Inches)					
Reversal Types	110-12	110-20	116	120	126-12	126-20	127	135-20 or 24	135-36	220	616	620	828	Long Rolls	2¼ x 3¼	3¼ x 4¼	4 x 5	5 x 7	8 x 10	11 x 14
EKTACHROME 64 Prof. 6117 (Day.)																	X	X	X	X
EKTACHROME 50 Prof. 6118 (Tung.)																X	X	X	X	X
EKTACHROME 64 Prof. (Daylight)				X*					X†	X										
EKTACHROME 200 Prof. (Daylight)				X*					X†	X										
EKTACHROME 50 Prof. (Tungsten)				X					X	X										
EKTACHROME 160 Prof. (Tungsten)				X*					X†	X										
EKTACHROME 64 (Daylight)		X				X	X	X	X											
EKTACHROME 200 (Daylight)						X		X	X											
EKTACHROME 160 (Tungsten)								X	X											
KODACHROME 25 (Daylight)								X	X†											
KODACHROME 64 (Daylight)		X				X		X	X†											
KODACHROME 40, 5070 (Type A)									X											
Negative Types																				
VERICOLOR II Prof. 4107, Type S															X		X	X	X	
VERICOLOR II Prof., Type S (6010)				X*					X*	X										
VERICOLOR II Prof. 2107, Type S														X						
VERICOLOR II Prof. 5025, Type S								X†	X†											
VERICOLOR II Prof. 4108, Type L															X		X	X	X	X
VERICOLOR II Prof., Type L (6013)				X*																
KODACOLOR II	X	X	X	X	X	X	X	X	X		X	X	X							
KODACOLOR 400	X	X		X				X	X											

*Pro-pack (5 rolls) also available.
†Pro-pack (4 rolls) also available.

FILTER DATA

KODAK COLOR COMPENSATING FILTERS

These filters can be used singly, or in combination, to introduce almost any desired color correction. Such corrections are often required, for example, with special light sources, such as fluorescent illumination. KODAK Color Compensating Filters are also used in critical color work to correct for minor variations in color balance caused by normal manufacturing variations or by causes beyond manufacturing control.

If you use several filters together over a camera or enlarger lens, you may adversely affect definition and contrast by scattering the light. Try to use the minimum number of filters that will produce the desired correction. Generally, the number should not exceed three, if definition is of major importance. Of course, definition is also affected by the condition of the filters. Keep the filters clean and free from scratches or other defects.

The density of each Color Compensating Filter is indicated by the numbers in the filter designation, and the color is indicated by the final letter. In a typical filter designation, CC20Y, "CC" stands for "Color Compensating," "20" for a density of 0.20, and "Y" for "Yellow."

The densities of CC Filters are measured at the wavelength of maximum absorption. That's the reason the term *peak density* is used in the table. Thus, for example, the density of a yellow filter is given for blue light. *But the density values do not include the density of the gelatin in which the filter dye is coated, nor do they include the density of the glass in which a filter may be mounted.* In critical work, the density of the gelatin or glass support may become significant. On a suitable densitometer, you can measure the exact density of the filter plus the gelatin and any glass support.

The standardized density spacing of these filter series (5, 10, 20, 30, 40, 50, in each color) helps you predict the photographic effects of filter combinations. In the red, green, and blue series, each filter contains the same dyes in approximately the same amounts as the two corresponding yellow and magenta, yellow and cyan, or magenta and cyan filters. Therefore, you can substitute, for example, a 10Y for a 10Y + 10M, 30G for a 30Y + 30C, or a 20B for a 20M + 20C.

KODAK LIGHT BALANCING FILTERS

There are two series of KODAK Light Balancing Filters: the No. 82 (bluish) series and the No. 81 (yellowish) series. Using filters in the bluish series is equivalent to raising the color temperature of the light, and you get pictures with a colder appearance. Using filters in the yellowish series is equivalent to lowering the color temperature of the light, and you get pictures with warmer color balance.

RECIPROCITY EFFECT

The term "color temperature" is usually designated by degrees Kelvin, such as 3200 K or 5500 K, which are used to identify the balance of white light emitted by various light sources. When the light approximates that emitted by a theoretical blackbody, as it does with most tungsten lamps, flashbulbs, electronic flash, and most conditions of daylight, the use of conversion and light-balancing filters to the balance of the film works very well. Other light sources, notably fluorescent lamps, do not emit blackbody type light, so that any color temperature listing for them only designates the visual appearance of the light and does not give adequate information about the spectral energy distribution (amounts of light at each wavelength), so is inadequate for photographic purposes.

The use of tables to find the right filters to use to obtain balanced color pictures is usually adequate, especially, as a starting point from which tests can be made. However, they cannot cover all the aspects that affect the balance of light, such as high or low voltage, aging of lamps, and color contribution of diffusers. Three-color temperature meters provide an even more accurate method

EASTMAN KODAK

of determining the spectral energy distribution of light sources as they relate to the sensitivities of the three layers in color films. Such meters as the Spectra® Tricolor Meter and the Minolta 3 Color Meter, while costly, provide the photographer the best means of finding the actual illumination balance, and what filters to use to balance the illumination to the film balance. Two-color meters (much less costly) show the balance between the red and blue light, and are adequate to provide a balance where the source has black body energy distribution, but not for other sources such as fluorescent lights.

Some meters give a choice of correcting the balance with either color balancing and conversion filters or with color compensating filters. In most instances it will be found that to make the main correction with color compensating filters requires the use of more filters, sometimes as many as seven, while the use of light balancing and conversion filters requires at the most two. Because of the increase in flare and decrease in sharpness resulting from the use of many filters over a camera lens, it is best to use light balancing and conversion filters for the color temperature(red-blue) correction and CC Filters for any green-magenta adjustment.

Kodak Color Compensating Filters

Peak Density	Yellow (Absorbs Blue)	Exposure Increase in Stops*	Magenta (Absorbs Green)	Exposure Increase in Stops*	Cyan† (Absorbs Red)	Exposure Increase in Stops*
.025	CC025Y	—	CC025M	—	CC025C	—
.05	CC05Y†	—	CC05M†	⅓	CC05C†	⅓
.10	CC10Y†	⅓	CC10M†	⅓	CC10C†	⅓
.20	CC20Y†	⅓	CC20M†	⅓	CC20C†	⅓
.30	CC30Y	⅓	CC30M	⅔	CC30C	⅔
.40	CC40Y†	⅓	CC40M†	⅔	CC40C†	⅔
.50	CC50Y	⅔	CC50M	⅔	CC50C	1

Peak Density	Red (Absorbs Blue and Green)	Exposure Increase in Stops*	Green (Absorbs Blue and Red)	Exposure Increase in Stops*	Blue (Absorbs Red and Green)	Exposure Increase in Stops*
.025	CC025R	—		—		—
.05	CC05R†	⅓	CC05G	⅓	CC05B	⅓
.10	CC10R†	⅓	CC10G	⅓	CC10B	⅓
.20	CC20R†	⅓	CC20G	⅓	CC20B	⅔
.30	CC30R	⅔	CC30G	⅔	CC30B	⅔
.40	CC40R†	⅔	CC40G	⅔	CC40B	1
.50	CC50R	1	CC50G	1	CC50B	1⅓

*These values are approximate. For critical work, they should be checked by practical test, especially if more than one filter is used.

†Another series of cyan color-compensating filters with more absorption in the far-red and infrared portions of the spectrum is available in the listed densities. These filters are designated with the suffix "-2" (i.e., CC025C-2) and should be used in preference to other cyan filters when required in filter packs for printing KODAK EKTACOLOR and EKTACHROME Papers. Similar KODAK Color Printing Filters (Acetate) are available in .025, .05, .10, .20, and .40 cyan densities.

‡Similar KODAK Color Printing Filters (Acetate) are available. For further information, see the Kodak Data Book No. E-66, *Printing Color Negatives*.

The Compact Photo-Lab-Index

We can express the conversion effect of a Light Balancing Filter in terms of the color temperature of the light source and the desired color temperature, as shown in the fourth and fifth columns of the table, "KODAK Light Balancing Filters." These color temperatures can also be expressed in *microreciprocal degrees*, or Mireds, obtained by dividing the color-temperature value into 1,000,000. The conversion effect of the filter can then be expressed as a Mired Shift Value, as in the sixth column.

The Decamired, another unit often used, equals ten Mireds.

To include the lowest color temperatures shown in the table, you have to use combinations of two filters in the No. 82 series.

At exposure times longer or shorter than those for which a color film is designed, the filters in the table may not produce exactly the results expected. At such short or long exposures, color films may change in sensitivity (reciprocity effect) and thus require a different filter (or adjustments with CC Filters).

KODAK Light Balancing Filters

Filter Color	Filter Number	Exposure Increase in Stops*	To obtain 3200 K from:	To obtain 3400 K from:	Mired Shift Value
Bluish	82C+82C	1⅓	2490 K	2610 K	−89
	82C+82B	1⅓	2570 K	2700 K	−77
	82C+82A	1	2650 K	2780 K	−65
	82C+82	1	2720 K	2870 K	−55
	82C	⅔	2800 K	2950 K	−45
	82B	⅔	2900 K	3060 K	−32
	82A	⅓	3000 K	3180 K	−21
	82	⅓	3100 K	3290 K	−10
	No Filter Necessary		3200 K	3400 K	
Yellowish	81	⅓	3300 K	3510 K	9
	81A	⅓	3400 K	3630 K	18
	81B	⅓	3500 K	3740 K	27
	81C	⅓	3600 K	3850 K	35
	81D	⅔	3700 K	3970 K	42
	81EF	⅔	3850 K	4140 K	52

*These values are approximate. For critical work, they should be checked by practical test, especially if more than one filter is used.

KODAK Conversion Filters

To Convert	Use KODAK Filter No.	Filter Color	Exposure Increase in Stops*	Mired Shift Value
3200 K to Daylight (5500 K)	80A	Blue	2	−131
3400 K to Daylight (5500 K)	80B	Blue	1⅔	−112
3800 K† to Daylight (5500 K)	80C	Blue	1	−81
4200 K‡ to Daylight (5500 K)	80D	Blue	⅓	−56
Daylight (5500 K) to 3800 K	85C	Amber	⅓	81
Daylight (5500 K) to 3400 K	85	Amber	⅔	112
Daylight (5500 K) to 3200 K	85B	Amber	⅔	131

*For critical work, check these values by practical test.
†Aluminum-filled clear flashbulbs, such as M2, 5, and 25.
‡Zirconium-filled clear flashbulbs, such as AG-1 and M3.

Mired Nomograph for Light Source Conversion

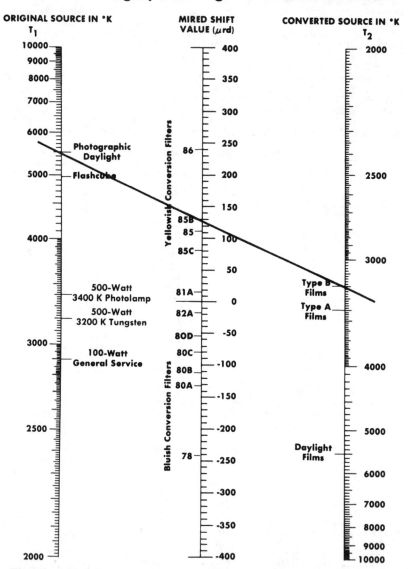

The Mired Nomographic can be used to find the filter required for a particular conversion by placing a straight-edge from an original source (T₁) to a second source (T₂) as illustration, daylight illumination at 5500K requires an approximate +130 mired shift to convert to Type B illumination at 3200K *Kodak Wratten* Filters No 85B with a mired shift value of +131 meets this requirement.

KODAK FILTERS FOR KODAK COLOR FILMS

See film instructions for current recommendations and corresponding speed values.

Light Source	Kodak Film			
	Daylight (Kodachrome, Ektachrome, Kodacolor, and Vericolor II Professional, Type S)	Type A (Kodachrome 40, 5070, Type A)	Tungsten (Ektachrome)	Type L (Vericolor II Professional, Type L)
Daylight	None*	No. 85	No. 85B	No. 85B
Electronic Flash	None†	No. 85	Not recommended†	Not recommended
Blue Flashbulbs	None	No. 85	Not recommended†	Not recommended
Clear Flashbulbs	No. 80C or 80D§	No. 81C	No. 81C	Not recommended
Photolamps (3400 K)	No. 80B	None	No. 81A	No. 81A
Tungsten Lamps (3200 K)	No. 80A	No. 82A	None	None

*With reversal color films, a Kodak Skylight Filter No. 1A can be used to reduce excessive bluishness of pictures made in open shade or on overcast days, or pictures of distant scenes, such as mountain and aerial views.

†If results are consistently bluish, use a CC05Y or CC10Y Filter with Kodak Ektachrome and Ektachrome Professional Films (Process E-6); use a No. 81B Filter with Kodachrome or Kodacolor Films. Increase exposure 1/3 stop when a CC10Y or 81B filter is used.

‡Kodak Ektachrome 160 or Ektachrome 160 Professional Films (Tungsten) can be exposed with a No. 85B Filter.

§Use No. 80D Filter with zirconium-filled clear flashbulbs, such as AG-1 and M3.

EASTMAN KODAK

105

EASTMAN KODAK

STARTING FILTERS AND EXPOSURE INCREASES* FOR TEST SERIES WITH FLUORESCENT ILLUMINATION

Kodak Film Type	Type of Fluorescent Lamp†					
	Daylight	White	Warm White	Warm White Deluxe	Cool White	Cool White Deluxe
Daylight Type and Type S	40M+40Y +1 stop	20C+30M +1 stop	40C+40M +1⅓ stops	60C+30M +2 stops	30M +⅔ stop	20C+10M +⅔ stop
Tungsten and TypeL	85B†+30M 10+Y +1⅓ stops	60M+50Y +1 stop	50M+40Y +1 stop	10M+10Y +⅔ stop	60M+60Y +2 stops	20M+40Y +⅔ stop
Type A	85§+40M +40Y +1⅓ stops	40M+30Y +1 stop	30M+20Y +1 stop	No Filter None	50M+50Y +1⅓ stops	10M+30Y +⅔ stop
E-64, K-64 E-400	50M+50Y +1⅓ stops	40M +⅔ stop	20C+40M +1 stop	60C+30M +2 stops	40M+10Y +1 stop	20C+10M +⅔ stop

*Increase a meter-calculated exposure by the amount indicated in the table to compensate for light absorbed by the filters recommended. If this makes the exposure time longer than that for which the film is designed, refer to the table on the following page for further filter and exposure-time adjustments that must be added to these lamp-quality corrections.
†When it is difficult or impossible to gain access to fluorescent lamps in order to identify the type, ask the maintenance department.
‡*Kodak Wratten* Filter No. 85 B. §*Kodak Wratten* Filter No. 85.
†*Kodak Wratten* Filter No. 85.

RECIPROCITY DATA: *KODAK* COLOR FILMS

Illumination (intensity of light) multiplied by exposure time equals exposure. You may have seen this relationship expressed as $I \times t = E$. Given this formula, it would appear that when the product of the two is held constant, the photographic effect will always be the same. Actually, the sensitivity of a photographic emulsion may change with changes in the illumination level and the exposure time.

When the lighting is very weak, and a film requires long exposures, the effective speed of an emulsion decreases. For black-and-white films, the loss of effective speed is relatively unimportant because of wide exposure latitude. With multilayer color films, on the other hand, it is often necessary to give more than the calculated exposure when the light intensity is low and the exposure time is long. Furthermore, since sensitivity changes may be different for each of the three emulsion layers, with consequent changes in color balance, it may be necessary to use color compensating filters.

(See chart on following page.)

EASTMAN KODAK

PRINTS AND DUPLICATES

Prints and transparencies from color originals can be made on a variety of *Kodak* materials. *Kodak* processing laboratories also supply prints and transparencies on orders placed through photo dealers.

PRINTS FROM COLOR TRANSPARENCIES

Kodak Ektachrome **RC Paper, Type, 1993,** is designed for direct printing or enlarging from color transparencies. It is supplied in rolls and in sheets.

A tungsten or tungsten-halogen light source equipped with a heat absorbing glass and an ultraviolet absorber (a No. 2B or 2E filter) is recommended for exposing this paper. Color balancing is accomplished by the use of CC or CP filters.

Kodak Ektachrome RC Paper, Type 1993, can be processed with *Kodak Ektaprint* R-5 or R-500 Chemicals. Mixing directions and complete processing instructions are included with the chemicals.

Kodak Ektachrome **RC Paper, Type 2203,** is also a direct printing material, designed for making color prints from color reflection prints. It is supplied in F surface (smooth) and in roll form. *Kodak Ektaprint* R-1000 Chemicals can be used to process this paper. Exposure and process information.

Kodak **Dye Transfer Process** permits full full-color-photographic prints of excellent quality. Contact-size or enlarged color-separation negatives are first made from the transparency through red, green, and blue filters. Each negative is then contact-printed or enlarged through the base of a separate sheet of *Kodak* Matrix Film 4150 (*Estar* Thick Base). After a tanning development, the matrix films are washed off with hot water to remove the gelatin in the unexposed areas, leaving on each matrix a positive relief image of gelatin.

After drying, the matrices are soaked in cyan, magenta, and yellow dye baths; each matrix absorbs dye in proportion to the thickness of the relief image. A color print is produced when the dye images are transferred, in register, to a sheet of *Kodak* Dye Transfer Paper. A color print that can be viewed by either reflected light or a combination of reflected light and transmitted light can be made on *Kodak* Dye Transfer Film 4151 (*Estar* Thick Base).

107

EASTMAN KODAK

EXPOSURE* AND FILTER COMPENSATION FOR THE RECIPROCITY CHARACTERISTICS OF KODAK COLOR FILMS

Exposure Time (Seconds)

Kodak Films	1/10,000†	1/1,000†	1/100	1/10	1	10	100
Kodacolor II			None No Filter		+½ Stop No Filter	+1½ Stops CC10C	+2½ Stops CC10C+10C
Kodacolor 400			None No Filter		+¾ Stop No Filter	+1 Stop No Filter	+2 Stops No Filter
Vericolor II Professional, Type S			None No Filter		Not Recommended		
Vericolor II Professional, Type L	Not Recommended		See film instructions for speed values at 1/50 through 60 seconds' exposure times				
Ektachrome 64 Professional (Daylight), rolls and 6117 sheet films Ektachrome 64 (Daylight)	+½ Stop No Filter		None No Filter		+1 Stop CC15B	+1½ Stops CC20B	Not Recommended
Ektachrome 50 Professional (Tungsten)‡, roll films	—		+½ Stop CC10G		+½ Stop CC10R	+1 Stop CC20B	Not Recommended
Ektachrome 200 Professional (Daylight) and Ektachrome 200 (Daylight)	+½ Stop No Filter		None No Filter		+½ Stop CC10R	Not Recommended	
Ektachrome 160 Professional (Tungsten) and Ektachrome 160 (Tungsten)	—		None No Filter		+½ Stop CC10R	+1 Stop CC15R	Not Recommended
Ektachrome Infrared	—		None No Filter	+1 Stop CC20B	Not Recommended		
Kodachrome 40 5070 (Type A)			None No Filter		+½ Stop No Filter	+1 Stop No Filter§	Not Recommended
Kodachrome 25 (Daylight)			None No Filter		+1 Stop CC10M	+1½ Stops CC10M	+2½ Stops CC10M
Kodachrome 64 (Daylight)			None No Filter		+1 Stop CC10R	Not Recommended	

*The exposure increase, in lens stops, includes the adjustment by any filter(s) suggested.
†Short exposure times and the color quality of some electronic flash units may cause a bluish color balance on some daylight-type films. If your results are consistently bluish, use a CP10Y or CP20Y filter over the flash unit or a CC10Y or CC20Y filter over the camera lens. Give ¼ stop more exposure unless your flash unit makes automatic allowance for a filter over the flash tube.
‡For 6118 sheet film, see supplementary data on the instruction sheet packaged with the film.
§For 5 seconds.

The Compact Photo-Lab-Index

Kodak Ektachrome **Slide Duplicating Film 5071 (Process E-6)** can be used for making duplicate slides from *Kodachrome* and *Ektachrome* Films. It is available in 100-foot and longer rolls (35-mm and 46-mm widths).

Kodak Ektachrome **Duplicating Film 6121 (Process E-6)** can be used for making duplicates of sheet-film-size original transparencies. It is available in sheet sizes only.

Color Internegatives. An intermediate color negative—such as one on *Kodak Vericolor* Internegative Film 4112 (sheet) or 6011 (roll)—made from a positive color transparency can be used to prepare duplicate color transparencies on *Kodak Vericolor* Print Film 4111 (*Estar* Thick Base); color enlargements and contact prints on *Kodak Ektacolor* 74 RC and 78 Papers; color prints by the *Kodak* Dye Transfer Process; and black-and-white prints on *Kodak Panalure II* RC Papers.

Kodak **Color Negatives from Color Slides.** *Kodak* processing laboratories will make color negatives from your color transparencies so that you can make your own color prints. Place your order with your photo dealer.

Kodak **Color Copyprints** (in 2S, 2R, 3S, and 3R sizes) can be made from 2½ by 2½-inch to 3½ by 5-inch original prints. *Kodak* Color Copy Enlargements (up to 11 by 14 inches) can be made from 2S, 2R, 3S, and 3R size prints.

Kodak **Color Prints and Enlargements** are full-color reflection prints made by *Kodak* processing laboratories from color transparencies 2¼ inches square and smaller. Orders can be placed through photo dealers.

Kodak **Color Slide Duplicates** are made by *Kodak* processing laboratories. Same-size duplicates are supplied from original color transparencies that are mounted in standard 2 by 2-inch mounts with central mask openings and from mounted 110 transparencies. Same-size duplicates are also supplied from either or both sides of mounted stereo slides. Reduced-size duplicates in standard 2 by 2-inch mounts are available from 8 by 10-inch and smaller color transparencies. Reduced-size duplicates can also be made 13 by 17-mm in 30 by 30-mm mounts from standard 135 mounted transparencies.

Requirements for Reproduction. Sheet-film transparencies are generally intended for reproduction by photomechanical or other methods of color printing. Besides being suitable in pictorial respects, a transparency for reproduction must meet one essential technical requirement: It must show all important details clearly in both highlight and shadow areas. If the original was overexposed, highlight areas lack modeling and color saturation, and important details are lost. If the original was underexposed, shadow areas lack transparency, and important details are obscured by the maximum density of the film. Excessive lighting contrast may, of course, cause loss of detail at either or both ends of the tone scale.

Transparencies that appear satisfactory when viewed on an illuminator in a dimly lighted room do not necessarily print well, because they may contain a range of tones too great to be reproduced by any method of color printing. A closer approximation of the appearance of the picture than can be expected in a print is obtained by viewing the transparency in a brightly lighted room, without masking off the surrounding area of the illuminator surface.

For improved highlight detail in color prints, the original transparency should often be given slightly less than the normal exposure. The most satisfactory results are obtained when the photographer works in close cooperation with the photomechanical worker or color printer who is to reproduce the transparencies. If you are not familiar with the problems of color reproduction, ask for and rely upon the advice of those experienced in this field.

Black-and-White Prints. Copy negatives of color transparencies from which black-and-white prints of high quality can be made are easily obtained by any of several methods: (1) Contact printing in a printing frame placed on the easel of an enlarger. With this arrangement, the enlarger furnishes a light source that can be controlled readily. (2) Enlarging the transparency onto a film held under glass on the easel. You should be careful to prevent stray light from fogging the negative material. (3) Copying with a copying camera to make same-size or reduced negatives. This method requires a device by which the original can be transilluminated in front of the camera. All white light around the edges of the transparency should be masked off with opaque paper to minimize flare.

If the subject is to be reversed from left to right, as it would be in an original negative

EASTMAN KODAK

made with a camera, the copy negative must be exposed through the base of the transparency. Improved rendering of flesh tones can be obtained by the use of the *Kodak Wratten* Filter No. 13. Contrast effects can be obtained by the use of other filters.

A panchromatic material should be used for the copy negative, and it should be developed to low contrast. *Kodak Super-XX* Pan Film 4142 (*Estar* Thick Base), developed in *Kodak* Developer D-76 for 6 minutes in a tray or 8 minutes in a tank at 20 °C (68 °F), is suggested.

PRINTS FROM COLOR NEGATIVES

Kodak Ektacolor **74 RC and** *Kodak Ektacolor* **78 Papers** are multilayer papers designed for direct printing or enlarging from color negatives.

Color prints are normally made with a single white-light exposure that is modified by color-compensating filters to give satisfactory color balance. You can use the same sort of dodging and burning-in control that you would use in black-and-white enlarging.

Ektacolor 74 RC and 78 Papers can be conveniently and quickly processed with *Kodak* Rapid Color Processors, Models 11, 16-K, and 30A. Prints are processed in 5 minutes (6½ minutes for the 30A). The Model 11 will process up to an 11 by 14-inch print; the Model 16-K, up to a 16 by 20-inch print; and the Model 30A, up to a 30 by 40-inch print. *Kodak Ektaprint* 2 Chemicals (including *Kodak Ektaprint* 300 Developer) are available for processing *Ektacolor* 74 RC and 78 Papers.

Kodak **Dye Transfer Process.** Color negatives, as well as color internegatives, are printed by the Dye Transfer Process in essentially the same manner as positive transparencies. However, the number of steps is reduced because the matrices can be printed directly from the negative. *Kodak* Pan Matrix Film 4149 (*Estar* Thick Base) can be used, so that the required color separation can be obtained by exposing through red, green, and blue filters. See *Kodak Dye Transfer Process* elsewhere in this section.

Kodak Vericolor **Print Film** (*Estar* **Thick Base**) makes it possible to produce any size or quantity of color transparencies from *Vericolor II* and *Kodacolor* Negatives or from color internegatives. The quality of the results is generally better than can be obtained by direct duplication of an original positive transparency. Equally important, the amount of work and the expense of making transparencies on *Vericolor* Print Film are substantially lower, as no supplementary masking procedures to correct the color rendering are necessary. *Kodak Vericolor* Slide Film 5072, available in 100-foot rolls (35-mm and 46-mm widths), can be used to make same-size transparencies from miniature color negatives or reduced-size transparencies from larger negatives.

Kodak **Color Prints and Enlargements** are full-color reflection prints made by *Kodak* processing laboratories from color negatives on orders placed through photo dealers. These color prints and enlargements are intended principally for the amateur photographer.

Kodacolor **Slides** are also made by *Kodak* processing laboratories and can be ordered through photo dealers. The slides are made from color negatives, 2¼ by 2¼ inches down to 28 by 28 mm. They are mounted in 2 by 2-inch mounts.

Black-and-White Prints. *Kodak Panalure* Papers are designed for making black-and-white enlargements and contact prints from color negatives. The tone rendering on these papers is similar to that of prints made from black-and-white negatives on panchromatic film and, of course, the gray-tone rendering of colors can be altered as desired by using *Kodak* Color Compensating Filters. The papers are available in one contrast grade only and in two different kinds as follows:

Kodak Panalure II RC Paper (F)—white, glossy, smooth, single weight, with a warm-black image tone.

Kodak Panalure II RC Portrait Paper (E)—white, fine-grained, lustre, double weight, with a brown-black image tone.

These papers should be exposed to a tungsten light source, such as the No. 302 or the No. 212 lamp, in an enlarger equipped with a color-corrected lens. For the best results, develop *Kodak Panalure* Paper (F) in *Kodak Dektol* Developer diluted 1:2. Develop *Kodak Panalure* Portrait Paper (E) in *Kodak Selectol* Developer diluted 1:1. For lower contrast, develop both papers in *Kodak Selectol-Soft* Developer at a 1:1 dilution.

EASTMAN KODAK

KODAK VERICOLOR II **PROFESSIONAL FILM 4107** Type S

A color-negative sheet film for exposure times 1/10 second or shorter. It is balanced for exposure without a filter by electronic flash, daylight, or blue flash, and with the appropriate filter by clear flash. Colored couplers in the film provide automatic color correction and make excellent quality in color reproductions possible without supplementary masking. This film can be processed with *Kodak Flexicolor* Chemicals for Process C-41. The negatives can be printed on *Kodak Ektacolor* 74 RC and 78 Papers or by the Kodak Dye Transfer Process. They can also be used to make color transparencies on *Kodak Ektacolor* Print Film 4111 (*Estar* Thick Base) or black-and-white prints on *Kodak Panalure* Papers. This film is also available as *Kodak Vericolor II* Professional Film, Type S, in several roll sizes.

SPEED

The number given after each light source is based on an ANSI Standard and is for use with meters and cameras marked for ASA speeds.

Light Source	ISO*	DIN	Speed	With Filter Such as:
Daylight	125/22°	22	ASA 125	None
Photolamp (3400 K)	40/17°	17	ASA 40	Kodak Photoflood Filter No. 80B
Tungsten (3200 K)	32/16°	16	ASA 32	Kodak 3200 K Filter No. 80A

* ISO rating refers to International Standards Organization designation of film speed rating.

CAUTION

Do not expose this film for times longer than 1/10 second, because the resulting negatives may contain color reproduction errors that cannot be corrected satisfactorily in the printing operation. For long exposures use *Kodak Vericolor II* Professional Film 4108, Type L.

INCLUSION OF GRAY CARD IN SCENE

As an aid in determining the exposures required in making prints from Vericolor II negatives, a neutral gray card having a reflectance of about 18½, such as the gray side of the *Kodak* Neutral Test Card, should be photographed with the subject. If possible, the card should be placed along the edge of the scene area in such a position that it receives the full subject lighting but does not interfere with the actual picture and can be trimmed off the final prints. Otherwise, the card should be photographed, with the full subject lighting, on a separate sheet of *Vericolor II* Professional Film, which should be processed at the same time as the negatives.

ELECTRONIC FLASH GUIDE NUMBERS

This table is intended as a starting point in determining the correct guide number. It is for use with equipment rated in beam candlepower-seconds (BCPS) or effective candlepower-seconds (ECPS.)

Divide the proper guide number by the flash-to-subject distance in feet to determine the f-number for average subjects.

EASTMAN KODAK

111

The Compact Photo-Lab-Index

ELECTRONIC FLASH GUIDE NUMBERS

Output of Unit (BCPS or ECPS)	350	500	700	1000	1400	2000	2800	4000	5600	8000
Guide Number Feet	45	55	65	80	95	110	130	160	190	220
For Trial Meters	14	17	20	24	29	33	39	48	58	67

Caution: Do not use shutter speeds longer than 1/50 second; otherwise, results may be influenced by illumination other than the electronic flash.

KODAK VERICOLOR II COMMERCIAL TYPE S, SO-172

Daylight	Photolamp	Tungsten
ASA 100	32	25
DIN 21	16	15
ISO 100/21°	32/16°	25/15°

FLASH EXPOSURE GUIDE NUMBERS

For flash pictures with this film use blue flashbulbs without a filter. With zirconium-filled clear flashbulbs (AG-1 and M3) use a filter such as the *Kodak* Photoflash Filter No. 80D, over the camera lens. With all other clear flashbulbs, use a No. 80C Filter. Divide the proper guide number by the flash-to-subject distance in feet to determine the f-number for average subjects. Use ½ stop larger for dark subjects, ½ stop smaller for light subjects.

Lens openings determined in this way apply to the use of a single flashbulb in all surroundings except small rooms with very light walls, ceilings, and furnishings. If two bulbs are used at the same distance to light the same area, or if the room is small and very light, use 1 stop smaller.

GUIDE NUMBERS* FOR FLASHBULBS
For Blue Flashbulbs (or Clear Flashbulbs with a No. 80C or No. 80D Filter)

Between-Lens Shutter Speed	Syn-chroni-zation	2B† 22B†	M2B‡	M3B‡ 5B§ 25B§	3¶ or 50¶ in a 12-Inch Bowl Reflector	Focal-Plane Shutter Speed	6B§ 26B§
Open 1/25-1/30	X or F	260	130	200		1/25-1/30	200
1/25-1/30	M	240	NR**	180	360	1/50-1/60	140
1/50-1/60	M	220	NR	180	(Use 1/25	1/100-1/125	100
1/100-1/125	M	200	NR	150	or	1/200-1/250	70
1/200-1/250	M	140	NR	120	Slower)	1/400-1/500	50
1/400-1/500	M	110	NR	90		1/1000	34

Footnotes for this table appear on following page.

EASTMAN KODAK

The Compact Photo-Lab-Index

*For use with bowl-shaped polished reflectors. If shallow cylindrical reflectors are used, divide these guide numbers by 2.

Bowl-shaped polished reflector sizes: ‡3-inch; §4- to 5-inch; †6- to 7-inch.

¶Clear bulbs are listed because blue bulbs are not available. Use with a No. 80C Filter.

**NR = Not Recommended.

These values are intended only as guides for average emulsions. They must be changed to suit individual variations in synchronization, battery, reflector, and bulb position in the reflector.

Caution: Since bulbs may shatter when flashed, the use of a flashguard over the reflector is recommended. Do not flash bulbs in an explosive atmosphere.

DAYLIGHT EXPOSURE TABLE

Lens openings with shutter at 1/125 second. For the hours from 2 hours after sunrise to 2 hours before sunset.

Bright or Hazy Sun on Light Sand or Snow	Bright or Hazy Sun on Light Sand or Snow	Weak, Hazy Sun (Soft Shadows)	Cloudy Bright (No Shadows)	Heavy Overcast	Shade* Open
f/22	f/16†	f/11	f/8	f/5.6	f/5.6

*Subject shaded from the sun but lighted by a large area of sky.
†For backlighted close-up subjects, use f/8.

PROCESSING

Professional photographic laboratories offer processing and printing services for *Vericolor II* Professional Films. Kodak Processing Laboratories offer processing and printing services for the Type S films only, in these sizes: 135, 120, 220, 620, and long rolls 35, 46, and 70mm wide. Film in sheets and short rolls can be processed in the sink-line equipment with *Kodak Flexicolor* Chemicals for Process C-41.

FILM SIZES AVAILABLE

Sheets (inches): 2¼ x 3¼, 4 x 5, 5 x 7, and 8 x 10 (film code 4107, *Estar* thick base). Rolls: VPS120, VPS220, VPS620 (film code 6010, acetate base), VPS135-20, VPS135-36 (film code 5025, acetate base). Long rolls: 35mm and 46mm widths (film code 5025, acetate base), 70mm and 3½-inch widths (film code 2107, *Estar* base).

DIFFUSE RMS GRANULARITY VALUE 6

(Read at a net diffuse density of 1.0,
using a 48-micrometer aperture, 12X magnification.)

RESOLVING POWER VALUES

Test-Object Contrast 1.6:1 40 lines per mm
Test-Object Contrast 1000:1 80 lines per mm

EASTMAN KODAK

KODAK VERICOLOR II **PROFESSIONAL FILM, Type S**

CHARACTERISTIC CURVES

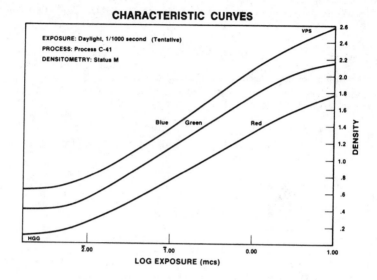

EXPOSURE: Daylight, 1/1000 second (Tentative)
PROCESS: Process C-41
DENSITOMETRY: Status M

SPECTRAL SENSITIVITY CURVES

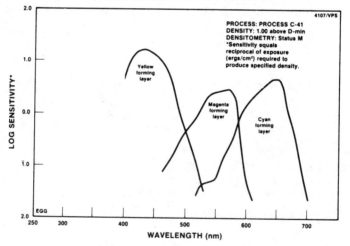

PROCESS: PROCESS C-41
DENSITY: 1.00 above D-min
DENSITOMETRY: Status M
*Sensitivity equals
reciprocal of exposure
(ergs/cm²) required to
produce specified density.

The Compact Photo-Lab-Index

MODULATION TRANSFER CURVE

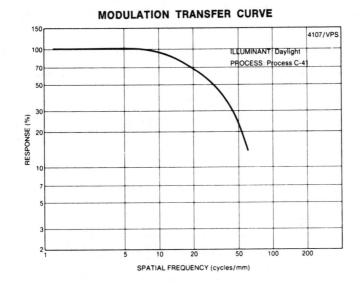

EASTMAN KODAK

SPECTRAL DYE DENSITY CURVES

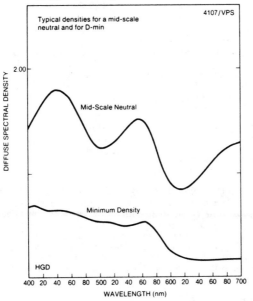

KODAK VERICOLOR II **PROFESSIONAL FILM 4108** Type L

A color-negative sheet film for exposure times of 1/50 second to 60 seconds with tungsten (3200 K) lamps or, with appropriate filters, by photolamp (3400 K) or daylight illumination. Colored couplers in the film provide automatic color correction and make excellent quality in color reproductions possible without supplementary masking. This film can be processed with *Kodak Flexicolor* Chemicals for Process C-41. The negatives can be printed on *Kodak Ektacolor* 74 RC and 78 Papers or by the Kodak Dye Transfer Process. They can also be used to make positive color transparencies on *Kodak Vericolor* Print Film 4111 (*Estar* Thick Base) or black-and-white prints on *Kodak Panalure* DIN 19 ISO 64/19° Papers. This film is also available in 120 size.

SPEED

Tungsten (3200 K)— **ASA 64** (for a 5-second exposure)
The effective speed depends upon the illumination level and exposure time. The number given in each is for use with meters marked for ASA, DIN, or ISO speeds.

Light Source	Filter	Exposure Time	Effective Speed	DIN	ISO
Tungsten (3200 K)	None	1/50 to 1/5 sec	ASA 100	21	100/21°
	None	1 sec	ASA 80	20	80/20°
	None	5 sec	ASA 64	19	64/19°
	None	30 sec	ASA 40	17	40/17°
	None	60 sec	ASA 32	16	32/16°

Set the meter calculator tentatively for a speed of 50, which applies to a 5-second exposure. Calculate a tentative exposure time for the desired lens opening. If this time is much shorter or much longer than 5 seconds, select from the table the effective speed which applies. Use this value to determine the correct exposure time at the desired lens opening.

Photolamps (3400 K)	81A	1 sec	ASA 64 (with filter)	19	64/19°
Daylight	85B	1/50 sec	ASA 64 (with filter)	19	64/19°

CAUTION

Do not expose *Kodak Vericolor II* Professional Film, Type L, for times shorter than 1/50 second or longer than 60 seconds, because the resulting negatives may contain color reproduction errors that cannot be corrected satisfactorily in the printing operation. For short exposures, use *Kodak Vericolor II* Professional Film 4107, Type S. If, however, a higher contrast result is desired for commercial applications, Type L film can be exposed with electronic flash and an 85C filter at a speed rating of ASA 50 or equivalent. The resulting negatives will require a filter pack slightly different from that used for negatives produced with the normal light source.

LIGHT SOURCES AND FILTERS

To avoid large changes in the filter pack used later during color printing, it is desirable to bring all negatives to approximately the same balance. Therefore,

EASTMAN KODAK

negatives exposed by photolamp (3400 K) or daylight illumination should be brought close to the same balance as negatives exposed with tungsten (3200 K) lamps by use of the filters listed in the table above.

INCLUSION OF GRAY CARD IN SCENE

As an aid in determining the exposures required in making prints from *Vericolor II* negatives, a neutral gray card having a reflectance of about 18%, such as the gray side of the *Kodak* Neutral Test Card, should be photographed with the subject. If possible, the card should be placed along the edge of the scene area in such a position that it receives the full subject lighting but does not interfere with the actual picture and can be trimmed off the final prints. Otherwise, the card should be photographed, with the full subject lighting, on a separate sheet of *Vericolor II* Professional Film, which should be processed at the same sime as the negatives.

PROCESSING

Professional photographic laboratories offer processing and printing services for *Vericolor II* Professional Films. The Type L films are not processed or printed by Kodak Processing Laboratories; they do, however, offer a development-only service for the 120-size Type L film. Film in sheets and short rolls can be processed efficiently in sink-line equipment with *Kodak Flexicolor* Chemicals for Process C-41.

FILM SIZES AVAILABLE

Sheets (inches): 2¼ x 3¼, 4 x 5, 5 x 7, 8 x 10, and 11 x 14 (film code 4108, *Estar* thick base). Rolls: VPL120 (film code 6013, acetate base). No long rolls.

KODAK VERICOLOR II **PROFESSIONAL FILM, Type L**
CHARACTERISTIC CURVES

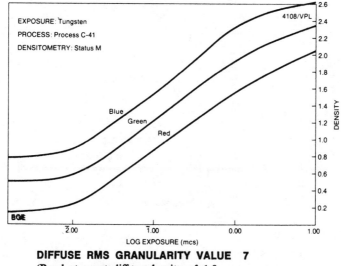

EXPOSURE: Tungsten
PROCESS: Process C-41
DENSITOMETRY: Status M

DIFFUSE RMS GRANULARITY VALUE 7
(Read at a net diffuse density of 1.0,
using a 48-micrometer aperture, 12X magnification.)

EASTMAN KODAK

117

SPECTRAL SENSITIVITY CURVES

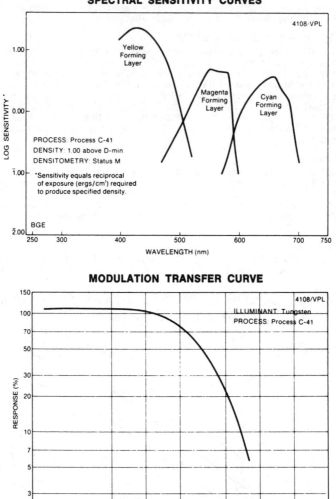

4108/VPL

Yellow
Forming
Layer

Magenta
Forming
Layer

Cyan
Forming
Layer

PROCESS: Process C-41
DENSITY: 1.00 above D-min
DENSITOMETRY: Status M

*Sensitivity equals reciprocal
of exposure (ergs/cm²) required
to produce specified density.

BGE

LOG SENSITIVITY *

WAVELENGTH (nm)

MODULATION TRANSFER CURVE

4108/VPL

ILLUMINANT: Tungsten
PROCESS: Process C-41

RESPONSE (%)

BGE

SPATIAL FREQUENCY (cycles/mm)

RESOLVING POWER VALUES
Test-Object Contract 1.6:1 40 lines per mm
Test-Object Contrast 1000:1 80 lines per mm

EASTMAN KODAK

118

SPECTRAL DYE DENSITY CURVES

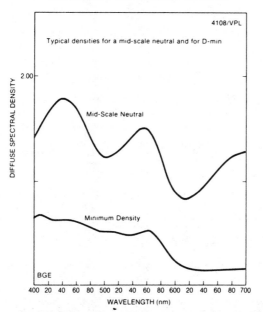

KODAK VERICOLOR II COMMERCIAL FILM TYPE S, SO-172

CHARACTERISTICS

High-contrast color negative film (contrast approximately equal to *Kodak* Vericolor II professional film, type L).

Compared to *Kodak* Vericolor II professional film, type S, SO-172 film has noticeably higher contrast with the same excellent color reproduction and exposure latitude.

Balanced for electronic flash, blue flash, or daylight. Designed for an exposure time of 1/10 second and shorter. Available in 120-size rolls.

APPLICATIONS

For commercial illustrations where a film with higher contrast and daylight (electronic flash) color balance is required.

For industrial applications (i.e., circuit boards) and aerial photography where increased contrast is desirable.

For copy work.

For outdoor environmental portraiture under low-contrast lighting conditions such as cloudy days, deep shade, etc.

Anywhere prints with more snap are desired.

STORAGE

Store unexposed film in a refrigerator at 13°C (55°F) or lower.

SAFELIGHT

None. Total darkness required.

EASTMAN KODAK

The Compact Photo-Lab-Index

EXPOSURE

Light Source	Kodak Wratten filter	Speed	
		ASA	DIN
Daylight, Electronic Flash, Blue Flash	None	80	20
Photolamp (3400 K)	80B	25	15
Tungsten (3200 K)	80A	20	14

PROCESSING
Process Vericolor II commercial film in standard process C-41 chemicals. For detailed processing information, see *Kodak* Publication No. Z-121, *Using Process C-41, Second Edition.*

PRINTING
The printing characteristics of Vericolor II commercial film are similar to those of Vericolor II professional film. Prints can be made on *Kodak* Ektacolor papers and *Kodak* Panalure papers. Transparencies can be made on *Kodak* Vericolor slide film 5072.

Initially, finishers may want to segregate Vericolor II commercial film negatives from other color negative materials in order to optimize slope adjustments for proper color correction.

JUDGING NEGATIVE EXPOSURES
Use an electronic densitometer equipped with filters such as the *Kodak* densitometer filter set MM (certified), or with a *Kodak* Wratten filter No. 92 (red). A properly exposed negative should have red density values approximately equal to those below.

The *Kodak* neutral test card (gray side) receiving the same illumination as the subject.	0.75 to 0.95
The lightest step (darkest in the negative) of a *Kodak* paper gray scale receiving the same illumination as the subject.	1.30 to 1.50

RECIPROCITY FAILURE CHARACTERISTICS

Exposure Times (seconds)	Kodak Color Compensating filters	Exposure Increase
1/50,000 to 1/10	None	None

Not recommended for exposure longer than 1/10 second.

KODAK INSTANT COLOR FILM PR10
COLOR FILM FOR USE IN KODAK INSTANT CAMERAS.

HANDLING

Hold the film pack by the edges only! When you remove the protective wrapping, *be careful not to squeeze the pack or apply pressure to the film cover,* since this could allow light to spoil your pictures. Hold the flap and pull in the direction of the arrows.

Before loading the camera, check to see that the rollers are clean. If the rollers need cleaning, see your camera manual.

EASTMAN KODAK

The Compact Photo-Lab-Index

LOADING

Whenever possible, avoid loading the film pack in direct sunlight.
See your camera instructions for specific loading procedures. Line up the orange stripe (on the gray side of the film pack) with the orange loading line on the inside of the camera. If the pack doesn't fit *easily* into the camera, check the camera manual for more detailed instructions. *You must eject film cover before you begin to take pictures* (see your camera manual).

TAKING PICTURES

When the camera is loaded and the film cover ejected, you are ready to take pictures.
Under most conditions, you will take pictures with the lighten/darken control on your camera in the center position. However, the lightness or darkness of your print can be affected by such factors as temperature and type and brightness of subject. The lighten/darken control helps you to compensate for these effects, especially in daylight picture-taking. See your camera manual.
Remember, if you take flash pictures of subjects outside the recommended flash distance range, subjects closer than the minimum distance will probably be too light; subjects farther than the maximum distance will probably be too dark. For additional information, see your camera or flash manual.
Temperature Effects on Prints—The recommended temperature range during development of prints is 60 to 100 °F (16 to 38 °C). At temperatures below 60 °F (16 °C), place prints in a warm place—an inside pocket, for example—*as soon as they are ejected from the camera,* and leave them there during development. Otherwise, prints may appear too light. It may be desirable at the upper end of the temperature range—approaching 100°F (38 °C)—to set the lighten/darken control toward lighten to keep prints from becoming too dark.
Flash—See your camera instructions for more detailed information on flash. Use blue flash or appropriate electronic flash.

DEVELOPMENT

Pictures begin to develop as they are ejected from the camera. *Hold the prints by their borders, and don't bend, flex, or attempt to fold them. Never leave prints in direct sunlight or on hot surfaces during development.* An image will begin to appear in about 30 seconds under normal conditions.
Do not attempt to make judgment of print appearance until development is sufficiently advanced. A 2- to 3-minute wait is usually adequate under normal temperature conditions. Prints will appear lighter when judged in direct sunlight than they will under normal room lighting.

UNLOADING

After you have ejected the tenth picture, a "0" will appear in the exposure counter. Open the camera and remove the empty pack. See your camera manual for specific instructions.

STORAGE AND CARE OF FILM AND PRINTS

Storing the camera and film in a hot place such as the glove compartment or rear-window of a car in the sun may lead to reduced picture quality and permanent damage to your camera. If you inadvertently leave the camera and film in a hot place, allow them to cool for at least one hour before taking any pictures. Also allow them to return to normal temperature if they have been left in a cold place.
Store your prints in a cool, dry place. Color dyes may change over a period of time. Print colors will remain unchanged longer if pictures are protected from long exposure to bright light. You can use a permanent-ink marker to write on white borders of the prints.
Each picture is a sealed unit that contains a caustic fluid. *Never cut, trim, puncture, tear, or separate the picture unit, since this may allow some of the fluid to escape and come into contact with skin or eyes.* (See caution notice.)
Caution: Picture units contain a caustic fluid. Normally fluid will not appear. If if does, alkali burn may result from direct contact. Keep fluid away from eyes, mouth, and skin. Avoid fluid contact with fabrics, carpeting, and furniture to prevent stain.
In case of contact with eyes, immediately flush with plenty of water and get medical attention. In case of any other contact, wash thoroughly at once.

EASTMAN KODAK

121

KODACOLOR II **FILM**

A color negative roll film for exposure by daylight, electronic flash, or blue flashbulbs. The negatives can be used to obtain color prints and enlargements, or they can be printed on *Kodak Ektacolor* 74 RC and 78 Papers. Transparencies can be made on *Kodak Vericolor* Print Film 4111 (*Estar* Thick Base) or *Kodak Vericolor* Slide Film 5872. *Kodacolor* Slides in 2 x 2-inch mounts can be ordered through photo dealers.

SPEED

The number given after each light source is based on an ANSI Standard and is for use with meters and cameras marked for ASA speeds.

Light Source	ISO	DIN	Speed	With Filter Such as:
Daylight	100/21°	21	**ASA 100**	None
Photolamp (3400 K)	32/16°	16	**ASA 32**	Kodak Photoflood Filter No. 80B
Tungsten (3200 K)	25/15°	15	**ASA 25**	Kodak 3200 K Filter No. 80A

Note: Exposure times longer than 1 second may require an increase in exposure to compensate for the reciprocity characteristics of this film.

DAYLIGHT EXPOSURE TABLE

Lens openings with shutter at 1/125 second. For the hours from 2 hours after sunrise to 2 hours before sunset.

Bright or Hazy Sun on Light Sand or Snow	Bright or Hazy Sun (Distinct Shadows)	Weak, Hazy Sun (Soft Shadows)	Cloudy Bright (No Shadows)	Heavy Overcast	Open Shade*
f/16	f/11†	f/8	f/5.6	f/4	f/4

*Subject shaded from the sun but lighted by a large area of sky.
†f/5.6 for backlighted close-up subjects.

FLASH

For flash pictures with this film use blue flashbulbs without a filter. With zirconium-filled clear flashbulbs (AG-1 and M3) use a filter such as the *Kodak* Photoflash Filter No. 80D over the camera lens. With all other clear flashbulbs use a No. 80C Filter. Divide the proper guide numbers by the flash-to-subject distance in feet to determine the f-number for average subjects. Use ½ stop larger for dark subjects, ½ stop smaller for light subjects.

FILL-IN FLASH

Blue flashbulbs are helpful in lightening the harsh shadows usually found in making close-ups in bright sunlight. A typical exposure is f/22 at 1/25 or 1/30 second with the subject 8 to 10 feet away.

GUIDE NUMBERS* FOR FLASHBULBS
For Blue Flashbulbs (or Clear Flashbulbs with a No. 80C or No. 80D Filter)

Between-Lens Shutter Speed	Syn-chroni-zation	Flash-cube	AG-1B†	M2B§	M3B† 5B§ 25B§	Focal-Plane Shutter Speed	6B§ or 26B§
Open 1/25-1/30	X or F	90	130	120	180	1/25-1/30	180
1/25-1/30	M	60	90	NR**	170	1/50-1/60	130
1/50-1/60	M	60	90	NR	160	1/100-1/125	85
1/100-1/125	M	50	75	NR	130	1/200-1/250	60
1/200-1/250	M	38	65	NR	110	1/400-1/500	44
1/400-1/500	M	32	50	NR	80	1/1000	30

*For use with bowl-shaped polished reflectors. If shallow cylindrical reflectors are used, divide these guide numbers by 2.

Bowl-shaped polished reflector sizes: †2-inch; ‡3-inch; §4- to 5-inch.

**NR = Not Recommended.

These values are intended only as guides for average emulsions. They must be changed to suit individual variations in synchronization, battery, reflector, and bulb position in the reflector.

Caution: Since bulbs may shatter when flashed, the use of a flashguard over the reflector is recommended. Do not flash bulbs in an explosive atmosphere.

ELECTRONIC FLASH GUIDE NUMBERS

This table is intended as a starting point in determining the correct guide number. It is for use with equipment rated in beam candlepower-seconds (BCPS) or effective candlepower-seconds (ECPS). Divide the proper guide number by the flash-to-subject distance to determine the *f*-number for average subjects. If color prints are consistently bluish, use a filter such as the *Kodak* Light Balancing Filter No. 81B over the camera lens and increase exposure ⅓ stop.

Output of Unit (BCPS or ECPS)	350	500	700	1000	1400	2000	2800	4000	5600	8000
Guide Number Feet	40	50	60	70	85	100	120	140	170	200
For Trial Meters	12	15	18	21	26	30	36	52	50	60

Caution: Do not use shutter speeds longer than 1/50 second; otherwise, results may be influenced by illumination other than the electronic flash.

COPYING AND CLOSE-UP WORK

In copying, the use of an incident-light meter or a reflected-light meter with a gray card is recommended for determing exposures. If the camera lens is extended for focusing on a subject closer than 8 times the focal length of the lens, allow for the decrease in effective lens opening. A *Kodak Professional Photoguide* furnishes an easy means of determining the effective lens opening.

EASTMAN KODAK

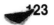

PHOTOLAMP (3400 K) EXPOSURE TABLE

For two new 500-watt, reflector-type photolamps (3400 K) at the same distance from the subject: fill-in light close to camera at camera height; main light on other side of camera at 45 degrees to camera-subject axis and 2 to 4 feet higher than fill-in light. A No. 80B Filter should be used over the camera lens.

Lamp-to-Subject Distance	4½ ft.	6 ft.
Lens Opening at 1/25 or 1/30 Second	f/4	f/2.8

Note: This table is for new lamps only. After burning lamps 1 hour, use ½ stop larger; after 2 hours, 1 full stop larger.

PROCESSING

Kodacolor II Film is developed by Kodak and other laboratories on orders placed through photo dealers. Some laboratories, including Kodak, also provide direct mail service whereby you can mail exposed film to the laboratory and have it returned directly to you. See your dealer for the special mailing devices required. Do not mail film without an overwrap or special mailing device intended for this purpose. Kodak Flexicolor Chemicals for Process C-41, available in kit form (1-pint size) and as individual components in larger sizes, can be used to process this film.

FILM SIZES AVAILABLE

C110-12, C110-20, C116, C120, C126-12, C126-20, C127, C135-12 C135-24 C135-36, C616, C620,C828.

KODACOLOR II **FILM**
CHARACTERISTIC CURVES

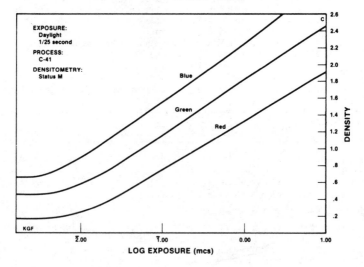

SPECTRAL SENSITIVITY CURVES

EFFECTIVE EXPOSURE:
1.4 seconds
PROCESS:
C-41
DENSITOMETRY:
Status M
DENSITY:
1.0 above D-min
*Sensitivity equals reciprocal of
exposure (ergs/cm²) required to
produce specified density.

LOG SENSITIVITY*

yellow forming layer

magenta forming layer

cyan forming layer

KGF

WAVELENGTH (nm)

MODULATION TRANSFER CURVE

EXPOSURE: Daylight
PROCESS: C-41
DENSITOMETRY: Visual

Response (%)

KGF

SPATIAL FREQUENCY (cycles/mm)

DIFFUSE RMS GRANULARITY VALUE 6
(Read at a net diffuse density of 1.0,
using a 48-micrometer aperture, 12X magnification.)

RESOLVING POWER VALUES
Test-Object Contrast 1.6:1 50 lines per mm
Test-Object Contrast 1000:1 100 lines per mm

EASTMAN KODAK

125

EASTMAN KODAK

SPECTRAL DYE DENSITY CURVES

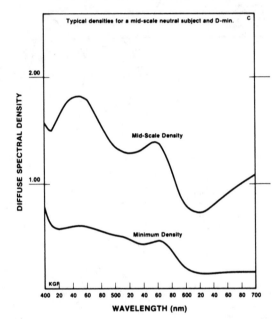

KODACOLOR 400 FILM

A high-speed, color negative roll film that can be used with daylight and most types of existing low-level illumination as well as with supplementary flash. It is color-balanced for daylight, blue flashbulbs, and electronic flash, but its special sensitizing characteristics minimize the photographic difference among various light sources so that conversion filters are not necessary to produce pleasing and acceptable color prints. This film is excellent for dimly lighted subjects, for fast action, for extending the distance range for flash pictures, and for subjects requiring good depth of field or high shutter speeds. For critical use correction filters can be used for photolamp and tungsten illumination.

SPEED

The number given after each light source is based on an ANSI Standard and is for use with meters and cameras marked for ASA speeds.

Light Source	ISO	DIN	Speed	With Filter Such as:
Dayight	400/27°	27	ASA 400	None
Photolamp (3400 K)	125/22°	22	ASA 125	Kodak Photoflood Filter No. 80B
Tungsten(3200 K)	100/21°	21	ASA 100	Kodak 3200 K Filter No. 80A

Note: Exposure times longer than 1 second may require an increase in exposure to compensate for the reciprocity characteristics of this film.

DAYLIGHT EXPOSURE TABLE

	1/500 Second		1/250 Second	
Bright or Hazy Sun on Light Sand or Snow	Bright or Hazy Sun (Distinct Shadows)	Cloudy Bright (No Shadows)	Heavy Overcast	Open Shade
f/16	f/16*	f/8	f/5.6	f/5.6†

*f/8 for backlighted close-up subjects.
†Subject shaded from the sun, but lighted by a large area of sky.

EXISTING-LIGHT TABLE

Subject	Shutter Speed	Lens Aperture
Well-lighted interiors	1/30	f/2.8
Dimly lighted interiors (details in dark objects barely visible)	1/30	f/2.0

ELECTRONIC AND BLUE FLASH EXPOSURE

No filter required. Guide numbers may be calculated on the basis of the film speed of ASA 400. Determine the f-number by dividing the guide number for your reflector and bulb or electronic flash unit by the distance in feet from the flash to your subject. Use these numbers as guides—if your flash negatives are consistently underexposed, use a lower guide number; if overexposed, use a higher guide number.

PROCESSING

Kodacolor 400 Film is developed by Kodak and other laboratories on orders placed through photo dealers. Some laboratories, including Kodak, also provide direct mail service whereby you can mail exposed film to the laboratory and have it returned directly to you. See your dealer for the special mailing devices required. Do not mail film without an overwrap or special mailing device intended for this purpose, *Kodak Flexicolor* Chemicals for Process C-41, available in kit form (1-pint size) and as individual components in larger sizes, can be used to process this film.

FILM SIZES AVAILABLE

CG110-12, CG110-20, CG120, CG135-12, CG135-24, CG135-36.

CHARACTERISTIC CURVES

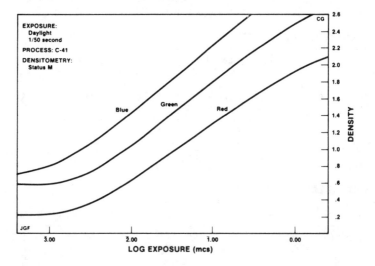

(See diagram on following pages.)

The Compact Photo-Lab-Index

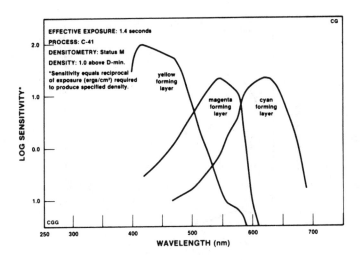

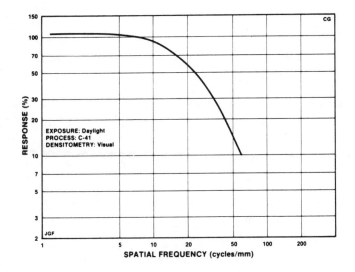

EASTMAN KODAK

129

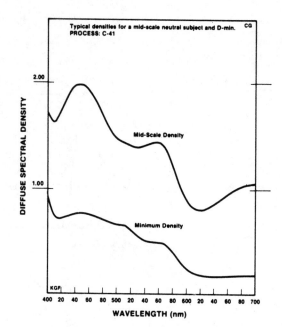

EASTMAN KODAK

KODAK EKTACHROME 64 PROFESSIONAL FILM 6117 (DAYLIGHT)

A color-reversal sheet film balanced for exposure in daylight and designed for Process E-6 to produce color transparencies. The transparencies can be viewed by transmitted light or projection, and can be printed in color by photomechanical methods. This film is also available as *Kodak Ektachrome* 64 Professional Film (Daylight) in 135-36 and 120 sizes. This professional film is color-balanced for direct viewing with the standard 5000 K light source adopted by the American National Standards Institute (ANSI Standard PH2.31-1960).

IMPORTANT

These instructions are based on average emulsions used under average conditions. Information applying to film of a specific emulsion number is given on the instruction sheet packaged with the film. The effective speed can be ASA 50, 64, or 80.

SPEED

The number given after each light source is based on an ANSI Standard and is for use with meters and cameras marked for ASA speeds.

Light Source	ISO	DIN	Speed	With Filter Such as:
Daylight	64/18°	19	ASA 64	None
Photolamp (3400 K)	20/14°	14	ASA 20	*Kodak* Photoflood Filter No. 80B
Tungsten (3200 K)	16/13°	13	ASA 16	*Kodak* 3200 K No. 80A

Note: Exposure times longer than 1/10 second may require an increase in exposure to compensate for the reciprocity characteristics of this film.

DAYLIGHT EXPOSURE TABLE

Lens openings with shutter at 1/125 seconds. *For the hours from 2 hours after sunrise to 2 hours before sunset.*

Bright or Hazy Sun on Light Sand or Snow	Bright or Hazy Sun (Distinct Shadows)*	Weak, Hazy Sun (Soft Shadows)	Cloudy Bright (No Shadows)	Heavy Overcast	Open Shade†
ƒ/16	ƒ/11	ƒ/8	ƒ/5.6	ƒ/4	ƒ/4

*With backlighted close-up subjects, use ƒ/5.6
†Subject shaded from sun but lighted by a large area of clear, unobstructed sky.

LIGHT SOURCES

In general, best color rendering is obtained in clear or hazy sunlight. Other light sources may not give equally good results even with the most appropriate filters.

The bluish cast which is otherwise evident in pictures taken in shade under a clear blue sky can be minimized by the use of a skylight filter, which requires no increase in exposure. The filter is also useful for reducing bluishness in pictures taken on an overcast day and in distant scenes, mountain views, sunlit snow scenes, and aerial photographs.

LONG EXPOSURES

At exposure times of 1/10 second or longer to daylight illumination. Under such conditions, it may be preferable to use *Kodak Ektachrome* Professional Film 6118 (Tungsten) with a *Kodak* Filter No. 85B.

EASTMAN KODAK

EASTMAN KODAK

The Compact Photo-Lab-Index

FLASH

For flash pictures with this film, use *blue flashbulbs* without a filter. With zirconium-filled clear flashbulbs (AG-1 and M3) use a filter such as the *Kodak* Photoflash Filter No.80D over the camera lnes. With all other clear flashbulbs, use a No. 80C Filter. Divide the proper guide numbers by the flash-to-subject distance in feet to determine the *f*-number for average subjects. Use ½ stop larger for dark subjects, ½ stop smaller for light subjects.

GUIDE NUMBERS* FOR FLASHBULBS
For Blue Flashbulbs (Or Flashbulbs with a No. 80C or No. 80D Filter)

Between-Lens Shutter Speed	Syn-chroni-zation	M2B‡	M3B‡ 5B§ 25B§	2B 22B	3¶ or 50¶ In a 12-Inch Bowl Reflector	Focal-Plane Shutter Speed	6B§ 26B§
Open, 1/25—1/30	X or F	100	150	180		1/25—1/30	140
1/25—1/30	M	NR**	130	170	260	1/50—1/60	100
1/50—1/60	M	NR	130	160	(Use 1/25	1/100—1/125	70
1/100—1/125	M	NR	110	140	or	1/200—1/250	50
1/200—1/250	M	NR	85	100	Slower)	1/400—1/500	34
1/400—1/500	M	NR	65	75		1/1000	24

*For use with bowl-shaped polished reflectors. If shallow cylindrical reflectors are used, divide these guide numbers by 2.
Bowl-shaped polished reflector sizes:‡3-inch; §4- to 5-inch.
¶Clear bulbs are listed because blue bulbs are not available. Use with a No. 80C Filter.
**NR = Not Recommended.
These values are intended only as guides for average emulsions. They must be changed to suit individual variations in synchronization, battery, reflector, and bulb position in the reflector.

Caution: Since bulbs may shatter when flashed, the use of a flashguard over the reflector is recommended. *Do not flash bulbs in an explosive atmosphere.*

ELECTRONIC GUIDE NUMBERS

This table is intended as a starting point in determining the correct guide number. The table is for use with equipment rated in beam candlepower-seconds (BCPS) or effective candle-power-seconds (ECPS). Divide the proper guide number by the flash-to-subject distance to determine the *f*-number for average subjects.

Effective Film Speed	Output of Unit (BCPS)		350	500	700	1000	1400	2000	2800	4000	5600	8000
ASA 50	Guide Number	Feet	30	35	40	50	60	70	85	100	120	140
	for Trial	Meters	9	11	12	15	18	21	26	30	36	42
ASA 64	Guide Number	Feet	32	40	45	55	65	80	95	110	130	160
	for Trial	Meters	10	12	14	17	20	24	29	33	40	50
ASA 80	Guide Number	Feet	35	45	55	65	75	90	110	130	150	180
	for Trial	Meters	11	14	17	20	22	27	33	40	46	55

If your transparencies are consistently bluish, use a CC05Y or CC10Y filter over the camera lens. Increase exposure ⅓ stop if a CC10Y or CC20Y filter is used.

PROCESSING

Chemicals for preparing a complete set of processing solutions are in the *Kodak Ektachrome* Film Processing Kit, Process E-6. The kit is available in 1-pint (containing two each of 1-pint units of each developer) and 1-gallon sizes. Chemical are also available as separate units in larger sizes.

FILM SIZES AVAILABLE

Sheets (inches): 4 x 5, 5 x 7, 8 x 10, and 11 x 14. Also 9 x 12 centimeters.
Rolls: EPR-135-36 (film code 5017) and EPR120 (film code 6017).

KODAK EKTACHROME 64 PROFESSIONAL FILM (Daylight)

CHARACTERISTIC CURVES

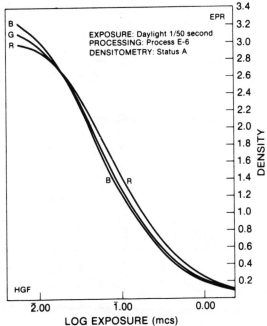

EPR

EXPOSURE: Daylight 1/50 second
PROCESSING: Process E-6
DENSITOMETRY: Status A

DENSITY

LOG EXPOSURE (mcs)

DIFFUSE RMS GRANULARITY VALUE: 12

(Read at a gross diffuse density of 1.0, using a 48-micrometer aperture, 12X magnification.)

RESOLVING POWER VALUES:

Test-Object Contrast 1.6:1 50 lines per mm
Test-Object Contrast 1000:1 125 lines per mm

EASTMAN KODAK

SPECTRAL SENSITIVITY CURVES

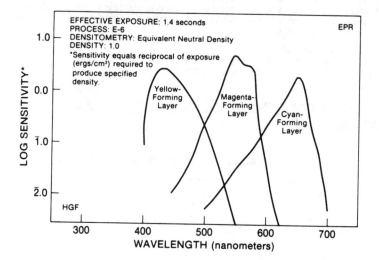

MODULATION TRANSFER CURVE

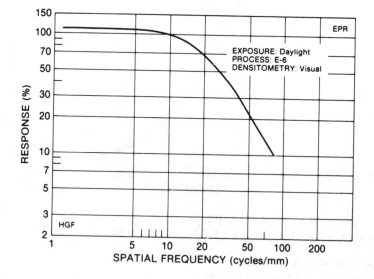

EASTMAN KODAK

SPECTRAL DYE DENSITY CURVES

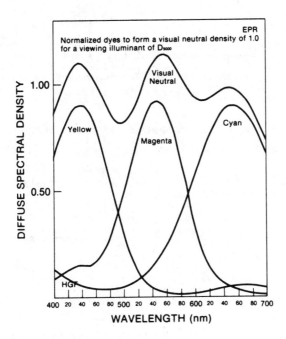

EASTMAN KODAK

KODAK EKTACHROME 200 PROFESSIONAL FILM (DAYLIGHT)

A high-speed color-reversal roll film recommended for color photography of fast action, interiors lighted by daylight and other dimly lighted subjects, close-ups that require the utmost depth of field, etc. It is color-balanced for exposure to daylight, blue flashbulbs, and electronic-flash illumination. No filters are required with any of these light sources. In general, for fluorescent illumination and arc lamps, this film is preferable to the tungsten film. When processed, this film produces color transparencies suitable for projection, direct viewing, or use as originals for color prints. This professional film is color-balanced for direct viewing with the standard 5000 K light source adopted by the American National Standard Institute (ANSI Standard PH2.31-1960).

IMPORTANT

These instructions are based on average emulsions used under average conditions. Information applying to film of a specific emulsion number is given on the instruction sheet packaged with the film. The effective speed can be ASA 160, 200, or 250.

SPEED

The number given after each light source is based on an ANSI Standard and is for use with meters and cameras marked for ASA speeds.

Light Source	ISO	DIN	Speed	With Filter Such as:
Daylight	200/24°	24	ASA 200	None
Photolamp (3400 K)	64/19°	19	ASA 64	*Kodak* Photoflood Filter No. 80B
Tungsten (3200 K)	50/18°	18	ASA 50	*Kodak* 3200 K No. 80A

Note: Exposure 1/10 second and longer may require filtration and exposure compensation.

Because of its extreme speed, this film is easy to overexpose under bright sunlight conditions.

Leaf shutters have the higher speed settings calibrated for the maximum lens openings. They are relatively more efficient at smaller lens openings, and so pass more light than calculated. Therefore, under lighting conditions that call for small lens openings at high shutter speeds, use an opening ½ stop smaller than that indicated by an exposure meter. The following table makes allowance for this shutter efficiency effect.

DAYLIGHT EXPOSURE TABLE

For average frontlighted subjects in daylight from 2 hours after sunrise to 2 hours before sunset.

Lens opening with shutter at 1/250 second					
Bright or Hazy Sun on Light Sand or Snow	Bright or Hazy Sun (Distinct Shadows)*	Weak, Hazy Sun (Soft Shadows)	Cloudy Bright (No Shadows)	Heavy Overcast	Open Shade†
f/22‡	*f*/16‡	*f*/11	*f*/8	*f*/5.6	*f*/5.6

*With backlighted close-up subjects, use *f*/8.
†Subject shaded from sun but lighted by a large area of clear, unobstructed sky.
‡With blade-type shutters, correct for high speed and small apertures.

136

FILL-IN FLASH

Blue flashbulbs are also helpful in lightening the harsh shadows usually found in making close-ups in bright sunlight. A typical exposure is $f/22$ at 1/100 second, with the subject 8 to 10 feet away. When you use a camera with a blade-type shutter, electronic flash is a good fill-in source for this film, as it can be synchronized more easily than flashbulbs at 1/100 second.

FLASH

For flash pictures with this film use *blue flashbulbs* without a filter. With zirconium-filled clear flashbulbs (AG-1 and M3) use a filter such as the *Kodak* Photoflash Filter No. 80D over the camera lens. With all other clear flashbulbs use a No. 80C Filter. Divide the proper guide numbers by the flash-to-subject distance in feet to determine the f-number for average subjects. Use ½ stop larger for dark subjects, ½ stop smaller for light subjects.

GUIDE NUMBERS* FOR FLASHBULBS
For Blue Flashbulbs (Or Flashbulbs with a No. 80C or No. 80D Filter)

Between Lens Shutter Speed	Syn-chroni-zation	Flash-cube	AG-1B‡	M2B‡	M3B‡ 5B‡	Focal-Plane Shutter Speed	6B§ or 26B§
Open, 1/25—1/30	X or F	130	180	170	260	1/25—1/30	260
1/25—1/30	M	85	130	NR**	240	1/50—1/60	180
1/50—1/60	M	85	130	NR	220	1/100—1/125	120
1/100—1/125	M	70	110	NR	180	1/200—1/250	85
1/200—1/250	M	55	90	NR	150	1/400—1/500	60
1/400—1/500	M	45	70	NR		1/1000	42

*For use with bowl-shaped polished reflectors. If shallow cylindrical reflectors are used, divide these guide numbers by 2.
Bowl-shaped polished reflector sizes: †2-inch; ‡3-inch; §4- to 5-inch.
**NR = Not Recommended.

These values are intended only as guides for average emulsions. They must be changed to suit individual variations in synchronization, battery, reflector, and bulb position in the reflector.

Caution: Since bulbs may shatter when flashed, the use of a flashguard over the reflector is recommended. *Do not flash bulbs in an explosive atmosphere.*

ELECTRONIC GUIDE NUMBERS

The table on the following page is intended as a starting point in determining the correct guide number. The table is for use with equipment rated in beam candlepower-seconds (BCPS) or effective candle-power-seconds (ECPS). Divide the proper guide number by the flash-to-subject distance to determine the f-number for average subjects.

ELECTRONIC GUIDE NUMBERS
Refer to bottom paragraph on previous page.

Effective Film Speed	Output of Unit (BCPS)		350	500	700	1000	1400	2000	2800	4000	5600	8000
ASA 160	Guide Number for Trial	Feet	55	65	75	90	110	130	150	180	210	250
		Meters	17	20	22	27	33	40	46	55	65	75
ASA 200	Guide Number for Trial	Feet	60	70	85	100	120	140	170	200	240	280
		Meters	18	21	26	30	36	42	50	60	70	85
ASA 250	Guide Number for Trial	Feet	65	80	95	110	130	160	190	220	260	320
		Meters	20	24	29	33	40	50	60	65	80	95

Do not use shutter speeds longer than 1/50 second; otherwise, results may be influenced by illumination other than electronic flash. If your transparencies are consistently bluish, use a CC05Y or CC10Y filter over the camera lens. Increase exposure ⅓ stop if a CC10Y filter is used.

PROCESSING
Chemicals for preparing a complete set of processing solutions ar in the *Kodak Ektachrome Film Processing Kit, Process E-6.* The kit is available in 1-pint (containing two each of 1-pint units of each developer) and 1-gallon sizes. Chemical are also available as separate units in larger sizes.

FILM SIZES AVAILABLE
EPD 135-36 (film code 5036), EPD 120 (film code 6036).

KODAK EKTACHROME 200 Professional Film (Daylight)

CHARACTERISTIC

CURVES

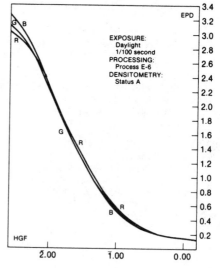

EXPOSURE:
Daylight
1/100 second
PROCESSING:
Process E-6
DENSITOMETRY:
Status A

EASTMAN KODAK

SPECTRAL SENSITIVITY CURVES

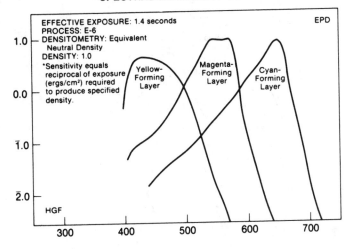

EFFECTIVE EXPOSURE: 1.4 seconds
PROCESS: E-6
DENSITOMETRY: Equivalent
 Neutral Density
DENSITY: 1.0
*Sensitivity equals
 reciprocal of exposure
 (ergs/cm²) required
 to produce specified
 density.

EPD

Yellow-Forming Layer

Magenta-Forming Layer

Cyan-Forming Layer

HGF

EASTMAN KODAK

MODULATION TRANSFER CURVE

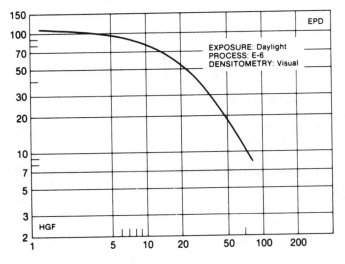

EPD

EXPOSURE: Daylight
PROCESS: E-6
DENSITOMETRY: Visual

HGF

139

SPECTRAL DYE DENSITY CURVES

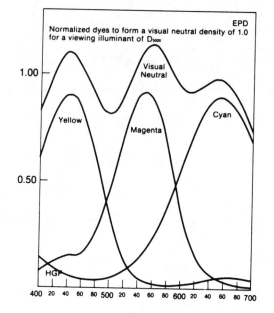

DIFFUSE RMS GRANULARITY VALUE: 13
(Read at a gross diffuse density of 1.0, using a 48-micrometer aperture, 12X magnification.)

RESOLVING POWER VALUES:
Test-Object Contrast 1.6:1 50 lines per mm
Test-Object Contrast 1000:1 125 lines per mm

KODAK EKTACHROME PROFESSIONAL FILM 6118 (TUNGSTEN)

A color-reversal *sheet* film balanced for exposure to 3200 K tungsten lamps and designed for Process E-6 to produce color transparencies. The transparencies are color-balanced for direct viewing with the standard 5000 K light source adopted by the American National Standards Institute and can be used for photomechanical reproduction. Duplicate transparencies and reflection prints can be made.

EXPOSURE WITH 3200 K TUNGSTEN LAMPS

The intended exposure range for this film is 1/10 second to 100 seconds. Under studio conditions the average exposure time to tungsten lamps is about 5 seconds. Therefore, this sheet film is color-balanced at a 5-second exposure time with 3200 K tungsten lamps and usually no color correction (CC) filters are necessary to obtain good color balance. Pictures taken at shorter or longer exposure times usually require CC filters to correct for color balance due to the reciprocity characteristics of the film. The instruction sheet in each box of sheet film has the following supplementary information for the particular emulsion number of film within the box:

1. The effective speed of the film at an exposure time of 5 seconds with 3200 K tungsten lamps is specified.

2. The effective speed of the film and suggested reciprocity correction CC filter(s) at exposure times of ½ and 30 seconds with 3200 K tungsten lamps are specified. The effective speed included the exposure increase required by the CC filter(s).

EXPOSURE WITH OTHER LIGHT SOURCES

This film is balanced for 3200 K tungsten lamps. Other light sources may not give equally good results even with the most appropriate filters. If 3400 K photolamps are used, apply the supplementary information data on the instruction sheet plus a *Kodak* No. 81A Filter and increase the exposure ⅓ stop. If daylight illumination is used, apply the supplementary data plus a *Kodak* No. 85B Filter and increase the exposure ⅔ stop.

TRIAL EXPOSURE

For the best color balance with your equipment and process, minor adjustments in speed and color balance may be necessary, even at a 5-second exposure time. Use trial exposure to determine these adjustments.

SPEED SETTINGS

The ASA settings apply to incident-light readings taken from the subject position, and to reflected-light readings from the camera position. For interior scenes, take a reading from the camera position only if both subject and background have about the same brightness. Otherwise, take the reading from a gray card of 18% reflectance* held close to the subject, facing halfway between the camera and the main light. Divide the speed by 2 if the reading is taken from the palm of the hand or the subject's face; divide it by 5 if the reading is taken from a white card of 90% reflectance.* Set the meter calculator as for a normal subject. When a card or the palm of the hand is used, or when incident-light readings are made, allow ½ stop more exposure for dark subject; ½ stop less for light subjects.

*The *Kodak* Neutral Test Card, which has a gray side of 18% reflectance and a white side of 90% reflectance, is recommended. In daylight, follow the instructions packaged with the card.

COPYING AND CLOSE-UP WORK

In copying, the use of a gray card as described above is recommended for determining exposures. *Whenever the subject is closer than 8 times the focal length of the lens, allowance should be made for the decrease in effective lens opening due to bellows extension.* The effective lens opening is easily determined with a *Kodak Professional Photoguide,* NO. R-28.

141

EASTMAN KODAK

PROCESSING

Chemicals for preparing a complete set of processing solutions are in the *Kodak Ektachrome* Film Processing Kit, Process E-6. The kit is available in 1-pint (containing two each of 1-pint units of each developer) and 1-gallon sizes. Chemicals are also available as separate units in larger sizes.

FILM SIZES AVAILABLE

Sheets (inches): 3¼ x 4¼, 4 x 5, 5 x 7, 8 x 10, and 11 x 14. Also 9 x 12 centimeters.
Rolls: EPY135-36 (film code 5018) and EPY120 (film code 6018).

KODAK EKTACHROME (TUNGSTEN) 50 PROFESSIONAL FILM IN ROLLS

This film in 135-36, 120, and long roll sizes is color balanced for exposure to 3200K tungsten lamps for exposure times from 1/100 to 1 second. The instruction sheet packaged with the film indicated the effective ASA speed of that particular emulsion. The speed can be 40, 50, or 64. When the speed is ASA 50, the table below indicates the speed and filter suggestions for other light sources. Adjust the speed values in the table accordingly when the indicated effective speed is other than 50.

Light Source	ISO	DIN	Speed	Filter
Tungsten (3200 K)	50/18°	18	ASA 50 (at 1/10 sec)	None
Photolamp (3400 K)	40/17°	17	ASA 40 (at 1/10 sec)	81A
Daylight	32/18°	16	ASA 32 (at 1/60 sec)	85B

CHARACTERISTIC CURVES

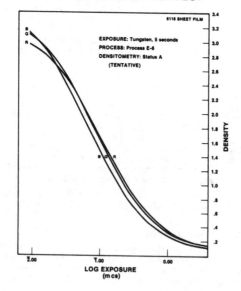

6118 SHEET FILM

EXPOSURE: Tungsten, 5 seconds
PROCESS: Process E-6
DENSITOMETRY: Status A
(TENTATIVE)

DENSITY

LOG EXPOSURE
(m cs)

SPECTRAL SENSITIVITY CURVES

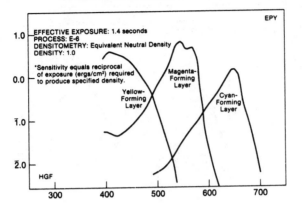

EASTMAN KODAK

MODULATION TRANSFER CURVE

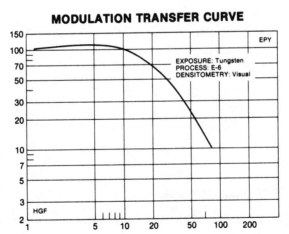

EASTMAN KODAK

SPECTRAL DYE DENSITY CURVES

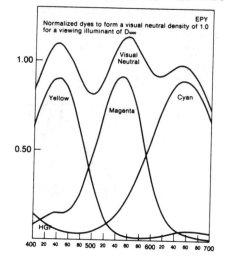

DIFFUSE RMS GRANULARITY VALUE: 11
(Read at a gross diffuse density of 1.0, using a 48-micrometer aperture, 12X magnification.)

RESOLVING POWER VALUES:
Test-Object Contrast 1.6:1 50 lines per mm
Test-Object Contrast 1000:1 125 lines per mm

KODAK EKTACHROME 160 PROFESSIONAL FILM (TUNGSTEN)

A high-speed color-reversal roll film balanced for exposure with tungsten (3200 K) lamps. It is a special-purpose, high-speed film intended primarily for use under existing tungsten light conditions. With most types of fluorescent lighting or arc lamps, *Kodak Ektachrome* 200 Professional Film (Daylight) will give more satisfactory results. When processed, this film produced positive color transparencies suitable for projection, direct viewing, or use as originals for color prints. This professional film is color-balanced for direct viewing with the standard 5000 K light source adopted by the American National Standards Institute (ANSI Standard PH2.31-1960).

IMPORTANT

These instructions are based on average emulsions used under average conditions. Information applying to film of a specific emulsion number is given on the instruction sheet packaged with the film. The effective speed can be ASA 125, 160, or 200, or equivalent.

SPEED

The number given after each light source is based on an ANSI Standard and is for use with meters and cameras marked for ASA DIN or ISO speeds.

Light Source	ISO	DIN	Speed	With Filter Such as:
Tungsten (3200 K)	160/23°	23	**ASA 160**	None
Photolamp (3400 K)	125/22°	22	**ASA 125**	*Kodak* No. 81A
Daylight	110/21°	21	**ASA 100**	*Kodak* No. 85B

Note: Exposures longer than 1/10 second may require filtration and exposure compensation.

TUNGSTEN (3200 K) REFLECTOR-TYPE LAMP EXPOSURE TABLE

Based on the use of two 3200 K reflector-type lamps—one as a fill-in light close to camera at lens level, the other as the main light 2 to 4 feet higher and at 45 degrees from the camera-subject axis.

Lens Opening at 1/50 or 1/60 Second			*f*/8	*f*/5.6	*f*/4	*f*/2.8	*f*/2
	EAL Lamps	Main Light	4	5½	8	11	15½
	(G. E.)	Fill-in Light	5½	8	11	15½	22
Lamp-to-Subject Distance in Feet	R-32 Lamps	Main Light	5	7	10	13½	20
	(Sylvania)	Fill-in Light	7	10	13½	20	28

Note: These values are intended only as guides. They give a lighting ratio of about 3 to 1. For a 2-to-1 ratio, move the fill-in light in to the same distance from the subject as the main light and use a ½-stop smaller lens opening.

EASTMAN KODAK

The Compact Photo-Lab-Index

TRIAL EXPOSURE SETTINGS FOR EXISTING-LIGHT SUBJECTS

Subject	Shutter Speed (Second)	Lens Opening
Home Interiors at Night		
Bright Light	1/30	$f/2.0$
Average Light	1/8*	$f/2.8$
Dim Light or Candlelight	1/4*	$f/2.8$
Brightly Lighted Street		
Scenes at Night	1/30	$f/2.8$
Well-Lighted		
Night or Indoor Sports	1/60	$f/2.8$

*Use a tripod or other firm camera support.

Note: Suggested exposure settings for additional *Kodak* films and existing-light subject are included in *Kodak* Publication No. R-28, *KODAK Professional Photoguide.*

BASIC DAYLIGHT EXPOSURE

With a filter such as the *Kodak Wratten* Filter No. 85B, for average subjects in bright sunlight: Between $f/11$ and $f/16$ at 1/125 second.

FLASHBULB GUIDE NUMBERS

Divide the proper guide number by the flash-to-subject distance in feet to determine the f-number for average subjects.

GUIDE NUMBERS* FOR BLUE FLASHBULBS AND A NO. 85B FILTER

Between-Lens Shutter Speed	Syn-chroni-zation	Flash-cube	AG-1B†	M2B‡	M3B‡ 5B‡ 25B§	Focal-Plane Shutter Speed	6B§ or 26B§
Open, 1/25—1/30	X or F	90	130	120	180	1/25—1/30	170
1/25—1/30	M	60	90	NR**	180	1/50—1/60	130
1/50—1/60	M	60	90	NR	160	1/100—1/125	90
1/100—1/125	M	50	75	NR	130	1/200—1/250	60
1/200—1/250	M	40	65	NR	105	1/400—1/500	45
1/400—1/500	M	32	50	NR	80	1/1000	30

*For use with bowl-shaped polished reflectors. If shallow cylindrical reflectors are used, divide these guide numbers by 2.
Bowl-shaped polished reflector sizes: †2-inch; ‡3-inch; §4- to 5-inch.
**NR = Not Recommended.

Caution: Since bulbs may shatter when flashed, the use of a flashguard over the reflector is recommended. *Do not flash bulbs in an explosive atmosphere.*

EASTMAN KODAK

The Compact Photo-Lab-Index

ELECTRONIC FLASH GUIDE NUMBERS

This table is a starting point in determining the correct guide number for your equipment. It is based on the use of the *Kodak* Filter No. 85B. The table is for use with equipment rated in beam candlepower-seconds (BCPS) or effective candlepower-seconds (ECPS). Divide the indicated guide number by the flash-to-subject distance to determine the *f*-number for average subjects. Adjust the guide number to fit your requirements.

Effective Film Speed	Output of Unit (BCPS)		350	500	700	1000	1400	2000	2800	4000	5600	8000
ASA 125	Guide Number	Feet	35	45	55	65	75	90	110	130	150	180
	for Trial	Meters	11	14	17	20	22	27	33	40	46	55
ASA 160	Guide Number	Feet	40	50	60	70	85	100	120	140	170	200
	for Trial	Meters	12	15	18	21	26	30	36	42	50	60
ASA 200	Guide Number	Feet	45	55	65	80	95	110	130	160	190	220
	for Trial	Meters	14	17	20	24	29	33	40	50	60	65

Do not use shutter speeds longer than 1/50 second; otherwise, results may be influenced by illumination other than electronic flash. If your transparencies are consistently bluish, use a CC05Y or CC10Y filter over the camera lens. Increase exposure ⅓ stop if a CC10Y filter is used.

PROCESSING

Chemicals for preparing a complete set of processing solutions are in the *Kodak Ektachrome* Film Processing Kit, Process E-6. The kit is available in 1-pint (containing two each of 1-pint units of each developer) and 1-gallon sizes. Chemical are also available as separate units in larger sizes.

FILM SIZES AVAILABLE

EPT135-36 (film code 5037), EPT120 (film code 6037).

DIFFUSE RMS GRANULARITY VALUE: 13

(Read at a gross diffuse density of 1.0, using a 48-micrometer aperture, 12X magnification.)

RESOLVING POWER VALUES:

Test-Object Contrast 1.6:1 50 lines per mm
Test-Object Contrast 1000:1 125 lines per mm

EASTMAN KODAK

147

KODAK EKTACHROME 160 Professional Film (Tungsten)

CHARACTERISTIC

CURVES

EASTMAN KODAK

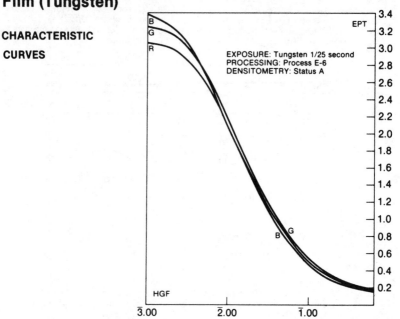

EXPOSURE: Tungsten 1/25 second
PROCESSING: Process E-6
DENSITOMETRY: Status A

SPECTRAL SENSITIVITY CURVES

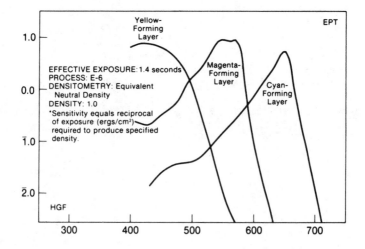

EFFECTIVE EXPOSURE: 1.4 seconds
PROCESS: E-6
DENSITOMETRY: Equivalent
 Neutral Density
DENSITY: 1.0
*Sensitivity equals reciprocal
of exposure (ergs/cm²)
required to produce specified
density.

148

The Compact Photo-Lab-Index

MODULATION TRANSFER CURVE

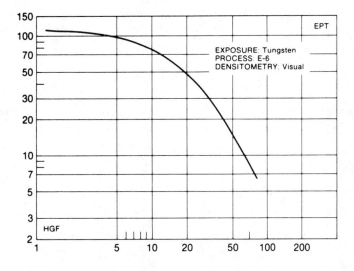

EPT

EXPOSURE: Tungsten
PROCESS: E-6
DENSITOMETRY: Visual

HGF

SPECTRAL DYE DENSITY CURVES

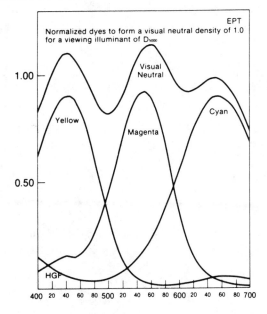

EASTMAN KODAK

149

MECHANICAL SPECIFICATIONS FOR PROCESS VNF-1

For purposes of the chart below, the films: *Eastman Ektachrome* Video News Film 5239 and 7239 (Daylight), *Eastman Ektachrome* Video News Film 5240 and 7240 (Tungsten), *Eastman Ektachrome* Video News Film High Speed 5250 and 7250 (Tungsten), and *Eastman Ektachrome* VN Print Film 5399 and 7399 are referred to as 39, 40, 50, and 99 respectively.

Process Steps	Temperature		Film	Time (sec)	Replenishment Rate per 30.5 m (100 ft) of 16-mm	
	°C	°F			Film	Leader
First Developer	37.8 ± 0.3	100 ± 0.5	99	126	975 ml	0 ml
			39, 40, 50	190	1700 ml	0 ml
First Stop	35 ± 3	95 ± 5	All	30	1100 ml	300 ml
Wash	38 ± 1	100 ± 2	All	60	8.0 L	8.0 L
Color Developer	43.3 ± 0.6	110 ± 1	All	215	800 ml	150 ml
Second Stop	35 ± 3	95 ± 5	All	30	650 ml	200 ml
Wash	38 ± 1	100 ± 2	All	60	8.0 L	8.0 L
Bleach	35 ± 3	95 ± 5	All	90	150 ml	150 ml
Fixer	35 ± 3	95 ± 5	All	90	625 ml	150 ml
Wash	38 ± 1	100 ± 2	All	60	8.0 L	8.0 L
Stabilizer	35 ± 3	95 ± 5	All	30	300 ml	150 ml

For force processing increase the first developer temperature **or** the first developer time according to the table below.

Stops	Temperature Increase		OR	Time Increase (sec)
	°C	°F		
1	3.6	6.5		70
2	7.2	13.0		160

Kodak, Eastman, and *Ektachrome* are trademarks of the Eastman Kodak Company

EASTMAN KODAK

150

KODAK EKTACHROME 400 FILM (DAYLIGHT)

A very high-speed color reversal slide film that features very fine grain, high sharpness, and medium resolving power. It is designed for exposure to daylight, blue flashbulbs, or electronic flash without filters, but it can also be exposed using photolamps (3400 K) or tungsten (3200 K) illumination with proper filtration. It is can excellent choice for dimly lighted daylight subjects or for action photography where good depth of field is desired. By obtaining special processing, you can expose the film at ASA 800.

Speed:

Light Source	ISO	Speed DIN	ASA	KODAK WRATTEN Gelatin Filter
Daylight	400/27°	27	400	None
Photolamp (3400 K)	125/22°	22	125	80B
Tungsten (3200 K)	100/21°	21	100	80A

NOTE: Exposure times longer than 1 second may require an increase in exposure to compensate for the reciprocity characteristics of this film. See the table on page DS-55.

Daylight Exposure Table:

	Shutter Speed			
1/1000 Second	1/500 Second			
Bright or Hazy Sun on Light Sand or Snow	Bright or Hazy Sun (Distinct Shadows)	Cloudy Bright (No Shadows)	Heavy Overcast	Open Shade
f/16	f/16*	f/8	f/5.6	f/5.6†

*f/8 for backlighted close-up subjects.
†Subject shaded from the sun, but lighted by a large area of sky.

Existing-Light Table:

Subject	Shutter Speed	Lens Aperture
Well-lighted interiors	1/30	f/2.8
Dimly lighted interiors (details in dark objects barely visible)	1/30	f/2.0

PROCESSING—Chemicals for Process E-6 are recommended for processsing KODAK EKTACHROME 40 Films. In small tanks, you can use KODAK EKTACHROME Film Processing Kits, Process E-6 (1-pint size)—complete instructions are packaged in the kit. For large-volume processing, see Kodak Publication No. Z-119, *Using Process E-6.*

For best results, use this film at its normal exposure index, ASA 400. When higher film speed is essential, the film can be exposed at an exposure index as high as 1600 if the first developer time is extended to compensate for the underexposure. Underexposed film results in a loss of maximum density, a decrease in exposure latitude, a color balance shift, and increased contrast. Run tests to see whether results are acceptable for your needs.

You can also obtain special processing from Kodak for a film speed of 800. Use the Kodak Special Processing Envelope, ESP-1, sold by photo dealers. (Cost of the ESP-1 envelope is in addition to the regular processing charge.) Other laboratories may also provide special processing to obtain various film speeds.

EASTMAN KODAK

151

The Compact Photo-Lab-Index

Starting points for exposure compensation by changing the first developer time:

	Suggested First Developer Time	
ASA Exposure Index	Sink Line	1-Pint Tanks
1,600 (2 stops underexposure)	11½ minutes	12½ minutes
800 (1 stop underexposure)	8 minutes	9 minutes
400 (normal exposure)	8 minutes	7 minutes
200 (1 stop overexposure)	4 minutes	5 minutes

ELECTRONIC AND BLUE FLASH EXPOSURE—No filter required. Guide numbers may be calculated on the basis of the film speed of ASA 400. Determine the f-number by dividing the guide number for your reflector and bulb or electronic flash unit by the distance in feet from the flash to your subject. Use these numbers as guides—if your flash slides are consistently under-exposed, use a lower guide number, if overexposed, use a higher guide number.

FILM SIZES AVAILABLE—EL135-20, EL135-36, EL120.

DIFFUSE RMS GRANULARITY VALUE 17—(Read at a net diffuse density of 1.0, using a 48-micrometre aperture, 12K magnification.)

RESOLVING POWER VALUES—Test-Object Contrast 1.6:1; 40 lines per mm

RESOLVING POWER VALUES—Test-Object Contrast 1000:1; 80 lines per mm

CHARACTERISTIC CURVES

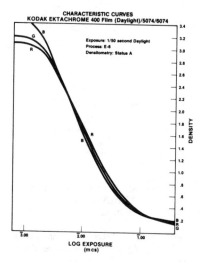

SPECTRAL SENSITIVITY CURVES

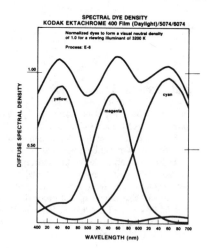

EASTMAN KODAK

152

The Compact Photo-Lab-Index

MODULATION TRANSFER CURVE

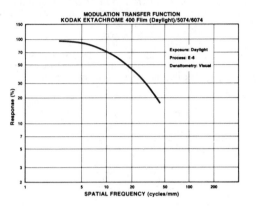

SPECTRAL DYE DENSITY CURVES

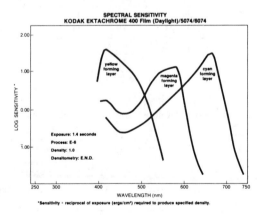

EASTMAN KODAK

153

MECHANICAL SPECIFICATIONS FOR PROCESS RVNP

For purposes of this chart, *Eastman Ektachrome* Video News Film 5239 and 7239 (Daylight), *Eastman Ektachrome* Video News Film 5240 and 7240 (Tungsten), *Eastman Ektachrome* Video News Film High Speed 5250 and 7250 (Tungsten), and *Eastman Ektachrome* VN Print Film 5399 and 7399 are referred to as 39, 40, 50, and 99 respectively.

Both process options for Process RVNP (Option 1; color developer—persulfate accelerator—wash—persulfate bleach and, Option 2; color developer—second stop—persulfate accelerator—persulfate bleach) have been included on the chart—simply ignore the option that does not apply to your particular machine's processing sequence.

Process Steps	Temperature		Film	Time (sec)	Replenishment Rate per 30.5 m (100 ft) of 16 mm	
	°C	°F			Film	Leader
First Developer	43.0 ± 0.3	109.4 ± 0.5	99	90	975 ml	0 ml
			39, 40, 50	120	1700 ml	0 ml
First Stop	40 ± 3	104 ± 5	All	19	1100 ml	300 ml
Wash	40 ± 1	104 ± 2	All	38	8.0 L	8.0 L
Color Developer	46.0 ± 0.6	114.8 ± 1.0	All	136	800 ml	150 ml
Persulfate Accelerator[1]				15	200 ml	150 ml
———— or ————	40 ± 3	104 ± 5	All			
Second Stop[2]				19	650 ml	200 ml
Wash[1]	40 ± 1	104 ± 2	All	5	8.0 L	8.0 L
———— or ————						
Persulfate Accelerator[2]	40 ± 3	104 ± 5	All	19	200 ml	150 ml
Persulfate Bleach	40 ± 3	104 ± 5	All	45	200 ml	150 ml
Fixer	40 ± 3	104 ± 5	All	40	625 ml	150 ml
Wash	40 ± 1	104 ± 2	All	25	8.0 L	8.0 L
Stabilizer	40 ± 3	104 ± 5	All	19	300 ml	150 ml

[1] Process Option 1
[2] Process Option 2

For force processing increase the first developer temperature **or** the first developer time according to the table below.

Stops	Temperature Increase		OR	Time Increase (sec)
	°C	°F		
1	4.0	9.0		50
2	—	—		110

Kodak, Eastman, and *Ektachrome* are trademarks of the Eastman Kodak Company

KODAK EKTACHROME **DUPLICATING FILMS** (PROCESS E-6)

There are four KODAK EKTACHROME Duplicating Films for Process E-6. They are:

KODAK EKTACHROME Slide Duplicating Film 5071, available in long rolls of various widths, and 135-36 magazines. This film is designed for making duplicate slides from slides made on KODACHROME or EKTACHROME Films and other brands of films.

KODAK EKTACHROME SE Duplicating Film SO-366 with availability and specifications the same as mentioned above.

KODAK EKTACHROME Slide Duplicating Film 7071 available in 16mm only.

KODAK EKTACHROME Duplicating Film 6121, a sheet film for making large sized duplicates by either direct printing or enlargement from various size original transparencies.

FEATURES COMMON TO ALL FOUR FILMS

These films have low duplicating film contrast: contrast adjustments not required normally; least filtration with tungsten light; good color reproduction characteristics; compatible with camera films in the same Process E-6 solutions; excellent dark storage keeping characteristics; good image stability to radiant energy.

DIFFERENCES AMONG THE FILMS

Ektachrome Film Code No.	Size Format	Light Source	Optimum Exposure Time	Base Thickness
5071	135-36; 35 & 46mm long rolls	Tungsten	1 second	5-mil acetate
SE, SO-366*	135-36; 35mm long rolls	Electronic flash	1/1000 sec	5-mil acetate
7071	16mm long rolls	Tungsten	1 second	5-mil acetate
6121	Sheets only	Tungsten	10 seconds	8.2-mil acetate

*KODAK EKTACHROME SE Duplicating Film SO-366 is not listed in dealers' catalogs. Use the following catalog numbers when you order from your dealer:

135-36 Cat. No. 159 0223 35mm x 100 ft SP 663 Cat. No. 159 0256

FILM STORAGE AND HANDLING

Color films are seriously affected by adverse storage conditions. High temperature or high humidity may produce undesirable changes in the film. These adverse conditions usually affect the three emulsion layers to differing degrees, thus causing a change in color balance as well as a change in film speed and contrast.

EASTMAN KODAK

155

The Compact Photo-Lab-Index

Keep unexposed film in a refrigerator or a freezer at 13°C (55°F), or lower, in the original sealed container. Remove film from a refrigerator and let it stand 1 to 3 hours before opening the container; remove film stored in a freezer 3 to 5 hours before opening. Sufficient warming time is necessary to prevent the condensation of atmospheric moisture on the cold film. Keep exposed film cool and dry. Process the film as soon as possible after exposure to avoid undesirable changes in the latent image. Store processed film in a dark, dust-free area at a temperature of 10 to 21°C (50 to 70°F) and at a relative humidity of 30 to 50 percent.

Handle unprocessed film only in total darkness. During processing, the film can be exposed to room light after it has been in the reversal bath for 1 minute.

PROCESSING AND PROCESS CONTROL

Process KODAK EKTACHROME Duplicating Films in Process E-6 chemicals. Duplicating film can be processed along with camera films; no adjustment in the process is necessary normally. Use the standard first developer time for all films (Kodak processing laboratories offer a processing and mounting service for the 135-36-size film).

Follow the process control methods recommended for Process E-6. Eastman Kodak Company supplies process control strips for Process E-6.

DATA FOR EXPOSING 5071, SO-366, AND 7071 FILMS

These films are intended for use in photofinishing and professional slide-duplicating operations for making slide sets or filmstrips. Either optical- or contact-printing equipment can be used, but a diffuse optical system offers the least difficulty with dust and scratches.

An ultraviolet absorber, such as the KODAK WRATTEN Filter No. 2B, should be included in the basic filter pack. When it is necessary to have the same filter pack for duplicating intermixed types of color slides on 5071 and 7071 films, use an infrared filter, such as the KODAK Infrared Cutoff Filter No. 304, in the light beam. This filter minimizes the effects of differing long wavelength red absorption properties of different cyan dyes used in color slide films. It is not necessary, however, to use this filter for printing segregated original slides or for printing a mixture of slides made on EKTACHROME Film (Process E-6) and KODACHROME Films (Process K-12 or K-14) with a common filter pack.

If you use the No. 304 Filter, position it with care in the light beam. See diagram below. Place the filter close to the light source, perpendicular to a specular. parallel part of the light beam. Face the coated side of the filter toward the light source, and use a loose-fitting holder to avoid cracking the filter. Tipping the filter or allowing the light to pass through the filter at an angle changes the spectral quality of the filter. The KODAK Infrared Cutoff Filter No. 304 is available in a 70mm (2¾-inch) square size (Kodak part No. 541052) to fit several slide duplicating units.

For best results, use Films 5071 and 7071 with tungsten or daylight illumination at exposure times of approximately 1 second. The SE Film SO-366, is recommended for short exposure times such as 1/1000 second from electronic flash illumination.

For noncritical applications, Films 5071 and 7071 can be used with electronic flash and SO-366 can be used for tungsten illumination at a one-second exposure time. Color reproduction errors may be evident in the highlights. Short exposure times with 5071 Film may cause a slight yellowing of the highlights. Use the starting point recommendations given in the table for these illumination conditions.

156

The Compact Photo-Lab-Index

PRINTER MAGNIFICATION

Adjust the printer to give a magnification of 1.03 diameters for 110-, 126-, or 135-size transparencies, or 0.92 diameter for 828-size transparencies. These magnifications represent the best compromise between critical positioning of the slide in the printer gate and minimum cropping. Check the lens magnification accurately by projecting the original slide and taking a measurement between any two points on the projected image. Then project the duplicate and measure the distance between the same two points. The distance measured on the duplicate divided by the distance measured on the original will give the lens magnification. The two points selected for measurement should be as far apart as possible to provide accuracy.

STARTING POINT RECOMMENDATIONS

Make a series of exposures to determine the proper exposure level. Start with the filter pack suggestions in the following table, varying the intensity of the light at the film plane until the slide density is correct. Filter requirements will vary according to the absorption of the particular diffusion glass and the heat-absorbing glass used. Once a satisfactory exposure time and filter pack have been selected and it subsequently becomes necessary to adjust the density level, keep the exposure time constant and vary the aperture to avoid small changes in the color balance.

	LIGHT SOURCE	
Kodak Film Originals To Be Duplicated	**5071, 7071 Film Tungsten (3200 K) 1 sec at f/5.6 to 11***	**SE Film SO-366 Electronic Flash† (5600 K)**
Ektachrome (E-6) Kodachrome (K-12) Kodachrome (K-14) (separately or intermixed)	Kodak Filter No. 2B + CC35Y + CC35C	Kodak Filter No. 2B + CC90Y + CC15C (f/11) High beam
Ektachrome (E-4)	Kodak Filter No. 2B + CC30Y + CC20C	Kodak Filter No. 2B + CC90Y + CC05C (f/11)
If Ektachrome (E-4) is intermixed with any of the following: Ektachrome (E-6) Kodachrome (K-12) Kodachrome (K-14)	Kodak Infrared Cutoff Filter No. 304 + Kodak Filter No. 2B + CC15M + CC50Y	Kodak Infrared Cutoff Filter No. 304 + Kodak Filter No. 2B + CC125Y + CC40M (f/8) High beam

*For making 110-size duplicates on 16mm film (7071), double the exposure.
†If the light source is higher or lower than 5600 K, increase or decrease the yellow filtration accordingly.

EASTMAN KODAK

The Compact Photo-Lab-Index

SLIDE DUPLICATING WITH A 35mm CAMERA

You can use a 135-36 magazine of EKTACHROME Slide Duplicating Film 5071 in a single-lens reflex camera equipped with a through-the-lens metering device and a suitable slide duplicating attachment.

As a starting point, with an illuminator and a 3200 K or 5000 K light source, or with sunlight on a white paper, use an exposure index of 4 with camera meters calibrated in ANSI speeds and the filters shown in the chart below for different original films. If your camera's lowest exposure index setting is 32, use 32 but increase the calculated exposure 3 stops. The optimum exposure time is 1 second.

Place filters between the transparency and the light source when measuring and making exposures. Make filter and exposure ring-arounds to determine the best exposure conditions for the equipment and film emulsion in use. In changing to a new film emulsion number, an appreciable change may be necessary in both the exposure index and the filter pack.

As a starting point for SO-366 Film and electronic flash, use 90Y + 15C in the filter pack.

Kodak Film Original To Be Duplicated	LIGHT SOURCE		
	3200 K	5000 K	Daylight
Ektachrome (E-4)	CC40G + CC45Y	CC10M + CC 100Y	CC20G + CC70Y
Ektachrome (E-6) Kodachrome (K-12) Kodachrome (K-14)	CC50G + CC35Y	CC90Y	CC30G + CC60Y

*Set a piece of white paper in the sunlight and point the camera with a slide copying attachment toward the paper.

JUDGING EXPOSURES AND ADJUSTING THE FILTER PACK

View slides or transparencies on a standard illuminator (5000 K, as recommended in ANSI Standard PH2.31-1969) or project the slides in a darkened room. After examining a transparency with illumination of the correct intensity and color distribution, decide if changes in density or color balance of the duplicate are necessary to make it match the original. The following table will be helpful in determining the filter pack adjustment.

If the overall color balance is	Subtract these filters	or	Add these filters
Yellow	Yellow		Magenta + Cyan
Magenta	Magenta		Yellow + Cyan
Cyan	Cyan		Yellow + Magenta
Blue	Magenta + Cyan		Yellow
Green	Yellow + Cyan		Magenta
Red	Yellow + Magenta		Cyan

EASTMAN KODAK

The Compact Photo-Lab-Index

When you make filter corrections in the filter pack, remove filters from the pack whenever possible. For example, if a slide is reddish, remove yellow and magenta filters rather than add a cyan filter. The filter pack should contain filters of only two of the three subtractive colors (cyan, magenta, yellow). The effect of including all three is to form neutral density, which only lengthens the exposure time without accomplishing any color correction. To eliminate neutral density, determine the color with the lowest filter value, remove filters of that color entirely, and remove the same density from the other two colors. For example:

$$\begin{array}{ll} & 40C + 40M + 20Y \text{ (Filter pack)} \\ \text{Subtract:} & \underline{20C + 20 + 20Y} \text{ (Removes neutral density)} \\ & 20C + 20M \qquad \text{(Minimum filter pack)} \end{array}$$

Note that in the example given, the filter pack of 20C + 20M is nominally equivalent to 20B. Thus, a single blue filter would serve in place of the two filters.

When making simplifications of the filter pack, such as removing neutral density or combining filters, keep these factors in mind:

1. The subtraction or substitution may not be exactly equivalent because of differences in absorption characteristics of the different filters.

2. A chance in the number of filter surfaces changes the total transmission of the filter pack, because a small amount of image-forming light is lost through reflection at each filter surface.

ADJUSTMENT FOR EMULSION NUMBER CHANGES

In order to simplify the crossover to a new emulsion, filter data in the form of cyan and yellow variations from average and speed data in the form of half-stop variations from average are printed in the emulsion number area of the outer packages of 5071 and SO-366 Films.

To cross over from one emulsion number to another, subtract the data on the old emulsion package from the data on the new emulsion package. Then apply the difference to the exposure conditions of the old emulsion. For example:

$$\begin{array}{ll} & -05C + 10Y + 0.5 \text{ (New package exposure)} \\ \text{Subtract:} & \underline{+10C - 05Y - 0.5} \text{ (Old package exposure)} \\ & -15C + 15Y + 1.0* \text{ (Change in exposure)} \end{array}$$

*This figure is an exposure factor and is provided in f-stop increments. In this example, the new emulsion needs an increase in exposure of 1 stop. Bear in mind, to subtract plus and/or minus values, change the signs of the old exposure values and add to the new package data.

The difference in exposure data from the old emulsion to the new one applies regardless of the filter pack that was used with the old emulsion. Assume that the old emulsion was used with a filter pack of 30C plus 50Y and a 1-second exposure at f/11. Change the exposure by removing 15C (or by adding 15R) adding 15Y (or taking out 15B), and increasing the exposure by 1 stop:

$$\begin{array}{lll} & +30C + 50Y \text{ f/11 @ 1 second} & \text{(Old exposure)} \\ \text{Add:} & \underline{-15C + 15Y + 1 \text{ stop}} & \text{(Change in exposure)} \\ & +15C + 65Y \text{ f/8 @ 1 second} & \text{(New exposure)} \end{array}$$

Where there is insufficient cyan or yellow filtration available for removal, add the complementary filter. Instead of a change in the aperture, a change in the exposure time is acceptable, although an additional adjustment in filtration or exposure may be necessary.

Be sure to adhere to storage and processing recommendations so that the printed exposure data will remain valid.

EASTMAN KODAK

The Compact Photo-Lab-Index

This sheet film is intended for exposure with tungsten illumination such as that supplied by Photo Enlarger Lamps No. 212 or 302, or with tungsten-halogen lamps. Pulsed-xenon light sources are not recommended. Appropriate light-balancing filters are usually required with sources other than tungsten. The exposing equipment should have a heat-absorbing glass and an ultraviolet absorbing filter such as the KODAK WRATTEN Filter No. 2B or KODAK Color Printing Filter CP2B. A constant-voltage power source minimizes short-term changes in light intensity and color balance. The intensity of the light should be controllable to allow an exposure time of approximately 10 seconds.

As a starting point for color correction with pulsed-xenon light, add a KODAK WRATTEN Filter No. 85B, or equivalent, to the filters recommended for tungsten light exposure. See the supplementary information on the instruction sheet packaged with each emulsion for suggested color correction filters for tungsten illumination. Neutral density filters may also be required to attain a 10-second exposure time.

COPYING

When used for copying color prints or other colored reflection copy such as paintings or drawings, KODAK EKTACHROME Duplicating Film yields transparencies of somewhat lower contrast than duplicate transparencies. A standard copy setup can be used for copying on this film, with great care being taken to provide even illumination on the copyboard.

When incandescent illumination is used (3000 to 3200 K) start with the filter pack recommended on the instruction sheet packaged with the film, and make changes based on results.

RETOUCHING DYES

KODAK E-6 Transparency Retouching Dyes are recommended for use on all KODAK EKTACHROME Professional Films in sheets for Process E-6 (original and duplicate transparencies) that are intended for graphic reproduction or duplicating onto 6121. The dyes have been designed so that their spectral transmission characteristics are similar to those of the image dyes of the film. Other dyes may not reproduce satisfactorily even though a visual match is achieved.

The thickness of the duplicating film base is the same as that of camera sheet films, so that both original and duplicate transparencies can be joined by cutting and butting operations. The base has a dyed gelatin antihalation backing, and while both sides of the film can be retouched., the retouching should be restricted to the base side whenever possible.

IMAGE STRUCTURE AND SENSITOMETRIC DATA

Resolving Power

Test-Object Contrast	1000:1	125 lines/mm
Test-Object Contrast	1.6:1	63 lines/mm

Diffuse RMS Granularity Value
9 (at gross diffuse density of 1.0)

NOTICE: The sensitometric curves and data shown represent product tested under the conditions of exposure and processing specified. They are representative of production coatings and, therefore, do not apply directly to a particular box or roll of photographic material. They do not represent standards or specifications which must be met by Eastman Kodak Company. The company reserves the right to change and improve product characteristics at any time.

EASTMAN KODAK

The Compact Photo-Lab-Index

CHARACTERISTIC CURVES

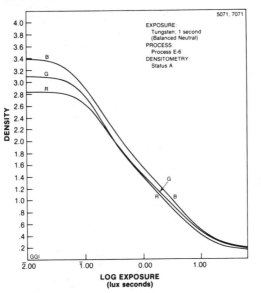

EASTMAN KODAK

CHARACTERISTIC CURVES

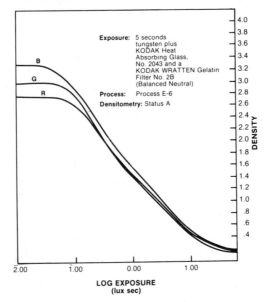

CHARACTERISTIC CURVES

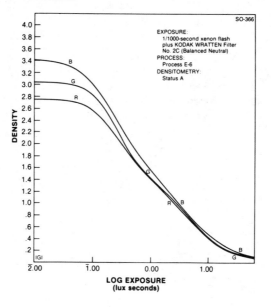

MODULATION-TRANSFER CURVE

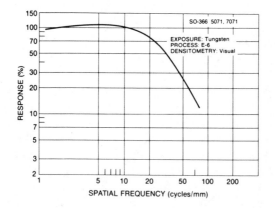

EASTMAN KODAK

The Compact Photo-Lab-Index

SPECTRAL SENSITIVITY CURVES

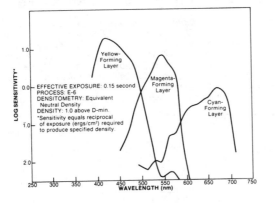

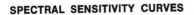

EFFECTIVE EXPOSURE: 0.15 second
PROCESS: E-6
DENSITOMETRY: Equivalent
 Neutral Density
DENSITY: 1.0 above D-min.
*Sensitivity equals reciprocal
of exposure (ergs/cm²) required
to produce specified density.

SPECTRAL DYE DENSITY CURVES

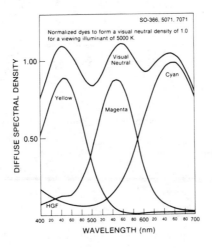

SO-366, 5071, 7071

Normalized dyes to form a visual neutral density of 1.0
for a viewing illuminant of 5000 K.

MECHANICAL SPECIFICATIONS FOR PROCESS RVNP

For purposes of this chart, *Eastman Ektachrome* Video News Film 5239 and 7239 (Daylight), *Eastman Ektachrome* Video News Film 5240 and 7240 (Tungsten), *Eastman Ektachrome* Video News Film High Speed 5250 and 7250 (Tungsten), and *Eastman Ektachrome* VN Print Film 5399 and 7399 are referred to as 39, 40, 50, and 99 respectively.

 Both process options for Process RVNP (Option 1; color developer—persulfate accelerator—wash—persulfate bleach and, Option 2; color developer—second stop—persulfate accelerator—persulfate bleach) have been included on the chart—simply ignore the option that does not apply to your particular machine's processing sequence.

Process Steps	Temperature		Film	Time (sec)	Replenishment Rate per 30.5 m (100 ft) of 16 mm	
	°C	°F			Film	Leader
First Developer	43.0 ± 0.3	109.4 ± 0.5	99	90	975 ml	0 ml
			39, 40, 50	120	1700 ml	0 ml
First Stop	40 ± 3	104 ± 5	All	19	1100 ml	300 ml
Wash	40 ± 1	104 ± 2	All	38	8.0 L	8.0 L
Color Developer	46.0 ± 0.6	114.8 ± 1.0	All	136	800 ml	150 ml
Persulfate Accelerator[1]	40 ± 3	104 ± 5	All	15	200 ml	150 ml
—— or ——						
Second Stop[2]				19	650 ml	200 ml
Wash[1]	40 ± 1	104 ± 2	All	5	8.0 L	8.0 L
—— or ——						
Persulfate Accelerator[2]	40 ± 3	104 ± 5	All	19	200 ml	150 ml
Persulfate Bleach	40 ± 3	104 ± 5	All	45	200 ml	150 ml
Fixer	40 ± 3	104 ± 5	All	40	625 ml	150 ml
Wash	40 ± 1	104 ± 2	All	25	8.0 L	8.0 L
Stabilizer	40 ± 3	104 ± 5	All	19	300 ml	150 ml

[1] Process Option 1
[2] Process Option 2

For force processing increase the first developer temperature **or** the first developer time according to the table below.

Stops	Temperature Increase		OR	Time Increase (sec)
	°C	°F		
1	4.0	9.0		50
2	—	—		110

Kodak, Eastman, and *Ektachrome* are trademarks of the Eastman Kodak Company

EASTMAN KODAK

KODACHROME 25 FILM (DAYLIGHT)

A color reversal roll film designed for exposure by daylight, electronic flash, or blue flash-bulbs. With a suitable filter, it can also be exposed by photolamp (3400 K) or tungsten (3200 K) illumination. Processed by reversal, it yields color transparencies for projection or color printing.

SPEED

The number given after each light source is based on an ANSI Standard and is for use with meters and cameras marked for ASA speeds.

Light Source	ISO	DIN	Speed	With Filter Such as:
Daylight	25/15°	15	**ASA 25**	None
Photolamp (3400 K)	8/10°	10	**ASA 8**	*Kodak* Photoflood Filter No. 80B
Tungsten (3200 K)	6/9°	9	**ASA 6**	*Kodak* 3200 K No. 80A

Note: Exposure times longer than 1/10 second may require filtration and exposure compensation.

DAYLIGHT EXPOSURE TABLE

Lens openings at shutter speeds stated. *For the hours from 2 hours after sunrise to 2 hours before sunset.*

Bright or Hazy Sun on Light Sand or Snow	Bright or Hazy Sun (Distinct Shadows)*	Weak, Hazy Sun (Soft Shadows)	Cloudy Bright (No Shadows)	Heavy Overcast	Open Shade†
Shutter at 1/125 Second				Shutter at 1/60 Second	
f/11	*f*/8†	*f*/5.6	*f*/4	*f*/4	*f*/4

*Subject shaded from sun but lighted by a large area of clear, unobstructed sky.
†*f*/4 for backlighted close-up subjects.

FILL-IN FLASH

Blue flashbulbs help to lighten the harsh shadows usually found in making close-ups in bright sunlight. A typical exposure is *f*/16 at 1/25 or 1/30 second, with the subject 8 to 10 feet away. For more information about fill-in flash.

LIGHT SOURCES

In general, best color rendering is obtained in clear or hazy sunlight. Other light sources may not give equally good results even with the most appropriate filters. The bluish cast that is otherwise evident in pictures taken in shade under a clear blue sky can be minimized by use of a skylight filter, which requires no increase in exposure. This filter is also useful for reducing bluishness in pictures taken on an overcast day and in distant scenes, mountain views, sunlit snow scenes, and aerial photographs.

EASTMAN KODAK

The Compact Photo-Lab-Index

ELECTRONIC FLASH GUIDE NUMBERS

This table is intended as a starting point in determining the correct guide number. The table is for use with equipment rated in beam candlepower-seconds (BCPS) or effective candlepower-seconds (ECPS). Divide the proper guide number by the flash-to-subject distance to determine the *f*-number for average subjects.

Output of Unit (BCPS or ECPS)		350	500	700	1000	1400	2000	2800	4000	5600	8000
Guide Number	Feet	20	24	30	35	40	50	60	70	85	100
For Trial*	Meters	6	7	9	11	12	15	18	21	26	30

*If your slides are consistently blue, use a No. 81B filter and increase exposure by ⅓ stop.

FLASH

For flash pictures with this film use *blue flashbulbs* without a filter. With zirconium-filled clear flashbulbs (AG-1 and M3) use a filter such as the *Kodak* Photoflash Filter No. 80D over the camera lens. With all other clear flashbulbs use a No. 80C Filter. Divide the proper guide numbers by the flash-to-subject distance in feet to determine the *f*-number for average subjects. Use ½ stop larger for dark subjects, ½ stop smaller for light subjects.

GUIDE NUMBERS* FOR FLASHBULBS
For Blue Flashbulbs (Or Flashbulbs with a No. 80C or No. 80D Filter)

Between-Lens Shutter Speed	Syn-chroni-zation	Flash-cube	AG-1B‡	M2B‡	M3B‡ 5B‡ 25B‡	Focal-Plane Shutter Speed	6B§ or 26B§
Open, 1/25—1/30	X or F	45	65	60	90	1/25—1/30	90
1/25—1/30	M	30	45	NR**	85	1/50—1/60	65
1/50—1/60	M	30	45	NR	80	1/100—1/125	42
1/100—1/125	M	26	38	NR	65	1/200—1/250	30
1/200—1/250	M	20	32	NR	55	1/400—1/500	22
1/400—1/500	M	16	24	NR	40	1/1000	15

*For use with bowl-shaped polished reflectors. If shallow cylindrical reflectors are used, divide these guide numbers by 2.
Bowl-shaped polished reflector sizes: †2-inch; ‡3-inch; §4- to 5-inch.
**NR = Not Recommended.

These values are intended only as guides for average emulsions. They must be changed to suit individual variations in synchronization, battery, reflector, and bulb position in the reflector.

Caution: Since bulbs may shatter when flashed, the use of a flashguard over the reflector is recommended. *Do not flash bulbs in an explosive atmosphere.*

PROCESSING

Your dealer can arrange to have this film processed by *Kodak* Process K-14 or any other laboratory offering this service. Some laboratories, including *Kodak*, also provide direct mail whereby you can mail exposed film to the laboratory and have it returned directly to you. See your dealer for the special mailing devices required. *Do not mail film without an overwrap or special mailing device intended for this purpose.*

EASTMAN KODAK

KODAK 25 Film (Daylight)

FILM SIZES AVAILABLE
KM135-20, KM135-36.

**CHARACTERISTIC
CURVES**

EASTMAN KODAK

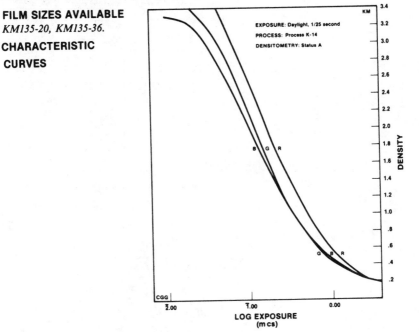

EXPOSURE: Daylight, 1/25 second
PROCESS: Process K-14
DENSITOMETRY: Status A

DENSITY

LOG EXPOSURE
(m cs)

SPECTRAL SENSITIVITY CURVES

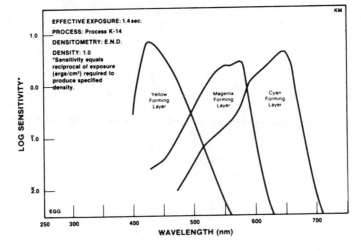

EFFECTIVE EXPOSURE: 1.4 sec.
PROCESS: Process K-14
DENSITOMETRY: E.N.D.
DENSITY: 1.0
*Sensitivity equals reciprocal of exposure (ergs/cm²) required to produce specified density.

Yellow Forming Layer

Magenta Forming Layer

Cyan Forming Layer

LOG SENSITIVITY*

WAVELENGTH (nm)

167

MODULATION TRANSFER CURVE

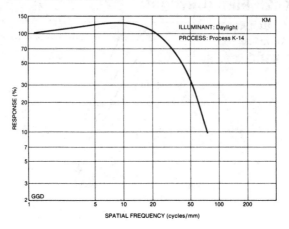

SPECTRAL DYE DENSITY CURVES

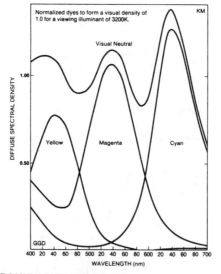

DIFFUSE RMS GRANULARITY VALUE: 9

(Read at a gross diffuse density of 1.0, using a 48-micrometer aperture, 12X magnification.)

RESOLVING POWER VALUES:

Test-Object Contrast 1.6:1 50 lines per mm
Test-Object Contrast 1000:1 100 lines per mm

KODACHROME 64 FILM (DAYLIGHT)

A color reversal roll film designed for exposure by daylight, electronic flash, or blue flashbulbs. With a suitable filter, it can also be exposed by photolamp (3400 K) illumination. Processed by reversal, it yields color transparencies for projection or color printing.

SPEED

The number given after each light source is based on an ANSI Standard and is for use with meters and cameras marked for ASA speeds.

Light Source	ISO	DIN	Speed	With Filter Such as:
Daylight	64/19°	19	**ASA 64**	None
Photolamp (3400 K)	20/14°	14	**ASA 20**	*Kodak* Photoflood Filter No. 80B
Tungsten (3200 K)	16/13°	13	**ASA 16**	*Kodak* 3200 K No. 80A

Note: Exposure times longer than 1/10 second may require an increase in exposure to compensate for the reciprocity characteristics of this film.

DAYLIGHT EXPOSURE TABLE

Lens openings with shutter at 1/125 second. *For the hours from 2 hours after sunrise to 2 hours before sunset.*

Bright or Hazy Sun on Light Sand or Snow	Bright or Hazy Sun (Distinct Shadows)*	Weak, Hazy Sun (Soft Shadows)	Cloudy Bright (No Shadows)	Heavy Overcast	Open Shade†
f/16	*f*/11†	*f*/8	*f*/5.6	*f*/4	*f*/4

*Subject shaded from sun but lighted by a large area of clear, unobstructed sky.
†*f*/5.6 for backlighted close-up subjects.

FILL-IN FLASH

Blue flashbulbs help to lighten the harsh shadows usually found in making close-ups in bright sunlight. A typical exposure is *f*/22 at 1/25 or 1/30 second, with the subject 8 to 10 feet away.

ELECTRONIC FLASH

This table is intended as a starting point in determining the correct guide number. The table is for use with equipment rated in beam candlepower-seconds (BCPS) or effective candle-power-seconds (ECPS). Divide the proper guide number by the flash-to-subject distance to determine the *f*-number for average subjects.

Output of Unit (BCPS or ECPS)		350	500	700	1000	1400	2000	2800	4000	5600	8000
Guide Number	Feet	32	40	45	55	65	80	95	110	130	160
For Trial*	Meters	10	12	14	17	20	24	29	33	40	50

*If your slides are consistently blue, use a No. 81B filter and increase exposure by ⅓ stop.

EASTMAN KODAK

The Compact Photo-Lab-Index

EASTMAN KODAK

FLASH

For flash pictures with this film use *blue flashbulbs* without a filter. With zirconium-filled clear flashbulbs (AG-1 and M3) use a filter such as the *Kodak* Photoflash Filter No. 80D over the camera lens. With all other clear flashbulbs use a No. 80C Filter. Divide the proper guide numbers by the flash-to-subject distance in feet to determine the *f*-number for average subjects. Use ½ stop larger for dark subjects, ½ stop for light subjects.

GUIDE NUMBERS* FOR FLASHBULBS
For Blue Flashbulbs (Or Clear Flashbulbs with a No. 80C or No. 80D Filter)

Between-Lens Shutter Speed	Syn-chroni-zation	Flash-cube	AG-1B‡	M2B‡	M3B‡ 5B‡ 25B‡	Focal-Plane Shutter Speed	6B§ or 26B§
Open, 1/25—1/30	X or F	70	100	100	150	1/25—1/30	140
1/25—1/30	M	50	75	NR**	130	1/50—1/60	100
1/50—1/60	M	50	70	NR	130	1/100—1/125	70
1/100—1/125	M	40	60	NR	110	1/200—1/250	50
1/200—1/250	M	30	50	NR	85	1/400—1/500	34
1/400—1/500	M	26	40	NR	65	1/1000	24

*For use with bowl-shaped polished reflectors. If shallow cylindrical reflectors are used, divide these guide numbers by 2.
Bowl-shaped polished reflector sizes: †2-inch; ‡3-inch; §4- to 5-inch.
**NR = Not Recommended.

These values are intended only as guides for average emulsions. They must be changed to suit individual variations in synchronization, battery, reflector, and bulb position in the reflector.

Caution: Since bulbs may shatter when flashed, the use of a flashguard over the reflector is recommended. *Do not flash bulbs in an explosive atmosphere.*

PROCESSING

Your dealer can arrange to have this film processed by *Kodak* Process K-14 or any other laboratory offering this service. Some laboratories, including *Kodak*, also provide direct mail whereby you can mail exposed film to the laboratory and have it returned directly to you. See your dealer for the special mailing devices required. *Do not mail film without an overwrap or special mailing device intended for this purpose.*

FILM SIZES AVAILABLE

KR135-20, and KR135-36.

DIFFUSE RMS GRANULARITY VALUE: 10

(Read at a gross diffuse density of 1.0, using a 48-micrometer aperture, 12X magnification.)

RESOLVING POWER VALUES:

Test-Object Contrast 1.6:1 50 lines per mm
Test-Object Contrast 1000:1 100 lines per mm

KODAK 64 Film (Daylight)

CHARACTERISTIC CURVES

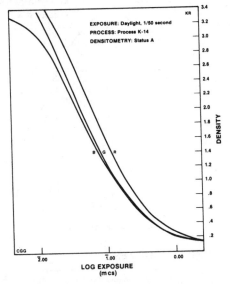

EXPOSURE: Daylight, 1/50 second
PROCESS: Process K-14
DENSITOMETRY: Status A

SPECTRAL SENSITIVITY CURVES

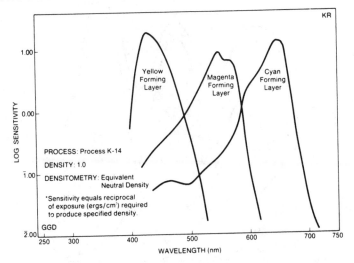

Yellow Forming Layer

Magenta Forming Layer

Cyan Forming Layer

PROCESS: Process K-14

DENSITY: 1.0

DENSITOMETRY: Equivalent Neutral Density

*Sensitivity equals reciprocal of exposure (ergs/cm²) required to produce specified density.

EASTMAN KODAK

MODULATION TRANSFER CURVE

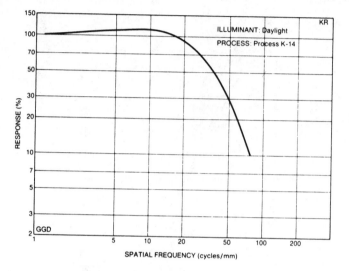

SPECTRAL DYE DENSITY CURVES

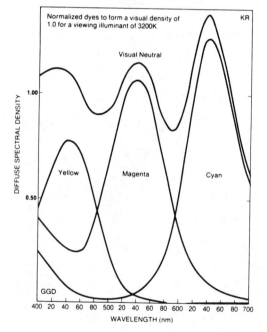

KODACHROME 40 FILM 5070 (TYPE A)

A color reversal roll film designed for exposure with photolamps (3400 K). Processed by reversal, it yields positive transparencies for projection or color printing.

SPEED

Light Source	ISO	DIN	Speed	With Filter Such as:
Photolamp (3400 K)	40/17°	17	ASA 40	None.
Tungsten (3200 K)	32/16°	16	ASA 32	*Kodak* No. 82A
Daylight	25/15°	15	ASA 25	*Kodak* No. 85B. With this filter the exposure for average subjects in bright sunlight is 1/125 second

The number given after each light source is for use with meters and cameras marked for ASA speeds. These settings apply to incident-light meter readings taken from the subject position and to reflected-light readings taken from a gray card of 18% reflectance* held close to the subject facing halfway between the camera and the main light. They also apply when a reflected-light reading of the scene is taken from the camera position provided both subject and background have approximately the same brightness. The speed should be divided by 2 if the reading is taken from the palm of the hand or the subject's face, or divided by 5 if the reading is taken from a white card of 90% reflectance. The *Kodak* Neutral Test Card, which has a gray side of 18% reflectance and a white side of 90% reflectance, is recommended for this purpose. Set the meter calculator arrow as for a normal subject.

When a card or the palm of the hand is used, or when incident-light readings are made, allow ½ stop more exposure for dark subjects, ½ stop less exposures for light subjects.

LONG EXPOSURES

When exposure times longer than 1/25 second are used, it is necessary to compensate for the reciprocity characteristics of this film by increasing the exposure and using CC filters such as the *Kodak* Color Compensating (CC) Filters suggested in the table on page DS-36.

Exposure times shorter than 1/10,000 second or longer than 100 seconds are not recommended for this film. The information in the table applies only when the film is exposed by photolamp (3400 K) illumination for which it is balanced. When other light sources are used, additional adjustments in exposure and filtration may be required (e.g., 3200 K lamps require a filter such as the *Kodak* Light Balancing Filter No. 82A).

COPYING AND CLOSE-UP WORK

In copying, the use of a gray card as described above is recommended for determining exposures. If the camera lens is extended for focusing on a subject closer than 8 times the focal length of the lens, allow for the decrease in effective lens opening. The *Kodak Professional Photoguide*, No. R-28, furnishes an easy means of determining the effective lens opening.

PHOTOLAMP (3400 K) EXPOSURE TABLE

For two new 500-watt, reflector-type photolamps (3400 K) at the same distance from the subject: fill-in light close to camera at camera height; main light on other side of camera at 45 degrees to camera-subject axis and 2 to 4 feet higher than fill-in light.

Lamp-to-Subject Distance	4½ ft	6 ft	9 ft
Lens Opening at 1/50 or 1/60 Second	*f*/4	*f*/2.8	*f*/2

Note: *This table is for new lamps only.* After burning lamps 1 hours, use ½ stop larger, after 2 hours, 1 full stop larger.

EASTMAN KODAK

The Compact Photo-Lab-Index

FLASH GUIDE NUMBERS

Divide the proper guide number by the flash-to subject distance in feet to determine the *f*-number for average subjects.

GUIDE NUMBERS* FOR BLUE FLASHBULBS AND A NO. 85 FILTER

Between-Lens Shutter Speed	Syn-chroni-zation	Flash-cube	AG-1B‡	M2B‡	M3B‡ 5B‡ 25B‡	Focal-Plane Shutter Speed	6B§ or 26B§
Open, 1/25—1/30	X or F	45	65	60	90	1/25—1/30	90
1/25—1/30	M	30	45	NR**	85	1/50—1/60	65
1/50—1/60	M	30	45	NR	80	1/100—1/125	42
1/100—1/125	M	26	38	NR	65	1/200—1/250	30
1/200—1/250	M	20	32	NR	55	1/400—1/500	22
1/400—1/500	M	16	24	NR	40	1/1000	15

*For use with bowl-shaped polished reflectors. If shallow cylindrical reflectors are used, divide these guide numbers by 2.
Bowl-shaped polished reflector sizes: †2-inch; ‡3-inch; §4- to 5-inch.
**NR = Not Recommended.

These values are intended only as guides for average emulsions. They must be changed to suit individual variations in synchronization, battery, reflector, and bulb position in the reflector.

Caution: Since bulbs may shatter when flashed, the use of a flashguard over the reflector is recommended. *Do not flash bulbs in an explosive atmosphere.*

ELECTRONIC FLASH GUIDE NUMBERS

This table is a starting point in determining the correct guide number. It is based on the use of the *Kodak* Filter No. 85. The table is for use with equipment rated in beam candlepower-seconds (BCPS) or effective candlepower-seconds (ECPS). Divide the proper guide number by the flash-to-subject distance in feet to determine the *f*-number for average subjects.

Output of Unit (BCPS or ECPS)		350	500	700	1000	1400	2000	2800	4000	5600	8000
Guide Number	Feet	20	24	30	35	40	50	60	70	85	100
For Trial*	Meters	6	7	9	11	12	15	18	21	26	30

*If your slides are consistently blue, use a No. 81B filter and increase exposure by ⅓ stop.

PROCESSING

Your dealer can arrange to have this film processed by *Kodak* or any other laboratory offering such service. Some laboratories, including *Kodak,* also provide direct mail service whereby you can mail exposed film to the laboratory and have it returned directly to you. See your dealer for the special mailing devices required. *Do not mail film without an overwrap or special mailing device intended for this purpose.*

FILM SIZES AVAILABLE

KPA135-36.

KODACHROME 40 Film 5070 (Type A)

CHARACTERISTIC CURVES

(not available)

SPECTRAL SENSITIVITY CURVES

(Similar to *Kodachrome* 25 Film)

MODULATION TRANSFER CURVE

(Similar to *Kodachrome* 25 Film)

SPECTRAL DYE DENSITY CURVES

(Same as *Kodachrome* 25 Film)

DIFFUSE RMS GRANULARITY VALUE: 9
(Read at a gross diffuse density of 1.0, using a 48-micrometer aperture, 12X magnification.)

RESOLVING POWER VALUES:
Test-Object Contrast 1.6:1 50 lines per mm
Test-Object Contrast 1000:1 100 lines per mm

KODAK EKTACHROME 64 FILM (DAYLIGHT)

KODAK EKTACHROME 200 FILM (DAYLIGHT)

KODAK EKTACHROME 160 FILM (DAYLIGHT)

These color reversal roll films are for general use and do not require refrigerated storage conditions prior to use. The changes in speed, color balance, and contrast that occur in film during normal room temperature storage, before and after exposure, are anticipated and the films are manufactured to compensate for average changes.

All the exposure and processing data (Process E-6 chemicals) stated on the previous pages for *Ektachrome* Professional Films of similar speed apply for these general-purpose films.

EASTMAN KODAK

MECHANICAL SPECIFICATIONS FOR PROCESS VNF-1

For purposes of the chart below, the films: *Eastman Ektachrome* Video News Film 5239 and 7239 (Daylight), *Eastman Ektachrome* Video News Film 5240 and 7240 (Tungsten), *Eastman Ektachrome* Video News Film High Speed 5250 and 7250 (Tungsten), and *Eastman Ektachrome* VN Print Film 5399 and 7399 are referred to as 39, 40, 50, and 99 respectively.

| | Temperature | | | | Replenishment Rate per 30.5 m (100 ft) of 16-mm | |
Process Steps	°C	°F	Film	Time (sec)	Film	Leader
First Developer	37.8 ± 0.3	100 ± 0.5	99	126	975 ml	0 ml
			39, 40, 50	190	1700 ml	0 ml
First Stop	35 ± 3	95 ± 5	All	30	1100 ml	300 ml
Wash	38 ± 1	100 ± 2	All	60	8.0 L	8.0 L
Color Developer	43.3 ± 0.6	110 ± 1	All	215	800 ml	150 ml
Second Stop	35 ± 3	95 ± 5	All	30	650 ml	200 ml
Wash	38 ± 1	100 ± 2	All	60	8.0 L	8.0 L
Bleach	35 ± 3	95 ± 5	All	90	150 ml	150 ml
Fixer	35 ± 3	95 ± 5	All	90	625 ml	150 ml
Wash	38 ± 1	100 ± 2	All	60	8.0 L	8.0 L
Stabilizer	35 ± 3	95 ± 5	All	30	300 ml	150 ml

For force processing increase the first developer temperature **or** the first developer time according to the table below.

| | Temperature Increase | | | |
Stops	°C	°F	OR	Time Increase (sec)
1	3.6	6.5		70
2	7.2	13.0		160

Kodak, Eastman, and *Ektachrome* are trademarks of the Eastman Kodak Company

KODAK FILTERS FOR KODAK COLOR FILMS

See film instructions for current recommendations and corresponding speed values.

	Kodak Film			
	Daylight	**Type A**	**Tungsten**	**Type L**
Light Source	**(Kodachrome, Ektachrome, Kodacolor, and Vericolor II Pro-fessional, Type S)**	**(Kodachrome 40, 5070, Type A)**	**(Ektachrome)**	**(Vericolor II Professional, Type L)**
Daylight	None*	No. 85	No. 85B	No. 85B
Electronic Flash	None†	No. 85	Not recom-mended‡	Not recom-mended
Blue Flashbulbs	None	No. 85	Not recom-mended‡	Not recom-mended
Clear Flashbulbs	No. 80C or 80D§	No. 81C	No. 81C	Not recom-mended
Photolamps (3400 K)	No. 80B	None	No. 81A	No. 81A
Tungsten (3200 K) Lamps	No. 80A	No. 82A	None	None

*With reversal color films, a Kodak Skylight Filter No. 1A can be used to reduce excessive bluishness of pictures made in open shade or on overcast days, or pictures of distant scenes, such as mountain and aerial views.

†If results are consistently bluish, use a CC05Y or CC10Y Filter with Kodak Ektachrome and Ektachrome Professional Films (Process E-6); use a No. 81B Filter with Kodachrome or Kodacolor Films. Increase exposure ⅓ stop when a CC10Y or 81B filter is used.

‡Kodak Ektachrome 160 or Ektachrome 160 Professional Films (Tungsten) can be exposed with a No. 85B Filter.

§Use No. 80D Filter with zirconium-filled flashbulbs, such as AG-1 and M3.

EASTMAN KODAK

STARTING FILTERS AND EXPOSURE INCREASES* FOR TEST SERIES WITH FLUORESCENT ILLUMINATION

Kodak Film Type	Type of Fluorescent Lamp†					
	Daylight	White	Warm White	Warm White Deluxe	Cool White	Cool White Deluxe
Daylight Type and Type S	40M+ 30Y + 1 stop	20C+ +30M +1 stop	40C+ 40M +1⅓ stops	60C+ 30M +1⅔ stops	30M +⅔ stop	30C+ 20M +1 stop
Type B or Tungsten and Type L	85B‡+ 30M +10Y +1⅔ stops	40M+ 40Y +1 stop	30M+ 20Y +1 stop	10Y +⅓ stop	50M+ 60Y +1⅓ stops	10M+ 30Y +⅔ stop
Type A	85§+ 30M +10Y +1⅔ stops	40M+ 30Y +1 stop	30M+ 10Y +1 stop	No Filter None	50M+ 50Y +1⅓ stops	10M+ 20Y +⅔ stop

*Increase a meter-calculated exposure by the amount indicated in the table to compensate for light absorbed by the filters recommended. If this makes the exposure time longer than that for which the film is designed, refer to reciprocity data elsewhere in this section for further filter and exposure-time adjustments that must be added to these lamp-quality corrections.

†When it is difficult or impossible to gain access to fluorescent lamps in order to identify the type, ask the maintenance department.

‡Kodak Wratten Filter No. 85B. §Kodak Wratten Filter No. 84.

RECIPROCITY DATA: KODAK COLOR FILMS

Illumination (intensity of light) multiplied by exposure time equals exposure. You may have seen this relationship expressed as I x t = E. Given this formula, it would appear that when the product of the two is held constant, the photographic effect will always be the same. Actually, the sensitivity of a photographic emulsion may change with changes in the illumination level and the exposure time.

When the lighting is very weak, and a film requires long exposures, the effective speed of an emulsion decreases. For black-and-white films, the loss of effective speed is relatively unimportant because of wide exposure latitude. With multilayer color films, on the other hand, it is often necessary to give more than the calculated exposure when the light intensity is low and the exposure time is long. Furthermore, since sensitivity changes may be different for each of the three emulsion layers, with consequent changes in color balance, it may be necessary to use color compensating filters.

EXPOSURE* AND FILTER COMPENSATION FOR THE RECIPROCITY CHARACTERISTICS OF KODAK COLOR FILMS

Exposure Time (Seconds)

Kodak Films	1/10,000	1/1000	1/100	1/10	1	10	100
Kodacolor II		None No Filter			+½ Stop No Filter	+1½ Stops CC10C	+2½ Stops CC10C+10G
Kodacolor 400		None No Filter			+½ Stop No Filter	+1 Stop No Filter	+2 Stops No Filter
Vericolor II Professional, Type S		None No Filter				Not Recommended	
Vericolor II Professional, Type L		Not Recommended			See film instructions for speed values at 1/50 through 60 seconds' exposure times		
Ektachrome 64 Professional (Daylight) and Ektachrome 64 (Daylight)	+½ Stop No Filter		None No Filter		+1 Stop CC15B	+1½ Stops CC20B	Not Recommended
Ektachrome 50 Professional (Tungsten) Roll Film†	—	+½ Stop CC10G		None No Filter	+1 Stop CC20B		Not Recommended

EASTMAN KODAK

EASTMAN KODAK

EXPOSURE* AND FILTER COMPENSATION FOR
THE RECIPROCITY CHARACTERISTICS OF KODAK COLOR FILMS

Kodak Films	Exposure Time (Seconds)						
	1/10,000	1/1000	1/100	1/10	1	10	100
Ektachrome 200 Professional (Daylight) and Ektachrome 200 (Daylight)	+½ Stop No Filter		None No Filter		+½ Stop CC10R	Not Recommended	
Ektachrome 160 Professional (Tungsten) and Ektachrome 160 (Tungsten)	—		None No Filter		+½ Stop CC10R	+1 Stop CC15R	Not Recommended
Ektachrome Infrared	—	None No Filter		+1 Stop CC20B	Not Recommended		
Kodachrome 40, 5070 (Type A)		None No Filter			+1 Stop CC10M	+1½ Stops CC10M	+2½ Stops CC10M
Kodachrome 25 (Daylight)			None No Filter		+1 Stop CC10M	+1½ Stops CC10M	+2½ Stops CC10M
Kodachrome 64 (Daylight)			None No Filter		+1 Stop CC10R	Not Recommended	

*The exposure increase, in lens stops, includes the adjustment required by any filter(s) suggested. They apply only to the type of illumination for which that film is balanced, and are rounded to the nearest ½ stop.
†For 6118 sheet film, see supplementary data on the instruction sheet packaged with the film.

Notes: The data for each film are based on average emulsions and assume normal recommended processing. The data should be used as guides only. The adjustments are subject to change due to normal manufacturing variations or subsequent film storage conditions after the film leaves the factory.

The Compact Photo-Lab-Index

KODAK AD-TYPE
A contact printing paper on a thin base which can be folded without cracking. It has a white tint, and neutral black image tone.

KODAK AZO
A general contact printing paper with neutral black image tone. For general photo-finishing and commercial work.

KODAK EKTALURE
A warm tone high speed portrait enlarging paper which can be toned. Particularly suited to portraiture and salon work.

KODAK EKTAMATIC SC
High speed selective contrast stabilization paper with warm black or neutral black image tone.

KODAK KODABROME II RC
Fast enlarging paper with warm black image on a resin coated base.

KODAK KODABROMIDE
High speed projection paper with neutral black image tone.

KODAK MEDALIST Enlarging paper of moderate speed and warm black tone.

KODAK MURAL
Enlarging paper with rough tweed surface and warm black image tone.

KODAK PANALURE
Panchromatic warm black emulsion paper for black and white prints from color negatives.

KODAK PANALURE II RC
Similar to Panalure but coated on resin coated base.

KODAK PANALURE PORTRAIT
Moderate speed enlarging paper with brown-black image tone for black and white prints from color negatives.

KODAK POLYCONTRAST
Selective contrast general purpose enlarging speed paper with warm brown-black image tone.

KODAK POLYCONTRAST RAPID
Selective contrast general purpose high speed enlarging paper with warm black tone, but colder than Polycontrast paper.

KODAK POLYCONTRAST RAPID II RC
Selective contrast paper on resin coated base with warm black image tone between Polycontrast, and Polycontrast Rapid Papers.

KODAK PORTRAIT PROOF
Developing out paper for projection printing with brown-black image tone.

KODAK RESISTO A contact printing paper with water resistant base.

KODAK RESISTO RAPID PAN
Panchromatic emulsion enlarging paper on water resistant stock.

KODAK STUDIO PROOF
A printing out paper suitable for portrait proofs. The reddish brown image is sensitive to light and will darken with continued exposure. It is for temporary use.

KODAK DIRECT POSITIVE PAPER
An orthochromatic paper which can be used in the camera. Is processed by reversal.

KODAK VELOX
A contact printing paper with a blue-black image used for general photofinishing.

KODAK VELOX PREMIER RC
A high speed paper on water resistant base. Blue-black image tone.

KODAK VELOX UNICONTRAST
A long scale orthochromatic enlarging speed paper with blue-black image tone.

KODAK COLOR PAPERS
KODAK EKTACOLOR 74 RC PAPER
Negative to positive color print paper on medium weight water resistant base.

KODAK EKTACOLOR 37 RC PAPER
Negative to positive color print paper on resin coated medium weight water resistant base.

KODAK EKTACHROME RC 1993
Reversal color print material on water resistant resin coated paper base.

SURFACES AND CONTRAST GRADES OF KODAK PHOTOGRAPHIC PAPERS
KODAK BLACK & WHITE MATERIAL

TEXTURE	Smooth	Smooth	Smooth	Smooth
BRILLIANCE	Glossy	Lustre	High Lustre	Matte
Ad-Type		A WH, LW 1-4		
Azo	F WH, SW 0-5 DW 1-3	N WH, DW 1-4		
Dye Transfer	F WH, DW			
Ektalure				
Ektamatic SC	F WH SW, DW	N WH, SW A WH, LW		
Kodabrome II RC	F WH, MW S-UH*	N WH, MW S-UH*		
Kodabromide	F WH, SW 1-5 DW 1-5	N WH, SW 2-4 DW 2-4 A WH, LW 2-5		
Medalist	F WH, SW 1-4 DW 2,3		J WH, DW 2,3	
Mural‡				
Panalure	F WH, SW			
Panalure II RC	F WH, MW			
Panalure Portrait				
Polycontrast	F WH SW, DW	N WH, SW, DW A WH, LW	J WH, SW, DW	

Dye Transfers (See B&W Listings on previous page)
WH—White paper stock; CR—Cream-white paper stock; WM-WH—Warm-white paper stock.
*Available in soft, medium, hard, extra-hard and ultra-hard grades.
†Available in rolls 54 inches wide.

EASTMAN KODAK

SURFACES AND CONTRAST GRADES
OF KODAK PHOTOGRAPHIC PAPERS (continued)
KODAK BLACK & WHITE MATERIAL (Continued)

Fine Grained Lustre	Fine Grained High Lustre	Tweed Lustre	Silk High Lustre	Tapestry Lustre
E WH, SW 1-4 DW 2,3				
G CR, DW				
E WM-WH, DW **G** CR, DW	**K** WM-WH, DW	**R** CR, DW	**Y** WM-WH, DW	**X** CR, DW
E WH, SW 2-4 DW 2-4 **G** CR, DW 2-4				
E WH, DW 2,3 **G** CR, DW 2-4			**Y** CR, DW 2,3	
		R, WRM CR, SW 2,3		
E WH, DW				
G CR, DW 2-4				

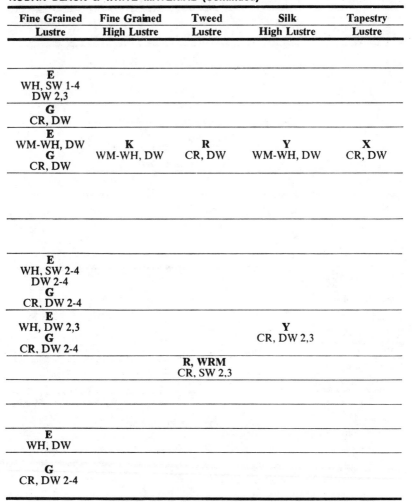

EASTMAN KODAK

SURFACES AND CONTRAST GRADES
OF KODAK PHOTOGRAPHIC PAPERS (continued)
KODAK BLACK AND WHITE MATERIAL

TEXTURE	Smooth	Smooth	Smooth	Smooth
BRILLIANCE	**Glossy**	**Lustre**	**High Lustre**	**Matte**
Polycontrast Rapid	**F** WH, SW, DW	**N** WH, SW		
Polycontrast Rapid II RC	**F** WH, MW	**N** WH, MW		
Portrait Proof				
Resisto		**N** WH, SW 2,3		
Resisto Rapid Pan		**N** WH, SW, 2, 3		
Studio Proof	**F** WH, SW			
Velox	**F** WH, SW 1-4			
Velox Premier RC	**F** WH, MW			
Velox Unicontrast	**F** WH, SW			
Kodak Color Material				
Ektacolor 74 RC	**F**	**N**		
Ektacolor 74 Duratrans/4023	**F**			
Ektachrome RC 1993	**F**			
Ektachrome 2203				
Dye Transfer (See B&W listings on previous page)				

WH—White paper stock; CR—Cream-white paper stock; WM-WH—Warm-white paper stock.
*Available in soft, medium, hard, extra-hard and ultra-hard grades.
†Available in rolls 54 inches wide.

SURFACES AND CONTRAST GRADES
OF KODAK PHOTOGRAPHIC PAPERS (continued)
KODAK BLACK AND WHITE MATERIAL (Continued)

Fine Grained Lustre	Fine Grained High Lustre	Tweed Lustre	Silk High Lustre	Tapestry Lustre
G CR, DW			**Y** CR, DW	
G WM-WH, DW		**R** CR, DW	**Y** WM-WH, DW	
		R CR, SW		
E WH, MW			**Y-WH** MW	
			Y WH, MW	

Kodak Color Material (Continued)

E Lustre-Luxe™			**Y**	
			Y	
			Y	

EASTMAN KODAK

EASTMAN KODAK

KODAK **PAPERS**

Choice of Surface and Color

Photographic papers come in a wide variety of tone ranges and surfaces. This permits the user to exercise his personal taste in choosing the paper best suited to the subject matter and the particular use of the print.

SURFACE

Glossy paper should be used for prints intended for reproduction, or for prints in which extremely fine detail is important. Glossy paper reproduces a wide brightness range. It has a long density scale. It should be ferrotyped for best results.

High Lustre surfaces give the maximum reflection scale possible without ferrotyping. It falls between the glossy and lustre surfaces in scale.

Lustre surfaces have a shorter density scale than glossy papers, and are suited for exhibition and general use.

Matte surfaces have the shortest density scale and flatten the over-all contrast of the print.

TINT

Some Kodak papers are supplied with a white stock, while others are available with warm-white, or cream-white tinted stock.

White should usually be used for cold-tone subjects, reproduction and commercial work, for high key subjects, snow scenes, seascapes, and for prints to be toned blue.

Cream-White is a warm base tint good for sunlighted and artificially lighted scenes.

Warm-white tint is intermediate between white and cream-white.

SPECIAL SURFACES

Silk paper has a fine clothlike texture and high lustre. It is useful for brilliant pictorial subjects, candid-wedding and school photography.

Tweed paper has a very rough lustre surface, and should be used where detail is to be reduced. Available on a cream-white stock, it is most effectively used in large sized prints.

Tapestry paper has a very rough lustre surface which is suited to large prints and massive subjects where subordination of detail is desirable.

THICKNESS

Kodak papers are designated as lightweight, Single Weight, Middleweight or Double Weight. Generally, Single Weight papers lend themselves to use as smaller prints, while Double Weight is preferable for larger prints. Some papers are supplied in light weight or medium weight for special purposes. Papers identified by the letter A are made to allow folding without cracking. Papers with the Resisto name or with an RC after the paper name have resin-coated bases, which allows for more rapid processing, washing and drying.

PHOTOGRAPHIC PROPERTIES

EMULSIONS

Photographic paper emulsions are usually made of light-sensitive silver salts suspended in gelatin. The speed of the paper is modified by the chemical composition of the silver salts and additives. Printing grade and image tone are likewise determined by the chemical structure of the emulsion. Silver chloride is often used in slower (contact) papers, while silver bromide is usually predominant in the faster projection papers. Sensitizing dyes are used to match sensitivity of the emulsion to different spectral response, and to modify the speed balance among various grades of paper.

CONTRAST

Like color, which must be described in terms of hue, brightness, and saturation, contrast is also a word which has a compound meaning. The two independent attributes which determine contrast are **gradient** and **extent.** Technically speaking, the gradient is the rate at which the density increases with exposure. The extent is the total range of densities available in the print from light to dark.

*Reflection density is $\dfrac{1}{\log \text{reflectance}}$ of

area concerned, where the illumination

is at 45° to the surface, and the sample is viewed at 90° to the surface.

Since contrast is concerned with subjective impressions, an unexposed sheet of photographic paper does not have contrast. However, it does possess a certain **contrast capacity** which is related to gradient and extent. Actually it is the combined effect of both factors, or technically speaking, the product of those two factors. It should be kept in mind also, that prints do not always utilize the full capacity of the paper contrast. Let's take a closer look at some of the factors which influence these characteristics:

Gradient. For prints made on No. 1 and No. 2 printing grades of the same paper, the available maximum density is the same. If the same negative is used for each, the print on the No. 2 printing grade appears more contrasty. In fact, it is too contrasty if the negative is best suited to the No. 1 printing grade. The reason is that the rate at which density increases with exposure is more rapid for No. 2 printing grade than for No. 1 printing grade. Therefore, No. 2 Printing grade reaches its maximum density sooner, speaking exposure-wise.*

The total interval in exposure is shorter for No. 2 printing grade, that is, its exposure scale is shorter. In the case we have chosen, it is too short to accommodate all the tones represented in the negative. The factor in a paper that makes it fit a negative is this exposure scale. It relates to the density scale of the negative, in a manner described later. Printing grades differ, then, in exposure scale. No. 4 and 5 printing grades have a very short exposure scale; 0 and 1, a long scale. No. 2 and 3 have exposure scales that are in the normal range, in that they fit most good negatives.

Exposure scale should not be confused with the speed of the paper or the exposure required to make a print. It is an expression of the **range** of light intensities required to produce a print having the full range of useful tones from white to black.

Kodak Azo, Velox, Kodabromide, and other papers are supplied in several printing grades to fit negatives which differ in density scale. Such differences may be due to variations in subject, lighting, exposure or development. Some papers such as Opal and Kodak Portrait Proof, are intended for use with negatives of uniform quality made under carefully controlled conditions of lighting, exposure, and development, and for this reason are supplied in only one printing grade.

Extent or Density Scale. The degree of gloss of the paper has a great effect on its maximum density. Consider two good prints made from the same negatives—one on No. 2 printing grade matte paper and the other on No. 2 printing grade glossy paper. The print on the glossy paper has the higher maximum density, and its shadow tones are somewhat darker than corresponding areas on the matte-surface print. Both papers fit the negative, and therefore both papers are rated as grade No. 2. However, the **glossy print has more contrast.**

*The type of enlarger also affects the image contrast. Prints made with condenser enlargers have more contrast than prints made in diffusion enlargers.

It is possible for prints made on two different types of paper, both having the same grade number and maximum density, to appear different. This is caused by "local" differences in gradient; in other words, their characteristic curves may differ in shape.

VARIATIONS IN HANDLING, AND THEIR EFFECT UPON CONTRAST AND DENSITY

The contrast of photographic papers is, for most practical purposes, inherent in the emulsion and the paper surface; hence it can be controlled only within narrow limits by variations in development time or developer composition.

SENSITOMETRIC CURVES

As photographic paper is exposed to increasing amounts of light, it produces more and more density. This can be shown as a curve by plotting the reflection density of the developed image against the logarithm of the exposure. Such a curve is called a "D-log E curve" or a "sensitometric curve." Logarithmic values are used because the human eye tends to respond logarithmically rather than arithmetically to different intensities of light.

(Courtesy of Eastman Kodak Co.)

EASTMAN KODAK

The Compact Photo-Lab-Index

The graph below shows a typical D-log E curves for the six different grades of a family of Kodak papers, all having a glossy surface. The maximum density tends to be the same for the different grades if the surface is the same, but the rate at which density increases with exposure is seen to be least of the grade 0 paper and greatest for the grade 5 paper.

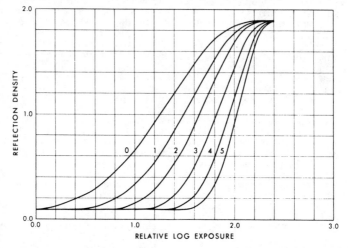

Papers having semimatte or matte surfaces usually give sensitometric curves which are similar to those shown for the glossy papers, except that the maximum densities of the semimatte and matte papers are lower. If the curves for a grade 2 matte paper, all of the same emulsion type, are compared, they usually will be found to be similar to those shown in the next illustration.

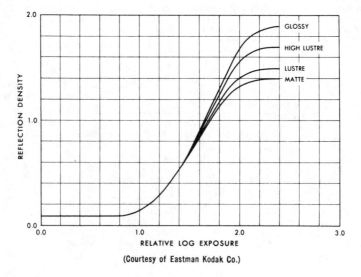

(Courtesy of Eastman Kodak Co.)

The Compact Photo-Lab-Index

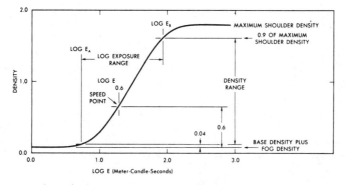

The curve above indicates the location of the speed point, showing how density range and log-exposure are derived.

EXPOSURE SCALE AND SCALE INDEX

The various printing grades of a paper need different ranges of exposures to produce the full scale of tones from white to black. The term "exposure scale" is used for the ratio between the exposure needed to give the faintest useful highlight tone and that required for a full black tone. Thus, a paper with an exposure scale of 1 to 20 will just reproduce all the tones in a negative in which the thinnest part of the image passes 20 times as much light as the densest part. Logarithmic units are usually used for expressing exposure scale because they relate directly to the density difference (density scale) between the highest and lowest densities in the negative. An arithmetic exposure scale of 1 to 20 corresponds to a log exposure scale of 1.30.

A method of determining log exposure scale values for the sensitometric curves of the papers is defined in ANSI Standard for Sensitometry and Grading of Photographic Papers, PH2.2*

Since the term "log exposure scale" is inconveniently long for general use, the American Standard recommends that the name "scale index" be applied to values of log exposure scale that have been rounded off for easy application in practical use. The values are rounded off to the closest figure following the decimal point.

The scale index is useful in the practical problem of fitting the paper to the negative and also in the more general problem of specifying paper characteristics.

*A copy of this standard can be purchased from the Institute, 1430 Broadway, N.Y., N.Y. 10018, ANSI PH 2.2-1966 (R-1972), American National Standards Institute.

GRADE NUMBER AND SCALE INDEX

The grade numbers, 0, 1, 2, 3, 4, and 5, have for many years been used as an indication of the scale indexes and thus of the types of negative which can be printed successfully on each grade of paper. A negative having a very long density scale usually prints best on a grade 0 paper, which has a long scale index, while a negative having a very short density scale usually prints best on grade 5 paper, which has a short scale index. More recent papers have the grade numbers replaced with grade names: soft, medium, hard, extra hard and ultra hard.

EXPOSURE SCALE VALUES
And Scale Indexes for Kodak Papers

Grade numbers from 0 to 5 have for many years been used as an indication of the scale indexes of papers and thus of the types of negatives which can be printed successfully on each grade of paper. A negative having a very long density scale usually prints best on a Grade 0 paper, which has a long scale index, while a negative having a very

(Courtesy of Eastman Kodak Co.)

189

The Compact Photo-Lab-Index

short density scale usually prints best on Grade 5 paper having a very short Scale Index.

For most Kodak papers there is a fairly definite relation between grade number and scale index as indicated in the table below. Some papers do not follow these relations exactly but the approximation is close enough for practical purposes.

Tests made by printing a large number of negatives on various grades of paper, and having observers choose the most pleasing print from each negative, showed that the scale index of the paper should, on the average, be about 0.2 greater than the density scale of the negative. The table which follows shows this relation between the density scale of the negative and the scale index or grade number of the paper.

Paper Grade Number	Log-Exposure Range	Density Scale of Negative Usually Suited For Each Grade
0	1.40-1.70	1.40 or higher
1	1.15-1.40	1.2 to 1.4
2	0.95-1.15	1.0 to 1.2
3	0.80-0.95	.8 to 1.0
4	0.65-0.80	.6 to .8
5	0.50-0.65	less than .6

Kodak Polycontrast Filter Number	Log Exposure Range
4	.65- .70
3½	.70- .80
3	.80- .90
2½	.90-1.00
2 (or 0)	1.00-1.10
1½	1.10-1.20
1	1.20-1.45

Note: All the log exposure range figures approximately describe a suitable negative density scale when contact printing or using a diffusion enlarger. When using a condenser, the required negative density range values are lower. Multiply the log exposure range value by .76 to find a negative density range suitable for a condenser enlarger. This applies to range guide, number grade and Kodak Polycontrast filter usage.

Paper Grade Name	Log Exposure Range
Soft	1.15-1.40
Medium	0.90-1.15
Hard	0.65-0.90
Extra Hard	0.50-0.65
Ultra Hard	0.35-0.50

PAPER SPEED

Photographic papers differ widely in their sensitivity to light, and thus in the amount of exposure required in printing. A means of numerical rating of their sensitivities or speeds can be helpful to the photographer by indicating the relative exposures required. Suppose for example, that you have made a print on a grade 2 KODABROMIDE Paper, and want to make another print from the same negative on KODAK EKTALURE Paper. The speed numbers show that EKTALURE Paper is about one fourth as fast as KODA-BROMIDE Paper, so it will require an exposure about four times as long. This is perfectly straightforward so long as you are concerned only with papers having the same exposure scale, but

(Courtesy of Eastman Kodak Co.)

EASTMAN KODAK

The Compact Photo-Lab-Index

becomes a little more complicated when you must compare papers of different scale indexes.

ANSI Paper Speed. When one negative is printed on different grades of paper, the best prints usually are those which reproduce the middle-tones of the picture at about the same density. Because of the differences between the exposure scales of the papers, the relative exposures to make such prints are not directly related to the shadow speeds. Special numbers, called "printing indexes," are given for this situation. They are inversely proportional to the middletone exposures, according to the formula

$$\text{ANSI Paper Speed} = \frac{10{,}000}{E_m}$$

where E_m is the exposure expressed in meter-candle-seconds, required to produce the middletone density of 0.60 on the paper.

Printing indexes are helpful in finding the new exposure when printing a given negative on a different paper or on a different grade of the same paper. For example, suppose that you have made a print on KODABROMIDE Paper, grade 3, using a 20-second exposure. On examining the print in good light you decide that it is too contrasty and that a better print could be made on grade 2 KODABROMIDE Paper. The exposure time for the second print is easily calculated from the printing indexes for the two grades. The exposure times inversely proportional to the printing indexes. Thus the exposure for grade 2 will be equal to the exposure found for grade 3 multiplied by the printing index for grade 3 divided by the printing index for grade 2, as follows:

20 seconds x 2000 over 3200, or approximately 12 seconds.

DEVELOPMENT LATITUDE

Sometimes when you're developing a print, the image appears very quickly, and you have to shorten the developing time to avoid getting the print too dark. At other times the print may not seem dense enough after the recommended developing time has elapsed, and you leave it in the developer a little longer than normal. This ability of a paper to produce an acceptable print by juggling development times is called development latitude.

You normally shouldn't have to "juggle" developing times to get a good print, of course. The best possible prints are made by exposing the paper so that it reaches the density you want when the recommended developing time has elapsed. Acceptable prints can be made, however, throughout a reasonable exposure range.

Warm tone papers, such as KODAK EKTALURE Paper, get progressively colder in image tone with increased development. Contrast also tends to change in such papers. The prints appear lower in contrast with over-exposure and underdevelopment, and show higher contrast with underexposure and overdevelopment. Prints made on KODAK VELOX and KODABROMIDE Papers show practically no change in either image tone or contrast throughout their wide development latitude.

COLOR SENSITIVITY AND SAFELIGHT EFFECTS

Black-and-white photographic papers usually are sensitive to ultraviolet, violet, blue, and blue-green light. This sensitivity does not cut off sharply, though. It decreases gradually as the color of light moves toward the red end of the spectrum. A darkroom safelight has to be a balance between adequate visibility and freedom from fogging. If the safelight recommendations are followed, especially with regard to lamp wattage and the working distances at which they are used fogging of paper by safelight exposure can be avoided.

Bad cases of safelight fogging are easy to detect because the masked border of the paper will show evidence of fogging. It's important to realize that a safelight can degrade the quality of the print image without actually fogging the clear border. This is due to the combined effect of the safelight exposure plus the printing exposure. The safelight exposure alone may not be enough to cause fogging, but when it's added to the normal printing exposure the safelight exposure becomes developable and shows up as gray highlights and a lowering of contrast in a picture.

(Courtesy of Eastman Kodak Co.)

191

EASTMAN KODAK

CONTRAST OF PRINTS

The contrast of a print depends on the character of the scene; on the type of film, its exposure, and processing; and on the kind of printing paper factors. This **subjective** contrast should not, incidentally be confused with **objective** contrast which refers to the measurable brightness ratio of any two areas. For example, the objective contrast of two adjacent steps on a gray scale can be measured with a densitometer. Subjective contrast, such as the contrast of a print from a given negative, depends on the printing paper and its handling.

The contrast of a print is a rather complex characteristic to describe. For example, a print made on a G-surface paper is more contrasty when it is wet than when it is dry. A print from a given negative is less contrasty when printed on KODABROMIDE Paper F-2 than when it is printed on KODABROMIDE F-3. A glossy print on No. 2 printing grade is more contrasty than a matte-surface print also on No. 2 printing grade. These are all correct uses of the word "contrast," yet they may be somewhat confusing examples unless the "two-dimensional" aspect of contrast is clear.

Contrast is a word which has two meanings. The two things which determine contrast are **gradient** and **range** (or **extent**). Technically speaking, the gradient is the rate at which the density increases with exposure. The range (or extent) is the total density range available in the print from light to dark. In other words, contrast can be increased by using a paper with a steeper gradient, a higher maximum density or both.

CONTRAST OF PAPERS

Each sheet of photographic paper has a contrast capacity as mentioned earlier. This capacity is the product of gradient and density range. If you print the same negative on No. 1 and No. 2 printing grades of the same paper, the available maximum density is the same. But the print made on the No. 2 paper looks more contrasty. This is because the rate at which density increases with exposure is more rapid for No. 2 printing grade than for No. 1 printing grade. In other words, No. 2 printing grade

paper reaches its maximum density sooner.

The exposure scale of the No. 2 printing grade is shorter. If the negative has a long density scale, the paper may not accommodate all the tones in the negative. Printing grades range in exposure scale from a long scale with a grade 0 to a very short scale with grade 5. No. 2 and 3 have exposure scales that are in the "normal" range—they fit most negatives that are correctly exposed and developed. These same principles apply to name grade papers and selective-contrast papers used with KODAK POLYCONTRAST filters or equivalent.

NEGATIVES FOR BEST PRINT QUALITY

The best prints are made from good negatives. But what exactly is a good negative? Actually, it's hard to describe what a good negative looks like. It should have not only detail in the shadows but also highlights that aren't blocked up from overexposure. From a convenience standpoint, a good negative is one that prints well on grade 2 or grade 3 paper.

A negative that prints best on a grade No. 2 or medium grade paper has a density scale between 1.0 and 1.20. This density scale also suits some single contrast grade paper or selective contrast papers with a PC-2 filter paper —another reason for aiming at such quality.

ADJUSTING NEGATIVE CONTRAST BY DEVELOPMENT

Negative contrast can be controlled by varying the film developing time; longer development gives higher contrast, shorter development gives lower contrast. The developing times recommended by the instruction sheets that accompany Kodak films are aimed to yield negatives of average contrast that print well on a normal grade paper. However, printing systems vary in the contrast they yield, and you may need to adjust negative development to suit your particular method of printing.

If your negatives of subjects having a normal brightness range print best on No. 1 paper then reduce the recommended film developing time by about 20 percent. On the other hand, if your

(Courtesy of Eastman Kodak Co.)

negatives print best on No. 4 paper, increase the recommended developing time by about 30 percent.

Thin underexposed or underdeveloped negatives generally yield satisfactory prints on No. 4 or No. 5 paper. Negatives with exceptionally high contrast require No. 0 or No. 1 paper. Although passable prints can be made from most negatives, the best print quality is obtained from negatives that print well on grade 2 paper. To minimize grain and keep printing exposure as short as possible, miniature negatives should be developed to a slightly lower contrast and density than the larger sizes.

OTHER FACTORS AFFECTING PRINT CONTRAST

The way a print is made can affect its contrast. Contact printing produces about the same degree of contrast as an enlarger with a diffuse light source. A condenser enlarger, on the other hand, produces greater contrast than diffuse light sources. The difference may be as much as the difference between one or two paper grades.

DEVELOPER AND DEVELOPMENT TIME

The contrast capacity of photographic papers is pretty much built in—there's not much you can do to change it appreciably. Contrast can be changed within fairly narrow limits by variations in development time or developer composition. KODAK SELECTOL-SOFT Developer, for example, is designed to reduce contrast slightly without loss of print quantity. When used with papers for which it's recommended, SELECTOL-SOFT Developer can change the exposure scale about one printing grade.

As we've already mentioned, prolonging processing time increases print density and gives the impression of more contrast. Underdevelopment gives the effect of less contrast. We repeat once more that it's best to pick an appropriate paper for your negative and to develop the paper for the recommended length of time. Over- and under-development can give you troubles in the form of mottle and stain. Some papers have greater development latitude than others.

SELECTIVE CONTRAST PHOTOGRAPHIC PAPERS

While the contrast of most photographic papers is fixed within narrow limits, recent advances have produced variable-contrast papers designed to give a wide range of contrasts. Some of these papers are KODAK POLYCONTRAST, KODAK POLYCONTRAST RAPID, RC, KODAK POLYCONTRAST Rapid, PORTRALURE, and KODAK EKTAMATIC SC. In each case, the contrast is varied by means of filters used between the light source and the printing paper. The KODAK POLYCONTRAST Filter Kit, Model A, can be used with the papers mentioned to provide seven different contrasts of paper, equivalent to printing grades from 1 through 4, in half-grade steps.

"Normal" negatives, which would regularly be printed on grade No. 2 paper, can be printed without a filter (although a No. 2 filter is included in the set so that uniform contrast steps will be available over the entire range). Variable-contrast paper is especially useful in reducing the amount of paper that must be kept in stock, because one box of paper provides all the contrast grades normally required. This eliminates the necessity for buying and storing several different boxes of paper to get a range of contrasts, and cuts the waste of having seldom-used grades spoil on your darkroom shelves.

PAPERS FOR PRINTING COLOR NEGATIVES

Color negatives are becoming increasingly important in all kinds of photography. Negatives from such films as KODACOLOR-II and KODAK VERICOLOR II are the source of almost anything photographic. A color negative can be used to make a color print, a black-and-white print, or a color transparency.

Color prints can be made on KODAK EKTACOLOR 37 RC Paper. This is a multilayer paper designed for direct printing or enlarging from color negatives. The storage requirements are more critical for these papers than for most black-and-white papers. Protect EKTACOLOR Paper against heat and

EASTMAN KODAK

(Courtesy of Eastman Kodak Co.)

EASTMAN KODAK

store it at temperatures at 50° F or lower.

Making the color prints requires the use of filters, such as KODAK Color Compensating Filters.

Making black-and-white prints from color negatives became practical with the introduction of KODAK PANA-LURE Paper. It's possible to make passable prints on ordinary photographic papers, such as KODABRO-MIDE or KODAK MEDALIST Paper, but PANALURE Paper lets you make really excellent prints. The reasons are simple. The built-in orange mask of KODACOLOR-II negatives acts almost like a safelight for ordinary papers, so exposures need to be very long. Also, black-and-white papers have no red sensitivity, so some of the color differences in the color negative don't register in the print. Reddish or tanned faces are rendered very dark for example. PANALURE Paper has a panchromatic emulsion that can record tone values correctly. Another advantage to using PANALURE Paper is that it provides you with control over tonal rendition. You can darken or lighten any color you wish by using filters during printing. To darken a subject color, use a complementary color filter in the enlarger. To lighten a subject color, use a filter of the same color in the enlarger. If you want a dark, dramatic sky effect in the print, for example, use a red filter, such as the KODAK WRATTEN Filter No. 25 (A), over the enlarger lens while making the print. The effect will be in the same direction as using the same filter over the camera's lens with black-and-white panchromatic film.

PANALURE Paper is available in one normal grade. Its speed is similar to that of KODAK MEDALIST Paper. Because it is sensitive to all colors of light, it should be handled in total darkness or with the KODAK Safelight Filter No. 10 (dark amber).

CHOICE OF PAPER GRADE

Picking the correct grade of paper is essential to good print quality.

A print without enough contrast looks muddy, while the print with too much contrast looks harsh. A print made on the wrong grade of paper may seem passable until you compare it with one made from the same negative on paper of the correct grade.

Remember that a wet print has more contrast and looks lighter than it will when it's dry. Also, darkroom safelight illumination isn't adequate for judging print quality.

PAPER DEVELOPERS

The different developers affect changes primarily in image tone and can be substituted freely if an exact tone is not important. The image tones listed above are the ones obtained with the primary developer recommendations which appear in boldface.

Dektol—Yields neutral and cold tones on cold-tone papers.

Ektaflo, Type 1—The liquid concentrate with characteristics similar to those of Dektol.

Selectol—For warm-tone papers and warmer tones on other papers.

Selectol-Soft—A companion to Selectol, gives lower contrast.

Ektonol—Specially designed for warm-tone papers which are to be toned.

Ektaflo, Type 2—A liquid concentrate with characteristics similar to those of Ektonol.

Versatol—An all-purpose developer for films, plates, and papers.

IMAGE TONE

The color of the silver deposit in the finished print is referred to as "image tone." If brownish the print is said to be "warm" in tone, and if blue-black, it is described as "cold." These differences in color are caused by variations in size and condition of the silver grains which form the image, and they are controlled by the emulsion composition and the conditions of development. KODAK VELOX Paper normally develops to a cold, blue-black image, while KODAK AZO, EKTALURE and PORTRALURE Papers, with normal handling, are warmer in image tone. Kodak papers are grouped here according to warmth of tone.

(Courtesy of Eastman Kodak Co.)

The Compact Photo-Lab-Index

Tone—Blue-Black
 Kodak Paper—Velox, Velox Unicontrast, Velox Premier
Tone—Neutral-Black
 Kodak Paper—Ad-Type, Azo, Super Speed Direct Positive, Kodabromide, Resisto, Resisto Rapid, Ektamatic SC (Tray), Ektamatic SC (Stabilization Processor) Poly-contrast Rapid, Medalist, School
Tone—Warm-Black
 Mural, Polycontrast, Panalure
Tone—Brown-Black

Kodak Paper — Ektalure, Portrait Proof, Portralure, Panalure Portrait

The warmth of tone of the papers listed as "Warm-Black" or "Brown-Black" can be varied considerably by changes in the developer. KODAK DEKTOL Developer and KODAK Developer D-72 produce comparatively cold tones, while KODAK SELECTOL Developer, KODAK SELECTOL-SOFT Developer, and KODAK Developer D-52 yield warm tones.

KODAK Papers	Safelight Filter	Image Tone Group*	Paper Speeds Contrast Grade or POLYCONTRAST Filter No.						
			WL†	0	1	2	3	4	5
Azo	OC	2	—	6	3	1.6	1.2	.8	.6
Ad-Type	OC	2	—	—	3	1.6	1.2	.8	—
Velox	OC	1	—	—	10	5	4	2	—
Resisto	OC	2	—	—	—	6	6	—	—
Polycontrast	OC	3	160	—	100	125	100	50	—
Panalure	10	3	—	—	—	—	—	250	—
Panalure Portrait	10	4	—	—	—	—	—	100	—
Ektalure	OC	4	—	—	—	—	80	—	—
Portralure	OC	4	50	—	32	—	20	—	—
Kodabromide	OC	2	—	—	500	320	200	160	125
Medalist	OC	3	—	—	160	125	160	200	—
Mural	OC	3	—	—	—	250	250	—	—
Polycontrast Rapid	OC	3	320	—	250	250	160	160	—
Polycontrast Rapid RC	OC	2	320	—	250	250	160	64	—
Portrait Proof	OC	4	—	—	—	—	64	—	—
Ektamatic SC—									
Stabilization	OC	3	400	—	250	250	200	64	—
Tray Processing		2	320	—	200	250	160	64	—

*Key: 1—blue-black 2—neutral-black 3—warm-black 4—brown-black
†White light. These speeds are for selective-contrast papers used without a filter.

(Courtesy of Eastman Kodak Co.)

EASTMAN KODAK

The Compact Photo-Lab-Index

PAPER SPEED

The paper speeds given in the table above are determined by ANSI Standard PH2.2-1966. They provide an approximate indication of the relative exposures needed for the various materials. For example, the speed number for EKTALURE Paper is 125 and that for Polycontrast Paper is 64. Since the higher number indicates a faster emul-

the exposure of EKTALURE Paper. The speeds given are for the average product; aging and adverse storage conditions may alter the speed of a paper. Moreover, the subjective nature of print density will require exposure to be adjusted to suit the subject matter.

Note that paper speeds bear no relationship to ASA film speeds. sion, Rapid Paper requires about twice

KODAK Developers†	Recommended Time in Sec at 68 F (21 C)	Useful Range in Sec
Dektol (1:2), **Ektaflo Type 1** (1:9), D-72 (1:2)	60	45 to 120
Ektonol (1:1), **Selectol** (1:1), D-52 (1:1)		
Ektaflo Type 2 (1:9), **Selectol-Soft** (1:1)	120	90 to 240
Dektol (1:2), **Ektaflo Type 1** (1:9), D-72 (1:2)	60	45 to 120
Dektol (1:2), **Ektaflo Type 1** (1:9), D-72 (1:2)	60	—
Dektol (1:2), **Ektaflo Type 1** (1:9), D-72 (1:2)	90	60 to 180
Dektol (1:2), **Ektaflo Type 1** (1:9), D-72 (1:2)	90	60 to 180
Ektaflo Type 2 (1:9, **Selectol** (1:1),		
Selectol-Soft (1:1)	120	60 to 180
Selectol (1:1)		
Ektaflo Type 2 (1:9), **Selectol-Soft** (1:1)	120	90 to 240
Ektonol (1:1), **Selectol** (1:1),		
Ektaflo Type 2 (1:9), **Selectol-Soft** (1:1)	120	90 to 240
Dektol (1:2), **Ektaflo Type 1** (1:9), D-72 (1:2)	90	60 to 180
Dektol (1:2), **Ektaflo Type 1** (1:9), D-72 (1:2)	60	45 to 120
Ektonol (1:1), **Selectol** (1:1),		
Ektaflo Type 2 (1:9), **Selectol-Soft** (1:1)	120	90 to 240
Ektonol (1:1), **Selectol** (1:1), D-52 (1:1)		
Ektaflo Type 2 (1:9), **Selectol-Soft** (1:1)	120	90 to 240
Dektol (1:2), **Ektaflo Type 1** (1:9), D-72 (1:2)	60	45 to 120
Dektol (1:2), **Ektaflo Type 1** (1:9), D-72 (1:2)	90	60 to 180
Dektol (1:2), **Ektaflo Type 1** (1:9), D-72 (1:2)	90	60 to 180
Dektol (1:2), **Ektaflo Type 1** (1:9), D-72 (1:2)	60	—
Ektonol (1:1), **Selectol** (1:1), D-52 (1:1)		
Ektaflo Type 2 (1:9), **Selectol-Soft** (1:1)	120	90 to 240
Stabilization Processing	—	—
Dektol (1:2), **Ektaflo Type 1** (1:9)	60	45 to 120

†Figures in parentheses refer to developer dilutions.

Developers in boldface type in the table are primary recommendations.

(Courtesy of Eastman Kodak Co.)

EXPOSURE DETERMINATION

With Kodak Projection Print Scale

The Kodak Projection Print Scale affords a quick and simple method of determining the correct exposure for any enlargement at any magnification and also aids in selecting the proper contrast of printing paper to use.

This scale is a transparent disk divided into ten sectors, each indicating a different printing time in seconds. In use, the scale should be placed over the sensitized paper on the easel and a test print exposed through it for sixty seconds. Upon development a ten-sector image appears, indicating respective exposures of 2, 3, 4, 6, 8, 12, 16, 24, 32, and 48 seconds. By inspection of this test print, the best exposure should be easily determined.

Complete instructions are printed on the face of the Projection Print Scale.

TEST STRIPS

Another practical and widely used physical aid for gauging exposure is the test strip. After the enlarger has been adjusted for making an enlargement, a narrow strip of the paper to be used is placed within the projected image area so as to include the most important parts of the picture. Successive areas of the test strip are given progressively increasing exposures by intercepting the light beam close to the test strip with a sheet of black photographic paper moved along the strip with the desired steps in exposure time. The exposed test strip is given the full recommended development. Approximately correct exposure may then be visually determined according to the density of the several "steps."

USING A PHOTOMETER

Various photometric methods utilizing homemade and manufactured photometers may be employed to aid in determining print exposures. These may be used to advantage by those who are experienced in their use and familiar with their principles and limitations. A density-exposure calculator method of exposure determination is furnished in the KODAK Darkroom DATA-GUIDE, Publ. No. R-20.

PROCESSING RECOMMENDATIONS

For Kodak Papers

For best print quality and physical performance, all photographic papers should be stored and used at approximately 70°F and 40% relative humidity as shown by dry and wet-bulb thermometers or other means.

SUMMARY
DEVELOPING, FIXING

1. Always prepare solutions carefully using either the ready-to-dissolve Kodak Chemical Preparations or Kodak Tested Chemicals which are ready especially for photographic use.

2. Use enough solution in trays to cover prints by at least ½ inch.

3. Keep all solution temperatures as near 68°F (20°C) as possible.

4. Immerse prints singly, and keep them entirely covered with solution during processing.

5. Agitate prints and separate them frequently while in each solution.

6. Expose prints so that they develop properly in the time recommended.

7. Rinse developed prints at least 30 seconds in Kodak SB-1 Stop Bath.

8. Fix 5 to 10 minutes in a fresh fixing bath, Kodak F-5, or F-6. Over-fixation destroys warmth of tone, bleaches the image, and increases the difficulty of washing hypo from the paper base.

KODAK RC papers require only 2 minutes in the recommended fixers.

DARKROOM ILLUMINATION

Most Kodak enlarging papers should be handled and developed by the light of a KODAK Safelight Filter 0C (light amber), used in a suitable safelight lamp with a 15-watt bulb kept at least 4 feet from the paper.

(Courtesy of Eastman Kodak Co.)

EASTMAN KODAK

EASTMAN KODAK

SAFELIGHT LAMP RECOMMENDATIONS
Minimum distance from lamp to work area is four feet

Name	Description	KODAK Safelight Filter	Bulb Size
Brownie Darkroom Lamp, Model B	Screws into light socket.	0 (Yellow) Plastic Cup	7-watt
Kodak 2-Way Safelamp	Two sided. Screws into light socket.	0C, 1A, 10 3¼ x 4¾"	15-watt
Kodak Darkroom Lamp	Parabolic, hung on drop cord over bench or sink.	0C, 1A, 10 5½" Circle	15-watt
Kodak Adjustable Safelight Lamp	Parabolic, on standard. For use on a table or mounted on a wall.	0C, 1A, 10 5½" Circle	15-watt
Kodak Utility Safelight Lamp, Model C	Suspended from ceiling by chains. With accessory bracket, used on table or shelf, or mounted on wall.	0C, 1A, 10 10 x 12"	25-watt, indirect at ceiling, 15-watt used on table or shelf.

DEVELOPERS

Some photographers are never happy unless they're manipulating chemicals and processing times for the "magic" combination that will give them better results. We don't want to discourage any budding chemists, but the fact remains that processing according to the manufacturer's recommendations gives more certain results than "home brews" or off-beat processing techniques. Consider this: Every manufacturer wants you to get the best possible results from his products.

In the photographic field, Kodak and other major manufacturers spend large amounts of money in exhaustive and continuing research programs designed to find the best possible ways to handle their products. Such recommendations are published in their data sheets and booklets.

Development Time. Excellent prints are possible only when the printing exposure produces proper print density in the normal developing time. A common cause of "muddy" prints is under-development. You naturally tend to pull out a rapidly darkening print before full development, but the image you get is poor in tone, lacking in contrast, and often mottled from uneven development.

Some papers, such as KODAK MEDALIST and KODABROMIDE, have more development latitude than others and require less critical exposure.

Overdevelopment, especially in an overworked solution, causes the formation of developer oxidation products which are likely to cause yellow stain. Oxidation also results from other causes such as exposing the developing print to air. Even slight processing stains degrade print quality. Exhausted developers make it difficult to judge print quality accurately because of the dark color of the solution.

Uniform Development. The developing tray should be a little larger than the print. This allows proper agitation and convenience in handling the prints. KODAK trays are made with this need

(Courtesy of Eastman Kodak Co.)

in mind. For example, an "8 by 10-inch" tray actually measures about 9 by 11 inches. For best results, slip the print edgewise and face up into the developer solution. Make sure it's covered quickly and evenly. Agitate the solution by rocking the tray or keeping the prints in motion. It's important to keep the prints completely immersed during development to avoid stains from uneven development and oxidation.

STOP BATH

After development, immerse the print for about 5 to 10 seconds in a stop bath, such as KODAK Indicator Stop Bath or KODAK Stop Bath SB-1, at 65 to 70F (18 to 21 C). Agitate the print continuously to make sure it's well treated. If the stop bath is made much stronger than the KODAK SB-1 formula, or if you leave prints in the stop bath considerably longer than necessary, a mottled, "soaking" effect may result.

The KODAK Testing Outfit for Print Stop Baths and Fixing Baths includes a simple test to determine when the stop bath is exhausted. KODAK Indicator Stop Bath and KODAK EKTAFLO Stop Bath, supplied as concentrates, are yellow liquids that change to a purplish blue on exhaustion; at this point, they should be discarded.

FIXING

Ffter the prints have been rinsed carefully in the stop bath, fix them for 5 to 10 minutes at 65 to 70 F with agitation in an acid hardening fixing bath. You could use a solution prepared from KODAK Fixer or made from the formula for KODAK Fixing Bath F-5 or F-6. F-6 is recommended for general use because it has less odor. F-5 is good if prints tend to stick to your ferrotype plates, belts, drums, or drier, or if they soften in the toning bath. KODAFIX Solution KODAK Rapid Fixer, and KODAK EKTAFLO Fixer are also recommended. As single baths, these solutions will fix about 8000 square inches of prints per gallon—100 8 x 10-inch prints, 400 4 x 5-inch prints, etc.

By far the best and most economical system is to use two fixing baths in succession. A two-bath system gives a much more permanent print and lets you use the fixing solution for many more prints.

Here's how it works. Have both baths at 65 to 70 F (18 to 21 C). Fix the prints, with frequent agitation, for 3 to 5 minutes in the first bath. Drain them for five seconds, then fix for 3 to 5 minuates in the second bath.

The two baths are "good" for two hundred 8 x 10-inch prints or their equivalent in other sizes, per gallon of the first bath. After that many prints have been fixed, throw away the first bath, put the second in its place, and mix a new second bath. The new two-bath setup is ready for two hundred more prints. After three more such changes (when you have fixed one thousand 8 x 10-inch prints or their equivalent in other sizes), throw away both baths and start over again. In any case, solutions shouldn't be kept longer than a week.

Avoid prolonged fixing or fixing at high temperatures, especially with warm-tone prints, because the bath tends to bleach the image and change its tone.

Resin-coated papers should be fixed for 2 minutes in a single bath fixer.

WASHING

Papers are washed to remove the fixing solution from both the emulsion and the paper base. If the hypo isn't removed, it will gradually transform the black silver image into a brown or yellowish one. Dissolved silver salts carried from the fixing bath must be removed or clear areas of prints will yellow. If you don't treat your prints in chemicals designed to accelerate washing, wash them for at least one hour with agitation and adequate water flow. Don't soak prints overnight in wash water, though, because bleaching and stains may result.

KODAK Hypo Clearing Agent can be used to reduce washing time and to obtain more complete washing. Transfer the prints, with or without previous rinse, to the clearing agent solution. Treat single-weight papers at least 2 minutes, with agitation, at 65 to 70 F (18 to 21 C). Double-weighted papers should be treated for at least 3 minutes. Wash single-weight papers at least 10

(Courtesy of Eastman Kodak Co.)

EASTMAN KODAK

EASTMAN KODAK

minutes and double-weight papers at least 20 minutes with agitation and normal water flow. If you maintain the water temperature at 65 to 70 F (18 to 21 C), a higher degree of stability can be obtained than you get with normal one-hour washing without the Hypo Clearing Agent Treatment. Here's a real bonus—when you use KODAK Hypo Clearing Agent, your water temperature can be as low as 35 F (1.7 C).

Prints not treated in KODAK Hypo Clearing Agent Solution should be washed for at least an hour in running water at 65 to 70 F (18 to 21 C). Water warmer than that tends to soften the emulsion and doesn't shorten washing time by much. Don't let the stream of water fall directly on the prints. When washing in a tray, place a tumbler or graduate in the tray and let the water overflow from it into the tray. The wash water should move fast enough to fill the washing container 10 to 12 times an hour, and it should keep the prints moving. Trays should not be so loaded that prints mat together and prevent proper washing action. The KODAK Automatic Tray Siphon converts any ordinary tray into an efficient print washer which assures proper movement and agitation of prints during washing.

Prints made on resin-coated papers should be washed for 4 minutes in running water. There is no need to use KODAK Hypo Clearing Agent.

TESTING FOR HYPO AND SILVER SALTS

Even small traces of hypo (fixing bath) retained in prints accelerate the rate of image fading.

If prints don't receive proper fixing, or if they're fixed in a used bath containig dissolved silver compounds in any quantity, some silver salts will be retained in the paper. These salts are very difficult to remove by washing. Eventually they may discolor and cover the prints with a brownish stain or silver sulfide. The remedy, of course, is adequate two-bath fixing and thorough washing. When testing for residual hypo, also check your prints for silver salts.

DRYING MATTE PRINTS

Sponge the surplus water from both the back and front of the prints, and dry them in a KODAK Photo Blotter Roll, on a muslin-covered rack, or on a twin-belt, matte drying machine.

Prints that dry with an excessive curl can be straightened with a KODAK Print Straightener, Model G.

FERROTYPING

All Kodak F-surface papers except for those with a resin-coated base can be ferrotyped on chromium-plated sheets or on a ferrotyping machine. Prints ferrotyped on plated sheets should be allowed to dry naturally. Those ferrotyped on heated-drum machines are best dried at a temperature of approximately 180 F (82 C).

Cleanliness is most important in all ferrotyping operations. The wash water should be filtered to remove solid particles; the glazing surfaces of plates and machines, as well as the conveyor belts of machines, should be protected from airborne dust.

F-surface resin-coated air-dry with a gloss without ferrotyping. DO NOT FERROTYPE resin coated papers.

TONING

You can choose from various papers to get the warmth of image tone you prefer in the print. You can vary the warmth of tone of such papers as KODAK AZO and MEDALIST by the choice of developer. Using KODAK SELECTOL and EKTAFLO, Type 2, Developers, for example, gives you warmer tones on such papers than KODAK DEKTOL and EKTAFLO, Type 1, Developers.

If you want a more strongly colored image, you can tone the picture. KODAK POLY-TONER is a concentrated solution that can be used to produce a whole range of reddish brown to warm brown, simply by varying the dilution. A number of packaged Kodak toners are available. Or, you can mix your own, using the formulas listed in this section.

The final hue of a toned print is influenced by emulsion type, age, and storage conditions of the paper, processing variations prior to toning, and variations in toning procedure. Successful toning is dependent on correct print processing, including full development, use of a fresh fixing bath, KODAK Hypo Clearing Agent, and adequate washing prior to toning.

(Courtesy of Eastman Kodak Co.)

PRINTING PROCEDURE

PROJECTION PRINTING

KODAK POLYCONTRAST Paper is designed for printing by exposure to tungsten lamps, such as Photo Enlarger No. 212 or No. 302. When a cool-white (4500 K) flourescent lamp is used, a CP40Y or CC40Y filter is recommended in addition to the appropriate KODAK POLYCONTRAST Filter.

CONTRAST CONTROL

KODAK POLYCONTRAST Filters No. 1, 2, 3, and 4 give a range of contrasts similar to that of the corresponding grades of KODAK Number Grade Papers. Filters No. 1½, 2½, and 3½ yield degrees of contrast midway between these grades.

Negatives of normal contrast, which would regularly be printed on grade No. 2 paper, can be printed without a filter (although a No. 2 filter is included in the set to give uniform contrast steps over the entire range).

The filters in the KODAK POLY-CONTRAST Filter Kit (Model A) or KODAK POLYCONTRAST Gelatin Filters are used at the lens. KODAK POLYCONTRAST Acetate Filters can be used **only** between the light source and the negative.

CONTACT PRINTING

Use KODAK POLYCONTRAST Acetate Filters, 11 x 14-inch, between the printing lights and the negative for contrast control. Reduce the total exposure to approximately 1/10 of that used for a contact speed paper.

RINSE

With agitation at 65 to 70 F (18-21 C) for 5 to 10 seconds in KODAK EK-TAFLO Stop Bath or KODAK Indicator Stop Bath. Discard when solution turns a purplish blue.
or in KODAK Stop Bath SB-1. Discard after processing 78 8 x 10-inch prints or equivalent per gallon.

FIX

With agitation at 65 to 70 F (18-21 C) in KODAK EKTAFLO Fixer (1:7), KODAK Fixer, KODAFIX Solution, KODAK Rapid Fixer, or KODAK Fixing Bath F-5 or F-6.

The two-fixing-bath method is recommended. Fix the prints from 3 to 5 minutes in each bath. After fixing 200 8 x 10-inch prints or equivalent per gallon, discard the first bath. Advance the second bath to replace the first and make a new second bath. Discard both solutions after 1000 8 x 10-inch prints or equivalent per gallon have been processed or after 1 week, whichever occurs first.

When the single-bath method is used, fix for 5 to 10 minutes. Discard after fixing 100 8 x 10-inch prints or equivalent per gallon. **Note:** Do not fix prints for total time longer than 10 minutes.

WASH

To reduce time and save water, use KODAK Hypo Clearing Agent. Then wash for 10 to 20 minutes, depending on stock weight of paper. See instructions packaged with chemicals.

Otherwise wash prints for at least 1 hour at 65 to 75 F (18-24 C) in a tank in which there is a complete change of water every 5 minutes. The KODAK Automatic Tray Siphon provides proper change of water for prints washed in a tray.

To minimize curl, bathe the prints in KODAK Print Flattening Solution after washing and before drying. All prints must be fixed and washed thoroughly or they can contaminate other prints treated in the Print Flattening Solution.

DRY

Remove as much excess water as possible. Then place prints on a belt dryer, on cheesecloth stretchers, or between white photo blotters.

Prints on glossy surface paper can be ferrotyped. Use KODAK Dry Mounting Tissue or KODAK Rapid Mounting Cement to mount prints.

TONING

Recommended toners are KODAK Brown Toner, KODAK Sepia Toner, and KODAK Sulfide Sepia Toner T-7a.

(Courtesy of Eastman Kodak Co.)

EASTMAN KODAK

RECOMMENDATIONS FOR TONING KODAK **PAPERS** IN KODAK **TONERS**

KODAK Paper	Hypo Alum Sepia T-1a	Sepia or Sulfide Sepia T-7a	Brown or Poly-sulfide T-8	Gold T-21	Rapid Selenium	Poly-Toner (1:24)	Blue
Ad-Type	X	X	P	NR	X	P	NR
Azo	X	X	P	NR	X	P	NR
Ektalure	X	X	X	P	P	P	X
Ektamatic SC*	P	P	P	NR	X	X	X
Kodabromide	X	P	NR	NR	NR	NR	NR
Medalist	P	P	P	NR	X	P	X
Mural	P	P	P	NR	X	P	X
Panalure	P	P	P	X	X	X	X
Panalure Portrait	X	X	X	X	P	P	X
Polycontrast, Polycontrast Rapid Polycontrast Rapid RC	P P	P	P	NR	X	X	X
Portralure	P	P	P	P	P	P	X
Portrait Proof	X	X	X	P	P	P	X
School	X	X	P	NR	X	P	X
Velox	P	P	X	NR	NR	NR	X
Velox Premier	X	X	X	NR	NR	NR	X
Velox Unicontrast	P	P	X	NR	X	NR	X

X—Although not a primary recommendation, a tone can be secured which may have an application for special purposes.
P—Primary recommendation. NR—Not Recommended.
*When processed by conventional tray methods.

(Courtesy of Eastman Kodak Co.)

KODAK **AZO PAPER**

APPLICATIONS

Contact-printing paper for commercial, industrial, and illustrative photography.

CHARACTERISTICS

Neutral-black image tone.

Surface and contrast characteristics are listed in the following table:

Tint	Brilliance	Texture	Symbol	Weight	Grade
White	Glossy	Smooth	F	Single Weight Double Weight	No. 0, 1, 2, 3, 4, 5 No. 1, 2, 3
White	Lustre	Smooth	N	Double Weight	No. 1, 2, 3, 4
White	Lustre	Fine-Grained	E	Single Weight Double Weight	No. 1, 2, 3, 4 No. 2, 3

SAFELIGHT

Kodak Safelight Filter OC (light amber)

PRINTING INFORMATION

Paper Grade	No. 0	No. 1	No. 2	No. 3	No. 4	No. 5
ANSI Paper Speed	6	3	1.6	1.2	.8	.6

DEVELOPMENT RECOMMENDATIONS —AT 68 F (20 C)

Kodak Developer	Dilution	Development Time in Minutes		Cap. (8x10" prints per gal.)	Purpose
		Recommended	Useful Range		
Dektol	1:2	1	¾ to 2	120	Cold Tones
Ektaflo, Type 1	1:9	1	¾ to 2	120	Cold Tones
D-72	1:2	1	¾ to 2	100	Cold Tones
Versatol	1:3	1	¾ to 2	80	Cold Tones
Ektonol	1:1	2	1½ to 4	80	Warmer Tones
Selectol	1:1	2	1½ to 4	80	Warmer Tones
Ektaflo, Type 2	1:9	2	1½ to 4	100	Warmer Tones
D-52	1:1	2	1½ to 4	80	Warmer Tones
Selectol-Soft	1:1	2	1½ to 4	80	Lower Contrast

TONING RECOMMENDATIONS

Kodak Brown Toner
Kodak Poly-Toner
Kodak Polysulfide Toner T-8

(Courtesy of Eastman Kodak Co.)

KODAK **EKTALURE PAPER**

APPLICATIONS

Enlarging paper (or contact-printing paper, with reduced illumination in the printer) particularly suitable for portrait or pictorial printing.

CHARACTERISTICS

Brown-black image tone. Surface and weight characteristics are listed in the following table:

IMAGE TONE

Neutral-black.

SAFELIGHT

KODAK Safelight Filter OC (light amber)

PRINTING INFORMATION

ANSI Paper Speed: 80

Tint	Brilliance	Texture	Symbol	Weight
Warm-White	Lustre	Fine-Grained	E	Double Weight
Cream-White	Lustre	Fine-Grained	G	Double Weight
Warm-White	High-Lustre	Fine-Grained	K	Double Weight
Cream-White	Lustre	Tweed	R	Double Weight
Warm-White	High-Lustre	Silk	Y	Double Weight
Cream-White	Lustre	Tapestry	X	Double Weight

DEVELOPMENT RECOMMENDATIONS —AT 68 F (20 C)

Kodak Developer	Dilution	Development Time in Minutes		Cap. (8x10″ prints per gal.)	Purpose
		Recommended	Useful Range		
Ektaflo, Type 2	1:9	2	1½ to 3	100	Warm Tones
Ektonol	1:1	2	1½ to 3	80	Warm Tones
Selectol	1:1	2	1½ to 3	80	Warm Tones
D-52	1:1	2	1½ to 3	80	Warm Tones
Selectol-Soft	1:1	2	1½ to 3	80	Lower Contrast

TONING RECOMMENDATIONS

KODAK POLY-TONER, KODAK Rapid Selenium Toner, and KODAK Gold Toner T-21.

If prints are to be selenium-toned, reduce developing time slightly because selenium toners tend to increase print density.

The formula for KODAK Toner T-21 is given elsewhere in this section.

(Courtesy of Eastman Kodak Co.)

EASTMAN KODAK

KODAK EKTAMATIC SC PAPER

APPLICATIONS

Proofing. Quality deadline work. Newspaper work. Medical, military, and police photography.

CHARACTERISTICS

A variable-contrast, enlarging paper. Designed primarily for exposure with tungsten light. Contrast can be varied by using KODAK POLYCONTRAST Filters.

Stabilization processing in the KODAK EKTAMATIC Processor, Model 214-K, or similar processors, provides high production speeds. Can also be processed conventionally in a tray. Keeping life of stabilized prints can be made more permanent by subsequent fixing and washing.

Warm-black image tone with stabilization processing; neutral-black image tone with trap processing. Surface and weight characteristics are listed in the following table:

SAFELIGHT

KODAK Safelight Filter OC (light amber)—since these papers depend on blue and yellow light for contrast control, avoid exposing them to the safelight for any length of time.

Tint	Brilliance	Texture	Symbol	Weight
White	Glossy	Smooth	F	Single Weight Double Weight
White	Lustre	Smooth	N	Single Weight
White	Lustre	Smooth	A	Light Weight

PRINTING INFORMATION

Polycontrast Filter	PC 1	PC 1½	PC 2	PC 2½	PC 3	PC 3½	PC 4	No Filter (white light)
ANSI Speed-Stab. Process	250	320	250	250	200	125	64	400
ANSI Speed-Tray Process	200	250	250	200	160	125	64	320

LIGHT SOURCE FOR PROJECTION PRINTING

Tungsten, similar to a Photo Enlarger No. 212 or 302. Although not recommended for optimum results, light sources other than tungsten may be used with light-source correction filters. Filters suggested as starting points with three common light sources are: CP 40Y or CC40Y with a cool-white (4500 K) fluorescent lamp; a CC or CP correction of 70Y for a 6500 K fluorescent lamp; a combination of the KODAK WRATTEN Filter No. 6 plus a correction of CP40Y or CC40Y with a mercury-arc light source. Light-source correction filters are required in addition to the appropriate KODAK POLYCONTRAST Filter that may be used for contrast control.

STABILIZATION PROCESSING

ACTIVATE

KODAK EKTAMATIC A10 Activator at 70 F (range, 65 to 85 F).

STABILIZE

KODAK EKTAMATIC S30 Stabilizer at 70 F (range, 65 to 85 F).

IMPORTANT

Do not rinse or wash the print after it comes out of the stabilizer.

DRY

Prints coming out of the processor are partially dry and are usable. Complete drying takes only a few additional minutes at room temperature. Auxiliary drying equipment is not recommended.

(Courtesy of Eastman Kodak Co.)

EASTMAN KODAK

EASTMAN KODAK

STABILITY OF PRINTS:

The stabilized prints are subject to deterioration with exposure to both light or heat and humidity. Because of the extreme dependence on the degree and combination of these factors, meaningful information can not be given regarding the expected useful life of the resultant prints.

REPLENISHMENT OF ACTIVATOR AND STABILIZER

After filling the trays of the processor, add additional solution to maintain the solution level as proctssing proceeds.

CAPACITY

Because of the variable volume of the trays in the equipment, a valid solution capacity in square feet per gallon is not applicable. However, tht processing chemicals should be discarded, and the processor should be cleaned, after about three hundred 8 x 10-inch prints (or the equivalent area in othèr sizes) have been processed, or after one week's use, whichever occurs first.

STORAGE LIFE

The storage life of the solutions is indefinite in the original sealed package. Do not store chemicals in areas having temperatures about 120 F.

POST STABILIZATION FOR PERMANENCE

If more stable prints are desired, the following post-stabilization treatments are recommended.

FIX

Immerse the stabilized prints for 8 to 12 minutes with agitations in KODAK Fixer, KODAK Fixing Bath F-5 or F-6, KODAK Rapid Fixer, or KODAFIX Solution at 65 to 70 F.

WASH

To reduce time and save water, use KODAK Hypo Clearing Agent. Then wash for 10 minutes. See instructions packaged with chemicals.

Otherwise wash prints for at least 1 hour at 65 to 70 F (18-21 C) in a tank in which there is a complete change of water every 5 minutes.

DRY

Prints can be dried (or prints on the F surface can be ferrotyped) in the normal manner.

RINSE

With agitation at 65 to 70 F (18-21 C) for 5 to 10 seconds in KODAK Indicator Stop Bath or KODAK Stop Bath SB-1.

FIX

With frequent agitation at 65 to 70 F (18-21 C) for 5 to 10 minutes in KODAK Fixer, KODAFIX Solution, KODAK Fixing Bath F-5 or F-6.

WASH

To reduce time and save water, use KODAK Hypo Clearing Agent. Then wash for 10 minutes. See instructions packaged with chemicals.

Otherwise wash prints for at least 1 hour at 65 to 70 F (18-21 C) in a tank in which there is a complete change of water every 5 minutes.

DRY

Remove as much excess water as possible. Then place prints on a belt dryer, on cheesecloth stretchers, or between white photo blotters. Prints on glossy surface paper can be ferrotyped.

TONING

Recommended toners are KODAK Brown Toner, KODAK Sepia Toner, and KODAK Sulfide Sepia Toner T-7a.

TONING RECOMMENDATIONS

These toners are recommended only for prints that have been fixed and washed:

Kodak Hypo Alum Sepia Toner T-1a
Kodak Sulfide Sepia Toner T-7a
Kodak Polysulfide Toner T-8
Kodak Sepia Toner
Kodak Brown Toner

(Courtesy of Eastman Kodak Co.)

KODABROMIDE **PAPER**

APPLICATIONS
General-purpose enlarging paper. Widely used for studio, commercial, press, photofinishing, and exhibition prints.

CHARACTERISTICS
Neutral-black image tone. Surface and contrast characteristics are listed in the following table:

Tint	Brilliance	Texture	Symbol	Weight	Grade
White	Glossy	Smooth	F	Single Weight Double Weight	No. 1, 2, 3, 4, 5 No. 1, 2, 3, 4, 5
White	Lustre	Smooth	N	Single Weight Double Weight	No. 2, 3, 4 No. 2, 3, 4
White	Lustre	Smooth	A	Light Weight	No. 1, 2, 3, 4, 5
White	Lustre	Fine-Grained	E	Single Weight Double Weight	No. 2, 3, 4 No. 2, 3, 4
Cream White	Lustre	Fine-Grained	G	Double Weight	No. 2, 3, 4

SAFELIGHT
Kodak Safelight Filter OC (light amber)

PRINTING INFORMATION

Paper Grade	No. 1	No. 2	No. 3	No. 4	No. 5
ANSI Paper Speed	500	320	200	160	125

DEVELOPMENT RECOMMENDATIONS—AT 68 F (20 C)

Kodak Developer	Dilution	Development Time in Minutes		Capacity (8 x 10-inch prints per gallon)	Purpose
		Recommended	Useful Range		
Dektol	1.2	1½	1 to 3	120	Cold Tones
D-72	1:2	1½	1 to 3	100	Cold Tones
Ektaflo, Type 1	1:9	1½	1 to 3	120	Cold Tones
Versatol	1:3	1½	1 to 3	80	Cold Tones

TONING RECOMMENDATIONS
Kodak Sepia Toner.
Kodak Sulfide Sepia Toner T-7a.

(Courtesy of Eastman Kodak Co.)

EASTMAN KODAK

207

KODAK MEDALIST PAPER

APPLICATIONS

General-purpose enlarging paper.
Excellent for illustrative, commercial, and pictorial subjects.
Good choice for printing candid wedding pictures.

CHARACTERISTICS

Warm-black image tone. Surface and contrast characteristics are listed in the following table:

Tint	Brilliance	Texture	Symbol	Weight	Grade
White	Glossy	Smooth	F	Single Weight Double Weight	No. 1, 2, 3, 4 No. 2, 3
White	High Lustre	Smooth	J	Double Weight	No. 2, 3
White	Lustre	Fine-Grained	E	Double Weight	No. 2, 3
Cream White	Lustre	Fine-Grained	G	Double Weight	No. 2, 3, 4
Cream White	High Lustre	Silk	Y	Double Weight	No. 2, 3

SAFELIGHT

Kodak Safelight OC (light amber).

PRINTING INFORMATION

Paper Grade	No. 1	No. 2	No. 3	No. 4
ANSI Paper Speed	160	125	160	200

DEVELOPMENT RECOMMENDATIONS—AT 68 F (20 C)

Kodak Developer	Dilution	Development Time in Minutes Recommended	Range Useful	Capacity (8 x 10-inch prints per gallon)	Purpose
Ektaflo, Type 1	1:9	1	¾ to 2	120	Warm Tones
Dektol	1:2	1	¾ to 2	120	Warm Tones
D-72	1:2	1	¾ to 2	100	Warm Tones
Versatol	1:3	1	¾ to 2	80	Warm Tones
Ektaflo, Type 2	1:9	2	1½ to 4	100	Warmer Tones
Ektonol	1:1	2	1½ to 4	80	Warmer Tones
Selectol	1:1	2	1½ to 4	80	Warmer Tones
D-52	1:1	2	1½ to 4	80	Warmer Tones
Selectol-Soft	1:1	2	1½ to 4	80	Lower Contrast

TONING RECOMMENDATIONS

Kodak Poly-Toner. Kodak Sepia Toner. Kodak Sulfide Sepia Toner T-7a. Kodak Brown Toner. Kodak Polysulfide Toner T-8. Kodak Hypo Alum Sepia Toner T-1a.

(Courtesy of Eastman Kodak Co.)

EASTMAN KODAK

KODAK **MURAL PAPER**

APPLICATIONS

Enlarging paper for photomural and other large-print work.

CHARACTERISTICS

Warm-black image tone. Surface and contrast characteristics are listed in the following table:

Tint	Brilliance	Texture	Symbol	Weight	Grade
Cream-White	Lustre	Tweed	WRM R	Single Weight	No. 2, 3

SAFELIGHT

KODAK Safelight Filter OC (light amber)

PRINTING INFORMATION

ANSI Paper Speed: 250

DEVELOPMENT RECOMMENDATIONS
—AT 68 F (20 C)

Kodak Developer	Dilution	Development Time in Minutes		Cap. (8x10" prints per gal.)	Purpose
		Recommended	Useful Range		
Ektonol	1:1	2	1½ to 4	80	Warm Tone
Selectol	1:1	2	1½ to 4	80	Warm Tone
D-52	1:1	2	1½ to 4	80	Warm Tone
Ektonol	1:3	4	3 to 8	—	Large Prints*
Selectol	1:3	4	3 to 8	—	Large Prints*
D-52	1:3	4	3 to 8	—	Large Prints*
Ektaflo, Type 2	1:9	2	1½ to 4	100	Warm Tone
Selectol-Soft	1:1	2	1½ to 4	80	Lower Contrast
Dektol	1:2	1	¾ to 2	120	Colder Tone
D-72	1:2	1	¾ to 2	100	Colder Tone
Dektol	1:4	2	1½ to 4	—	Large Prints*
D-72	1:4	2	1½ to 4	—	Large Prints*
Ektaflo, Type 1	1:9	1	¾ to 2	120	Colder Tone

*In processing large prints, prolonged development in a dilute solution helps to prevent the streaks and marks caused by uneven development.

TONING RECOMMENDATIONS

Kodak Poly-Toner
Kodak Sepia Toner
Kodak Sulfide Sepia Toner T-7a
Kodak Brown Toner
Kodak Polysulfide Toner T-8
Kodak Hypo Alum Sepia Toner T-1a

(Courtesy of Eastman Kodak Co.)

EASTMAN KODAK

KODAK **PANALURE AND PANALURE PORTRAIT PAPER**

APPLICATIONS

Black-and-white enlargements (or contact prints, with reduced illumination in the printer) from color negatives. Especially useful in the fields of commercial, portrait, and school photography.

CHARACTERISTICS

Panalure—Warm-black image tone. Panalure Portrait—Brown-black image tone. Surface and weight characteristics are listed in the following table:

Kodak Paper	Tint	Brilliance	Texture	Symbol	Weight
Panalure	White	Glossy	Smooth	F	Single Weight
Panalure Portrait	White	Lustre	Fine-Grained	E	Double Weight

SAFELIGHT

KODAK Safelight Filter No. 10 (dark amber)—keep safelight exposure to a minimum.

PRINTING INFORMATION

Kodak Paper	ANSI Paper Speed	
	With Color Negatives	With Black-and-White Negatives
Panalure	250	400
Panalure Portrait	100	160

DEVELOPMENT RECOMMENDATIONS FOR KODAK PANALURE PAPER—AT 68 F (20 C)

Kodak Developer	Dilution	Development Time in Minutes		Cap. (8x10″ prints per gal.)	Purpose
		Recommended	Useful Range		
Ektaflo, Type 1	1:9	1½	1 to 3	120	Warm Tones
Dektol	1:2	1½	1 to 3	120	Warm Tones
D-72	1:2	1½	1 to 3	100	Warm Tones
Versatol	1:3	1½	1 to 3	80	Warm Tones
Ektaflo, Type 2	1:9	2	1 to 3	100	Warmer Tones
Ektonol	1:1	2	1 to 3	80	Warmer Tones
Selectol	1:1	2	1 to 3	80	Warmer Tones
D-52	1:1	2	1 to 3	80	Warmer Tones
Selectol-Soft	1:1	2	1 to 3	80	Lower Contrast

(Courtesy of Eastman Kodak Co.)

EASTMAN KODAK

KODAK **PANALURE AND PANALURE PORTRAIT PAPER** (continued)

DEVELOPMENT RECOMMENDATIONS FOR KODAK PANALURE PORTRAIT PAPER—AT 68 F (20 C)

Kodak Developer	Dilution	Development Time in Minutes		Cap. (8x10″ prints per gal.)	Purpose
		Recommended	Useful Range		
Selectol	1:1	2	1½ to 4	80	Warm Tones
Ektaflo, Type 2	1:9	2	1½ to 4	100	Warm Tones
Selectol-Soft	1:1	2	1½ to 4	80	Lower Contrast
Dektol	1:2	1½	1 to 3	120	Colder Tones
Ektaflo, Type 1	1:9	1½	1 to 3	120	Colder Tones

TONING RECOMMENDATIONS

For Panalure Paper
Kodak Sepia Toner
Kodak Sulfide Sepia Toner T-7a
Kodak Brown Toner
Kodak Polysulfide Toner T-8
Kodak Hypo Alum Sepia Toner T-1a

For Panalure Portrait Paper
Kodak Poly-Toner
Kodak Sulfide Sepia Toner T-7a
Kodak Rapid Selenium Toner
Kodak Polysulfide Toner T-8
Kodak Hypo Alum Sepia Toner T-1a

KODAK **POLYCONTRAST PAPER**

APPLICATIONS

Enlarging paper (or contact-printing paper, with reduced illumination in the printer) particularly useful in the fields of commercial, industrial, photofinishing, and school photography.

Variable-contrast paper for general photographic use and for the darkroom hobbyist.

CHARACTERISTICS

Variable-contrast paper. Use without a filter with normal-contrast negatives, or with KODAK POLYCONTRAST Filters to obtain seven degrees of contrast. Warm-black image tone. Surface and weight characteristics are listed in the following table:

Tint	Brilliance	Texture	Symbol	Weight
White	Glossy	Smooth	F	Single Weight Double Weight
White	Lustre	Smooth	N	Single Weight Double Weight
White	Lustre	Smooth	A	Light Weight
White	High-Lustre	Smooth	J	Single Weight Double Weight
Cream-White	Lustre	Fine-Grained	G	Double Weight

(Courtesy of Eastman Kodak Co.)

EASTMAN KODAK

The Compact Photo-Lab-Index

SAFELIGHT

KODAK Safelight Filter OC (light amber). Because the paper depends on blue and yellow light exposures for contrast control, keep safelight exposures to a minimum to avoid unwanted contrast changes.

PRINTING INFORMATION

Polycontrast Filter	PC 1	PC 1½	PC 2	PC 2½	PC 3	PC 3½	PC 4	No Filter (white light)
ANSI paper Speed	100	125	125	100	100	80	50	160

LIGHT SOURCE FOR PROJECTION PRINTING

Tungsten, similar to a Photo Enlarger No. 212 or 302. Although not recommended for optimum results, light sources other than tungsten may be used with light-source correction filters. Filters suggested as starting points with three common light sources are: CP 40Y or CC40Y with a cool-white (4500 K) fluorescent lamp; a CC or CP correction of 70Y for a 6500 K fluorescent lamp; a combination of the KODAK WRATTEN Filter No. 6 plus a correction of CP40Y or CC40Y with a mercury-arc light source. Light source correction filters are required in addition to the appropriate KODAK POLYCONTRAST Filter that may be used for contrast control.

CONTACT PRINTING

Use KODAK POLYCONTRAST Acetate, 11 x 14-inch, between the printing lights and the negative for contrast control. Reduce the total exposure to approximately 1/10 of that used for a contact speed paper.

DEVELOPMENT RECOMMENDATIONS —AT 68 F (20 C)

Kodak Developer	Dilution	Development Time in Minutes		Cap. (8x10″ prints per gal.)	Purpose
		Recommended	Useful Range		
Dektol	1:2	1½	1 to 3	120	Warm Tones
D-72	1:2	1½	1 to 3	100	Warm Tones
Ektaflo, Type 1	1:9	1½	1 to 3	120	Warm Tones

TONING RECOMMENDATIONS

Kodak Sepia Toner
Kodak Sulfide Sepia Toner T-7a
Kodak Brown Toner
Kodak Polysulfide Toner T-8
Kodak Hypo Alum Sepia Toner T-1a

(Courtesy of Eastman Kodak Co.)

EASTMAN KODAK

KODAK **POLYCONTRAST RAPID PAPER**

APPLICATIONS

Enlarging paper especially useful in the fields of commercial, industrial, photofinishing, and school photography.

Variable-contrast paper for general photographic use.

Valuable for printing from dense negatives and for enlarging small negatives to high magnifications.

CHARACTERISTICS

Variable-contrast paper. Use without a filter with normal-contrast negatives, or with KODAK POLYCONTRAST Filters to obtain seven degrees of contrast. Warm-black image tone. Surface and weight characteristics are listed in the following table:

Tint	Brilliance	Texture	Symbol	Weight
White	Glossy	Smooth	F	Single Weight Double Weight
White	Lustre	Smooth	N	Single Weight
Cream-White	Lustre	Fine-Grained	G	Double Weight
Cream-White	High-Lustre	Silk	Y	Double Weight

SAFELIGHT

KODAK Safelight Filter OC (light amber). Because the paper depends on blue and yellow light exposures for contrast control, limit safelight exposures to 3 minutes or less in order to avoid unwanted contrast changes.

PRINTING INFORMATION

Polycontrast Filter	PC 1	PC 1½	PC 2	PC 2½	PC 3	PC 3½	PC 4	White Light (no filter)
ANSI Paper Speed	250	320	250	200	160	125	64	320

LIGHT SOURCE FOR PROJECTION PRINTING

Tungsten, similar to a Photo Enlarger No. 212 or 302. Although not recommended for optimum results, light sources other than tungsten may be used with light-source correction filters. Filters suggested as starting points with three common light sources are: CP 40Y or CC40Y with a cool-white (4500 K) fluorescent lamp; a CC or CP correction of 70Y for a 6500 K fluorescent lamp; a combination of the KODAK WRATTEN Filter No. 6 plus a correction of CP40Y or CC40Y with a mercury-arc light source. Light-source correction filters are required in addition to the appropriate KODAK POLYCONTRAST Filter that may be used for contrast control.

TONING RECOMMENDATIONS

Kodak Sepia Toner
Kodak Sulfide Sepia Toner T-7a
Kodak Brown Toner
Kodak Polysulfide Toner T-8
Kodak Hypo Alum Sepia Toner T-1a

DEVELOPMENT RECOMMENDATIONS —AT 68 F (20 C)

Kodak Developer	Dilution	Development Time in Minutes		Cap. (8x10″ prints per gal.)	Purpose
		Recommended	Useful Range		
Dektol	1:2	1½	1 to 3	120	Warm Tones
D-72	1:2	1½	1 to 3	100	Warm Tones
Ektaflo, Type 1	1:9	1½	1 to 3	120	Warm Tones

(Courtesy of Eastman Kodak Co.)

EASTMAN KODAK

EASTMAN KODAK

KODAK **POLYCONTRAST RAPID RC PAPER**

APPLICATIONS

This paper combines the variable-contrast characteristics of KODAK POLYCONTRAST Rapid Paper with the water-resistant base of KODAK RESISTO Papers, which gives it broad applications in commercial, industrial, photofinishing, school, press, nightclub, identification, map-making, and general black-and-white photography.

CHARACTERISTICS

Designed for fast and economical processing. Variable-contrast paper. Use without a filter for normal-contrast negatives, or with KODAK POLYCONTRAST Filters to obtain 7 degrees of contrast. Neutral-black image tone. Dimensionally stable and water-resistant base. Surface and weight characteristics are listed in the following table:

Tint	Brilliance	Texture	Symbol	Weight
White	Glossy	Smooth	F	Medium Weight
White	Lustre	Smooth	N	Medium Weight

SAFELIGHT

KODAK Safelight Filter OC (light amber). Because the paper depends on blue and yellow light exposures for contrast control, limit safelight exposures to 3 minutes or less in order to avoid unwanted contrast changes or chance of fog.

PRINTING INFORMATION

Polycontrast Filter	PC 1	PC 1½	PC 2	PC 2½	PC 3	PC 3½	PC 4	White Light (no filter)
ANSI Paper Speed	250	320	250	200	160	100	50	320

LIGHT SOURCE FOR PROJECTION PRINTING

Tungsten, similar to a Photo Enlarger No. 212 or 302. Although not recommended for optimum results, light sources other than tungsten may be used with light-source correction filters. Filters suggested as starting points with three common light sources are: CP 40Y or CC40Y with a cool-white (4500 K) fluorescent lamp; a CC or CP correction of 70Y for a 6500 K fluorescent lamp; a combination of the KODAK WRATTEN Filter No. 6 plus a correction of CP40Y or CC40Y with a mercury-arc light source. Light-source correction filters are required in addition to the appropriate KODAK POLYCONTRAST Filter that may be used for contrast control.

DEVELOPMENT RECOMMENDATIONS —AT 68 F (20 C)

Kodak Developer	Dilution	Development Time in Minutes		Cap. (8x10″ prints per gal.)	Purpose
		Recommended	Useful Range		
Dektol	1:2	1½	1 to 3	120	Neutral Tones
D-72	1:2	1½	1 to 3	100	Neutral Tones
Ektaflo, Type 1	1:9	1½	1 to 3	120	Neutral Tones

(Courtesy of Eastman Kodak Co.)

KODAK **POLYCONTRAST RAPID RC PAPER** (continued)

RINSE
For 5 seconds, with agitation, in KO-DAK EKTAFLO Stop Bath, KODAK Indicator Stop Bath, or in KODAK Stop Bath SB-1, at 65 to 70 F (18 to 21 C).

FIX
2 minutes, with agitation at 65 to 70 F (18 to 21 C) in a fresh solution prepared from KODAK EKTAFLO Fixer, KODAK Fixer, KODAK Rapid Fixer, KODAFIX Solution, or in KODAK Fixing Bath F-5 or F-6.

WASH
For 4 minutes only, with agitation, at 65 to 70 F (18 to 21 C).

DRYING
Sponge surface water from both sides of prints, and dry prints at room temperature, by circulated warm air, or on a double belt drum dryer. The drum temperature should not exceed 190 F (88 C). Low drying temperatures provide maximum dimensional stability.

MOUNTING
KODAK POLYCONTRAST RC Papers can be dry-mounted if the temperature of the press does not exceed 190 F (88 C). Small prints can be mounted with KODAK Rapid Mounting Cement.

TONING RECOMMENDATIONS
Kodak Sepia Toner
Kodak Sulfide Sepia Toner T-7a
Kodak Brown Toner
Kodak Polysulfide Toner T-8
Kodak Hypo Alum Sepia Toner T-1a

KODAK **PORTRALURE PAPER**

APPLICATIONS
Enlarging paper (or contact-printing paper, with reduced illumination in the printer) particularly suitable for portrait and exhibition printing.

CHARACTERISTICS
Brown-black image tone. The warm image tone may make it possible, in some cases, to oil-color a print without toning. Wide development latitude. Excellent toning and oil-coloring characteristics. Use without a filter with normal contrast negatives. Limited contrast variability may be obtained by the use of KODAK POLYCONTRAST Filters. Surface and weight characteristics are listed in the following table:

Tint	Brilliance	Texture	Symbol	Weight
Warm-White	Lustre	Fine-Grained	G	Double Weight
Warm-White	Matte	Smooth	M	Double Weight
Cream-White	Lustre	Tweed	R	Double Weight
Warm-White	High-Lustre	Silk	Y	Double Weight

SAFELIGHT
KODAK Safelight Filter OC (light amber)—total safelight exposure not to exceed 3 minutes.

PRINTING INFORMATION

Polycontrast Filter	PC 1	PC 3	No Filter (white light)
ANSI Paper Speed	32	20	50

(Courtesy of Eastman Kodak Co.)

EASTMAN KODAK

215

KODAK **PORTRALURE PAPER** (continued)

LIGHT SOURCE FOR PROJECTION PRINTING

Tungsten, similar to a Photo Enlarger No. 212 or 302. Although not recommended for optimum results, light sources other than tungsten may be used with light-source correction filters. Filters suggested as starting points with three common light sources are CP 40Y or CC40Y with a cool-white (4500 K) fluorescent lamp; a CC or CP correction of 70Y for a 6500 K fluorescent lamp; a combination of the KODAK WRATTEN Filter No. 6 plus a correction of CP40Y or CC40Y with a mercury-arc light source. Light-source correction filters are required in addition to the appropriate KODAK POLY-CONTRAST Filter that may be used for contrast control.

CONTACT PRINTING

Because of the speed of this paper, reduce exposure significantly from that used for an average contact-printing paper. KODAK POLYCONTRAST Acetate Filters PC1 or PC3, 11 x 14-inch, can be used between the printing lights and the negative for contrast control.

DEVELOPMENT RECOMMENDATIONS —AT 68 F (20 C)

Kodak Developer	Dilution	Development Time in Minutes		Cap. (8x-0″ prints per gal.)	Purpose
		Recommended	Useful Range		
Selectol	1:1	2	1¼ to 4	80	Warm Tone
Ektaflo, Type 2	1:9	2	1¼ to 4	100	Warm Tone
Ektonol	1:1	2	1¼ to 4	80	Warm Tone
D-52	1:1	2	1¼ to 4	80	Warm Tone
Selectol-Soft	1:1	2	1¼ to 4	80	Lower Contrast
Dektol	1:2	1	¾ to 2	80	Colder Tone

TONING RECOMMENDATIONS

Kodak Rapid Selenium Toner
Kodak Poly-Toner
Kodak Gold Toner T-21
Kodak Hypo Alum Sepia Toner T-1a

Kodak Brown Toner
Kodak Polysulfide Toner T-8
Kodak Sulfide Sepia Toner T-7a
Kodak Sepia Toner

KODAK **RESISTO**

APPLICATIONS

Intended for jobs that require fast print service or moderately close size maintenance; valuable for newspaper photographers, night-club operators, identification pictures, and map-making.
 KODAK RESISTO Paper is for contact printing.

SAFELIGHT

KODAK Safelight Filter OC (light amber)

CHARACTERISTICS

Image-tone, paper-base, surface, and contrast characteristics are listed in the following tables:

Paper	Image Tone	Base
Resisto	Neutral-Black	dimensionally stable and water-resistant

(Courtesy of Eastman Kodak Co.)

EASTMAN KODAK

KODAK **RESISTO** (continued)

Paper	Tint	Brilliance	Texture	Symbol	Weight	Grade
Resisto	White	Lustre	Smooth	N	Single Weight	No. 2, 3

PRINTING INFORMATION

Paper Grade	No. 1	No. 2	No. 3	No. 4
ANSI Speed—Resisto	—	6	6	—

DEVELOPMENT RECOMMENDATIONS FOR RESISTO AND RESISTO RAPID—AT 68 F (20 C)

Kodak Developer	Dilution	Development Time in Minutes		Cap. (8x10″ prints per gal.)
		Recommended	Useful Range	
Ektaflo, Type 1	1:9	1	¾ to 2	120
Dektol	1:2	1	¾ to 2	120
D-72	1:2	1	¾ to 2	100

DRYING

Sponge surface water from both sides of prints, and dry prints at room temperature, by circulated warm air, or on a double-belt drum dryer. The drum temperature should not exceed 190 F (88 C). Low drying temperatures provide maximum dimensional stability.

MOUNTING

Prints made on KODAK RESISTO Paper can be dry-mounted if the temperature of the press does not exceed 190 F (88 C). Small prints can be mounted with KODAK Rapid Mounting Cement.

RINSE

For 5 seconds, with agitation, in KODAK EKTAFLO Stop Bath, KODAK Indicator Stop Bath, or in KODAK Stop Bath SB-1, at 65 to 70 F (18 to 21 C).

FIX

2 minutes, with agitation at 65 to 70 F (18 to 21 C) in a fresh solution prepared from KODAK EKTAFLO Fixer, KODAK Fixer, KODAK Rapid Fixer, KODAFIX Solution, or in KODAK Fixing Bath F-5 or F-6.

WASH

For 4 minutes only, with agitation, at 65 to 70 F (18 to 21 C).

(Courtesy of Eastman Kodak Co.)

EASTMAN KODAK

KODAK VELOX PAPER

CHARACTERISTICS

Blue-black image tone. Surface and characteristics are listed in the following table:

APPLICATIONS

Contact printing of negatives.

SAFELIGHT

KODAK Safelight Filter OC (light amber)

Tint	Brilliance	Texture	Symbol	Weight	Grade
White	Glossy	Smooth	F	Single Weight	No. 1, 2, 3, 4

PRINTING INFORMATION

Paper Grade	No. 1	No. 2	No. 3	No. 4
ANSI Paper Speed	10	5	4	2

DEVELOPMENT RECOMMENDATIONS
—AT 68 F (20 C)

Kodak Developer	Dilution	Development Time in Minutes		Cap. (2½x3½" prints per quart)	Purpose
		Recommended	Useful Range		
Dektol*	1:2	1	¾ to 2	275	Cold Tones
D-72	1:2	1	¾ to 2	230	Cold Tones
Ektaflo, Type 1	1:9	1	¾ to 2	275	Cold Tones
Versatol	1:3	1	¾ to 2	180	Cold Tones

*If you are using KODAK Tri-Chem Packs, dissolve a packet of developer (Dektol) in 8 ounces of water and develop prints for 1 minute at 68 F (20 C). The developer capacity of a packet is approximately fifty 2½ x 3½-inch prints per 8 ounces of developer solution.

TONING RECOMMENDATIONS

Kodak Sepia Toner
Kodak Sulfide Sepia Toner T-7a
Kodak Hypo Alum Sepia Toner T-1a

ADDITIONAL INFORMATION

In addition the contact-speed paper described in this data sheet, three other kinds of VELOX Paper are manufactured: KODAK VELOX Rapid, VELOX UNICONTRAST, and VELOX PREMIER Paper. These materials are used mainly in commercial photofinishing for continuous-roll printing and processing.

(Courtesy of Eastman Kodak Co.)

EASTMAN KODAK

KODAK **SUPER SPEED DIRECT POSITIVE PAPER**

An orthochromatic neutral-tone emulsion of sufficient speed for camera use from which a positive print is produced by chemical reversal. Its water-resistant paper base permits rapid processing and drying. It has a smooth, matte surface, and is available in rolls or sheets.

EXPOSURE

Good results with Kodak Super Speed Direct Positive Paper can be secured only if the exposure is correct. Therefore the lighting arrangement must be standardized to a degree which will produce uniform and reproducible exposures. Underexposures will result in prints which are too dark, while overexposure will result in prints which are too light and lacking detail in the lighter portions of the picture.

Moisture and dust in the air will cause the outside surfaces of the camera lens to become coated with a film of dirt which diffuses the light and produces a flat and fogged effect in the prints. To prevent trouble from this source, clean the lens regularly; and if the camera is equipped with a reversing prism, be sure to clean this also.

SAFELIGHT

KODAK Super Speed Direct Positive Paper should be handled and developed by the light of a KODAK Safelight Filter No. 2 (dark red), in a suitable safelight lamp **with a 15-watt bulb, kept at least 4 feet from the paper.**

Note: Excessive safelight exposure caused by the use of the wrong safelight filter or a faded safelight filter, or by the safelight being too close to the paper, will make the finished prints too light.

PROCESSING

In the processing of KODAK Super Speed Direct Positive Paper, there are the three simple but extremely important rules to be followed; neglect of these precautions will cause stains, streaks, and general loss of quality.

1. Wash the prints for at least 15 seconds in running water between the different solutions. If running water is not available, use separate containers for washing the prints after each solution.

2. Do not allow one chemical solution to contaminate another. Always use the same trays for the same solutions, and wash them thoroughly after use.

3. Do not use exhausted solutions. Replace each solution as soon as its action becomes noticeably slow.

KODAK **PREPARED CHEMICALS**

Correctly prepared chemicals for making each of the processing solutions needed for KODAK Direct Positive Paper, are supplied in convenient packages. **KODAK Developer D-88, KODAK Bleach, KODAK Clearing Bath, KODAK Fixer, and KODAK Direct Positive Paper Redeveloper** are available in units to make 1 gallon of working solution. **KODAK Direct Positive Toning Redeveloper** is available in units to make 2 gallons of working solution.

DEVELOPMENT

Develop the prints for 45 seconds to 1 minute in **KODAK Developer D-88** at 68 F (20 C); then wash them for at least 15 seconds in running water.

Note: KODAK Developer D-88 has a short life after exposure to the air; if desired, it can be stored longer after mixing by dividing the solution into four 1-quart bottles filled to the neck and tightly stoppered.

Underdevelopment in the first developer, like underexposure, will result in prints which are too dark; while overdevelopment, like overexposure, will result in prints which are too light. The developer should not be overworked or allowed to remain in the developing tray for too long a time; otherwise yellow stains caused by developer oxidation will occur.

(Courtesy of Eastman Kodak Co.)

EASTMAN KODAK

KODAK DEVELOPER D-88

Dissolve chemicals in the order given:	Avoirdupois U.S. Liquid	Metric
Water about 125 F (50C)	96 ounces	750 ml
KODAK Sodium Sulfite, desiccated	6 ounces	45.0 grams
KODAK Hydroquinone	3 ounces	22.5 grams
*KODAK Boric Acid, **crystals**	¾ ounce	5.5 grams
KODAK Potassium Bromide	145 grains	2.5 grams
**KODAK Sodium Hydroxide (Caustic Soda)	3 ounces	22.5 grams
Water to make	1 gallon	1.0 liter

*Boric acid should be used in the crystal form. The powdered variety is difficult to dissolve.

**Caution: Dissolve the caustic soda in a small volume of water in a separate container; then add it to a solution of the remaining constituents and dilute the whole to 1 gallon. If a glass container is used for dissolving the caustic soda, stir the mixture constantly until the soda is dissolved, to prevent cracking the container by the heat evolved.

BLEACHING

Bleach the prints in **KODAK Bleach** or KODAK Bleaching Bath R-9 for about 30 seconds at 65 to 75 F (18 to 24 C); then wash them for at least 15 seconds in running water. The prints must remain in the bleach until the image disappears.

KODAK BLEACHING BATH R-9

	Avoirdupois U.S. Liquid	Metric
Water	1 gallon	1.0 liter
KODAK Posassium Bichromate	1¼ ounces	9.5 grams
*Sulfuric Acid, concentrated	1½ ounces	12.0 ml

*Caution: Always add the sulfuric acid to the water slowly, stirring constantly, and never the water to the acid; otherwise the solution may boil and spatter the acid on the hands or face causing serious burns.

CLEARING

Clear the prints in **KODAK Clearing Bath** or KODAK Clearing Bath CB-1 for about 30 seconds at 65 to 70 F (18-21 C); then wash them for at least 15 seconds in running water. When the prints are placed in the clearing bath, the white light ca be turned on and left on. Be sure to clear the prints for the full time; otherwise yellow stains may rseult.

KODAK CLEARING BATH CB-1

	Avoirdupois U.S. Liquid	Metric
KODAK Sodium Sulfite, desiccated	12 ounces	90 grams
Water	1 gallon	1 liter

(Courtesy of Eastman Kodak Co.)

The Compact Photo-Lab-Index

RE-EXPOSURE

Either turn on the white light as soon as the prints are placed in the clearing bath or expose the prints for 2 or 3 seconds to a 40-or-60-watt bulb placed 6 to 8 inches from the paper.

Note: Re-exposure is necessary only for prints which are to be redeveloped in KODAK Developer D-88.

REDEVELOPMENT

For black-and-white results, redevelop the prints in a fresh batch of **KODAK Developer D-88, KODAK Direct Positive Paper Redeveloper,** or **KODAK Sulfide Redeveloper T-19.**

If **KODAK Developer D-88** is used, redevelop the prints for about 30 seconds at 68 F (20 C) then wash the prints for 30 seconds* in running water.

*After redevelopment with KODAK Developer D-88, results of slightly greater brilliance can be secured by rinsing the pirnts in running water and then fixing them for about 30 seconds at 68 F (20 C) in a solution prepared from **Kodak Fixer** or in Kodak Fixing Bath F-5 or F-6. If the prints are fixed, it is important to **wash them for 5 to 10 minutes after fixing** to insure removal of the hypo. Fixing is not necessary to make black-and-white prints permanent.

If either **KODAK Direct Positive Paper Redeveloper** or KODAK Sulfide Redeveloper T-19 is used, redevelop the prints for about 60 seconds; then drain, rinse and dry the prints.

KODAK **SULFIDE REDEVELOPER T-19**

	Avoirdupois U.S. Liquid	Metric
Kodak Sodium Sulfide (not Sulfite)	290 grains	20 grams
Water	32 ounces	1 liter

For brown tones, redevelop the prints in **KODAK Direct Positive Toning Redeveloper** for about 60 seconds.

DRYING

The emulsion of KODAK Super Speed Direct Positive Paper is coated on a water-resistant support, and the drying of prints is therefore rapid. To hasten drying, artificial heat can be employed if desired.

SUMMARY OF PROCESSING
KODAK **BLACK-AND-WHITE-PAPERS**

CONVENTIONAL PAPERS

DEVELOPMENT

Recommended developers and development times are given in the appropriate data sheets. The "Purpose" column in the table of development recommendations in the data sheets shows the effects of the developers on image tone and contrast, if any.

For best results, maintain the developer temperature at 68 F (20 C). To avoid uneven development, keep the prints completely immersed in the solution, and agitate them throughout the developing time.

STOP BATH

Rinse the prints for 5 to 10 seconds, **with agitation,** in one of the following stop baths: KODAK Indicator Stop Bath, KODAK EKTAFLO Stop Bath,

(Courtesy of Eastman Kodak Co.)

EASTMAN KODAK

EASTMAN KODAK

or KODAK Stop Bath SB-1. Indicator Stop Bath and EKTAFLO Stop Bath are yellow liquids that turn purplish blue when exhausted. At this point, they should be discarded.

FIXING

Fix the prints, **with agitation,** for 5 to 10 minutes at 65 to 70 F (18 to 21 C) in one of the recommended Kodak fixers. For the most efficient fixing and the greatest economy of chemicals, use the two-bath fixing system in which prints are fixed for 3 to 5 minutes in each of two successive baths.

WASHING

After fixing the prints, wash them for 1 hour either in a tray equipped with a KODAK Automatic Tray Siphon, or in a washing tak where the water changes completely every 5 minutes. For efficient washing, the water should be at 65 to 75 F (18 to 24 C).

To conserve water, to reduce washing time, and to obtain more complete washing, use KODAK Hypo Clearing Agent before washing. This preparation saves at least two-thirds of the time needed to wash single-, light-, and double-weight papers. Directions for use of KODAK Hypo Clearing Agent are printed on the package.

DRYING

To promote even drying, sponge the surface water from the backs and fronts of the prints, and then place them on drying racks, or between clean photo blotters, or on a drying machine.

FERROTYPING

All Kodak F-surface papers except RC papers can be ferrotyped by squeegee-ing them in contact with chromium-plated sheets, or by use of a ferrotyp-ing machine.

TONING

The primary toners recommended for use with particular papers are given in the data sheets. Toners other than pri-mary may be used to secure tones for special-purpose applications. Formulas for KODAK Toner T-21, KODAK Polysulfide Toner T-8, KODAK Sul-fide Sepia Toner T-7a, and KODAK Hypo Alum Sepia Toner T-1a are given in Kodak Data Book No. J-1, **Processing Chemicals and Formulas,** available from photo dealers.

RESIN-COATED PAPERS

Developing recommendations are given in the appropriate data sheets. Stop bath recommendations are as above for regular papers.

Fix, with agitation, for 2 minutes in one of the recommended fixers.

Wash as above for regular papers, but for 4 minutes only. There is no need to use KODAK Hypo Clearing Agent.

Sponge or squeegee the water from the surface of the prints and air-dry. Do not ferrotype F-surface RC papers; they dry to a high gloss without ferro-typing. Warm air circulation shortens the drying time.

See text for further drying instruc-tions.

TONING

See the data sheet for appropriate toners.

Wash for 4 minutes after fixing and for 4 minutes after toning. Avoid leav-ing RC papers in water and or solu-tions for longer times than recom-mended or the advantages of the resin-coating may be lost.

PROCESSING KODAK EKTAMATIC SC PAPER

This paper is designed to be processed in an activator-stabilizer processor such as the KODAK EKTAMATIC Pro-cessor, Model 214-K, which processes about 5.9 feet of paper per minute. It can also be processed as a conventional paper in the developers listed on the data sheet, and following the proce-dures for conventional papers shown elsewhere on this page.

(Courtesy of Eastman Kodak Co.)

KODABROME II Paper and EKTABROME SC Paper

(For Machine Processing on Kodak Royalprint Processor Model 417 and many roller transport and continuous paper processors that employ ordinary black-and-white paper processing solutions.

KODABROME II Paper

DESCRIPTION

A fast black-and-white enlarging paper for general purposes. Available in five contrast grades: Soft, Medium, Hard, Extra Hard, and Ultra Hard.

CHARACTERISTICS

The paper has a developing agent incorporated in the emulsion. It has a water resistant base for rapid processing and drying. Image tone is warm black and the paper is optically brightened for brilliant prints.

SURFACES

The F (smooth glossy) surface does not require ferrotyping, but dries to a glossy finish.

It is also available in N (smooth lustre) surface.

PROCESSING

The **Kodak Royalprint Processor,** Model 417 yields dry, properly fixed and washed prints in 55 seconds for two 8 x 10 prints, and can handle paper up to 17 inches wide. Minimum length is 5 inches.

This paper can be processed in some roller transport and continuous paper processors that use ordinary black and white processing solutions. It is not a stabilization paper.

Prints have optimum process stability, the highest of the three American National Standards Institute (ANSI) categories, the lower two being **short term,** and **commercial.** Prints processed with this paper on the Model 417 are as stable or more stable than conventionally processed prints made on resin-coated paper.

EKTABROME SC Paper

DESCRIPTION

A fast enlarging paper with selective contrast for general purpose black and white printing.

CHARACTERISTICS

Developing agent is incorporated in the emulsion. Contrast is controlled by the use of filters in the enlarger. It has a water resistant base for rapid processing and drying. Image tone is warm black and the paper is optically brightened for brilliant prints.

SURFACES

The F (smooth glossy) surface does not require ferrotyping, but dries to a glossy finish.

It is also available in N (smooth lustre) surface.

PROCESSING

The **Kodak Royalprint Processor,** Model 417 yields dry, properly fixed and washed prints in 55 seconds for two 8 x 10 prints, and can handle paper up to 17 inche wide. Minimum length is 5 inches.

This paper can be processed in some roller transport and continuous paper processors that use ordinary black and white processing solutions. It is not a stabilization paper.

Prints have optimum process stability, the highest of the three American National Standards Institute (ANSI) categories, the lower two being **short term,** and **commercial.** Prints processed with this paper on the Model 417 are as stable or more stable than conventionally processed prints made on resin-coated paper.

EASTMAN KODAK

The Compact Photo-Lab-Index

EASTMAN KODAK

KODAK **EKTACHROME PROCESS E-6**

PROCESSING THE FILMS

KODAK chemicals for Process E-6, in various sizes, are available for processing the new KODAK Ektachrome professional films in small and large tanks, in rack-and-tank processors, in rotary tubes, and in continuous processing machines, such as the KODAK EKTACHROME E-6 Processor. Kodak chemicals for Process E-6 are supplied as liquids and liquid concentrates in Cubitainers® for in-line replenishment.

Here are some important items to consider about sink-line processing for these films:

1. For better temperature control at lower cost: (a) Use recirculated heated water. (b) Use stainless steel tank for the first developer.

2. To conserve water and energy in wash steps, nonflowing washes can be used.

3. Only manual agitation is recommended for roll film on reels.

4. Gaseous-burst agitation is recommended for sheet film.

5. Nitrogen used for the first and color developers must be humidified.

6. Air used for the bleach and fixer must be oil-free.

7. The gaseous-burst agitation consists of a 2-second burst every 10 seconds Initial manual agitation must be used in sink lines.

8. No gaseous-burst agitation should be given in the reversal bath, conditioner, or stabilizer.

9. An initial manual agitation is required in each solution except the reversal bath, conditioner, and stabilizer. In these solutions, merely tap the hangers or reels to dislodge air bubbles.

10. The agitation procedures are similar to those used for Process E-3 films.

SUMMARY OF STEPS FOR PROCESS E-6 SINK LINE (TENTATIVE)

Solution of Procedure	Remarks	Temperature °C	°F	Time in Minutes*	Total Time End of Step
1. First Developer	First three	38±0.3	100.4±0.5	6†	6
2. First Wash‡	steps in	33 to 39	92 to 102	2	8
3. Reversal Bath	total darkness	33 to 39	92 to 102	2	10
Remaining steps can be done in normal room light					
4. Color Developer		38±0.6	100.4±1.1	6	16
5. Conditioner		33 to 39	92 to 102	2	18
6. Bleach		33 to 39	92 to 102	6	24
7. Fixer		33 to 39	92 to 102	4	28
8. Final Wash‡	Two tanks:	33 to 39	92 to 102	2	30
	Counterflow	33 to 39	92 to 102	2	32
9. Stabilizer		Ambient		½	32½
10. Dry	Remove films from hangers or reels before drying	Not over 60	Not over 140		

*Include drain time of 10 seconds in each step.

†Time for nitrogen agitation for sheet films. Increase time by 15 seconds when only manual agitation is used. Manual agitation must be used for roll films in reels.

‡For flowing water washes. Nonflowing water washes can be used as follows: for the first wash, use a single tank filled with water at 25 to 39°C (77 to 102°F).

The Compact Photo-Lab-Index

EASTMAN KODAK

Replace this wash after two processing runs, regardless of the quantity of film processed. For the final wash, use three tanks filled with water at 20 to 39°C (68 to 102°F) for two minutes each. Replace the water in all three tanks after four processing runs, regardless of the total quantity of film procssed. Do not use any final wash tank for a first wash tank. All wash tanks should be drained at the end of each day and left empty over night.

Film Exposure	First Development Time
One stop under	Approx. 8 minutes
(Normal)	(6 minutes)
One stop over	Approx. 4\minutes

IDENTIFYING PROCESSED E-6 EKTACHROME FILMS

Kodak-processed and mounted E-6 Ektachrome slides have a plus (+) symbol on the front and back of the mounts to distinguish them from E-4 Ektachrome slides. Other laboratories may use the same symbol for this purpose. On un-mounted E-6 Ektachrome film strips, the edge print reads "Kodak Safety Film," followed by a four-digit code number. This is repeated at approximately 2-inch intervals. A solid square follows each frame number. On 135-20 size film, the three-digit emulsion number appears at the No. 4 frame; on 135-36 size film, the emulsion number is at the No. 21 frame. In addition, the 135-size E-6 films have a 0.05-inch-diameter hole after every fourth perforation along one edge. Long rolls of 35mm E-6 films are frame numbered 1 through 44, and the emulsion number is printed at 12-inch intervals. The 120-size film has frame numbers 1 through 12, with the emulsion number between the 3rd and 4th frame. Sheet films can be identified by code notches.

RETOUCHING DYES FOR E-6 TRANSPARENCIES

Use KODAK E-6 Transparency Retouching Dyes for retouching original trans-parencies intended for photomechanical reproduction or for duplicating on KODAK EKTACHROME Duplicating Film 6121 (Process E-6). Process E-3 retouching dyes can be used but some color mismatch may result.

PROCESSING ADJUSTMENTS FOR UNDEREXPOSED OR OVEREXPOSED FILMS

Process E-6 Ektachrome professional film should always be exposed at its stated effective speed for the best results. Compensating for under- or over-exposure with process adjustments produces a loss in picture quality. Underexposed and over-developed film results in a loss of D-max, a decrease in exposure latitude, a color balance shift, and a significant increase in contrast. Overexposure and under-developed film results in a low toe contrast and a color shift. If these losses in quality can be tolerated, and if the processing machine has the flexibility, the first development time in the following table can be used as a guide to compensate for abnormal exposures.

PRINTING THE FILMS

No infrared cutoff filter is required when E-6 Ektachrome films are printed onto KODAK EKTACHROME RC Paper, Type 1993. It is recommended, however, that a KODAK infrared Cutoff Filter No. 301A be used for printing mixtures of Process E-3, E-4, and E-6 Ektachrome films for printing compatibility.

DUPLICATING THE FILMS

Two new Ektachrome duplicating films for use with Process E-6 are available

for making duplicate transparencies. KODAK EKTACHROME Duplicating Film 6121 (Process E-6) is a color sheet film for the making of high-quality duplicate color transparencies.

KODAK EKTACHROME Slide Duplicating Film 5071 (Process E-6) is available in 135-36 size and long rolls in 35mm and 46mm widths. It is for making duplicate slides from original Kodachrome and Kodak Ektachrome transparencies.

IDENTIFYING E-6 PROCESSING ERRORS

When the effects of inadequate storage or improper exposure are eliminated as the causes of poor-quality Ektachrome transparencies, incorrect processing in Process E-6 may be the source of the fault. Errors can occur in chemical mixing, order of solutions in processing, solution temperatures, agitation rates, washing, replenishment rates and contamination of processing solutions. The table relates abnormal appearance of the processed film to possible causes.

Visual examination of processed films is one method for discovery of processing faults. While such examination may point out the type of processing error, it cannot provide all of the information to correct the deficiency. The extent of deviation from normal and the corrective action required are more readily assessed with the aid of sensitometric control strips which are evaluated on a densitometer or compared with a reference strip.

VISUAL EXAMINATION OF PROCESSED FILM

Appearance of Film	Possible Fault
Very High Maximum Density (no image apparent)	First developer and color developer reversed. First developer omitted.
Dark Overall	Inadequate time or low temperature in first developer. First developer diluted, exhausted, or under-replenished. Color developer starter added to first developer.
Very Dark (overall or in random areas)	Bleach or fixer (or both) omitted, reversed, diluted, exhausted, or underreplenished.
Light Overall	Excessive time or high temperature in first developer. Film fogged by light prior to processing. First developer too concentrated. First developer overreplenished or starter omitted in preparation of working (tank) solution. First developer contaminated with color developer.
Light Overall, Blue Color Balance	First developer contaminated with fixer.
Overall Density Variation from Batch to Batch	Inconsistencies in time, temperature, agitation, or replenishment of first developer.

EASTMAN KODAK

VISUAL EXAMINATION OF PROCESSED FILM (Continued)

Appearance of Film	Possible Fault
Blue	Reversal bath too concentrated. Color developer alkalinity too low. Excessive color developer starter used in preparing tank solution. Color developer replenisher mixed with Part B only. Process E-4 used in error.
Cyan	First and color developers underreplenished.
Yellow	Color developer alkalinity too high. Color developer starter added to first developer. Color developer replenisher mixed with only Part A.
Low Densities, Blue-Green, High Densities Yellow	Color developer contaminated with first developer. Color developer contaminated with fixer.
Blue-Red with High Maximum Density	Color developer replenisher too dilute.
Green	Reversal bath exhausted, diluted, or under-replenished. Film fogged by green safelight. Wash used between reversal bath and color developer.
Very Yellow	Film exposed through base. Film fogged by room lights during first developer step.
Cross-Width Bar Marks (When using stainless steel reels)	Gaseous burst agitation used in first developer.
Scum and Dirt*	Stabilizer requires replacement. (Replace once a week.) Filters in recirculating systems require replacement. (Change once a week.) Air filters in dryer need changing. Dirt in other solutions. Use floating covers on tanks and replenisher solutions whenever possible. Stabilizer too concentrated.

*Foreign particles may be due to buildup of fungus or algae in processing solutions or wash tanks. To minimize this buildup, drain water wash tanks when not in use. When the processing equipment will be out of use for more than 6 weeks, drain and rinse the reversal bath tank and replenisher storage tanks. To remove fungus or algae, scrub the tanks with a stiff brush and a sodium hypochlorite solution (1 part household bleach to 9 parts water). Rinse the tank thoroughly with water to remove the last traces of sodium hypochlorite solution. Use a 50-micrometer (or finer) filter in the water supply.

EASTMAN KODAK

KODAK **EKTACHROME CHEMICALS FOR PROCESS E-6**

Process E-6 was developed for the processing of new KODAK EKTACHROME Films introduced in the past several years. The Process E-6 chemicals are now available in convenient kit form.

The KODAK EKTACHROME Film Processing Kit, Process E-6, contains first developer, reversal bath, color developer, conditioner, bleach, fixer, and stabilizer.

All chemicals are supplied as easy-to-mix concentrates, ready to dilute and use. They are available separately in larger concentrate quantities.

Process E-6 offers improved uniformity and process stability for consistently high-quality results without frequent adjustment of the process. It meets expected environmental requirements and, when operated to capacity, uses less water and energy than earlier processes.

Using Process E-6, roll films can be processed in one-pint tanks, sink lines and automatic processors. Sheet films can be processed in sink lines and automatic processors. Following is a Process E-6 summary of steps for one-pint tanks:

PROCESS E-6 SUMMARY OF STEPS (for 1-Pint Tanks)

Solution or Procedure	Remarks	Temperature		Time in Minutes	Total Time at End of Step
		°C	°F		
1. First Developer	First 4 steps in total darkness. Initial and subsequent agitation in first 3 steps	37.8±0.3	100±½	7	7*
2. Wash†		33.5-39	92-102	1	8
3. Wash†		33.5-39	92-102	1	9
4. Reversal Bath	Initial only	33.5-39	92-102	2	11
Remaining steps can be done in normal room light.					
5. Color Developer	Initial and subsequent agitation	37.8±1.1	100±2	6	17
6. Conditioner	Initial only	33.5-39	92-102	2	19
7. Bleach	Initial and subsequent agitation	33.5-39	92-102	7	26
8. Fixer	Initial and subsequent agitation	33.5-39	92-102	4	30
9. Wash (running water)	Initial and subsequent agitation	33.5-39	92-102	6	36
10. Stabilizer	Initial only	33.5-39	92-102	1	37
11. Dry	Remove film from reels; temperature should not exceed 4949°C (120°F)				

*For initial films through a 1-pint set of solutions. See instruction sheet for times or subsequent films through the same set of solutions.

†Still water washes. Alternate wash in running water for 2 minutes.

SEE CHEMICAL TABLE NEXT PAGE

EASTMAN KODAK

KODAK EKTACHROME CHEMICALS FOR PROCESS E-6

NAME	Process E-6 Chemicals SIZES—To Make:						Process E-6AR Chemicals A 5-gal Cubitainer® will prepare the following amounts of Replenisher°
	1 pint	½ gal	1 gal	3½ gal	5 gal	25 gal	
KODAK EKTACHROME Film Processing Kit, Process E-6							
KODAK Developer Kit, Process E-6	• Contains two 1-pint units of First and Color Developers						
KODAK First Developer, Process E-6				•	•		
KODAK First Developer Replenisher, Process E-6			•				
KODAK First Developer Replenisher, Process E-6AR							25 gallons
KODAK First Developer Starter, Process E-6			Starts 25 gallons				
KODAK Reversal Bath, Process E-6			•				
KODAK Reversal Bath and Replenisher, Process E-6				•		•	
KODAK Reversal Bath and Replenisher, Process E-6AR							100 gallons
KODAK Color Developer, Process E-6				•	•		
KODAK Color Developer Replenisher, Process E-6			•				
KODAK Color Developer Replenisher, Part A, Process E-6AR							25 gallons
KODAK Color Developer Replenisher, Part B, Process E-6AR							25 gallons
KODAK Color Developer Starter, Process E-6			Starts 25 gallons				
KODAK Conditioner, Process E-6				•			
KODAK Conditioner and Replenisher, Process E-6			•				
KODAK Conditioner and Replenisher, Process E-6AR							25 gallons
KODAK Bleach, Process E-6				•			
KODAK Bleach Replenisher, Process E-6AR							5 gallons
KODAK Bleach Starter, Process E-6			Starts 25 gallons				
KODAK Fixer, Process E-6				•			
KODAK Fixer and Replenisher, Process E-6			•			•	
KODAK Fixer and Replenisher, Process E-6AR							50 gallons
KODAK Stabilizer, Process E-6				•			
KODAK Stabilizer and Replenisher, Process E-6			•			•	
KODAK Stabilizer and Replenisher, Process E-6AR							320 gallons
KODAK Defoamer (4 oz. bottle)		•					

°For use in automatic replenishment processes or can be used to prepare varying quantities of replenishers or working solutions.

230

MANUAL PROCESSING OF BLACK-AND-WHITE FILMS

KODAK CHEMICALS
FOR MANUAL PROCESSING

Indicates Recommended Kodak Chemicals

Kodak Black-and-White Films	Kodalith	Developer D-8	Developer D-11	Developer D-19	Developer DK-50	Developer D-76	HC-110 Developer	Dektol Developer	Microdol-X Developer	Polydol Developer	Indicator Stop Bath	Kodafix Solution	Fixer	Rapid Fixer
Commercial 4127/6127		■			■									
Contrast Process Ortho 4154		■												
Contrast Process Pan 4155		■												
Ektapan 4162														
Fine Grain Positive 7302/5302														
High Contrast Copy 5069														
High Speed Infrared 4143														
Pan Masking 4570														
Panatomic-X														
Panatomic-X Professional														
Plus-X Pan and Plus-X Portrait 5068														
Plus-X Pan Professional 2147/4147														
Professional Copy 4125			■											
Recording 2475														
Royal Pan 4141														
Royal-X Pan 4166														
Separation Negative 4131, Type 1														
Separation Negative 4133, Type 2			■											
Super-XX Pan 4142														
Tri-X Ortho 4163														
Tri-X Pan														
Tri-X Pan Professional 4164														
Verichrome Pan (Cirkut)														
Verichrome Pan														

EASTMAN KODAK

The Compact Photo-Lab-Index

KODAK DEVELOPERS—Major Properties and Uses

D-8—Extremely high contrast, fast, tray developer which produces high densities on process and continuous-tone films.

D-11—High-contrast tray or tank developer for commercial and graphic arts work, and for film positives and lantern slides.

D-19—A high-capacity tank and tray developer that yields high-contrast negatives in short times. Suited to technical and scientific work.

HC-110—A very versatile developer that comes in concentrated form. Dilution A provides short development times suitable for tray. Dilution B givs longer times with sharpness and grain similar to D-76 Developer. Other dilutions used in graphic arts.

DK-50—Medium activity, general purpose developer for tank or tray, with or without dilution. Excellent keeping characteristics, and excellent tone reproduction with medium grain.

POLYDOL—A long-life high-capacity medium-grain developer for sheet or roll films. Stable replenishment characteristics for consistent quality in sink-line or production processing equipment.

D-76—Produces maximum film speed and shadow detail with normal contrast and moderately fine grain. Gives long density scale and relatively low fog on forced development. Gives greater sharpness diluted 1:1. Excellent for roll films.

MICRODOL-X—Gives finest grain with minimum speed loss with most films. Excellent choice for miniature films. Gives greater sharpness diluted 1:3; gives finer grain undiluted.

VERSATOL—Handy, versatile fast-working developer for films and papers. Good choice for small darkroom where finest grain is not required and exceptional keeping qualities are useful.

EASTMAN KODAK

KODAK DEVELOPER D-76

Kodak Developer D-76 produces full emulsion speed and maximum shadow detail with normal contrast, and is well known for superior performance. It produces images with high definition and moderately fine grain. Kodak Developer D-76 is recommended for tray or tank use. For greater sharpness, but with a slight increase in graininess, you can dilute the developer 1:1.

The excellent development latitude of Developer D-76 permits pushed development with very little fog. However, pushed development increases graininess with any developer. Follow the times in the table on the following page for normal development.

LIFE AND CAPACITY

Mix the entire contents of the developer (or replenisher) package at one time. The keeping qualities of unused Kodak Developer D-76 stored in a full, tightly stoppered bottle are excellent. You may want to keep the developer in several smaller bottles rather than one large bottle. This lets you exclude as much air as possible as you use up the developer. The unused solution will keep for six months in a full, tightly stoppered bottle and for two months in a tightly stoppered bottle that is half full.

The capacity of Developer D-76 is 16 rolls of 135-size film (36-exposure), 87 square inches per roll, or their equivalent, per gallon when used full strength without replenishment. This is based on using the developer and pouring it back into the bottle. Increase the development time by 15 percent after each four rolls of film have been processed.

When you use Developer D-76 at the 1:1 dilution, dilute it just before use. No reuse or replenishment is recommended. The capacity of the 1:1 dilution in a single use is about 8 rolls of 135-size film (36-exposure), or equivalent, per gallon of diluted developer. If you use only 8 ounces of solution (1:1) for each 36-exposure roll of 135-size film, increase the recommended development times by approximately 10 percent. The capacity for each gallon of 1:1 solution will then be increased to 16 rolls of film. Do not store the diluted developer for future use or leave it in processing equipment for extended periods.

REPLENISHMENT

Proper replenishment of Developer D-76 with Kodak Replenisher D-76R will maintain a constant rate of development, film speed, and moderately fine grain characteristics without the necessity of increasing the development time. Replenish only full-strength solutions of the developer. Discard Developer D-76 diluted 1:1 after each use, and do not replenish it.

To replenish developer in small tanks, use ¾ ounce of Replenisher D-76R for each 36-exposure roll of 135 film (87 square inches) developed. Add the replenisher to the developer bottle before returning the used developer from the tank.

In large tanks, add replenisher as needed to replace the developer carried out by the films and to keep the liquid level constant in the tank. Ordinarily, you can do this by adding ¾ ounce of Replenisher D-76R for each 8 x 10-inch sheet of film or equivalent, that you process. Add the replenisher and stir it in thoroughly after each batch of film or after not more than four 8 x 10-inch sheets (320 square inches) of film or equivalent have been processed per gallon of developer. Refer to the replenishment table below.

PACKAGE SIZES

Kodak Developer D-76 is packaged to make 1 quart or ½, 1, or 10 gallons of stock solution. Kodak Replenisher D-76R is available in a 1-gallon size.

KODAK DEVELOPER D-76♦ Dissolve chemicals in the order given.
Elon-Hydroquinone Borax Developer for Low Contrast and Maximum Shadow Detail on Panchromatic Films and Plates

Water (125°F or 52°C)	24	ounces	750.0 ml
Kodak Elon	29	grains	2.0 grams
Kodak Sodium Sulfite, desiccated ... 3 oz.	145	grains	100.0 grams
Kodak Hydroquinone	73	grains	5.0 grams
Kodak Borax (decahydrated)	29	grains	2.0 grams
Add cold water to make	32	ounces	1.0 liter

DIRECTIONS FOR MIXING LARGE VOLUMES

Dissolve the Elon separately in a small volume of water (at about 125°F or 52°C) and add the solution to the tank. Then dissolve approximately one-quarter of the sulfite separately in hot water (at about 160°F or 71°C), add the hydroquinone with stirring until completely dissolved. Then add this solution to the tank. Now dissolve the remainder of the sulfite in hot water (about 160°F or 71°C), add the borax and when dissolved, pour the entire solution into the tank and dilute to the required volume with cold water. ♦Available in units to make 1 quart, ½ gallon, 1 gallon, 10 gallons.

KODAK REPLENISHER D-76R ♦
Replenisher for Tank Use with Kodak Developer D-76

Water (125°F or 52°C)	24	ounces	750.0 ml
Kodak Elon	44	grains	3.0 grams
Kodak Sodium Sulfite, desiccated ... 3 oz.	145	grains	100.0 grams
Kodak Hydroquinone	¼	ounce	7.5 grams
Kodak Borax (decahydrated)	290	grains	20.0 grams
Add cold water to make	32	ounces	1.0 liter

Dissolve chemicals in the order given.

In small tank work and intermittent use, add 1 ounce (30.0 ml) of Replenisher for each 80 square inches of film processed, discarding some of the used developer if necessary. 80 square inches is equal to one 8-exposure roll of size 120 film or one 36-exposure roll of 35mm.

In deep tank work, use the replenisher without dilution and add to the tank to maintain the level of the solution. It is frequently advisable to discard some of the developer before adding the replenisher to maintain proper negative quality. The life of Kodak Developer D-76 will be at least 5 times greater if this replenisher is used.
♦Available in units to make one gallon.

REPLENISHMENT TABLE FOR FULL-STRENGTH KODAK REPLENISHER D-76R

Film Size	Area (inch²)	Ounces of Kodak Replenisher D-76R Needed
110	11.5	⅛
126	25	¼
135 (20-exposure)	49	½
135 (36-exposure)	87	¾
828	25	¼
127	43	½
120, 620	80	¾
616	105	1
4 x 5-inch sheets	20	¼
8 x 10-inch sheets	80	¾

Kodak Replenisher D-76R extends the capacity of Kodak Developer D-76 to 120 rolls or 8 x 10-inch sheets (9600 square inches) or equivalent per gallon.

EASTMAN KODAK

DEVELOPMENT TIMES (IN MINUTES) IN KODAK DEVELOPER D-76

KODAK Film	Dilution	Small Tank Agitation at 30-second intervals throughout development					Large Tank Agitation at 1-minute intervals throughout development				
		65°F 18°C	68°F 20°C	70°F 21°C	72°F 22°C	75°F 24°C	65°F 18°C	68°F 20°C	70°F 21°C	72°F 22°C	75°F 24°C
Verichrome Pan (Rolls and Cartridges)	Full Strength	8	7	5½	5	4½	9	8	7	6	5
	1:1	11	9	8	7	6	12½	10	9	8	7
Plus-X Pan (135 and Long Rolls)	Full Strength	6½	5½	5	4½	3¾	7½	6½	6	5½	4½
	1:1	8	7	6½	6	5	10	9	8	7½	7
Plus-X Pan Professional (Rolls and Packs)	Full Strength	6½	5½	5	4½	3¾	7½	6½	6	5½	4½
	1:1	8	7	6½	6	5	10	9	8	7½	7
Panatomic-X (135 and Long Rolls)	Full Strength	6	5	4½	4¼	3¾	6½	5½	5	4¾	4
	1:1	8	7	6½	6	5	9	7½	7	6½	5½
Panatomic-X Professional (Rolls)	Full Strength	6	5	4½	4¼	3¾	6½	5½	5	4¾	4
	1:1	8	7	6½	6	5	9	7½	7	6½	5½
Tri-X Pan (Rolls, 135, and Long Rolls)	Full Strength	9	8	7½	6½	5½	10	9	8	7	6
	1:1	11	10	9½	9	8	13	12	11	10	9
Tri-X Pan Professional (Rolls and Packs)	Full Strength	9	8	7½	7	6	10	9	8½	8	7
High Speed Infrared (135 and Long Rolls)	Full Strength	13	11	10	9½	8	14	12	11	10	9

EASTMAN KODAK

EASTMAN KODAK

DEVELOPMENT TIMES (IN MINUTES) IN KODAK DEVELOPER D-76 FULL STRENGTH

KODAK Film (Sheets)	Tray Continuous Agitation					Large Tank Agitation at 1-minute intervals throughout development				
	65°F 18°C	68°F 20°C	70°F 21°C	72°F 22°C	75°F 24°C	65°F 18°C	68°F 20°C	70°F 21°C	72°F 22°C	75°F 24°C
Royal Pan 4141 (Estar Thick Base)	9	8	7½	7	6	11	10	9½	9	8
Tri-X Pan Professional 4164 (Estar Thick Base)	6	5½	5	5	4½	7½	7	6½	6	5½
Plus-X Pan Professional 4147 (Estar Thick Base)	7	6	5½	5	4½	9	8	7½	7	6
Ektapan 4162 (Estar Thick Base)	9	8	7	6½	5½	11	10	9	8½	7½
High Speed Infrared 4143 (Estar Thick Base)	11	9½	8½	7½	6½	14	12	11	10	9
Tri-X Ortho 4163 (Estar Thick Base)	6½	6	5½	5	4½	8	7½	6½	6	5½

KODAK HC 110 DEVELOPER
HOW TO MIX THE STOCK SOLUTION

To make a stock solution from the smaller size (473 ml or 16 ounce) bottle of concentrate:

1. Pour the entire contents of the original plastic bottle into a container that holds at least 1.9 liters (2 quarts).
2. Rinse the plastic bottle thoroughly with water and pour the rinse water into the container.
3. Add enough water to bring the total volume to 1.9 liters (2 quarts).
4. Stir or shake thoroughly until the solution is uniform.

To make a stock solution from the larger (828 ml or 28 ounce) bottle of concentrate:

1. Pour the entire contents of the original plastic bottle into a container that holds at least 3.4 liters (3½ quarts).
2. Rinse the plastic bottle thoroughly with water and pour the rinse water into the container.
3. Add enough water to bring the total volume to 3.4 liters (3½ quarts).
4. Stir or shake well until the solution is uniform.

To make the replenisher stock solution:

1. Pour the entire contents of the plastic bottle of replenisher concentrate into a container that holds at leas 3.8 (1 gallon).
2. Rinse the bottle thoroughly with water and pour the rinse water into the container.
3. Add enough water to bring the total volume to 3.8 liters (1 gallon).
4. Stir or shake until the solution is uniform.

To mix working dilutions A, B, C, D, E, and F from the stock solution, see table 1.

USES OF WORKING-STRENGTH DILUTIONS

Dilution A: This is the most active of the dilutions. It is especially useful for tray development and gives short developing times for sheet and roll films.

Dilution B: This dilution permits longer development time; it is recommended for most Kodak sheet and roll films. Developing times for these materials are given in tables 3 and 4.

Dilutions C, D, and E: These dilutions are generally used for Kodak continuous-tone sheet films used in graphic arts reproduction. Recommended developing times are given in table 5.

Dilution F: This dilution is for use with Kodak Pan Masking Film 4570 in certain masking procedures used in color printing and some allied processes. Developing times are given in the instruction sheet that accompanies the film.

DEVELOPING TIMES

The developing times given in table 2 assume exposure with camera lenses of moderate flare. They are aimed at giving negatives of full-scale subjects that will match the contrast of normal grade papers when printed with diffusion-type enlargers. For printing with condenser enlargers, shorter development times are required (usually 30 to 50% less). The best developing time depends on a number of conditions, including the flare level of the camera lens.

One way of determining the best time, is to make a series of test negatives at different exposures, including a gray scale in the subject, and keeping a record of your test exposures.

Another method is trial and error. Start with the time given in the tables and adjust it according to your results. If your negatives are consistently too high in contrast, decrease the developing time; if too low in contrast, increase the time.

EASTMAN KODAK

Table 1

TO MIX WORKING DILUTIONS FROM THE STOCK SOLUTION

Working Dilution	Developer to Water Ratio		To Mix All Quantities	To Mix		To Mix		To Mix		To Mix	
				500 ml	1 Pint	1 Liter	1 Quart	4 Liters	1 Gallon	1 Decaliter	3½ Gallons
A	1:15	Stock	1 Part	125 ml	4 oz	250 ml	8 oz	1 l	1 qt	2.5 l	3 qt 16 oz
		Water	3 Parts	375 ml	12 oz	750 ml	24 oz	3 l	3 qt	7.5 l	10 qt 16 oz
B	1:31	Stock	1 Part	63 ml	2 oz	125 ml	4 oz	500 ml	16 oz	1.25 l	1 qt 24 oz
		Water	7 Parts	437 ml	14 oz	875 ml	28 oz	3.5 l	3 qt 16 oz	8.75 l	12 qt 8 oz
C	1:19	Stock	1 Part	100 ml	3¼ oz	200 ml	6½ oz	800 ml	26 oz	2.0 l	2 qt 26 oz
		Water	4 Parts	400 ml	28¾ oz	800 ml	25½ oz	3.2 l	3 qt 6 oz	8.0 l	11 qt 6 oz
D	1:39	Stock	1 Part	50 ml	—	100 ml	3¾ oz	400 ml	13 oz	1.0 l	1 qt 13 oz
		Water	9 Parts	450 ml	—	900 ml	28¾ oz	3.6 l	3 qt 19 oz	9.0 l	12 qt 19 oz
E	1:47	Stock	1 Part	42 ml	—	84 ml	2½ oz	333 ml	11 oz	835 ml	1 qt 6 oz
		Water	11 Parts	458 ml	—	916 ml	29½ oz	3.667 l	3 qt 21 oz	9.2 l	12 qt 26 oz
F	1:79	Stock	1 Part	25 ml	—	50 ml	1½ oz	200 ml	6 oz	500 ml	22 oz
		Water	19 Parts	475 ml	—	950 ml	30½ oz	3.8 l	3 qt 26 oz	9.5 l	13 qt 10 oz

NOTE: Some quantities of stock solutions are too small for convenient measurement. Where quantities are specified for mixing 1 pint or 1 quart, they are rounded to the nearest ¼ fluidounce. Quantities for mixing larger volumes are rounded to the nearest fluidounce.

EASTMAN KODAK

238

The Compact Photo-Lab-Index

Table 2

DEVELOPING TIMES FOR KODAK SHEET FILMS AND FILM PACKS

Developing Time (Minutes)

DILUTION A	Tray*					Large Tank†				
KODAK Sheet Films	65 F 18 C	68 F 20 C	70 F 21 C	72 F 22 C	75 F 24 C	65 F 18 C	68 F 20 C	70 F 21 C	72 F 22 C	75 F 24 C
Ektapan 4162 (Estar Thick Base)	3¼	3	2¾	2½	2¼	4	3¾	3¼	3	2¾
Royal Pan 4141 (Estar Thick Base)	3½	3	2¾	2½	2¼	4	3¾	3¼	3	2¾
Royal-X Pan 4166 (Estar Thick Base)	5	4½	4¼	4	3½	7	6	5½	5	4½
Super-XX Pan 4142 (Estar Thick Base)	4½	4	3¾	3½	3	6	5½	4½	4¼	3½
KODAK Film Packs										
Tri-X Pan Professional						6	5½	5	4½	4

DILUTION B	Tray*					Large Tank†				
KODAK Sheet Films	65 F 18 C	68 F 20 C	70 F 21 C	72 F 22 C	75 F 24 C	65 F 18 C	68 F 20 C	70 F 21 C	72 F 22 C	75 F 24 C
Commercial 6127 and 4127 (Estar Thick Base)	2¾	2¼	2¼	2	1¾	NR	NR	NR	NR	NR
Ektapan 4162 (Estar Thick Base)	5	4½	4¼	4	3½	7	6	5½	5	4¼
Plus-X Pan Professional 4147	6	5	4¾	4½	4	8	7	6½	6	5½
Royal Pan 4141 (Estar Thick Base)	7	6	5½	5	4½	9	8	7½	7	6
Royal-X Pan 4166 (Estar Thick Base)	8½	8	7½	7	6½	11	10	9	8½	7½
Super-XX Pan 4142 (Estar Thick Base)	8	7	6½	6	5	11	9	8	7	6
Tri-X Pan Professional 4164 (Estar Thick Base)	6	5½	5	4½	4	8	7½	7	6	5
Tri-X Ortho 4163 (Estar Thick Base)	6½	5½	5	4½	4	8½	7½	7	6½	5
KODAK Film Packs										
Tri-X Pan Professional	10	9	8	7	6	11	10	9	8	7
Plus-X Pan Professional	5	4½	4	3¾	3¼	6½	5½	5	4¾	4

*Development in a tray with continuous agitation.
NOTE: Development times shorter than 5 minutes in a tank may cause poor uniformity
†Development on a hanger in a large tank with agitation at 1-minute intervals.

NR = Not recommended.

EASTMAN KODAK

239

EASTMAN KODAK

Table 3

DEVELOPING TIMES FOR KODAK ROLL FILMS

	Developing Time (Minutes)								
	Small Tank*					Large Tank†			
DILUTION A KODAK Roll Films	65 F 18 C	68 F 20 C	70 F 21 C	72 F 22 C	75 F 24 C	68 F 20 C	70 F 21 C	72 F 22 C	75 F 24 C
Royal-X Pan	6	5	4¾	4½	4¼	6	5½	5	4½
Tri-X Pan	4¼	3¾	3¼	3	2½	4¼	4	3¾	3¼
Tri-X Pan Professional	NR	NR	NR	NR	NR	5½	5	4½	4
135 Films									
Tri-X Pan	4¼	3¾	3¼	3	2½	4¼	4	3¾	3¼

	Small Tank*					Large Tank†			
DILUTION B KODAK Roll Films	65 F 18 C	68 F 20 C	70 F 21 C	72 F 22 C	75 F 24 C	68 F 20 C	70 F 21 C	72 F 22 C	75 F 24 C
Panatomic Professional	4¾	4¼	4	3¾	3¼	4¾	4¼	4	3½
Plus-X Pan Professional	6	5	4½	4	3½	5½	5	4¾	4
Royal-X Pan	10	9	8	7½	6½	10	9	8½	7½
Tri-X Pan	8½	7½	6½	6	5	8¼	8	7½	6½
Tri-X Pan Professional	10	9	8	7	6	10	9	8	7
Verichrome Pan	6	5	4½	4	2	6½	6	5½	4½
135 Films									
Panatomic-X	4¾	4¼	4	3¾	3¼	4¾	4¼	4	3½
Plus-X Pan	6	5	4½	4	3½	5½	5	4¾	4
Tri-X Pan	8½	7½	6½	6	5	8½	8	7½	6½

*Development on a spiral reel in a small roll tank, with agitation at 30-second intervals.
†Development of several reels in a basket, with agitation at 1-minute intervals.
NR = Not recommended.
NOTE: Development times shorter than 5 minutes in a tank may cause poor uniformity.

Table 4
DEVELOPING TIMES FOR KODAK CONTINUOUS-TONE GRAPHIC ARTS FILMS

KODAK Films	APPLICATIONS Graphic Arts	Kodak HC-110 Developer Dilutions	Tray Development Times (minutes) at 68°F (20°C) with continuous agitation
Commercial 4127 (Estar Thick Base)	Gravure	C	3
Gravure Positive 4135	Continuous-tone positives for photogravure and photoengraving	C	4
	Premasks for two-stage masking	C	3
Blue Sensitive Masking 2136	Positive Masks	E	2½

		Kodak HC-110 Developer Dilutions	When exposed through color-separation filters:			
			Cyan 4	Magenta 3½	Yellow 4	Black 3¾
	Color-separation negatives from masked color transparencies	C	4	3½	4	3¾
			Red	Green	Blue	
	Color Prints					
Separation 4131, Negative Type 1	Color-separation negatives from original subjects or from masked color transparencies	E	4	4	5	
		D	3	3	4	
	Color-separation negatives from unmasked color transparencies	E	2½	2½	3	

EASTMAN KODAK

EASTMAN KODAK

Table 5 (continued)

DEVELOPING TIMES FOR KODAK CONTINUOUS-TONE GRAPHIC ARTS FILMS

KODAK Films	APPLICATIONS Graphic Arts	Kodak HC-110 Developer Dilutions	Tray Development Times (minutes) at 68°F (20°C) with continuous agitation			
			Cyan Printer Mask	Black Printer Mask	Magenta Printer Mask	Yellow Printer Mask
Super-XX Pan 4142 (Estar Thick Base)	For color-separation negatives made directly from the subject or from masked color transparencies	A			4½	7
	For color-separation negatives made from unmasked transparencies	B			4½	7
Graphic Arts						
Pan Masking 4570	Camera-back masking	E	4	4	4	—
	Masks on transparencies (for cyan, magenta, yellow, and black printers)	D	3¼	3¼	3¼	3¼
Professional Copy 4125 (Estar Thick Base)	For photomechanical reproduction (for 1.70 highlight aim-density)	C	Tray (continuous agitation) 5½		Tank (intermittent agitation) 8	

The Compact Photo-Lab-Index

With an average drain period between the developer and the stop bath, the stated replenishment rate will usually be sufficient to match the carry-out of developer. However, if much more of the solution is lost in the process than is replaced by replenishment, make up the loss by adding fresh HC-110 Developer of the appropriate dilution.

When dilutions A, B, C, D, and E are used for tank development with the replenishment procedure just described, the developer activity should be monitored by Kodak Control Strips, 10-step (for professional B/W film). The solution can be kept in service for at least 1 month if these strips indicate proper developer activity.

If control strips are not used, Dilutions A, B, C, D, and E can be replenished until 50 20.3 x 25.4cm films per liter (200 8 x 10-inch films per gallon), or the equivalent area in other sizes, have been processed; or when the volume of added replenisher equals the original volume of solution in the tank; or after the developer has been replenished for 1 month.

Dilution F is generally used in a tray for developing masks; therefore it should not be replenished, but used and discarded frequently.

CAPACITY OF WORKING DILUTIONS

	Tray		Tank Without Replenishment		Tank With Replenishment*	
Dilution	20.3 x 25.4 cm Sheets per Liter	8 x 10 Sheets per Gallon	20.3 x 25.4 cm Sheets per Liter	*8 x 10 Sheets per Gallon	20.3 x 25.4 cm Sheets per Liter	8 x 10 Sheets per Gallon
A	5	20	10	40	50	200
B	2.5	10	5	20	50	200
C	4	15	8	30	50	200
D	2	8	4	15	50	200
E	1.5	5	3	10	50	200
F	1	2	Not recommended	Not recommended	50	200

*Use and replenish for 1 month only.

STORAGE LIFE OF UNUSED SOLUTIONS

Dilutions	Full stoppered glass bottle	½ Full stoppered glass bottle	Tank with floating lid
Stock solution	6 months	2 months	—
Stock replenisher	6 months	2 months	—
A	6 months	2 months	2 months
B	3 months	1 month	1 month
C	6 months	2 months	2 months
D	3 months	1 month	1 month
E	2 months	1 month	1 month
F	Do not store	—	—

The Compact Photo-Lab-Index

EASTMAN KODAK

The dilutions of Kodak HC-110 Developer can be replenished with appropriate dilutions made from the replenisher stock solution as given in table 4.

To maintain constant developer activity, replenish the working dilutions, with properly diluted replenisher, at the rate of 22 milliliters per 516 square centimeters (¾ fluid ounce per 80 square inches) of film. However, if the negatives start to get too thin and low in contrast, or too dense and high in contrast, increase or decrease the replenishment rate.

REPLENISHER DILUTIONS

To replenish working dilution	Replenisher stock solution*	Water
A use	1 part	none
B use	2 parts	1 part
C use	1 part	none
D use	1 part	1 part
E use	8 parts	11 parts
F.....	Do not replenish	—

TO MIX WORKING-STRENGTH DILUTIONS FROM THE CONCENTRATE

Because small amounts of the concentrate are difficult to measure accurately, the working dilutions of Kodak HC-110 Developer should not be prepared directly from the concentrate. However, if a relatively large quantity of developer is needed for immediate use, you can mix a whole bottle of concentrate with a given amount of water. For example, a 16-ounce bottle of concentrate makes 4 gallons of dilution B. The table below shows how the various dilutions can be mixed directly from whole bottles of concentrate.

To Make this Working Dilution	Developer to Water Ratio	Use this amount of concentrate		With this amount of water		Use this amount of concentrate		With this amount of water	
		Milliliters	Fluidounces	Liters	Quarts	Milliliters	Fluidounces	Liters	Quarts/ Fluidounces
A	1:15	473	16	7.1	7½	828	28	12.5	13/4
B	1:31	473	16	14.7	15½	828	28	25.75	27/4
C	1:19	473	16	9	9½	828	28	15.75	16/20
D	1:39	473	16	18.4	19½	828	28	32.5	34/4
E	1:47	473	16	22.2	23½	828	28	39	41/4
F	1:79	473	16	37.4	39½	828	28	65.5	69/4

The Compact Photo-Lab-Index

KODAK DEKTOL DEVELOPER

A prepared, single-powder developer for producing neutral and cold-tone images on cold-tone papers. It remains unusually free from muddiness, sludge, precipitation, and discoloration throughout the normal solution life. It has high capacity and uniform development rate. Although best known as a paper developer, it is also recommended for rapid development of some high-speed negative materials.

Development Recommendations: Papers – Dilute 1 part of stock solution to 2 parts of water. Develop KODABROMIDE, POLYCONTRAST RAPID, and PANALURE Papers about 1½ minutes; all other recommended papers, about 1 minute at 68 F (20 C).

Package Sizes: Carton of 6 packets each to make 8 ounces of working solution; also packages to make 1 quart and ½, 1, 5, 25, and 50 gallons of stock solution.

KODAK EKTAFLO DEVELOPER, TYPE 1

A concentrated liquid prepared developer for print processing. It has similar characteristics to those of DEKTOL Developer, in that it yields neutral or cold tones on cold-tone papers. The concentrate is diluted 1:9 for use.

Development Recommendations: Develop KODABROMIDE, POLYCONTRAST, POLYCONTRAST RAPID, and PANALURE Papers for 1½ minutes at 68 F (20 C). Develop all other recommended papers for 1 minute.

Package Size: 1 gallon of the concentrate in a plastic container.

KODAK SELECTOL DEVELOPER

A long-life prepared developer specially designed for the development of warm-tone papers. It produces the same image tone and contrast as KODAK Developer D-52, remains clear during use, and has high development capacity and good keeping properties. Since the development activity decreases only very slowly with use, constant image tone is easy to maintain.

Development Recommendations: Dilute 1 part of stock solution with 1 part of water. For average results, develop 2 minutes at 69 F (20 C). For slightly warmer image tone, develop 90 seconds. Contrast can be increased slightly with some papers by developing up to 4 minutes. Increased development times will produce colder image tones.

Package Sizes: To make ½, 1, 5, and 50 gallons of stock solution.

KODAK SELECTOL-SOFT DEVELOPER

Except for what the name implies, is similar in all respects to KODAK SELECTOL DEVELOPER. It is recommended whenever results with SELECTOL DEVELOPER tend to be too contrasty for adequate shadow detail. Much softer results can be obtained than with regular SELECTOL DEVELOPER, and there is no sacrifice in tonal scale.

Package Size: To make 1 gallon of stock solution. The stock solution is diluted 1 to 1 for use.

KODAK EKTAFLO DEVELOPER, TYPE 2

A concentrated, prepared, liquid developer for warm-tone papers. It has similar characteristics to those of EKTONOL Developer, and yields rich warm tones on KODAK EKTALURE, POLYLURE, and OPAL Papers. The concentrate is diluted 1:9 for use.

Development Recommendations: Develop warm-tone papers for 2 minutes at 68 F (20 C). Increased developing time results in colder tones.

Package Sizes: 1 gallon of the concentrate in a plastic container.

245

The Compact Photo-Lab-Index

KODAK EKTONOL DEVELOPER

A non-carbonate prepared developer designed for use with warm-tone papers. It minimizes stain on prints which are to be toned. The development rate remains practically uniform throughout the useful life and thus holds the image tone constant from print to print.

Development Recommendations: Dilute 1 part of stock solution with 1 part of water. For average results, develop prints 2 minutes at 68 F (20 C).

Package Sizes: To make 1 and 5 gallons of stock solution.

KODAK VERSATOL DEVELOPER

An ideal all-purpose, prepared developer for use with films, plates, and papers. Remains unusually clear during use.

Development Recommendations: Papers – dilute 1 to 3; develop KODABROMIDE, POLYCONTRAST, POLYCONTRAST RAPID, and PANALURE Papers about 1½ minutes; other papers, about 1 minute at 68 F (20 C). Films and Plates – dilute 1 to 15 and develop VERICHROME PAN FILM about 4½ minutes at 68 F (20 C) in a tray or about 5 minutes at 68 F (20 C) in a tank. Dilute 1 to 3 and develop KODAK PROJECTOR SLIDE PLATES, Contrast, 2 to 6 minutes at 68 F (20 C) in a tray.

Package Sizes: Available in 8-ounce, 32-ounce, and 1-gallon bottles.

The Compact Photo-Lab-Index

MIXING DEVELOPER AND FIXING SOLUTIONS

It is a good general rule to mix the chemicals in the order given in the formula. Certain ingredients in any developer or fixing bath serve to protect other ingredients, either from aerial oxidation or from reacting with each other. Thus the sulfite in a developer protects the developing agents, Elon and/or hydroquinone, from both aerial oxidation and reaction with the sodium carbonate, or other alkali. Therefore, if the alkali is added to the solution of the developing agents before the sulfite is added, the bath will usually become discolored and practically inert as a developer. Generally the sulfite is dissolved first, followed by the developing agents and the alkali; however, since Elon is practically insoluble in a sulfite solution, developers containing Elon are usually prepared by dissolving the Elon first, followed by the sulfite, hydroquinone, and alkali in that order.

When large quantities of developer are prepared, some oxidation of the Elon may take place before the sulfite is added. In this case, it is usually the best practice to dissolve a small part of the sulfite, insufficient to cause precipitation of the Elon, first, after which the Elon is dissolved, followed by the remainder of the sulfite and the other ingredients.

In preparing fixing baths containing an acid hardener, it should be remembered that the sulfite protects the hypo from decomposition by the acetic acid, while alum precipitates from solutions not containing the acid. For this reason, it is equally important to observe the correct order of mixing in preparing hardening fixing baths. The preparation of fixing baths containing chrome alum is even more critical, and instructions concerning the order of mixing and the stirring and temperature must be closely followed.

If clean water and pure chemicals are used, it is usually unnecessary to filter the solutions. If any amount of sediment is noticed, however, the solution should be filtered before storage or use. While cotton in a glass funnel will do an efficient job of filtering, the process may be expedited by the use of a suction pump attached to the water faucet, a large filter flask, and a rapid filter paper in a Buechner funnel.

Kodak Sodium Sulfite, desiccated, is specified in Kodak formulas. In those formulas specifying sodium carbonate, the use of Kodak Sodium Carbonate, monohydrated, is recommended.

MEASUREMENT OF SMALL QUANTITIES

Since the usual studio balance is not sensitive to fractions of a gram or to 1 or 2 grains, accuracy the measurement of small quantities may be obtained by preparing a 10% solution and using that as required. A 10% solution, for example, of potassium bromide (or of any other chemical) contains 10 grams of the chemical in 100 ml of water, hence 10 ml of the solution which is easily measured, contains exactly 1 gram, 1 ml contains 1/10 of a gram, etc.

To prepare a 10% solution correctly, dissolve 1 ounce of the chemical in about 8 ounces of water; after it is completely dissolved, add sufficient water to make the total volume 10 ounces. If the 1 ounce of chemical is dissolved in 10 ounces of water, the total solution volume will be more than 10 ounces and it will not be a 10% solution. In metric measure, to prepare a 10% solution, dissolve 10 grams of the chemical in about 80 ml of water; after it has dissolved, add sufficient water to make a total quantity 100 ml.

STORAGE OF SOLUTIONS

Most stock solutions have good keeping qualities when stored in tightly corked bottles when are practically full. A partly filled bottle contains a good deal of air, which will cause the developer to oxidize; hence it is a better practice to store stock solutions in several small bottles rather than in one large one. The entire contents of a small bottle can be used at one time, leaving the remaining bottles undisturbed.

Developers which are stored in developing tanks should be covered by a floating lid made either of wood, or, in the form of a shallow boat, of Kodacel sheeting. After removing the lid, the surface of the developer should be skimmed with a clean blotter to remove any incrustation before the developer is used.

EASTMAN KODAK

The Compact Photo-Lab-Index

TIME OF DEVELOPMENT

The length of time during which an exposed film must remain in the developer depends upon a number of factors. Certain types of film emulsion require more development than others to produce equal contrasts. With any particular emulsion, the controlling factors are as follows:

a) The activity of the developer
b) The temperature of the developer
c) The degree of agitation of either the materials or the solutions.

In addition, certain workers require a higher contrast than others, depending on the type of work they are doing.

THE USE OF REPLENISHERS

In large-scale processing, it is not economical to attempt to use a developer to the practical exhaustion point and discard it. Usually the quality of the image falls off seriously long before the exhaustion point is reached, and discarding the developer at this stage is wasteful. For this reason, replenishers are usually resorted to in commercial processing. The strength of the replenishers is usually so adjusted that they may be added to the tank to replace the developer carried out on the processed films; thus it is only necessary to maintain the level of the tank at a fixed point to maintain the activity of the developer at its normal degree. Where changes occur in spite of replenishment under these conditions, it is the custom to change the strength of the replenisher until the activity of the developer does remain constant under working conditions of developer loss and replacement.

Replenishment is also applied to small-scale work with low-energy fine-grain developers which fall off markedly in strength even with intermittent use. In this case, however, little developer is lost in processing, and the rule is to add a measured amount of replenisher to the stock bottle before returning the developer to the bottle. Any surplus of used developer is then discarded.

The exact strength and quantity of replenisher required varies with different formulas; specifications for the recommended replenishers and recommended procedures for their use will be found following the respective developer formulas.

Replenishment of developers cannot be carried to an extreme, however, due to the accumulation of silver sludge, dirt, and gelatin in the working bath. Working developers should be discarded at the first sign of stain, fog, or instability.

THE USE OF PREPARED DEVELOPERS

Most of the Kodak developers are available in packaged form, as indicated by the symbol ◆ following the Kodak formula number.

The ingredients and proportions of many of these formulas will be found in the following pages. In addition, Kodak supplies a number of developers in packaged form for which formulas are not published. Where possible, data for the use of these developers is given in this section. A large measure of convenience results from the use of packaged developers, as well as assurance of accuracy in mixing.

HIGH-TEMPERATURE DEVELOPMENT

A number of procedures are given for processing at elevated temperatures. While it is recommended that processing be carried out at between 65° and 75°F (18° to 24°C), it is recognized that this cannot always be done, and special precautions make it possible to carry out the processing of films at higher temperatures.

At temperatures up to 90° to 95°F (32° to 35°C) processing can safely be carried out with the addition of sodium sulfate· (not sulfite) to the developer and suitable precautions in fixing and washing. Information on this procedure will be found in this section.

EASTMAN KODAK

The Compact Photo-Lab-Index

In emergencies, at temperatures as high as 110°F (43°C) processing may be carried out by prehardening the film in the special prehardener bath Kodak SH-5. Full instructions for the use of this prehardener, and necessary adjustment in development time, are given under this heading.

RAPID FILM PROCESSING

In military and newspaper work, it is sometimes essential to complete a negative as quickly as possible. This is usually accomplished by the use of a highly concentrated developer such as Kodak D-19 or Kodak D-72 and by taking advantage of certain means of shortening fixing and washing times.

For rapid processing in fresh hypo, fixing may be considered complete when the film has cleared. Constant agitation and a rapid fixing bath, such as Kodak F-7, decrease the fixing time considerably. Kodak F-7 contains approximately 3 pounds of sodium thiosulfate per gallon, with the addition of ammonium chloride and the standard hardener as used in Kodak F-5. It has a shorter fixing time and a considerably greater life than the conventional fixing bath.

Processing is completed by washing the film a few minutes in a rapid stream of water, and drying with a blast of warm air, directed against both sides of the film.

To hasten drying and prevent water marks on the negative, both sides should be wiped with a chamois or a viscose sponge. Rapid drying can also be obtained by one of the following methods:

1. Treat the film in a saturated solution of potassium carbonate, which will remove the water and leave the film dry enough for printing. The film must later be rewashed to remove the potassium carbonate, after which it is again fixed, washed, and dried.
2. Soaking the film for a minute or so in a 90% alcohol bath before drying. Methyl alchol must not be used, because it attacks the film base. Ethyl alcohol may be used successfully provided that the film is not immersed too long, the alcohol is diluted with a least 10% of water, and the drying is carried out at a temperature not over 80°F (27°C). The use of undiluted alcohol or too much heat in drying will cause the film to become opalescent; this, however, may be removed in most cases by rewashing the film and drying slowly.

After the rush prints have been made, the negatives should be returned to the fixing bath for 5 or 10 minutes, and then washed thoroughly and dried in the usual manner, to prevent fading or stain if the negatives are to be stored for any length of time.

For more image stability, films can be treated after fixing with Kodak Hypo Clearing Agent. After fixing, remove excess hypo by rinsing the films in Kodak Hypo Clearing Agent Solution for 1 to 2 minutes with moderate agitation, and wash them for 5 minutes using a water flow sufficient to give a complete change of water in 5 minutes.

For papers (Black-and-White Prints) after normal fixing, transfer prints to the clearing agent solution with or without rinsing. Treat single-weight or thinner papers at least 2 minutes and double weight papers at least 3 minutes, with agitation, at 65° to 70°F (18° to 21°C).

Then wash single-weight or thinner papers at least 10 minutes and double weight papers at least 20 minutes with agitation and normal water flow. The water temperature may be as low as 35°F (2°C). However, if the water temperature can be maintained at 65° to 70°F (18° to 21° to 21°C), a higher degree of stability will result than can be obtained with normal one-hour washing without Kodak Hypo Clearing Agent treatment.

WASHING PROCEDURES

In normal processing, where extreme speed is unnecessary, washing should be as thorough as possible in order to secure the maximum possible permanence of negatives and prints.

Complete washing is obtained in the minimum time when the emulsion is exposed to a rapid flow of fresh water, as when the stream from a hose or a faucet is allowed to flow over the emulsion surface. Under the best conditions of water change, the following times of washing will result in substantially complete removal of hypo from films, plates, and papers:

Films and plates 30 minutes
Single Weight papers 60 minutes
Double Weight papers 1 to 2 hours

249

The Compact Photo-Lab-Index

Hypo is generally eliminated from negatives in 30 minutes, if the flow of water is rapid enough to replace the water in the washing vessel once every 5 minutes. This can be ascertained by adding a few drops of red dye or potassium permanganate to the water in the washing apparatus (without any negatives present) and noting the time needed for complete clearing of the water under normal washing conditions.

Under the same conditions paper prints should be washed for a least 1 to 2 hours to assure freedom from hypo. The time is measured from the placement of the last print or negative in the washer, since the washed and partly washed emulsions absorb hypo from contaminated water as rapidly as they give it up to clean water.

PRINT PERMANENCE

Papers require a longer washing time than films, because small quantities of hypo are held by the fibers of the paper base and are difficult to remove by washing. Thus even after long washing, traces of hypo remain in the paper.

When permanence of the image is essential, the well-washed prints should be treated with Hypo Eliminator HE-1. This eliminator, which is volatile, and does not remain in the paper, oxidizes the hypo to sodium sulfate, which is inert and readily washed out of the print.

Although the use of Formula HE-1 completely removes the hypo, the silver image. on papers particularly, is susceptible to attack by atmospheric gases and vapors. To increase the permanency of the image still further, the print should be treated with the Kodak Gold Protective Solution GP-1. This protects the image with a gold coating. which is far less susceptible to attack by external influences. Additional protection from the atmosphere is obtained by insulating the print from both sides. This is done by mounting the print on a heavy card with Kodak Dry Mounting Tissue and covering the face of the print with Kodak Print Lacquer.

An alternative procedure is to use Kodak Hypo Clearing Agent. After normal fixing, the prints are transferred to the clearing agent solution with or without rinsing. Single-weight papers or thinner require at least two minutes of treatment, while double-weight should be treated for at least three minutes with agitation at 65° to 70°F (18° to 21°C).

Then wash single-weight or thinner papers at least 10 minutes and double-weight papers at least 20 minutes with agitation and normal water flow. The water temperature may be as low as 35°F (2°C). However, if the water temperature can be maintained at 65° to 70°F (18° to 21°C), a higher degree of stability will result than can be obtained with normal one hour washing without the Kodak Hypo Clearing Agent treatment. For further information about this method see later pages in this section. (consult section index)

EASTMAN KODAK

The Compact Photo-Lab-Index

CHARACTERISTICS OF KODAK BLACK-AND-WHITE DEVELOPERS

KODAK Developer	Contrast	Special Properties	KODAK Developer Replenisher	
			Name	Packages Available
D-8	Very High	High capacity; rapid development		
D-11	High	General purpose for high contrast		
D-16	Medium	Especially for prints to be toned	D-16R	✓
D-19	High	High capacity; clean working; rapid development	D-19R	
D-23	Medium	General purpose; simple formula	DK-25R	
D-25	Medium	Fine grain	DK-25R	
DK-50	Medium	General purpose; clean working	DK-50R	✓
D-52	Medium	Similar to SELECTOL Developer		
DK-60a	Medium	General purpose; rapid development	DK-60aTR	✓
D-61a	Medium	Old time favorite for tank development	D-61R	
D-72	Medium	Similar to DEKTOL Developer		
D-76	Medium	General purpose; full emulsion speed; low fog	D-76R	✓
D-85	Very High	Similar to KODALITH Developer		
D-88	Medium	Especially for direct positive photography		
D-94	Medium	Rapid development; for continuous processors	D-94R	
D-95	Medium	Rapid development; for continuous processors	D-95R	
D-96	Medium	Can be modified to suit individual needs	D-96R	
D-97	Medium	Can be modified to suit individual needs	D-97R	
DEKTOL	Medium	High capacity; rapid development		
HC-110	Medium	General purpose; similar to D-76 Developer	HC-110	✓
HRP	High	High capacity; high image quality		
KODAGRAPH	Very High	High capacity		
KODAGRAPH Liquid	Very High	High capacity		
KODALITH	Very High	Rapid development		
KODALITH Liquid	Very High	Rapid development		
KODALITH Super	Very High	Rapid development	KODALITH Super	
LINAGRAPH	High	High capacity		
LINAGRAPH 320	High	High capacity		
MICRODOL-X	Medium	Fine-grain; clean working	MICRODOL-X	✓
POLYDOL	Medium	General purpose	POLYDOL	✓
VERSATOL	Medium	General purpose		
EKTAFLO, Type 1	Medium	High capacity; rapid development		
EKTAFLO, Type 2	Medium	High capacity; useful for papers to be toned		
EKTONOL	Medium	Specially for papers to be toned		
SELECTOL	Medium	Clean working; useful for papers to be toned		
SELECTOL-SOFT	Medium	Similar to SELECTOL but with lower contrast		
Dental X-ray	High	Concentrate can also be used as replenisher		
Liquid X-ray	High	Supplied with replenisher	Liquid X-ray	✓
Rapid X-ray	High	High capacity	Rapid X-ray	✓

EASTMAN KODAK

251

CHARACTERISTICS OF KODAK BLACK-AND-WHITE DEVELOPERS (CONT'D)

Usually Employed For	Availability		
	Packaged, Liquid Concentrate	Packaged Powder	Published Formula
Continuous-tone and process films and plates		✓	✓
Continuous-tone and process films and plates		✓	✓
Continuous processing of motion picture postive films		✓	✓
Instrumentation films; scientific plates		✓	✓
Roll and 35mm films			✓
Roll and 35mm films			✓
Sheet and 70mm films		✓	✓
Warm-tone enlarging and contact papers			✓
Sheet and 70mm films		✓	✓
Sheet and 70mm films			✓
Cold-and-neutral-tone enlarging and contact papers			✓
Roll, sheet, 35mm, motion picture, and instrumentation films		✓	
Process and graphic arts films and plates			✓
KODAK Super Speed Direct Positive Paper		✓	✓
Reversal processing of motion picture and instrumentation films			✓
Reversal processing of motion picture and instrumentation films			✓
Continuous processing of motion picture negative films			✓
Continuous processing of motion picture positive films			✓
Enlarging, contact, and instrumentation papers		✓	
Roll, sheet, 35mm films	✓		
KODAK High Resolution Plates and Electron Image Plates	✓		
Drafting reproduction films and papers		✓	
Drafting reproduction films and papers	✓		
Process, reproduction, graphic arts films, plates, papers		✓	
Process, reproduction, graphic arts films, plates, papers	✓		
Process, reproduction, graphic arts, plates, papers		✓	
Instrumentation films and papers		✓	
Instrumentation films and papers	✓		
Roll and 35mm films	✓	✓	
Roll and sheet films		✓	
Roll films and enlarging papers	✓		
Cold and neutral-tone enlarging and contact papers	✓		
Warm-tone enlarging and contact papers	✓		
Warm-tone enlarging and contact papers		✓	
Warm-tone enlarging and contact papers		✓	
Warm-tone enlarging and contact papers		✓	
Dental x-ray films	✓		
Medical and industrial x-ray films	✓		
Medical and industrial x-ray films, monitoring films		✓	

EASTMAN KODAK

The Compact Photo-Lab-Index

KODAK POLYDOL Developer

KODAK POLYDOL Developer has been formulated to meet the needs of portrait, commercial, industrial, and school photographers for a developer which yields high negative quality as well as long life and high capacity. Although KODAK POLYDOL is primarily a tank developer for sheet and roll films, it performs equally well as a tray developer for sheet films or as a developer for spiral-reel and machine processing of films in long rolls.

With the recommended replenishment procedure, this developer maintains uniform activity throughout a long period of use. Furthermore, KODAK POLYDOL Developer is free from the high peak of activity characteristic of most developers when they are freshly mixed.

KODAK POLYDOL Developer is available in packages to make 1, 3 1/2, and 10 U.S. gallons of working solution. KODAK POLYDOL Replenisher is supplied in packages to make 1 and 5 U.S. gallons of replenisher.

EASTMAN KODAK

DEVELOPMENT OF SHEET FILMS

Recommended Developing Time in Minutes				
	Tray		Tank	
KODAK Sheet Film	68F (20C)	75F (24C)	68F (20C)	75F (24C)
RS Pan (ESTAR Thick Base)	9	6	11	8
ROYAL Pan (ESTAR Thick Base)	6	4½	8	6
Super Panchro-Press, Type B	9	6	11	8
SUPER-XX Pan (ESTAR Thick Base)	9	6	11	8
PLUS-X Pan Professional (ESTAR Thick Base)	6	4½	8	6
Portrait Panchromatic	8	5	10	7
PANATOMIC-X	9	6	11	8
TIR-X Pan Professional (ESTAR Thick Base)	6	4½	8	6
TRI-X Ortho (ESTAR Thick Base)	6	4½	8	6

Agitation: The times recommended for tray development are for continous agitation, either by tilting the tray for single films or by leafing through the stack when several films are developed together. The times recommended for tank development are for the development of films in hangers, with agitation by lifting and tilting hangers at 1-minute intervals. Details of these recommended agitation procedures are given in the KODAK Data Books **Negative Making with KODAK Black-and-White Sheet Films**, No. F-5, and **Processing Chemicals and Formulas**, No. J-1.

Agitation: The times recommended for a small tank apply when the film is developed on a spiral reel with agitation at 30-second intervals. The times given for a large tank are for development of several reels in a basket with agitation at 1-minute intervals.

Developing times given for KODAK films are aimed to yield negatives that print well on normal-contrast paper. However, if your negatives are consistently too low in contrast, increase development time, if they are consistently too high in contrast, decrease the developing time. The developing computer in the *KODAK Master Darkroom DATAGUIDE* is a useful aid in making such adjustments.

The Compact Photo-Lab-Index

DEVELOPMENT OF ROLL AND 135 FILMS

KODAK Film	Small Tank 68F (20C)	Small Tank 75F (24C)	Large Tank 68F (20C)	Large Tank 75F (24C)
Recommended Developing Time in Minutes				
VERICHROME Pan, Rolls	10	7	11	8
PLUS-X Pan, Rolls and 135	7	5	8	6
PLUS-X Pan Professional, Rolls	7	5	8	6
PANATOMIC-X, Rolls and 135	7	4½	8	5
TRI-X Pan, Rolls and 135	8	6	9	7
TRI-X Pan Professional, Rolls	7	5	8	6

DEVELOPMENT OF FILMS IN LONG ROLLS

Films in long rolls, such as 35mm or 70mm by 100 feet or 3 1/2 inches by 75 feet, can be developed in spiral reels or in continous processing machines.

DEVELOPMENT IN SPIRAL REELS

KODAK Film	68F (20C)	75F (24C)
Recommended Developing Time in Minutes*		
PLUS-X Pan – 35mm and 7mm rolls	8	6
PLUS-X Pan Professional (ESTAR Thick Base) – 3½-inch rolls	9	6½
PLUS-X Pan Professional (ESTAR Base) – 35mm, 46mm, and 70mm rolls	9	6½
TRI-X Pan – 35mm rolls	9	6
TRI-X Pan Professional (ESTAR Base) – 70mm	10	7
TRI-X Pan Professional (ESTAR Thick Base) – 3½-inch rolls	10	7
ROYAL Pan (ESTAR Thick Base) – 70mm and 3½-inch rolls	9	6
RS Pan (ESTAR Thick Base) – 3½-inch rolls	14	9
PANATOMIC-X – 35mm and 70mm rolls	8	5
LS Pan (ESTAR Base) – 70mm rolls	10	7
LS Pan (ESTAR Thick Base) – 3½-inch rolls	10	7

*These times apply when the reel is agitated as described in the instruction sheet that accompanies the film.

NOTE: In certain situations, about 4 gallons of solution is required to cover the films adequately. To obtain the required 4 gallons of developer, the 3 1/2-gallon size of KODAK POLYDOL Developer can be used, with the addition of 1 quart of KODAK POLYDOL Replenisher and 1 quart of water. The above time of development will still apply.

Agitation: Films on spiral reels should be agitated once each minute by the lifting-and-turning technique described in detail in the film instruction sheets.

DEVELOPMENT IN CONTINUOUS-PROCESSING MACHINES

KODAK Control Strips, 10-step (for professional B/W film), can be used as a guide in establishing the proper development level for film in a continuous processor. Adjust the development time and temperature to produce the diffuse-density difference recommended in the individual film instruction sheets. Adjustments can be made from these values to suit your particular system or individual preference.

254

EASTMAN KODAK

The Compact Photo-Lab-Index

REPLENISHMENT

After developing sheet films or films in rolls, add KODAK POLYDOL Replenisher as required to maintain a constant level of developer in the tank, or at a rate of approximately 5/8 to 3/4 fluidounce per 80 square inches of film. If the carry-out rate should vary, or if the average negatives are unusually dense or thin, it may be necessary to adjust the replenishment rate to keep the activity constant.

For films in long rolls, after each roll developed, KODAK POLYDOL Replenisher should be added to the developer tank as follows:

Size of film	Replenisher
35 mm by 100 feet	15 fluidounces
46 mm by 100 feet	20 fluidounces
70 mm by 100 feet	30 fluidounces
3 1/2 in. by 75 feet	30 fluidounces

USEFUL CAPACITY

Without replenishment – About 40 sheets of 8 by 10-inch film can be developed per gallon of KODAK POLYDOL Developer.

With replenishment – The KODAK POLYDOL Developer and KODAK POLYDOL Replenisher system has been designed to maintain constant developing characteristics for an indefinite period when the replenishment rate is properly adjusted. The replenishment rate should be checked by periodic monitoring of the developer activity. For this purpose, we suggest the use of KODAK Control Strips, 10-step (for professional B/W film), and the procedure described in the KODAK Quality Control System for KODAK Black-and-White Film and Roll Papers.

The sesitometric control strips are available from the Eastman Kodak Regional Marketing and Distribution Centers, and are packaged in 30-strip boxes. The KODAK Quality Control System for KODAK Black-and-White Film and Roll Papers is supplied from Rochester only.

Although some sludge may appear, the system is free from massive sludge formation as well as from staining tendency. Therefore, the working solution should not need replacement for several months. However, it should be replaced if the activity increases or decreases markedly (which indicates that the replenishment rate needs revision); if the bath shows excessive sludging or develops staining or scumming tendency (usually the result of contamination, as with hypo); or if the bath has been exposed excessively to the air (which can be minimized by the use of a floating cover).

STORAGE LIFE

Unused KODAK POLYDOL Developer and POLYDOL Replenisher can be stored in a full, tightly stoppered bottle for 6 months; in a partially full, tightly stoppered bottle for 2 months; in a tank with a floating cover for 1 month; or in an open tray for 24 hours.

TIME-TEMPERATURE CHART

Showing the development time at various temperatures corresponding to certain of the recommended times at 68 F. For other times at 68 F, additional lines can be drawn parallel to those now shown.

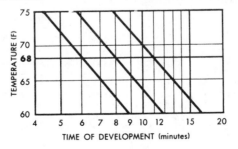

EASTMAN KODAK

KODAK MICRODOL-X DEVELOPER

(Liquid volumes are given in the U.S. system)

KODAK MICRODOL-X Developer is balanced to produce lower graininess and higher acutance (sharpness) than normal developers, with very little loss in effective film speed. In common with some other fine-grain developers, it tends to produce an image of slightly brownish tone, which gives more printing contrast than is apparent to the eye.

Tank development is recommended. For negatives of best quality and minimum graininess, adhere strictly to the recommended times of development. Forced development increases graininess with any developer.

Recommended Developing Time (in minutes)* in Small Tanks								
	Microdol-X (stock solution)					Microdol-X (1:3)†		
KODAK Films	65 F (18 C)	68 F (20 C)	70 F (21 C)	72 F (22 C)	75 F (24 C)	70 F (21 C)	72 F (22 C)	75 F (24 C)
Verichrome Pan, roll	11	9	8	7	6	12	11	10
Plus-X Pan, 135	11	9	8	7	6	13	12	11
Plus-X Pan Professional 4147 (Estar Thick Base), sheet‡	11	10	9½	9	8	NR	NR	NR
Plus-X Pan Professional, roll and pack	11	9	8	7	6	13	12	11
Royal Pan 4141 (Estar Thick Base), sheet‡	12	11	10½	10	9	NR	NR	NR
Panatomic-X, 135 and roll	11	9	8	7	6	13	12	11
Panatomic-X 6140, sheet‡	17	16	15	14	13	NR	NR	23
Tri-X Pan, 135 and roll	13	11	10	9	8	17	16	15
Tri-X Pan Professional, roll and pack	10	9	8½	8	7	NR	NR	NR
Tri-X Pan Professional 4164 (Estar Thick Base), sheet‡	11	10	9½	9	8	NR	NR	NR
Tri-X Ortho 4163 (Estar Thick Base), sheet‡	11	10	9½	9	8	NR	NR	NR
Infared, 135	17	14	12	11	9	NR	NR	22
Infrared 6130, sheet‡	12	10	9	8	7½	NR	NR	NR
Ektapan 4162 (Estar Thick Base), sheet‡	16	13	12	10	9	NR	NR	NR

*Agitation at 30-second intervals.

†When developing 135-size 36-exposure roll in 8-ounce tank, increase recommended time about 10 percent.

‡ Large Tank, agitation at 1-minute intervals

NR – Not Recommended

LIFE AND CAPACITY

In a completely full and tightly stoppered bottle, an unused KODAK MICRODOL-X stock solution should remain in good condition for about 6 months, and in a partly full, tightly stoppered bottle, about 2 months. In a large tank with floating cover, the safe storage life is about one month.

Without replenishment, the useful capacity is about 320 square inches of film per quart; 160 square inches per pint; 80 square inches per 8 ounces. To maintain uniformity of contrast, a progressive increase in development time is necessary—about 15 percent after each 80 square inches in a quart or after each 320 square inches developed in a gallon of developer.

256

The Compact Photo-Lab-Index

The roll films and corresponding areas are as follows:

828, 126 (12-exp)	=25 sq. in.	120, 620, 135 (36-exp) =	80 sq. in.
127	=45 sq. in.	116, 616	=100 sq. in.
135 (20-exp)	=50 sq. in.	220	=160 sq. in.

REPLENISHMENT

KODAK MICRODOL-X Replenisher will maintain a remarkably constant rate of development, film speed, and fine-grain characteristics.

In large tanks, add replenisher as needed to replace the developer carried out by the films and to keep the liquid level constant in the tank. On the average, this will take about ¾ ounce per roll or 6 gallons per thousand rolls of film developed.

For best results, the replenishment rate should be checked by periodic monitoring of the developer activity. For this purpose, we suggest the use of KODAK Control Strips, 10-step (for professional B/W film) and the procedure described in the Kodak Quality Control System for Kodak Black-and-White Films and Roll Papers. Information on the use of the control strips can be obtained from Professional, Commercial, and Industrial Markets Division.

With small tanks, add the replenisher at the rate of 1 ounce for each 80 square inches of film developed. This is equivalent to one 36-exposure roll of 35mm film, one No. 120 roll, or two No. 127 rolls.

When KODAK MICRODOL-X Developer is replenished as recommended, about 15 rolls or the equivalent (1200 square inches) can be developed per quart of original developer. The solution should be discarded after 4 months' use, regardless of the number of rolls developed.

DILUTION FOR MAXIMUM SHARPNESS

KODAK MICRODOL-X Developer produces images with excellent definition by combining extremely fine grain and very high acutance (sharpness). Still greater image sharpness can be achieved by diluting one part of MICRODOL-X solution with three parts of water, and increasing the development as shown in the table. To avoid unduly long developing times, the temperature of the solution can be increased to 75 F (24 C).

The diluted developer should not be stored or replenished after use. One roll of film (80 square inches) can be developed in a pint of the diluted developer; or two rolls can be developed simultaneously in a quart. When a 36-exposure roll of 35mm film is developed in an 8-ounce tank, the recommended time should be increased about 10 percent.

KODAK MICRODOL-X Developer contains p-methylaminophenol sulfate. **KEEP OUT OF THE REACH OF CHILDREN.**

CAUTION! Repeated contact may cause skin irration. May be harmful if swallowed. If swallowed, induce vomiting. **CALL A PHYSICIAN AT ONCE.**

Eastman Kodak Company will not be responsible for any skin ailment caused by this product.

EASTMAN KODAK

SUMMARY OF STEPS FOR
KODAK COLOR FILM PROCESS C-22

Agitation: See instructions and follow them closely.
Timing: Include drain time (10 seconds) in time for each processing step.

Step or Procedure	Remarks	Temp	Manual Processing		Automatic Processing	
			Time in Min	Total Min at End of Step	Time in Min	Total Min at End of Step
1. Develop	Total darkness	75 ± ½ F (24 ± 0.3 C)	13 See note	13	12 See note	12
2. Stop Bath	Total darkness	73–77 F (23–25 C)	4	17	4	16
3. Harden	Total darkness	73–77 F (23–25 C)	4	21	4	20
Remaining steps can be done in normal room light						
4. Wash	Running water	73–77 F (23–25 C)	4	25	4	24
5. Bleach	See warning on label	73–77 F (23–25 C)	6	31	6	30
6. Wash	Running water	73–77 F (23–25 C)	4	35	4	34
7. Fix		73–77 F (23–25 C)	8	43	8	42
8. Wash	Running water	73–77 F (23–25 C)	8	51	8	50
9. Final Rinse	KODAK PHOTO-FLO Solution	73–77 F (23–25 C)	1	52	1	51
10. Dry	See instructions	Not above 110 F (43 C)				

Note: Time specified is for KODACOLOR-X Film, KODAK EKTACOLOR Professional Film, Types S and L, and KODAK EKTACOLOR ID/Copy Film 5022. Increase the Developer, Bleach, and Fixer replenishment rates by 40% for KODAK EKTACOLOR ID/Copy Film 5022.

In all systems, develop KODAK EKTACOLOR Print Film 4109 for 11 minutes and subtract 1 or 2 minutes from each figure in the "Total Min" column. Develop KODAK EKTACOLOR Slide Film 5028 for 17 minutes and add 4 minutes to each figure in the "Total Min" column for manual processing. For automatic processing, develop the slide film for 16 minutes and add 4 minutes to each figure in the "Total Min" column. Note that KODAK EKTACOLOR Print Film Additive must be used with the print and slide films.

NOTICE: Observe precautionary information on containers and in instructions.

EASTMAN KODAK

INSTRUCTIONS FOR USING THE
KODAK FLEXICOLOR PROCESSING KIT FOR PROCESS C-41

1-U.S. PINT (473-ml) SIZE FOR PROCESSING KODACOLOR II FILM **AND** KODAK VERICOLOR II PROFESSIONAL FILM

PRECAUTIONS IN HANDLING CHEMICALS

Notice: Observe precautionary information on containers and in instructions.

The developing agent used in this process may cause skin irritation. In case of contact of solutions with the skin, wash at once with an acid-type hand cleaner and rinse with plenty of water. The use of clean rubber gloves is recommended, especially in mixing or pouring solutions and in cleaning the darkroom. Before removing gloves after each use, rinse their outer surfaces with acid hand cleaner and water. Keep all working surfaces, such as bench tops, trays, tanks, and containers, clean and free from spilled solutions.

The Stabilizer contains formaldehyde, which is a skin and eye irritant. Provide adequate ventilation to prevent the accumulation of formaldehyde vapor in the vicinity of the solution or the drying area. Keep storage containers tightly covered when they are not in use.

CONTAMINATION OF SOLUTIONS

The photographic quality and life of the processing solutions depend upon the cleanliness of the equipment in which solutions are mixed, stored, and used. Clean processing reels and tanks thoroughly after each use. Avoid the contamination of any chemical solution by any other. The best procedure is to use the same tanks for the same solutions each time, and to make sure that each tank or other container is thoroughly washed before it is refilled.

PROCESSING CHEMICALS

This kit contans the following chemicals. Carefully follow mixing directions. Two pints of developer are needed for each pint of the other solutions. Do not mix the second pint of developer until the first pint is exhausted, as explained under Capacity of Solutions.

Kodak Flexicolor Developer—
2 units

Kodak Flexicolor Bleach—
1 unit

Kodak Flexicolor Stabilizer—
1 unit

Kodak Flexicolor Fixer—
1 unit

MIXING DIRECTIONS

As you are mixing, rinse each container of solution and add the rinse to the mixing vessel.

CAUTION: This kit contains materials that may be hazardous. Observe precautionary information given on the containers and in the instructions.

Developer (This kit contains 2 units of Developer).

One unit of Developer consists of 3 parts:

Part A—A bottle of liquid.
Part B—A bottle of liquid.
Part C—A bottle of liquid.

● To Prepare:

1. Start with 11 fluidounces (325 ml) of water at 80 to 90°F (26.5 to 32°C).

2. With stirring, add the contents of the bottle, Part A.

3. With stirring, add the contents of the bottle, Part B.

4. With stirring, add the contents of the bottle, Part C.

5. Add sufficient water to bring the volume of Developer solution to 16 fluidounces (473 ml). Stir until uniform.

EASTMAN KODAK

The Compact Photo-Lab-Index

Bleach (This kit contains 1 unit of Bleach).

One unit of Bleach consists of 3 parts:

Part A—A packet of dry chemicals.
Part B—A bottle of liquid.
Part C—A bottle of liquid.

• To Prepare:

1. Start with 11 fluidounces (325 ml) of water at 80 to 90°F (26.5 to 32°C).

2. With stirring, add the contents of the packet, Part A, and stir until the chemicals are dissolved completely.

3. With stirring, add the contents of the bottle, Part B.

4. With stirring, add the contents of the bottle, Part C.

5. Add sufficient water to bring the volume of the Bleach solution to 16 fluidounces (473 ml). Stir until uniform.

Fixer (This kit contains 1 unit of fixer.)

One unit of Fixer consists of 1 part:
A bottle of liquid.

• To Prepare:

1. Start with 11 fluidounces (325 ml) of water at 70 to 80°F (21 to 26.5°C).

2. With stirring, add the contents of the bottle of liquid.

3. Add sufficient water to bring the volume of the Fixer solution to 16 fluidounces (473 ml). Stir until uniform.

Stabilizer (This kit contains 1 unit of Stabilizer).

One unit of Stabilizer consists of 1 part:
A bottle of liquid.

• To Prepare:

1. Start with 11 fluidounces (325 ml) of water at 70 to 80°F (21 to 26.5°C).

2. With stirring, add the contents of the bottle of liquid.

3. Add sufficient water to bring the volume of the Stabilizer solution to 16 fluidounces (473 ml). Stir until uniform.

STORAGE OF SOLUTIONS

For best results, do not use solutions which have been stored longer than the following times:

Mixed Solutions (Unused, Used, or Partially Used)	Full Stoppered Glass Bottles
Developer	6 weeks
Bleach	Indefinitely
Other Solutions	8 weeks

CAPACITY OF SOLUTIONS

For consistent and satisfactory photographic quality, fresh solutions or replenishment is recommended. The larger size **Flexicolor Processing Kit** and larger size individually packaged **Flexicolor Chemicals** are recommended for this purpose. Time adjustments are not used when developing in large tanks.

FOR KODACOLOR II FILM

In small tank processing where solution replenishment is not possible, best results are obtained if the development time is increased in the **same pint** of Developer. If not replenished, the Developer can be used to process the number of rolls of film shown in the table below. The Bleach, Fixer, and Stabilizer solutions have **twice the** capabilities shown and normal processing times are used for these solutions and washes.

FOR KODAK VERICOLOR II PROFESSIONAL FILM

In small tank processing where replenishment is not possible, it is recommended that each solution be used only once and discarded. Processing more than one roll of film in used solutions without replenishment will most likely result in undesirable photographic results. Film so processed may require abnormal printing conditions and could produce inferior prints.

If you are willing to accept the possibility of inferior results, use the above table as a guide for development time compensation. In all cases, handle the film very carefully.

The Compact Photo-Lab-Index

Film Size	*Rolls	Developer Time in Minutes and Seconds						**Rolls
		Processes						
		1st	2nd	3rd	4th	5th	6th	
110-12	3	3'15"	3'20"	3'26"	3'31"	3'37"	3'43"	18
110-20	3	3'15"	3'22"	3'30"	3'37"	3'45"	NR	15
126-12	2	3'15"	3'21"	3'28"	3'36"	3'45"	NR	10
126-20	2	3'15"	3'25"	3'37"	NR	NR	NR	6
135-20	2	3'15"	3'23"	3'33"	3'45"	NR	NR	8
135-36	2	3'15"	3'29"	3'47"	NR	NR	NR	6
828	2	3'15"	3'19"	3'24"	3'30"	3'37"	NR	10
127	2	3'15"	3'23"	3'33"	3'45"	NR	NR	8
120,620	1	3'15"	3'27"	3'42"	4'00"	NR	NR	4
116,616	1	3'15"	3'30"	3'47"	NR	NR	NR	3

NR = Not Recommended
*Rolls of film processed per pint before each time increase.
**Discard solution after developing this number of rolls per pint.

EQUIPMENT
Tanks—Small 1-pint tanks which use spiral reels

Reels—**Kodak 110 Processing Reel**
or
Stainless steel spiral reels of other manufacture

TEMPERATURE
The Developer temperature must be maintained at 100 ± ¼°F (37.8 ± 0.15°C). The importance of maintaining the Developer at this temperature cannot be overemphasized. The other solutions and the wash water should be used at the temperature recommended in the table.

To control the temperature of the solutions, maintain a water bath in a tray. Adjust the depth of the bath so that it is at least equal to the solution depth in the processing tank. The temperature of the water bath should be 100.5°F (38°C) for a room temperature of 75°F 24°C). Processing solutions and the empty processing tank can be kept at a room temperature of 75°F (24°C) before processing, but they must be brought to 100°F (37.8°C) just prior to processing. After development begins, place the processing tank in the water bath between agitation cycles.

TIMING
Start the timer **immediately** after the Developer solution is poured into the tank. The time of each processing step includes the drain time (usually about 10 seconds). This will vary, depending on the construction of the tank and whether the cover is on or off. In each case, start draining in time to end the processing step (and start with the next one) on schedule.

HANDLING
Load the reels and tanks in total darkness. Total darkness is required during development and the Bleach step.

PROCESSING STEPS AND AGITATION
The use of a single small reel in a multiple reel tank is not recommended. The back-and-forth motion of the reel in the solution (with inversion) can give excessive agitation in the Developer. If a single roll of film is processed, use blank spacer reels to hold the loaded reel in place.

Vigorous agitation as described below is recommended. Because of variations in personal technique, these recommendations may have to be altered to obtain satisfactory results.

Agitation, especially in the developer, is critical and must be done with care

EASTMAN KODAK

261

EASTMAN KODAK

and precision. Agitation is accomplished by inverting the processing tank, rotating the tank or rotating the reels. Tanks that can be inverted are recommended.

Developer—As soon as the solution is poured into the tank, start the clock and rap the bottom of the tank firmly on the sink or table to dislodge any air bells, then agitate for 30 seconds. If the inversion method is used, complete one inversion cycle per second. After the initial agitation, place the tank in 44°F water bath for 13 seconds, then agitate the tank for 2 seconds. Continue the subsequent agitation procedure until 10 seconds before the end of the development step, then pour the solution out and drain for 10 seconds to complete the specified development time.

Bleach—Pour the bleach solution into the tank and agitate for 30 seconds, using the same procedure as for the developer. After the initial agitation, place the tank in 100°F water bath for 25 seconds, then agitate for 5 seconds. Continue these 30-second cycles of agitation until 10 seconds before the end of the processing step, then pour the solution out and drain for 10 seconds to complete the specified solution time.

Fixer—Pour the fixer solution into the tank and agitate for 30 seconds, using the same procedure as for the developer. After the initial agitation, place the tank in 100°F water bath for 25 seconds, then agitate for 5 seconds. Continue these 30-second cycles of agitation until 10 seconds before the end of the processing step, then pour the solution out and drain for 10 seconds to complete the specified solution time.

Stabilizer—Pour the stabilizer solution into the open tank and rotate the reels for 30 seconds. No agitation is required for the remainder of this step.

SUMMARY OF CHEMICAL WARNING NOTICES

Keep Out Of The Reach Of Children

Developer Part B contains Hydroxylamine Sulfate.

WARNING! Harmful is swallowed. Causes skin and eye irritation. Avoid contact with skin and eyes. In case of contact, flush skin or eyes with plenty of water. If swallowed, induce vomiting. Call a physician at once. Keep out of the reach of children.

Developer Part C contains 4-Amino-3-methyl-N-ethyl (B-hydrovyethyl) aniline Sulfate.

CAUTION! Repeated contact may cause skin irritation and allergic skin reaction. May be harmful if swallowed. If swallowed, induce vomiting. Call a physician at once. Keep out of the reach of children.

Stabilizer contains Formaldehyde and Methanol.

☠

POISON

☠

DANGER! Strong sensitizer causes irritation of skin, eyes, nose, and throat. Avoid prolonged or repeated contact. In case of contact, flush skin or eyes with plenty of water. Vapor is harmful. Use with adequate ventilation. May be fatal or cause blindness if swallowed. If swallowed, induce vomiting. Call a physician at once. Keep out of the reach of children.

Bleach Part A contains Ammonium Bromide.

CAUTION! May be harmful if swallowed. If swallowed, induce vomiting. Call a physician at once. Keep out of the reach of children.

Bleach Part B contains Acetic Acid.

☠

POISON

☠

DANGER! Causes severe burns. Do not get liquid or vapor in eyes, on skin, on clothing. In case of contact, flush skin or eyes with plenty of water for at least 15 minutes. Harmful if swallowed. If swallowed, **do not** induce vomiting. Give milk or water. Call a physician at once. Keep out of the reach of children.

SUMMARY OF STEPS FOR PROCESSING
KODACOLOR II FILM **and** KODAK VERICOLOR II FILM IN THE
KODAK FLEXICOLOR PROCESSING KIT FOR PROCESS C-41

1 U.S. PINT (473 ml) SIZE

Summary of Steps for Processing **KODACOLOR II** Film
and **KODAK VERICOLOR II** Film in the

KODAK FLEXICOLOR Processing
Kit for Process C-41
1-U.S. Pint (473-ml) Size

Solution or Procedure	Remarks	Temp (°F)	Temp (°C)	Time in Min*	Total Min at End of Step	Agitation		
						Initial†	Rest	Agitate
1. Developer	Total darkness	$100 \pm \frac{1}{4}$	37.8 ± 0.15	$3\frac{1}{4}$	$3\frac{1}{4}$	30 sec	13	2
2. Bleach	Total darkness	75 to 105	24 to 40	$6\frac{1}{2}$	$9\frac{3}{4}$	30 sec	25	5
Remaining steps can be done in normal room light.								
3. Wash	Running water‡	75 to 105	24 to 40	$3\frac{1}{4}$	13			
4. Fixer		75 to 105	24 to 40	$6\frac{1}{2}$	$19\frac{1}{2}$	30 sec	25	5
5. Wash	Running water‡	75 to 105	24 to 40	$3\frac{1}{4}$	$22\frac{3}{4}$			
6. Stabilizer		75 to 105	24 to 40	$1\frac{1}{2}$	$24\frac{1}{4}$	30 sec		
7. Dry	See instructions below	75 to 110	24 to 43	10 to 20				

*Includes 10-second drain time in each step.

†Rap the bottom of the tank firmly on the sink or table to dislodge any air bells. Be sure you have read the agitation recommendations elsewhere in these instructions.

‡Use fresh water changes throughout the wash cycles. Fill the processing tank as rapidly as possible from a running water supply for about 4 seconds. When full, agitate vigorously for about 2 seconds and drain for about 10 seconds. Repeat this full wash cycle. If desired, use a running water inflow-overflow wash with the cover removed from the tank.

DRYING

Remove the film from the reels and hang it up to dry for 10 to 20 minutes at 75 to 105°F (24 to 41°C) in a dust-free atmosphere with adequate air circulation. If a drying cabinet is used, the air should be filtered and its temperature must not exceed 110°F (43°C).

Increase the relative humidity if excessive curl is encountered.

If you are troubled with water spots on the base side of the film, use a sponge moistened with stabilizer solution to carefully wipe these spots away (base side only).

KODAK FLEXICOLOR **CHEMICALS**

Instructions for Processing Kodak Kodacolor II Film **and** Kodak Vericolor II Film

For Process C-41 and Process C-41V

IMPORTANT NOTICE! Observe all precautionary information on containers, and in instructions.

GENERAL INFORMATION

These films can be processed in various ways. Sink line processing using tanks or reels, or automatic equipment can be used. It is of utmost importance to handle these films very carefully to avoid abrasions, scratches, kinks and creases. When processing on reels, use only one film roll per reel. It is important to minimize dirt, water spotting, and other defects which would impair the negative image. Careful squeegeeing before drying can reduce this tendency.

PROCESSING CHEMICALS

The chemicals for each of the processing solutions are supplied in prepared form in various sizes. To prevent contamination of the processing chemicals or physical damage to the film, do **not** process any other kinds of films in these chemicals. Carefully follow mixing directions and precautionary information furnished with the chemicals.

CONTAMINATION OF SOLUTIONS

The photographic quality and life of the processing solutions depend upon the cleanliness of the equipment in which solutions are mixed, stored, and used. Clean processing reels, racks, and tanks thoroughly after each use. Likewise, avoid the contamination of any chemical solution by any other. The best procedure is to use the same tanks for the same solutions each time, and to make sure that each tank or other container is thoroughly washed before it is refilled.

PRECAUTIONS IN HANDLING CHEMICALS

NOTICE: Observe precautionary information on containers and in instructions.

The developing agents used in these processes may cause skin irritation. In case of contact of solutions or solid chemicals (especially developers or developing agents) with the skin, wash at once with an acid-type hand cleaner and rinse with plenty of water. The use of clean rubber gloves is recommended, especially in mixing or pouring solutions and in cleaning the darkroom. Before removing gloves after

	Gallons
Kodak Flexicolor Developer	1, 3½
Kodak Flexicolor Developer Replenisher	5, 25, 75
Kodak Flexicolor Developer Starter	1 quart concentrate
Kodak Flexicolor Bleach	1
Kodak Flexicolor Bleach Replenisher	5, 25, 75
Kodak Flexicolor Bleach Starter	1 quart
Kodak Flexicolor Bleach Regenerator	5, 25, 75
Kodak Flexicolor Fixer and Replenisher	1, 5, 25, 75
Kodak Flexicolor Stabilizer and Replenisher	1, 3½, 5, 12½
Kodak Hardener and Replenisher, Process C-41V	25
Kodak Stabilizer and Replenisher, Process C-41V	25

EASTMAN KODAK

each use, rinse their outer surfaces with acid hand cleaner and water. Keep all working surfaces, such as bench tops, trays, tanks, and containers, clean and free from spilled solutions or chemicals.

The Stabilizers contain formaldehyde, which is a skin and eye irritant. Adequate ventilation should be provided to prevent the accumulation of formaldehyde vapor in the vicinity of the solution or the drying area. Tanks should be tightly covered when not in use.

STORAGE OF SOLUTIONS

For best results, do not use solutions which have been stored longer than the following times.

Mixed Solutions (Unused, Used, or Partially Used)

	Full Stoppered Glass Bottles	Tanks with Floating Covers
Developer or Developer Replenisher	6 weeks	4 weeks
Bleach	Indefinitely	Indefinitely
Other Solutions	8 weeks	8 weeks

BLEACH REGENERATION

You can obtain significant savings and help reduce pollution with automatic processors by using a simple method for regenerating **Kodak Flexicolor Bleach.** A recommended procedure is as follows:

1. The bleach overflow may be collected in a polyethylene, **Tenite,** or a fiber glass tank, or in a Type 316 stainless steel tank. Since corrosion problems will occur if the wrong type of stainless steel is used (e.g., Type 304), plastic materials are preferred for tanks, piping, pumps, and fittings.

It may be desirable to use a small, intermediate transfer tank to collect bleach overflow at the machine and automatically pump it to a larger, remote holding tank in the chemical mixing area.

2. Since bleach regenerator kits are available in 5-, 25-, and 75-gallon sizes, the volume of bleach overflow collected for each regeneration should be based on the production level of the machine. For example, bleach overflow from a **Kodacolor Dual-Strand Film Processor, Model 2,** may be regenerated in 5-gallon batches. Over flow from a **Kodak Viscount Processor** may be regenerated in 25-gallon batches.

PROCESS MONITORING

Process the control strips on a regular basis to assist you in monitoring the quality of your process. Use **Kodak Professional Control Strips, Process C-41,** if most of the film processed is **Kodak Vericolor II Professional Film.** Use **Kodak Control Strips, Process C-41,** if most of the film processed is **Kodacolor II.** Instructions for the use of control strips are given in Kodak Publication No. Z-99, **Introduction to Color Process Monitoring,** and No. Z-121, **Using Process C-41** available from your photo dealer, or from Eastman Kodak Company, Dept. 454, Rochester, New York 14650.

3. Care should be taken in measuring the volume for regeneration. Dilution errors will tend to multiply with successive regenerations.

4. When the desired volume of bleach overflow is collected, the solution should be transferred to a mix tank. There, the regenerator may be added, and the regenerated bleach overflow returned to the replenisher tank.

5. The bleach must be regenerated after each collection; bleach overflow cannot be used without regeneration.

6. No analytical test is required.

7. The number of times the bleach may be collected and regenerated is unlimited.

8. Fresh bleach replenisher may be added to the system at any time to make up for any volume lost.

SILVER RECOVERY

Complete information for recovering silver can be obtained from the Kodak Technical Sales Representative.

PROCESSING IN SMALL TANKS (1 Pint)

Information for processing in small tanks is packaged with the **Kodak Flexicolor Processing Kit** (for Process C-41), 1-pint kit.

EASTMAN KODAK

EASTMAN KODAK

PROCESSING IN ROTARY-TUBES

This information is available by writing to Eastman Kodak Company, Dept. 761-B, Rochester, New York 14650, asking for a copy of **Special Instructions for Using Rotary-Tube Processors for Process C-41,** publication No. Z-121A.

SINK-LINE PROCESSING EQUIPMENT

Sinks—To maintain a solution processing temperature of 100°F (38°C), a tempered-water bath for the processing tanks is required. Equipment especially designed for this is recommended.

Processing Tanks—Processing tanks, such as the **Kodak Hard Rubber Tanks,** the **Kodak No. 3F Processing Tanks,** or tanks supplied with processing lines are suitable. For optimum heat transfer and solution temperature control, (especially for the developer), stainless steel tanks are recommended.

Processing Reels—Processing reels, such as the **Kodak 110 Processing Reel** for 110-size film rolls, may be used to hold the film. Other commercially available wire or plastic reels accommodating the various size film rolls may be used. Care should be taken in selecting the reel to make sure that it fits into the reel holder since certain reels may not fit. The diameter of the plastic side of some reels is slightly too large to easily load into some holders. When using the lightweight **Kodak 110 Processing Reel** it may be necessary to provide weights to keep reels from moving upward and out of place in the reel holder during vigorous agitation.

The metallic clip on the loading tab of some reels may impinge on the emulsion side of the film and leave a mark on the film caused by lack of development. Minimize this by loading the film emulsion side out rather than in the conventional way of emulsion side in toward the core.

Reel Holders—Reel holders, such as the **Kodak Processing Rack** may be used. Caution is required in selecting reel holders and processing tanks, since sizes are not standardized.

Sheet Film Hangers and Separators—For processing sheet films, suitable hangers and carriers must be provided. Typical equipment includes the **Kodak Film and Plate Developing Hanger, No. 4** (available for various sheet sizes), the **Kodak Developing Hanger Rack No. 40,** with **Kodak Hanger Separators,** or their equivalent. During processing, hangers should be separated by approximately equal spaces of at least ½ inch (13 mm).

Gaseous-Burst Agitation Equipment—Suggested are the **Kodak Intermittent Gaseous Burst Valve, Model 90B,** and the **Kodak Gas Distributor** or their equivalent. Compressed nitrogen gas and oil-free compressed air must be provided either from cylinders or a general supply.

CAPACITY OF SOLUTIONS

If not replenished, the Developer can be used to process the number of rolls of film shown in the table below. The Bleach, Fixer, and Stabilizer solutions have **twice** the capacities shown. For optimum process results, use of replenishment is recommended.

SEE TABLES ON FOLLOWING PAGE

The Compact Photo-Lab-Index

Film Size	Developer Capacity (Rolls) Per	
	Gallon	3½ Gallons
110-12	24	84
110-20	24	84
126-12	16	56
126-20	16	56
135-20	16	56
135-36	16	56
828	16	56
127	16	56
120, 620	16	56
116, 616	8	28
220	8	28
4 x 5	32	112
5 x 7	16	56
8 x 10	8	28

PROCESSING STEPS AND CONDITIONS

Solution/Step	Time [1]	Temperature	
		°F	°C
Developer	3′ 15″	100 ± ¼[2]	37.8 ± 0.15
Bleach[3]	6′ 30″	75 to 105	24 to 40
Wash	3′ 15″	75 to 105	24 to 40
Fix	6′ 30″	75 to 105	24 to 40
Wash	3′ 15″	75 to 105	24 to 40
Stabilizer	1′ 30″	75 to 105	24 to 40
Dry[4]	10′ to 20′	75 to 110	24 to 43

[1]Times include a 10-second drain at the end of each step.

[2]The developer temperature specified is the recommended temperature range during development. It is NOT THE RECOMMENDED STARTING TEMPERATURE FOR THE DEVELOPER. See paragraph entitled DEVELOPER STARTING TEMPERATURE.

[3]Room lights may be turned on after the bleach.

[4]Remove film from reels and hang in a dust-free place with adequate air circulation. In a drying cabinet, forced air should be filtered and not exceed 110°F (43.5°C). If excessive curl is encountered, ambient conditions are probably too dry. Increase relative humidity.

EASTMAN KODAK

DEVELOPER STARTING TEMPERATURE

The processing temperature for the developer is the recommended temperature range during development. IT IS NOT THE RECOMMENDED STARTING TEMPERATURE OF THE DEVELOPER.

The starting temperature of the developer should be determined and maintained as follows:

1. Bring the developer up to the temperature of 100°F (38°C).

2. Immerse a thermometer in the developer for several minutes to allow it to register equilibrium temperature. Record this measured temperature. Leave the thermometer immersed in the developer.

3. Immerse a full rack of processed scrap film (similar in configuration to that used in actual processing and at ambient room temperature) into the developer. Be sure to use the initial agitation procedure that is used in actual processing. At the end of the first 30 seconds (measured from the time the rack of film was immersed in the developers), record the temperature indicated by the immersed thermometer.

4. Determine the temperature drop which is the difference between the initial temperature and the temperature recorded in step three above. The temperature drop value is valid only at the ambient room temperature at which it was measured.

5. The starting temperature is equal to 100°F (38°C) plus the temperature drop.

For example, the temperature drop for one sinkline and a metal carrier filled with thirteen 8 x 10-inch films (on hangers) might have a temperature drop of 1.0°F at an ambient room temperature of 70°F (21°C). Under the same room conditions, the temperature drop for a small tank (one pint) might be 0.7°F (0.4°C) for two 36-exposure, 35mm reels and film. These data illustrate the magnitude of possible temperature drops. Although the temperature drop is small, it should be considered whenever processing in sinkline and small tank equipment to maintain consistency from one process run to the next. It is important that the temperature drop be determined for each unique set of process conditions and configurations.

AGITATION

Three types of agitation can be used in sink-line processing: manual, gaseous-burst, and a combination of manual and gaseous-burst. Tests indicate the combination of manual and gaseous-burst agitation should be used to achieve optimum uniformity in processed film, particularly sheet film.

In either the combination or gaseous-burst agitation procedures, nitrogen must be used in the developer to avoid air oxidation of the developer during the agitation cycle. In the fix, wash, and stabilizer solutions, either compressed air or nitrogen can be used. Air agitation **must** be used in the bleach in order to maintain a stable solution. If air cannot be used to agitate the bleach during processing, some other method for mixing air into the bleach should be used.

If only nitrogen-burst agitation is used in the developer, optimum uniformity should not be expected. The extent of image nonuniformity will depend on a number of factors, i.e., reel or hanger design, location of the reel or hanger in the tank, and the distributed gaseous-burst pattern, frequency, and bubble size. Nitrogen-burst agitation, as described, is intended only as a guide for those findings the results satisfactory for their needs.

SPECIAL TREATMENT REQUIRED FOR BLEACH SOLUTIONS

In a seasoned process, the efficiency of the action of the bleach depends upon a certain amount of aerial oxidation of the bleaching solution. The best way to achieve this oxidation is to use air-burst agitation. For maximum effect, air burst should continue in the bleach during the complete process cycle. If nitrogen or lift-and-drain procedures are used for agitation, some other provision for mixing air into the bleach should be provided. This can be done by bubbling air through the bleach from a separate compressed-air supply through a sparger (such as the **Kodak Gas Distributor,** or equivalent) for about 30 minutes for each full

process run at a valve pressure of about 2½ lbs./in.². Aerating at a lower rate should continue longer.

If no method of bubbling aeration is available, the bleach should be vigorously stirred with a mixer in such a manner that air is drawn into the solution.

COMBINATION OF MANUAL AND GASEOUS-BURST AGITATION

The procedure starts with a continuous nitrogen burst for the first 15 seconds in the developer followed by a 2-second burst every 28 seconds thereafter. Thirteen seconds from the end of each nitrogen burst, hand agitation is executed. This procedure involves lifting the rack carrier from the developer, tilting it toward the front of the tank, rapping the rack carrier against the top edge of the tank, reimmersing the rack carrier, lifting the rack carrier, tilting it toward the back of the tank, rapping it against the back edge of the tank, and reimmersing the rack carrier into the developer. For an experienced sink-line operator, this should take 2 to 3 seconds. This will give agitation every 15 seconds, alternating between nitrogen burst and manual agitation.

The bleach, first wash, and fixer solutions use the same agitation procedure described above except air is used instead of nitrogen. The final wash uses gaseous agitation only, with a 2-second burst every 28 seconds. The stabilizer uses continuous hand agitation for the first 15 seconds followed by no agitation during the remainder of the stabilizer solution time.

MANUAL AGITATION

The following procedures are intended only as a guide for those who find the resulting uniformity satisfactory:

Developer, Initial—Immerse the rack fully into the developer. Rapidly tap it on the bottom of the tank to dislodge any air bubbles, then raise the rack until the bottom is out of the developer once and reimmerse it. This requires 4 to 5 seconds.

Developer, Subsequent—After the initial agitation is completed, allow the rack to remain at rest for a total time of 10 seconds. Raise the rack straight up until the bottom is just out of the

developer solution, then reimmerse it without draining. The lifting and reimmersing cycle should be done in an even, uniform manner, taking 2 to 3 seconds to complete.

Repeat the lifting and reimmersing cycle once every 10 seconds, (6 times per minute).

Ten seconds before the developing time is completed, (after about 3 minutes in the developer, including the time for initial agitation), raise the rack, tilt it about 30 degrees toward one corner (held over the tank), and drain for 10 seconds. At the end of 10 seconds, immerse the rack into the bleach.

Note: The agitation frequency of one 2-second lifting cycle 6 times per minute should be adequate to maintain satisfactory process control contrast. If, however, the contrast plots slightly high or low, the frequency of agitation may be reduced or increased.

Increasing the frequency to 10 times per minute may help in increasing the contrast plot, and, conversely, reducing the frequency may help in reducing the contrast. However, the frequency should not be reduced to less than twice each minute.

Solutions After Developer—Initial Agitation—Use one lifting cycle.

Solutions After Developer—Subsequent Agitation—Use four lifting cycles per minute at 15-second intervals. (See special bleach treatment.)

Agitation — Washes — Agitate initially with one lifting cycle. No agitation thereafter is required for a running-water wash.

GASEOUS-BURST AGITATION

The following procedures are intended only as a guide for those who find resulting uniformity satisfactory.

Developer, Initial—Use the same procedure described for manual agitation.

Developer, Subsequent—Use only nitrogen in the developer. Eight seconds after the film has first been immersed, give a 2-second burst of nitrogen. Repeat the 2-second burst at 10-second intervals, (6 times per minute). The frequency of the 2-second burst may be increased up to 10 times per minute or decreased to twice per minute to optimize the contrast plot, if desired.

EASTMAN KODAK

269

The Compact Photo-Lab-Index

SINK LINE

Development, bleaching, fixing, etc., involve chemicals reactions; therefore, solutions as used must be maintained at normal strength and condition. In addition (in manual processing), film reels, hangers, and carriers carry over a substantial amount of each solution into the following solution in the processing sequence. Proper solution replenishment is essential to maintain photographic results as measured by control strip results.

In the table following, **starting point** replenishment rates are given for individual rolls and sheets and for different kinds of carriers and holders. It will be necessary to calculate batch replenishment rates based on the number and kind of film processed. Established rates can then be adjusted, depending on over- or underreplenishment, as indicated by control strip results. Recommended wash water flow rate is 3 gallons per minute.

Solution Replenishment Rates* (Volume in Milliliters)

	Developer	Bleach	Fixer	Stabilizer
Equipment Without Film				
Reel Carrier	0	30	30	30
Sheet Film Carrier	0	50	50	50
110-12/20 Reel**	0	10	10	10
126-12/20 Reel**	0	15	15	15
135-20 Reel**	0	15	15	15
135-36 Reel**	0	23	23	23
120 Reel**	0	20	20	20
4 x 5 Hanger (4 sheets)	0	15	15	15
5 x 7 Hanger (2 sheets)	0	10	10	10
8 x 10 Hanger (1 sheet)	0	10	10	10
Film in Reel or Hanger				
110-12	19.6	10	10	10
110-20	28.8	15	15	15
828	24.0	29	29	29
126-12	33.6	29	29	29
126-20	55.2	37	37	37
135-20	45.6	39	39	39
135-36	81.6	58	58	58
120	100	67	67	67
127	53	41	41	41
116	142	71	71	71
616	142	71	71	71
4 x 5 sheet*** (4 sheets)	132	111	111	111
5 x 7 sheet*** (2 sheets)	116	88	88	88
8 x 10 sheet (1 sheet)	134	105	105	105

*The replenishment rates for the different sizes of film include the reel or sheet film hanger. The rates for individual reels or sheet film hangers are to be used only if empty reels or hangers are run through the process.

**Data is for metal reels; plastic reels have a higher carryover rate and will require an increase in bleach and fixer replenishment rates of approximately 60 percent for 110-size reels, and 25 percent for 126-, 135-, and 120-size reels.

***Developer, bleach, fixer, and stabilizer replenishment rates for these sizes assume a filled hanger. For developer, subtract 33 ml for each 4 x 5 sheet missing, and 58 ml for each 5 x 7 sheet missing from the replenishment rate given if the holder is not filled to capacity. For bleach, fixer, and stabilizer, subtract 24 ml for each 4 x 5 sheet missing, and 39 ml for each 5 x 7 sheet missing from the replenishment rate given.

EASTMAN KODAK

270

KODAK EKTACHROME 2203 Paper

A fast, versatile color paper for making color prints direct from slides, and also for many direct in-camera applications.
KODAK EKTACHROME 2203 Paper is a high-speed, resin-coated reversal paper designed for making color prints directly from slides and larger transparencies, and also from existing color prints. Sheets are available in F surface, rolls in F and Y surface.

SUGGESTED APPLICATIONS
In addition to its primary application for making color prints directly from slides, the many outstanding features of KODAK EKTACHROME 2203 Paper permit several other applications in a number of areas of photography. Among these are the following:

Commercial Photographers can use the paper to make high-quality direct color reversal print from their original color transparencies to use in their studios.

They can also use the paper with image-reversal optics for direct in-camera production of copyprints (or "color stats") from original prints or artwork.

Aerial Photographers can use the paper to produce excellent high-quality direct prints from color tranparencies and color infrared film.

Medical Photographers can use the paper for production of high-quality prints from color slides.

Professional Color Labs can use the paper to reduce printing time, boost productivity, and help make darkroom work (such as burning-in) faster and easier.

Photofinishers can use the paper to make direct copyprints more potentially profitable, as well as save valuable processing time.

Photo Hobbyists can use the paper to make enlargements from their favorite slides.

FEATURES
High-speed emulsion. At least four times faster than previous *Kodak* color reversal paper. Allows short printing times and high productivity. Permits fast, easy burning at the enlarger for creative control, and greater diffusion in printers for high uniformity. High speed of paper permits direct use in-camera for making prints from prints and/or artwork.

Increased sharpness. Provides crisp, detailed prints with increased sharpness.

High color saturation. Renders pleasing colors with bright reds, greens, blues, and yellows.

Excellent dye stability. Light-fading resistance comparable with EKTACOLOR 74 RC and 78 Paper and *Kodak* dye transfer material.

High D-max. Produces deep, rich blacks.

PROCESSING
Two different *Kodak* chemical processes are available for KODAK EKTACHROME 2203 Paper, depending upon the processing method. Both processes permit fast processing and are supplied as all-liquid chemicals.

Use KODAK EKTAPRINT R-1000 Chemicals for processing EKTACHROME 2203 Paper in KODAK Rapid Color Processors, other manufacturers' automated drum-type processors, and in small tube-type or rotary processors which employ single-use chemicals. Use KODAK EKTAPRINT R-100 Chemicals when processing in continuous and roller-transport processor.

The chemicals are available as follows:

KODAK EKTAPRINT R-100 Chemicals	KODAK EKTAPRINT R-1000 Chemicals
First Developer Starter	First Developer
First Developer Replenisher	Stop Bath
Stop Bath and Replenisher	Color Developer
Color Developer and Replenisher	Bleach-Fix
Bleach-Fix and Replenisher	Stablizer
Bleach-Fix Regenerator	
Bleach-Fix Regenerator Starter	
Stabilizer and Replenisher	

EASTMAN KODAK

PROCESS *KODAK EKTACHROME 2203* PAPER IN TUBES USING *KODAK EKTAPRINT R-1000* CHEMICALS

The information given here has much of the information you need to make color prints from slides or other transparencies using EKTACHROME 2203 Paper and EKTAPRINT R-1000 Chemicals. However, you will also find it helpful to consult the more detailed processing instructions that are packaged with the EKTAPRINT R-1000 Color Developer.

Also, keep in mind that the color balance and density of your prints will be affected by processing *as well as by* filtration and exposure. To get the best possible quality images, you must process your prints as recommended and you must do so consistently. Changes in solution times or volumes, temperature variation, and incorrect mixing can all cause unpredictable color and density shifts that will confuse you in trying to arrive at the correct filtration and exposure. However, you can easily avoid these problems simply by following the recommended instructions and *processing each print exactly the same way.*

GENERAL PROCESSING CYCLE FOR TUBE- AND DRUM-TYPE PROCESSORS

Processing Step	Time* in Minutes of Processing Step	Total Time at End
1. Prewet (water)	1	1
2. First Developer	2	3
3. Stop Bath	½	3½
4. Wash	1	4½
5. Wash	1	5½
6. Color Developer	2	7½
7. Wash	½	8
8. Bleach-Fix	3	11
9. Wash	½	11½
10. Wash	½	11½
11. Wash	½	12½
12. Stabilizer	½	13
13. Rinse (water)	¼	13¼
TOTAL	13¼	13¼

*Note, all times include a 10-second drain time (to avoid excess carry-over). Some processing tubes may require a slightly longer drain time. Be sure to allow enough time to make certain the tube is drained and to add the next solution on time for the next step. The next step begins when the solution contacts the paper.

TEMPERATURE CONTROL

The nominal solution temperature required for this process is 38°C (100°F). However, the temperatures described in the following two procedures should be noted:

Procedure A: For tubes designed to be used in a constant temperature bath, maintain the temperature of the bath, the processing solutions, and the water used for the prewet, washes, and rinse at 38 ±0.3°C (100 ±0.5°F).

Procedure B: For tubes used without a constant temperature bath, find the room temperature in the left column of the following table and maintain all processing solutions and water used for the prewet, washes, and rinse at the temperature indicated in the right column. If this method is followed, the temperature drop druing proceing will result in an average temperature of 38°C (100°F). The temperature of the first developer should be within ±0.3°C (±0.5°F) of the temperature in the left column. The other solutions should be within ±1°C (±2°F).

Room Temperature		Solution Temperature	
°F	°C	°F	°C
60	15.5	118	47.7
65	18.5	116	46.7
70	21.0	114	45.5
75	24.0	112	44.5
80	26.5	110	43.5
85	30.0	108	42.2

EASTMAN KODAK

The Compact Photo-Lab-Index

AGITATION

The proper amount of agitation is provided by the rolling of the tube in the normal course of processing. However, remember to keep the tube *level* when agitating to allow the solution to contact the print evenly.

HOW TO EVALUATE PRINT DENSITY

Evaluate density before color balance, since it is nearly impossible to correct balance until the test print has about the right density.

The *color balance and the density* in the test print need correction. To do this, you have to ignore the color of the print and estimate what exposure correction is needed. Then make another test print at the corrected exposure time. This second print should have about the right density, although the color balance may still be off considerably. Once you have made a print with about the right *density,* you can better evaluate the *color balance.*

Test strips to determine density: To minimize wasted time and materials, many printers expose their first print as test strips. To do this, cover all but about a 1-inch strip of the paper in the easel, and expose for 5 seconds. Then, without moving the paper, uncover another inch and expose for another 5 seconds. Continue doing this until the entire print is exposed.

After processing, the test print will have several parallel strips of increasing density, each strip having received 5 seconds more exposure than the light strip next to it. Pick the strip that has about the right density and determine how much exposure it received. This is the exposure you should use for your next test print.

ADDITIONAL PROCESSING CYCLE DATA FOR OTHER TYPES OF DRUM PROCESSORS

Time in Minutes and Seconds:

Processing Step	KODAK Rapid Color Processor Models 11 and 16K	Model 30A	Motorized Rotary Tube Processors
1. Prewet	1:00	:20	1:00
2. Drain	:30	:10	*
3. First Developer	1:30	2:00	1:30
4. Stop	:30	:30	:30
5. First Wash	2:00	1:00	2:00
6. Color Developer	2:00	2:00	2:00
7. Second Wash	:30	:30	:30
8. Bleach-Fix	2:30	1:30	2:30
9. Third Wash	1:30	1:00	1:30
10. Stabilizer	:30	:30	:30
11. Rinse	:15	:15	:15
Total	12:45	9:45	12:15

Temperatures

Prewet, Washes, Rinse	97 to 104°F (36 to 40°C)	112±2°F (44.5±1°C)	97 to 104°F (36 to 40°C)
KODAK EKTAPRINT R-1000 First Developer	100.4±0.5°F (38±0.3°C)	112±0.5°F (44.5±0.3°C)	100.4±0.5°F (38±0.3°C)
Other Solutions	100.4±2°F (38±1.0°C)	112±2°F (44.5±1°C)	100.4±2°F (38±1.0°C)

*Drain times for rotary tube processors depend on the design of the processors. Consult the manufacturer's literature for suggested times.

PROCESSING IN *KODAK* RAPID COLOR PROCESSOR, MODELS 11, 16K AND 30A

The following modifications are required in order to process KODAK EKTACHROME 2203 Paper in KODAK Rapid Color Processor, Models 11, 16K and 30A, using KODAK EKTAPRINT R-1000 Chemicals.

Models 11, 16K require a change in the nylon net blanket supplied with the processor. A new, modified

273

EASTMAN KODAK

net blanket for use in processing EKTACHROME 2203 Paper may be ordered from your dealer in *Kodak* professional products.*

Model 30A requires a change in the timing disc supplied with the processor. A new timing disc for processing EKTACHROME 2203 Paper may be ordered from your dealer.**

Also, please note that there may be some nonuniformity in large continuous-tone areas when EKTACHROME 2203 Paper is processed in equipment such as the KODAK Rapid Color Processor, Model 16K.

*Model 11 —Part No. 605342
Model 16K—Part No. 605343

**KODAK EKTACHROME 2203 Timing Disc, Model 30A
CAT. No. 103 9478 60 Hz
CAT. No. 103 9510 50 Hz

HOW TO EVALUATE PRINT COLOR BALANCE

Color balance refers to the relative amount of dye in each of the three emulsion layers in the paper. If a print has unacceptable color balance, there is relatively more or less dye in one layer than in the other. A print has proper color balance when the right amount of dye is formed in each layer.

You can evaluate prints for proper color balance by deciding:
1. **What color is in excess?**
2. **How much in excess is it?**

Change Desired	Approximate Correction
very slight	10
slight	20
moderate	40

Making color balance corrections can be frustrating until you've gained some experience. A helpful technique that can save you much time is to record the exposure and the filtration for each print right on the print (porous-point, felt-tipped pens write easily on the print emulsion).

For example: Print No.: 1

This Print: 25C + 10M
10 sec, f/8

Next Print: 25C + 20M
10 sec, f/8

If you are making a series of test prints, it is also helpful to number them consecutively. This information is valuable for showing you exactly what effect the corrections you made had on the way the prints look.

TECHNICAL DATA AND SPECIFICATION

HOW TO STORE AND HANDLE

Storage: High temperature or high humidity may produce undesirable changes in KODAK EKTACHROME 2203 Paper. For this reason, keep unexposed paper at 50°F (10°C) or lower in the original sealed package.

After removing the paper to be exposed, be sure to restore the moisture barrier (foil envelope) around the unused paper by pressing out excess air, making a double fold in the open end of the bag, and securing it with a rubber band or piece of tape.

Handling: Do not use safelight with unprocessed KODAK EKTACHROME 2203 Paper. *Handle only in total darkness.*

HOW TO PRINT

This paper can be exposed on enlargers with tungsten illumination of color quality equivalent to Photo Enlarger Lamp No. 212 or No. 302, or tungsten halogen lamps.

The enlarger should be equipped with the following: 1. A heat-absorbing glass. 2. An ultraviolet absorber, such as KODAK WRATTEN Gelatin Filter No. 2A. 3. Color-correction filters, such as KODAK Color Printing Filters (acetate), KODAK Color Compensating Filters (gelatin), or dichroic filters. If your enlarger does not have dichroic filters for the color-correction filter pack you can use KODAK Color Printing Filters (Acetate) or KODAK Color Compensating Filters (Gelatin). The CP filter can be used *only* between the light source and the transparency, but the CC filters can also be used between the transparency and the paper where they are in the path of image-forming light. Any number of filters (CP

The Compact Photo-Lab-Index

or CC) can be used between light source and transparency, but the number of CC filters used between transparency and paper should be as small as possible, preferable not over three. Also, when using filtration, do not use filters identified by the suffix "2" as in "CC10C-2" or "CP10C-2."

Trial Exposure: The following information is for the initial setup of exposing equipment using a selected batch of KODAK EKTACHROME 2203 Paper for the first time. Use good-quality transparencies to make trial exposures. The following table gives starting-point exposure times and appropriate filters for slides made on different *Kodak* films.

SUGGESTED STARTING EXPOSURE TIMES AND FILTER PACKS
For 8 × 10-Inch Prints on *KODAK EKTACHROME* 2203 Paper from
35mm Slides in Enlargers with Tungsten-Halogen Lamps

When You Print from Slides on These *Kodak* Films	Use a Filter Pack Containing a *Kodak Wratten* Gelatin Filter No. 2A and These Filters	And These Exposure for Trial
Ektachrome (E-4)	20C + 10M	
Ektachrome (E-6)	25C + 10M	4, 8, and 16
Kodachrome 25 Kodachrome 64	10C + 05M	seconds at f/8
Random Mix of Slides	20C + 10M	

After making the first test print, proceed as follows:

1. Process and dry the test print as recommended; then evaluate color balance and exposure.

2. Make the necessary filter pack changes and make another test print at selected exposure time and f/stop. Once again, process dry, and evaluate the test print.

3. Once you obtain a satisfactory print, use that exposure/lens opening/filter-pack combination for other slides on the same type film.

HOW TO DRY AND MOUNT PRINTS

Drying: To minimize the drying time, squeegee or sponge the paper prints before drying. KODAK EKTACHROME Paper can be dried on racks or air-impingement dryers. You can speed up rack drying by using forced circulation of warm air, 49 to 66°C (120 to 150°F). Prints made on EKTACHROME 2203 Paper cannot be hot- or cold-ferrotyped, nor can they be dried in contact with plastic sheets, between blotter rolls, or on belt dryers.

Mounting: Prints can be mounted satisfactorily with KODAK Dry Mounting Tissue, Type 2, or KODAK Rapid Mounting Cement. If you use tissue, the temperature across the heating plate should be 82 to 99°C (180 to 120°F), and pressure should be applied for 30 seconds or longer in case of thick mount. Preheat the cover sheet used over the face of the print to remove moisture which might otherwise cause sticking. If prints are displayed behind glass, maintain a slight separation between the prints and the glass.

For White Borders: White borders can be obtained by exposing the border areas of a print while the picture area is protected by an opaque mask. When the enlarger is adjusted as suggested in these instructions, and exposure from 1½ to 2 times the print exposure time will be required, with no transparency in the beam. The filters can be included when the border is flashed. Overlap the print exposure and the border to eliminate dark edges.

The Compact Photo-Lab-Index

HOW TO USE CHEMICALS

When KODAK EKTACHROME 2203 Paper is processed in tubes, the KODAK EKTAPRINT R-1000 Chemicals (initially available as MX1077-1 Chemicals) required for each of the processing solutions are available in separate units as follows:

KODAK EKTAPRINT R-1000 First Developer
KODAK EKTAPRINT R-1000 Stop Bath
KODAK EKTAPRINT R-1000 Color Developer
KODAK EKTAPRINT R-1000 Bleach-Fix
KODAK EKTAPRINT R-1000 Stabilizer

When mixing, carefully follow the directions included with the chemicals, and always observe the precautionary information on the containers. For best results do not use solutions that have been stored longer than the following times:

	Full Containers	Partially Full Containers
First Developer	4 weeks	2 weeks
Stop Bath	8 weeks	8 weeks
Color Developer	4 weeks	2 weeks
Bleach-Fix	4 weeks	4 weeks
Stabilizer	8 weeks	8 weeks

Remember that good results depend on accurate control of temperature during the development step.

RECOMMENDED SOLUTION CAPACITIES

	Amounts of Solutions (in Millilitres) Required:	
Size of Tube	EKTAPRINT R-1000 Chemicals	Prewet, Washes, Rinse
8 × 10	70	150
11 × 14	130	300
16 × 20	260	550

Conserving chemicals: With some processing tubes it *may* be possible to use less than the recommended amount of each solution. The solution volumes suggested above contain sufficient safety factors to accommodate the wide variety of these tube-type processors. They also are sufficient to minimize agitation effects. You may, when using a particular type of tube or drum, reduce the volumes of solutions used per run in an attempt to maximize solution usage. However, keep in mind that, as the solution volumes are reduced, agitation becomes more and more critical and repeatability becomes harder to maintain. Do not reduce the wash volumes or reduce the solution volumes below $0.6mL/in^2$. In order of increasing sensitivity to volume reduction, the solutions are: stabilizer, stop bath, bleach-fix, color developer, and first developer.

EASTMAN KODAK

KODAK EKTACOLOR 74 RC AND 78 PAPERS/TYPE 2492

These papers consists of a red-sensitive, a green-sensitive, and a blue-sensitive emulsion on a medium-weight, water-resistant (resin-coated) base. Negatives made from KODAK VERICOLOR II Film, KODACOLOR Film, and similar color films, can be printed directly onto these papers to produce high-quality reflection prints. Exposures can be made using enlargers and automated printing equipment. The water-resistant base minimizes the absorption of processing solutions and water, which makes possible reduced processing and drying times. Prints made on these papers have greater strength, dimensional stability, and durability than those made on fiber-base papers. They also have less tendency to curl and crack under low-relative-humidity conditions.

KODAK EKTACOLOR 74 RC Paper (Type 2492) has normal contrast and maximum density characteristics which makes the 74 RC Paper particularly suitable for printing professionally exposed portrait color negatives.

KODAK EKTACOLOR 78 Paper (Type 2492) possesses higher contrast and maximum density characteristics which makes the 78 Paper more suitable for photofinisher applications where more snap and color saturation are desirable. Prints from many commercial and industrial subject color negatives can usually benefit from the higher contrast and color saturation of this paper.

Both papers can be processed interchangeably using KODAK EKTAPRINT 2 or EKTAPRINT 200 Chemicals in manual or automatic processors.

SURFACES AVAILABLE—Both papers are available in sheet and roll sizes in the following indicated surfaces:

	E	F	N	Y
KODAK EKTACOLOR 74 RC Paper	X	X	X	X
KODAK EXTACOLOR 78 Paper	X	X	X	

E-Fine-grained lustre—also known as LUSTRE-LUXE® Surface
F-Smooth glossy
N-Smooth lustre
Y-Silk lustre

The various print surfaces result from normal air drying after processing. This includes the F-smooth, glossy surface, which must not be ferrotyped. Placing wet prints against smooth or patterned surfaces is not recommended. The moisture in the emulsion cannot readily escape through the resin-coated base. This usually results in long drying times and most likely, stuck prints. Also, higher temperatures will increase sheen and gloss.

SAFELIGHT—Use a KODAK Safelight Filter No. 13 (amber,* or the equivalent, with a 7 1/2-watt bulb in a suitable safelight lamp at a distance of a least 4 feet. After exposure, the paper can be handled for no longer than 1 1/2 minutes under the safelight. Before exposure, a slightly longer safelight exposure can be tolerated, but in any case safelight exposure should be kept to a minimum.

Recommendations for testing the adequacy of safelights are given in Kodak Publication No. K-4, *How Safe Is Your Safelight?*

STORAGE—As with any sensitized photographic material, storage at high temperatures and high humidity can cause undesirable changes in the sensitometric properties of KODAK EKTACOLOR 74 RC and 78 Papers (Type 2492). Store unexposed paper at 50°F (10°C) or lower, in the original sealed package.

EASTMAN KODAK

The Compact Photo-Lab-Index

EASTMAN KODAK

WARM-UP TIME—To avoid moisture condensation on the surfaces, paper that has been held in cold storage should be allowed to warm up to room temperature before the sealed bag is opened. Ideally, the packages should be removed from cold storage the day before the paper is used. Otherwise, follow the warm-up directions in the instruction sheet packaged with the material.

EXPOSING EQUIPMENT—KODAK EKTACOLOR 74 RC and 78 Papers can be exposed on enlargers and printers with tungsten or tungsten-halogen light sources. The printer or enlarger should have a heat-absorbing glass and an ultraviolet absorber such as the KODAK WRATTEN Gelatin Filter No.2B or No. 2C, or the KODAK Color Printing Filter CP2B (Acetate). Some enlargers are already equipped with a heat-absorbing glass and the equivalent of a CP2B filter. Since voltage variations affect both light output and color quality, a suitable voltage regulator is recommended. Recommendations for proper ultraviolet absorbers and heat-absorbing glass are given in the instruction sheet packaged with the paper.

EXPOSURE—The exposure methods and conditions for KODAK EKTACOLOR 74 RC Paper are the same as those used for KODAK EKTACOLOR 78 Paper.

For white-light printing the suggested starting filter pack is 50M + 90Y. If your enlarger does not have dichroic filters, use KODAK Color Compensating Filters (Gelatin) if the filters are to be placed between the negative and the paper. If the filters are to be placed between the light source and the negative, use KODAK Color Printing Filters (Acetate). If cyan filtration is necessary, use filters identified by the suffix "-2" as in "CC10C-2" and "CP10C-2." Since light quality, optical components, filters, and dial settings may vary considerably among enlargers, this starting filter pack is intended only as guide. Detailed exposure information appears in Kodak Publication No. E-66, *Printing Color Negatives,* sold by photo dealers.

For tricolor printing, the recommended KODAK WRATTEN Filters are No. 25 (red), No. 99 (green), and No. 98 (blue). Since each of these filters absorbs ultraviolet radiation, the use of the No. 2B, 2C, or CP2B (acetate) filter is not necessary. A heat-absorbing glass should be in place near the light source. Assuming a Photo Enlarger Lamp No. 212 or No. 302 as the light source, typical exposure times at f/8 for a 3X enlargement from a normal color negative are: red, 2 seconds; green, 12 seconds; and blue, 5 seconds.

PROCESSING—KODAK EKTACOLOR 74 RC and 78 Papers can be processed by either batch or continuous methods using KODAK EKTAPRINT 2, or similar chemical solutions. Complete processing details are given in Kodak Publication No. Z-122, *Using KODAK EKTAPRINT 2 Chemicals.* For information about processing these papers in KODAK Rapid Color Processors with KODAK EKTAPRINT 200 Chemicals, refer to Kodak Publication No. Z-122B, *Instructions for Processing KODAK EKTACOLOR Papers in KODAK Rapid Color Processors.*

For information about processing these papers in tube-type processors with KODAK EKTAPRINT 200 Developer, refer to Kodak Publication No. Z-211, *Now You Can Choose the Temperature For Tube Processing KODAK EKTACOLOR Papers in KODAK EKTAPRINT 2 Chemicals.* Also see Publication No. Z-122D, *Tube-Processing KODAK EKTACOLOR Papers Using KODAK EKTAPRINT 2 Chemicals.*

MOUNTING—Prints on KODAK EKTACOLOR Papers can be mounted with KODAK Dry Mounting Tissue, Type 2, or a similar mounting tissue. The press temperature across the heating plate should be 180 to 210 °F (82 to 99 °C). Pressure should be applied for 30 seconds, or longer for thick mounts. To remove moisture that might cause sticking, preheat the cover sheet used over the face of the print.

CAUTION: Temperatures above 210 °F (99 °C) and/or high pressures may cause physical and color changes in color prints.

Prints can also be mounted satisfactorily with KODAK Rapid Mounting Cement. For more information, see Kodak Publication No. E-67, *Finishing Prints on KODAK Water-Resistant Papers.*

STORAGE AND DISPLAY OF PRINTS—Photographic dyes, like dyes used in other products, can change with time and environmental factors such as excessive heat, humidity, sunlight, and ultraviolet radiation can accelerate the change. Eastman Kodak offers the following suggestions which, if followed, will assist you in obtaining many years of pleasure from you color photographs:

1. Process all photographic materials in strict accordance with the manufacturer's specifications.
2. Illuminate with tungsten light where possible.
3. Display prints in the lowest light level consistent with viewing needs.
4. If sunlight—either direct or indirect—or fluorescent light strikes the print, an ultraviolet-absorbing filter should be used between the light source and the print.
5. When displaying or storing color photographic materials, keep the temperature and humidity as low as conveniently possible.
6. Preserve your color negatives and transparencies, that may have future value, through refrigerated or deep-freeze storage.

PROCESSING AT VARYING TEMPERATURES

The information contained in this data release is provided as a simple, alternate method of processing KODAK EKTACOLOR Papers in KODAK EKTAPRINT 2 Chemicals at a temperature between 68 and 91 °F (20 and 32.8 °C). You process the paper with the developer and other solutions at the temperature you've chosen. Development times will vary according to the temperature. Times for the other steps are summarized in Table II.

Acceptable results can be obtained with these alternate temperatures when processing in a tube. However, if optimum quality is desired, use the current recommendation for processing at a constant temperature of 91 ± 0.5 °F.

MATERIALS NEEDED

KODAK EKTACOLOR 74 RC or 78 Paper, KODAK EKTAPRINT 2 Developer, KODAK EKTAPRINT 2 Stop Bath (or a stop bath prepared from KODAK 28% Acetic Aci), KODAK EKTAPRINT 2 Bleach-Fix, tube-type processor, accurate thermometer, clock with a second hand, graduate, stirring rod or mixing paddle, funnel, two sets of containers. One for mixed solutions, another set for the volume of solution needed for processing. Processing tray, Printing equipment and filters.

See the instructions packaged with the paper. These instruction will also provide you with starting-point exposure recommendations.

CHEMICAL MIXING

Instructions for mixing the solutions are packaged with the chemicals. Since the prewet step in the tube processing cycle dilutes the developer, be sure to follow Procedure 1 of the mixing directions accompanying the developer.

If EKTAPRINT 2 Stop Bath should be unavailable, you may use a stop bath prepared as follows:

1. Start with 1 litre (33.8 fluidounces) of water.
2. With stirring, add 48 millilitres (1.63 fluidounces) of KODAK 28% Acetic Acid.

NOTE: To make approximately 28% acetic acid from glacial acetic acid, add 3 parts of glacial acetic acid to 8 parts of water.
CAUTION: Add the acid to the water, never water to acid.

EASTMAN KODAK

SELECT YOUR PROCESSING PROCEDURE

PROCEDURE A—Processing steps, including agitation recommendations, will be done with the tube-type processor placed in the constant temperature bath. If processing is done at room temperature, the air temperature of the room becomes your "constant temperature bath" and no tempering equipment is needed. For a complete, even process, the tube MUST be level (flat) to allow an even distribution of each solution. If the processing tube has any kind of opening in it that would allow water to enter it during the processing steps, then use Procedure B.

When using the time versus temperature table, use the temperature of your constant temperature bath to determine your development time.

This procedure is recommended over Procedure B.

PROCEDURE B—Processing steps, including agitation recommendations, will be done on a level surface (not in the constant temperature bath). Remember, the tube must be level (flat) to allow an even distribution of each solution.

Since Procedure B is run outside a constant temperature bath, heat can be transferred between the processor and the surroundings. To obtain an average developer temperature, run the following procedure:

1. Place a sheet of KODAK EKTACOLOR 74 RC or 78 Paper in the tube (this can be a scrap print).

2. Follow the prewet and developer steps of the processing cycle (steps 1 and 2) using the correct volumes and times. The prewet and developer (water can be substituted for the developer in this test) will be at the temperature of the constant temperature bath before running the process.

3. At the end of the developer step, collect the solution discarded from the tube and measure the temperature. When averaged with the constant temperature bath, the result will be the temperature you should use to find the development time required.

For example, if your constant temperature bath is 91 °F (32.8 °C) and the temperature of the developer after the processing step is 79 °F (26.1 °C), the average temperature will be 85 °F (29.4 °C) and the development time will be 5 minutes 40 seconds.

4. This setup test procedure needs to be done only once for a given processor, providing the room temperature remains fairly constant. Use the bath temperature established by this technique for all future processes.

TABLE 1
DEVELOPER TIME VERSUS PROCESS TEMPERATURE

Temperature		Developer Time	Temperature		Developer Time
°F	°C	(min, seconds)	°F	°C	(min, seconds)
91	32.8	3'30"	79	26.1	9'10"
90	32.2	3'45"	78	25.6	10'00"
89	31.7	4'05"	77	25.0	10'50"
88	31.1	4'25"	76	24.4	11'50"
87	30.6	4'50"	75	23.9	12'45"
86	30.0	5'10"	74	23.3	13'50"
85	29.4	5'40"	73	22.8	15'00"
84	28.9	6'10"	72	22.2	16'20"
83	28.3	6'40"	71	21.7	17'40"
82	27.8	7'15"	70	21.1	19'10"
81	27.2	7'50"	69	20.6	20'50"
80	26.7	8'30"	68	20.0	22'30"

EASTMAN KODAK

AGITATION—Use the following recommendations for either processing procedure.
TUBE—rotate the tube 30 to 60 revolutions per minute (rpm) in its horizontal position. The tube must be level. Agitation is critical during the development step.
TRAY (wash steps)—rock the tray so that the print moves from side to side every 2 seconds. Use the KODAK Automatic Tray Siphon for washing prints efficiently.
DRAIN TIME—Drain times vary from 7 to 15 seconds depending on the model of tube used and on the quanitity of liquid in the tube. An average drain time is 10 seconds. Adjust timing to incorporate the drain time as part of each processing step.

PRELIMINARY PROCESSING STEPS

1. Unless you are processing at room temperature, make sure the constant temperature bath is adjusted to the correct temperature.
2. Pour the amount of solution needed for each processing step into the premeasured bottles. Mark the bottles and continue to use them for the same solution at all times. (Solution amounts are provided in the summarization table.) Place these solutions in the constant temperature bath or allow them to reach room temperature.
3. Check the processing tube. IT MUST BE CLEAN AND DRY. Cleaning the processing tube after each process helps to prevent contamination.
4. In a completely dark room, load the exposed paper in the processing tube, emulsion (exposed) side away from the tube wall and facing in. Replace the cover on the tube and make sure it is lighttight. Turn on the lights.
5. Recheck processing temperatures.
6. In normal room light, set your timer clock and proceed to process by following the processing step and agitation recommendations. Remember to include the drain time as part of each processing step.

PROCESSING STEPS

PREWET—½ minute. Pour in the prewet solution (water) and start the timer. Agitate as recommended. Drain in time to start the next step. Let the timer run and continue with the following steps.
DEVELOPER—Use the time from Table I determined from either Procedure A or B. Agitation is critical during the development step.
STOP BATH—½ minute.
BLEACH-FIX—depends upon process temperature, as shown below.

Process Temperature	Bleach-Fix Time
80 to 91 °F (26.7 to 32.8 °C)	1 minute
68 to 79 °F (20.0 to 26.1 °C)	1½ minutes)

WASH—four ½-minute washes
The print can be washed in the tube or in a processing tray.
TUBE—use the four ½-minute washes. Remove the print from the tube and place it in a tray for additional washing. This will provide for greater print stability and removal of chemicals. Do not hesitate to wash for an additional 10 to 15 minutes. The KODAK Automatic Tray Siphon is a convenient, efficient device for washing prints in an ordinary processing tray.
TRAY—carefully remove the print and place it in the tray. Proceed with the four ½-minute washes using tray agitation procedures. The place the print in a separate tray for additional washing using the KODAK Automatic Tray Siphon.
DRY—To avoid water marks on prints, use a squeegee to wipe off excess water. Prints can be dried at room temperature or on racks. For fast drying, use forced, warm air not exceeding 200 °F (93 °C), as from a hand-held hair dryer. NEVER ferrotype prints on RC paper.
 A summary of these processing steps is provided at the end of this data release.

EASTMAN KODAK

281

EASTMAN KODAK

STORAGE OF SOLUTIONS

Mixed solution should be stored at room temperature (60 to 80 °F [15.5 to 26.7 °C]). For best results, do not use solutions which have been stored longer than the following times:

	Full, Tightly Closed Bottles	Partially Full, Tightly Closed Bottles
Developer	6 weeks	2 weeks
Stop Bath	Indefinitely	Indefinitely
Bleach-Fix	8 weeks	2 weeks

ADDITIONAL INFORMATION

1. Do not reuse chemicals. Do not try to process with an insufficient volume of any solution.

2. Always mix solutions to the recommended volumes. Never attempt to mix fractional amounts.

3. Thoroughly wash and dry the processor tube and bottles after each process.

4. Make sure the tube is drained after each step. In some cup-type tubes it may be necessary to (a) drain the tube, (b) tilt the tube 180 degrees, and then (c) tilt the tube back to the draining position. It may help to run through a processing cycle using water only (no paper in the tube) to become totally familiar with the processing tube.

TABLE II
SUMMARY OF STEPS FOR TUBE PROCESSING
USING KODAK EKTAPRINT 2 CHEMICALS

Processing Step	Time in Minutes	Amount of Solution (in millilitres) Per Tube Size		
		8 × 10	11 × 14	16 × 20
Prewet	½	500*	1000*	1500*
Developer	See Table 1	70	130	260
Stop Bath	½	70	130	260
Bleach-Fix	1 (80 to 90 °F)			
	1½ (68 to 79 °F)	70	130	260
	½	500	1000	1500
	½	500	1000	1500
Wash	½	500	1000	1500
	½	500	1000	1500
	Additional washing increases print stability.			
Dry	As required			

*Some processing tubes will not hold the indicated volume. In this case, fill with as much water as possible.

IMPORTANT: Always clean and dry the processing tube thoroughly after each process to help prevent contamination.

70 mL = 2.4 fl oz	500 mL = 17 fl oz
130 mL = 4.4 fl oz	1000 mL = 34 fl oz
260 mL = 8.8 fl oz	1500 mL = 51 fl oz

AGFA COLOR STILL FILMS

SPEEDS OF AGFA COLOR FILMS

	ASA	DIN
Agfachrome 64 (CT 19)	D 64*	19
Reversal Slide Film	T 16*	13*
Agfachrome 100	D 100	21
Reversal Slide Film	T 25*	15*
Agfacolor CNS	D 80	20
Negative Color Film	T 20*	20*

*3200 K Lamps with Kodak Filter No. 80A or equivalent.

AGFACHROME 64 (CT 19)　　　　　　El—Daylight 64, Tungsten 16*

A very fine-grain medium speed color transparency film balance for 5500 K (Daylight, electronic flash, or blue flash bulbs) without a filter and for tungsten (3200 K) with a Kodak Filter No. 80A. Available in 35mm, 120 rolls and 126 cartridges.

AGFACHROME 100　　　　　　El—Daylight 100, Tungsten 25*

A higher speed reversal color transparency film balanced for 5500 K (Daylight, electronic flash, or blue flash bulbs) without a filter and for tungsten (3200 K) with a Kodak Filter No. 80A. Available in 35mm, 120 rolls and 126 cartridges.

AGFACOLOR CNS　　　　　　El—Daylight 80, Tungsten 20*

A double-masked, very fine-grain color negative film balanced for daylight exposure without a filter and for tungsten (3200 K) exposure with a Kodak Filter No. 80A. Available in 35mm, 120 rolls, 126 cartridges. Sold with processing included.

*3200 K Lamps with Kodak Filter No. 80A or equivalent.

AGFACHROME 64 (CT 19)　　El—Daylight 64, Tungsten 16*

REVERSAL COLOR FILM
GENERAL PROPERTIES

Agfachrome CT 19 is a reversal type color film producing color transparencies for projection and other uses. It is designed for daylight exposure without filters, and is sold with processing and mounting included. Available in 35mm, 120 rolls, 126 cartridges.

FILM SPEED

Daylight—ASA 64 No Filter required.
Tungsten—(3200 K)—ASA 16 With Filter No. 80A.

283

The Compact Photo-Lab-Index

AGFA-GEVAERT

DAYLIGHT EXPOSURE TABLE
Lens Opening and Exposure Value with Shutter
1/100 to 1/125 seconds

Subjects	Bright Sun	Hazy Sun	Heavy Forecast
Beach, snow scene	f/16 (15)	f/11 (14)	f/5.6 (12)
Open landscape	f/11 (14)	f/8 (13)	f/8 (13)
Landscape with foreground	f/8-11 (13½))	f/5.6-8 (12½)	f/4-5.6 (11½)
Persons outdoors	f/8-11 (13½))	f/5.6-8 (12½)	f/4-5.6 (11½)
Portraits in shadow	f/5.6 (12)	f/4 (11)	f/2.8 (10)

FILL-IN FLASH OUTDOORS

Blue flash lamps or electronic flash can be used to fill in harsh shadows when exposing outdoors in bright sunlight. Use the table below to set lens openings and shutter speeds for various flash lamps.

Blue Bulb Type	Bowl-Shaped Reflector Size	Distance in Feet	Lens Opening	Shutter Speed
5B, 25B	3-inch	5-8	22	1/25
M5B, M25B	3-inch	8-12	22	1/25
5B, 25B	4-inch	12-18	16	1/50
11B, 40B, 22B	6-7-inch	12-18	22	1/25
2B	6-7-inch	16-22	16	1/50

UNIT OUTPUT
EFFECTIVE CANDLE-

POWER SECONDS	350	500	700	1000	1400	2000	2800	4000	5600
GUIDE NUMBER	36	45	50	60	72	85	100	125	145

Synchronization Between Lens Shutter Speed	X or F		M		2B or	Focal-plane Shutter Speed	6B or
	AG-1B M2B	M25B	M5B, 5B or 25B	11B or 40B	22B		26B
1/25-1/30	85	110	110	140	160	1/50	85
1/50-1/60	—	100	100	120	140	1/100	52
1/100-1/125	—	—	90	110	120	1/250	32
1/200-1/250	—	—	70	90	110	—	—

ELECTRONIC FLASH GUIDE NUMBERS

Trial exposures with various electronic flash units may be estimated from the table below, but some correction will probably have to be made due to variation in unit efficiency and reflector design. An 81A filter may be used to compensate for the excessive blue output of some electronic flash units.

FLASH EXPOSURE GUIDE NUMBERS

Guide numbers for the blue flash lamps are given in the table below; they also apply to the same lamps without blue coating, if an 80C filter is used over the camera lens.

RECIPROCITY FACTOR

Neutral color balance is based on an exposure of 1/125 second. Longer exposures may tend to produce a slight shift to warmer tones; shorter exposures tend to cooler tones.

FILTERS

The following filters may be used with Agfachrome:
 Skylight Filter—Useful for obtaining extra contrast in photos at high altitudes and at the beach, where ultraviolet rays ray result in excessive blueness.

284

The Compact Photo-Lab-Index

No. 80C Filter—Use this filter when lighting with clear flash bulbs only. Blue flash bulbs require no filter.

No. 80B—Filter—Use when lighting with photoflood lamps of 3400 K rating.

No. 81A Filter—New electronic flash units whose lighting elements are not yet broken-in may cause excessive blueness. This filter corrects the blueness.

PROCESSING

Agfachrome CT-19 is sold with processing and mounting included in the purchase price for processing in Agfa's own processing stations.

SPECTRAL CHARACTERISTICS: (Curves)

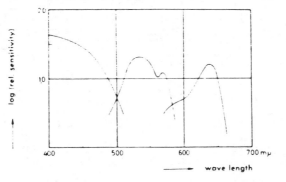

COLOR RESPONSE: (Curves)

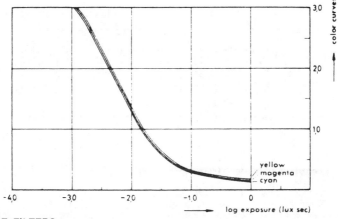

USE OF FILTERS

For exposures at high altitudes, at the seaside and when using many electronic flash units we recommend a colorless UV filter. No increase in exposure is necessary for these filters. Neutral polarizing filters can be used to reduce reflections or achieve special effects if the appropriate exposure corrections are made.

Filters used for black and white photography are not suitable for color reversal films as they cause definite color casts.

285

FLASH FACTORS

An 81A filter may be used to compensate for the excessive blue output of some electronic flash units.

I. Apparent Loss Of Emulsion Speed

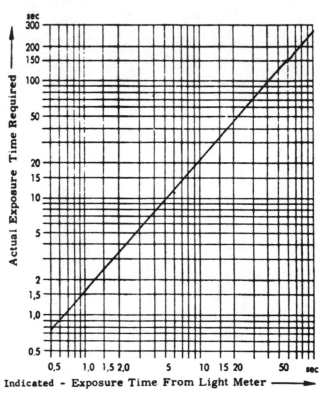

Indicated - Exposure Time From Light Meter ➝

STORAGE

Store in a cool, dry place away from harmful gases and vapors.
Best storage conditions:
 Temperatures below 68°F. (20°C.), relative humidity 50-60%.
 Films should be sent in for development as soon as possible after exposure as changes in the color balance may occur as a result of long storage — particularly under unfavorable climatic conditions. Developed films should be stored in cool and dry rooms and not be exposed to direct lights.
 AGFACHROME 64 is available only in the United States.
 AGFACOLOR CT18 is sold outside the United States with processing included, but with and without mounting. Travelers who obtain this film abroad should purchase it with mounting included so that additional charges for this service by the laboratory can be avoided. Special charges exist for mounting AGFACOLOR CT18 sold without mounting; stereo or single frame mounting; and mounting in plastic frames.

AGFACHROME 100

AGFACHROME 100 is a daylight balanced color reversal film, yielding clean whites, crisp greens and blues, with excellent flesh tones.

SPECIFICATIONS

SPEED
All sizes, ASA 100, DIN 21.

GRAIN STRUCTURE
Fine.

RESOLVING POWER
Approximately 80 lines/mm.

GRADATION
1.6-1.8 gamma when processed normally.

EMULSION
Three emulsion layers with dye couplers in each.

THICKNESS OF EMULSION
20-22 microns.

ANTIHALATION PROTECTION
Highly effective protection against halation by special layer (colloidal silver).

BASE THICKNESS
35mm films—0.13mm, roll films—0.10mm.

COLOR BALANCE
Daylight (5500° Kelvin = 18 decamired).

EMULSION STRUCTURE

Layer	Sensitive to	Color Coupler for
Top	Blue	Yellow
Filter (colloidal silver)		
Middle	Green	Magenta
Bottom	Red	Cyan
Antihalation		

USE OF FILTERS
For exposure at high altitudes, at the seashore or when using several electronic flash units, a colorless UV filter is recommended. No increase in exposure is necessary for this filter. Neutral polarizing filters can be used to reduce reflections or achieve special effects. The appropriate exposure correction must be made.

Filters used for black and white photography are not suitable for color reversal films as they cause definite color casts.

The Compact Photo-Lab-Index

SPECTRAL CHARACTERISTICS

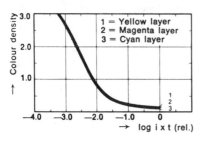

COLOR RESPONSE: (Curves)

Spectral sensitivity for
equal energy spectrum.

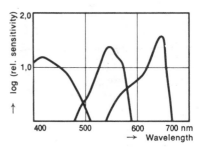

RECIPROCITY FACTOR

Neutral color balance is based on an exposure of 1/125 second. Longer exposures may tend to produce a slight shift to warmer tones, shorter exposures to cooler tones.

FLASH FACTORS

An 81A filter may be used to compensate for the excessive blue output of some electronic flash units.

STORAGE

Store in a cool, dry place away from harmful gases and vapors.
Best storage conditions:
Temperatures below 68°F. (20°C.), relative humidity 50-60%.
Films should be sent in for development as soon as possible after exposure as changes in the color balance may occur as a result of long storage — particularly under unfavorable climatic conditions. Developed films should be stored in cool and dry rooms and not be exposed to direct light.
AGFACHROME 100 is available only in the United States. Prices include processing and mounting, for which a special prepaid mailer is attached.
AGFACHROME 100 should be sent for processing and mounting in the USA to:
AGFACHROME SERVICE
P. O. Box 2000
Flushing, New York 11352
AGFACHROME 100 is sold as AGFACHROME CT21 outside the United States with processing, but with and without mounting. Travelers who obtain this film abroad should purchase it with mounting included so that additional charges for this service by the laboratory can be avoided. Special charges are made for mounting AGFACOLOR CT21 sold without mounting.

AGFACOLOR FILM CNS

CHARACTERISTICS
Double-masked, fine-grain color negative film for exposure in daylight, by the light of electronic flash or blue flashbulbs.

SENSITIVITY
Speed rating 20 DIN — ASA 80.

RESOLVING POWER
Recorded with a lens of high resolution:

Yellow emulsion	70 lines/mm
Magenta emulsion	40 lines/mm
Cyan emulsion	20 lines/mm

GRAIN Fine.

GRADATION
CNS film has a gamma of 0.53 when developed in accordance with instructions.

ANTI-HALATION PROTECTION
Highly effective protection against halation by a layer of colloidal silver beneath the emulsion layers.

MASKING
With AGFACOLOR CNS the masks form automatically in the bleach according to negative gradation and density resulting during color development. Yellow secondary density of the magenta dye is corrected by the *yellow mask*.

Effect in the print:

Yellow:	More saturated
Blue:	Lighter
Green:	Less blue
Magenta:	Less Yellow

The *red mask* compensates for yellow and magenta secondary densities of the cyan dye.

BASE
Safety film (cellulose acetate) as specified by German Standard DIN 15 551.

Thickness:

Miniature film	Approximately 0.13mm
Roll film	Approximately 0.10mm

LIGHTING
Suitable light sources: Daylight, electronic flash and blue flashbulbs (approximately 5,500°K — 18 Decamired), and xenon lighting.

USE OF FILTERS
There is no need to use correction filters on the camera as neutral prints are obtained during the printing process by the use of suitable compensating filters.

AGFA-GEVAERT

289

AGFA-GEVAERT

AGFACOLOR CNS (110 FILM)

CHARACTERISTICS
Very fine-grain color negative film. Extra high definition with a double mask for exposure in daylight, by the light of electronic flash or blue flashbulbs.

SENSITIVITY
Speed rating 20 DIN — ASA 80.

RESOLVING POWER
Recorded with a lens of high resolution:
 100 Lines per mm (yellow emulsion)
 60 Lines per mm (magenta emulsion)
 25 lines per mm (cyan emulsion)

GRAIN Very fine.

GRADATION
CNS 100 film has a gamma of 0.58 when developed in accordance with instructions.

ANTI-HALATION PROTECTION
Highly effective protection against halation by a layer of colloidal silver beneath the emulsion layers.

MASKING
With AGFACOLOR CNS the masks form automatically in the bleach according to negative gradation and density resulting during color development. Yellow secondary density of the magenta dye is corrected by the *yellow mask.*

Effect in the print:

Yellow:	More saturated
Blue:	Lighter
Green:	Less blue
Magenta:	Less Yellow

The *red mask* compensates for yellow and magenta secondary densities of the cyan dye.

BASE
Safety film (cellulose acetate) as specified by German Standard DIN 15 551.

Thickness:

Miniature film	Approximately 0.13mm
Roll film	Approximately 0.10mm

LIGHTING
Suitable light sources: Daylight, electronic flash and blue flashbulbs (approximately 5,500°K — 18 Decamired), and xenon lighting.

USE OF FILTERS
There is no need to use correction filters on the camera as neutral prints are obtained during the printing process by the use of suitable compensating filters.

SECTION OF CNS FILM (schematic)

	Sensitized for	Color couplers for
Upper emulsion	blue	yellow
Yellow Filter Layer	Colloidal silver	
Middle emulsion 2) Middle emulsion 1)	green	magenta
Yellow mask layer		
Lower emulsion 2 (with red mask) Lower emulsion 1 (with red mask)	red	cyan

The individual layers are separated by supercoats. Total emulsion thickness about 25 um.

SECTION OF AGFACOLOR POCKET SPECIAL (schematic) CN 100

	Sensitized for	Color couplers for
Upper emulsion	blue	yellow
Yellow filter layer	Colloidal silver	
Middle emulsion 2) Middle emulsion 1)	green	magenta
Red filter		
Lower emulsion 2 Lower emulsion 1	red	cyan

The individual layers are separated by supercoats. Total emulsion thickness about 19.9 um.

REPLENISHMENT OF PROCESSING SOLUTIONS FOR AGFACOLOR NEGATIVE FILMS

The particulars given below apply to either one 120 size roll film or one 35mm film with 36 exposures but should be regarded as a guide only since different processing conditions at the various labs make it impossible to give exact amounts that are generally applicable. Replenishment must therefore be undertaken on the basis of results obtained from sensitometric tests. Rates of replenishment 30% lower are sufficient for 35mm films with 20 exposures and for PAK 126 cartridge films.

Agfacolor Processing Bath	Amt. of replen. per 120 roll film/35mm film with 36 exp.	Amt. of replen. per 110 size film with 12/20 exp.	Permissible pH range	Permissible Spec. Grav. Range	Spec. Grav. of replen. solutions (68°F)
Film Developer S	8 ml RNPS	11 ml/16 ml	11.0-11.2	non-indicative	1.070-1.075

AGFA-GEVAERT

Inter-mediate	100-150 ml NZW working solution (without addition of developer)	21 ml/30 ml	10.2-10.5	non-indicative	1.025
Bleach	RN II 50-60 ml	8.5 ml/12 ml	5.8-6.2	non-indicative	1.060-1.065
Fixing	RN III 50-60 ml	8.5 ml/12 ml	7.0-7.8	1.080-1.120	1.110-1.115

DARKROOM LIGHTING
Total darkness.

PROCESSING TABLE

Baths	Code	Process. time in minutes	Temp. in degrees F	Working capacity films per litre	Useful life of fresh baths
Agfacolor Film Developer S	NPS 1	8[1]	68°F 20 ± 0.2	6	6 weeks
Agfacolor Intermediate [2]	NZW	4[3]	68°F 20 ± 0.5	6	6 weeks
Thorough wash	—	14	60-68°F 14-20	—	—
Agfacolor Bleach[4]	N II	6	68°F 20 ± 0.5	6	3 months
Wash	—	6	60-68°F 14-20	—	—
Agfacolor fix	N III	6	65-68° 18-20	6	3 months
Final Wash	—	10	60-68°F 14-20	—	—
Agepon (1 + 200) Wetting Agent	—	1	60-68°F	10	—

Notes:

1. The development time may be varied between 7 and 9 minutes, depending on the result of sensitometric tests.
2. To achieve uniform results 30 ml Film Developer S must be added to each litre of Agfacolor Intermedate.
3. If necessary, the time given in the intermediate may be varied between 3 and 5 minutes for adjustment to the number of cycles and cycle time of frame type processing machines.
4. As the masks form in the bleaching, care should be taken to see that the processing time and temperature of the original bleaching bath are maintained exactly (at 68°F ± 0.5).

Only original Agfacolor processing chemicals should be used for development and replenishment of this film.

AGFAPAN 25 BLACK AND WHITE FILM

A slow panchromatic film of extra-fine grain and outstanding definition, particularly suitable for rendering subjects rich in detail.

SENSITIVITY:	ASA 25/15 DIN
RESOLVING POWER:	185 lines per mm.
GRAIN:	Finest grain attainable
EMULSION STRUCTURE:	Single coating with super coat
EMULSION THICKNESS:	5.5. um
BASE:	Safety film, cellulose acetate, gray, with an anti-halation coating which dissolves in the developer
BASE THICKNESS:	130 um
DEVELOPING:	Rodinal, 1:25, 3-5 minutes, 68 °F, Gamma .7 Rodinal, 1:50, 8-10 minutes, 68 °F, Gamma .7
AGITATION:	Daylight tank: Continuous tank inversion for the first minute, then every 30 seconds. Development times may be varied within the given range due to inherent processing particulars.

GAMMA/TIME CURVE:

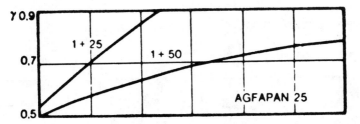

SENSITIZATION:

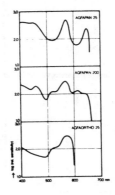

The Compact Photo-Lab-Index

SENSITIVITY/TIME CURVE:

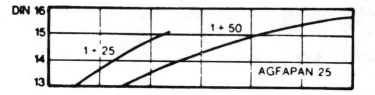

TEMPERATURE/TIME CURVE:

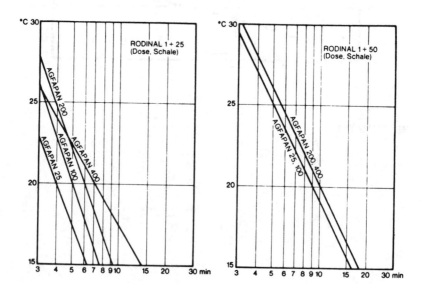

AGFAPAN® 100 BLACK & WHITE FILM

SENSITIVITY
ASA 100/21 DIN

RESOLVING POWER
145 lines mm

GRAIN
Agfapan 100 has the finest grain attainable in the relevant speed category.

EMULSION STRUCTURE
Double coating with super coat.

EMULSION THICKNESS
7 u m

BASE
Cellulose acetate

ANTI-HALATION PROTECTION
Dark green gelatin backing, which loses its color in the developer.

SENSITIZATION

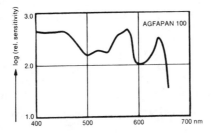

STRUCTURE

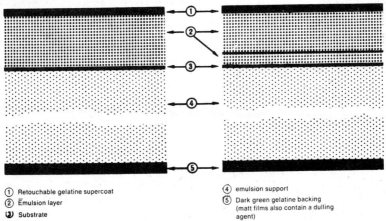

① Retouchable gelatine supercoat
② Emulsion layer
③ Substrate
④ emulsion support
⑤ Dark green gelatine backing
(matt films also contain a dulling agent)

The Compact Photo-Lab-Index

CHARACTERISTIC CURVE

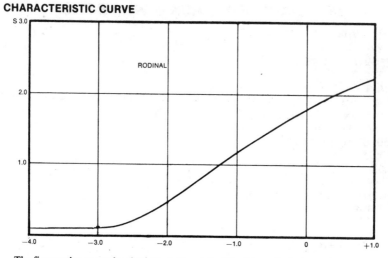

The figures shown on the abscissa represent the logarithm of relative exposure; the density values are given on the ordinate.

DEVELOPMENT

Rodinal, 1:25—4-6 minutes, 68 °F; 1:50—8-10 minutes, 68 °F.

AGITATION

Tank: Continuous tank inversion for the first minute, then every 30 seconds.

Development times may be varied within the given ranges due to your inherent processing particulars.

GAMMA/TIME

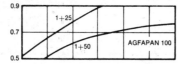

SENSITIVITY/TIME

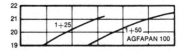

296

AGFAPAN® 400 BLACK & WHITE FILM

SENSITIVITY
ASA 400/27 DIN

RESOLVING POWER
100 lines mm

GRAIN
Agfapan 400 has the finest grain attainable in the relevant speed category.

EMULSION STRUCTURE
Double coating with super coat.

EMULSION THICKNESS
13 u m

BASE
Cellulose acetate

ANTI-HALATION PROTECTION
Dark green gelatin backing, which loses its color in the developer.

SENSITIZATION

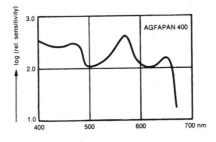

STRUCTURE

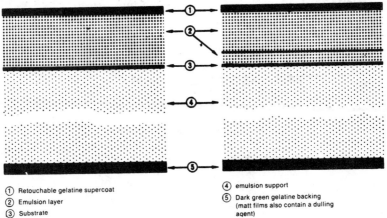

① Retouchable gelatine supercoat
② Emulsion layer
③ Substrate
④ emulsion support
⑤ Dark green gelatine backing
(matt films also contain a dulling agent)

297

CHARACTERISTIC CURVE

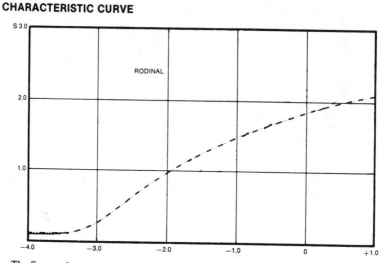

The figures shown on the abscissa represent the logarithm of relative exposure; the density values are given on the ordinate.

DEVELOPMENT
Rodinal, 1:25—9-11 minutes, 68 °F.

AGITATION
Tank: Continuous tank inversion for the first minute, then every 30 seconds.

Development times may be varied within the given ranges due to your inherent processing particulars.

GAMMA/TIME

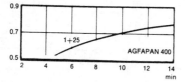

SENSITIVITY/TIME

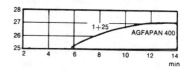

298

AGFAPAN® VARIO-XL PROFESSIONAL FILM

AGFA-GEVAERT

GENERAL DESCRIPTION—Variable speed B/W film with a single processing time. Extra high speed film to be processed in C 41 type color negative developer. Silver is removed during process resulting in a dye coupled reddish image.

AVAILABLE SIZES—135/36; 120

SENSITIVITY RANGE—125 ASA/22 DIN or ISO 125/22° to 1600 ASA/33 DIN or ISO 1600/33°.

FOR EXTRA FINE GRAIN—Expose as for 125 ASA/22 DIN or ISO 125/22°.

FOR MAXIMUM FILM SPEED—Expose as for 1600 ASA/33 DIN or ISO 1600/33°.

FOR EXTREME FILM SPEED—(Coupled with coarser grain.) Expose as for 3200 ASA/36 DIN or ISO 3200/36°.

FILTERS—No camera filters are necessary with the exception of the usual neutral density filters like polarizing filter.

PROCESSING/DEVELOPNGG—Film cannot be processed in normal B/W developers. To be processed in color negative developer, bleach and fix or bleach fix. Developing and bleaching in *total* darkness.

TIME—Standard processing times and temperatures as prescribed for C-41 processes. The same standard processing times are used with all exposure speeds.

ASSESSMENT OF NEGATIVES—The gradation, exposure, and definition of AGFAPAN® Vario-XL professional negatives can be assessed in exactly the same way as for other B/W negatives.

GRAIN—AGFAPAN® Vario-XL professional has extremely fine grain unequaled by the usual B/W film of this speed group. Unlike other B/W films, a further reduction in grain is achieved by overexposure.

RESOLVING POWER—125 Lines per mm.

EMULSION STRUCTURE—Double coated film with super coat.

EMULSION THICKNESS—20 um.

ENLARGEMENTS—Optimal prints and enlargements are obtained from AGFAPAN® Vario-XL professional negatives on all B/W papers. We particularly recommend BROVIRA® 1,111,119; and PORTRIGA® Rapid, and BROVIRA® Speed 310PE, 312PE (PE or resin-coated papers).

FILM STORAGE—Keep in cool, dry place away from harmful gases or vapors. Best storage conditions: 50°F or an average temperature not to exceed 68°F.

AGFA-GEVAERT

SENSITIZATION

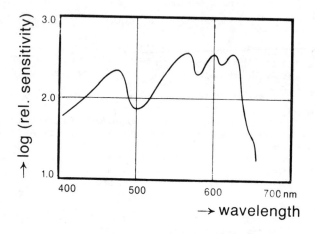

CHARACTERISTIC CURVE
(BLUE FILTER)

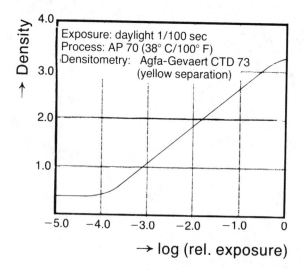

Exposure: daylight 1/100 sec
Process: AP 70 (38° C/100° F)
Densitometry: Agfa-Gevaert CTD 73
(yellow separation)

The Compact Photo-Lab-Index

FILM CROSS SECTION

AGFA-GEVAERT

① = gelatine supercoat

② = high speed emulsion layer with colour couplers

③ = low-speed emulsion layer with colour couplers

④ = anti-halation layer (colloidal silver)

⑤ = emulsion support

Sine wave response
(Definition)

Diffusion of light within the emulsion layer reduces reproduction of contrast as the interval between the lines of a line screen exposed on the film decreases. The reduction in contrast measured with a microdensitometer is represented in a graph by the sine wave response.

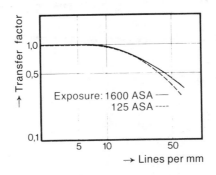

301

AGFA-GEVAERT

RECIPROCITY FAILURE

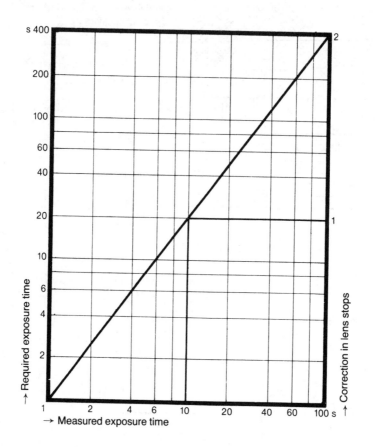

AGFACHROME SUPER 8

A fine-grain film with brilliant colors for Super 8 cameras. For daylight and movie light.

SPECIFICATIONS

SPEED
Daylight with built in filter — 15 DIN = ASA 25. Movie light — 17 DIN = ASA 40.

GRAIN STRUCTURE
Very fine.

RESOLVING POWER
Recorded with a lens of high resolution — 143 lines per mm.

GRADATION
1.6 gamma.

EMULSION
Integral tri-pack with yellow filter layer.

THICKNESS OF EMULSION
Approximately 14 um.

ANTI-HALATION PROTECTION
Highly effective protection against halation by a special layer (colloidal silver beneath the emulsion layers).

BASE
Safety film (cellulose acetate) as specified by German standard DIN 15 551.
Thickness approximately 0.13mm.

PERFORATION
Super 8 film perforated on 1 side as specified by German standard DIN 15 823.

COLOR BALANCE
3400K (= 29 decamired). Movie light (eg tungsten halogen lamps 3400K) to suit the color balance. When shooting under daylight conditions, the conversion filter which is always in position in Super 8 cameras when not using a movie light, is used.

EMULSION STRUCTURE
Integral tripack films with yellow filter layer.

Emulsion	Sensitized for	Color Couplers for
Upper Emulsion	Blue	Yellow
Filter Layer		Colloidal Silver
Middle Emulsion	Green	Magenta
Lower Emulsion	Red	Cyan

The Compact Photo-Lab-Index

SENSITIZATION
Spectral sensitivity for equal-energy spectrum.

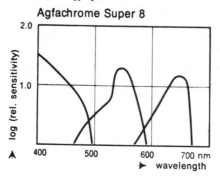

COLOR DENSITY CURVES

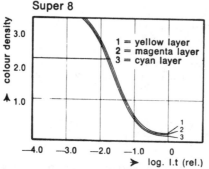

USE OF FILTERS

For exposures at high altitudes or at the seashore we recommend a colorless UV filter or the more effective skylight filter. These filters require no correction of the lens stop or increase in exposure. Neutral polarizing filters may be used to reduce reflections or achieve special effects.

Filters normally used for black-and-white photography are not suitable for color reversal film; they cause a color cast.

STORAGE

Keep in a cool, dry place away from harmful gases and vapors.

BEST STORAGE CONDITIONS

Temperatures below 68°F (20°C), relative humidity 50-60%.

Film should be sent in for development as soon as possible after exposure as changes in the color balance may occur as a result of long storage — particularly when the films are subjected to unfavorable climatic conditions. Developed films should be stored in cool and dry rooms and not exposed to direct light.

DEVELOPMENT

Films are processed in the AGFACHROME Service Laboratory, P.O. Box 2000, Flushing, NY 11352. The cost of processing is included in the price of the film. Developed films are returned first class mail on spools ready for projection.

AGFA-GEVAERT BLACK AND WHITE PAPERS

Brovira—1	Double Weight—Glossy
Brovira—111	Single Weight—Glossy
Brovira—119	Double Weight—Glossy
Brovira-Speed 310 S	Double Weight—Extra White Luster
Portriga Rapid 111	Polyethelene Coated—Glossy
Portriga Rapid 118	Double Weight—Fine-grain semi-matte

European Letter Grade	Old U.S. Numerical Grade	New U.S. Numerical Grade	Old Color Coding	New Color Coding
BEW—Extra Soft	1	0	Purple	Purple
BW—Soft	2	1	Dark Green	Green
BS—Special	3	2	Light Green	Dark Blue
BN—Normal	4	3	Red	Red
BH—Hard	5	4	Blue	Light Blue
BEH—Extra Hard	6	5	Yellow	Brown

Old Available Grades		New Available Grades
Brovira—1	2,3,4,5,6	1,2,3,4,5
Brovira—111	2,3,4,5,6	1,2,3,4,5
Brovira—119	2,3,4,5	1,2,3,4
Brovira Speed 310-S	1,2,3,4,5	1,2,3,4,5
Portriga Rapid 111	2,3,4,	1,2,3
Portriga Rapid 118	2,3,4	1,2,3

AGFA BROVIRA

Agfa Brovira is a standard enlarging speed paper used for all kinds of photography. It is available in both single and double weight, six degrees of contrast and a variety of surfaces. Image tone of Brovira is neutral black on white stock. The white paper base contains an optical brightening agent which produces a brilliant white in the highlights.

AGFA PORTRIGA RAPID

A chlorobromide enlarging paper of moderate speed yielding warm black to brown-black image tones, in double weight glossy and fine-grain semi-matt surfaces for salon prints, portraits, etc.

DEVELOPMENT OF AGFA PAPERS

Agfa papers respond well to almost any conventional paper developer, producing tones from black to brown-black. Several developers producing very warm black to chocolate brown and even olive brown colors are given in this section.

AMERICAN NATIONAL STANDARDS SPEED RATING
BROVIRA

Grade 0 through 3 (EW-N)	360
Grade 4 (H)	250
Grade 5 (EH)	90

PORTRIGA RAPID

Grades 1, 2, 3 (W-K)	230

Note: Brovira Grades One through Four are the same speed. PORTRIGA Rapid, all grades, have the same speed.

AGFA-GEVAERT

SPOTTING COLORS
PORTRIGA Rapid Spotone #0
BROVIRA Spotone #1

TONING PORTRIGA RAPID
 Kodak Brown Toner
 Kodak Poly Toner
 Kodak Rapid Selenium
 (As per manufacturer's instruction)
Rodinal Processing Ilford HP-4
 1:25 dilution 5- 7 minutes 68°F
 1:50 dilution 10-11 minutes 68°F

BROVIRA BLACK AND WHITE PAPER

SENSITIVITY
BROVIRA papers have a fast bromide emulsion. A universal, fast enlarging paper in six grades. Over and under-exposed prints can be compensated for by reducing or increasing the development time. Other qualities include good resistance to prolonged development, long exposure and development latitude with a quick buildup of the image.

EMULSION STRUCTURE
BARYTA COATING
The baryta coating is a layer between the base and the emulsion. It influences the surface tint, and because of that fact, it prevents the emulsion from diffusing into the paper. It also affects detail and depth of the shadows. The baryta coating also contains a whitening agent.

EMULSION
The photosensitive emulsion consists of bromide, silver halide crystals precipitated in gelatin.
 A thin coat of gelatin protects all BROVIRA papers against mechanical damage and emulsion abrasion after development.

SENSITIZATION
Spectograms (incandescent light, 2,800° Kelvin).

SURFACE AND GRADES

BROVIRA 1	White Glossy	Grades 0-5
BROVIRA 111	Double Weight Glossy	
BROVIRA 119	Double Weight Matte	

STORAGE
Store BROVIRA papers in a cool, dry place, away from harmful vapors. Best storage conditions:
 Temperature approximately 50° to 70°F. Relative humidity 50 to 60%.

EXPOSURES
Exposure should be adjusted so as to produce a print with clear highlights, richly graduated middle tones and deep shadows which is obtained after correct developing time, the developer used, and the particular grade of paper.

The Compact Photo-Lab-Index

IMAGE TONE
In standard print developers, BROVIRA paper produces a neutral black image.

DARKROOM LIGHTING
A yellow-green darkroom safelight, such as a wratten OA using a ten watt lamp at a distance of five feet should be used with BROVIRA papers.

DEVELOPMENT
BROVIRA paper can be used in any standard black and white paper developer.
 Development time: 1½-2 minutes at 68°F.

STOP BATH
A two percent acetic acid bath is recommended for all BROVIRA papers. Treatment time: one half to not more than one minute.
 The use of a stop bath assures the production of consistent print quality, prevents staining and arrests development beyond the desired point. It neutralizes the alkaline carryover from the developer, and maintains the activity of the fixing bath for a longer time because the fixer is not polluted by residual developer as much as would be the case if the stop bath were not used.

FIXING
Prints are fixed in an acid fixing bath for five to a maximum of ten minutes, depending upon the degree of exhaustion of the bath, temperature and agitation. Excessively long fixation can result in bleached highlights and will change a warm black or brown tone to a neutral or cold black.

WASH
Thirty to forty minutes, depending upon agitation, flow of water and thickness of paper.

DRYING
BROVIRA has a hardened emulsion which makes it acceptable for ferroytype drying.

BROVIRA 310 S, 312 S, BLACK AND WHITE POLYETHELENE COATED PAPER

AGFA BROVIRA 310 S, 312 S, is a universal, highly sensitive projection paper for black and white enlargements. It is supplied in five contrast grades.
 The thin emulsion has an ideal silver to gelatin ratio. Developer substances are incorporated in the emulsion and are therefore suited for high speed processing.
 In tray processing, over and under-exposures can be corrected by adapting processing times, which is a paper saving factor. BROVIRA 310 S, 312 S, has a wide time/temperature tolerance.
 The extremely short processing times are achieved by the thin emulsion layer with less carry-over than with baryta coated papers. This will also result in faster drying times.
 The results are higher output of prints, chemical, water and paper savings.

CHARACTERISTICS
BROVIRA 310 S, 312 S, papers on a polyethelene coated base have less chemical carry-over, faster washing and drying; do not require ferrotyping; are self-glossing. BROVIRA 310 S, 312 S, papers have a fast bromide emulsion.

The Compact Photo-Lab-Index

EMULSION STRUCTURE
The photosensitive emulsion consists of bromide, silver halide crystals precipitated in gelatin.
 A thin coat of gelatin protects all BROVIRA 310 S, 312 S, papers against emulsion abrasion after development and mechanical damage.
 Protective gel
 Emulsion
 P. E. coating
 Paper
 P. E. coating
 Anti-static coating

SENSITIZATION
Spectograms (incandescent light, 2,800° Kelvin).

SURFACE AND GRADES

BROVIRA 310 S	White glossy, P.E.	Grades 1-5
BROVIRA 312 S	Semi Matt, P.E.	Grades 1-5

STORAGE
Store BROVIRA 310 S, 312 S, papers in a cool, dry place away from harmful vapors. Best storage conditions: Temperature approximately 50° to 70°F. Relative humidity 50 to 60%.

EXPOSURES
Exposure should be adjusted so as to produce a print with clear highlights, richly graduated middle tones and deep shadows which is obtained after prescribed development time, the developer used and the particular type of paper.

IMAGE TONE
In standard print developers, BROVIRA 310 S, 312 S, paper produces a black image on extremely white base.

DARKROOM LIGHTING
A yellow-green darkroom safelight, such as a Wratten OA, using a ten watt lamp at a distance of five feet, should be used with BROVIRA 310 S, 312 S, papers.

DEVELOPMENT
BROVIRA 310 S paper can be used in any standard black and white paper developer.
 Development time in trays: 60 seconds at 68°F, (45 seconds at 75°F).

STOP BATH
A two percent acetic acid bath or four percent sodium bisulfite is recommended for all BROVIRA 310 S papers. Treatment time: 5-10 seconds.
 A stop bath permits smooth work without any continuation of development and prevents staining. It neutralizes alkaline constituents of the developer and thus maintains the activity of the fixing bath for a longer time.

FIXING
Prints are fixed in an acid fixing bath for 60-90 seconds, depending upon exhaustion, temperature and agitation. Excessively long fixation can result in bleached highlights and will change a warm black or brown tone to a neutral or cold black.

WASH
Four (4) minutes, depending upon agitation and flow of water.

DRYING

BROVIRA 310 S, 312 S, with a P.E. emulsion support, does not need ferrotype drying. It can be dried by air at room temperature or forced warm air after the prints have been squeegeed.

PAPER THICKNESS

P. E. paper and emulsion	= 0.220mm
Top coat	= 0.006mm
Total thickness	= 0.226mm

SILVER CONTENT

1.4 to 1.7 gr/m^2 (0.14 to 0.16 gr/ft.2)

PORTRIGA-RAPID BLACK AND WHITE PAPER

SENSITIVITY

Portriga-Rapid is a fast chlorobromide paper. Exposure times to achieve a density of 1.0 using a constant light source are the same for all three grades of paper.

EMULSION STRUCTURE

BARYTA COATING

The Baryta coating is a layer between base and emulsion. It influences the surface tint and surface character and, because it prevents the emulsion from diffusing into the paper, the detail and depth of the shadows is controlled.

EMULSION

The sensitive emulsion consists of silver halide crystals (chlorobromide mixed crystals) precipitated in gelatin.

A thin overcoat of gelatin protects Portriga-Rapid papers against abrasion marks and mechanical damage.

SURFACES AND GRADES

Portriga-Rapid — Double weight paper.

Type	Surfaces	Grades		
		1	**2**	**3**
111	White Glossy	PRW 111	PRN 111	PRK 111
118	White Fine Grain Semi-Matt	PRW 118	PRN 118	PRN 118

SENSITIZATION

Spectrogram (Incandescent light 2800° K).

STORAGE

Store in a dry, cool place. Best storage conditions: Temperature approximately 53-68°F; relative humidity 50-60%.

Surface	Maximum Density
High gloss	1.70
Glossy	1.65
Semi-matte	1.50
Matte	1.30

IMAGE TONE
Warm black to brownish black. Portriga-Rapid paper can be toned with sulphur or selenium toners.

PROCESSING

DARKROOM FILTER
A greenish yellow filter such as a OA can be used.

DEVELOPER
Any standard paper developer can be used.

STOP-BATH
A 2% acetic acid solution is recommended as a stop-bath for all Portriga-Rapid papers.
 Treatment time: ½ to 1 minute with continuous agitation. The stop-bath stops any continuation of development and prevents staining. It neutralizes alkaline constituents of the developer and thus maintains the activity of the fixing bath for a long time. It is highly recommended before using a rapid fixing bath and is indispensable when using a hardening-fixing bath.

FIXING
Prints are fixed in an acid fixing bath for 5 to a maximum of 10 minutes, depending on exhaustion, temperature and agitation. Excessively long fixing has an unfavorable effect on the warm black image tone and results in bleached highlights.
 Portriga-Rapid papers are hardened less and swell to a correspondingly greater degree. When these papers are heat-dried, a hardening bath should be used.

WASH
30 to 40 minutes, depending on agitation and flow of water.

DRYING
Since Portriga-Rapid papers have distinguished surface characteristics, it is recommended that they not be subjected to heat drying. Should heat drying be necessary, a hardening fix bath should be used. Portriga-Rapid 111 may be heat dried glossy, but not with the emulsion side to the apron (semi-matte drying).

AGFACOLOR MCN 310 AND MCS 317 PAPERS

MCN 310
Agfacolor Paper MCN 310 is a resin coated, self-glossing, high speed color paper designed for printing color negatives for photofinishing use. Available in rolls only.

MCS 317
Agfacolor Paper MCS 317 is a resin coated, silk surface, high speed color paper designed for portrait printing. Available in rolls only.

SAFELIGHT
Agfa-Gevaert 08.

STORAGE
Below 50°F.

PROCESSING
Agfacolor process 86.

TECHNICAL DATA
PROCESS 86

Agfacolor paper, process 86, is designed to be used with Agfacolor P.E. color print papers.

Developer	86 CD	1 min. 50 sec.	$95° \pm \frac{1}{2}°$
Bleach-Fix	85/86BXR	2 min. 45 sec.	$95° \pm 2°$
Wash		2 min. 45 sec.	$80° - 95°$
Final Bath	86FI	55 sec.	$80° - 95°$
Spray Wash		5 sec.	$80° - 95°$

DEVELOPER 86 CD
1. It is advisable to install a squeegee between the developer and Bleach-Fix.
2. The keeping properties of a properly replenished and active developer are excellent.

BLEACH-FIX 86 BXR
1. Do not use brass tanks or other brass parts in conjunction with the Bleach-Fix.
2. To prepare starter solution, 85/86 BXS (Bleach-Fix Starter) must be added to the Bleach-Fix Replenisher 85/86 BXR. The Replenisher itself is prepared without the addition of the Starter.
3. It is important that sufficient turbulence be achieved in the Bleach-Fix. If necessary, two or more pumps can be connected in parallel. A good rule of thumb is, that a pump capable of circulating 6g pm should be provided for every 10 gallons of Bleach-Fix. 4C processor must be set-up so that the Bleach-Fix pumps push into the top of the tank and pull from the bottom. PAKO processors must be equipped with an upper turbulator bar in the first Bleach-Fix tank,
4. The Bleach-Fix Replenisher has to be introduced into the first Bleach-Fix tank. The Bleach-Fix can then be either cascaded via the overflow or intercirculated with the remaining Bleach-Fix tanks.

WASH (80°-95°)

1. The optimum flow rate required for a particular processor can be calculated by taking the speed of the processor in inches per minute, and providing a ½ gallon per minute flow rates for every 12 inches of processor speed. Temperature of wash water should not exceed 95°F.

2. The minimum flow rate, regardless of the speed of the processor, is four (4) gallons per minute.

3. If the above recommendations cannot be achieved, it would be advisable to install a squeegee between the Bleach-Fix and the First Wash Tank.

4. To insure cleanliness, the water should be filtered.

FINAL BATH 86 FI

Starter solution and replenisher are the same.

SIZES

Starter solutions are available in 5 and 25 gallon sizes only.

DRUM DRYERS

1. Excess moisture must be removed from the emulsion side and the back side of the paper by means of a squeegee and/or an Air Knife.

2. In order to prevent dull spots, the paper should be lifted briefly from the drum after it has traveled about half-way around the drum.

3. The temperature should be so adjusted as not to over-dry the paper.

AIR DRYERS

1. As with the drum type dryers, all excess moisture should be removed from both sides of the paper.

2. Temperature and circulation should be so adjusted as not to over-dry the paper.

REPLENISHERS

Solution	Code	Keeping Properties
Developer	86 CDR	2 Weeks
Bleach-Fix	85/86 BXR	4 Weeks
Final Bath	86 FI	4 Weeks

SIZES

Replenishers are available in 5, 25, and 100 gallon sizes.

DEVELOPER REPLENISHER 86 CDR

1. Floating lids are absolutely necessary for all developer replenisher storage tanks.

2. Developer Replenisher with the **Code 86 CDR must be used.** There are no substitutes.

The Compact Photo-Lab-Index

REPLENISHMENT RATES (CCs per foot of paper)

	3½"	5"	8"	11"
86 CDR	6	8.5	14.0	19.0
85/86 BXR	8.5	12.5	20.0	27.5
86 FI	8.5	12.5	20.0	27.5

PROCESS CONTROL STRIPS

For optimum process control, Agfacolor paper control strips Process 86 should be run at least three times per shift.

Process 86 control strips are available in 5 packages of 5 pre-exposed strips and one factory processed master. These strips are 3½" x 10¾" and are exposed on MCN 310 material.

The following information can be obtained from Process 86 control strips: 1. Contrast; 2. Speed; 3. Highlights; 4. Stain; 5. Maximum density.

Process 86 control strips can be ordered in the usual manner or they can be ordered by placing a standing monthly order thus insuring that you will automatically receive the desired amount of strips the first of every month.

PRINT DEFECTS AND THEIR CAUSES

Change in color balance to Yellow.
1. Temperature of developer too high.
2. Developer over-replenished
3. Heavy contamination of developer by final bath.

Change in color balance to Magenta.
1. Bleach fix under-replenished.

Change in color balance to Cyan.
1. Developer too concentrated
2. Developer oxidized.

Change in color balance to Blue.
1. Developer contaminated by bleach-fix.
2. Development time too short.
3. Temperature of developer too low.
4. Developer-fix under-replenished.

Change in color balance to Green.
1. Bleach-fix over-replenished.

Change in color balance to Red.
1. Developer diluted.
2. Developer over-replenished.
3. Temperature of developer too high.

Poor Whites.
1. Development time too long.
2. Developer over-replenished.
3. Bleach-fix under-replenished.
4. Developer contaminated with bleach-fix.
5. Temperature of developer too high.
6. Developer oxidized.
7. Final bath contaminated with bleach-fix.
8. Temperature of wash water is too high. (Should not exceed 95°).
9. Poor agitation in Bleach-Fix.
10. Too much carry-over of developer into the Bleach-Fix.

313

RODINAL

AGFA-GEVAERT

One of the first products to bear the now famous Agfa-Gevaert trademark was Rodinal developer. Based upon para-aminophenol, Rodinal was developed in Germany by Dr. M. Andresen and has remained unchanged throughout the years.

Rodinal was originally used as a rapid developer for high-speed processing of plates and sheet film and was rediscovered with the introduction of modern thin-emulsion, ultrafine grain films. Upon dilution, Rodinal was found to deliver extreme sharpness and acutance.

Rodinal is a highly concentrated solution which is diluted by the user to make a working solution. Generally, one part Rodinal is added to 25-100 parts of water. This working solution is discarded after use. It is interesting to note that the Rodinal system outdates by about 60 years the now fashionable "one shot" developing method.

Despite the initial cost, Rodinal is extremely economical to use because of the high degree of dilution. One ounce of Rodinal can be used to develop up to 6 rolls of 120 or 35mm, making it one of the least expensive developers in terms of cost per roll.

Rodinal is recommended primarily for the slower, fine-grain, thin-emulsion films. Rodinal is also recommended for highspeed, available light, purposes because it is a powerful developer which will bring out all the inherent sensitivity of the film.

Negatives developed in Rodinal are free from stain and have a tight, even, very sharp grain structure. Rodinal is ideal for today's high resolution, thin-emulsion films where the problem is to maintain, not to reduce the already extremely fine grain. Since it is used in highly diluted form, Rodinal has compensation action. This means that highlights develop quickly, while shadows develop slowly. The developer in the highlight area is exhausted, while the developer in the shadow area is still working bringing out shadow detail. The effect on the negative is to give even contrast and avoid blocked highlights.

CONTRAST CONTROL

The degree of dilution can be varied by the photographer to fit the contrast characteristics of his film and of the scene. To increase contrast, the degree of concentration is increased. To decrease contrast, the degree of dilution is increased. For example, if a photographer photographs a subject with low contrast, he can decrease his negative contrast by using a more concentrated solution.

TEMPERATURE CONTROL

Temperature control is easy with Rodinal since the temperature of the water can easily be adjusted and maintained because of the small quantity of Rodinal to be added. Development times are given for 68°F. For 65°F., increase development time by 20%, for 72°F., decrease development time by 20%.

DEVELOPMENT TIME — TEMPERATURE
FILM AND TIME TEMPERATURE DILUTION

The table on the following page gives approximate recommendations for using Rodinal developer with black and white films. Under normal circumstances, there should not be too much difference in processing methods using Rodinal with films of the same ASA rating. Since Rodinal is extremely flexible, the individual photographer can determine the degree of dilution and the developing times which best suits his working methods and his materials.

DEVELOPING TIMES FOR RODINAL WITH AGFA-GEVAERT FILMS

Film	ASA	Dilution	Time/Temperature
Agfapan 25	25	1:50	8-10 minutes at 68°F
Agfapan 100	100	1:50	8-10 minutes at 68°F
Agfa Ortho 125	125	1:50	9-11 minutes at 68°F
Agfapan 200	200	1:50	9-11 minutes at 68°F
Agfapan 400	400	1:25	9-11 minutes at 68°F

USEFUL LIFE

Rodinal keeps indefinitely in the original bottle. After opening the bottle the concentrated developer keeps for at last 6 months, if the bottle is kept tightly closed with a childproof screw cap. When diluted to working strength Rodinal keeps for only a short time and the developer solution must, therefore, be prepared just before use.

AGITATION

Daylight Tank: Agitate continuously for the first minute, making sure to bang the tank to dislodge air-bells. After the first minute, every thirty seconds give mild agitation for about five seconds, and continue this method until the desired development time has been achieved.

DEVELOPING TIMES FOR RODINAL WITH KODAK AND ILFORD FILMS

Film	ASA	Developed As	Dilution	Time/Temperature
Panatomic/X	64	64	1:50	9 min. at 68°F
Panatomic/X	64	32	1:100	16 min. at 68°F
Plus X	125	125	1:100	11 min. at 68°F
Plus X	125	160	1:75	12 min. at 68°F
Plus X	125	400	1:75	13 min. at 68°F
Plus X	125	800	1:50	14 min. at 68°F
Tri X	250	250	1:85	14 min. at 68°F
Tri X	250	400	1:50	15 min. at 68°F
Tri X	250	800	1:100	18 min. at 68°F
Tri X	250	1600	1:50	19 min. at 68°F
2475 Recording	1000	1000	1:25	11 min. at 68°F
Ilford FP4	125	125	1:25	5 min. at 68°F
Ilford HP5	400	400	1:25	10 min. at 68°F

The Compact Photo-Lab-Index

FUJICOLOR F-II 400 COLOR NEGATIVE FILM
135, 120, 110

Fujicolor F-II 400 is an ultra high-speed, daylight type color negative film. In addition to being fully suitable for every kind of normal photography, Fujicolor F-II 400 film is excellent for action photography. Its ultra high-speed capability makes it a natural for sports photography of all kinds, as well as indoor, outdoor night scenes where there are low light levels. Since Fujicolor F-II 400 is a daylight type film, the use of filters under daylight or with blue flashbulbs and electric flash unit is not required.

Under tungsten or fluorescent lighting conditions, the use of appropriate filters indicated in the chart below is recommended for accurate color rendering.

But, even without the use of filters, Fujicolor F-II 400 film will give you quality prints, preserving dramatic atmosphere of the lighting. This is because of the specially designed spectral sensitivity of this film.

F-II 400 boasts the concentrated latent-image grain technology, producing an especially stable ultra high-speed emulsion. Also because of the use of an image controlling layer within each of the three color image layers, the film has excellents sharpness and fine grain characteristics. Colored couplers are used in the film emulsion, for finest color rendition. All these innovations mean, of course, that the very highest quality color prints are guaranteed, even under ordinary shooting circumstances even though the film has ultra high-speed characteristics.

Printing either on Fujicolor Paper or other color papers will result in high quality color prints with this film. Using Fuji Dye Color Print material also ensures increased quality results. Further the use of Fujicolor Print Film allows production of top grade color slides from this negative material.

EXPOSURE INDEX

Light Source	Exposure Index	Filter Requirements
Daylight	ASA 400, 27 DIN	Not Required
Tungsten Lamps (3200°K)	ASA 100*, 22 DIN*	LBB-12** (or Wratten No. 80A)
Fluorescent Lamps:		
White	ASA 200*, 24 DIN*	CC-20M + CC-20B***
Deluxe White	ASA 250*, 25 DIN*	CC-20B***
Daylight	ASA 200*, 24 DIN*	CC-30M + CC-10R***

*These exposure indexes include the exposure factors for the filters.
**Fuji Light Balancing Filters, or equivalent.
***Color Compensating Filters.

Fluorescent light has special spectral energy distribution characteristics. Therefore, even with the use of these filters absolutely faithful color reproduction is not possible. To compound the problem, there are light quality differences in lamps of differing manufacture, and even color change in the same fluorescent lamps are seen with the aging process. Consequently, the above indicated filters should be used only as a guide.

EXPOSURE UNDER DAYLIGHT CONDITIONS

For derivation of the most beautiful color prints the use of an exposure meter for accurate exposure is recommended. If such an exposure meter is not available the following table can be used as a guide.

317

The Compact Photo-Lab-Index

FUJI

EXPOSURE GUIDE TABLE

Light Condition	Seashore or Snow Scenes Under Bright Sun	Bright Sunlight	Hazy Sunlight	Cloudy Bright	Cloudy Day or Open Shade
Lens Aperture	f/22	f/16	f/16	f/11	f/8
Shutter Speed	1/500	1/500	1/250	1/250	1/250

This table applies for conditions prevailing from 2 hours after sunrise until 2 hours before sunset.

The use of an exposure meter is highly recommended in cloudy weather or in open shade since light intensity differentials are under continual change.

Apertures increased by one or two stops are usually suitable for back lighted close-up subjects.

It is recommended for the adequate recording of snow scenes, mountain scenes or distant landscapes that ultraviolet absorbing filters, such as the Fuji Filter SC-40 or SC-40M (or Wratten No. 1A), be employed.

FLASHBULB EXPOSURE

Blue flashbulbs suitable as light sources with Fujicolor F-II 400 film. When clear flashbulbs are to be employed the use of a Fuji Light Balancing Filter LBB-8 (or Wratten No. 80C) will be required. For ordinary subjects the correct aperture for flash photography can be determined by dividing the flash guide number by the flash-to-subject distance in meters or feet.

The following table offers an indication of applicable guide numbers when single flash bulbs are used in surroundings of relative low reflectivity.

GUIDE NUMBERS FOR FLASHBULBS: in meters (in feet)

Lens Shutter Speed (sec.)	Up to 1/30	1/30	1/60	1/125	1/250	1/500
Synchro-nization	X or F	M	M	M	M	M
AG-1B	56 (180)	40 (130)	40 (130)	32 (100)	26 (86)	20 (66)
M2B	64 (210)	Not Recommended				
M3B 5B 25B	112 (370)	112 (370)	96 (320)	84 (280)	68 (220)	52 (170)
11	96 (320)	88 (290)	80 (260)	72 (240)	60 (200)	44 (140)

Focal Plane Shutter Speed (sec.)	1/30	1/60	1/125	1/250	1/500
Synchronization	FP	FP	FP	FP	FP
6B 26B	100 (330)	76 (250)	56 (180)	40 (130)	28 (90)

Note: The letter B in flashbulb designations indicates blue coated bulbs.

The Compact Photo-Lab-Index

*Clear flashbulb guide numbers are calibrated for use with a Fuji Filter LBB-8 (or Wratten No. 80C) over the lens.

*The guide numbers indicated above are derived for flashbulbs used with medium sized reflectors (13-cm diameter matted reflectors). When a small shallow cylindrical reflector or a large-sized bowl-shaped polished reflector is to be employed, a single stop larger or smaller lens aperture should be used respectively.

*The table indicated above should be considered only as a guide since flashbulbs of the same type may have differing light output and color temperaturee characteristics relative to differing manufacture. Since also the amount of light made available for subject illumination will differ with the type, size and area of the reflector as well as battery condition and reflectivity characteristics of the surroundings, values indicated are only general guidelines. When using flashbulbs in highly reflective surroundings, aperture size decreases of ½ to 1 stop should be employed relative to actual conditions.

*When two flashbulbs are to be used in parallel, the above indicated guide numbers should be multiplied by 1.4 or a single stop smaller aperture should be employed.

*Blue flashbulbs can also be used for light source supplementation as contrast reducing fill-in under sunlight exposure conditions or for the regulation of the brightness ratio for a shaded subject with a sunlit background.

ELECTRONIC FLASH EXPOSURE

The lens aperture for electronic flash is determined by dividing the guide number for the particular flash unit by the flash-to-subject distance in meters or feet relative to guide number requirements.

$$\text{Lens Aperture (f-number)} = \frac{\text{Guide Number (ASA 400)}}{\text{Flash-to-Subject Distance}}$$

When an automatic electronic flash unit is used the lens aperture should be closed down two stops smaller than for conditions required with an ASA speed of 100.

Electronic flash is also subject to the reflectivity of the surroundings requiring that lens aperture be opened 1 stop when the subject is found in low reflectivity conditions. This is especially the case for small electronic flash units where, because of the small light output, there is a tendency toward underexposure.

PHOTOFLOOD LAMP EXPOSURE

The following table approximates adequate exposure conditions when making portraits using two 500-watt photoflood lamps. The two lamps are located at the same distance from the subject, one being close to the camera as the fill-in light and the other being placed one meter higher than the former at an angle of 45° with respect to the camera, as the principal light.

Lamp-to-Subject Distance	Exposure	Required Filters
1.5 meters	1/30 sec. with lens closed down 2/3 stop smaller than f 5.6	Fuji Filter LBB-12 (or Wratten No. 80A)
2.0 meters	1/30 sec. with lens closed down 2/3 stop smaller than f4.	Fuji Filter LBB-12 or Wratten No. 80A)

PROCESSING

The price of the film does not include processing. For processing and printing the film should be sent to an authorized Fuji laboratory or other laboratory offering similar services. This film is intended for processing in Fujicolor Negative Film Processing Chemicals process CN-16 (or Process C-41).

FUJI

The Compact Photo-Lab-Index

FILM SIZES AVAILABLE

	135	12, 24 and 36 exposures
Fujicolor F-II 400	120	(6 x 6cm 12 exposures)
	110	12 and 24 exposures

STORAGE

Inadequate storage conditions may result in lowered film performance even prior to the expiration date. Since prolonged storage under high temperature and humidity conditions will have adverse effects on both processed and unprocessed film, these materials should be stored under cool and dry conditions. Film should not be handled in atmospheres containing formaldehyde or automobile exhaust gases, for these vapors have untoward effects on the film. (Formaldehyde gas is often emitted from such things as synthetic interior finishing materials or adhesives used in ordinary furniture.) For prolonged storage, unexposed films should be enclosed in a sealed container and kept at a temperature of lower than 10°C (50°F). Temperatures lower than 0° (32°F) permit even longer storage. After exposure films should be processed as soon as possible in order to prevent eventual changes in the latent image. Processed films should be kept in a cool dry place at room temperatures of about 20°C (68°F) or lower and humidity levels of 60% or lower. Further, processed film should be handled in such a manner as to prevent scratches and fingerprints especially since the latter encourage the growth of molds.

FUJI

TECHNICAL DATA—FILM STRUCTURE

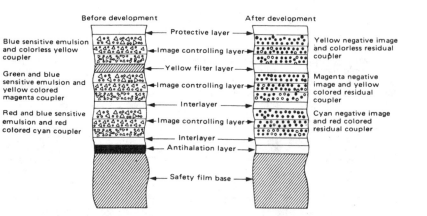

*Image Controlling Layer: New technical innovations producing significant increases in sharpness, graininess and tone reproduction.

RECIPROCITY CHARACTERISTICS

Exposure Time (in seconds)	1/1000-1/10	1	10	100
Exposure Compensation	None	+ ½ stop	+ 1 stop	+ 2 stops
Color Compensating Filters	None	None	None	None

The Compact Photo-Lab-Index

SPECTRAL SENSITIVITY CURVES

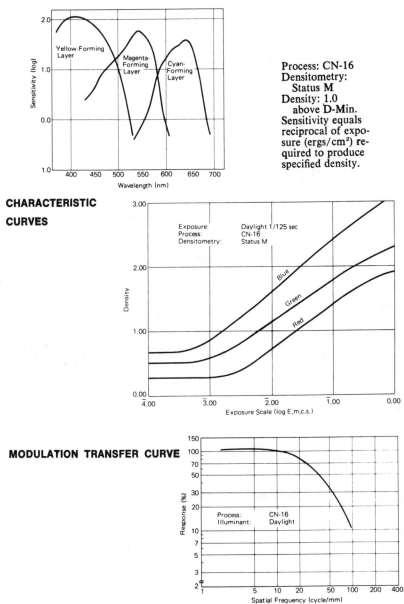

Process: CN-16
Densitometry:
 Status M
Density: 1.0
 above D-Min.
Sensitivity equals
reciprocal of expo-
sure (ergs/cm²) re-
quired to produce
specified density.

CHARACTERISTIC CURVES

MODULATION TRANSFER CURVE

321

The Compact Photo-Lab-Index

SPECTRAL DYE DENSITY CURVES

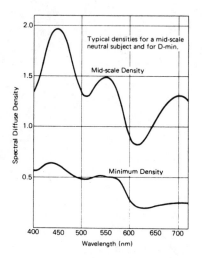

DIFFUSE RMS GRANULARITY VALUE—6

Micro-Densitometer Measurement Aperture: $48\mu\phi$
Magnification: 12X; Measured Sample Density (NET): 1.0.

NOTICE—The sensitometric curves and other data were derived from materials taken from general production runs. As such they do not represent in exact duplication the characteristics of every individual piece of material sold. Nor do these data represent a standard for Fuji Film products. Fuji Film is in a constant process of upgrading the quality characteristics of its product line.

FUJICHROME 100 (Daylight Type)

FUJI PROCESS CR-56, PROCESS E-6

Fujichrome 100 Film is a color reversal film designed for exposure under daylight conditions. After exposure and processing under specified conditions this film will yield high quality transparencies as a result of high sensitivity, wide exposure latitude, exceptional color gradation and saturation as well as high resolving power.

These transparencies can be used for a variety of purposes including color printing originals, projection and viewing originals and originals for various types of color prints.

EXPOSURE INDEX

Daylight—ASA 100/21 DIN.
Tungsten (3200K)—ASA 25/15 DIN (when exposed through a Fuji LBB-12 or Wratten No. 80A filter).

When accurate color rendition is essential, test exposures should be made to determine the best filter and exposure combination.

LONG EXPOSURES

No compensation is required for exposure or color balance if exposure times remain within the 1/1000 to 1 second range. However, in cases where exposures of 4 seconds or longer are needed, compensation for color balance and exposure becomes necessary because of the reciprocity characteristics of the film under such long exposure conditions.

Exposure Correction Table for Reciprocity Characteristics

Shutter Speed (sec.)	1/1000 to 1	4	16	64
Exposure Correction*	None	+ ⅓ stop	+ 1 stop	+ 1⅓ stop
Color Compensating Filter**	None	None	5C	10C

*Exposure correction values include the exposure factors for the color compensating filters.
**The use of Fuji Color Compensating Filters (or Wratten CC Filters) is recommended.

EXPOSURE METHODS RELATIVE TO VARIOUS LIGHT SOURCES

General Exposure Orientations

Relative to the various light sources employed, a light meter set to the indicated exposure index is to be used. Exposure meters are classed into reflection type and incident type units but for exposure measurement and lighting ratio determination the incident type meter is most useful. When employing a reflection type meter or an EE camera there will be instances where the exposure of the main photographic subject will not be sufficient because of the effect on the light sensing device of an excessively bright background. For the purposes of avoiding this kind of problem the exposure meter can be oriented downward or an 18% gray neutral test card can be employed in the determination of correct exposure

FUJI

The Compact Photo-Lab-Index

DAYLIGHT EXPOSURE

No filter is required for general subjects under good weather conditions. But for subjects listed in the following table, the use of indicated filters is recommended.

Subject Conditions	Filter	Exposure Correction
Fair weather open shade, and shadowed landscapes		
Bright distant scenes, snow landscapes, seashore scenes, aerial scenes and other open landscapes	Fuji Filter SC-40M* (or Wratten Filter No. 1A)	None
Close-ups of plants and subjects with bright colors (porcelain wares etc.)		

When the color temperature of the subject is either too high or too low correction is recommended in accordance with the following table.

Subject Conditions		Filter	Exposure Correction
High color temperature	Cloudy weather landscapes and portraits or clear weather open shade subjects.	Fuji Filter SC-40M* or LBA-2** (Wratten Filter No. 1A or No. 81A)	+½ stop
Low color temperature	Scenes and portraits in early morning or evening twilight conditions	Fuji Filter LBB-2** or LBB-4** (Wratten Filter No. 82A or 82B)	+½ + 1 stop

*Fuji Skylight Filter
**Fuji Light Balancing Filter

DAYLIGHT EXPOSURE TABLE

The use of an exposure meter is most effective in determining correct exposures. When such is not available, reference should be made to the following table as a guide. This table applies to the daylight period between 2 hours after sunrise and 2 hours before sunset. Increase the respective exposure apertures by one stop for dark subjects.

Lens aperture with shutter speed of 1/250 second

Light Conditions	Seashore or Snow Scenes under Bright Sun	Bright Sunlight	Hazy Sunlight	Bright Cloudy	Cloudy Day or Open Shade
Lens Aperture	f/16	f/11	f/8	f/5.6	f/4

Decrease the exposure by ½ stop during the summer and increase it by ½ stop during the winter. For exceptionally bright subjects the exposure should be decreased by one stop and increased by the same amount for very dark subjects.

For close proximity, recording of back-lighted subjects the exposure should be increased by one or two stops.

FUJI

The Compact Photo-Lab-Index

ELECTRONIC FLASH

Pictures taken with electronic flash will result in photographs most closely resembling those taken under bright sunlight conditions. A check of the equipment is necessary prior to use when studio type or portable type electronic flash units are used, as differences in effective light intensity or color balance may be inherent in them.

Caution should be exercised when exposing the film using shutter speeds longer than 1/60 second since other light sources such as modeling lamps for example, will adversely affect the finished photographs.

FLASHBULBS

There are two types of flashbulbs, the clear bulbs and the blue bulbs. No filter is required when using blue flashbulbs. For photographic work with clear flashbulbs, the use of a Fuji light balancing filter LBB-8 (or Wratten Filter No. 80C) is recommended.

The guide numbers in the following table are for rooms with relatively little reflectivity and are practical for single flashbulb exposure.

GUIDE NUMBERS FOR FLASHBULBS

Guide numbers are for meter distances, with the bracketed numbers being footage equivalents.

Flashbulb Type		Synchro-nization	Shutter Speed			
			1/30	1/60	1/125	1/250
Blue Flashbulbs	3B	M	43 (140)	39 (128)	32 (105)	24 (80)
	5B	M	55 (180)	47 (155)	40 (130)	24 (80)
	6B	FP	40 (130)	31 (102)	20 (65)	14 (46)
	Press B	M	61 (200)	55 (180)	38 (125)	28 (92)
	Press 6B	FP	45 (148)	36 (118)	24 (80)	16 (52)
	22B	M	70 (230)	66 (217)	43 (140)	29 (95)
	Press	M	48 (155)	36 (118)	31 (102	23 (75)
Clear Flashbulbs*	Press 6	FP	40 (130)	30 (98)	24 (80)	17 (55)
	22	M	56 (185)	52 (170)	40 (130)	31 (102)

*The values indicated for clear flashbulbs are for use with light balancing filters such as the Fuji Filter LBB-8 (or Wratten Filter No. 80C) and include the exposure factors for the filters.

For normal subjects the lens opening is determined by dividing the guide number by the flash-to-subject distance.

FUJI

The Compact Photo-Lab-Index

The values in the guide number table are for 15cm matte surfaced, bowl-shaped reflectors. Since there are differences in the quality of light with bulb type, or manufacturer as well as light output variations with differing lighting equipment and methods, it is recommended that the equipment to be used be checked before use for particular light conditions.

When two flashbulbs are used together side by side the guide numbers in the guide number table should be increased by 1.4 times. (This works out to be a single f-stop smaller lens opening.)

EXPOSURE WITH FLUORESCENT LAMPS

For fluorescent lamps, the proper filters should be used in order to adjust for color balance. With this light source, testing becomes necessary with various filter combinations, since fluorescent lamps are subject to changes in light intensity and colar balance. Use of shutter speeds slower than 1/30 of a second is recommended. The following table can be used as a guide for tests to determine optimum exposure.

EXPOSURE CORRECTIONS: With shutter speed at ⅛ second.

Type of Fluorescent Lamps	White	Daylight	Deluxe White
Color Compensating Filter*	CC 30 M + 10B	CC25R + 20M	CC 10B
Exposure Correction**	+ 1 stop	+ 1⅓ stop	+ ⅔ stop

*The use of Fuji Color Compensating Filters (or Wratten CC Filters) is recommended.

**Exposure correction values include the exposure factors for the color compensating filters.

EXPOSURE PRECAUTIONS

Suggested Exposure Corrections: With shutter speed at 1/8 second

1. Artificial light from such sources as electronic flash, flashbulbs, fluorescent lamps and the like are subject to variations in effective light intensity and color quality because of manufacturing differences, type differences and other similar factors. These fluctuations are especially pronounced with the aging of light sources and voltage fluctuations. Therefore, it is necessary to be familiar with these variations in lighting equipment used.

2. Auxiliary lighting equipment such as reflectors and diffusers may reduce the effective light intensity or change the color quality of the light source because of differences in material quality. It is desirable therefore, to check for any such changes before long term use.

3. In order to correct for variations in the color quality of light sources, the utilization of various types of filters is recommended, such as Fuji Color Compensating Filters of the CC series, (or Wratten CC Filters) Fuji Light Balancing Filters of the LBA or LBB series (or Wratten Light Balancing Filters of the No. 80 and No. 82 series or the No. 81 and No. 85 series).

FILM HANDLING, LOADING

In the loading of roll film it is important that direct sunlgiht not be allowed to hit the roll. For film that has been stored under refrigerated conditions it is important to allow at least one hour after removal of the package from the refrigerator before opening in order that film reaches room temperature.

The film should be exposed and processed before the expiration date.

The Compact Photo-Lab-Index

STORAGE

Unopened film can be stored for short periods of time at temperatures below 10°C (50°F). Film stored for long periods of time should be kept under refrigeration at temperatures below 0°C (32°F) in order to minimize quality changes.

When unexposed film is stored under high temperature and humidity conditions not only are there changes in the film speed and color balance but since there are also other undesirable physical changes it is essential to store film in a cool, dry and darkened place.

Film removed from its plastic seal is especially susceptible to temperature related changes and should be enclosed in vinyl or polyethylene bags and stored after sealing under cool conditions at temperatures below 10°C (50°F).

Of course, film loaded in cameras or film holders is susceptible to temperature and humidity but has a particular susceptibility to formaldehyde or other noxious gases. Formaldehyde gas is to be found emitting from new building materials (paneling and furniture in which certain bonding agents have been used. Care is required in avoiding such surroundings.

In order to avoid changes in the latent image of exposed film it is important to process film as soon as possible. When immediate processing is not possible, the film should be enclosed in a vinyl or polyethylene bag and stored after sealing in a cool place with temperatures under 10°C (50°F).

Processed film should be stored at temperatures below 20°C (68°F) and at relative humidities of less than 60%. Do not store processed film in direct sunlight or under high temperature or humidity conditions because such conditions make the film susceptible to image deterioration.

PROCESSING

Exposed films should be processed as soon as possible. For processing, these films should be sent to a FUJI authorized laboratory or other laboratory offering similar services, or processed with Fujichrome Film Processing Chemicals. Process CR-56 or KODAK Process E-6. The price of the film does not include processing.

FILM SIZE AVAILABLE

Rolls: 135—20 and 36 exposures 120—(6 x 6ml 12 exposures)

FILM STRUCTURE

327

The Compact Photo-Lab-Index

TECHNICAL DATA—SPECTRAL SENSITIVITY CURVES

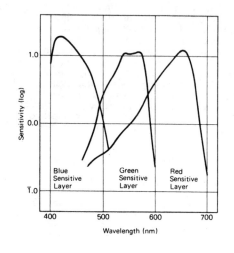

Process: CR-56
Densitometry:
 Status A
Density: 2.0
 above D-min
Sensitivity equals
reciprocal of expo-
sure (ergs/2) re-
quired to produce
specified density.

CHARACTERISTIC CURVES

The following are the characteristic curves of this film processed under standard processing conditions.

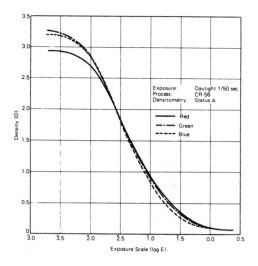

FUJI

328

The Compact Photo-Lab-Index

MODULATION TRANSFER CURVE

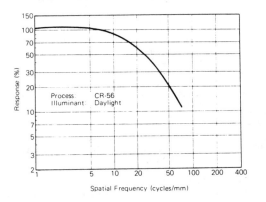

Spatial Frequency (cycles/mm)

SPECTRAL DYE DENSITY CURVES

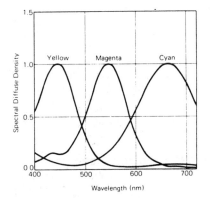

Wavelength (nm)

FUJI

DIFFUSE RMS GRANULARITY VALUE
Micro-Densitometer Measurement Aperture: 48μ in diameter.
Measured Sample Density (NET): 1.0.

RESOLVING POWER
Chart Contrast 1.6:1 50 lines/mm
Chart Contrast 1000:1 125 lines/mm

NOTICE—The sensitometric curves and other data were derived from materials taken from general production runs. As such they do not represent in exact duplication the characteristics of every individual piece of material sold. Nor do these data represent a standard for Fuji Film products. Fuji Film is in a constant process of upgrading the quality characteristics of its product line.

329

FUJICHROME 400 RH (Daylight Type)

Fujichrome 400 is an ultra high-speed, daylight type color reversal film. Its very high-speed and quality make it highly suitable for use under a variety of conditions such as those found in recording stage scenes, shows, night sports events, indoor scenes, and twilight or night scenes, Further, it is highly suited to sports events that call for higher action-freezing shutter speeds, and for other photographic work that requires small apertures in obtaining increased depth of field. Fujichrome 400 also incorporates increased sharpness, fine grain quality and excellent color reproduction. The positive transparencies made from this film are suitable for a wide variety of applications including color slide projection, color photomechanical reproduction and reversal color printing. Being designed for use under daylight conditions or with electronic flash, Fujichrome 400 does not normally require the use of filters. This film incorporates spectral sensitivity distribution optimization for even better results than with ordinary color reversal films when exposures are made under tungsten or fluorescent light. It is of course recommended that for critical color rendition, appropriate filters be used when exposures are made under such light sources. Ultra high-speed and excellent image quality have been realized in Fujichrome 400 through original concentrated latent image grain technoogy, with image controlling layers and the latest advances in the creation of color forming materials.

FUJI

EXPOSURE INDEX

Daylight	ASA 400/27 DIN
Tungsten Lamps (3200K)	ASA 100/21 DIN*

*When exposed through a Fuji LBB-12 or Wratten No. 80A Filter

It is recommended that for best results an exposure meter or exposure automated camera be used. The meter or camera should be set to ASA 400 or 27 DIN when using Fujichrome 400 film. When an exposure automated camera or a reflection type meter is used, the main subject may be improperly exposed if the background is excessively lighter or darker than the main subject. To avoid improper exposure under such circumstances, make measurements at a sufficiently short distance from the subject or from an 18% gray Neutral Test Card to determine optimum exposure.

SHUTTER SPEEDS AND EXPOSURE CORRECTION

No compensation is required for exposure or color balance if exposure times remain within the 1/1000 to 1 second range. However, in cases where exposures of 4 seconds or longer are needed, compensation for exposure and color balance becomes necessary because of the reciprocity characteristics of the film under such long exposure conditions.

Exposure Correction Table for Reciprocity Characteristics

Shutter Speed (seconds)	1/1000 to 1	4	16	32
Exposure Correction*	Unnecessary	+ ⅔ stop	+ 1⅓ stop	+ 1⅓ stop
Color Compensating Filter**	Unnecessary	5C	10C	15C

*Exposure correction values include exposure factors for the color compensating filters.
**Fuji Color Compensating Filter (or Wratten CC Filter)

The Compact Photo-Lab-Index

EXPOSURE GUIDE

The use of an exposure meter is recommended in determining appropriate exposure. If such equipment is not at hand, the following tables can be used as a guide.

DAYLIGHT EXPOSURE TABLE

Light Condition	Seashore, Mountain or Snow Scenes under Bright Sunlight	Bright Sunlight	Hazy Sunlight	Cloudy Bright	Cloudy Day or Open Shade
Aperture	f/16	f/11	f/11	f/11	f/8
Shutter Speed	f/1000	1/1000	1/500	1/250	1/250

This table applies for conditions prevailing from 2 hours after sunrise until 2 hours before sunset. (Use half a stop smaller during the summer and use a half stop larger during the winter.)

If the main subject is very light decrease the exposure by 1 stop and if the main subject is dark increase the exposure by 1 stop.

When taking close-ups of backlighted subjects, use 1 or 2 stops more exposure.

INDOOR AND NIGHT SCENE EXPOSURE TABLE

In indoor or night scene photography the illumination conditions vary considerably from scene to scene. The values given below should therefore be used only as a guide.

Scene	Brightly Daylighted Rooms	Indoors under Fluorescent Light, Show Stage Scenes	Twilight and Floodlit Sports Events	Evening
Aperture	f/2.8 to 4	f/2.8 to 4	f/2.8 to 4	f/2.8 to 4
Shutter Speed	1/60	1/30	1/60	1/30

EXPOSURE METHODS RELATIVE TO VARIOUS LIGHT SOURCES

No particular filter is required for general subjects under fine weather conditions. But for subjects listed in the following table, the use of indicated filters is recommended.

Subject Conditions	Filter	Exposure Correction
Fair Weather, Open Shade, and Shadowed Landscapes		
Bright Distant Scenes, Snow Landscapes, Seaside, Aerial or Other Wide Open Areas	Fuji Filter SC-40M* (or Wratten No. 1A)	Unnecessary
Close-ups of Plants, Subjects with Bright Colors (e.g., Porcelain Wares)		

The Compact Photo-Lab-Index

If the color temperature of the subject is either too high or too low, compensate according to the information in the following table.

Subject Conditions		Filter	Exposure Correction
High Color Temperature	Landscapes or Portraits on a Cloudy Day or Subjects in Open Shade on a Clear Day	Fuji Filter LBA-2** (or Wratten No. 81A)	+ ½ stop
Low Color Temperature	Landscapes or Portraits in Morning or evening Sunlight	Fuji Filter LBB-2** or LBB-4** (Wratten No. 82A or No. 82B)	+ ½ to + 1 stop

*Fuji Skylight Filter
**Fuji Light Balancing Filter

ELECTRONIC FLASH

Pictures taken with electronic flash will result in photographs most closely resembling those taken under bright sunlight conditions. With electronic flash no filter is required. It is recommended that a flash meter be used to determine appropriate exposure. Customarily, electronic flash exposures are made at a shutter speed of 1/60, the resulting photographs may be adversely affected by light from sources other than the electronic flash. When the very best quality is to be derived, make test exposures to evaluate the conditions.

FLUORESCENT LIGHT

When fluorescent lamps are used as the main light source, it is recommended that exposure and color balance correction be made for the fluorescent lamp type involved. As the intensity and color of fluorescent light varies to some extent with the manufacturer and cumulative use time, it is recommended that test exposures be made to determine optimum conditions if high quality results are desired. Use the following table as a guide in making test exposures.

Type of Fluorescent Lamps	White	Daylight	Deluxe White	Color Evaluation ..White..	Photographic Lamps
Color Compensating Filter*	35M	30R + 5M	15B + 5M	20B + 5M	Unnecessary
Exposure Correction**	+ 1 stop	+ 1⅓ stop	+ ⅔ stop	+ ⅔ stop	Unnecessary

*Fuji Color Compensating Filter (or Wratten C Filter)
**Note Exposure correction values include the exposure factors for the color compensating filters.
NOTE: The shutter speeds should be 1/30 or slower.

The Compact Photo-Lab-Index

TUNGSTEN LIGHT

It is recommended that a Fuji Filter LBB-12 (Wratten No. 80A) be used with photoflood lamps. In such a case increase the exposure by 2 stops. Fuji Filter LBB-12 (Wratten No. 80A) or Fuji Filters LBB-12 (Wratten No. 80A plus No. 82A) should be used with household tungsten lamps. In that case increase the exposure by 2 stops.

MERCURY VAPOR LAMPS

It is recommended that Fuji Color Compensating Filters CC-30M plus CC-15R (Wratten CC Filters) be used with high pressure or ordinary mercury vapor lamps. In such an instance increase the exposure by 1 stop.

MIXED LIGHT SOURCE ILLUMINATION

When exposure is made under mixed light source illumination, the types of color compensating filters are to be chosen according to the characteristics of the main light.

EXPOSURE PRECAUTIONS

Artificial light from such sources as electronic flash, fluorescent lamps and mercury vapor lamps is subject to variations in effective intensity and color quality because of manufacturing differences, type differences, voltage fluctuations, cumulative use times, and other factors. The effective intensity and color quality of such artificial light can also vary with the material and quality of the reflectors or diffusers used to adjust light intensity or to diffuse light flux. It is a recommended practice to make test exposures to evaluate exposure conditions.

The changes in light color quality that can occur from the causes mentioned above, may be corrected through the use of various types of filters, such as the CC series Fuji Color Compensating Filters and the LBA and LBB series Fuji Light Balancing Filters. Further, care should be exercised in selecting filter types that are consonant with the intended photographic purposes. In any case, it is wise to bracket exposures when photographing important matter.

FILM HANDLING

Film should be handled in subdued light. When loading and unloading your camera, turn your back toward the sun to protect the film from direct sunlight.

For best results, use the film before the expiration data indicated on the film package and have it processed promptly after exposure.

Packaged film that is removed from a refrigerator should be allowed to stand for 1 hour or more until it reaches room temperature. If opened while still cold, condensation may adversely affect the film.

UNPROCESSED FILM STORAGE

Unprocessed film may be adversely affected with respect to speed, color balance and fog when stored under high temperature and humidity conditions. Further, physical properties may also undergo undesired changes. Noxious gases like formaldehyde vapor can also impair the photographic performance of film. To prevent such adverse effects during storage, care should be exercised as suggested below.

Unopened film can be stored for short periods of time at temperatures below 10°C (50°F). For prolonged storage, film should be kept under refrigeration at temperatures below 0°C (32°C). For this type of storage, film should be enclosed in sealed vinyl or polyethylene bags. Film bags taken out of storage should be allowed to reach room temperature before they are opened.

The film loaded into a camera should be exposed as soon as possible, and should be developed promptly after exposure.

The Compact Photo-Lab-Index

A loaded camera should be kept in a cool, dry place which is free from noxious gases or vapors. New furniture made of modern materials (e.g., plywood panels) may have adverse effects on film because formaldehyde vapor may be released from the paint or synthetic glues used in their manufacture.

PROCESSED FILM STORAGE

The image quality of processed film can be impaired by high temperature or humidity or by strong light (especially ultraviolet rays). To avoid these undesired effects care should be exercised in processed film storage.

Processed film should be kept at temperatures below 20°C (68°F) and at humidities below 60% RH.

Processed film should be kept in as dark a place as possible, avoiding exposure to full sunlight.

NOTICE: The dyes used in Fujichrome 400 film can change over a long period of time as is the case with other dyes. Such unavoidable changes are therefore excluded from the Fujichrome 400 film warranty.

PROCESSING

Exposed films should be processed as soon as possible by having them sent to a FUJI authorized laboratory or other laboratory offering such services. Films are to be processed in Fujichrome Film Processing Chemicals Process CR-56 or KODAK Process E-6.

FILM SIZES AVAILABLE

Rolls: 135 20 and 36 exposures.

FILM STRUCTURE

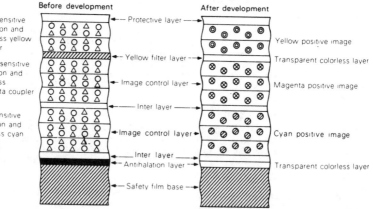

The Compact Photo-Lab-Index

SPECTRAL SENSITIVITY CURVES

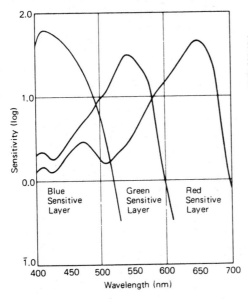

Process: CR-56
Densitometry: Status A
Density: 2.0 above D-min
Sensitivity equals reciprocal
of exposure (ergs/cm²) required
to produce specified density

CHARACTERISTIC CURVES

The following are characteristic curves for this film processed under standard conditions.

STAT 18

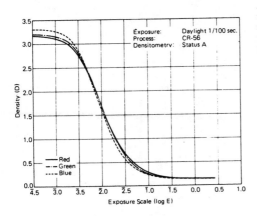

Process: CR-56
Densitometry: Status A
Density: 2.0 above D-min
Sensitivity equals reciprocal
of exposure (ergs/cm²)required
to produce specified density

FUJI

SPECTRAL DYE DENSITY CURVES

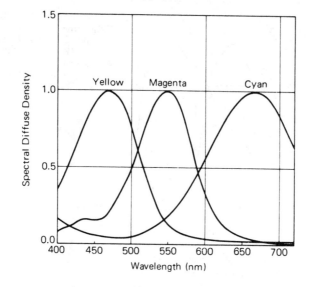

FUJI

NOTICE—The sensitometric curves and other data were derived from materials taken from general production runs. As such they do not represent in exact duplication the characteristics of every individual piece of material sold. Nor do these data represent a standard for Fuji Film products. Fuji Film is in a constant process of upgrading the quality characteristics of its product line.

FUJICOLOR F-II COLOR NEGATIVE FILM

135, 126, 110, 120

Fujicolor F-II is a color negative film designed for exposure under daylight conditions. It offers many outstanding features, such as excellent color rendition, superior graininess, and sharpness, and faithful tone reproduction. Furthermore, high consistency and stability are also salient qualities of Fujicolor F-II.

Since Fujicolor F-II is a daylight type film no filtering is required when exposure is made under daylight conditions, with blue flash bulbs or with electronic flash. Under tungsten lighting conditions, the use of appropriate filters indicated in the chart below is recommend~d for accurate color rendition. Because of these excellent features of Fujicolor F-II film, specially beautiful color prints can be derived when used with Fujcolor Paper or even in combination with color paper of other manufacturers. Further, color prints of high color stability and beauty can be derived when this film is used in conjunction with Fuji Dye Color Print materials while color slides can be made through direct printing on print film.

EXPOSURE INDEX

Light Source	Exposure Index	Filter Used
Daylight	**ASA 100**	None
Tungsten (3200K)	**ASA 25***	LBB-12** (or Wratten No. 80A)

*Exposure index includes the exposure factor of the light balancing filter.
**Fuji Light Balancing Filter or equivalent.

EXPOSURE UNDER DAYLIGHT

In case of Fujicolor F-II, 126 and 110 sizes, no particular operation is required for determining exposure, because the film speed is automatically set on the camera by the film speed notch provided on the cartridge.

To make beautiful color prints, it is advisable to use an exposure meter to determine correct exposure. The exposure meter is available in reflective light type or incident light type, but the latter is generally more convenient for determining exposure or measuring the illumination ratio. In case of using reflective light type exposure meter or electric-eye camera, it is recommended to determine the exposure with the meter or camera pointing slightly downwards or to use an 18% reflectance gray card since the subject may be underexposed if the subject is surrounded by brighter background. If an exposure meter is not available, refer to the following table.

EXPOSURE GUIDE TABLE:* Shutter speed at 1/250

Light Condition	Seashore & Snow Scenes Under Bright Sun	Bright Sunlight	Hazy Sunlight	Cloudy Bright	Cloudy Day or Open Shade
Lens Aperture	f/16	f/11	f/8	f/5.6	f/4

*This table applies from 2 hours after sunrise to 2 hours before sunset.
*Use of an exposure meter is recommended in cloudy weather or in the open shade since the difference between bright and dark changes continually for each shot.
*1 or 2-stops larger aperture is usually suitable for close-up back-lighted subjects.

FUJI

The Compact Photo-Lab-Index

ELECTRONIC FLASH EXPOSURE

The lens aperture for electronic flash is determined by dividing the guide number for the particular flash unit by the flash-to-subject distance in meters or feet relative to guide number requirements.

$$\text{Lens Aperture (f-number)} = \frac{\text{Flash-to-Subject Distance}}{\text{Guide Number (ASA 100)}}$$

When an automatic electronic flash unit is to be used, it should be set to a film speed of ASA 100. As the exposure made with electronic flash is influenced by the reflectivity of the surroundings of the subject as in flashbulb photography, follow the manufacturer's instructions for your electronic flash.

EXPOSURE WITH FLASHBULB OR FLASHCUBE

Blue flashbulbs or flashcubes are suitable for flash pictures with Fujicolor F-II. Fuji Light Balancing Filter LBB-8 (or Wratten No. 80C) is required for clear flashbulbs. For ordinary subjects, the correct aperture can be determined by dividing the guide number by the distance from the flash to the subject.

Following table shows the guide number applicable when using one flashbulb in a room with relatively weak reflection:

GUIDE NUMBERS FOR FLASHBULBS:* in meters (in feet)

Lens Shutter Speed (sec.)	Open or 1/30	1/30	1/60	1/125	1/250	1/500
Synchronization	X or F	M	M	M	M	M
Flashcube	30 (100)	22 (70)	22 (70)	18 (60)	14 (45)	12 (40)
AG-1B	28 (90)	20 (65)	20 (65)	16 (50)	13 (43)	10 (33)
M2B	32 (105)	Not Recommended				
M3B 5B 25B	56 (185)	56 (185)	48 (160)	42 (140)	34 (110)	26 (85)
11	48 (160)	44 (145)	40 (130)	36 (120)	30 (100)	22 (70)

Focal Plane Shutter Speed (sec.)	1/30	1/60	1/125	1/250	1/500
Synchronization	FP	FP	FP	FP	FP
6B 26B	50 (165)	38 (125)	28 (90)	20 (65)	14 (45)

Note: The letter B stands for blue flashbulb.

*Guide numbers for clear flashbulbs are indicated when Fuji Filter LBB-8 (or Wratten No. 80C) is used over the lens.

FUJI

The Compact Photo-Lab-Index

*The above table, with the exception of flashcube, is applicable to a middle-sized folding reflector (matted of 13-cm size). In case of using small-sized shallow cylindrical reflector or large-sized bowl-shaped polished reflector, use 1-stop larger or smaller lens aperture respectively.

*The table given above should be considered as a general guide since flash bulbs of the same type may give a different light intensity and have differences in colors of blue coating according to the manufacturer, and since the amount of light is affected by the type, area and size of reflector, battery condition or reflection from the surroundings. Furthermore, when using a flashbulb in a light room with strong reflection, it is recommended to use a still smaller aperture by ½ to 1-stop according to the actual condition.

*If two flash bulbs are used in parallel, multiply the guide number on previous page by 1.4 or use 1-stop smaller aperture.

*Blue flashbulbs can also be used as a supplementary light source to decrease contrast when the main subject is exposed to sunlight while the side of subject or background is insufficiently lighted thus making an intense contrast, or to regulate the ratio of brightness when the main subject is in the shade while background is under sunlight.

EXPOSURE USING PHOTOFLOOD LAMPS

The following table shows exposure conditions when taking portraits under standard lighting with two 500-watt photoflood lamps. In this case two lamps are located at the same distance from the subject, one being located close to the camera as the supplementary light while the other one being placed 1 meter higher than the former at an angle of 45° with respect to the camera and used as the main lighting.

Distance from Lamp to Subject	Exposure	Filter Used
1.5 meters	1/30 at f/3.5	LBB-12 (or Wratten No. 80A)
2.0 meters	1/30 at f/2.5	

FILM HANDLING, LOADING

In the loading of roll film it is important that direct sunlight not be allowed to hit the roll. For film that has been stored under refrigerated conditions it is important to allow at least one hour after removal of the package from the refrigerator before opening in order that film reaches room temperature. The film should be exposed and processed before the expiration date.

STORAGE

Unopened film can be stored for short periods of time at temperatures below 10°C (50°F). Film stored for long periods of time should be kept under refrigeration at temperatures below 0°C (32°F) in order to minimize quality changes.

When unexposed film is stored under high temperature and humidity conditions not only are there changes in the film speed and color balance but since there are also other undesirable physical changes it is essential to store film in a cool, dry and dark place.

Film removed from its plastic case is especially susceptible to temperature related changes requiring that it be enclosed in vinyl or polyethylene bags and stored after sealing under cool conditions at temperatures below 10°C (50°F).

Film loaded in cameras is susceptible to temperature and humidity but has a particular susceptibility to formaldehyde or other noxious gases. Formaldehyde

FUJI

The Compact Photo-Lab-Index

gas is found emitting from new building materials (such as paneling) and furniture in which certain bonding agents have been used. Such surroundings should be avoided.

To avoid changes in the latent image of exposed film it is important to process film as soon as possible after exposure. When immediate processing is not possible, the film should be enclosed in a vinyl or polyethylene bag and stored after sealing, in a cool place with temperatures under 10°C (50°F).

Processed film should be stored at temperatures below 20°C (68°F) and at relative humidities of less than 60%

PROCESSING

The film prices does not include processing. For processing and printing, the film should be sent to a Fuji's authorized laboratory or other laboratory offering such service, or processed with Fujicolor F-II Processing Chemicals. Process CN-16 (or Process C-41).

FILM SIZES AVAILABLE

	135	12, 24- and 36-exposure
Fujicolor F-II	126	12- and 20-exposure
	110	12- and 24 exposure
	120	6 x 6 cm 12-exposure

TECHNICAL DATA—FILM STRUCTURE

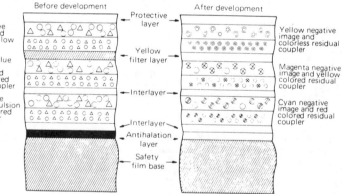

FUJI

The Compact Photo-Lab-Index

SPECTRAL SENSITIVITY

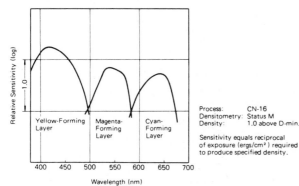

Process: CN-16
Densitometry: Status M
Density: 1.0 above D-min.

Sensitivity equals reciprocal
of exposure (ergs/cm²) required
to produce specified density.

Process: CN-16
Densitometry:
 Status M
Density: 1.0
 above D-min.
Sensitivity equals
reciprocal of expo-
sure (ergs/cm²) re-
quired to produce
specified density.

CHARACTERISTIC CURVES

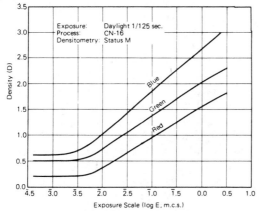

MODULATION TRANSFER CURVE

FUJI

The Compact Photo-Lab-Index

SPECTRAL DENSITY CURVES

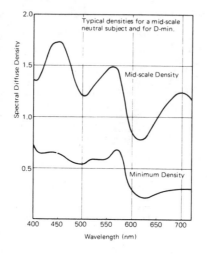

FUJI

RMS GRANULARITY—5

Micro-Densitometer Measurement Aperture: $48\mu\phi$
Measured Sample Density (NET): 1.0

NOTICE—The sensitometric curves and other data were derived from materials taken from general production runs. As such they do not represent in exact duplication the characteristics of every individual piece of material sold. Nor do these data represent a standard for Fuji Film products. Fuji Film is in a constant process of upgrading the quality characteristics of its product line.

FUJI AUTHORIZED LABS IN U.S.A.
FUJICOLOR AND FUJICHROME PROCESSING

	PRINT	**SLIDE**
EAST	P.O. BOX 300	P.O. BOX 300
	HARRISON, NJ 07029	HARRISON, NJ 07029
SOUTHWEST		P.O. BOX 5364 DALLAS, TX 75281
WEST	P.O. BOX 10428 HONOLULU, HI 96816	P.O. BOX 10428 HONOLULU, HI 96816

FUJI FILM PROCESSING STATION

SINGLE-8 FILM PROCESSING

P.O. BOX 300, HARRISON, N.J. 07029

SINGLE-8 FUJICHROME R25

FEATURES
This is a daylight type color reversal 8mm film, designed for use with Single-8 movie cameras. This film provides excellent sharpness, graininess and color rendition. It is ideally suited for outdoor movie-taking under daylight conditions.

EXPOSURE INDEX

Light Source	Exposure Index	
Daylight	ASA 25	15 DIN

SHOOTING
This film is designed for getting best results when shooting in bright sunlight.

1. Load the cartridge correctly by following the directions of your Single-8 movie camera and the film speed will be automatically set.

2. Film base is extremely thin and strong, and has total footage of 50 ft. (15.25 m) enclosed in a compact cartridge enabling the film to run continuously. Film cartridges may be interchanged at any time during shooting with a minimum loss of about 2 in. (5 or 6 cm) of the film.

3. Running at the standard speed of 18 frames per second, this film will give continuous shooting of approximately 3 minutes and 20 seconds.

The Compact Photo-Lab-Index

Shooting Speed and Running Time

Frames/sec	18	24	36
Running Time	3 min 20 sec	2 min 30 sec	1 min 40 sec

4. Strong light at sea or on a snowy mountain in bright sunlight may sometimes cause overexposure. In such a case use ND filter designed to reduce the light intensity without varying color balance.

5. For indoor movie-making under existing light conditions with tungsten lamps such as movielights or photoflood lamps, tungsten-type Fujichrome RT200 (ASA 200) is recommended.

6. The film has a start mark. When film comes to the end, running is automatically stopped at notch in the perforation.

Start Mark and End Notch

FUJI

PROCESSING
This film should be processed in MCR-57 processing chemicals.

PROCESSING CHARGE
The film price includes processing at any Fuji Film or Fuji Film authorized laboratory.

SPLICING
Be sure to use a Single-8 tape splicer and splicing tape when editing. Because this film uses polyester base for support, it cannot be spliced with conventional splicer and film cement.

PROJECTION
Single-8 projectors should be used for projection of the film.
Listed below are running times against footage of the film.

Footage		Running Time	
Feet	Meters	18 frames/sec	24 frames/sec
1	0.305	4 sec	3 sec
2	0.610	8 sec	6 sec
3	0.914	12 sec	9 sec
5	1.52	20 sec	15 sec
10	3.05	40 sec	30 sec
50	15.25	3 min 20 sec	2 min 30 sec
100	30.48	6 min 40 sec	5 min 00 sec

The Compact Photo-Lab-Index

STORAGE

1. Film before processing is liable not only to deteriorate in film speed and color balance but a physical change may also occur if it is stored in a place of high temperature or humidity. The film should be stored in a cool, dry place.

2. If the film is stored in a refrigerator be sure to take out the film at least one hour before use and allow it to reach room temperature. Be sure to expose and process film before the expiration date printed on the film box.

3. Noxious gases such as engine exhaust fumes, and formaldehyde gas emitted by adhesives used in new furniture and new building materials can adversely affect the unexposed film when it is removed from the envelope or loaded in the camera.

4. Have exposed film processed as soon as possible to prevent it from changing in color balance.

5. Store processed film in a can with a drying agent since it may become mildewed if kept in a humid place. In case of fingerprints or dust on your film, clean with a soft cloth dampened with film cleaner before putting it away.

SPECTRAL SENSITIVITY 5400K Exposure

CHARACTERISTIC CURVES

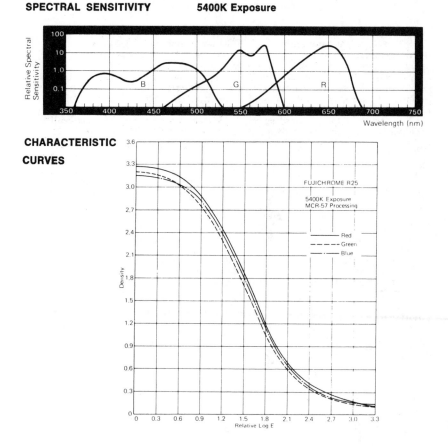

FUJI

SINGLE-8 FUJICHROME RT200

FEATURES

This is a tungsten type color reversal 8mm film, designed for use with Single-8 movie cameras. This film provides excellent sharpness, graininess and color rendition, and is especially designed for use under low-level-light conditions, indoors, on stage or at night.

EXPOSURE INDEX

Light Source	Exposure Index		Filter Used
Tungsten Light (3400K)	ASA 200	24 DIN	—
Daylight	ASA 50	18 DIN	LBA-12A × 4*

*Fuji Light Balancing Filter specially designed for Fujichrome RT200.

SHOOTING

This film is designed for getting best results when shooting under tungsten light.

1. Load the cartridge correctly by following the directions of your Single-8 movie camera and the film speed will be automatically set.

2. Film base is extremely thin and strong, and has total footage of 50 ft. (15.25 m) enclosed in compact cartridge, enabling the film to run continuously. Film cartridges may be interchanged at any time during shooting with a minimum loss of about 2 in. (5 or 6 cm) of the film

3. Running at the standard speed of 18 frames per second, this film will give continuous shooting of approximately 3 minutes and 20 seconds.

Shooting Speed and Running Time

Frames/sec	18	24	36
Running Time	3 min 20 sec	2 min 30 sec	1 min 40 sec

4. Daylight exposure may give rather a bluish color cast or overexposure. Use of Fuji Light Balancing Filter LBA-12A × 4 is recommended for exposure under daylight conditions. In this case the film speed corresponds with exposure index to ASA 50 (15 DIN).

5. A fluorescent light may give a slightly bluish-green effect Although it is difficult to expect perfect color correction in this case, a combined use of tungsten lamps will improve the color considerably.

Start Mark and End Notch

6. Direct lighting at a short distance may cause excessively high contrast, so soft illumination with indirect lighting is more desirable.

7. The film has a start mark. When film comes to the end, running is automatically stopped at notch in the performation. (See diagram on previous page.)

PROCESSING

This film should be processed in MCR-57 processing chemicals.

PROCESSING CHARGE

The film price includes processing at any Fuji Film or Fuji Film authorized laboratory.

SPLICING

Be sure to use a Single-8 tape splicer and splicing tape when editing. Because this film uses polyester base for support, it cannot be spliced with conventional splicer and film cement.

PROJECTION

Single-8 projectors should be used for projection of the film.
Listed below are running times against footage of the film.

Footage		Running Time	
Feet	**Meters**	**18 frames/sec**	**24 frames/sec**
1	0.305	4 sec	3 sec
2	0.610	8 sec	6 sec
3	0.914	12 sec	9 sec
5	1.52	20 sec	15 sec
10	3.05	40 sec	30 sec
50	15.25	3 min 20 sec	2 min 30 sec
100	30.48	6 min 40 sec	5 min 00 sec

STORAGE

1. Film before processing is liable not only to deteriorate in film speed and color balance but a physical change may also occur if it is stored in a place of high temperature or humidity. The film should be stored in a cool, dry place.

2. If the film is stored in a refrigerator be sure to take out the film at least one hour before use and allow it to reach room temperature. Be sure to expose and process film before the expiration date printed on the film box.

3. Noxious gases such as engine exhaust fumes, and formaldehyde gas emitted by adhesives used in new furniture and new building materials can adversely affect the unexposed film when it is removed from the envelope or loaded in the camera.

4. Have exposed film processed as soon as possible to prevent it from changing in color balance.

5. Store processed film in a can with a drying agent since it may become mildewed if kept in a humid place. In case of fingerprints or dust on your film, clean with a soft cloth dampened with film cleaner before putting it away.

The Compact Photo-Lab-Index

SPECTRAL SENSITIVITY 3400K Exposure

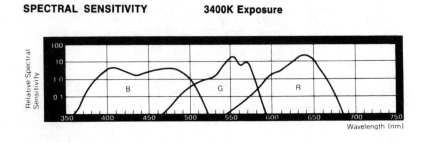

CHARACTERISTIC CURVES

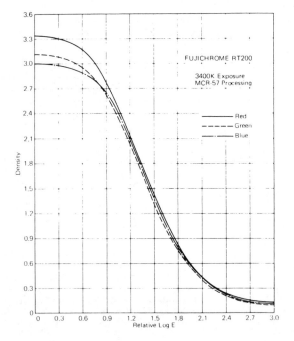

FUJICOLOR REVERSAL FILM RT125

16mm TYPE 8427

GENERAL PROPERTIES

This is a fine-grain, high-resolution tungsten type color reversal film designed for indoor and outdoor photography. This film will serve various photographic p rposes in many fields includ.ng color TV news, industrial and scientific needs. This film exhibits a gradation and color balance suitable for color TV broadcasting or projection using a xenon light source.

FILM STRUCTURE

This film is composed of three emulsion layers sensitive to red, green and blue light, respectively, as well as a yellow layer and an antihalation layer, all coated on a clear safety base. A protective layer is coated on the emulsion surface. Each one of the three emulsion layers contains a different coupler and when the exposed film is processed, the three emulsion layers together form positive images in the predetermined colors of cyan, magenta and yellow.

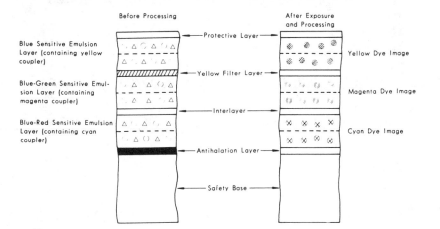

EXPOSURE INDEX

3200K tungsten lamps—125
Daylight—80 (with Fuji Light Balancing Filter LBA-12 or Kodak Daylight Filter No. 85)

These numbers apply to exposure meters marked for American National Standards Institute film speeds. In some cases, the published exposure indexes may not be applicable exactly as they are, depending upon the type or use of the exposure meter or the type of processing equipment. Therefore, it is recommended that exposure tests be made to determine ANSI speeds that would apply under your working conditions.

Exposure (Incident Light) Table for Tungsten Light (3200K)

Shutter speed approximately 1/50 second—24 frames per second

Lens Aperture	f/1.4	f/2	f/2.8	f/4	f/5.6	f/8	f/11
Foot-Candles	20	40	80	160	320	640	1250

349

The Compact Photo-Lab-Index

COLOR BALANCE

Since this film is color balanced for 3200K tungsten lamps, a light balancing filter is not required under such conditions. However, the film is often exposed under low color temperature tungsten lamps, sunlight (which varies according to season, place, and time of day), skylight, cloudy sky and rainy weather. Under these varying conditions, satisfactory color reproduction cannot be obtained unless light balancing filters (amber filters for high color temperature light sources and bluish filters for low color temperature light sources) are used. Light sources, such as fluorescent lamps having an incomplete line spectrum, will not render adequate color reproduction. Within certain limits color compensation for this film is possible with filters, but since the exposure index would fall so low, it is recommended that the ultra high speed Fujicolor Reversal Film RT500 16mm Type 8428 be used.

SPECTRAL SENSITIVITY CURVES
Spectrogram to Tungsten Light (3200K)

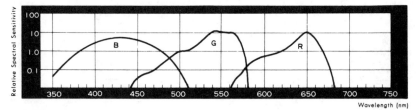

PROCESSING

This film is primarily designed for processing in Fuji MCR-42 or Fuji MCR-45 processes, but Eastman Kodak's VNF-1 or RVNP processes can also be used without modification.

SAFELIGHT

Total darkness is required.

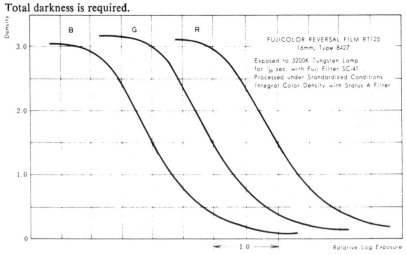

FUJICOLOR REVERSAL FILM RT125
16mm, Type 8427

Exposed to 3200K Tungsten Lamp
for $\frac{1}{50}$ sec. with Fuji Filter SC-41
Processed under Standardized Conditions
Integral Color Density with Status A Filter

CHARACTERISTIC CURVES
(See diagram on previous page)

The characteristic curves indicated in the graph were derived by measuring and plotting the integral color density of the film as exposed to a 3200K light source equipped with a Fuji Filter SC-41 to simulate the absorption of ultraviolet rays through the lens in practical photography and processed under standardized conditions. The curves have been separated on the Log Exposure scale by 1.0 to avoid any overlap.

SPECTRAL DENSITY CURVES

SCREEN PROJECTION
Use a xenon lamp projector for screen projecton of this film. A tungsten or halogen lamp projector will impart a reddish cast. If only the latter type projector is on hand, install a Fuji Light Balancing Filter LBB-12 or equivalent over the projector lens to make necessary color temperature corrections.

FILM BASE
Clear safety (TAC)

EDGE MARKINGS
Footage numbers and the film identification mark (6) are both printed as latent images.

PERFORATION TYPE
1R-7,605mm (1R-2994) 2R-7,605mm (2R-2994).

PACKAGING
16mm 30.5 m (100 ft), Camera spool for daylight loading. 61 m (200 ft), Camera spool for daylight loading. 122 m (400 ft), Type 16P2 core. 366 m (1,200 ft), Type 16P2 core.

The Compact Photo-Lab-Index

STORAGE OF RAW STOCK

Like all other color films, Fujicolor Reversal Film RT125 may undergo certain changes in photographic properties as a result of extended storage. Such changes can be accelerated particularly by heat and moisture. It is therefore recommended that raw stock should be stored at temperatures below 10°C (50°F) to avoid any changes in photographic properties. When raw stock is opened after removal from refrigerated storage, keep the package sealed until the temperature of the film has reached equilibrium with the room temperature, otherwise condensation of moisture will result.

HANDLING OF EXPOSED FILMS

Exposed film should be processed as quickly as possible. When processing is unavoidably delayed, the film should be stored and handled in the same careful manner as with raw stock. Refrigerated storage is required if the storage period is to be longer than one week.

STORAGE OF PROCESSED FILMS

Processed film should be kept in a cool, dark place, fully protected against possible heat, moisture and light. Preferably for such storage purposes is a dark place where the temperature is not higher than 20°C (68°F) and the relative humidity is within a range of 40 to 50 percent.

FUJI

FUJICOLOR REVERSAL FILM RT500

16mm TYPE 8428

GENERAL PROPERTIES

An ultra high-speed tungsten type color reversal film designed for low light level indoor photography, nighttime outdoor photography, and high speed cinematography. This film will serve various photographic purposes in many fields including color TV news, industrial and scientific needs. Even higher speed can be obtained through forced development, making this film ideal for low light level photography. This film exhibits a gradation and color balance suitable for color TV broadcasting or projection using a xenon light source.

FILM STRUCTURE

This film is composed of three emulsion layers sensitive to red, green and blue light, respectively, as well as a yellow filter and an antihalation layer, all coated on a clear safety base. A protective layer is coated on the emulsion surface. Each one of the three emulsion layers contains a different coupler and when the exposed film is processed, the three emulsion layers together form positive images in the predetermined colors of cyan, magenta and yellow.

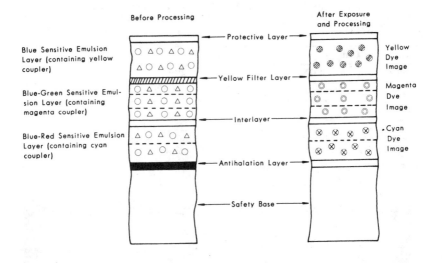

EXPOSURE INDEX

3200K tungsten lamps—500.
Daylight—320 (with Fuji Light Balancing Filter LBA-12 or Kodak Daylight Filter No. 85).

These numbers apply to exposure meters marked for American National Standards Institute film speeds. In some cases, the published exposure indexes may not be applicable exactly as they are, depending upon the type or use of the exposure meter or the type of processing equipment. Therefore, it is recommended that exposure tests be made to determine ANSI speeds that would apply under your working conditions.

The Compact Photo-Lab-Index

Exposure (Incident Light) Table for Tungsten Light (3200K)
Shutter speed approximately 1/50 second—24 frames per second.

Lens Aperture	f/1.4	f/2	f/2.8	f/4	f/5.6	f/8	f/11
Foot-Candles	5	10	20	40	80	160	320

Since the light proofing of this film as wound on the camera spool is fully adequate, this film, in spite of its high speed, can be handled, when loading and unloading in the same manner as Fujicolor Reversal Film RT125 16mm Type 8427.

COLOR BALANCE

Since this film is color balanced for 3200K tungsten lamps, a light balancing filter is not required under such conditions. However, the film is often exposed under low color temperature tungsten lamps, fluorescent lamps, sunlight (which varies according to season, place, and time of day), skylight, cloudy sky or rainy weather. Under these varying conditions, light balancing filters (amber filters for high color temperature light sources and bluish filters for low color temperature light sources) should be used to obtain satisfactory color reproduction.

Light sources, such as fluorescent lamps, having an incomplete line spectrum, will not render adequate color reproduction. Thus in order to provide color compensation within the range of certain limits the filters listed below with the exposure indexes are recommended.

Fluorescent Lamp Type		Filter	Exposure Index
Daylight	(D)	LBA-12* + CC-40R	160
White	(W)	CC-50 R	200
High Color Rendition White	(W-SDL)	LBA-8**	400

*Kodak Daylight Filter No. 85 or equivalent can also be used.
**Kodak Daylight Filter No. 85C or equivalent can also be used.

SPECTRAL SENSITIVITY CURVES
Spectrogram to Tungsten Light (3200K)

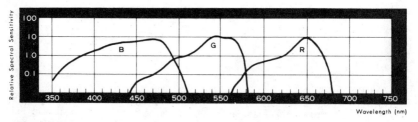

PROCESSING

This film is primarily designed for processing in Fuji MCR-42 or Fuji MCR-45 processes, but Eastman Kodak's VNF-1 or RVNP processes can also be used without modification with this film.

SAFELIGHT

Total darkness is required.

354

The Compact Photo-Lab-Index

SCREEN PROJECTION

Use a xenon lamp projector for screen projection of this film. A tungsten or halogen lamp projector will impart a reddish cast. If only the latter type projector is on hand, install a Fuji Light Balancing Filter LBB-12 or equivalent over the projector lens to make necessary color temperature corrections.

FILM BASE

Clear safety (TAC)

EDGE MARKINGS

Footage numbers and the film identification mark (8) are both printed as latent images.

PERFORATION TYPE

1R-7,605mm (1R-2994) 2R-7,605mm (2R-2994)

PACKAGING

16mm 30.5 m (100 ft), Camera spool for daylight loading. 61 m (200 ft), Camera spool for daylight loading. 122 m (400 ft), Type 16P2 core. 366 m (1,200 ft), Type 16P2 core.

STORAGE OF RAW STOCK

Like all other color films, Fujicolor Reversal Film RT500 may undergo certain changes in photographic properties as a result of extended storage. Such changes can be accelerated particularly by heat and moisture. It is therefore recommended that raw stock should be stored at temperatures below 10°C (50°F) to avoid any changes in photographic properties.

When raw stock is opened after removal from refrigerated storage, keep the package sealed until the temperature of the film has reached equilibrium with the room temperature, otherwise condensation of moisture will result.

HANDLING OF EXPOSED FILMS

Exposed film should be processed as quickly as possible. When processing is unavoidably delayed, the film should be stored and handled in the same careful manner as with raw stock. Refrigerated storage is required if the storage period is to be longer than one week.

STORAGE OF PROCESSED FILMS

Processed films should be kept in a cool, dark place, fully protected against possible heat, moisture and light. Preferable for such storage purposes is a dark place where the temperature is not higher than 20°C (68°F) and the relative humidity is within a range of 40 to 50 percent.

FUJI

The Compact Photo-Lab-Index

CHARACTERISTIC CURVES

The characteristic curves indicated in the graph were derived by measuring and plotting the integral color density of the film as exposed to a 3200K light source equipped with a Fuji Filter SC-41 to simulate the absorption of ultraviolet rays through the lens in practical photography and processed under standardized conditions.

The curves have been separated on the Log Exposure scale by 1.0 to avoid any overlap.

CHARACTERISTIC CURVES

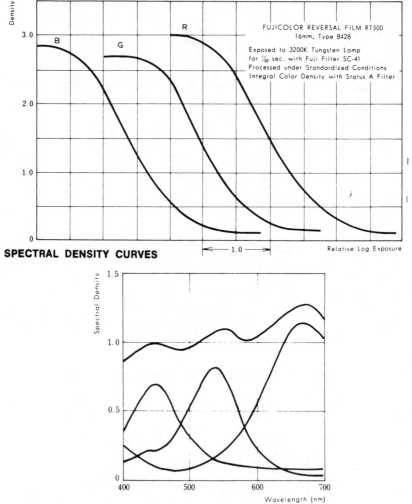

FUJICOLOR REVERSAL FILM RT500
16mm, Type 8428

Exposed to 3200K Tungsten Lamp
for 1/50 sec. with Fuji Filter SC-41
Processed under Standardized Conditions
Integral Color Density with Status A Filter

SPECTRAL DENSITY CURVES

FUJICOLOR NEGATIVE FILM

35mm TYPE 8517 16mm TYPE 8527

GENERAL PROPERTIES

This is a tungsten type color negative film especially designed for motion picture photography being balanced for 3200K tungsten lamps and incorporating automatic color masking based on color couplers. Even with its high speed this film exhibits superior graininess, definition, gradation and excellent color rendition making it suitable for indoor and outdoor photography and assuring fine reproductions when printed on Fujicolor Positive Film or other color print of similar type.

FILM STRUCTURE

The film is comprised of three emulsion layers being respectively sensitive to red, green and blue light along with a protective layer, a yellow filter layer, an antihalation layer and other layers all coated on a clear safety base. Incorporated in each one of the color layers is to be found a differing coupler and through the processing that takes place after exposure color dye images and color mask images are formed in the emulsion layers. Through the use of this orange colored mask image correct color rendition is assured when this negative film is printed on Fujicolor Positive Film for making color release prints.

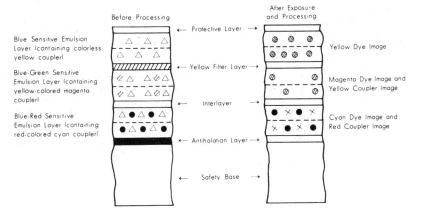

EXPOSURE INDEX

3200K Tungsten Lamps—100.
Daylight—64 (with Fuji Light Balancing Filter LBA-12 or Kodak Daylight Filter No. 85).

These numbers are appropriate for use with exposure meters marked for ASA speed. Since these exposure indexes may not apply exactly as published due to differences in the use of exposure meters and in processing conditions it is recommended exposure tests be made prior to use for the best results.

EXPOSURE

Since this film is color balanced for 3200K tungsten illumination, under such photographic conditions the use of light balancing filters is not necessary but when using this film outdoors under daylight conditions the use of the Fuji Filter LBA-12 (or a light balancing filter of similar characteristics) is required. Exposure

under tungsten light at **24** frames/sec will require the following lens openings and illumination levels at an exposure time of 1/50th of a second.

Lens Aperture	f/1.4	f/2	f/2.8	f/4	f/5.6	f/8	f/11
Foot-Candles	25	50	100	200	400	800	1600

SPECTRAL SENSITIVITY CURVES
Spectrogram to Tungsten Light

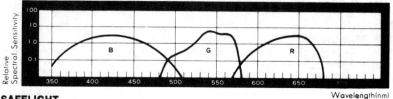

SAFELIGHT
Handle in total darkness.

PROCESSING
This film is to be processed in accordance with the designated processing conditions and formulas provided for Fujicolor Negative Film. Further this film may be processed under conditions and in formulas of process ECN-II published by the Eastman Kodak Company for Eastman Color Negative II Film.

CHARACTERISTIC CURVES
In order to reach conditions closest to actual photographic conditions the exposure was rendered under a 3200K tungsten lamp as the light source with the use of an ultraviolet absorbing filter, the Fuji Filter SC-41. Processing was carried out under standard conditions and the three color densities were measured to render the results indicated in the graph below.

CHARACTERISTIC CURVES SPECTRAL DENSITY CURVES

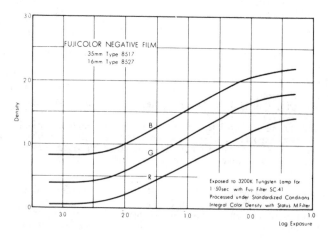

FUJICOLOR NEGATIVE FILM
35mm Type 8517
16mm Type 8527

Exposed to 3200K Tungsten Lamp for
1/50sec with Fuji Filter SC-41
Processed under Standardized Conditions
Integral Color Density with Status M Filter

SPECTRAL DENSITY CURVES

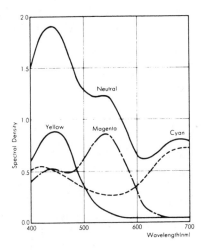

FILM BASE
Clear safety base. (TAC)

EDGE MARKINGS
35mm Edge number, frame mark and film identification mark (N7) are all printed as latent images.
16mm Edge number and film identification mark (N7) are printed as latent images.

PERFORATION TYPES
35mm N-4.740mm (BH-1866). 16mm 1R-7.605mm (1R-2994) and 2R-7.605mm (2R-2994).

PACKAGING
35mm 61 m (200 ft), Type 35P2 core. 122 m (400 ft), Type 35P2 core. 305 m (1000 ft), Type 35P2 core.
16mm 30.5 m (100 ft), Camera spool for daylight loading. (B winding for single perforation film). 61 m (200 ft), Camera spool for daylight loading, (B winding for single perforation film). 122 m (400 ft), Type 16P2 core. (B winding for single perforation film). 366 m (1200 ft.) x 2 rolls, Type 16P2 core (B winding for single perforation film.

STORAGE OF RAW STOCK
Fujicolor Negative Film, like other types of color films, may undergo some changes in photographic properties as a result of extended storage. As these changes can be accelerated particularly through the action of heat and moisture during the storage period it is recommended that raw stock be stored at temperatures below 10°C (50°F). When raw stock that has been in refrigerated storage is to be used, leave the package sealed until the temperature of the film is brought into equilibrium with the room temperature, otherwise condensation of water on the film surface may result.

FUJICOLOR POSITIVE FILM

35mm TYPE 8812 16mm TYPE 8822
16/8mm TYPE 8822 16/8mm-Type S TYPE 8822

GENERAL PROPERTIES

This film is a high-definition, fine-grain color positive film designed for making color release prints with sound track from color negative films and sound recording films.

SPEED

The speeds of all emulsion layers are so balanced that the optimum results can be obtained when prints are made from color negative films having color couplers incorporated in the emulsion layers. Its high speed enables efficient printing operations even for reduction printing with relatively low light intensity.

FILM STRUCTURE

This film is a multilayer, coupler-incorporated color film comprising three emulsion layers sensitive to red, green, and blue lights respectively, all coated on a clear safety base. These emulsion layers contain colorless couplers which produce yellow, cyan, and magenta dye image respectively when exposed and processed. A protective layer is provided on the top surface to protect the raw stock from scratches or other damages which may be caused during handling. The reverse side of the base is coated with an antihalation layer consisting of synthetic resin containing carbon black, which is removed in alkaline solution during processing.

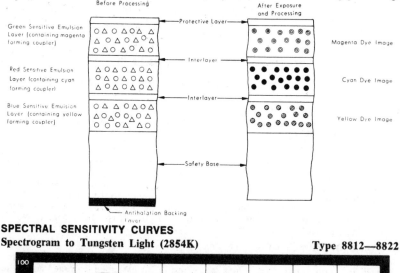

SPECTRAL SENSITIVITY CURVES
Spectrogram to Tungsten Light (2854K) Type 8812—8822

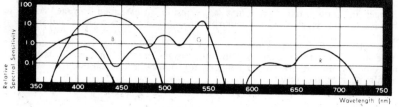

The Compact Photo-Lab-Index

SAFELIGHT
A Fuji Safelight Filter No. 101A for Fujicolor Positive Film is used with a 20-watt bulb at not less than 1 meter (3½ feet) away.

PROCESSING
This film is processed in accordance with the designated processing conditions and formulas for Fujicolor Positive Film Type 8812 and Type 8822. Also the processing conditions and formulas published by Eastman Kodak Company for Eastman Color Print Film, Type 5381 and Type 7381, may be applied without any modification.

CHARACTERISTIC CURVES
To obtain the characteristic curves, the film was exposed to a light source (2854K) through a set of filters consisting of color compensating filters CC-90Y and CC-60M having a density corresponding to the mask density of the color negative film and a Fuji Filter SC-41 for absorption of ultraviolet rays so as to simulate practical printing conditions. The exposed film was processed under standardized conditions. Then, the measurement was taken of the integral color density with Status A Filter. The characteristic curves have been shifted on the Log E scale by 1.0 to Log E to prevent overlapping.

CHARACTERISTIC CURVES

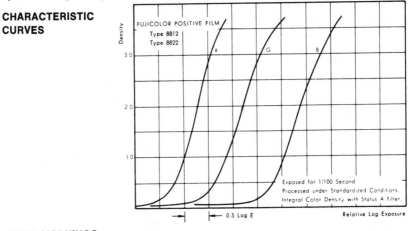

EDGE MARKINGS
35mm Frame mark printed as latent image.
No film identification mark.
16mm No film identification mark.
16/8mm No film identification mark.
16/8—Type S No film identification mark.

SPECTRAL DENSITY CURVES

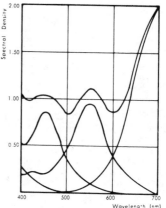

FILM DIMENSIONS

35mm American National Standard PH22•36—1964, KS-1870.
16mm American National Standard PH22•109—1974, 1R-3000.
16/8mm American National Standard PH22•17—1965, 2R-1500
16/8mm American National Standard PH22•167, 2R-1667 (1-4).
Type S American National Standard PH22•150—1967, 2R-1667 (1-3)

PACKAGING

35mm 610 m (2,000 ft), Type 36P3 core. 915 m (3,000 ft), Type 35P3 core.
16mm 610 m (2,000 ft) x 2 rolls, Type 16P3 core. (A winding or B winding).
16/8mm 610 m (2,000 ft) x 2 rolls, Type 16P3 core.
16/8mm Type S (1-4) 610 m (2,000 ft) x 2 rolls, Type 16P3 core. (1-3) 610 m
 (2,000 ft) x 2 rolls, Type 16P3 core. (A winding or B winding).

STORAGE OF RAW STOCK

It is recommended that the raw stock should be stored at temperature below 10°C (50°F) to avoid any changes in photographic properties. When raw stock is opened after removal from refrigerated storage, keep the package sealed until the temperature of film has reached equilibrium with the room conditions, otherwise condensation of moisture may result.

STORAGE OF PROCESSED FILM

Processed Fujicolor Positive Films should be kept in a cold, dry place, fully protected against possible heat, moisture and light. Preferable for such storage purposes is a dark place where the temperature is not higher than 20°C (68°F) and the relative humidity is within the range of 40 to 50 percent.

FUJICOLOR POSITIVE HP FILM

35mm TYPE 8813 35/16mm TYPE 8823 16mm TYPE 8823
35/8mm-Type S TYPE 8823 16/8mm-Type S TYPE 8823
16/8mm-Type R TYPE 8823

GENERAL PROPERTIES

This film is a high-definition, fine-grain color positive material designed for making sound track included color release prints from color negative and sound recording films. It is designed for high temperature rapid processing.

SPEED

The film speed is so balanced that optimum results are obtained with prints made from color mask-incorporated negative films and related duplicating materials. High speed enables efficient printing operations even for reduction printing using relatively low light intensities.

FILM STRUCTURE

As a multilayer, coupler-incorporated color material this film is comprised of three emulsion layers coated on a clear safety base sensitive respectively to red, green, and blue lights. These emulsion layers contain colorless couplers which produce respectively yellow, cyan, and magenta dye images when exposed and processed. A protective layer is provided on the emulsion surface to protect the raw stock from scratches or other possible damage to which it may be subjected during handling. The reverse side of the base is coated with an antihalation layer consisting of a synthetic resin containing carbon black which is removed during processing.

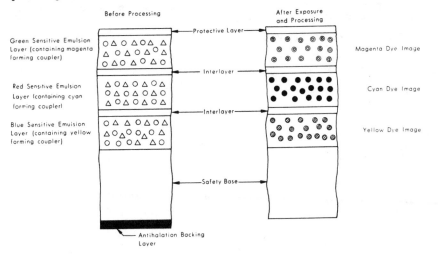

SAFELIGHT

A Fuji Safelight Filter SLG101A or equivalent for Fujicolor Positive Film is used with a 20-watt bulb at a distance of not less than 1 meter (3½ feet) from the film surface.

SPECTRAL SENSITIVITY CURVES
Spectrogram for Tungsten Light (2854K)

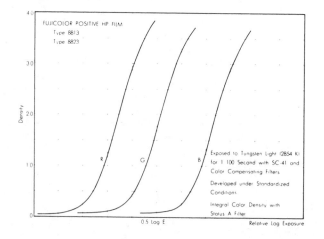

Wavelength(nm)

PROCESSING
This film is processed in accordance with designated processing conditions and formulas for Fujicolor Positive HP Film, Type 8813 and Type 8823. Also the processing conditions and formulas published by Eastman Kodak Company for Eastman Color SP Print Film, Type 5383 and Type 7373 (Process ECP-2), may be applied without modification.

CHARACTERISTIC CURVES
To obtain these characteristic curves, the film was exposed to a 2854K light source through a set of CC-90Y and CC-60M color compensating filters having a density corresponding to the mask density of color negative film and a Fuji SC-41 Filter for absorption of ultraviolet rays in simulation of practical printing conditions. The exposed film was processed under standardized conditions. Then, measurement was made of the integral color density through a Status A Filter. The characteristic curves have been shifted on the scale by 1.0 Log E to prevent overlapping.

CHARACTERISTIC CURVES

FUJICOLOR POSITIVE HP FILM
Type 8813
Type 8823

Exposed to Tungsten Light (2854 K)
for 1/100 Second with SC-41 and
Color Compensating Filters

Developed under Standardized
Conditions

Integral Color Density with
Status A Filter

Density

0.5 Log E Relative Log Exposure

FUJI

SPECTRAL DENSITY CURVES

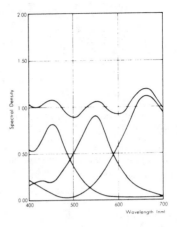

FILM BASE
Clear safety base (TAC).

EDGE MARKINGS
35mm Frame mark and film identification mark (HP) printed as latent image.
35/16mm Film identification mark (HP) printed as latent image.
16mm Film identification mark (HP) printed as latent image.
35/8mm-Type S Film identification mark (HP) printed as latent image.
16/8mm-Type S Film identification mark (HP) printed as latent image.
16/8mm-Type R No film identification mark.

PERFORATION TYPES
35mm P-4.750mm (KS-1870).
35/16mm 3R-7.620mm 1-3-0 (3R-3000, 1-3-0).
16mm 1R-7.620mm (1R-3000).
35/8mm-Type S 5R-4.234mm, 1-3-5-7-0 (5R-1667, 1-3-5-7-0).
16/8mm-Type S 2R-4.234mm, 1-3 (2R-1667, 1-3), 2R-4.234mm, 1-4 (2R-1667, 1-4).
16/8mm-Type R 2R-3.810mm, 1-4 (2R-1500, 1-4).

PACKAGING
35mm 610 m (2,000 ft), Type 35P3 core, 915 m (3,000 ft), Type 35P3 core.
35/16mm 610 m (2,000 ft), Type 35P3 core (A winding or B winding).
16mm 610 m (2,000 ft) x 2 rolls, Type 16P3 core (A winding or B winding).
35/8mm-Type S 610 m (2,000 ft), Type 35P3 core (A winding or B winding).
16/8mm-Type S (1-3) 610 m (2,000 ft) x 2 rolls, Type 16P3 core (A winding or B winding), (1-4) 610 m (2.000 ft) x 2 rolls, Type 16P3 core.
16/8mm-Type R (1-4) 610 m (2,000 ft) x 2 rolls, Type 16P3 core.

STORAGE OF RAW STOCK
It is recommended that the raw stock be stored at temperatures below 10°C (50°F) to avoid any changes in photographic properties. When raw stock is opened after removal from refrigerated storage, keep the package sealed until the temperature of the film has reached equilibrium with the ambient air, otherwise condensation of moisture may result.

STORAGE OF PROCESSED FILM
Processed Fujicolor Positive Films should be kept in a cold, dry place. Preferable for such storage purposes are darkened conditions where the temperature is not higher than 20°C (68°F) and the relative humidity is within the range of 40 to 50 percent.

365

FUJICHROME PAPER TYPE 31

Fujichrome Paper Type 31 is a resin coated reversal paper designed for making high quality color prints from color slides, color prints, color printed material and will also provide positives from black and white prints all through the positive-to-positive method.

All the way from the extreme highlight areas through to the deepest shadow details, this paper provides excellent image rendition and high fidelity in color reproduction ior the derivation of prints with whiteness, gradation and good color balance. In addition, the high speed and very slight variation in sensitivity and gradation quality between production lots, keeps productivity to a high level. Fujichrome Paper Type 31 is designed for processing in Fuji Process RP-300 or in Kodak Ektaprint R-100 chemicals.

Processed prints are very stable and maintain original quality with very limited color image changes over a long period of time.

PAPER STRUCTURE

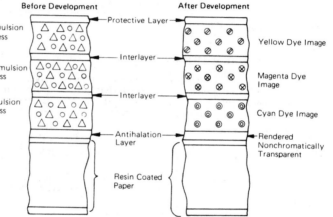

SPEED

Fujichrome Paper Type 31 has speed equal to or higher than that of other high-speed color reversal papers presently available. This speed ensures reduced printing time and a large increase in productivity. There is sufficient speed for making color prints from color printed materials and color enlargements from color slides.

SAFELIGHT

Fujichrome Paper Type 31 is to be handled in total darkness and cannot be used with any safelight.

PROCESSING

Fujichrome Paper Type 31 can be processed in automatic processors designed to use with either Fuji Process RP-300 or Kodak Ektaprint R-100 chemicals.

It is recommended that exposed color papers be processed as soon as possible after exposure. The time between exposure and development should be fixed for purposes of maximum uniformity. Avoid holding exposed papers over for development the next day.

Fujichrome Paper Type 31 can be processed without any modifications, in Kodak Ektaprint R-100 chemicals under designated conditions as to temperature, time, wash water flow rate, replenishment rates and the like, exactly in the same manner as with Ektachrome 2203 paper processing.

PROCESSING CONDITIONS

The standard conditions for automatic processing in Fuji Process RP-300 chemicals are as indicated below.

Step	Time*	Temperature °C	Temperature °F	Room Illumination
First Developer	1 min. 30 sec.	38 ± 0.3	100.4 ± 0.5	Total
First Wash	3 min.	24 to 33	75 to 91	darkness
Reversal Exposure	Expose paper surface to 1000 lux or more for 5 to 10 seconds.			
Color Developer	2 min. 15 sec.	38 ±1	100.4 ± 2	
Second Wash	45 sec.	24 to 33	75 to 91	Normal
Bleach-Fix	3 min.	35 to 40	95 to 104	room light
Third Wash	2 min. 15 sec.	24 to 33	75 to 91	
Drying	—	65 ± 5	149 ± 10	

*All times include a 10-second period for paper transfer from bath to bath.

REPLENISHMENT RATES

The standard replenishment rates for Fujichrome Paper Type 31 processing are as indicated below.

Solution	Standard Replenishment Rates ml/m² of Paper	Standard Replenishment Rates ml/ft² of Paper
First Developer	1,080	100
Color Developer	970	90
Bleach-Fix	750	70

The replenishment rates for each length in meters or feet of the roll paper size employed should be calculated from the standard replenishment rates indicated above.

STORAGE OF RAW PAPER

The raw paper should be stored in environments of 10°C (50°F) and 65% RH or less. High temperatures and humidity are detrimental to color reversal paper affecting therefore, the finished prints.

Color reversal paper which has been stored at 10°C (50°F) or less should remain in their moisture proof wrap and allowed to warm up to room temperature prior to use. This will prevent moisture condensation and a detrimental loosening of the color reversal paper coating. Minimum temperature equalization periods are as follows.

20°C (68°F) Temperature Equalization Periods

Paper Size	Storage Temperature −20°C (−4°F)	0°C (32°F)	10°C ʌ50°F)
8.9 cm × 175.3m (3½ in. × 575 ft)	6 hours	5 hours	3½ hours

The Compact Photo-Lab-Index

Do not heat the color reversal paper in any attempt to expedite temperature equalization. Make it a rule to prepare color reversal paper the day before use.

PAPER SIZES AVAILABLE
Roll Paper

Width	Length	83.8 m (275 ft)	175.3 m (575 ft)	236.3 m (775 ft)
8.9 cm (3½ in.)		●	●	●
12.7 cm (5 in.)		●	—	—
20.3 cm (8 in.)		●	—	—

Paper Surface: All sizes are available in a lustre surface only.

SPECTRAL DENSITY OF COLOR DYES

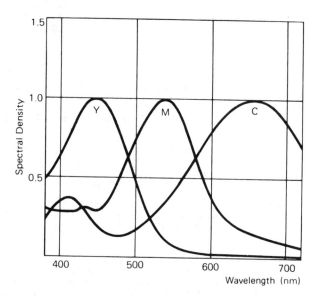

SPECTRAL SENSITIVITY

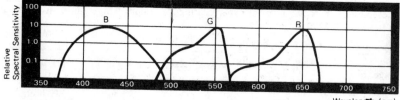

FUJICOLOR PAPER TYPE 8908

Fujicolor Paper Type 8908 is designed to render quality color prints when contact printed or enlarged through such color negative films as Fujicolor F-II and Fujicolor F-II400. Good results are also obtained with other types of color negative film. From the highlight to shadow areas faithful color and tone reproduction, fine gradation and excellent color balance are obtained. When processed properly, color prints of high permanence, clear reds, blues and greens and faithful flesh tones result.

This color paper finds a wide variety of applications which include amateur, commercial and school photography.

Fujicolor Paper Type 8908 is designed to be processed with either Fujicolor Paper Processing Chemicals, Process CP-21, Ektaprint 2 Chemicals or an equivalent. Of course, it is also compatible with 3 step processing chemicals like Ektaprint Chemicals.

Fujicolor Paper Processing Chemicals, Procsss CP-21 is of the 2-bath type and its features include rapid processing resulting in high productivity, low chemical costs, minimum space requirements and simplified processing control. In addition, the use of non-polluting chemicals eliminates environmental contamination.

FUJI

PAPER STRUCTURE

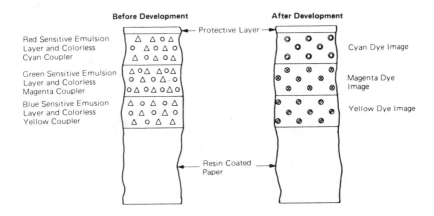

SPEED

Fujicolor Paper Type 8908 has a speed equal to or higher than other high-speed color papers presently available. This speed ensures reduced printing time and a large increase in productivity.

SAFELIGHT

The recommended safelight filter for dark room use is the Fuji Safelight Filter No. 103A (or Kodak Safelight Filter No. 13). Use this filter with a 10-watt tungsten lamp when handling unexposed Fujicolor Paper. Be sure also to work at a distance of at least 1 meter from the light source and to finish printing within 3 minutes. Once exposed, the color paper becomes susceptible to the safelight. Use care to finish printing as quickly as possible when handling exposed color paper.

The Compact Photo-Lab-Index

VIEWING LIGHT SOURCE

A suitable fluorescent lamp with excellent color rendering characteristics is to be used as a light source for inspecting finished prints. The prints are to be examined for color reproduction under illumination levels of 500 to 1,000 lux.

PROCESSING

Fujicolor Paper, Type 8908, can be processed in any processing equipment using Fuji's Process CP-21 Chemicals, Ektaprint 2 Chemicals, Ektaprint 3 Chemicals or equivalent without altering the standard procedure (processing time, processing temperature, replenishment rate, agitation and equipment for bleach-fix regeneration). It is recommended that exposed color papers be processed as soon as possible after exposure. The time between exposure and development should be fixed for purposes of maximum uniformity. Avoid holding exposed papers over for development the next day.

Processing conditions and replenishment rates for Process CP-21 and Ektaprint 2 Chemicals are shown in the table below.

Processing Step	Processing Conditions		Replenishment Rates
	Time	Temp. °C (°F)	Process CP-21 Chemicals (Ektaprint 2 Chemicals)
Color Developer	3½ min.	33 ± 0.3 (91 ± 0.5)	323 ml/m² (30m/ft²)
Bleach-Fix	1½ min.	30 to 34 (86 to 93)	323 ml/m² (30ml/ft²)*
Water Wash	3½ min.	24 to 34 (75 to 93)	—
Drying	As required	80 ± 5 (175 ± 10)	—

*When using Ektaprint 2 Bleach-Fix and Replenisher NR the standard replenishment rate is 53.8 ml/m² (5ml/ft²).

For replenishment rates relative to the various color paper sizes, refer to the Fuji Film Processing Manual "Process CP-21."

CHEMICAL PACKAGING

Processing Chemicals Process CP-21 are supplied in 38-liter (10 U.S. gal.) and 95-liter (25 U.S. gal.) packaging. For usage refer to the Fuji Film Processing Manual "Process CP-21" or the Fuji Film Data Sheet "Fujicolor Paper Processing Chemicals, Process CP-21" available from the manufacturer.

BLEACH-FIX REGENERATION

For regeneration of the Process CP-21 bleach-fix chemicals see the Fuji Film Processing Manual "Process CP-21."

STORAGE OF RAW PAPER

The raw paper should be stored in environments of 10°C (50°F) and 65% RH or less. High temperatures and humidity are detrimental to color paper affecting the finished prints adversely.

Color paper which has been stored at 10°C (50°F) or less should remain in their moisture-proof wrap and allowed to warm up to room temperature prior to use. This will prevent moisture condensation and a detrimental loosening of the color paper coatings. Minimum temperature equalization periods are as shown on the following page.

The Compact Photo-Lab-Index

1. 20°C (68°F) Temperature Equalization Periods

Paper Size	Storage Temperature	−20°C (−4°F)	0°C (32°F)	10°C (50°F)
8.9 cm × 175.3 m (3½ in. × 575 ft)		6 hours	5 hours	3½ hours

2. Warm-up Periods 5°C (41°F) to 20°C (68°F) (By Paper Size)

8.9 cm × 175.3 m	12.7 cm × 83.8 m	13 cm × 18 cm	20.3 cm × 25.4 cm
4½ hours	5 hours	2 hours	2 hours

Do not heat the color paper in any attempt to expedite temperature equalization. Make it a rule to prepare color paper the day before use.

PAPER SIZES AVAILABLE
Paper Surfaces: Matte, lustre, silk and glossy surfaces are available.

Roll Paper

Width \ Length	83.8 m (275 ft)	175.3 m (575 ft)	236.3 m (775 ft)	350.7 m (1,150 ft)	50 m
7.6 cm (3 in)	●	●	—	—	—
8.9 cm (3½ in)	●	●	●	●	—
10.2 cm (4 in)	●	●	●	—	—
10.8 cm (4¼ in)	—	●	—	—	—
12.7 cm (5 in)	—	●	—	—	—
15.2 cm (6 in)	—	●	—	—	—
17.8 cm (7 in)	●	●	—	—	—
20.3 cm (8 in)	●	—	—	—	—
25.4 cm (10 in)	●	●	—	—	—
27.9 cm (11 in)	●	—	—	—	—
30.5 cm (12 in)	●	—	—	—	—
50.8 cm (20 in)	●	—	—	—	—
134 cm	—	—	—	—	●

Other sizes than those specified above can be supplied.

Sheet Paper
Sheet paper of various sizes and of surfaces indicated above can be supplied.

FUJI

371

The Compact Photo-Lab-Index

SPECTRAL DENSITY OF COLOR DYES

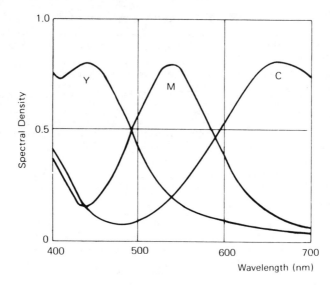

SPECTRAL SENSITIVITY

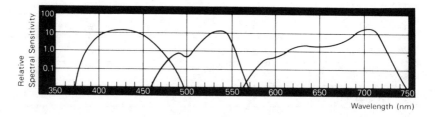

FUJI

372

ILFORD PRODUCTS
BLACK & WHITE FILMS

ILFORD HP5

An excellent 400 ASA film that gives brilliant, full scale negatives with remarkable detail in both highlight and shadow areas. HP5 can be pushed for added speed without any appreciable loss of quality. HP5 can be pushed to 800, 1600, 3200, even 6400, yielding acceptable quality negatives.

ILFORD FP4

For situations requiring a wide tonal range and less speed, Ilford FP4, 125 ASA film can be used. Ilford FP4 delivers tight-grained negatives of tremendous richness for large scale enlargements without loss in quality. Blacks print richer, whites far brighter...with tonal separation greater than most other films. Ilford FP4's extremely long tonal range is perfectly matched to Ilfobrom Galerie.

Over, under or normally exposed, Ilford FP4's shadow areas hold detail. Highlights don't block up. FP4's 10 stop exposure latitude allows for a wide margin of error.

ILFORD PAN F

Ilford Pan F is used when image detail is of prime importance. It is a fine grain 50 ASA film which provides maximum sharpness and resolution with the highest film speed in its class.

Extreme blow-ups reveal super detail, brilliant highlights, and excellent shadow rendition. And Ilford Pan F negatives can be enlarged up to 30 diameters with no image breakup, no loss in definition.

For razor sharp negatives with super-fine grain, Ilford Pan F is the indicated choice.

ENLARGING PAPERS

ILFOBROM

A high quality fiber-based paper, available in six contrast grades...0-to-5...with equal and constant grade spacing. With Ilfobrom, there's no variation in contrast due to changes in exposure time. Grades 0-to-4 have the same speed...grade 5 is 50 percent shorter. Once exposure is determined for a negative, that exposure remains constant even when you switch to a different contrast grade. Ilfobrom is available in a wide range of surfaces and sizes...in both single weight and double weight.

ILFOSPEED

A graded RC paper that approaches fiber-based enlarging paper quality. It provides rich blacks, crisp whites and exceptional tone separation in shadows, mid-tones and highlights. Processes and dries quickly because it's resin coated. Ilfospeed is available in a wide range of surfaces including Pearl.

For professional application the Ilfospeed System includes the Ilfospeed 5250 Print finisher/dryer and the Ilfospeed 2000 Chemistry. This system provides the fine print quality.

ILFOSPEED MULTIGRADE

Ilford's premium resin-coated variable contrast paper. With evenly spaced contrast grades...0-to-4...in precise, even, half-step increments. Like Ilfospeed, Multigrade provides rich blacks, clean whites and exceptional tone separation. Available in both glossy and Pearl surfaces.

ILFORD

ILFOPRINT

Quality stabilization papers for finished, semi-dry prints within seconds. Ilfoprint papers have a special developing agent incorporated into the emulsion. When fed through a low cost stabilization processor, activator and stabilizer solutions process the paper automatically to a ready-to-use print. Ideal for applications where print permanence is not critical.

ILFOBROM GALERIE

A high quality enlarging paper for extremely high standards of print quality. It has an extended tonal range holding separation of densities in highlight and shadow areas. It offers wide latitude for printing and developing, and is suited to archival processing and handling.

BLACK & WHITE CHEMISTRY

ILFOBROM ARCHIVAL CHEMISTRY

Available in convenient kit form, and in individual components, Ilfobrom Archival Chemistry can be used with Ilfobrom Galerie, Ilfobrom, and other quality fiber-based enlarging papers. .
The system components include...Ilfobrom Developer...Ilfobrom Stop Bath...Ilfobrom Fixer...and Ilfobrom Archival Wash Aid.

ILFORD ID-11 PLUS DEVELOPER

A general purpose fine grain film developer with additive 4BZ for maximum negative brilliance. Prevents the build-up of silver complexes in partially exhausted developer. Supplied in powder form.

MICROPHEN® DEVELOPER

A fine grain, high-energy powder film developer that yields an effective increase in film speed. When coupled with Ilford HP5 high speed film, Microphen permits exposure indexes of 800, 1600, 3200, even 6400.

PERCEPTOL® DEVELOPER

An extra fine-grain, powder film developer recommended where maximum enlargements will be required. Ideal for use with Ilford FP4 and Pan F films.

BROMOPHEN® DEVELOPER

An active Phenidone®-hydroquinone based, powder paper developer that ensures full tonal range in prints made on Ilfobrom and Ilfobrom Galerie fiber-based papers.

ILFOSPEED® DEVELOPER

A high activity, fast-induction, highly concentrated liquid developer (dilute 1 + 9) to develop Ilfospeed graded resin-coated papers in 60 seconds.

MULTIGRADE® DEVELOPER

An active Phenidone®-hydroquinone based, liquid concentrate developer for use with Ilfospeed Multigrade variable contrast RC papers. Multigrade Developer gives a very brief induction period and full development in 60 seconds.

ILFOSPEED® FIXER

A highly concentrated liquid fixer that will completely fix Ilfospeed and Ilfospeed Multigrade resin-coated papers in 30 seconds. Can also be used for all fiber-based papers.

ILFORD

THE CIBACHROME® COLOR PRINT SYSTEM

A total system to make brilliant color prints directly from your slides. Cibachrome lets you capture all of your slide's detail in high quality 4x5, 8x10, 11x14 and 16x20-inch color prints...prints so beautiful, crisp and saturated that they compare to the finest professionally produced enlargements. And Cibachrome's unique dyes provide an excellent degree of fade resistance.

Printing and processing time is just 12 minutes at normal room temperature, and Cibachrome eliminates the need for elaborate equipment, complicated processing techniques and internegatives.

Cibachrome Color Print System consists of a complete line of printing materials, chemistry and accessories.
System components include:

CIBACHROME PRINT MATERIAL

Available in both Cibachrome Hi-Gloss and new Cibachrome Pearl, a lustrous and rich, muted-gloss surface with an RC paper base.

CIBACHROME P-12 CHEMISTRY

Makes processing color almost as easy as processing black & white. Cibachrome P-12 Chemistry features a 12 minute cycle time, with 3 steps plus final wash. Processing is at normal room temperature...75°F with a ±3°F temperature latitude. All processing steps take place in normal room light when a Cibachrome Processing Drum is used.

ILFORD MOUNTING PANELS

A convenient way to mount and display your black & white and Cibachrome prints. Each panel consists of a super smooth, rigid plastic panel...factory-coated with a new high-strength adhesive for clean, fast and professional print mounting. Will not fray or bend at corners...unaffected by moisture...no heat or drying time required.

Ilford Mounting Panels are available in single weight and double weight...in a full range of sizes. Pressure sensitive hanger tabs are also available for hanging your Ilford Mounting Panels.

ILFORD

ILFORD HP5 FAST BLACK & WHITE FILM

INTRODUCTION

HP5 is a fast black and white film. When given standard development it has a rating of 400 ASA 27 DIN to daylight. HP5 has the fine grain, excellent edge contrast and sharpness to give high image quality. These characteristics give prints with outstanding brightness and tonal range.

HP5 can be pushed by extending development with developers such as Ilford Microphen. Useful speed increases are obtained in this way making HP5 the ideal film for all photography where factors such as poor lighting and high shutter speeds demand greatest emulsion sensitivity.

Ilford HP5 will yield excellent negatives when processed in tanks, in continuous roller transport or drum processors.

FILTER FACTORS

The factors quoted below give a practical guide to the increase in exposure necessary when using the filters listed. The factors for tungsten light are based on an average tungsten source which has a color temperature of 3200 K.

Filter	Daylight	Tungsten
Light Yellow(K1) (Kodak Wratten® #6)	1.5	1.25
Medium Yellow(K2) (Kodak Wratten #8)	2.0	1.5
Dark Yellow(G) (Kodak Wratten #15)	2.0	1.5
Light Yellow-Green(X1) (Kodak Wratten #11)	3.5	4.0
Tricolor Red(A) (Kodak Wratten #25)	6.0	4.0
Tricolor Blue(C5) (Kodak Wratten #47)	7.0	13.0
Tricolor Green(B) (Kodak Wratten #58)	6.0	6.0

RECIPROCITY CHARACTERISTICS

HP5 need not be corrected for reciprocity law failure when exposures between 1/2 and 1/10,000 second are given. Exposure times longer than 1/2 second must be adjusted to allow for reciprocity failure: use the graph below to calculate the increased exposure time which should be given once the measured time is known. For extremely short exposure times it may be necessary to use a larger lens aperture than that indicated.

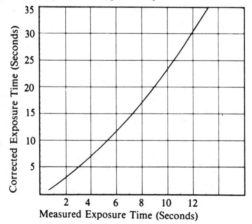

The Compact Photo-Lab-Index

SAFELIGHT RECOMMENDATIONS

Safelights must be used with great discretion with this fast film: during the first three quarters of the planned development time HP5 should be handled in total darkness. After this time, periodic use of a Kodak Wratten Series 3 safelight (very dark green) may be made to check negative density.

NORMAL EXPOSURE DEVELOPMENT DATA

The following table gives the recommended ASA settings for HP5 and corresponding development times for most commonly used developers. These data assume processing in a spiral tank with agitation for the first 10 seconds of development and then for 10 seconds every minute for the remainder of the development time.

Developer	Dilution	ASA	Development Time: at 68°F(20°C)	at 75°F(24°C)
ID-11	none	400	7½	5
or	1 + 1	400	12	8
D-76	1 + 3	400	23	15½
	none	640	6	4
Microphen	1 + 1	640	9½	6¼
	1 + 3	640	21	14
HC-110	1 + 7	400	6	4
DK-50	1 + 1	400	6½	4¼
Diafine	none	500	3	3
	none	200	11	7¼
Perceptol	none	400	16½	11
	1 + 1	200	14	9¼
	1 + 3	200	22	14½
	none	160	11	7¼
Microdol-X	none	320	16½	11
	1 + 1	200	14	9¼
	1 + 3	200	22	14½
	1 + 25	250	7	4¾
Rodinal	1 + 50	250	14	9¼
	1 + 75	200	16	10¾

The development times given are for negatives printed in condenser-type enlargers with normal average scene brightness on Ilford contrast grades 2 and 3 enlarging paper.

When continuous agitation is used, recommended development times should be decreased by from 25% to 40%.

For more consistent results, processing times longer than 5 minutes are recommended.

Also, if you are switching to Ilford HP5 from another brand of film, the ASA/developer/time/temperature and agitation procedures you have already established for films with a basic 400 ASA speed rating represent excellent starting points from which you can make changes if you find them necessary.

ILFORD

The Compact Photo-Lab-Index

PUSH PROCESSING DEVELOPMENT DATA

Ilford HP5 will produce quality prints even when forced to extreme exposure indexes thru push processing techniques. Natural and low-light situations can easily be coped with and special situations requiring high shutter speeds such as sports events and news photography can be easily handled with HP5.

Knowledgeable professional and serious amateur photographers realize that the exposure indexes given for push processing are based on practical evaluation of film speed and not based on the rendering of shadow detail as is ASA. Thus, HP5 can be used over an enormous range of exposure indexes and development times yet still yield optimum quality prints by proper selection of the appropriate contrast grade of printing paper.

The following table gives the recommended higher-than-rated ASA settings for HP5 and corresponding push development times for most commonly used high energy developers. These data assume processing in a spiral tank with agitation for the first 10 seconds of development and then for 10 seconds every minute for the remainder of the development time.

A range of developing times are given for the higher film speeds because subject matter, lighting and individual preference for negative quality preclude giving more specific times.

Developer	Dilution	Exposure Index	Development Time at 68°F(20°C)	Development Time at 75°F(24°C)
ID-11 or D-76	none none	800 1600	11½ 18-22½	7¾ 12-15
Microphen	none none none	800 1600 3200	8 9½-12 14-18	5¼ 6¼-8 9¼-12
HC-110	1 + 7	1200	12	8
Acufine	none none	800 1600	4¼ 10	3 6¾
Acu-1	1 + 5 1 + 5	800 1200	7½ 15	5 10
Ethol UFG	none	1200	5¾	3¾

As noted in the normal development section, if you are switching to Ilford HP5 from another brand of film, the EI/developer/time/temperature and agitation procedures you have already established for pushing films with a basic 400 ASA speed rating represent excellent starting points for push processing too.

FIXATION

After development the film should be rinsed and then fixed in a conventional non-hardening rapid fixer such as Ilfospeed fixer, which fixes the film in about 2 minutes. If a hardening fixer is used, the time should be extended to 3–5 minutes.

WASHING

The washing time for a film largely depends on whether or not it has been hardened during fixation.

Where films have been hardened in a hardening fixer, thoroughly wash the film in running water for 15 to 20 minutes.

Where films have been fixed in a non-hardening fixer, thoroughly wash the film in running water (not over 25°C) for 5 to 10 minutes.

Where it is considered unnecessary to harden film and where the processing temperature is below 25°C an alternative method of washing may be followed which not only saves water and time, but still gives archival permanence.

1. Process your film in a spiral tank.
2. Fix it, using a non-hardening fixer such as Ilfospeed fixer.

ILFORD

The Compact Photo-Lab-Index

3. After fixation, fill the tank with water at the same temperature as the processing solutions, and invert it five times.
4. Drain the water away and refill. Invert the tank ten times.
5. Drain and refill it for the third time and invert the tank twenty times.

A final rinse in water to which a conventional wetting agent has been added will aid rapid and uniform drying. The film should then be dried in a dust-free atmosphere.

SPECTRAL SENSITIVITY
Wedge spectrogram to tungsten light (2850 K)

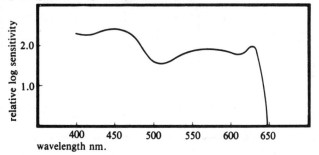

EQUAL ENERGY CURVE
Wedge spectrogram to tungsten light (2850 K)

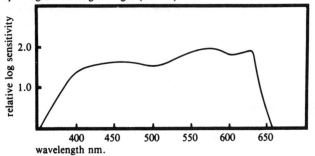

ILFORD

CONTRAST/TIME CHARTS
The charts that follow show the development times for 'normal' and 'high' contrast, and, in addition offer other times to compensate for subject brightness variations. The N − and H − times may be used where the subject brightness range is large, and conversely the longer times indicated by N + and H + may be used where the subject brightness range is low. The times below are a guide because it is appreciated that certain conditions may require even greater variations in development time. Further, the effective exposure index that occurs due to the length of development time is indicated along the right hand edge of the charts.

The Compact Photo-Lab-Index

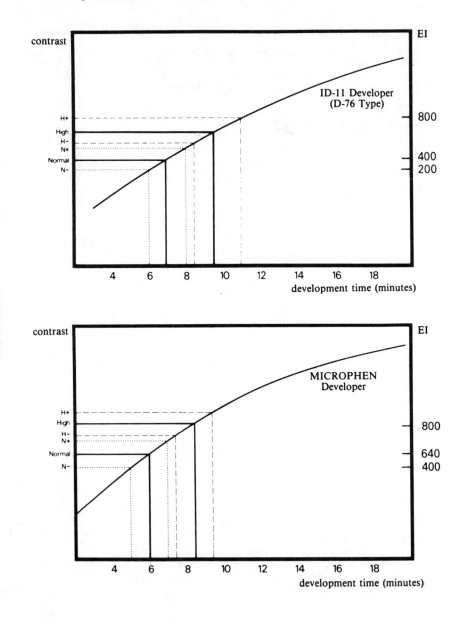

ILFORD

The Compact Photo-Lab-Index

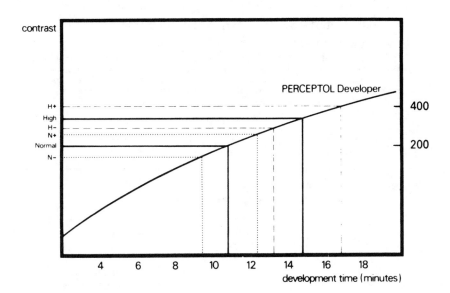

CHARACTERISTIC CURVE

HP5 developed in ID-11 (D-76 Type) at 20°C (68°F) with intermittent agitation.

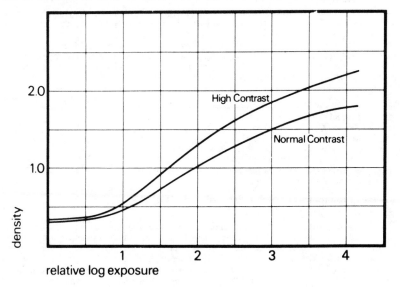

ILFORD

ILFORD HP4 FAST BLACK & WHITE FILM

DESCRIPTION AND USES

HP4 roll film is a medium-contrast, fine grain panchromatic film which has a speed rating of 400 ASA to daylight. It is the ideal film to use under adverse lighting conditions — extra speed can be gained by developing it in Microphen — and has a particularly good response to electronic flash, maintaining film contrast even for extremely short exposure times.

METER SETTINGS

Meter calibration (see also 'Development')

ASA	400
DIN	27

WEDGE SPECTROGRAM

Wedge spectrogram to tungsten light (2,850°K)

| U.V. | Blue | Green | Red |

FILTER FACTORS

The factors quoted give a practical guide to the increase in exposure necessary when using the filters listed. The daylight factors may vary with the angle of the sun and the time of day. In the late afternoon, or in the winter months when the daylight contains more red light, the factors for green and blue filters may have to be slightly increased. The factors for tungsten light are based on an average tungsten source which has a color temperature of 2850 K. The filter factors are intensity scale factors, but for most purposes exposures can be increased by either using a larger aperture or a slower shutter speed.

Filter	Daylight	Tungsten
Light Yellow(K1) (Kodak Wratten® #6)	1.5	1.25
Medium Yellow(K2) (Kodak Wratten #8)	2.0	1.5
Dark Yellow(G) (Kodak Wratten #15)	2.0	1.5
Light Yellow-Green(X1) (Kodak Wratten #11)	3.5	4.0
Tricolor Red(A) (Kodak Wratten #25)	6.0	4.0
Tricolor Blue(C5) (Kodak Wratten #47)	7.0	13.0
Tricolor Green(B) (Kodak Wratten #58)	6.0	6.0

® Wratten is a trademark of The Eastman Kodak Company

RECIPROCITY CHARACTERISTICS

HP4 film is designed to give maximum emulsion speed for the range of exposure times normally used in photography—from 1 second to 1/1000 second. At extremely long or very short exposure times, the nominal exposure — obtained from an exposure meter or guide — should be increased to compensate for the falling off in film speed due to the reciprocity effect. The graph can be used to calculate the new exposure times allowing for reciprocity characteristics. The times on the horizontal axis represent the estimated exposure times; the vertical axis gives the corrected exposure times. For exposure times between 1/1,000 and 1/10,000 second, the lens aperture should be opened up by ½ stop over the indicated setting.

ILFORD

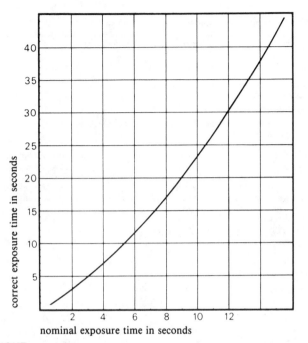

correct exposure time in seconds

nominal exposure time in seconds

ILFORD

SAFELIGHT

HP4 should be developed in total darkness. A Kodak Wratten Series 3 safelight (very dark green) may, however, be used provided that no direct light is allowed to fall on the film.

DEVELOPMENT

The characteristic curves show a range of development times in Ilford ID-11 (a D-76® type developer), and the contrast time curves illustrate how contrast varies in different developers. An increase in the film speed of HP4 can be obtained if it is developed in Ilford Microphen fine grain developer. For the finest grain, HP4 should be developed in Ilford Perceptol. When HP4 is to be developed in Microphen or Perceptol (full strength) the meter settings quoted below should be used.

® D-76 is a trademark of The Eastman Kodak Company.

Meter settings	Microphen	Perceptol
ASA	650	200
DIN	29	24

The development times given will depend on the negative contrast required. Ilford measures contrast in terms of G, that is, the slope of the straight line joining the characteristic curve 0.1 above for density and a point 1.5 log exposure units away. A negative developed to a G of 0.55 is satisfactory for most purposes. In some cases, a slightly contrastier negative may be required, for example, when using a cold cathode enlarger, when a G of 0.70 is recommended.

The Compact Photo-Lab-Index

The table below gives HP4 development times in minutes for processing in a spiral tank at 20°C (68°F) with agitation for the first 10 seconds of development and then for 10 seconds every minute for the remainder of the development time.

Ilford Developer	G0.55	G0.70
ID-11 (D-76 type)	7	10
Microphen	5	7½
Perceptol	9	13

Where continuous agitation is to be used—as in a tray or some types of developing tank—these times should be reduced by one-quarter.

Development of HP4 in diluted ID-11, Microphen or Perceptol further increases acutance. Dilute development is particularly suitable for subjects with long tonal scales—shadow and highlight densities are retained while negatives are sufficiently contrasty to produce bright prints. Diluted developer should be used only once and then discarded.

When using dilute development technique with ID-11, there is no need to alter the film speed. With Microphen the film speed must be set to ASA 650, DIN 29. With Perceptol the film speed must be set to ASA 320, DIN 26.

Development Times (minutes)—intermittent agitation

Ilford developer	Dilution	G0.55	G0.70
ID-ll (D-76 type)	1 + 1	12	18
	1 + 3	20	30
Microphen	1 + 1	9	18
	1 + 3	18	27
Perceptol	1 + 1	13	19
	1 + 3	21	30

CONTRAST/TIME CURVES

Contrast-time curves for HP4 in ID-11 with continuous and intermittent agitation give the average gradient over a range of 1.5 log exposure units from a point 0.1 above fog.

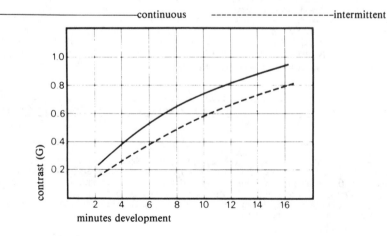

The Compact Photo-Lab-Index

Contrast-time curves for HP4 in Microphen with continuous and intermittent agitation give the average gradient over a range of 1.5 log exposure units from a point 0.1 above fog.

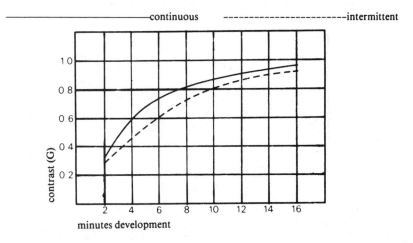

Contrast-time curves for HP4 in Perceptol (full strength) with continuous and intermittent agitation give the average gradient over a range of 1.5 log exposure units from a point 0.1 above fog.

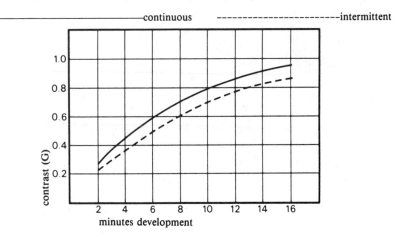

The Compact Photo-Lab-Index

CHARACTERISTIC CURVES

HP4 developed in ID-11 at 20°C (68°F) with intermittent agitation.

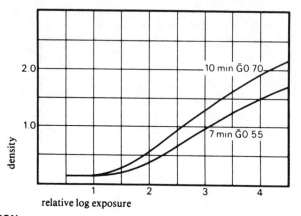

FIXATION

After development, HP4 should be rinsed in water or a stop bath and then fixed in an acid fixer which fixes the film in 2 minutes. If a hardening fixer is required, the fixing time should be 3 to 5 minutes.

WASHING

After fixing, the film should be thoroughly washed in running water for 15 to 20 minutes. A final rinse in water to which a wetting agent has been added will aid rapid and uniform drying.

386

ILFORD FP4 MEDIUM SPEED BLACK & WHITE FILM

DESCRIPTION AND USES

Ilford FP4 films are very fine grain medium-contrast panchromatic films with a speed rating of 125 ASA to daylight. FP4 films have a high acutance emulsion which, combined with its fine grain and exposure latitude, ensures high quality — the ideal film to use for all critical indoor and outdoor photography, particularly when giant enlargements are to be made. FP4 will give good quality results even if it is overexposed by as much as six stops, or underexposed by two stops.

METER SETTINGS

Meter calibration	
ASA	125
DIN	22

WEDGE SPECTROGRAM

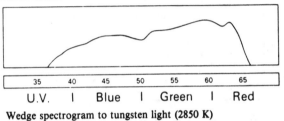

U.V.	Blue	Green	Red

Wedge spectrogram to tungsten light (2850 K)

FILTER FACTORS

These are intensity scale factors, but for most purposes exposure can be increased either by using a larger aperture or a slower shutter speed.

Filter	Daylight	Tungsten
Light Yellow(K1) (Kodak Wratten® #6)	1.5	1.25
Medium Yellow(K2) (Kodak Wratten #8)	2.0	1.5
Dark Yellow(G) (Kodak Wratten #15)	2.0	1.5
Light Yellow-Green(X1) (Kodak Wratten #11)	3.5	4.0
Tricolor Red(A) (Kodak Wratten #25)	6.0	4.0
Tricolor Blue(C5) (Kodak Wratten #47)	7.0	13.0
Tricolor Green(B) (Kodak Wratten #58)	6.0	6.0

® Wratten is a trademark of The Eastman Kodak Company

RECIPROCITY CHARACTERISTICS

There is no need to compensate for reciprocity characteristics when FP4 is given exposure times between ½ and 1/1000 second. Exposure times which are longer than ½ second must be adjusted to allow for reciprocity failure.

The graph below can be used to calculate the new exposure times allowing for reciprocity characteristics. The times on the horizontal axis represent the estimated exposure times, the vertical axis gives the corrected exposure times.

387

The Compact Photo-Lab-Index

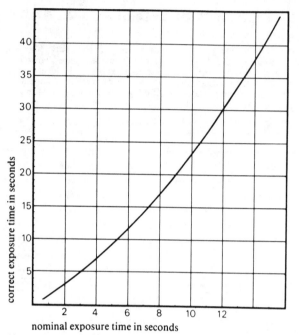

nominal exposure time in seconds

(Y-axis: correct exposure time in seconds)

For extremely short exposure times, such as 1/1,000 second, the lens aperture should be opened by ½ stop over the indicated setting.

SAFELIGHT

FP4 film should be handled and developed in total darkness. A Kodak Wratten Series 3 safelight (very dark green) can be used for brief inspection during processing.

DEVELOPMENT

FP4 is shown to best advantage if it is developed in either Ilford ID-11, a D-76® type developer, Ilford Microphen, or Ilford Perceptol. These are fine grain developers—Microphen giving FP4 a speed increase of 2/3rds of a stop.

When FP4 is to be developed in Microphen or Perceptol (full strength) the meter settings quoted below should be used.

® D-76 is a trademark of The Eastman Kodak Company

Meter calibration	Microphen	Perceptol
ASA	200	64
DIN	24	19

The development times given below are in minutes and refer to development at 20°C (68°F) using intermittent agitation, that is, agitation for the first 10 seconds of development, then for 10 seconds every minute for the remainder of the development time. Negatives should be developed to a G of 0.55 except when a cold cathode enlarger is used when a negative developed to a G of 0.70 is more satisfactory—a slightly contrastier negative giving better results with this type of enlarger.

Ilford Developer	G 0.55	G 0.70
ID-11 (D-76 type)	6½	10
Microphen	5	7½
Perceptol	10	13

If continuous agitation is given—as in a tray or with some types of developing tank—three-quarters of the development time stated should be given.

Development of FP4 in diluted ID-11, Microphen or Perceptol further increases the already high acutance of this film. Dilute development is particularly suitable for subjects with long tonal scales — shadow and highlight densities are retained while negatives are sufficiently contrasty to produce bright prints. Diluted developer should be used only once and then discarded.

When using dilute development technique with ID-11, there is no need to alter the film speed setting. With Microphen the film speed must be set to ASA 200, DIN 24. With Perceptol the film speed must be set to ASA 100, DIN 21.

Ilford developer	Dilution	G 0.55	G 0.70
ID-11 (D-76 type)	1 + 1	9 min.	14 min.
	1 + 3	15 min.	22 min.
Microphen	1 + 1	8 min.	13 min.
	1 + 3	11 min.	20 min.
Perceptol	1 + 1	11 min.	15 min.
	1 + 3	16 min.	28 min.

CONTRAST/TIME CURVES

Contrast-time curves for ID-11 with continuous intermittent agitation give the average gradient over a range of 1.5 log exposure units from a point 0.1 above fog.

——————————— continuous ------------------ intermittent

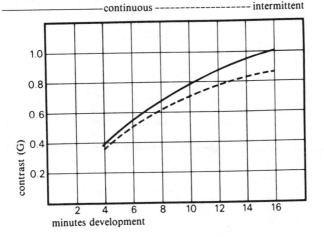

ILFORD

CONTRAST/TIME CURVES

Contrast-time curve for Microphen with intermittent agitation gives the average gradient over a range of 1.5 log exposure units from a point 0.1 above fog.

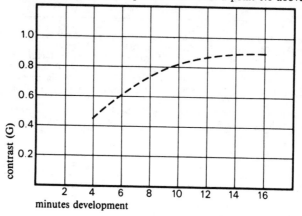

Contrast-time curve for Perceptol with intermittent agitation gives the average gradient over a range of 1.5 log exposure units from a point 0.1 above fog.

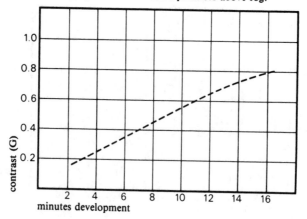

390

The Compact Photo-Lab-Index

CHARACTERISTIC CURVES
Developed in ID-11 at 20°C (68°F) with intermittent agitation.

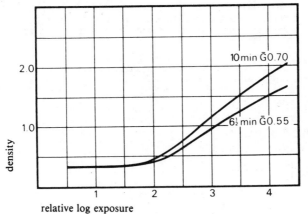

FIXING
After development, rinse the film in water and fix in an acid fixer, which fixes the film in 2 minutes.
 Alternatively, an acid hardening fixer can be used—it fixes and hardens the film in 5-10 minutes.

WASHING
After fixing, films should be thoroughly washed in runnng water for 15-20 minutes. A final rinse in water to which a wetting agent has been added will aid rapid and uniform drying.

ILFORD PAN F FINE GRAIN BLACK & WHITE FILM

DESCRIPTION AND USES

Pan F film is an extremely fine grain panchromatic emulsion which is recommended for artificial light and daylight photography, particularly where sharpness and lack of grain are more important than film speed.

METER SETTINGS

Meter calibration (see also 'Development')

ASA	50
DIN	18

WEDGE SPECTROGRAM

Wedge spectrogram to tungsten light (2850 K)

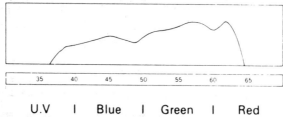

U.V | Blue | Green | Red

FILTER FACTORS

The factors quoted below give a practical guide to the increase in exposure necessary when using the filters listed. Daylight factors may vary with angle of the sun and the time of day. In the late afternoon, or in the winter months when the daylight contains more red light, the factors for green and blue filters may have to be slightly increased. Factors for tungsten light are based on an average tungsten source which has a color temperature of 2850 K. The filter factors are intensity scale factors, but for most purposes exposures can be increased by either using a larger aperture or a slower shutter speed.

Filter	Daylight	Tungsten
Light Yellow(K1) (Kodak Wratten® #6)	1.5	1.25
Medium Yellow(K2) (Kodak Wratten #8)	2.0	1.5
Dark Yellow(G) (Kodak Wratten #15)	2.0	1.5
Light Yellow-Green(X1) (Kodak Wratten #11)	3.5	4.0
Tricolor Red(A) (Kodak Wratten #25)	6.0	4.0
Tricolor Blue(C5) (Kodak Wratten #47)	7.0	13.0
Tricolor Green(B) (Kodak Wratten #58)	6.0	6.0

® Wratten is a trademark of The Eastman Kodak Company

RECIPROCITY CHARACTERISTICS

Pan F is designed so that maximum emulsion speed is obtained over the range of exposure times normally used in photography — from ½ to 1/1000 second. At extremely long or very short exposure times, the nominal exposure — obtained from an exposure meter or guide — should be increased to compensate for the falling off in speed due to the reciproci-

ty effect. The graph shows the relationship between the nominal exposure time and that which would actually be given in practice.

For extremely short exposures, such as 1/10,000 second, the lens aperture should be opened by ½ stop over the indicated setting.

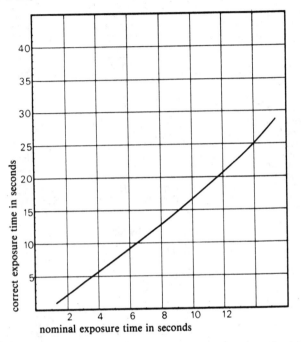

SAFELIGHT

Pan F should be handled and developed in total darkness. A Kodak Wratten Series 3 safelight (very dark green) can be used provided that no direct light is allowed to fall on the film.

DEVELOPMENT

The characteristic curves show a range of development times in Ilford ID-11 (D-76® type), and the contrast time curves show how contrast varies with development time in different developers. If Pan F is developed in Ilford Microphen developer a speed increase of about ½ a stop can be obtained. For the finest grain, Pan F should be developed in Ilford Perceptol. For details of these developers see the appropriate Technical Information Sheets. When the film is to be developed in Microphen or Perceptol (full strength) the meter settings quoted below should be used.

® D-76 is a trademark of The Eastman Kodak Company.

Meter settings	Microphen	Perceptol
ASA	80	25
DIN	20	15

The Compact Photo-Lab-Index

The development times will depend on the contrast required. Contrast is measured in terms of G, that is the slope of the straight line joining the point on the characteristic curve 0.1 above fog density and the point 1.5 log exposure units away.

A negative developed to a G of about 0.55 is satisfactory for most purposes. In some cases a slightly harder negative may be required, for example when using a cold cathode enlarger, and in such cases a G of 0.70 is recommended. The following table gives development times in minutes for processing in a spiral tank at 20°C (68°F) with agitation for the first 10 seconds of development and for 10 seconds every minute for the remainder of the development time.

Ilford developer	G 0.55	G 0.70
ID-11 (D-76 type)	6	9
Microphen	4½	6
Perceptol	11	15

When continuous agitation is given — as in a tray or with some types of developing tank — the development times should be reduced by one-quarter.

Development of Pan F in diluted Perceptol achieves further acutance. Dilute development is particularly suitable for subjects with long tonal scales — shadow and highlight densities are retained while negatives are sufficiently contrasty to produce bright prints. Diluted developer should be used only once and then discarded.

When using dilute development technique with ID-11, there is no need to alter the film speed. With Microphen the film speed must be set to ASA 80, DIN 20. With Perceptol the film speed must be set to ASA 32, DIN 16.

Development Times (minutes) - intermittent agitation

Ilford developer	Dilution	G 0.55	G 0.70
ID-11 (D-76 type)	1 + 1	9	14
	1 + 3	14	21
Microphen	1 + 1	5	8
	1 + 3	9	14
Perceptol	1 + 1	12	17
	1 + 3	15	24

CONTRAST/TIME CURVES

Contrast-time curves for Pan F with intermittent agitation give the average gradient over a range of 1.5 log exposure units from a point 0.1 above fog.

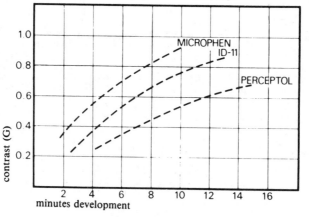

The Compact Photo-Lab-Index

CHARACTERISTIC CURVES

Developed in ID-11 at 20°C (68°F) with intermittent agitation.

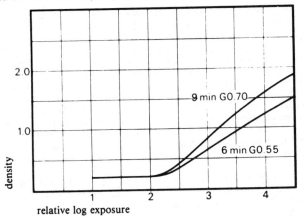

FIXATION

After development the film should be rinsed and then fixed in an acid fixer, such as Ilfospeed Fixer, which fixes the film in 2 minutes. If a hardening fixer is required, the fixing time should be 3 to 5 minutes.

WASHING

After fixing, the film should be thoroughly washed in running water for 15 to 20 minutes. A final rinse in water to which a wetting agent has been added will aid rapid uniform drying.

ILFORD

395

ILFORD XP1

ILFORD XP1 400 is a new type of panchromatic black & white film that combines high emulsion speed with significant gains in image quality. When exposed at its normal ASA 400/27 rating, ILFORD XP1 yields sharp, fine grain negatives closely resembling those otherwise obtainable only from very slow films. Unlike conventional black & white materials that exhibit increased granularity in denser negatives areas, ILFORD XP1 400 actually produces finer grain within the brighter parts of the picture, or when overexposed.

These performance characteristics of ILFORD XP1 400 film are derived from the use of new chromogenic color-coupler technology in a monochromatic negative material. Special DIR (developer inhibitor releasing) couplers invented by ILFORD for XP1 400 film assure ultra-fine grain, high-acutance images. These sharpness-enhancing and fine grain features are supported by an innovative chemistry employed in the ILFORD XP1 processing kit.

ILFORD XP1 film can also be processed in conventional C-41 chemistry.

After processing, the ILFORD XP1 400 negative is completely silver-free, being composed only of very stable dyes.

The ILFORD XP1 emulsion layer is coated onto a conventional 0.13mm (.005'') triacetate film base that provides virtually no after-processing curl. ILFORD XP1 400 is supplied in standard 35mm spools of 36 exposures, and is loaded exactly as any other 35mm film.

HIGH SPEED AND FINE GRAIN—ILFORD XP1 400 combines the high speed of an ASA 400/27 film with the exceptionally fine grain of much slower films. XP1 400 permits very high technical standards at high emulsion speeds. Subjects requiring the use of a last film can now be recorded on negatives that enlarge without excessive grain.

WIDE EXPOSURE LATITUDE—ILFORD XP1 400 film has great exposure latitude and a tonal range. It is tolerant to overexposure. Negatives overexposed by as much as two f-stops (ASA 100) and given standard processing time will provide finer grain than normally exposed negatives. This gives the creative photographer a new and effective means for bridging high subject and lighting contrast ratios without compromising image quality. Of course, such finer-grained ASA 200 or ASA 100 exposures will produce denser negatives requiring proportionally longer enlarger printing times.

ILFORD XP1 400 may also be underexposed by about one f-stop (ASA 800), and still provide generally adequate printing density even though the developing time is not changed. Such underexposed XP1 negatives will show slightly increased graininess, but these negatives still have less grain than conventional films exposed at ASA 800.

For "extended-range" photography, when an exceptionally great range of subject brightnesses must be recorded in a single exposure. ILFORD XP1 film offers the added security of long-scale exposure latitude combined with improved quality in the overexposed image areas. This special feature is also a valuble protection against exposure errors.

STANDARDIZED PROCESSING—ILFORD XP1 400 negatives exposed between ASA 100 and ASA 1,600 respond best to the standard developing time of five minutes. ILFORD XP1 will benefit from extended development only when working at ASA 1,600 under very lighting conditions. Standard development is recommended for subjects of normal or high contrast exposed within the five-stop range from ASA 100 to 1,600.

GRADATION—In addition to their unusually sharp, fine grain features, ILFORD XP1 400 negatives provide remarkable long-scale gradation with exceptional shadow and highlight separation. There is much less need for burning-in or holding-back parts of the image, or for the use of especially hard or soft paper grades. ILFORD XP1 400 negatives print well with practically all diffusion and condenser enlarger types, although a change of paper grade (or printing filter) may be required by some cold-cathode enlarger lamphouses.

ILFORD XP1 PROCESSING CHEMISTRY—ILFORD XP1 processing chemistry has been

ILFORD

designed for ILFORD XP1 400 film. It consists of just two working solutions—a developer and a bleach-fix, or "blix." Both are mixed from convenient liquid concentrates. When processed in ILFORD XP1 chemistry, ILFORD XP1 negatives attain optimum grain, tonality and sharpness characteristics.

The C-41 process can also be used and when processed C-41, ILFORD XP1 negatives are superior to conventional film processed either by hand or by machine.

EXPOSURE AND DEVELOPMENT

ILFORD XP1 400 should be exposed at ASA 400 for subjects of normal contrast. This sensitometrically determined ASA 400/27 speed index provides exceptionally fine grain and high image sharpness combined with an excellent tonal range.

With subjects of very high lighting contrast, overexposure is frequently advantageous—and indexes of ASA 200, or even ASA 100, can be used very effectively to bridge extreme subject brightness ratios. These one-and two-stop overexposures also result in a further reduction of grain. Greater overexposures, for examples at ASA 50, are not recommended because of the high negative density that will result.

When higher emulsion speeds are needed for low light conditions, an index of ASA 800—and in some cases even ASA 1,600—can be employed in conjunction with the standard ILFORD XP1 processing chemistry development time of 5 minutes. Because underexposure reduces the effective overlapping of dye clouds, negatives graininess will be increased even though the normal development time is used. If a very high exposure index (like ASA 1,600) is used with subjects of very low lighting contrast, the developing time can be extended in order to increase negative contrast. Any such lengthened developing time will, of course, produce additional grain, and in no case is a development time longer than 7½ minutes recommended. The standard ILFORD XP1 5-minute development will provide optimum results for almost all indoor and outdoor photography.

Contrast/time curve

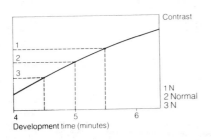

Contrast

1
2
3

1 N
2 Normal
3 N

4 5 6
Development time (minutes)

FINE TUNING ILFORD XP1 TECHNIQUE—ILFORD XP1 400 provides a new and highly effective mechanism for contrast control through the selection of appropriate exposure indexes within the ASA 100 to 800 range. *These can be used on the same roll of XP1 400 film, and many photographers will find this as valuable as the film's finer grain and enhanced sharpness.*

So-called "normal" subjects having a luminance range of ±3 f-stops respond well to ASA 400 exposures which provide negatives with easily printable highlight and shadow detail. More generous exposures based on indexes of ASA 200 or 100 greatly reduce subject contrast, with a bonus of finer grain. ASA 800 exposures add "snap" to flat-lighted scenes, with a slight increase in grain.

When all pictures are made at the same exposure index—for example, when using an auto-exposure camera—additional personal contrast control can be achieved by very slightly changing the development time, as indicated in the "Contrast/time curve" above. The N$^+$ time (line 1) is about 5½ minutes, and is recommended for subjects of low contrast. The N$^-$ time (line 3) is about 4½ minutes, for subjects of high contrast.

397

FILTER FACTORS—ILFORD XP1 400 film may be used with all filters intended for use with panchromatic black & white films, in the normal way. No special adjustments are required. The factors quoted in the table below provide a practical guide to the exposure increase factors for the filters listed. The tungsten light factors assume an average color temperature of 3,200 °K.

Filter	Daylight	Tungsten
Light Yellow (K1) (Kodak Wratten* #6)	1.5	1.25
Medium Yellow (K2) (Kodak Wratten #8)	2.0	1.5
Dark Yellow (G) (Kodak Wratten #15)	2.0	1.5
Light Yellow-Green (X1) (Kodak Wratten #11)	3.5	4.0
Tricolor Red (A) (Kodak Wratten #25)	6.0	4.0
Tricolor Blue (C5) (Kodak Wratten #47)	7.0	13.0
Tricolor Green (B) (Kodak Wratten #58)	6.0	6.0

*Kodak and Wratten are trademarks of Eastman Kodak

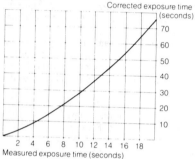

Corrected exposure time (seconds)

70
60
50
40
30
20
10

2 4 6 8 10 12 14 16 18
Measured exposure time (seconds)

RECIPROCITY CHARACTERISTICS— ILFORD XP1 400 film requires no reciprocity correction for exposures between ½ and 1/10,000 second.

Exposure times longer than ½ second must be extended in order to compensate for reciprocity law failure as indicated by the graph. For extremely short exposure times with certain electronic-flash units, it may be necessary to use a lower guide-number in order to obtain a larger lens opening.

PREPARING STOCK SOLUTIONS

ILFORD XP1 processing chemicals are supplied as liquid concentrates—three developer parts (A,B, and C) and two bleach-fix parts (A and B).

Warning—Read all cautions on the individual containers carefully. These photographic chemicals may be harmful if misused.

Keep all photographic chemicals out of the reach of children.

The developing agent used in the process may cause skin irritation and allergic skin reaction. In the case of contact of solutions with the skin, wash at once with an acid hand cleaner and rinse with plenty of water. The use of rubber gloves is recommended when mixing or pouring solutions and cleaning the darkroom. Before removing gloves after each use, rinse them well with an acid hand cleaner and water.

Developer part B is harmful if swallowed and is irritating to skin and eyes. Part B contains Hydroxylamine sulfate and sulfuric acid.

Developer part C is irritating to eyes, respiratory system and skin. It is a strong sensitizer and repeated contact may cause allergic skin reaction. In case of contact with eyes, rinse immediately with plenty of cold water and seek medical aid. Part C contains a p-phenylenediamine derivative.

The Bleach-fix Part B contains an alkaline solution and contact with skin or eyes should be avoided.

Avoid spilling the liquid concentrates and protect working surfaces. Developer part C in particular will stain when it dries. To prevent cross-contamination of solutions, ensure that all mixing vessels, graduates, and processing tanks are clean before use, and prepare developer stock solution before bleach-fix. Avoid chipped enamel or low-grade stainless steel vessels.

Stock solutions should be stored in tightly capped bottles. For convenience, the component bottles may be used to store the stock solutions, after they have been thoroughly rinsed. Store developer stock solution only in developer component bottles, and bleach-fix stock only in its component bottles. Use the labels supplied with the processing kit instructions to properly identify all bottles.

ILFORD

To prepare developer stock solution. . .

1. Pour the contents of bottles A and B into mixing vessel and stir.
2. Add the contents of bottle C. Stir thoroughly.
3. Rinse out the component bottles and refill with stock solution.
4. Affix a 'stock solution' label on each bottle to confirm that stock solution has been prepared.
5. Wash out mixing vessel thoroughly before preparing bleach-fix stock solution.

To prepare bleach-fix stock solution. . .

1. Pour the contents of bottles A and B into a mixing vessel and stir.
2. Rinse out the component bottles thoroughly and refill with mixed stock solution.
3. Affix a 'stock solution' label on each bottle to confirm that a stock solution has been prepared.

PROCESSING

The ILFORD XP1 processing kit has been designed specifically for ILFORD XP1400 film in order to provide optimum grain, tonality and sharpness characteristics. Other processes intended for color negative films, such as the C-41 process, can also be used. But in general terms, the ILFORD XP1 kit will produce better image sharpness (acutance) then other compatible chemistry. This is partly because of the XP1 kit chemistry, and partly because processing procedures are based upon the use of intermittent agitation. Thus, for best sharpness it is advisable to rely upon ILFORD XP1 processing chemistry. If chemical kits made by other firms are used, better sharpness will result from intermittent agitation than from machine processing.

The recommended processing temperature is 100 °F (38 °C). Temperatures down to 86 °F (30 °C) may be used with appropriately lengthened times, as indicated in the graph on page 9. The use of processing temperatures higher than 100 °F (38 °C) is not recommended.

SAFELIGHT RECOMMENDATIONS—ILFORD XP1 400 film should be handled in total darkness. (A green inspection safelight suitable for use with ILFORD HP5 film will not fog ILFORD XP1, but its use is questionable because of the milkiness of the chromogenic negative which prevents useful evaluation of the developing negative.)

USE OF A WATER-JACKET—The use of a water-jacket surrounding the processing tank or tanks is strongly recommended in order to maintain the ideal processing temperature of 100 °F (38 °C). If plastic tanks and/or reels are used, the water-jacket temperature should be regulated to about 104 °F (40 °C). For stainless steel receptacles the jacket should be brought to processing temperature, that is, 100 °F (38 °C).

A time-saving tip: Before beginning to set up and regulate your water-jacket and processing-tank temperature, place your five ILFORD XP1 chemistry kit component bottles in a shallow tray of very hot water. This avoids the bother of pouring liquid chemicals at room temperature into a container of 100 °F (38 °C) water, and then having to bring the temperature up again.

PREPARING WORKING-STRENGTH SOLUTIONS—Table 1 shows the volumes of stock solutions and water required for a range of processing tank capacities.

To compensate for temperature losses during processing, developer and bleach-fix should be prepared at about 104 °F (40 °C). This precaution is unnecessary if stainless steel tanks are deeply immersed in a water-jacket.

Table 1

Tank capacity (ml)	Developer (dilute 1 + 3)		Bleach-fix (dilute 1 + 1)	
	Stock solution	Water	Stock solution	Water
200	50	150	100	100
260	65	195	130	130
300	75	225	150	150
400	100	300	200	200
500	125	375	250	250
800	200	600	400	400
1000	250	750	500	500

Developer: dilute the stock solution 1 + 3 with water.
Bleach-fix: dilute the stock solution 1 + 1 with water.

399

The Compact Photo-Lab-Index

Table 2

	Temperature	Time	Comments
Develop	100°F (38°C)	5 minutes	(A)
Bleach-Fix	100°F (38°C)	5 minutes	(B)
Wash	90-104°F (35-40°C)	3 minutes	(C)
Final Rinse		½ minute	(D)
Drying	up to 130°F (55°C)		(E)

Note: ILFORD XP1 400 negatives have a milky appearance when wet. This disappears as they dry, and should not be associated with insufficient fixation.

STANDARD ILFORD XP1 PROCESSING—Table 2 gives standard ILFORD XP1 400 processing recommendations for 100°F (38°C). Closed-tank agitation during development should be by the inversion method, with 10 seconds of agitation (4 to 5 inversions) at the beginning and 10 seconds agitation every minute thereafter.

The processing tank should be shaken vigorously after the bleach-fix is poured in, and occasionally during this 5-minute treatment. (Constant agitation is detrimental in development, but excellent for bleach-fixing.)

It is recommended that ILFORD XP1 400 film be washed at the same temperature used for processing, but this is not absolutely essential. Washing can be done at lower temperatures—but not below 59 °F (15 °C)—as long as the temperature is lowered gradually, in order to avoid reticulation. The washing for ILFORD XP1 400 film at 68 °F (20 °C) should be extended to 10 minutes.

(A) For plastic processing tanks prepare water-jacket at about 104 °F (40 °C).
(B) Do not rinse between DEVELOP AND BLEACH-FIX.
(C) Shake open reel continuously.
(D) Use a suitable photographic wetting agent at room temperature.
(E) Dry in a dust-free atmosphere. Treat exactly as any other 35mm black & white film.

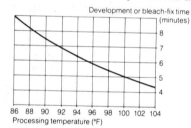

Development or bleach-fix time (minutes)

Processing temperature (°F)

TIME-TEMPERATURE CHART—ILFORD XP1 400 development and bleach-fix times are the same throughout the recommended range of processing temperatures. For optimum results adjust processing temperature as closely as possible to 100 °F (38 °C).

Processing temperature (°F)

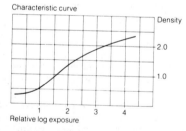

Characteristic curve

Density

Relative log exposure

PUSH PROCESSING—The popular term "push processing" does not apply to chromogenic materials like ILFORD XP1 400 film in the same way that it does to conventional silver-image materials which can be overdeveloped, or processed in a variety of different developer formulations. In most cases, ASA 800 exposures will provide readily printable densities without any extension of the standard ILFORD XP1 400 5-minute developing time. If ASA, 1,600 exposures are made under extremely flat lighting conditions, shadow-area contrast can be increased by extending development to a maximum of 7½ minutes.

ILFORD XP1 400 film processed for 5 minutes at 100 °F (38 °C). The above curve was plotted from readings obtained using a tricolor blue filter.

ILFORD

ILFOBROM® GALERIE

Ilfobrom® Galerie is a high quality black & white enlarging paper designed for the photographer who demands the very highest standards of print quality and permanence.

Ilfobrom Galerie has an extended density range. It has a significantly higher maximum density than the regular enlarging papers, and gives richer, truer blacks and prints with a greater tonal range. In addition, excellent tonal separation in the deep shadow areas, coupled with crisp highlights accentuated by a new brilliant white base are characteristic of Ilfobrom Galerie.

Ilfobrom Galerie provides the printer with wide development latitude for improved creative control. Contrast modification can be accomplished easily during exposure and/or processing. The paper responds well to most standard exposure, processing and finishing techniques.

Ilford has also perfected a new processing method, coupled with a new line of chemistry, to make archival processing of Ilfobrom Galerie and other fiber-based papers...faster, more convenient, and reliable. This new method, using Ilfobrom Archival Chemistry, provides results equal to or better than those achieved with techniques specified in the ANSI procedure for maximum print permanence, and in substantially less time.

Ilfobrom Galerie is a high quality black & white enlarging paper which provides excellent quality for outstanding prints.

PAPER CHARACTERISTICS

BASE

Ilfobrom Galerie has a high quality, double weight paper base. It has a nominal thickness of 0.28mm and weighs 240 grams per square meter. Optical brightening agents are incorporated into the paper base of Ilfobrom Galerie. Thus, the base has a brilliant whiteness that improves highlight brilliance. The finished Ilfobrom Galerie print has a warm-neutral image color.

PAPER SURFACE

Ilfobrom Galerie is available in the United States in a glossy surface only. Preferred by most users, this surface may be air-dried to a semi-gloss finish. Galerie prints may also be ferrotyped to a high gloss finish if required.

CONTRAST GRADES

Ilfobrom Galerie is made in three grades—1, 2, and 3. These grades are evenly spaced and have equal speed. This eliminates the need to change exposure when going from one contrast grade to another.

The grade spacing for Ilfobrom Galerie is somewhat wider than that of other Ilfobrom enlarging papers. Precise contrast comparisons are not meaningful because of the different shapes of the characteristic curves, a slightly warmer image color and, to a lesser extent, the base tint. The contrast of grade 2 Ilfobrom Galerie corresponds closely to grade 2 Ilfobrom. Grade 1 Ilfobrom Galerie is somewhat softer than Ilfobrom grade 1; and grade 3 Ilfobrom Galerie is somewhat harder than Ilfobrom grade 3.

The visual spacing of Ilfobrom Galerie glossy compared to Ilfobrom glossy is illustrated below.

Ilfobrom® Galerie Contrast Grades 1 2 3

Ilfobrom® Contrast Grades 0 1 2 3 4

DENSITY AND TONAL RANGE

Ilfobrom Galerie has a wider density range than Ilfobrom and other photographic papers. This gives excellent tonal reproduction, particularly in the shadow areas. The improvement in rendition in the shadow areas is obtained as a result of the higher maximum density and improved gradation in the upper region of the tone reproduction scale. In addition, Ilfobrom Galerie also yields excellent tonal separation in the midtones and highlights.

For these reasons, the long scale characteristics of Ilford FP4 film can best be exploited when used in conjunction with Ilfobrom Galerie.

The extended tonal range characteristic of Ilfobrom Galerie can be analyzed from the following graphs:

ILFOBROM GALERIE
SPECTRAL SENSITIVITY **CHARACTERISTIC CURVES**

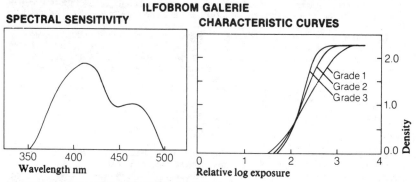

SAFELIGHT RECOMMENDATIONS

The suggested recommendations for Ilfobrom Galerie are the same as for Ilfobrom...a standard safelight filter such as the Kodak OC or OA or equivalent, used with a 15-watt tungsten lamp. For direct lighting, the safelight should be at a distance of not less than three feet.

If there are any doubts as to the safety of the light level in a particular darkroom, this test should be run...

1. Using a test negative, expose a test print at normal exposure levels, in the normal way.
2. Cover half the print with a mask and expose the uncovered half to the safelight for an extended period...perhaps 10 minutes.
3. Develop the print and inspect it carefully along the line where the mask separated the two exposure levels. Look for both a line of demarcation and fog.

EXPOSURE

NEGATIVE QUALITY

When working to achieve the highest standards of print quality, the suitability of the negative for printing cannot be stressed too strongly. It takes skill to make quality from an average negative; it is almost impossible to make a quality print from a poor one.

For the photographer seeking high standards, the greatest possible effort must be made to produce negatives of superior quality. This includes the production of clean, unblemished negatives which require the minimum of retouching. Not only should negatives be fixed, washed, dried and stored carefully, they should also be exposed and developed in the way best suited to the tonal reproduction of the scene photographed and the enlarger to be used in print making.

There are a number of excellent techniques and systems in use by photographers today to produce negatives of extremely high quality. Film selection, exposure determination and film development are elements that must be controlled as a system to produce a negative that basically contains all the elements necessary to produce a print that matches the images visualized by the photographer.

ILFORD

ENLARGER LIGHT SOURCES

The type of lamp and illumination system used in the enlarger has a basic effect on the contrast and gradation of the resultant prints. At one extreme is the point source (clear bulb) condenser type enlarger which produces maximum contrast, sharpness and detail. At the other extreme is the diffusion source, such as cold cathode or a color head, which gives lower contrast. The difference in contrast produced by these two types of lighting systems is about one paper contrast grade.

A disadvantage of the point source system is that it emphasizes grain and any surface defects on the negative such as dust particles or scratches. The diffusion system suppresses these to a considerable degree, consequently reducing the need for spotting and etching on the finished print. However, this is achieved at some sacrifice in edge definition and small area contrast. Also, the diffusion light source tends to yield lower light output.

Between these extremes is the diffuser/condenser type of enlarger light source which uses an opal lamp and condensers to achieve a compromise between the point source and the diffusion system. This type of light source makes good use of the light output while suppressing some of the negative defects outlined above.

The fact that all of these systems are in wide use today indicates that serious photographers recognize and want the advantages each offers.

PAPER SPEED

Ilfobrom Galerie paper is of similar speed to Ilfobrom enlarging paper. It has an effective ANSI paper speed of 320. Speed is equal for all contrast grades.

CONTRAST MODIFICATION

Occasionally, an expert printer may want a paper contrast that is slightly different than the contrast grade built into the paper. Or the printer may wish to modify the contrast in selective areas of the print.

With Ilfobrom Galerie, overall or local contrast modification may be accomplished either during exposure or during processing. Contrast modification during exposure is covered below. Contrast modification during processing is covered later.

CONTRAST MODIFICATION DURING EXPOSURE

Four standard techniques may be used with Ilfobrom Galerie...1. dodging...2. burning...3. masking...4. flashing. Because the first three techniques are so commonly used, we will not discuss them further here. However, contrast modification by flashing is reviewed because it may be less well known to many printers.

FLASHING

This is an old and well-established method of contrast reduction, carried out either immediately prior to or after the main exposure. Known respectively as 'preflashing' and 'postflashing', this method consists of giving some extra exposure to the entire print.

The simplest way of achieving this extra exposure, without having to remove the negative from the enlarger, is to hold a small sheet of opal glass or diffused plastic under the lens while exposing the paper for a pre-determined time. The duration of this exposure has to be determined by a test.

Other darkroom technicians flash the print during development. Here, the opal sheet or frosted plastic is placed in a light source over the developing tray. The print is exposed by a low wattage bulb (ideally about 15-watts). The effect can be varied by the length of the flash exposure and the stage during development when the flash exposure is made. An exposure made in the early stages of development will have more effect than one made later. It should be noted, however, that too much flash exposure will produce pseudo solarization.

PROCESSING

The selection of chemistry for archival print making and the techniques used for archival print processing, have long been a matter of concern for photographers. The only widely accepted standard is the ANSI recommended 'Method of Processing for Maximum Print Permanence', Standard PH4.32-1974.

To coincide with the introduction of new Ilfobrom Galerie enlarging paper, Ilford photographic scientists reevaluated the traditional concepts and chemistries used for archival print processing. As a result, a new concept has evolved which combines a group of specially formulated chemical agents with an innovative view of the fixing/washing cycle. This new technique produces prints that are as permanent or more permanent than those produced by earlier systems, yet they require a processing sequence that is considerably more convenient and reliable.

This chemistry and processing sequence represents a major step forward in the establishment of photography as a truly permanent art form.

The skill and technique of the printer are as important as any recommended process of specific chemistry. Attention to detail, a constant awareness of the function and possibilities of each stage in the process, care in handling, and a dedication to improving skills constantly are all essential prerequisites in making prints of the highest quality.

ILFOBROM ARCHIVAL CHEMISTRY AND PROCESSING SEQUENCE

Ilfobrom Archival Chemistry is available in both kit form and as individual elements. This special chemistry consists of—Ilfobrom Developer, Ilfobrom Stop Bath, Ilfobrom Fixer (a non-hardening fixer), and Ilfobrom Archival Wash Aid.

The recommended processing sequence with Ilfobrom Archival Chemistry is as follows:

Development	Ilfobrom Developer (1 + 9)	2 minutes
Stop bath	Ilfobrom Stop Bath (1 + 9)	5-10 seconds
Fixation	Ilfobrom Fix (1 + 4)	30 seconds
First wash	Good supply of fresh running water	5 minutes
Wash aid	Ilfobrom Archival Wash Aid (1 + 4)	10 minutes
Final wash	Good supply of fresh running water	5 minutes

All processing times are at 68°F (20°C)

This sequence, totalling less than 23 minutes, is shorter than the more-than-60-minute sequence detailed in the ANSI method.

DEVELOPMENT

Ilfobrom Developer is supplied as a liquid concentrate and is diluted 1 + 9 with water for use. The recommended development time is two minutes at 68°F (20°C). On correctly exposed prints, the image will begin to appear after about 20 seconds.

With Ilfobrom Developer, development time may be reduced to one minute or extended to four or more minutes without any noticeable change in contrast or fog.

Exposure/development latitude with Ilfobrom Galerie is illustrated in the table below.

Ilfobrom Galerie 1K glossy, grade 2 with Ilfobrom Developer

Exposure	Development
13 seconds	1 minute
10 seconds	2 minutes
8.5 seconds	4 minutes

The excellent exposure/development latitude illustrated here has two important benefits to the printer—

1. Slight exposure errors...up to nearly one full stop...can be corrected easily by longer or shorter development times without risk of changing the contrast or fog level of the print.
2. Perhaps more important, when the printer elects to modify local areas of the print using such techniques as hot or concentrated developer, the wide response built into a paper like Ilfobrom Galerie allows a greater control of density and thus permits effects not normally achievable.

The image tone of Ilfobrom Galerie does not change over the recommended range of development times. However, the image tone can be changed to a certain extent depending on the type of developer used. For example, Ilford Multigrade Developer yields a cooler tone than Ilfobrom Developer, whereas Kodak Selectol Soft developer will yield a warmer image tone.

Ilford Bromophen developer is supplied as a powder. If used with Ilfobrom Galerie, the Bromophen stock solution should be diluted 1 + 3 with water for use as a working solution.

STOP BATH

After development, prints should be rinsed in Ilfobrom Stop Bath, a specially formulated acid stop bath. Ilfobrom Stop Bath shuld be diluted 1 + 9 for use.

The use of the stop bath terminates development immediately and helps maintain the fixer bath in good condition. The importance of maintaining the fixer at optimum levels will be discussed later.

SPECIAL FIXING SEQUENCE

The fixing step in the Ilford Archival Processing technique is substantially shorter than the traditional method. Because this step is so vital to the making of permanent images, a detailed explanation of the concept is given below.

The major cause of image instability is residual thiosulfate complexes and their decomposition products. These thiosulfates originate in the fixing bath and attach themselves to the fibers of the paper base.

The key to understanding the Ilfobrom Archival Processing technique is the recognition that the rate of fixation of the silver image is substantially faster than the rate of build-up of thiosulfate complexes in the fibers of the paper.

In actuality, the thiosulfate complexes that can ultimately damage the print build up at a rather slow rate. The longer the fix, the greater the time these thiosulfates have to penetrate the paper.

405

The ideal fix, then, is one that provides for complete fixation of the silver image in the shortest possible time, to minimize the time thiosulfate complexes have to build up.

The Ilford Archival Processing technique is based on this fact. It uses Ilfobrom fixer (diluted 1 + 4) for just 30 seconds.

This short fix time not only provides complete silver fixation, but also minimizes the amount of thiosulfates that enter the fibers during fixation. After fixing, thiosulfate levels are lower than those achieved with the ANSI sequence (ANSI PH4.32-1974). And, as a result, wash time can be significantly shortened.

In practical terms, the fixing and washing sequence specified in the Ilford Archival Processing technique takes just over 20 minutes and gives residual thiosulfate levels about one-quarter of those achieved with 5-to-10 minute fixation followed by normal washing in running water for 60 minutes. This sequence leaves residual thiosulfate levels equal to or lower than those achieved with the ANSI processing method.

When using Ilfobrom Fixer, thorough fixation will be achieved in 30 seconds at 68°F (20°C) provided that—1. the fixer capacity has not been exceeded; 2. reasonable agitation has been given; 3. too many prints are not being fixed at the same time.

The level of residual thiosulfate present in the paper after this sequence is, on average, 0.2 micrograms/cm². This extremely low level is only detectable by relatively sophisticated analytical techniques...such as the ANSI Methylene Blue Method for measuring Thiosulfate (PH4.8-1971).

Less sensitive tests such as the Thiodet type and other residual hypo test solutions (e.g. the HT-2 Residual Hypo Test Solution recommended by Kodak) are unable to detect these small quantities of thiosulfate.

FIXER SOLUTION CAPACITY

The recommended capacity of Ilfobrom Fixer for Ilfobrom Galerie and conventional fiber-base papers is 40 sheets of 8 x 10 inch paper (20.3 x 25.4 cm), or equivalent, per liter of working strength solution.

This figure is determined by the limit set on the amount of silver that can be tolerated in the fixer bath (the silver concentration in fixer gradually builds up with use). A level of 1.5-to-2 grams per liter of silver has been established as a safe limit for fiber-base printing papers. It is important that such a limit is not exceeded.

When in doubt about the number of prints that have been fixed in a particular bath, it is an easy matter to determine the silver concentration with the aid of estimator papers (e.g. Kodak Silver Estimating Test Papers, Catalog#196 5466).

ILFOBROM ARCHIVAL WASH AID

Ilfobrom Archival Wash Aid is specifically formulated to aid the efficient removal of the by-products of fixation. As a result, sufficient washing can be achieved while overall wash time can be substantially reduced. Ilfobrom Archival Wash Aid is supplied as a liquid concentrate and should be diluted 1 + 4 with water to make a working strength solution.

As with Ilfobrom Fixer, Ilfobrom Archival Wash Aid has a capacity for 40 sheets of 8 x 10 inch paper (20.3 x 25.4 cm), or equivalent, per liter of working strength solution.

ALTERNATIVE FIXING AND WASHING SEQUENCE

ANSI PROCESSING SEQUENCE

The American National Standards Institute publishes its recommended method of processing for maximum print permanence. Though it is a longer sequence, it can be used with Ilfobrom Galerie with comparable results. For the sake of comparision, the ANSI processing sequence is shown on the following page.

Recommended ANSI processing sequence

Stop bath:	Immerse and agitate for approximately 10 seconds	
1st Fixing bath:	5 minutes in fresh solution	
2nd Fixing bath:	5 minutes in fresh solution	
1st Wash:	30 minutes in running water with suitable agitation. The water should be flowing at such a rate as to fill the wash vessel once every 5 minutes.	
Hypo Eliminator:	5 minutes with intermittent agitation.	
Sulfite Bath:	2 minutes with intermittent agitation in a 1% solution of sodium sulfite.	
Final Wash	20 minutes in running water (as above for 1st wash).	

The temperature of the wash water and of the stop, fix, hypo eliminator and sulfite baths shall be $68°F \pm 2°F(20°C \pm 1.1°C)$.

Complete details of this method are given in ANSI Standard PH4.32-1974 available from the American National Standards Institute, 1430 Broadway, New York, New York 10018.

CONVENTIONAL FIXING AND WASHING

Where a short fixing time cannot be accommodated, and where prints containing slightly higher levels of residual thiosulfates are acceptable, the following more conventional sequence will still produce prints with a very high degree of permanence.

Fix	Two-bath fixation, using Ilfobrom Fixer (1 ± 9)	2 minutes in each bath
Clearing Bath	Ilfobrom Archival Wash Aid	60 minutes
Wash	Good supply of fresh, running water	60 minutes

With this sequence, two-bath fixation is recommended. The first bath converts the silver halides remaining in the emulsion to silver thiosulfate complexes; the second bath removes most of the complexes from both the emulsion and from the paper base.

Two-bath fixation is carried out as follows: Make up two separate fixing baths of the same volume. Fix the prints in the first bath for two minutes and then drain and transfer them to the second bath for an additional two minutes. Continue to work in this way until the first bath has fixed the recommended number of prints—40 8 x 10 inch prints (20.3 x 25.4 cm), or equivalent, per liter. Discard this first fixer bath and replace it by the second. Prepare a completely fresh second bath. Repeat the process as required.

WASHING AND WASHING EQUIPMENT

Thorough, efficient washing is important. There should be sufficient change of water in the wash. Generally, wash water should flow at a rate that would fill the wash tank once every

407

five minutes. Also, the prints should circulate and not clump together. Most commercially produced print washers will achieve proper circulation provided they are not overloaded with prints. Time of washing should always be taken from the time the last print is transferred from the fix or washing aid to the wash bath. Where space allows, the cascade wash system is undoubtedly one of the best.

VIEWING WET PRINTS

When Ilfobrom Galerie prints are assessed wet, either in the fix or wash, they may appear slightly unsharp. This may be particularly noticeable in prints from small-format negatives where the grain is visible and may appear unsharp. This is quite normal. It is caused by increased swelling of the thicker-than-normal emulsion and protective non-stress (supercoat) layers of the Ilfobrom Galerie paper. When the print dries, the effect completely disappears.

CONTRAST MODIFICATION

Occasionally an expert printer may want a paper contrast that is slightly different than the contrast grade built into the paper. Or the printer may wish to modify the contrast in selective areas of the print. This can be accomplished during exposure or during processing.

Four options exist for contrast modification during processing...1. Developer choice...2. Local use of water and/or concentrated or hot developer...3. Dr. Beer's variable contrast developer...4. Bleaching to open up areas. Details on the last two options appear in the sections that follow.

VARIABLE CONTRAST DEVELOPER

The long established Dr. Beer's formula provides an easily controllable method of achieving subtle changes in print contrast with Ilfobrom Galerie. It consists of two stock solutions which are mixed in varying proportions to provide low, medium and high contrast solutions. The formula is as follows:

(Normal Development Time—2 minutes)

Stock Solution A-

Water at 122°F(50°C)	750 ml
Metol	8.0 g
Sodium Sulfite (anhydrous)	23.0 g
Potassium Carbonate (anhydrous)	20.0 g
Potassium Bromide	1.1 g
Water to make	1000 ml

Stock Solution B-

Water at 122°F(50°C)	750 ml
Hydroquinone	8.0 g
Sodium Sulfite (anhydrous)	23.0 g
Potassium Carbonate (anhydrous)	27.0 g
Potassium Bromide	2.2 g
Water to make	1000 ml

ILFORD

For use, the stock solutions are diluted with water according to the table below:

Nominal Contrast Obtained

Formula, parts	—Low—			Normal	—High—		
Solution No.	1	2	3	4	5	6	7
Solution A	8	7	6	5	4	3	2
Solution B	0	1	2	3	4	5	14
Water	8	8	8	8	8	8	0
Total	16	16	16	16	16	16	16

The contrast range obtainable with this developer is generally considered to be at least one contrast grade between the use of Solution 1 and the use of Solution 7.

BLEACHING

Overall bleaching is sometimes required to brighten the highlights of prints. The following formulae my be used successfully:

Solution A—	
Potassium Ferricyanide	100 g
Water to make	1000 ml

Solution B—	
Sodium Thiosulphate (hypo crystals)	200 g
Water to make	1000 ml

For use, add to Solution B only enough Solution A to color the mixture pale yellow (i.e. about 10 ml of A to 200 ml of B). Too high a concentration should be avoided because it makes the process of bleaching very difficult to control. The mixed solution does not keep and should be used immediately.

A similar effect can be achieved by using Blaze Artist's Photo Bleach (manufactured by Urban Art Service, Box 125, Elmhurst, Illinois 60126, and available at many art stores).

When the required density has been reached, the print should be rinsed and then transferred to a fresh fixing bath. This will stop the bleaching and also clear the yellow stain. For maximum permanence, the Ilfobrom archival washing sequence should then be repeated. If bleaching is done "in line", a separate tray of fix should be used to prevent the ferricyanide from contaminating the working fix.

An alternative bleaching formula is the Ilford IR4-Iodine Reducer—

Stock Solution	
Potassium Iodide	16 g
Iodine	4 g
Water to make	1000 ml

For use, dilute 1 part stock solution with 19 parts of water.

After the bleaching, rinse and re-fix in a fresh fix bath and repeat the Ilfobrom archival washing sequence.

Either formula can be successfully employed for local bleaching. With practice, very fine control of density may be achieved by applying the bleach to the desired area with a brush or small pad of cotton wool (cotton bud). This can be done with either wet or dry prints.

ILFORD

When working with a wet print, it should first be removed from the wash, placed on a clean, dry surface, and then squeegeed thoroughly to remove surplus moisture. The remaining part of the procedure is the same for both wet and dry prints. The bleach can then be carefully applied to the desired area and the action stopped by brushing the same area with fresh fix.

After the work is complete the print should be thoroughly washed, preferably repeating the Ilfobrom archival washing sequence.

One disadvantage of bleaching (slightly more apparent when working with wet prints) is that the bleach is apt to spread, leaving a light halo effect around the areas being worked. Using a brush overloaded with bleach (i.e. too wet) will aggravate the problem. This area must then be spotted to match the surrounding areas and this can be rather laborious.

PRINT FINISHING

Ilfobrom Galerie responds satisfactorily to the majority of traditional methods of toning, mounting and retouching.

TONING

Certain toners can be used with Ilfobrom Galerie.

Essentially there are two basic reasons for toning prints:

1. To provide additional protection for the image. Toners convert or coat the silver image giving it greater resistance to damage by atmospheric or other external contaminants. Hence, a toned print is generally "more archival".

2. For aesthetic effect and creating mood. For many years, photographers have used toners to improve the appearance of their prints and as an aid in creating a certain atmosphere that they may wish to convey. For example, subjects such as snow scenes, seascapes and night views are often enhanced by the use of blue toners. Subjects like portraits, sunlit landscapes and sunsets often benefit from warm brownish or even reddish toning.

IMAGE PROTECTION

Research has clearly indicated that selenium toning offers Ilfobrom Galerie very good protection from external contaminants. Sulfite (sepia) toning offers slightly less image protection. Gold toning...using various formulae including Kodak GP1, GP2 and Ilford IT4...slightly increases the resistance of Ilfobrom Galerie to attack by external contaminants.

Tests have also been carried out with some of the more modern color toner kits for black & white papers. Although these do work and may be of interest for their aesthetic effects, those tested were found to have an adverse effect on the long-term keeping properties of the image.

SELENIUM TONER

Owing to the difficulty and possible hazards involved in preparing this toner from individual chemicals (selenium compounds are extremely toxic substances), it is recommended that a proprietary brand be used, such as Kodak Rapid Selenium Toner. This is diluted 1 + 3 or 1 + 9 for use.

Ilfobrom Galerie prints may be toned after completion of the Ilfobrom archival wash sequence, or may be resoaked in water for 2 minutes prior to toning. Maximum protective effect with Ilfobrom Galerie is achieved in about 4 minutes of toning with a 1 + 3 diluted toner (8 minutes) with a 1 + 9 diluted toner). The process is completed by repeating the Ilfobrom archival wash sequence—using Ilfobrom Archival Wash Aid Solution kept only for this purpose.

In general, there is a small increase in print density with selenium toning. As such, toning can make Ilfobrom Galerie's blacks even deeper. To compensate, if increased print density is not desired, it is recommended that prints made for selenium toning be printed slightly lighter than normal.

SULFITE TONER (SEPIA TONER)

This is a two-stage process using separate bleach and toning solutions.

1. Fix and wash the prints as recommended in the special processing sequence. Re-soak for 2 minutes if prints have been dried.
2. Bleach the prints for between 1 and 3 minutes, depending on the number of prints which have been through the bath.

Bleaching Solution:

Water	500 ml
Potassium Ferricyanide	50 g
Potassium Bromide	50 g
Water to make	1000 ml

3. Wash for up to 10 minutes in order to remove the yellow bleach stain.
4. Immerse the bleached and washed prints in the sulfite toner.

Sulfite Toner:

Sodium Sulfite	50 g
Water to make	1000 ml

For use, dilute 1 + 9

Toning is usually complete in about 5 minutes and the process is completed by repeating the Ilfobrom archival washing sequence—using Ilfobrom Archival Wash Aid solution kept only for this purpose.

Similar results will be achieved with Thiourea Carbonate toner, which has the additional advantage of being odorless.

Thiourea Carbonate Toner:

Thiourea	2 g
Sodium Carbonate (anhydrous)	100 g
Water to make	1000 ml

Use at working strength.

Toning is usually complete in about 2-to-4 minutes, and the process is completed by repeating the Ilfobrom archival washing sequence—using Ilfobrom Archival Wash Aid solution kept only for this purpose.

DRYING

There are three traditional ways to dry fiber-based enlarging papers: air-drying, blotting or heat drying.

AIR-DRYING

After taking prints from the wash, they should be placed face up on a clean surface, allowed to drain, and then squeegeed on both sides to remove excess water. They can then be hung on a line with clips or placed face down on a clean nylon or plastic mesh screen to dry.

Many technicians make these screens themselves—using wood or plastic frames that slip into racks providing about 3 inches (7.5 cm) of separation. These frames can be readily slid out to remove dry prints or put in additional ones. At regular intervals, the screens should be cleaned with water. Several versions of this type of air dryer are available.

Air drying does have one disadvantage, however. Prints tend to curl while drying and can be difficult to flatten-out effectively.

PHOTOGRAPHIC BLOTTERS

The use of photographic blotters is widespread, since they assist in producing neat, flat prints which are easy to work with for mounting or storage.

It is essential that only photographic quality blotters be used; others invariably contain contaminants which can have an adverse effect on the archival quality of the resultant prints. Photographic blotters are generally available in most photographic stores.

The following procedure, advocated by David Vestal of *Popular Photography,* has been found to work well in practice—

1. Squeegee the print and place it on a clean blotter.
2. Place a blotter on top of the print and rub the blotter lightly.
3. Squeegee a second print and place it on the second blotter and rub lightly. Continue in this way until all the prints have been placed between blotters.
4. Turn the stack of prints and blotters over and place the top print on three clean blotters. Cover that print with three clean blotters and transfer the second print from the first stack to this new stack. Continue in this way until all the prints have been transferred to the second stack.
5. When all the prints have been placed between sets of three sheets of blotters, place a weight on top of the stack to flatten the prints and leave the prints for about half an hour.
6. Repeat steps 4 and 5 with clean blotters to form a third stack. Place a weight on top and leave the prints until completely dry.

HEAT DRYING

There are two problems associated with heat drying on flatbed and rotary dryers. The first is of a general nature and concerns prints sticking to the blanket. The second relates to the requirement that the blanket must be perfectly clean to assure maximum permanence for the prints.

The first problem is typically alleviated by the addition of hardener to the fixer.

This is not recommended for prints requiring a high degree of permanence. However, it is highly recommended that Ilfobrom Wash Aid be used, for it is formulated with a special ingredient to minimize sticking without the addition of hardener.

The second problem is associated with the difficulty of keeping the dryer blanket or apron absolutely clean. Great care must be taken to ensure that only those prints that have been thoroughly washed are dried on such equipment, otherwise the blanket can easily become contaminated with fixer. Remember, it takes only one insufficiently washed print to contaminate all others that are dried subsequently.

MOUNTING

Ilfobrom Galerie can be mounted successfully using either dry mounting or wet mounting techniques.

DRY MOUNTING

This technique is very convenient, fast and clean. It provides a permanent, perfect bond between print and mount. The procedure itself is very straightforward, but there are certain points to be conscious of when using this method.

It is essential that both print and mounting board are perfectly dry. This can be easily ensured by placing both print and board in the mounting press for a few seconds prior to tacking on the tissue and mounting.

The choice of dry mounting tissue is important when mounted prints are required for archival use. The dry mounting tissue should be of neutral pH and the process should ideally be fully reversible (i.e. it should be possible to remove the print from the mount at a later date without damaging the print in any way).

The best assurance that mounting tissue is of acceptable quality is to use a product certified by its manufacturer to meet ANSI Standard PH4.20-1958.

It is also very important that the board selected be of suitable photographic quality for mounting photographs. It is usually advocated that the mounting board be 'acid-free' and

ILFORD

100% rag. The best assurance that the mounting board is of acceptable quality is that it be certified by its manufacturer to meet ANSI Standard PH4.20-1958.

Cleanliness of the work area and meticulous handling techniques are also essential. Even the tiniest particle of dust or dirt trapped between print and mounting board will be seen as an unsightly and permanent lump on the print. Board, tissue and print should always be carefully cleaned before putting them in the press.

Prints should not be subjected to heat in the press for longer than necessary or at a higher temperature than recommended by the tissue manufacturer. 20 seconds should normally suffice at temperatures between 175°F (80°C) and 195°F (90°C). Excessive time and/or higher temperatures will cause the print to undergo a mild form of accelerated aging.

WET MOUNTING

Wet mounting is generally used to mount very large prints for display purposes and is not recommended where the highest level of image permanence is required. Conservationists are unanimous in their condemnation of this method, because it is assumed that the vast majority of adhesives (with the possible exception of flour paste or rice starch) will have a long term destructive chemical action on the fiber papers.

Therefore, this technique can only be recommended where long term storage or display are not important considerations.

RETOUCHING

SPOTTING

This is the name given to the correction of small, light toned or white defects on prints caused by opaque defects in the negative or, more commonly, by dust particles on the negative carrier glass or negative itself.

In the past, it was a fairly common practice to use ordinary India ink for spotting. More recently, modern photo-dyes such as SpotTone have become almost univeral, because they are considerably easier to work with. They provide a much finer control over matching image color since they can be readily blended to achieve the desired match. SpotTone is manufactured by Retouch Methods Company, P.O. Box 345, Chatham, N.J. 07928, and is generally available in photographic stores.

When older, water based dyes are used, working with glossy material may result in the spotted areas appearing dull compared with the surrounding print. This can be effectively overcome by mixing the dye with a little gum arabic or Lepage's arabic gum. The mixture imparts a gloss that, with practice, will closely match that of the unferrotyped glossy surface.

As a first requirement, it is essential that a good brush with a fine well-pointed tip be used. The actual size of the brush is not so important as is the tip. Often a larger brush, say sizes 1-to-3, will be found more useful than a 0 or 00.

The color should be applied in very small amounts and the density should be built up gradually, using a stippling action rather than attempting to do too much at one time. Before actually applying the color to the print, it should be carefully blended to match the required image color—then tested on some white paper or blotting paper to check for density and color. It is much easier to work with a fairly dry brush, since using the brush too wet will inevitably cause the color to spread outwards resulting in a halo of increased density around the spotted area.

If the print has been handled prior to spotting, it is likely that the surface will have picked up some grease from the fingers and this will often prevent the dye taking properly. Wiping the print carefully with a soft, clean dry cloth will usually overcome this, but in extreme cases, a mild solvent may be used. The addition of a little wetting agent to the spotting dye sometimes also helps.

Where very faint or fine lines are involved, many technicians find it easier to apply a soft pencil lightly to the affected area—rubbing gently with a cloth or tissue afterwards to blend it. It is vital that this is done very lightly, since any undue pressure by the pencil will leave a permanent mark in the emulsion layer of the print.

ILFORD

ETCHING

Dark spots or streaks may be physically removed by carefully scraping away the emulsion of the print. This is a technique which requires both patience and practice before consistently successful results can be achieved.

A very sharp blade with a rounded point is required. The blade should be held perpendicular to the print and the surface should be scraped very lightly, taking a great many strokes to gradually wear down the density of the defect or spot. A magnifying glass is a useful aid to follow the progress being made.

A disadvantage of etching is that it inevitably leaves marks on the print surface which will show up, particularly on glossy prints when they are viewed at varying angles to the light. This effect can sometimes be reduced by resoaking and redrying the print to help reduce the roughening effect. Alternatively, a glossy lacquer may be applied with a brush to the etched area.

STORAGE AND CONSERVATION OF PRINTS

Photographs, like other art, are perishable. They must be treated with care and protected from injury.

Much debate has surrounded this subject in recent years. Understandably, not all workers in this field are agreed on the relative importance of all the various factors involved, but there are a number of well understood and proven guidelines which can be stated with a fair degree of confidence. (ANSI Standards PH1.48-1974 and PH4.20-1958 should be consulted for a comprehensive discussion of print storage and conservation.)

Before proceeding further, it is important to appreciate fully exactly what true *archival* storage entails—

For true archival permanence, material should be stored under precise conditions of controlled humidity and temperature—with minimum daily cycling within prescribed limits. Storage should be in total darkness at 30-50% humidity. Temperatures should be maintained between 68°F and 77°F (15°C to 25°C). Daily cycling greater than 7°F (4°C) should be avoided. When materials have to be viewed, tungsten illumination should be used. Daylight or fluorescent light tubes should never be used because they are too rich in ultraviolet radiation.

Repeated handling deteriorates photographs. In particular, the surface of a photograph should never be touched with the fingers since this will inevitably transfer grease and/or acid to the photographs. Most galleries and archives that permit viewing original prints insist that white gloves be worn.

Envelopes and containers used for print storage must be constructed of suitable materials. This is vital. Cabinets made of newly varnished or bleached wood, composition board, hardboard, etc. should all be avoided because the resins and glues used in their construction release gases which, over the years, will have a harmful effect on the images. Baked-enamel metal boxes and filing cabinets are probably the safest of all and have the added advantage of offering some degree of fire-protection.

Individual boxes, envelopes and sleeves for prints should also be chosen with great care and should be specifically recommended for this type of use. General purpose manila envelopes usually have glued seams and are made of relatively impure material—either or both properties being likely to cause problems eventually. Plastic sleeves are now very much in vogue but, regrettably, most are made of PVC. As a result of the plasticizers used in PVC formulation, these sleeves can release chlorine and other harmful gases which will be detrimental to print life. An inert polyester such as Mylar or Estar, both expensive, is much more suitable. In any case, one should only use products that the manufacturer certifies as meeting ANSI Standard PH4.20-1958.

MATTING ARCHIVAL PRINTS

Prints should not be allowed to come in direct contact with framing glass. A mat can provide the necessary separation. When matting prints to archival standards, the print surface can be protected against abrasion and glass contact by the use of an overmat. Prints with an overmat need not be mounted at all but simply held down by a tape hinge or corner gripping tapes. Adhesive tapes of the cellulose type must be avoided. In a relatively short time

414

they liquefy, turn yellow, and the base dries out—inevitably staining prints in contact with them. Special tapes are available for archival use.

The overmat should be cut first, its outside dimension being controlled by the print size and, to a lesser extent, the size of standard frames and boards. The opening size is obviously controlled by the photograph, while the placement of it on the overmat is determined by personal taste. The opening itself may be smaller than the picture area, or may reveal the entire picture plus a small relief of white paper.

The next stage is to carefully and lightly draw the opening in pencil on the reverse side of the mat. Although the opening can be cut by using a steel rule and a craft knife or scalpel, this requires both practice and patience to achieve a neat angle and a uniformly beveled edge. An easier and more effective solution is to use a tapered blade held in a device called a mat cutter.

A number of excellent mat cutters are available—ranging from inexpensive to highly sophisticated. The needs of the individual printmaker dictate the best choice.

The simplest finishing procedure, after the overmat is cut, is to join the overmat to a support by means of a tape hinge, located across the top.

Locate the unmounted print on the backing board, under the window in the overmat. It is best to wear cotton editing gloves at this stage to prevent finger prints from marring the print. Hold the print down and move it gently until it is in correct position. Place a smooth weight on the print to prevent it from shifting, then open the window mat. Mark the print's top edge with a light pencil line, just for a check. Take a 1-inch strip of archival tape, fold it lengthwise so the adhesive side is out. Moisten it, and slip it between the print and the mat, along the top edge so that the print is hinged to the mat. Press the print-tape-mat junction until it is dry and adhered.

An alternative method is to place the print under the window in the correct position. Hold it in place and then, with the overmat lifted away, affix the print to the backing board with small diagonal strips of linen tape that just hold the corners.

A third system is to dry mount the print onto a large sheet of acid-free paper. The print can be placed on the center of an oversized sheet. The sheet is then positioned under the window on the overmat, the edges marked, and the paper trimmed to size. This system offers a floating print, stiffened by the addition of the dry mounting tissue and the bond paper. Yet it is thin enough to be trimmed out and remounted in one of the conventional systems described above, should the need arise.

The print can be protected further during storage by covering it with a sheet of acid-free interleaving tissue or clear polyester positioned under the window of the mat.

THE INCLUSION OF A BORDER

Where prints with optimum permanence characteristics are required, it is standard practice by many archivists to arrange for a border of at least 1 inch to be left surrounding the image area. Such a border protects the processed print from external contamination longer than normal, because the first signs of deterioration usually occur at the edges of a print.

ILFORD

ILFOBROM ENLARGING PAPER

DESCRIPTION AND USES

Ilfobrom® is an extremely versatile enlarging paper which combines a number of features enabling prints of consistently high quality to be produced with maximum efficiency, even under difficult working conditions.

The main characteristics of Ilfobrom are:

AN EQUAL AND CONSTANT GRADE SPACING.

The results of research carried out by Ilford have shown that a grade spacing of 0.2 logarithmic exposure units is ideal for most purposes. The six grades of paper have been designed to accommodate the complete range of negative contrasts and are intended for use with both diffuser and condenser enlargers. The small but constant difference in contrast between the grades ensures that there is a 'right' grade of paper for every type of negative. If in fact the spacing between the grades was any smaller it would be difficult to detect the contrast difference between adjacent grades of paper.

CONSTANT SPEED FROM GRADE TO GRADE AND BATCH TO BATCH.

Ilfobrom glossy grades 0-4 have the same emulsion speeds, while grade 5 is half the speed of the others. This enables reprints to be made on adjacent grades of paper without the need for further tests. It is also a great advantage when using enlarger exposure meters as one calibration will cover all six grades of paper—for grade 5 the readings are simply doubled.

NO VARIATION IN EITHER IMAGE COLOR OR BASE TINT.

Ilfobrom has been specially designed to give a constant image color and base tint from grade to grade and batch to batch. The image color is neutral black, while the addition of a new type of optical bleach to both the emulsion and the new paper base ensures clean, bright prints.

CHANGES IN EXPOSURE DO NOT AFFECT IMAGE CONTRAST.

A variation in the length of exposure given for a negative on any grade of paper will not affect print contrast. A change in contrast can only be achieved by using a different grade of paper.

A 'BUILT-IN' RESISTANCE TO CONTAMINATED SOLUTIONS.

Ilfobrom maintains its handling properties in partially exhausted developer and also has a very good resistance to the effects of developer contamination. This allows print quality to be maintained under less than ideal conditions.

WEDGE SPECTROGRAM

Wedge spectrogram to tungsten light (2850 K)

SAFELIGHT

A Kodak Wratten® OC safelight (light brown) should be used with Ilfobrom enlarging paper.

® Wratten is a trademark of The Eastman Kodak Company.

The Compact Photo-Lab-Index

DEVELOPMENT

Ilford Bromophen developer diluted 1 + 3, which is supplied in powder form, is particularly recommended for use with Ilfobrom. Any other standard print developer can also be used. Ilfobrom paper should normally be developed for 1½ to 2 minutes at 20°C (68°F). Whenever rapid development is required, as for instance in press work, Ilfobrom should be developed in Ilford Ilfospeed Developer for 60 seconds at 20°C (68°F).

FIXATION

Ilfobrom paper should be fixed in acid fixer for 5 to 10 minutes.

WASHING

Prints should be thoroughly washed in running water for a minimum of 30 minutes.

DRYING

Ilfobrom prints can be heat dried or ferrotyped in the normal manner. Prints which are to be air dried rather than ferrotyped should be wiped to remove any excessive moisture in order to prevent the formation of drying marks.

CHARACTERISTIC CURVES

Developed in Bromophen (1 + 3) for 2 minutes at 20°C (68°F) with continuous agitation.

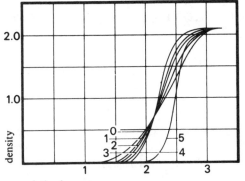

relative log exposure

PAPER CONTRAST SCALE

The contrast of a paper is a measure of its capacity to accept extremes of exposure and indicates the difference in exposure between that required to produce a tone just distinct from the base and that producing the maximum black. The greater the difference between the two exposures, the lower the contrast of the paper. The difference in this value in terms of log exposure is known as the exposure or contrast scale of the paper. If optimum quality prints are to be obtained from a negative it shoud be printed on a paper grade whose contrast scale value is slightly greater than the negative density range when measured on the baseboard.

Ilfobrom paper grade	Contrast scale
0	1.6
1	1.4
2	1.2
3	1.0
4	0.8
5	0.6

ILFOSPEED TRAY PROCESSING SYSTEM

INTRODUCTION

The Ilfospeed Tray Processing System has revolutionized high quality print making. Prints made the Ilfospeed way have that quality only previously associated with the long tray processing, washing and ferrotyping times used since the earliest days of photography. Developing times are shorter with Ilfospeed, as are fixing times and washing times. With the Ilfospeed 5250 Dryer producing a glossy print has been made straightforward—the 5250 reduces the time normally involved with standard glazing.

Ilfospeed prints tray processed are made in a tenth of the time taken previously.

The Ilfospeed System comprises Ilfospeed paper, Ilfospeed developer, Ilfospeed fixer and the Ilfospeed 5250 Dryer, which, when used together can produce high quality prints in four minutes.

SUMMARY OF THE ILFOSPEED SYSTEM

PRINTING

Ilfospeed paper is similar to Ilfobrom® in that it is a projection speed paper with equal contrast spacing between grades and a neutral black image color.

DEVELOPING

Ilfospeed developer (1 + 9) at 20°C. Development is complete in 60 seconds. Rinse the prints and transfer them to the fixer.

FIXING

Ilfospeed fixer (1 + 3) at 20°C. Fixation is complete in 30 seconds.

WASHING

Wash the prints in a good supply of fresh running water for 2 minutes.

DRYING

Use the Ilfospeed 5250 Dryer, which will dry a 20.3 × 25.4 cm (8 × 10 inch) print in approximately 30 seconds.

Total time for processing and drying — 4 minutes.

ILFOSPEED PAPER

Ilfospeed paper is a high quality material specially designed for rapid processing and drying. It is a midweight, polyethylene laminated paper which has a neutral black image color and a pure white base, and is available with a Glossy, Semi-matt, Silk and Pearl finish. Pearl retains the high maximum density associated with Ilfospeed glossy prints but has a low surface reflectance. This makes it especially suitable for retouching and reproduction work. It also has an ideal surface for exhibition work.

Ilfospeed paper can be used with all types of enlargers and is available in six equally spaced grades. All grades have a high maximum density, and are consistent from batch to batch. With Ilfospeed, as with Ilfobrom, grades 0-4 have the same emulsion speed and grade 5 has half the speed.

Because Ilfospeed paper has a polyethylene coating on each side of the paper base, it is not only firmer than conventional papers but is flatter and can be exposed without a masking frame, for borderless prints. Ilfospeed paper also remains flat during and after processing.

Ilfospeed has a special backwriting coat. This special surface accepts pencil, most ballpoint pens, some felt tip pens, certain stamp pad inks and all printing inks formulated for polyethylene printing.

Ilfospeed paper should not be ferrotyped using conventional equipment, because in a conventional dryer there is no way for the water to escape from the emulsion layer, and print damage would result. Use the Ilfospeed 5250 Dryer or air dry.

The Compact Photo-Lab-Index

SAFELIGHT RECOMMENDATIONS
A safelight such as a Kodak Wratten® OA (light brown) is suitable for use with Ilfospeed.
® Wratten is a trademark of The Eastman Kodak Company.

CHARACTERISTIC CURVES
Developed in Ilfospeed developer (1 + 9) for one minute at 20°C with continuous agitation.

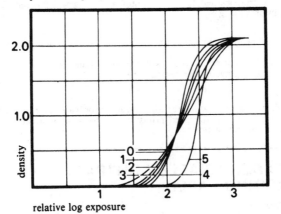

ILFOSPEED DEVELOPER
Ilfospeed developer contains Phenidone® and hydroquinone, and gives a very brief induction period with a short developing time. The image appears after six seconds and Ilfospeed paper is fully developed in only one minute. Image build-up can be carefully controlled even when developing an overexposed print for the minimum recommended time of 35 seconds. Ilfospeed paper can be used with other developers but, like other papers, will require approximately 30 seconds for the image to appear, and two or even three minutes for complete development to take place.

PREPARATION
Ilfospeed developer is supplied as a liquid concentrate and is economical to use. The recommended dilution is one part developer to nine parts water.

USE
The recommended development time for Ilfospeed paper is one minute at 20°C. This short development time produces prints similar in contrast and maximum density to prints processed for two minutes in other tray developers.

The minimum recommended development time using Ilfospeed developer is 35 seconds. Over-exposed prints processed in this way are almost indistinguishable from those correctly exposed and processed. When batch processing, exposure can be adjusted and development times extended to ensure even development and print consistency.

After development, rinse the prints and transfer them to Ilfospeed fixer.

ILFOSPEED FIXER
Ilfospeed Fixer is a rapid acting ammonium thiosulphate fixer, supplied in liquid concentrate form.

PREPARATION
Ilfospeed Fixer should be mixed by adding one part concentrate to three parts water.

419

USE

The recommended fixing time is 30 seconds at 20°C. Thorough initial agitation should be given.

Hardener should not be used with the Ilfospeed System.

After fixing the prints should be washed. With conventional papers, long wash times are necessary to remove chemicals which have been absorbed by the paper. The polyethylene coating on each side of Ilfospeed paper prevents this absorption, and wash times are therefore short. A print washed for two minutes in runnng water is completely free of chemicals used in processing.

MOUNTING

Ilfospeed prints can be mounted using either dry mounting tissue or double-sided adhesive tapes and tissues.

Manufacturers of mounting materials will provide detailed instructions on using their materials for mounting polyethylene coated papers.

RETOUCHING

Ilfospeed prints can be spotted and airbrushed using dye or watercolor, in the same way as conventional papers. Knifing Ilfospeed prints should be done with care, using a sharp pointed blade in a stippling action.

MULTIGRADE VARIABLE CONTRAST RC ENLARGING PAPER

INTRODUCTION

Ilfospeed Multigrade now offers the quality of Ilfospeed RC printing paper with the convenience of variable contrast. Multigrade has rich blacks and crisp clean whites. Multigrade offers the longest contrast range available in any variable contrast paper today and Multigrade contrast steps are spaced at precise increments for controlled selection of optimum print quality.

As with Ilfospeed graded paper, Multigrade is projection speed, midweight, polyethylene laminated paper. It has a neutral black image color and a pure white base tint.

Multigrade is available in both Glossy and Pearl surfaces. Pearl retains the high maximum density associated with glossy prints but has a slightly stippled surface texture. This makes Pearl surface especially suitable for retouching and reproduction work. It also is an ideal surface for exhibition work.

Because Multigrade paper has a polyethylene coating on each side of the paper base, it is not only firmer than conventional papers but is flatter and can be exposed without a masking frame, for borderless prints. Multigrade paper also remains flat during and after processing.

Multigrade paper has a backwriting coat. This special surface accepts pencil, most ballpoint pens, some felt tip pens, certain stamp pad inks and all printing inks formulated for polyethylene printing.

Multigrade glossy paper is designed for maximum gloss through the use of the Ilfospeed 5250 Dryer. It may also be air dried. Multigrade paper should not be ferrotyped using conventional equipment, because in a conventional dryer there is no way for the water to escape from the emulsion layer, and print damage would result.

CONTRAST AND FILTRATION

Multigrade is designed for printing by exposure to tungsten light (2850 K) such as a standard No. 212 bulb. Although other light sources may not give optimum results, they can be used if proper color correction is made. For instance, cool white fluorescent lights (4500 K) require a color correction of 40Y and daylight fluorescent lights (6500 K) require a color correction of 70Y.

The variable contrast feature of Multigrade enlarging paper is controlled by changing the

ILFORD

basic color of the light used for exposure. This is achieved through the use of filters especially formulated for this purpose. Ilford makes available sets of seven filters numbered 1 through 7 in both above-the-lens and below-the-lens types. These filters provide a contrast range that approximates grades 0 through 4 of Ilfospeed graded paper.

The chart below shows the visual comparison of Multigrade contrast using Multigrade filters and Ilfospeed graded contrast.

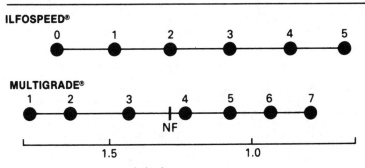

relative log exposure range

Filters designed to work with Kodak Polycontrast® papers will give results similar to those obtained with Multigrade filters. However, to obtain maximum contrast range, Multigrade filters are recommended.

® Polycontrast is a trademark of The Eastman Kodak Company.

To a degree, contrast can be extended beyond the indicated range through the use of two filters in combination such as Filters 1 and 2 or Filters 6 and 7. Exposure time will be increased considerably, however.

Multigrade can also be used with a conventional dichroic filter head to achieve variable contrast. Although dichroic filters differ from enlarger to enlarger, the following filter combinations my be used as starting points.

Ilfospeed Contrast Grade	Suggested Dichroic Setting	
0	35Y	00M
1	00Y	00M
2	00Y	40M
3	00Y	75M
4	00Y	170M

EXPOSURE ADJUSTMENT BETWEEN FILTERS

The table below is useful in calculating exposure for Multigrade paper when changing from one filter to another after a correct exposure at the original filter has been determined. Simply locate the original filter number in the left hand column. Then read across the column in which the new filter appears at the top. Then multiply the original correct exposure by the factor you have located.

The Compact Photo-Lab-Index

Original Filter	New Filter							
	No Filter	1	2	3	4	5	6	7
No Filter	1.0	2.0	1.6	1.4	1.6	2.0	2.6	5.0
1	0.5	1.0	0.8	0.7	0.8	1.0	1.3	2.5
2	0.6	1.3	1.0	0.9	1.0	1.2	1.7	3.1
3	0.7	1.4	1.1	1.0	1.1	1.4	1.8	3.5
4	0.6	1.3	1.0	0.9	1.0	1.3	1.7	3.1
5	0.5	1.0	0.8	0.7	0.8	1.0	1.3	2.5
6	0.4	0.8	0.6	0.5	0.6	0.8	1.0	1.9
7	0.2	0.4	0.3	0.3	0.3	0.4	0.5	1.0

For instance, if you had a correct exposure of 14 seconds when using filter 4 and wish to change to filter 5, multiply 14 seconds by 1.3. The new exposure should be 18.2 seconds.

Alternatively, the Multigrade exposure calculator may be used for rapidly determining new exposure times when changing from one filter to another. A calculator is provided with each Multigrade filter set.

PAPER SPEED

As with all variable contrast papers, the speed of Multigrade paper varies with the contrast filter used. Speed is based on the ANSI standard PH2.2: Sensitometry of Photographic Papers (1972) and can be used to calculate approximate exposure times when changing from one filter to another. However, exposure times can be determined more easily from the table above or from the Multigrade exposure calculator. These ANSI speeds are not related to ASA film speeds.

Multigrade Filter Number	ANSI Speed With Multigrade Filter	ANSI Speed With Polycontrast Filter
No Filter	400	400
1	200	250
2	250	250
3	250	250
4	250	250
5	200	200
6	160	125
7	80	50

WEDGE SPECTROGRAM
Wedge spectrogram to tungsten light (2850 K) with no filter.

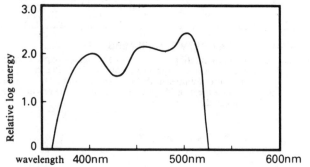

ILFORD

The Compact Photo-Lab-Index

CHARACTERISTIC CURVES

Developed in Multigrade developer (1 + 9) for one minute at 20°C (68°F) with continuous agitation. Curves using filters 2 through 6 fall evenly between the extremes shown.

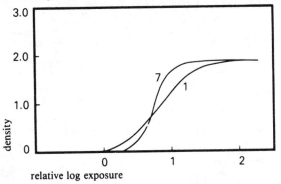

relative log exposure

SAFELIGHT RECOMMENDATIONS

A safelight filter such as a Kodak Wratten® OC (light brown) may be used with a 25 watt bulb at four feet distance with Multigrade.

®Wratten is a trademark of The Eastman Kodak Company

TRAY DEVELOPMENT OF MULTIGRADE PAPERS

Multigrade prints can be tray developed in the usual manner. We strongly recommend the use of Ilford chemistry for this purpose because it is designed to optimize the prints made on Multigrade paper.

Multigrade developer is supplied as a liquid concentrate and is economical to use. The recommended dilution is one part developer to nine parts water.

Multigrade developer contains Phenidone® and hydroquinone, and gives a very brief induction period with a short developing time.

The image appears after about 10 seconds and Multigrade paper is fully developed in 1 minute at 68°F (20°C). This short development time produces prints similar in contrast and maximum density to prints processed for two minutes in other tray developers.

The minimum recommended development time using Multigrade developer is 35 seconds. Over-exposed prints processed in this way are almost indistinguishable from those correctly exposed and processed. When batch processing, exposure can be adjusted and development times extended to ensure even development and print consistency.

Multigrade paper can be used with other developers but should be used with Multigrade Developer for optimum print quality and contrast spacing.

After development, rinse the prints and transfer them to Ilfospeed fixer.

Ilfospeed fixer is a rapid acting, non-hardening ammonium thiosulphate fixer, supplied in liquid concentrate form. Ilfospeed Fixer is mixed by adding one part concentrate to three parts water. The recommended fixing time is 30 seconds at 68°F (20°C). Prints should be thoroughly agitated in the fixer.

Multigrade enlarging paper can be fixed in a hardening fixer. However, washing time would be extended as much as 5 times that required with Ilfospeed fixer.

After Ilfospeed fixing, the prints should be washed. With conventional papers, long wash times are necessary to remove chemicals which have been absorbed by the paper. The polyethylene coating on each side of Multigrade paper prevents this absorption, and wash times are therefore short. A print washed for two minutes in running water is essentially free of chemicals used in processing.

ILFORD

TONING

Multigrade paper can be toned with most commercial two-solution toners.

MACHINE PROCESSING OF MULTIGRADE PAPERS

Multigrade paper, both rolls and sheets, is suitable for processing in automatic roller transport and continuous machine processors. Optimum speed, contrast and grade spacing are achieved when Ilfospeed 2000 developer/replenisher and fixer/replenisher are used in the processor.

Ilfospeed 2000 developer/replenisher is supplied as a liquid concentrate with a starter solution and is economical to use. Ilfospeed 2000 developer should be mixed and used as described below.

Dilute one part Ilfospeed 2000 Developer/Replenisher with four parts water to make working strength solution. Mix thoroughly.

When it is necessary to fill the processing tank with fresh developer (always clean the tank and roller assemblies first), transfer the developer/replenisher solution from the replenisher storage tank to the processing tank. Then add 10ml of Ilfospeed Developer/Starter to the processing tank for each liter of the transferred developer/replenisher to make working strength developer solution. Mix thoroughly.

Ilfospeed developer/replenisher is designed for use at normal rapid processing temperatures of 86° to 90°F (30° to 32°C).

The working developer solution in a processor should be replenished at a rate of 7.5ml of developer/replenisher for each 8×10 inch sheet (or its equivalent) that is developed. Some processors may require a slightly higher or lower replacement rate.

Ilfospeed 2000 fixer/replenisher, a non-hardening rapid fixer, is also supplied as a liquid. It should be mixed and used as described below.

Dilute one part of Ilfospeed 2000 Fixer/Replenisher with three parts water to make working strength solution. Mix thoroughly. This solution is designed for use as fixer and fixer/replenisher, and may be used to charge the processing tank initially and to replenish the solution in use.

Ilfospeed fixer/replenisher is designed for use at normal rapid processing temperatures of 86° to 90°F (30° to 32°C).

The working fixer solution in a processor should be replenished at a rate of 12.5ml of fixer/replenisher for each 8×10 inch sheet (or its equivalent) that is fixed. Some processors may require a slightly higher or lower replenishment rate.

Multigrade papers that are machine processed with Ilfospeed 2000 chemistry should be washed with filtered water according to the recommendations of the processor manufacturer.

MOUNTING

Multigrade prints can be mounted using either dry mounting tissue or double-sided adhesive sheets specifically designed for resin-coated papers. Spray adhesives are also suitable. Manufacturers of mounting materials will provide detailed instructions on using their materials for mounting polyethylene coated papers.

RETOUCHING

Multigrade prints can be spotted and airbrushed using dye or watercolor, in the same way as conventional papers. Knife etching of Multigrade prints should be done with care, using a sharp, pointed blade in a stippling action.

ILFORD

ILFOPRINT STABILIZATION SYSTEM
ILFOPRINT YR (PROJECTION) & CS, DS (CONTACT)
INTRODUCTION

Ilfoprint® is a complete photo-stabilization system. It comprises a range of activation/stabilization papers and chemicals and processors, which accepts paper up to 30.5 cm (24 inches) wide. With the Ilfoprint system high quality prints can be ready for use about twenty seconds after exposure.

ILFOPRINT PAPERS

Ilfoprint papers have the same photographic characteristics as conventional silver sensitized papers and should be exposed in the normal way. Ilfoprint has excellent tone gradation, and has a similar image color to conventional bromide prints. Continuous tone and line papers are available in the Ilfoprint system with both projection and contact speed. While Ilfoprint papers are intended for processing in an Ilfoprint processor with Ilfoprint Activator and Stabilizer, they can be processed in other activation/stabilization systems, or conventionally. Where stabilized prints are to be ferrotyped they must be fixed and washed first.

ILFOPRINT PROJECTION PAPERS - YR

Ilfoprint YR is a projection speed paper with similar speed to Ilfobrom® and Ilfospeed®. The recommended safelight is the same as for Ilfobrom and Ilfospeed—a Kodak Wratten® OC (light brown). Alternatively Ilfoprint YR papers may also be handled in Graphic Arts darkrooms where light red safelight filters are fitted.

Ilfoprint YR papers are continuous tone papers recommended primarily for the production of high quality enlargements, although they are suitable for making quick contact prints. The high contrast single-weight glossy paper (YR4.1P) in particular, is also ideal for producing excellent screen and line contact prints of lith negatives and positives.

The print quality of YR is enhanced by its neutral black image color. Ilfoprint YR glossy papers are available in four equally-spaced contrast grades; grade 1 to 3 have the same speed while grade 4 is half the speed of the others.

® Wratten is a trademark of The Eastman Kodak Company.

ILFOPRINT CONTACT PAPERS - CS, DS

Ilfoprint CS and DS papers should be exposed using document copying equipment employing a high intensity light source. Both these contact speed papers may be safely handled in artificial lighting for the length of time needed to make a print. Prolonged exposure to artificial light should be avoided as this may cause a loss of print quality.

Ilfoprint CS papers are intended for the production of contact prints from continuous tone negatives. The higher contrast grades may also be used for making half-tone prints by contact for page make-up when such work has to be carried out in normal artificial lighting.

Ilfoprint DS papers are intended for making same-size copies of letters, drawings, plans and other documents, and also for proofing line and screen negatives.

CHOOSING THE ILFOPRINT FOR THE JOB

	Recommended Ilfoprint Paper	
Job	Continuous Tone	Line
Enlargements (tungsten and cold cathode)	YR	YR3 or 4
Contact prints in the enlarger	YR	YR3 or 4
Contact prints in the contact frame	CS	DS4, CS3 or 4

ILFORD

The Compact Photo-Lab-Index

ILFORD

ILFOPRINT ACTIVATOR

Extremely rapid processing is made possible because the developing agent, hydroquinone, is incorporated in Ilfoprint emulsions. Development, the reduction of exposed silver halides to metallic silver, is almost instantaneous when the paper comes into contact with a highly alkaline solution, the activator.

ILFOPRINT STABILIZER

In conventional development-fixation processes the function of the fixer is to convert the unexposed, undeveloped silver halides to soluble salts which are removed from the emulsion. In the Ilfoprint system the stabilizer converts these silver halides to stable compounds which remain in the emulsion. The stabilizing agent is ammonium thiocyanate, and the halides are converted to silver thiocyanate complex salts.

RETOUCHING ILFOPRINTS

All Ilfoprints accept retouching very well. For retouching stabilized prints use oil based solutions as the water based types can cause staining.

THE PERMANENCE OF ILFOPRINTS

Ilfoprint stabilization techniques produce an Ilfoprint which maintains its quality for several years if stored in cool, dry conditions, away from direct sunlight. A high degree of permanence can be achieved if the print is fixed in a conventional fixer and washed. This can be done immediately after the Ilfoprint has emerged from the processor or at any time before the print has begun to deteriorate. In this way prints may be produced extremely rapidly for a particular purpose and then fixed and washed for archival records.

Since Ilfoprint papers have silver halide emulsions, fixing follows the usual procedure, except that the print should be immersed in fixer for twice the time recommended for conventional prints (for example, approximately 10 minutes in standard acid) and subsequently washed for about 30 minutes. After fixing and washing, the prints may be heat dried or ferrotyped and retouched in the normal manner. Ferrotyping must not be attempted with a print which has not been fixed and washed.

CONVENTIONAL PROCESSING

Ilfoprint papers may be conventionally processed if required, and are very similar to Ilfobrom papers under the same processing conditions, although an increase in contrast can be expected.

Any tray developer such as Ilford Bromophen is suitable. Normal paper fixers are recommended for fixing, both when the image has been developed in conventional developers, and when a stabilized print is being fixed for archival permanence.

SPECTRAL SENSITIVITY
ILFOPRINT YR

Wedge Spectrogram to Tungsten Light (2850 K).

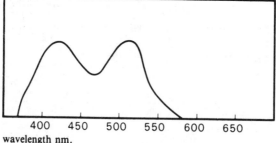

wavelength nm.

The wedge spectrograms for other Ilfoprint materials are similar to the one above.

The Compact Photo-Lab-Index

CHARACTERISTIC CURVES
Characteristic curves for Ilfoprint papers processed in an Ilfoprint Processor containing Il-
foprint Activator and Stabilizer.

ILFOPRINT YR

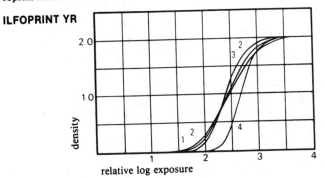

ILFOPRINT DS

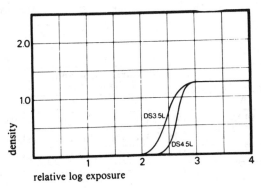

ILFOPRINT CS

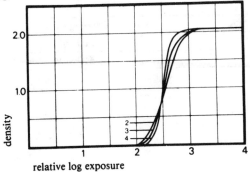

PAPER SELECTOR CHARTS

The following tables show the surface and contrast grade availability as well as the specific product designation for Ilford enlarging papers.

Ilfobrom Papers	Contrast Grade And Ordering Code					
Single Weight	0	1	2	3	4	5
Glossy	1B0.1P	1B1.1P	1B2.1P	1B3.1P	1B4.1P	1B5.1P
Semi-Matt		1B1.24P	1B2.24P	1B3.24P	1B4.24P	
Double Weight	0	1	2	3	4	5
Glossy		1B1.1K	1B2.1K	1B3.1K	1B4.1K	
Semi-Matt		1B1.24K	1B2.24K	1B3.24K	1B4.24K	
Matt			1B2.5K	1B3.5K		
Velvet Stipple		1B1.26K	1B2.26K	1B3.26K	1B4.26K	

Ilfospeed® Papers	Contrast Grade And Ordering Code					
Mid Weight	0	1	2	3	4	5
Glossy	1S0.1M	1S1.1M	1S2.1M	1S3.1M	1S4.1M	1S5.1M
Semi-Matt		1S1.24M	1S2.24M	1S3.24M	1S4.24M	
Silk		1S1.35M	1S2.35M	1S3.35M	1S4.35M	
Pearl		1S1.44M	1S2.44M	1S3.44M	1S4.44M	

Ilfospeed® Multigrade	Ordering Code
Glossy	MG1 M
Pearl	MG 44M

ILFORD

The Compact Photo-Lab-Index

Ilfoprint® Papers	Contrast Grade And Ordering Code			
Light Weight	1	2	3	4
Document Matt PS			DR3.5L	DR4.5L
Document Matt CS				DS4.5L
Single Weight	1	2	3	4
Glossy PS	YR1.1P	YR2.1P	YR3.1P	YR4.1P
Glossy CS		CS2.1P	CS3.1P	CS4.1P
Semi-Matt PS		YR2.24P	YR3.24P	
Double Weight	1	2	3	4
Glossy PS		YR2.1K	YR3.1K	

PS—Projection Speed
CS—Contact Speed

ILFORD

ILFORD FILMS PROCESSING GUIDE

The following development times for Ilford films at 68°F with agitation for 10 seconds each minute are recommended starting points only. Each photographer may vary actual development to fit individual needs and processing procedures.

Developer	Dilution	PAN F		FP4		HP5	
		ASA	Time	ASA	Time	ASA	Time
Microphen	None	64	4½	200	5	650	6
	1 + 1	80	5	200	8	650	9½
	1 + 3	80	9	200	11	650	21
Perceptol	None	25	11	64	10	200	11
or	1 + 1	32	12	100	11	200	14
Microdol-X	1 + 3	32	15	100	16	200	22
D-76	None	50	6	125	6½	400	7½
or	1 + 1	50	9	125	9	400	12
ID-11	1 + 3	50	14	125	15	400	23
DK-50	1 + 1	—	—	100	4½	400	6½
HC-110	1 + 7	—	—	125	5½	400	6

These developing times may be increased up to 50% for additional contrast when using diffusion or cold light type enlargers.

For more consistent results, processing times longer than 5 minutes are recommended.

Additionally, the following information is based on data published by the manufacturers of the developers shown. It is suggested that anytime a new film/developer combination is tried for the first time, the photographer pre-test and determine if the results obtained meet his requirements and expectations.

There is no endorsement guarantee for the performance of these developers or the accuracy of the times given. It is recommended that you contact the manufacturer of these products if you require further information on their preparation and use.

Developer	Temp.	Dilution	PAN F		FP4		HP5	
			ASA	Time	ASA	Time	ASA	Time
Acufine	70°	None	64	2	250	4(1)	800	4
Acufine	70°	None	—	—	—	—	1600	9
Acu-1	75°	1 + 5	—	—	—	—	800	5
Acu-1	75°	1 + 5	—	—	—	—	1200	10
	75°	1 + 10	64	5(2)	250	7(3)	—	—
Diafine	75°	None	125	3A 3B	320	3A 3B	800	3A 3B
Ethol TEC	70°	1 + 15	64	6½	320	10	1000	11
Ethol Blue (4)	70°	1 + 30	—	—	320	3	1000	5
	70°	1 + 60	80	4½	320	6	—	—
Ethol UFG	70°	None	80	2¼	320	3½	1200	5
Rodinal	70°	1 + 25	—	—	125	10	250	7
Edwal FG7	70°	1 + 2	50	2½	125	3½	400	3½

(1) For 120 roll film — change time to 5 minutes.
(2) For 120 roll film — change time to 5½ minutes.
(3) For 120 roll film — change time to 11¼ minutes.
(4) Consult manufacturer for times for 120 roll film.

ILFORD

430

PUSH PROCESSING DEVELOPMENT DATA

Many photographers occasionally find need to use higher-than-normal film speeds especially in taking pictures under adverse lighting conditions. To compensate for this underexposure, they push process their films.

Ilford films are capable of being push processed. However, as with any film, while a printable negative can be produced, it will usually show increased granularity, higher contrast, a higher fog level than a normally processed negative and a decreased degree of shadow detail. These characteristics will vary depending on subject matter and the amount of forced processing.

Perhaps the most interesting attribute of Ilford HP5 is its ability to produce quality prints even when forced to extreme exposure indexes thru push processing techniques. Natural and low-light situations can easily be coped with and special situations requiring high shutter speeds such as sports events and news photography can be easily handled with HP5.

Knowledgeable professional and serious amateur photographers realize that the exposure indexes given for push processing are based on practical evaluation of film speed and not based on the rendering of shadow detail as is ASA. Thus, HP5 can be used over an enormous range of exposure indexes and development times yet still yield optimum quality prints by proper selection of the appropriate contrast grade of printing paper.

The following table gives the recommended higher-than-rated ASA settings and corresponding push development times for most commonly used high energy developers at 68°F. These data assume processing in a spiral tank with agitation for the first 10 seconds of development and then for 10 seconds every minute for the remainder of the development time.

A range of developing times are given for the higher film speeds because subject matter, lighting and individual preference for negative quality preclude giving more specific times.

Developer	Dilution	FP4		HP5	
		ASA	Time	ASA	Time
Microphen	None	320	9	800	8
	None	400	13	1600	9½-12
	None	650	17	3200	14-18
ID11 or D-76	None	320	12	800	11½
	None	800	20	1600	18-22½
HC-110	1 + 7	250	7½	1200	12
	1 + 7	1000	16	—	—

Also, if you are switching to Ilford film from another brand of film, the ASA/developer/time/temperature procedures you have already established for films with comparable basic speed ratings represent excellent starting points from which you can make changes if you find them necessary.

ILFORD

MICROPHEN FINE GRAIN HIGH ENERGY DEVELOPER

DESCRIPTION AND USES

Ilford® Microphen® is a fine grain developer which gives an effective increase in film speed. Grain size is reduced and grain clumping prevented because of the low alkalinity of the developer. The majority of developers which give an increase in film speed usually produce a corresponding increase in grain size.

Microphen, however, has been specially formulated to overcome this disadvantage—and is therefore said to have a high speed/grain ratio. That is, it yields a speed increase while giving the type of fine grain result associated with MQ borax developers. A speed increase of half a stop can be achieved from most films. HP4, for example, can be up rated from 400 ASA to 650 ASA if it is developed in Microphen.

Microphen is a clean working long life developer, supplied as a powder, which is dissolved to make a working strength solution. Microphen can also be used at dilutions of 1 + 1 and 1 + 3.

USEFUL LIFE

Without replenishment.

If Microphen is stored in a well-stoppered bottle it will keep well and can be repeatedly used. Under normal conditions six 120 rolls or 36 exposure 35mm films can be developed in 600 ml of developer — to maintain uniform contrast for all six films the development time should be increased by 10 percent for each successive film developed.

With replenishment.

Microphen Replenisher is available for deep tank processing. It is designed to prolong the useful life of the developer and to maintain constant activity over a long period of time. The replenisher should be made up according to the instructions packed with it.

The most satisfactory method of replenishing Microphen is to add a small quantity of replenisher when the original volume has decreased by 5 percent or when about 1.3mm² (14 sq. feet) of sensitized material has been processed in each 4.5 litres (1 gallon) of developer. No limit is set to the amount of replenisher which may be added to a given volume of original developer. Replenishment may be continued until it becomes necessary to discard the solution in order to clean out the tank. If the tank is only used intermittently, it should be covered with a well-fitting floating lid to minimize developer oxidation and loss of water through evaporation.

DEVELOPMENT TIMES

Recommended times for the development of Ilford films are given below. These times may be increased by up to 50 percent for greater contrast, or where the highest speed is essential—as in the case of known under-exposure. General purpose materials are normally developed to a G (average contrast) of 0.55 if a tungsten enlarger is used for printing, and to a G of 0.70 if a cold cathode enlarger is used. The times given below are in minutes and refer to development at 20°C (68°F) with intermittent agitation. If continuous agitation is used these times should be reduced by one quarter.

General purpose films	ASA	G 0.55	G 0.70
Sheet film			
HP4 Professional	650	5	8
FP4 Professional	200	5	8½
120 rolls and 35mm			
HP5	650	6	7½
FP4	200	5	7½
Pan F	64	4½	6

ILFORD

DILUTE DEVELOPMENT

Development of FP4 and HP4 in diluted Microphen increases acutance; the greater the dilution, the better the acutance. Dilute development is particularly suitable for subjects with long tonal scales; shadow and highlight densities are retained while negatives are sufficiently contrasty to produce bright prints. With this development technique film speed is fully maintained, but development times have to be increased.

Diluted developers should be used once only and then discarded.

Ilford Film	ASA	dilution	G 0.55	G 0.70
FP4	200	1 + 1	8	13
	200	1 + 3	11	20
HP5	50	1 + 1	9½	18
	650	1 + 3	21	27
Pan F	80	1 + 1	5	8
	80	1 + 3	9	14

When developing to a G0.70, film speed is increased by approximately ⅓ stop.

PERCEPTOL EXTRA FINE GRAIN DEVELOPER

DESCRIPTION

Perceptol® is an extra fine grain developer which gives excellent image quality and very fine grain. It has been specifically formulated to get optimum results from high-resolution lenses, to exploit the very fine grain structure of FP4 and to produce significantly finer grain in HP4 negatives when compared with development in ID-11 or D-76®.

Perceptol produces excellent results with any lens/film combination and is therefore ideal when texture and definition are critical—negatives processed in Perceptol are capable of producing sharper and better-quality enlargements than those produced in a standard fine grain developer. Perceptol is supplied as a powder from which a solution is made by dissolving two separately-packed ingredients in warm water at about 40°C (105°F). The solution can be diluted for special techniques as explained later.

Perceptol contains a sequestering agent to prevent the formation of hard water precipitates and, as the developer is in powder form, it has excellent keeping properties even in the tropics. When made up, the unused solution will last for about six months in air-tight bottles. The solution can be replenished but without replenishment, 4.5 litres (1 gallon) of full-strength Perceptol will develop twenty 120 rolls, whether in deep tanks or machines. When replenished, 4.5 litres (1 gallon) will develop ninety films or equivalent.

® D-76 is a trademark of The Eastman Kodak Company

FULL-STRENGTH DEVELOPMENT AND REPLENISHMENT

When it is known that full-strength Perceptol will be the developer used, films must receive about double the normal exposure. Films should therefore be re-rated at the following figures:

	Nominal Rating		Adjusted Rating	
Film	ASA	DIN	ASA	DIN
Pan F	50	18	25	15
FP4	125	22	64	19
HP4	400	27	200	24

DEVELOPMENT TIMES

For enlarging with a tungsten light source, films should be developed to a G (average gradient) of 0.55. For enlarging with a cold cathode source films should be developed to G0.70. In full-strength Perceptol, the times quoted below will give these values. The times

ILFORD

are in minutes and assume intermittent agitation, i.e. agitation for the first ten seconds of development, then for ten seconds every minute for the remainder of the time. Temperature of the solution should be 20°C (68°F). To compensate for loss of activity, increase the development time by 10 percent after eight films have been processed in each 4.5 litres (1 gallon), or forty films per 22.5 litres, of developer.

General Purpose Films	G 0.55	G 0.70
Sheet film		
HP4	9	13
FP4	9½	13½
120 rolls and 35mm		
HP5	11	15
FP4	10	13
Pan F	11	15

REPLENISHMENT TECHNIQUE

When processing in deep tanks or machines, effective developer life is increased if Perceptol developer is replenished. Replenisher should be added at the following rates:

Tank Size	When to Add Replenisher	Amount of Developer to Be Removed	Amount of Replenisher to Be Added
2.5 litres (½ gallon)	After every 6 films*	70 ml (2½ oz)	116 ml (4 oz)
4.5 litres (1 gallon)	After every 10 films*	120 ml (4¼ oz)	210 ml (7½ oz)
13.5 litres (3 gallons)	After every 30 films*	350 ml (12½ oz)	630 ml (22½ oz)
22.5 litres (5 gallons)	After every 50 films*	600 ml (21 oz)	1050 ml (37½ oz)
54 litres (12 gallons)	After every 120 films*	1400 ml (50 oz)	2520 ml (90 oz)

*One 120 roll is the equivalent of one 36 exposure 35mm film or one 8 x 10 inch sheet film.

DILUTION TECHNIQUE

To increase acutance, Perceptol can be used as a "one-shot" developer. For this technique Perceptol solution can be diluted 1 + 1 or 1 + 3 with water. When diluted 1 + 1, the 600 ml size will make 1200 ml providing enough solution for four 120 rolls to be processed using a 300 ml tank — with the 1 + 3 dilution, the 600 ml size will make up to 2400 ml so that eight of these films can be processed using a 300 ml tank. With this technique, the film should have previously been rated at the ASA/DIN figure recommended below. Dilute Perceptol immediately before use and ensure that there is enough working strength solution to fill the processing tank. Use once and discard. The following times and speed ratings for dilution, or "one-shot", technique are recommended when processing at 20°C (68°F) with intermittent agitation, i.e. agitation for the first ten seconds of development, then for ten seconds every minute for the remainder of the time. The times are in minutes, for G0.55.

Film	ASA/DIN	for 1 + 1		ASA/DIN	for 1 + 3	
HP5	320	26	14 min	320	26	22 min
FP4	100	21	11 min	100	21	16 min
Pan F	32	16	12 min	32	16	15 min

The Compact Photo-Lab-Index

TIME/TEMPERATURE PROCESSING CONVERSION CHART

Often, you will find it necessary to process Ilford films at temperatures other than those recommended. This chart provides you with the information necessary to compensate for the new temperature. To use this chart, start with the developing time recommended at 20°C (68°F). Locate the point representing this time on the 20°C line (note the row of figures in the center of the chart). Follow the diagonal line corresponding to this time to the point where it crosses the horizontal line representing the temperature to be used. The new development time is shown vertically below the intersection.

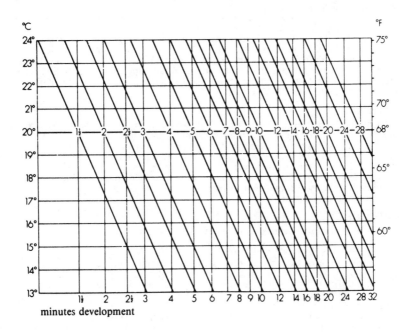

minutes development

ILFORD

COLOR PRINT MATERIAL TYPE A

Cibachrome® print material Type A is a multilayer color material from which brilliant prints can be made directly from slides.

Cibachrome-A is a silver-dye bleach material in which pure azo dyes of the highest quality are incorporated in the emulsion layers during manufacture. In processing, these dyes are destroyed (bleached) imagewise, in proportion to the developed silver, and thus, a direct positive image is obtained.

The base of Cibachrome-A Hi Gloss is an opaque white cellulose triacetate material of 0.20mm (7 mils) thickness.

The base of Cibachrome-A Pearl is midweight polyethylene resin coated paper. It has a lusterous surface that enhances color and resists fingerprinting.

Other advantages include its high resistance to fading, its high resolution (about 41 lines per mm), its brilliant color saturation and its excellent rendition of shadow detail.

Cibachrome prints are made with a simple 3-step process, plus final wash, and takes only 12 minutes. Process advantages include: wide latitude in exposing, wide latitude in processing, both in time and temperature, and good keeping qualities of print material. No refrigeration is required.

STORAGE

Cibachrome print material is packaged in light-tight hermetically-sealed plastic pouches which protect it from moisture and other harmful vapors until the seal is broken.

Unopened packages of Cibachrome print material may be kept at temperatures near 70 °F for periods of several months. For longer storage, refrigeration is recommended. After refrigeration, the material should be allowed to come back to room temperature before opening the package to avoid moisture condensation on the emulsion layers.

Opened packages of Cibachrome print material should not be refrigerated, but kept at normal room temperature.

SAFELIGHT

Cibachrome should be handled in total darkness.

IDENTIFICATION OF CIBACHROME EMULSION SIDE

The emulsion side of Cibachrome print material is smooth, but the back side is almost as smooth, and it may be difficult at first to determine the emulsion side in total darkness. If you have difficulty in feeling the difference, try swishing your thumb across one side at a time while holding it close to your ear. You will hear a "whisper" from the *back* side, and no sound from the emulsion side.

If you should make a mistake and try to expose through the back side, you will be able to tell during exposure. The emulsion side is dark gray, and the back side is gleaming white.

EXPOSING CIBACHROME PRINT MATERIAL

Cibachrome can be exposed on any enlarger having tungsten or tungsten-halogen light sources and equipped with: a color-corrected lens of at least f/4.5 maximum aperture; a light source of 150 or 100 watts (a 75 watt lamp will be satisfactory if the enlarger has efficient utilization of light); a heat absorbing glass in the enlarger head; a color head, or filter drawer or system to hold color filters, preferably between the light source and the slide to be protected. Optionally a voltage regulator is helpful, especially if your electrical supply is subject to voltage fluctuations of more than ± 10 volts.

FILTERS

A set of color-printing filters are needed, including
- an ultra-violet absorbing filter
- yellow: .05 .10 .20 .30 .40 .50
- magenta: .05 .10 .20 .30 .40 .50
- cyan: .05 .10 .20 .30 .40 .50

Cibachrome color printing filters available from your photo dealer are recommended.

ILFORD

The Compact Photo-Lab-Index

DIFFERENCES IN EXPOSING CIBACHROME AND NEGATIVE-TO-POSITIVE MATERIALS

If you have ever made black-and-white prints or prints from conventional color negatives, you will find that making Cibachrome prints will be entirely different.

Cibachrome is a *direct positive* material which reacts to exposure variations and changes in the same way as your color slide film. These materials react to light just as you would expect; that is, more light gives you a lighter image, and less light a darker image. And if the light becomes more yellow, the direct positive color image becomes more yellow, etc.

Therefore, in exposing Cibachrome print material, to lighten a print, you must give it more light and/or time; to make a print more yellow, you must add more yellow filtration, etc. For detailed information and exposure and color correction of Cibachrome print material, see detailed Cibachrome information pages which follow.

BASIC FILTER PACK INFORMATION

On the back of each package of Cibachrome-A print material is a printed label listing the basic pack information for each of the following types of slide film material: Kodachrome, Ektachrome, Agfachrome and Fujichrome. The filter pack recommendation for Kodachrome can be used also for GAF slide films. For example:

BASIC FILTER PACK

	Kodachrome	Ektachrome	Agfachrome	Fujichrome
Y	60	70	50	45
M	00	00	00	00
C	15	25	05	10

This chart indicates that under standardized average printing conditions, like those used at the factory, a filter pack of Y 60, M 00 and C15 would provide optimum color reproduction of a properly exposed and processed Kodachrome slide. Therefore, *when you make your first Cibachrome print,* use the appropriate filter pack listed on the back of the print material envelope for the specific type of slide film you are printing.

For a variety of reasons, however, the test conditions in the factory may be different from the working conditions in your own darkroom, and therefore you may need to "adjust" the basic filters pack to get a proper color balance in your print.

The inherent color balance of Cibachrome print material, like that of all other color printing materials, varies to some extent from batch to batch. For that reason you may find different basic filter pack information on different batches of Cibachrome print material.

Once you determine "your system correction factor" for your first batch of Cibachrome print material, merely apply the same factor to the filter pack on different batches of Cibachrome print material.

LATENT IMAGE

The latent image of Cibachrome print material is very stable. You may process immediately after exposure, or if you wish, prints may be kept at room temperature unprocessed overnight or even over a weekend without noticeable change in overall density or color balance.

PROCESSING

Cibachrome-A print material should be processed only with Cibachrome chemistry, process P-12, available at your photo dealer. Instructions for processing Cibachrome-A print material are furnished with the Cibachrome chemistry kit, and detailed instructions and handy reference charts are included in the Cibachrome manual.

AVAILABILITY

Cibachrome-A print material is available in the following sizes and quantities:

 4 × 5 inches: boxes of 50 sheets
 8 × 10 inches: envelopes of 20 sheets
 8 × 10 inches: boxes of 50 sheets
 11 × 14 inches: envelopes of 10 sheets
 11 × 14 inches: boxes of 25 sheets
 16 × 20 inches: envelopes of 10 sheets

ILFORD

CIBACHROME P-12 CHEMISTRY

The Cibachrome chemistry kit process P-12 has been specially formulated for home darkroom use in processing Cibachrome color print material Type A, both Hi Gloss and Pearl finish. The chemicals offer a wide latitude in processing temperature ($75° \pm 3°F$), some latitude in time (both the bleach and the fixer go to completion at the end of their cycles), and a flexibility in agitation techniques.

Caution: Cibachrome P-12 chemicals are photographic chemicals that may be harmful if misused. Read carefully, and observe all cautions printed on packages and labels. Cibachrome chemicals are not to be used by children except under adult supervision.

Even though the solid chemicals are provided in sealed packages and all liquids are protected by child-resistant safety caps, KEEP ALL CHEMICALS OUT OF REACH OF CHILDREN.

STORAGE

All Cibachrome chemicals should be stored at room temperature in well-sealed glass or polyethylene bottles.

The concentrated stock solutions will keep for several months up to a year in the tightly sealed bottles. Part 1B of the developer may turn yellowish on extended storage but this will not affect its strength or cause staining of prints.

Storage life of the working solutions at room temperature is as follows:

developer:	4 weeks (full bottle)
	2 weeks (partially full bottle)
bleach:	4 to 6 months
fixer:	4 to 6 months

Fortunately, the developer may be mixed even for individual prints, and so if you prepare for your short-term needs, there should be no problem with degradation of chemicals. (See direction for mixing chemicals.)

GENERAL INSTRUCTIONS FOR MIXING

There are only three solutions required for processing Cibachrome-A print material: developer, bleach and fixer.

In mixing the chemicals, be sure to follow all directions carefully as errors in preparation can cause various faults in the final prints. Use clean vessels for mixing, and be sure to wash and rinse with hot water after each use to avoid contamination. (Just 2 or 3 drops carryover of dilute fixer into subsequent developer can spoil a print!)

MIXING THE DEVELOPER

There are two parts ot Cibachrome developer: Developer part 1A and Developer 1B.

As previously mentioned, the developer can be mixed as needed, even for a single print. To prepare developer for a single 8 × 10 inch print: Mix 15 ml of part 1A, 15 ml of part 1B, add water to make 90 ml or 3 ounces of developer.

If you plan to make 4 prints in an evening or over a weekend, for example, it would be advisable to mix developer for just those 4 prints as follows: Mix 60 ml of part 1A, 60 ml of part 1B, add water to make 360 ml or 12 ounces of ready-to-use developer (3 ounces per 8 × 10 inch print).

To mix large quantities; follow the instructions in the chemistry kit you purchase. Instructions will vary depending upon the size of kit and upon quantity to be mixed at one time.

MIXING THE BLEACH

There are two parts to Cibachrome bleach: Bleach part 2A in powder form and bleach part 2B in liquid form. Follow the instructions in the chemistry kit you purchase. Instructions will vary depending upon size of kit and upon quantity to be mixed at one time.

MIXING THE FIXER

Follow the instructions included in the chemistry kit you purchase. Instructions will vary depending upon size of kit and upon quantity to be mixed at one time.

ILFORD

NEUTRALIZING THE CHEMICALS AFTER USE

Included in each package of Cibachrome P-12 chemistry is a neutralizing agent to be used to neutralize the used chemicals before disposal. Read and follow carefully the instructions in the package.

AVAILABILITY

Cibachrome P-12 chemistry is available in 2 quart and economical 5 quart kits.

CIBACHROME COLOR PRINTING FILTERS

Cibachrome color printing filters are as durable and resistant to mechanical damage as is possible without loss of desirable characteristics.

Available as a set o nineteen (19) filters, 6×6 or $3\frac{1}{2} \times 3\frac{1}{2}$ inches in size, as follows:

- an ultra-violet absorbing filter
- yellow: .05, .10, .20, .30, .40, .50
- magenta: .05, .10, .20, .30, .40, .50
- cyan: .05, .10, .20, .30, .40, .50

All 6×6 filters are identified in all four corners by color and density for added convenience. For those workers whose enlargers accept a 3×3 inch filter, the Cibachrome filter may be cut to make four (4) complete sets of filters 3×3 inches in size, and each set identified by color and density. One set may be used for viewing prints to assist in making color corrections. Other sets may be retained to use in case filters become scratched or faded with time and use.

CIBACHROME PRINT SPRAYS

Cibachrome print sprays are high-quality lacquer specially formulated for photographic use. The sprays can be helpful in protecting Cibachrome prints from scratches, fingerprints, dirt and moisture, as well as providing different surface characteristics.

Available in three surfaces: Glossy, a high gloss surface used to retain the glossy quality of a Cibachrome print, but protect it from surface damage; Velvet lustre, a soft matte surface which retains the color in a Cibachrome print, but reduces the gloss; Matte, a flat matte surface, ideal for portraiture and similar work.

All Cibachrome spray surfaces, when properly dry, may be cleaned with a damp cloth. Equally suitable for color and black-and-white photographs.

ILFORD

CIBACHROME PROFESSIONAL
CIBACHROME PROCESS P-18

INTRODUCTION

Cibachrome Process P-18 is a 3-step silver dye-bleach process for Cibachrome Print Material Type D (CCP-D-182). It is *not* suitable for processing Cibachrome Transparent Material.

The three chemical processing steps involved in the P-18 process are (1) development, (2) silver/dye bleaching, and (3) fixing, with a plain water wash following each step.

Process P-18 is designed for machine processing with roller transport or continuous roll-paper processors using economical replenishing procedures. It may also be used with total loss processors by utilizing only starter solutions.

AVAILABILITY OF P-18 CHEMISTRY

Cibachrome P-18 chemicals are supplied as liquid concentrates in the following sizes:

Chemistry	Quantity of Working Solution	Concentrate Contents
Developer DE 1813	3.5 gallons (13 liters)	2 liquid concentrates. Parts A & B
Bleach BL 1818	3.5 gallons (13 liters)	2 liquid concentrates. Parts A & B
Fixer FX 1813	3.5 gallons (13 liters)	1 liquid concentrate.
Developer DE 1838	10 gallons (38 liters)	2 liquid concentrates. Parts A & B
Bleach BL 1838	10 gallons (38 liters)	2 liquid concentrates. Parts A & B
Fixer FX 1838	10 gallons (38 liters)	1 liquid concentrate.
Developer Replenisher DER 1819	5 gallons (19 liters)	2 liquid concentrates. Parts A & B
Bleach Replenisher BLR 1819	5 gallons (19 liters)	2 liquid concentrates. Parts A & B
Fixer Replenisher FXR 1819	5 gallons (19 liters)	1 liquid concentrate.
Developer Replenisher DER 1895	25 gallons (95 liters)	2 liquid concentrates. Parts A & B
Bleach Replenisher BLR 1895	25 gallons (95 liters)	2 liquid concentrates. Parts A & B
Fixer Replenisher FXR 1847	12.5 gallons (47 liters)	1 liquid concentrate.

Unused liquid concentrates of Cibachrome P-18 chemistry should be stored at temperatures above 45°F (10°C).

As a guide in remembering product code numbers, the last two digits indicate the number of liters of working solution; e.g., DE 1813 will make 13 liters (3.5 gallons) of working solution.

Process P-18 offers the user a number of advantages over earlier Cibachrome processes, such as the well-known Process P-10. These improvements mark another advance in the development of the inherent simplicity, reliability and rapid-access capability of the silver dye-bleach process in direct positive color photography. The most noteworthy differences are:

1. P-18 has only *three* chemical processing steps. The dye and silver bleach steps, which require separate solutions in Process P-10, have been combined into a single solution in P-18.

440

ILFORD

2. P-18 takes less time—only 15 minutes, as opposed to 32 minutes for P-10.

3. P-18 has significantly better ecological properties. It does not contain any ferricyanides, and the concentration of other chemicals is reduced.

4. In total-loss processing, Process P-18 is more economical than P-10.

5. All P-18 chemical are liquid concentrates and therefore are convenient to mix and use.

6. It is very stable and tolerant of variations in time and temperature, as long as minimum processing periods have been met. This is different from Process P-10, in which some deliberate adjustments can be made in image contrast through variations in treatment time and/or solution temperature but at the expense of process stability.

7. Process P-18 is suitable *only* for the processing of Cibachrome Print Material Type D, while P-10 may be used with both Cibachrome Print Type D and Cibachrome Transparent Type D materials.

PREPARATION OF CIBACHROME P-18 PROCESSING SOLUTIONS

MIXING FACILITIES

Chemicals, mixers and storage containers for processing solutions should *not* be stored in the same room with photographic materials, enlargers, printers or other equipment. It is recommended that the preparation of processing solutions for Process P-18 be carried out in a well-ventilated room specifically finished and equipped for the purpose.

The floor of the mixing room should be inert to photographic solutions and resistant to solutions of very low and high pH. Untreated concrete floors are not satisfactory. Drains and drain pipes must also be of proper composition, even though liquid wastes are diluted and/or treated before discharge into the sewer system.

The walls and ceiling of the mixing room should be covered with a coating resistant to photographic chemicals. They should be washed periodically to prevent accumulation of solid chemical residues that may become airborne and cause contamination.

MIXING CONTAINERS AND STORAGE TANKS

To avoid contamination, separate mixing tanks should be used for each of the three processing chemicals. At the very least, a separate container *must* be available for the developer, since contamination of the developer by bleach or fixer leads to fog and/or color degradation in finished prints.

Mixers, mixing tanks, storage tanks, pumps and connection must be made of materials which are resistant to the processing solutions.

Type 316 stainless steel, PVC (polyvinyl-chloride), polypropylene and polyethylene are suitable for use with all P-18 processing solutions. Mixing and storage containers, as well as pumps and piping, made of these "safe" materials are readily available.

Not all materials that are normally used in processors and laboratory equipment are suitable for use with photographic processing solutions. In particular, some of the metals and plastics frequently used in processors will be corroded by the acid P-18 bleach solution.

When purchasing such equipment, the buyer should check to see that *all* parts of the unit are made from the proper materials. Occasionally, small components such as screws, washers, nuts or bushing made of iron, plain steel, aluminum or nylon are inadvertently or unknowingly used. In time, these will corrode, soften or disintegrate and cause leakage or serious contamination of the P-18 processing solutions.

All storage tanks should be covered with lids to avoid evaporation and contamination. Floating lids are desirable on the tanks for developer, developer replenisher, bleach and bleach replenisher to minimize oxidation.

ILFORD

THE SUITABILITY OF VARIOUS MATERIALS FOR USE WITH PROCESS P-18

The table following indicates the suitability of common materials for use with Cibachrome P-18 solutions:

Material	Developer	Bleach	Fixer	Water
Aluminum	U	U	U	U
Iron	U	U	U	U
Hastealloy C	S	S	S	S
Bronze	U	U	U	U
Brass	U	U	U	U
Nickle	U	U	U	U
Stainless Steel AISI 316	S	S	S	S
V4A-Steel DIN 1.4401 and 1.4436	S	S	S	S
Titanium	S	S	S	S
Zinc	U	U	U	U
Copper	U	U	S	S
Acrylic Glass (flexiglass, Plexiglas, Lucite)	S	P	S	S
Epoxy Resin with Fiberglass	S	U	S	S
Glass	S	S	S	S
Rubber, Hard Rubber	P	P	P	S
Neoprene	S	P	S	S
Polyamide (Nylon)	S	U	S	S
Polychlorotrifluorethylene	S	S	S	S
Polyethylene, polythene	S	S	S	S
Polypropylene	S	S	S	S
Polyester with Fiberglass	P	P	S	S
Polystyrene	S	S	S	S
Polytetrafluorethylene (Teflon)	S	S	S	S
Polyurethane	U	U	U	U
Polyvinylchloride (PVC)	S	S	S	S

KEY: S = Suitable P = Only Partly Suitable U = Unsuitable, should not be used

All materials designated "P" (Only partly suitable) must be tested specifically for stability due to differences in the composition of the many varieties available. For more information, contact the Ilford Inc. Technical Service Department.

ILFORD

The Compact Photo-Lab-Index

PREPARATION OF WORKING-STRENGTH SOLUTIONS

Preparation of the working-strength solutions is fast and easy, since it merely involves diluting the P-18 liquid concentrates with water.

Normally, clean, filtered tap water at a temperature of 85°F to 105°F (29°C-40°C) should be used. Deionized or distilled water is only required when tap water is excessively hard (over 400 ppm hardness), or when it contains organic matter, which will cause fogging of the image layers.

A number of precautions should be taken during the preparation of P-18 processing solutions. These are explained in the section on Handling and Safety Procedures and should be studied carefully by all personnel involved in mixing and handling of chemicals.

The following table gives specific instructions for mixing the package quantities of the various chemicals of the P-18 process:

Product & Code	Water to Start 85°F (29°C)	Add	Mixing	Add	Add Water to make	Additional Mixing Time
Developer DE 1813	1.5 gallons	3 bottles of DE 1813 Part A	1 minute	2 bottles of DE 1813 Part B	3.5 gallons	3 minutes
Developer DE 1838	6 gallons	2 bottles of DE 1838 Part A	1 minute	1 bottle of DE 1838 Part B	10 gallons	3 minutes
Developer Replenisher DER 1819	3 gallons	1 bottle of DER 1819 Part A	1 minute	1 bottle of DER 1819 Part B	5 gallons	3 minutes
Developer Replenisher DER 1895	17 gallons	2 bottles of DER 1895 Part A	1 minute	1 bottle of DER 1895 Part B	25 gallons	3 minutes
Bleach BL 1813	1.5 gallons	3 bottles of BL 1813 Part A	1 minute	2 bottles of BL 1813 Part B	3.5 gallons	3 minutes
Bleach BL 1838	6 gallons	2 bottles of BL 1838 Part A	1 minute	1 bottle of BL 1838 Part B	10 gallons	3 minutes
Bleach Replenisher BLR 1819	3 gallons	1 bottle of BLR 1819 Part A	1 minute	1 bottle of BLR 1819 Part B	5 gallons	3 minutes
Bleach Replenisher BLR 1895	17 gallons	2 bottles of BLR 1895 Part A	1 minute	1 bottle of BLR 1895 Part B	25 gallons	3 minutes
Fixer FX 1813	1.5 gallons	3 bottles of FX 1813	None	None	3.5 gallons	3 minutes
Fixer FX 1838	5.5 gallons	2 bottles of FX 1838	None	None	10 gallons	3 minutes
Fixer Replenisher FXR 1819	2.5 gallons	2 bottles of FXR 1819	None	None	5 gallons	3 minutes
Fixer Replenisher FXR 1847	7 gallons	2 bottles of FXR 1847	None	None	12.5 gallons	3 minutes

ILFORD

443

MIXING SMALL QUANTITIES

Since the working-strength solutions have limited keeping properties, the quantities prepared at any one time should not exceed the amount normally expected to be used during the life of the solutions.

Instructions for mixing smaller than standard package quantities of the P-18 processing solutions are given in the following table:

DEVELOPER AND DEVELOPER REPLENISHER & BLEACH AND BLEACH REPLENISHER

Desired Quantity	Water to Start 85°F (29°C)	Add Part A	Mixing	Add Part B	Add Water to make	Additional Mixing Time
1 pint (473 ml)	9.5 ounces (280 ml)	3.2 ounces (95 ml)	1 minute	1.6 ounces (47 ml)	1 pint (473 ml)	3 minutes
1 quart (946 ml)	19 ounces (560 ml)	6.4 ounces (189 ml)	1 minute	3.2 ounces (95 ml)	1 quart (946 ml)	3 minutes
½ gallon (1893 ml)	38 ounces (1125 ml)	12.8 ounces (378 ml)	1 minute	6.4 ounces (189 ml)	½ gallon (1893 ml)	3 minutes
1 gallon (3785 ml)	77 ounces (2280 ml)	25.6 ounces (757 ml)	1 minute	12.8 ounces (378 ml)	1 gallon (3785 ml)	3 minutes

FIXER AND FIXER REPLENISHER

Desired Quantity	Water to Start 85°F (29°C)	Add Concentrate	Add Water to make	Mixing Time
1 pint (473 ml)	8.5 ounces (250 ml)	6.4 ounces (189 ml)	1 pint (473 ml)	3 minutes
1 quart (946 ml)	17 ounces (500 ml)	12.8 ounces (378 ml)	1 quart (946 ml)	3 minutes
½ gallon (1893 ml)	35 ounces (1000 ml)	25.6 ounces (757 ml)	½ gallon (1893 ml)	3 minutes
1 gallon (3785 ml)	70 ounces (2000 ml)	51.2 ounces (1520 ml)	1 gallon (3785 ml)	3 minutes

AGING CONSIDERATIONS OF CIBACHROME P-18 PROCESSING SOLUTIONS

SHELF LIFE OF FRESH WORKING-STRENGTH SOLUTIONS

The properties of photographic processing solutions can change during storage. The main changes and their causes are:

Increase in concentration due to water evaporation. Solution exhaustion by oxidation. Contamination by dirt or other external matter. Precipitation and/or crystallization of some chemicals.

The useful life of *unused* working-strength P-18 processing solutions in clean, covered storage tanks with floating lids is as follows:

Developer—2 weeks; Developer replenisher—4 weeks; Bleach and bleach replenisher—6 weeks; Fixer and fixer replenisher—6 months.

USEFUL LIFE OF REPLENISHED PROCESSING SOLUTIONS

When properly replenished, the activity of fresh P-18 solutions can be maintained for periods of several months, provided that the solutions are used regularly. This means that

ILFORD

the throughput of exposed Cibachrome print material must be above a certain minimum level so that at least one-half of the solution volume in each processing is replaced by replenisher solution within a 2-week period.

In terms of continuous roll paper or roller transport processors, the following data are applicable:

Minimum Amount of Processed Material Per Week

Tank Capacity	25% Volume	Square Meters	Square Feet	Number of 8 × 10's or Equivalent
10 gal.	2.5 gal.	18.9	203	363
15 gal.	3.76 gal.	28.4	306	546
20 gal.	5.00 gal.	37.8	407	727
25 gal.	6.25 gal.	47.3	509	909
50 gal.	12.25 gal.	92.7	998	1782
75 gal.	18.75 gal.	141.9	1527	2727
100 gal.	25.00 gal.	189.2	2036	3636

Since the developer replenishment rate is the lowest of the three, the data given in the above table are based on this rate. In choosing a processor, the short and longer term print volume should be assessed first. The size of processor required can then be determined from the data given in the right hand column. If necessary, the required throughput can be obtained by processing prints flashed to 0.60 neutral density.

In order to maintain the proper solution activity in a replenished system, it is also essential to avoid contamination of one chemical solution by another, particularly contamination of the developer by bleach or fixer. Oxidation, evaporation, and air-borne contamination of the solutions may be minimized through (1) the use of well-functioning pumps and associated circulation, filtration, and agitation systems; (2) proper temperature control in processing tanks (70 °F-90 °F or 25 °C-32 °C); and (3) the use of floating lids on storage tanks.

All chemical processing solutions should be filtered continuously or periodically during active processing periods to prevent build-up of sludge and other foreign matter which might affect the photographic or physical qualities of the prints. The filters must be made of a suitable material, such as polypropylene (see the preceding chart for additional information on suitability of materials).

CIBACHROME P-18 HANDLING AND SAFETY PROCEDURES

GENERAL CAUTIONARY INFORMATION

Photographic chemicals and processing solutions must be handled with caution. It is strongly recommended that all personnel involved in mixing and handling P-18 solutions, especially the Bleach Part A concentrate, be made aware of the potential hazards, appropriate safety measures, and first aid procedures in case of accidental misuse.

To prevent injury and/or irritation to the skin and eyes, safety goggles, rubber gloves and protective clothing are essential when mixing or handling chemicals or solutions. An industrial-type eye and face rinse facility should be provided in the mixing room.

The following specific precautions should be observed:

DEVELOPER AND DEVELOPER REPLENISHER

Chemicals in Developer Part A may be harmful if placed in contact with skin, eyes or clothing, or if swallowed. In case of contact with skin, flush the skin thoroughly with water. If skin irritation occurs, call a physician at once. In case of contact with the eyes, flush the eyes thoroughly with water for at least 15 minutes and call a physician at once. If this product is swallowed, call a physician at once. *Do NOT induce vomiting.*

Chemicals in Developer Part B may also be harmful if allowed to contact skin, eyes or

ILFORD

445

clothing, or if swallowed. The same steps should be taken as described above for Developer Part A, except that if Developer Part B or developer working solution is swallowed, *induce vomiting* and call a physician at once.

After Developer Part A is mixed with Developer Part B, cautions for Developer Part B must be followed.

BLEACH AND BLEACH REPLENISHER

Cibachrome bleach and bleach replenisher contain sulfuric acid. Part A concentrates contain up to 28% sulfuric acid on a weight/volume basis and the working-strength starter and replenisher solutions contain up to 5.5% sulfuric acid on a weight/volume basis.

These bleach solutions are harmful if placed in contact with the skin, eyes or clothing, or if swallowed. If these products come in contact with the skin or clothing, wash with soap and water, and treat the affected area with sodium bicarbonate (baking soda). If skin irritation occurs, call a physician at once. In case of contact with the eyes, flush the eyes thoroughly with water for at least 15 minutes and call a physician at once. If Bleach Part A is swallowed, call a physician at once. *Do NOT induce vomiting.*

Chemicals in Bleach Part B may also be harmful if placed in contact with the skin, eyes or clothing, or if swallowed. The same steps should be taken as described above except that if Bleach Part B or bleach working solution is swallowed, *induce vomiting* and call a physician at once.

After Bleach Part B is mixed with Bleach Part A, cautions for Bleach Part A must be followed.

FIXER AND FIXER REPLENISHER

These products may be harmful if placed in contact with the eyes or if swallowed. In case of contact with the eyes, flush the eyes thoroughly with water for at least 15 minutes and call a physician at once. If these products are swallowed, *induce vomiting,* and call a physician at once.

ADDITIONAL MEDICAL INFORMATION

If your physician requires additional information on any Cibachrome chemicals, have him call Ciba-Geigy Corporation (Product Misuse) at (914) 478-3131.

DISPOSAL AND SPILLS

At no time should Cibachrome bleach be mixed with or drained at the same time as developer and/or fixer, because the bleach will make the developer and/or fixer acidic to a point where sulphite and thiosulphate will break down to produce sulphur and sulphur dioxide. Sulphur dioxide, a pungent, strong-smelling gas, may cause severe or prolonged coughing. The precipitated sulphur that results from this reaction can cause drains to block up over a period of time.

If bleach is spilled onto PVC-coated floors, it causes yellow stains. In most cases, these stains can be removed by applying a solution of Cibachrome fixer for about 12 hours and then washing the floor well with water.

BASIC TIME-TEMPERATURE DATA

	Processing sequence	Time (minutes)	Temperature (°C)	Temperature (°F)	Total elapsed time at end of each step (minutes)
1.	Developer	3	30° ± ½°	86° ± 1°	3
2.	Wash	¾	28° to 32°	82° to 90°	3¾
3.	Bleach	3	30° ± 1°	86° ± 2°	6¾
4.	Wash	¾	28° to 32°	82° to 90°	3¾
5.	Fixer	3	30° ± 1°	86° ± 2°	10½
6.	Final Wash	4½	28° to 32°	82° to 90°	15
7.	Dry		◄70°	◄160°	

ILFORD

Processing sequence and standard time and temperature conditions for Cibachrome P-18 chemistry and Cibachrome Print Material Type D are:

Processing steps 1 to 3 (that is, up to and including the bleach) must be carried out in total darkness. After bleaching, processing can be continued under normal room lighting.

The final wash (step 6) must be divided between 2 separate wash tanks in automatic processors. Usually, the first part of the final wash should be 1½ minutes and the second part should be 2 minutes. When running water is not available or cannot be used, five complete changes of water are needed (i.e., a complete dump of wash water every 45 to 50 seconds).

PROCESSING TIMES

The processing times are defined as the intervals between immersion of the print material in two successive solutions.

For best results processing conditions should be kept within the limits published in the above table.

TEMPERATURE AND SOLUTION CIRCULATION

The Cibachrome P-18 process is designed for operation at 86°F (30°C). Permissible variations in temperature for each step have been noted above.

Temperature differences between the chemical processing solutions should always be less than 2°F (1°C), and differences between chemical solutions and wash water should always be less than 9°F (5°C).

All solution tanks require a recirculation system with heating and cooling provisions in order to assure consistent solution temperature. Separate, independent thermostats and temperature controls are recommended for each bath. Control of the developer solution temperature alone is apt to lead to quality fluctuations.

The circulation system should have in-line filters for removal of dirt and sediment. The filter elements should be made of polypropylene and of a mesh size that will ensure removal of all particles larger than 25 microns. Filters made from cotton, nylon or metals are not suitable for the Cibachrome P-18 process.

BASIC PROCESSING STEPS

CIBACHROME P-18 DEVELOPER

In the P-18 process, development is the only processing step that influences print density (speed). Unlike the bleach and fixing steps, the development process continues very slowly after the end of the prescribed processing time. Therefore, recommended time and temperature limits in development should be adhered to.

In order to secure uniform action of the developer over the entire image area, a certain minimum amount of agitation is required. In most processors, adequate agitation is provided by solution circulation and movement of the print material through the solution generally.

Drum-type processors should be operated at a rotational speed of 28 to 36 revolutions per minute.

However, in deep tank lines, nitrogen burst agitation normally is needed, especially during the initial phases of development. Compressed air agitation should not be used as it will cause rapid solution oxidation.

CIBACHROME P-18 BLEACH

The bleaching step is the unique processing step of the silver dye-bleach process. In the P-18 process, it is particularly noteworthy because both bleach reactions take place in a single solution. However, since the bleaching of the image dyes requires the presence of metallic silver, the dye-bleach reaction must and does proceed at a much faster rate than the silver bleaching reaction.

In other words, both reactions occur simultaneously, but the dyes are bleached much faster than the silver. All chemical reactions come to an end when all the silver has been bleached. However, some additional time is needed for the removal of dye by-products

ILFORD

447

through diffusion into bleach solution. Treatment beyond this point will not cause any deleterious photographic effects.

The rates of the various reactions that occur in the bleach step are affected similarly by changes in temperature; therefore, variations in temperature can be offset within rather wide limits by appropriate changes in time of treatment. However, the recommended temperature is 86°F ± 2°F.

BLEACH AGITATION REQUIREMENTS

Strong agitation is required during the 30 seconds of bleaching to ensure a rapid and uniform supply of fresh bleach solution to all parts of the print surface. This is very important for the attainment of good image uniformity and uniform color balance. After this initial phase, agitation is desirable but not critical.

In most roller-transport processors, adequate solution agitation is generally achieved by compression of the print material between the transport rollers. Further agitation is therefore not usually required.

Continuous processors with band, chain or leader transport mechanisms require a supplementary agitititation system to ensure sufficient turbulence at the material surface during the first 30 seconds of bleaching.

A simple spray bar can provide satisfactory agitation. Such a bar is made from a tube at least one inch in diameter with holes of about 2mm diameter spaced at 10-millimeter intervals. The bar should be mounted so that the bleach solution being pumped through the holes impinges onto the emulsion of the Cibachrome print material at an angle of 90° during the first 30 seconds.

A pressure of 4.5 PSI will be sufficient to operate this system, provided the spray bar is mounted within 1 to 2 inches of the surface of the print material.

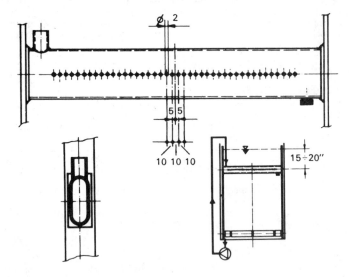

Drum-type processors normally provide sufficient agitation for the bleach step without further modification.

In tank lines, an initial 30-second burst of nitrogen at a pressure of 11-14 pounds per square inch may be used to provide the necessary agitation.

PRECAUTIONS IN MIXING AND DISPOSING OF BLEACH SOLUTIONS

The bleach and bleach replenisher are strongly acid solutions which contain about 4% and 5.5% sulphuric acid, respectively. Never mix bleach together with developer and/or fixer, nor pour both into a drain at the same time. In processing machines which provide separate outlets for wash water and processing solutions, the bleach must pass through pipes separate from developer and fixer and be diluted with the wash water before mixing with developer and fixer effluent. Where this cannot be accomplished, the bleach must be neutralized with a chemical such as sodium bicarbonate before coming into contact with these solutions.

FIXING

The fixer in the Cibachrome P-18 process is an almost-neutral rapid fixer. It is well buffered so that the pH value is not easily altered through carried-over bleach solution. This is important since the cyan dye of the print material can change its color if the pH value of the fixer falls below 6.0.

Normal agitation is recommended. In tank lines bursts of nitrogen can be used.

WASHING

The three washes in the P-18 process are necessary and important parts of the total process and must not be slighted.

The first wash (between developer and bleach) serves to minimize the carry-over of developer chemicals into the bleach solution. Thereby it helps in maintaining the integrity and activity of the bleach with minimum replenishment. Moreover, it prevents the formation of sulfur dioxide gas and sulfur, which would be formed through decomposition of the developer in the highly acid bleach.

The second wash (after bleaching), like the first, minimizes carry-over of one chemical solution into another—in this case bleach into fixer. It also prevents excessive decomposition of thiosulphate in the fixer by the acid bleach. This, too, would yield the undesirable and malodorous sulfur dioxide.

The final wash is required for the removal of all remaining chemical by-products from the emulsion (and back) layers of the Cibachrome material. This is essential to the achievement of good image permanence and freedom from discoloration.

Washing efficiency is influenced by many factors including water quality, quantity, temperature, time, agitation, type of processor and material throughput. It is, therefore, very important to adhere to the following directions.

WASH WATER TEMPERATURE

The wash water temperature must be at least 82 °F (28 °C) for a 4½ minute wash cycle. Use of colder water will require increased wash times. However, in extreme cases, large temperature differences between processing solutions and wash water can lead to reticulation or crazing of the print surface. The maximum recommended temperature is 90 °F (32 °C). Higher wash water temperatures may cause physical damage to the print material.

WATER QUALITY AND CONDITION

Only filtered, iron-free water should be used (filter size 50 microns).

The water hardness is also of concern because very soft water (below 80 ppm) is relatively inefficient for washing and may cause excessive swelling and softening of the emulsion layers. Very hard water (above 400 ppm), on the other hand, may cause white residues to form on the print surface after drying.

Water from a water softener or deionizer should not be used to wash Cibachrome prints.

THE FINAL WASH

The final wash must either be divided between 2 separate tanks with a complete change of water in each tank every 1½ minutes, or the water must be changed five times (i.e., a complete dump of wash water every 45 to 50 seconds). In roller transport or continuous processors, a cascade-type of water flow can be used to advantage in the final wash tank (tanks no. 6 and 7): fresh water is run in at the bottom of tank no. 7 and is made to flow into the

449

bottom of tank no. 6. The overflow from tank no. 6 is fed to the drain. Similarly, a cascade flow arrangement can be provided between the second and first washes (tanks no. 4 and 2): fresh water should be fed into tank no. 4 and the overflow fed into tank no. 2, with overflow being fed to the drain.

WIPER INSTALLATION IN AUTOMATIC PROCESSORS

For automatic processors with speeds over 6 feet per minute, a wiper should be installed after the first wash (between developer and bleach) and the second wash (between bleach and fixer) in order to minimize solution carry-over and thereby the replenishment rates.

QUANTITY OF WATER REQUIRED

The required quantity of water for the wash and the cascade depends on the capacity of the processor. The necessary amount of fresh water for each washing step can be calculated from the following simple formula:

$$A = \frac{V \times B}{323}$$

where: A = required water quantity in gallons/minute
B = effective width of the processor, or total width of processed material in inches
V = machine throughput speed in inches/minute.

This formula is only valid when the final wash is divided into 2 separate tanks.

The usual rule-of-thumb is that the flow rate should be such that one quarter of the total volume of water used in the wash step is replaced each minute.

DRYING

In continuous processing situations, surface water should be removed from the top and bottom of the Cibachrome print material before it enters the air dryer. This can be accomplished by means of two squeegee rollers or two soft rubber wipers which are adjusted to prevent damage to the print surface. After surface water has been wiped off, about 110-140 mls. of water per square meter still remain in the emulsion layers of Cibachrome print material. The air dryer must have sufficient capacity for removal of this water load with an air temperature not exceeding 160 °F (70 °C).

If a processor without a built-in dryer is used Cibachrome print material can be dried in a drying-cabinet or dust-free room. Surface water should be removed by means of a squeegee or wiper to prevent spotting.

REPLENISHING CIBACHROME P-18 WORKING SOLUTIONS

In order to maintain the concentration and activity of processing solutions at a constant level, each solution in the processor must be regularly replenished. The required quantity of replenisher depends on both the amount of processed material and the solution carry-over. For roller and continuous processors with average carry-over rates, the following table gives the standard replenishment rates. These may be used as starting points for other replenishing-type processing systems. In all cases, however, the process control system developed specifically for the P-18 process should be used. It is described in the section on Process Control Procedures which follows.

STANDARD REPLENISHMENT

Replenisher quantities are as follows:

Standard Units	Replenisher		
	Developer	Bleach	Fixer
Milliliters per square foot	47 ml (1.6 oz.)	93 ml (3.1 oz.)	56 ml (1.9 oz.)
Milliliters per square meter	500 ml (16.9 oz.)	1000 ml (33.8 oz.)	600 ml (20.3 oz.)

The Compact Photo-Lab-Index

Replenisher quantities for standard sheet sizes are as follows:

Sheet Size	Replenisher Solution		
	Developer	Bleach	Fixer
8 × 10 inches	26 ml (.9 oz.)	52 ml (1.8 oz.)	31 ml (1 oz.)
11 × 14 inches	50 ml (1.7 oz.)	99 ml (3.3 oz.)	59 ml (2 oz.)
12 × 16 inches	62 ml (2.1 oz.)	124 ml (4.2 oz.)	74 ml (2.5 oz.)
16 × 20 inches	102 ml (3.4 oz.)	206 ml (7 oz.)	124 ml (2.5 oz.)
20 × 24 inches	155 ml (5.2 oz.)	310 ml (10.5 oz.)	186 ml (6.3 oz.)

Replenisher quantities per foot of standard roll widths are as follows:

Roll Width	Replenisher Solution		
	Developer	Bleach	Fixer
5 inches (12.7 cm)	20 ml (.7 oz.)	39 ml (1.3 oz.)	23 ml (.8 oz.)
8 inches (20.3 cm)	31 ml (1 oz.)	62 ml (2.1 oz.)	37 ml (1.3 oz.)
11 inches (27.9 cm)	43 ml (1.5 oz.)	85 ml (2.9 oz.)	51 ml (1.7 oz.)
12 inches (30.5 cm)	47 ml (1.6 oz.)	93 ml (3.1 oz.)	56 (1.9 oz.)

However, each processor system has unique characteristics. Therefore, the standard replenishment rates may have to be adjusted to compensate for individual processor variations.

Replenishment for the carry-over caused by the transport band in continuous processors is normally not necessary. If, however, little or no material is processed over a long period with the transport band (or chain) running continuously, then the carry-over caused by the transport mechanism must be compensated for by extra replenishment.

AUTOMATIC METERING DEVICES

Modern roller and continuous processor generally have automatic metering devices for solution replenishement, which can be adjusted to deliver the required quantities of replenishers per measured area of processed print material. These devices are generally quite reliable, but it is important to check the delivery system and control settings by measuring the actual amount of solution delivered at any particular setting.

REPLENISHING TANK LINES

Two factors must be taken into account when replenishing tank lines. The first is fairly straightforward and easy to calculate. The line must be replenished for the amount of material processed. This can be calculated by using the last three charts.

The second factor must take into account the amount of solution carried out by the hangers or baskets used in processing. A large mesh-type basket can carry out a significant amount of solution, while film-type hangers normally will carry out considerably less. In order to arrive at a reasonably accurate determination, the following procedure should be used.

1. Weigh and record the dry weight of the processing basket or hangers.

2. Immerse the basket or hangers in a tank filled with water and agitate to eliminate trapped air.

3. Remove the basket or hangers and drain as you normally would during processing.

4. Weigh and record the wet weight of the basket or hangers.

5. The difference in weight between the wet and dry basket hangers can be taken as the

amount of processing solution carried over in milliliters (mls).

6. Multiply this number by a factor of 4.

7. Add this amount of replenisher to the amount calculated for the Cibachrome material and this will be the total amount of replenisher to be added.

8. Before adding the replenisher, note the solution level in the tank. Remove an amount of solution equal to the amount of replenisher to be added. Add the replenisher and then top off with the working solution previously taken out to restore the original level. This will serve to keep the activity level of the P-18 solutions at their optimum.

However, over a period of time, the photographic performance of the solutions will deteriorate and fresh solutions will have to be substituted. This is due to the fact that certain chemical by-products, as well as gelatin and silver, will build up with time and use, and these will cause a loss of photographic image quality.

The point at which replenished solution in a tank line should be replaced is best defined in terms of maximum throughput, as indicated in the following table:

MAXIMUM THROUGHPUT OF CIBACHROME PRINT MATERIAL TYPE D IN REPLENISHED P-18 SOLUTIONS USED IN SMALL TANK LINES

Developer Volume	Maximum Throughput in Terms of—		
	8 × 10 Prints	Square Feet	Square Meters
1 gallon (3.7 liters)	70	38.8	3.6
3.5 gallons (13.25 liters)	245	136.0	11.6
10.0 gallons (37.8 liters)	700	388.8	36.1
Bleach & Fixer Volume			
1 gallon (3.7 liters)	95	52.7	4.9
3.5 gallons (13.25 liters)	330	183.3	17.0
10.0 gallons (37.8 liters)	945	525.0	48.7

PROCESSING CIBACHROME P-18 IN SPECIAL SYSTEMS

AUTOPAN PROCESSORS

GENERAL INFORMATION

Cibachrome P-18 may be processed in Autopan drum processors using the standard procedures as for other types of machines. Time and temperature data for the three chemical baths do not change (see earlier chart "Basic Time and Temperature Data"). Wash times and replenishment procedures vary somewhat from the standard techniques, however.

WASH TIMES

The recommended times for the first and second washes (following the developer and bleach steps) should be extended to 1½ minutes in Autopan machines, due to technical reasons associated with this type of processor. It should be noted that the *effective* wash time (total immersion time, excluding filling and drain times) must be *at least* 45 seconds.

The final wash is divided into three parts of 1½ minutes each, using three separate tanks, instead of the usual two tanks. Total time for this step, however, remains the same (4½ minutes).

REPLENISHMENT OF AUTOPAN PROCESSORS

Autopan Color-Automat drum processors have high solution carry-over rates. The quantity of solution carried over per print is greater than with other machines, and is not proportional to the area of material processed.

The required quantity of replenisher solutions per batch is calculated from the solution carry-over in the machine plus carry-over by the developed material. The solution carry-over associated with the machine is constant for each drum width, but the carry-over caused by the material varies in relation to the quantity of material processed. The total of

ILFORD

both carry-over volumes gives the total carry-over used to determine the amount of replenishment.

The quantity of replenisher in relation to the amount of processed material can be determined from the following table.

The addition of replenisher is best carried out before each development. This provides the best way of ensuring constant processing conditions.

Replenisher quantities for each processing cycle for Autopan processors are as follows:

Autopan Drum Width	Solution	
	Developer & Fixer Replenisher	Bleach Replenisher
90 cm drum width	910 ml per cycle plus 54 ml per square foot of print material	1810 ml per cycle plus 110 per square foot of print material
110 cm drum width	1210 ml per cycle plus 59 ml per square foot of print material	2380 ml per cycle plus 112 ml per square foot of print material
140 cm drum width	1420 ml per cycle plus 59 ml per square foot of print material	3000 ml per cycle plus 112 ml per square foot of print material

BASKET LINES

Cibachrome Print Material CCP-D-182 can be processed successfully in basket lines using the Cibachrome P-18 process.

The most common problem encountered is that of "basket marks". This can be easily avoided by employing the following techniques:

a) The developer must be slightly over-replenished, since lack of developer activity accentuates the marks. A 10% over-replenishment is usually sufficient to maintain desired activity.

b) The technique of pre-wetting will help to eliminate basket marks. When the dry basket is loaded, it should be completely immersed in a plain water bath and shaken to ensure that no air bubbles are present and that prints are not stuck to the mesh. The basket should then be drained until most of the water has run off. When the flow of draining water has slowed to a dribble, processing can begin.

c) Strong, sustained agitation will also help eliminate the marks. A gaseous burst in cycle of 2-3 seconds every 5-6 seconds at a pressure of 11-14 pounds per square inch is recommended.

d) After 8 to 10 weeks of high volume throughput, the P-18 developer should be dumped and replaced with fresh developer starter solution. This will avoid problems due to build-up of gelatin and other process by-products.

Further information on replenishing and replacing P-18 solutions in basket lines is given in the section on Replenishing Tank Lines.

TOTAL LOSS PROCESSING

REQUIRED QUANTITIES OF SOLUTIONS

Cibachrome P-18 starter solutions may be used in total loss processing.

The necessary quantity of processing solutions depends on the machine type, the size of the drum used and the loading (heavy or light). Machine manufacturers provide correct solution quantities for each variation and these should be strictly observed.

Large differences in the load, i.e., big variations in the number of sheets introduced into

ILFORD

the same drum, should be avoided since the reproducibility of the process cannot be controlled. With low loading, the prints will be somewhat darker and yellower. With high loads, the prints will be somewhat lighter and redder.

The following table will serve as a guide to the maximum number of prints that may be processed in a given quantity of starter solution. These quantities are based on processing 3.5 square feet of Cibachrome print material per liter of starter solution.

Solution Quantity	Maximum number of prints processed			
	8x10 inches	11x14 inches	16x20 inches	20x24 inches
1 quart (1.056 liter)	6	3	1	1
½ gallon (1.892 liter)	12	6	3	2
1 gallon (3.785 liters)	24	12	6	4

Before each processing cycle, the tube and other parts of the processor must be completely cleaned and dried, and both the processor and all solutions must be brought to the standard processing temperature.

The processing tube or development chamber must remain closed during the total processing cycle in order to maintain constant humidity and temperature.

WASH TIMES AND PROCEDURES

In drum-type processors with total loss processing, the recommended time for the first and second washes is one minute at 82°-90°F (28°-32 °C). No change is required for the final wash procedure, which should run for the standard 4½ minutes.

However, as noted earlier, the final wash must either be divided between 2 separate tanks with a complete change of water in each tank every 1½ minutes, or the water must be changed five times.

PRE-WASHING

Pre-washing of the Cibachrome print material is recommended in one-shot drum or tube processing to promote more even development. Pre-washing time is not critical.

ROTATION SPEED OF THE DRUM

The rotation speed of the drum or tube should be 25 to 28 revolutions per minute, so that the critical "airtime" is reduced to a minimum. Too slow a rotation speed can lead to poor processing uniformity. Bidirectional rotation is recommended.

TIME-TEMPERATURE DATA

The following table give time and temperature recommendations for total loss processing of Cibachrome P-18 in rotating drum machines:

Processing sequence	Time (minutes)	Temperature (°C)	Temperature (°F)	Total elapsed time at end of each step (minutes)
1. Developer	3	30° ± ½°	86° ± 1°	3
2. Wash	1	28° to 32°	82° to 90°	4
3. Bleach	3	30° ± 1°	86° ± 2°	7
4. Wash	1	28° to 32°	82° to 90°	8
5. Fixer	3	30° ± 1°	86° ± 2°	11
6. Final Wash	4½	28° to 32°	82° to 90°	15½
7. Dry		◄70°	◄160°	

ILFORD

The Compact Photo-Lab-Index

PROCESS CONTROL PROCEDURES

GENERAL INFORMATION

Under normal conditions of use, the P-18 process is exceptionally tolerant and stable. However, there are many variables which can influence the activity of the processing solutions, such as a) average density of the processed prints, b) frequency of use, c) throughput volume, d) carry-over of chemistry from one solution to another, and e) actual volumes of replenishers used. Consequently, most processing systems will deviate to some extent from a theoretical standard system.

In any given processing system, small deviations from normal are to be expected due to differences in agitation, time, temperature, and the general characteristics of the given processor. It is more important to run a consistent process than one that matches a master control strip exactly.

In order to detect deviations in the photographic results and keep them within tolerable limits, a sound process control program is required. This should include a) daily processing of P-18 Cibachrome Print Process Control Strips, b) densitometric measurement of prescribed reference steps, and c) plotting of the data on a process control chart. Charting the data will enable the operator to spot process trends early and to take corrective action before the quality of results is impaired.

Process control, however, actually begins much earlier in the processing sequence, with the purchase, storage and preparation of the chemicals. Other requirements for a good process control program are a competent operator, and regular checking and servicing of the processor and its controls, and of the replenishing system and its controls.

THE CHEMICALS

Only chemicals packaged and supplied by Ilford are recommended for use in the Cibachrome Process P-18. This is a silver dye-bleach process. It differs significantly from conventional color processes and therefore requires distinctly different processing solutions.

Storage of the chemicals and of the working-strength solutions is extremely important, since improper storage may result in changes in their properties and quality. Unused chemicals, as noted earlier, should be stored in a cool, dry area away from harmful fumes, moisture and heat. Working-strength P-18 solutions should be stored in covered tanks equipped with floating lids in order to minimize evaporation, oxidation and contamination.

Mixing of the P-18 chemicals should be done by a competent operator, utilizing a separate and properly equipped mixing room and containers of the proper composition, with careful attention to the prescribed procedures.

THE PROCESSOR

A photographic processor, except the very simplest type, normally has controls to regulate temperature, immersion times, and the transport speed. All of these controls must be regularly checked to ensure that the system is operating within the prescribed limits.

Solution temperature is an important factor in photographic systems. The recommended standard temperatures for the P-18 chemical steps and washes must be used. In order to ensure that the correct temperatures are maintained, separate, independent thermostats and temperature controls are recommended *for each bath*, and these should be checked regularly and recalibrated if necessary.

The developer is the only chemical step in the P-18 process which does not go entirely to completion. Thus, the recommended temperatures and processing times for this step must be adhered to, and particular attention must be paid to the machine controls regulating this step.

Agitation plays an important part in photographic processing because it determines, to a great extent, the rate at which fresh solution is supplied to the emulsion surfaces of the print material and by-products are removed. In order to maintain sufficient agitation for each step, the agitation system must be serviced regularly. Failure to do so may result in streaks, mottling and other sensitometric problems on the finished prints. In addition, agitation in the bleach step is critical in regulating the dye and silver bleaching rates that occur simultaneously. Thus, a minimum agitation level is necessary.

ILFORD

The Compact Photo-Lab-Index

THE REPLENISHING SYSTEM

Photographic processing solutions become depleted through use, and through oxidation or other chemical reactions that occur during storage. In the P-18 system, a starter solution is used at the beginning and is replenished by adding a properly formulated replenisher solution. The volume and rate of replenishment, as noted before, is related to the amount of processed material and to the solution carry-over.

In manual replenishing systems, it is important to maintain a constant solution volume, regardless of how much or how little solution is carried out by the film and processing hangers or baskets. This means that sometimes a certain amount of solution must be removed to permit addition of the required quantity of replenisher.

Automatic replenishing systems relieve the machine operator of the burden of remembering and initiating proper replenishment. In such systems, the replenisher often is introduced by means of a pipe into the bottom of the tank. Excess solution drains out through an overflow opening at the top.

It must be remembered that all replenishing tables are based on the assumption that films of an average overall density will be processed at regular intervals at a fairly uniform rate. Occasionally, wide variations in loads may necessitate adjustment in the basic replenishing rates. Also, mechanical or optical systems can malfunction so that replenishment is altered without the operator's knowledge. For all these reasons, it is recommended that the actual consumption of replenishers be compared periodically with the actual area of material processed. Of course, the sensitometric control program will indicate when, and if, an adjustment may be needed to correct undesirable trends.

pH VALUES OF WORKING-STRENGTH SOLUTIONS

Occasionally, other chemical tests may be necessary to check the quality of the processing solutions. For example, the effects of excessive solution carry-over can be determined by measuring the pH of the solution. This will often confirm or clarify observations made through photographic tests and help to pinpoint the source of a problem.

The pH values of working-strength Cibachrome P-18 solutions are as follows:

Processing solutions	Correct pH value and tolerances
Developer	9.60 ± 0.05
Developer replenisher	9.95 ± 0.05
Bleach	under 1.0
Bleach replenisher	under 1.0
Fixer	6.60 ± 0.05
Fixer replenisher	6.85 ± 0.05

If the pH of the developer and fixer solutions is too low, potassium hydroxide (technical grade) can be added to bring it within tolerance. If the pH is too high, add glacial acetic acid to bring it within tolerance.

With proper care, cleanliness, attention to prescribed procedures, and regular checks of each element of the system, the Cibachrome Process P-18 is extremely easy to use, control and maintain with a minimum of effort on the part of the operator.

MATERIALS AND EQUIPMENT REQUIRED

PROCESSING CONTROL STRIPS

Ilford supplies Cibachrome Process Control Strips for monitoring the P-18 process. These strips have been exposed under precisely controlled sensitometric conditions. Process control strips are provided in boxes of 30: each box containing five separate moisture-proof and light-proof packages of six strips, plus a processed master strip.

Prior to use, control strips should be stored in the original, unopened package in a refrigerator at approximately 50°F (10°C), or in a freezer, until needed. Before opening,

the moisture-proof package should be allowed to come to room temperature for a period of at least ½ hour in order to avoid harmful condensation of moisture on the strip.

The Cibachrome Process Control Strip packages are marked with expiration dates. Strips should not be used after the last day of the month marked on the label unless they have been stored in a freezer since the day they were received. In no case should strips be used longer than 60 days after removal from freezer storage.

Cibachrome Process Control Strips have the following features:

a) Areas of different densities for assessing minimum and maximum density, speed and contrast.

b) A batch number corresponding to the number of the processed master strip. This number is also stamped on the label of the box.

The master strip carries a printed serial number at one end and may only be used for comparison with test strips of the same serially numbered pack.

DENSITOMETER

For precise control of the processing system, the control strips must be measured with an accurate color reflection densitometer. Visual evaluation of the strips does not yield sufficiently accurate readings to provide all necessary information and to detect trends in solution activity.

The densitometer must be equipped with the Status "A" or the following filters:

1) Blue filter—Wratten #94 or equivalent
2) Green filter—Wratten #93 or equivalent
3) Red filter—Wratten #92 or equivalent.

These filters are available with most densitometers.

Prior to use, the densitometer must be properly calibrated according to the manufacturer's instructions. Most manufacturers provide calibration materials for this purpose.

CONTROL STRIP MEASUREMENT

In evaluating the control strips, only the steps of the gray scale with red numbers are involved:

Step 1: White step
Step 7: Light-gray step
Step 12: Dark-gray step
Step 23: Black step (unexposed)

At the start, steps 1, 7, 12, and 23 of the processed master control strips are measured with red, green and blue filters, and the densities recorded. These values then serve as references, to which the densities on the control strips processed in the user's system will be compared.

For example, you may determine the following values when you measure the processed master control strips:

	Densities of Master Control Strip		
	Blue	**Green**	**Red**
Step 1: White step	0.08	0.07	0.05
Step 7: Light-gray step	0.30	0.33	0.29
Step 12: Dark-gray step	1.20	1.15	1.18
Contrast: Step 12 minus step 7	0.09	0.82	0.89
Step 23: Black step	2.18	2.10	2.04

Density readings from step 1 measure fog level, and densities from step 7 measure speed (higher densities than the control strip indicate lower speed, lower densities indicate higher speed). The difference in density between steps 7 and 12 gives a contrast evaluation. An increase in the value of steps 12-7 indicates a gain in contrast; a decrease indicates a loss in

contrast. The density from step 23 indicates maximum (unexposed) density of the material.

The control strips processed in your own processing system are measured in exactly the same way as the master strip (steps 1, 7, 12, and 23), and the deviations are determined by subtracting these values from the corresponding densities of the master strip.

Example:

	Density		
	Blue	**Green**	**Red**
Step 1 (Density Minimum)			
master strip	0.08	0.07	0.05
control strip	0.07	0.05	0.05
deviation from standard	−0.01	−0.02	0.00
Step 7 (Speed)			
master strip	0.03	0.33	0.29
control strip	0.28	0.30	0.31
deviation from standard	−0.02	−0.03	+0.02
Step 12—Step 7 (Contrast)			
master strip	0.90	0.82	0.89
control strip	0.94	0.84	0.84
deviation from standard	+0.04	+0.02	−0.05
Step 23 (Density Maximum)			
master strip	2.18	2.10	2.04
control strip	2.23	2.04	2.04
deviation from standard	+0.05	−0.06	0.00

Deviations from the standard densities of steps 1, 7, 12 minus 7, and 23 are plotted directly on a control chart. The trends of the curves as plotted on the chart provide information about processing uniformity and are described at length in the following section.

ANALYZING THE RESULTS OF CONTROL STRIP MEASUREMENTS

Each process is subject to random fluctuations that result from normal variations in control strips, processor performance, and evaluation of the control strips. The quality control chart should be monitored with this in mind. Corrective action should not be taken on the basis of a variation determined from a single control strip but only after additional control strips confirm the existence of a significant variation. Don't forget to check the densitometer against its calibration standards before making a recheck of a control strip.

Some potential causes of one-time fluctuations are:

1) Scratched, dirty, or finger-printed control strips.
2) Densitometer incorrectly calibrated.
3) Control strip compared to the master strip of a different batch.
4) Incorrect calculation.
5) Intermittent mechanical or electronic failure.

If a definite trend away from normal is observed (indicating a small but continuous change of processing conditions), the following problems may be responsible:

1) Repeated over- or under-replenishment.
2) Use of partially or badly deteriorated replenishers.
3) Slow, but steady contamination of a processing solution due to use of improperly mixed replenisher, inadequate washing, a leak, or improper processor construction materials.
4) A malfunctioning heat control device or circulation pump failure.

5) An undetected gradual change in machine speed (usually the result of motor trouble).

A consistent out-of-control situation would indicate that one of the process variable is off its standard set point, e.g., incorrect processing times, incorrect agitation, or too high or too low temperatures.

The following list will aid in identifying the causes of out-of-control situations as indicated by the plots of control strip readings.

Problem:	Photographic speed too high (step 7). Contrast normal (step 12 minus step 7).
Possible Causes:	Process temperature too high. Developer temperature too high.
Problem:	Red speed high. Blue contrast slightly high.
Possible Causes:	Bleach temperature too high.
Problem:	Photographic speed too low (step 7). Contrast too low (step 12 minus step 7).
Possible Causes:	Developer under-replenished.
Problem:	Photographic speed high (step 7). Blue and green contrast high, red contrast low.
Possible Causes:	Bleach under-replenished.
Problem:	Photographic speed too low. Contrast normal.
Possible Causes:	Bleach over-replenished.

In the P-18 process, the bleach solution has the greatest effect on image quality, and especially on image contrast and overall density (speed). Nevertheless, development is the only critical processing step. Contrary to the bleach and fixing steps, the development process continues slowly after the end of the prescribed processing time. Therefore, tight limits are placed on development with respect to time and temperature.

PROCESS CONTROL OF CIBACHROME PROCESS P-18

TROUBLE SHOOTING

ANALYZING OUT-OF-CONTROL SITUATIONS

The best way to prevent most processing faults is to follow processing instructions carefully, along with regular servicing and cleaning of the processor and the storage and mixing tanks at four-month intervals.

Deviations from the standard trends and other errors are usually caused by:

Variations in mixing and/or processing formulas as well as incorrectly read instructions.

Shortcomings, defects or dirt in the processor, storage tanks or feed pipes.

Contaminated processing solutions.

Overaged replenisher solutions.

When the process is out of control (i.e., results clearly deviate from standard or show up as a trend on the control chart); or other faults, such as fog, stains or uneven results, occur; then the cause of the problem can best be determined by a careful, systematic check. The interpretation of faults seen on test strips or pictures is easier and more accurate if these two questions are answered first:

What has changed?

What has not changed?

The answers to these questions can establish clearly whether a fault (i.e., a change) has really occurred and in what way it has manifested itself.

For this purpose, you'll find the following checklist helpful:

ILFORD

459

The Compact Photo-Lab-Index

changed unchanged

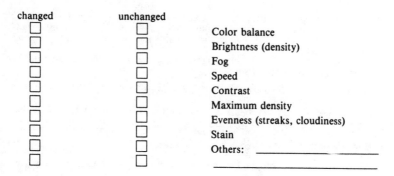

Color balance
Brightness (density)
Fog
Speed
Contrast
Maximum density
Evenness (streaks, cloudiness)
Stain
Others: _____

SIDE TESTING PROCEDURE

Effective troubleshooting of any process requires a reasoned, systematic approach to the problem. Such an approach will insure that the problem is solved in the least possible time and with a minimum of effort. Accordingly, certain basic principles must be followed.

One of the most important principles of troubleshooting is to change only one variable at a time. By doing this, it is easy to find the exact cause of the problem and, possibly, to prevent it from happening again.

In most photographic processes, the easiest way to accomplish this is through the use of the "side test" technique. In this procedure, a small quantity of fresh solution is mixed and is used for testing each step of the process. Usually one control strip is run through the normal process and one through the "side test" process. The illustrations below detail this method:

It is particularly easy to mix small quantities of P-18 solutions for side testing because they are all in liquid concentrates. Refer to mixing instructions mentioned earlier.

In example A, strip #1 is run through the regular process. Strip #2 is developed in the fresh developer and then put back in the regular process from completion. Side testing the developer has been completed. After processing, both strips are evaluated, and, if no difference is found, then it is a reasonable assumption that the process developer is good.

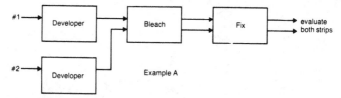

In example B, we are evaluating the bleach in the same manner that we evaluated the developer in the previous example.

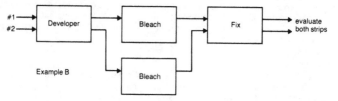

The Compact Photo-Lab-Index

This technique is carried out until the faulty processing solution is determined. At that point, it is a simple matter to change the suspect process solution and regain control of the process.

As a cautionary note, one must remember to be sure that the temperature and agitation of the side test solution is similar to that in the regular processor. It is also wise to run the strips side by side, except for the side test, in order to further minimize differences.

PROCESSING FAULTS, THEIR CAUSES & CURES

In the following table a selection of possible faults are given, along with possible causes.

Once the origin of the problem is found, it can usually be quickly corrected. Basically, all processing faults caused by changes in the chemistry composition (such as gross under- or over-replenishment, contamination, oxidation and old solution) should be corrected by discarding the solution at fault and replacing it with fresh solution.

Fault noticed on test strips or pictures	Possible causes of fault	Remarks
Yellow or yellow-green darker. (colors producing partial black)	*Developer:* temperature too low; time too short, under-replenished	Discard the under-replenished developer and replace with fresh solution.
	Transport speed in processor is too fast.	
	Thermostat incorrectly set or defective; replenishment rate too low, wrongly set or defective.	Repair and/or reset thermostat, replenishment or transport system.
Blue or blue-magenta, lighter, rather contrasty	*Developer:* temperature too high; time too long, over-replenished	Discard the over-replenished developer and replace with fresh solution.
	Transport speed in processor is too slow.	Repair and/or reset thermostat, replenishment or transport system.
	Thermostat incorrectly set or defective; replenishment rate too high, wrongly set or defective.	
Reddish, somewhat lighter	*Bleach:* temperature too high	Repair and/or reset thermostat.
	Thermostat incorrectly set or defective.	
Blue-green (cyan) slightly darker	*Bleach:* temperature too low, over-replenished	Discard over-replenished bleach bath and replace with fresh solution.
	Thermostat incorrectly set or defective; replenishment rate too high, wrongly set or defective transport system.	Repair and/or reset thermostat. Repair replenishment or transport system.
Gray-brown silver fog in light parts of the print; cyan prints.	*Bleach:* Temperature much too low.	Repair and/or reset thermostat.
	Thermostat incorrectly set or defective.	

ILFORD

The Compact Photo-Lab-Index

Fault noticed on test strip or pictures *(continued)*	Possible causes of fault *(continued)*	Remarks *(continued)*
Definite yellow-brown, matt surface or prints density.	*Fixer*: temperature much too low, time too short, under-replenished.	Discard under-replenished fixer and replace with fresh solution.
	Transport speed in processor is too fast.	Repair and/or reset thermostat.
	Thermostat incorrectly set or defective.	Repair replenishment or transport system.
	Replenishment rate too low, incorrectly set or defective transport system.	
Red-magenta shadows in prints; highlights cyan especially somewhat brighter	*Bleach:* under-replenished, too little or no agitation during the first 30 seconds.	Discard old bleach bath and replace with fresh solution.
	Replenishment rate too low, incorrectly set or defective transport system.	Repair replenishment system. Check and adjust agitation system.
	Agitation system too weak or failing. Outlet holes blocked.	
Strongly blue-violet bluish and too low maximum density.	*Developer contaminated with fixer*	
	Mixing tanks contaminated; wrong mixing tank used for developer.	Pour out developer and replace with fresh solution.
	Backwards carry-over in processor by the transport belt or chain, possibly through inadequate final washing.	
Light stains with dark edges	Material splashed or wetted with water before processing.	
Light-red stains in *light* parts of picture.	Material splashed with fixer after the final wash.	Fault can be rectified by re-fixing and washing.
Dark-red stains and streaks in dark and black parts of picture.	Material splashed with developer or bleach after the final wash.	Fault can be rectified by re-fixing and re-washing.

ILFORD

SQUARE FEET CONVERSION TABLE

CONVERSION OF VARIOUS STANDARD SHEET SIZES TO SQUARE FEET
OF PRINT MATERIAL

Number of Prints	Print Size				
	8x10	11x14	12x16	16x20	20x24
1	0.56	1.07	1.33	2.22	3.33
2	1.11	2.14	2.67	4.44	6.67
3	1.67	3.21	4.00	6.67	10.00
4	2.22	4.28	5.33	8.89	13.33
5	2.78	5.35	6.67	11.11	16.67
6	3.33	6.42	8.00	13.33	20.00
7	3.89	7.49	9.33	15.56	23.33
8	4.44	8.56	10.67	17.78	26.67
9	5.00	9.62	12.00	20.00	30.00
10	5.55	10.69	13.33	22.22	33.33
11	6.11	11.76	14.67	24.44	36.67
12	6.67	12.83	16.00	26.67	40.00
13	7.22	13.90	17.33	28.89	43.33
14	7.78	14.97	18.67	31.11	46.67
15	8.33	16.04	20.00	33.33	50.00
16	8.89	17.11	21.33	35.56	53.33
17	9.44	18.18	22.67	37.78	56.67
18	10.00	19.25	24.00	40.00	60.00
19	10.55	20.32	25.33	42.22	63.33
20	11.11	21.39	26.67	44.44	66.67
21	11.67	22.46	28.00	46.67	70.00
22	12.22	23.53	29.33	48.89	73.33
23	12.78	24.60	30.67	51.11	76.67
24	13.33	25.67	32.00	53.33	80.00
25	13.89	26.73	33.33	35.56	83.33

ILFORD

SQUARE METERS CONVERSION SCALE

CONVERSION OF VARIOUS STANDARD SHEET SIZES TO SQUARE METER OF PRINT MATERIAL

Number of Prints	Print Size				
	8x10	11x14	12x16	16x20	20x24
1	0.05	0.10	0.12	0.21	0.31
2	1.10	0.20	0.25	0.41	0.62
3	0.15	0.30	0.37	0.62	0.93
4	0.21	0.40	0.50	0.83	1.24
5	0.26	0.50	0.62	1.03	1.55
6	0.31	0.60	0.74	1.24	1.86
7	0.36	0.70	0.87	1.44	2.17
8	0.41	0.79	0.99	1.65	2.48
9	0.46	0.89	1.11	1.86	2.79
10	0.52	0.99	1.24	2.06	3.10
11	0.57	1.09	1.36	2.27	3.41
12	0.62	1.19	1.49	2.48	3.72
13	0.67	1.29	1.61	2.68	4.02
14	0.72	1.39	1.73	2.89	4.33
15	0.77	1.49	1.86	3.10	4.64
16	0.83	1.59	1.98	3.30	4.95
17	0.88	1.69	2.10	3.51	5.26
18	0.93	1.79	2.23	3.72	5.57
19	0.98	1.89	2.35	3.92	5.88
20	1.03	1.99	2.48	4.13	6.19
21	1.08	2.09	2.60	4.33	6.50
22	1.14	2.18	2.72	4.54	6.81
23	1.19	2.28	2.85	4.75	7.12
24	1.24	2.38	2.97	4.95	7.43
25	1.29	2.48	3.09	5.16	7.74

ILFORD

SAFETY PHOTOGRAPHIC FILM:

CIBACHROME COMPLIANCE

The American National Standard provides specifications and test procedures for establishing the safety of photographic film with respect to hazards from fire. The specifications apply to both unprocessed and processed film on any type of currently known plastic support.

If an additional treatment, such as a lacquer coating, has been applied after processing, the safety characteristics may or may not be affected. In case of doubt, both unprocessed and processed films must be tested.

Photographic films are classified as safety photographic film if they are difficult to ignite, slow burning, and low in nitrate nitrogen content.

Cibachrome products are considered safety photographic films, since they meet all criteria as defined by the standard. The criteria and their definition is indicated below:

1. Ignition time
Photographic films are classified as difficult to ignite when the ignition time is greater than 10 minutes at 300°C.

2. Burning time
Photographic films having a thickness equal to or greater than 0.08mm (0.0032 in.) are classified as slow burning when the burning time is not less than 45 seconds.

3. Nitrogen content
Photographic films that have a nitrate nitrogen content less than 0.40% by weight are classified as having a low nitrate nitrogen content.

The following is test data generated based upon this standard:

TEST DATA BASE

	Triacetate Base (CCP-D)	Polyester Film (CRT&CCT)	Opaque Polyester	Laminated Paper (CRC)	Safety Base Requirement
Ignition Time	►10 min.	►10 min.	►10 min.	►10 min.	►10 min.
Burning Time	Samples do not burn after 5 cm flame dies			270 sec.	45 sec.
Nitrogen content of	◄0.002%	◄0.3%	◄0.3%	◄0.4%	◄0.4%

Reference: ANSI PH 1.25-1974

ILFORD

THE CIBACHROME SYSTEM
HOW CIBACHROME IS DIFFERENT FROM OTHER PRINT MATERIALS

CHARACTERISTICS

Figure 1: The effective color response characteristics of Cibachrome print material.

In the Cibachrome process, the three sensitive silver halide layers are sensitized for blue, green and red light. The blue sensitive layer contains a yellow dye, the green sensitive layer a magenta dye, and the red sensitive layer a cyan dye.

Unlike conventional chromogenic processes in which dyes are formed from color couplers during processing, the pure azo dyes used in the Cibachrome process are incorporated in the silver halide layers during manufacture.

The high quality dyes used in Cibachrome have far better color saturation than most conventional chromogenic materials and have significantly superior stability.

Figure 2: During print exposure, light scatters in conventional chromogenic materials as it bounces from one silver halide crystal to another.

In Cibachrome material, however, the dyes that are incorporated into the silver halide layers act as a screen to help prevent light scatter during exposure. As a result, image sharpness is exceptionally good.

Figure 3: The combination of less light scatter during exposure, as illustrated in Figure 2, and the fact that many slide materials have little or virtually no grain will give you extremely sharp Cibachrome prints.

Figure 3 illustrates the resolution of a chromogenic negative-positive paper via internegative, of chromogenic positive-positive paper and of Cibachrome print material, showing that Cibachrome has superior resolution.

CIBACHROME PRINT MATERIAL

Cibachrome print material consists of a white opaque support coated with light-sensitive emulsion layers and auxiliary layers on one side, and a matte, anticurl gelatin layer on the opposite side.

When unexposed, unprocessed material is viewed in white light, it appears dark brownish-gray from the front (emulsion side) and pure white from the back.

Cibachrome print material is packaged in light-tight, hermetically-sealed plastic pouches which protect it from moisture and other harmful vapors until the seal is broken.

STORAGE

Unopened packages of Cibachrome print material may be kept at temperatures near 70°F for periods of several months. For longer storage, refrigeration is recommended. After refrigeration, the material should be allowed to come to room temperature before opening the package to avoid moisture condensation on the emulsion layer.

Opened packages of Cibachrome print material should not be refrigerated, but kept at normal room temperature.

BASIC FILTER PACK INFORMATION

On the back of each package of Cibachrome-A print material is a printed label listing the basic filter pack information for each of the following types of slide film material: Kodachrome, Ektachrome, Agfachrome and Fujichrome. The filter pack recommendation for Kodachrome can be used also for GAF slide films.
For example:

BASIC FILTER PACK

	Kodachrome	Ektachrome	Agfachrome	Fujichrome
Y	60	65	55	70
M	00	00	00	15
C	15	15	05	00

ILFORD

The Compact Photo-Lab-Index

This chart indicates that under standardized average printing conditions, like those used at the factory, a filter pack of Y 60, M 00 and C 15, would provide optimum color reproduction of a properly exposed and processed Kodachrome slide.

Therefore, *when you make your first Cibachrome print,* use the appropriate filter pack listed on the back of the print material envelope for the specific type of slide film you are printing.

For a variety of reasons, however, the test conditions in the factory may be different from the working conditions in your own darkroom, and therefore you may need to "adjust" the basic filter pack to get a proper color balance in your print.

Suppose, for example, that upon using the filter pack listed on the pack of print material your first Cibachrome print was too magenta and that you had to add Y 15 and C 15 (equals green 15) to get a correctly balanced color print to match the Kodachrome slide. Your "adjusted" filter pack would then be:

Basic filter pack from envelope:	Y 60	M 00	C 15
Your "system correction factor":	+ Y 15		+ C 15
"Adjusted" filter pack:	Y 75		C 30

The "adjusted" filter pack of Y 75 and C 30 would then be used for all Kodachrome slides with that particular package of Cibachrome print material. To shift to other types of slide films, simply apply your "system correction factor" of + Y 15 and + C 15 to the filter values shown on the print material package for the type of slide film to be printed. For example, your Ektachrome filter pack would be Y 80 and C 30 instead of the recommended Y 65 and C 15 as listed on the package.

The inherent color balance of Cibachrome print material, like that of all other color printing material, varies to some extent from batch to batch. For that reason you may find different basic filter pack information on different batches of Cibachrome print material.

Once you determine your "system correction factor" for your first batch of Cibachrome print material, merely apply the same factor to the filter pack data on the next package of Cibachrome you use.

EXAMPLE:

1st package of Cibachrome print material purchased:

Kodachrome data (on 1st package):	Y 60	M 00	C 15
Your "system correction factor":	+ Y 15		+ C 15
"Adjusted" filter pack for 1st package:	Y 75		C 30

2nd package of Cibachrome print material purchased:

Kodachrome data (on 2nd package):	Y 50	M 00	C 20
Your "system correction factor":	+ Y 15		+ C 15
"Adjusted" filter pack for 1st package:	Y 65		C 35

3rd package of Cibachrome print material purchased:

Kodachrome data (on 3rd package):	Y 65	M 05	C 00
Your "system correction factor":	+ Y 15		+ C 15
"Adjusted" filter pack for 1st package:	Y 80	M 05	C 15

Because the combination of yellow, magenta, and cyan filters in the same filter pack would create neutral density and reduce the light intensity, it is desirable to eliminate the neutral density from the filter pack by subtracting the lowest filtration factor in the same amount from each of the 3 filter colors; that is subtract Y 05, M 05, and C 05.

Therefore, the "adjusted" filter pack for the 3rd package would be:

Y 80	M 05	C 15
− Y 05	− M 05	− C 05
Y 75	M 00	C 10

The Compact Photo-Lab-Index

Although your system correction factor will tend to remain the same for appreciable periods of time, it may have to be adjusted occasionally owing to aging of your enlarger lamp and filters and changes in processing procedures, etc. However, the Cibachrome system is quite tolerant to color balance changes and you will find it easy to secure good results consistently.

CIBACHROME CHEMISTRY

Caution: Read carefully and follow all directions, and observe all cautions printed on packages and labels. Cibachrome chemicals are not to be used by children except under adult supervision.

Keep out of reach of children.

It is recommended that clean rubber gloves be used in all mixing of chemicals and whenever chemicals can come in contact with the skin. Remove spilled solutions from all surfaces in the darkroom.

MIXING

There are only three solutions required for processing Cibachrome print material: Step 1: developer; Step 2: bleach; Step 3: fixer.

In mixing the chemicals, be sure to follow all the directions in the instruction sheet carefully as errors in preparation can cause various faults in final prints.

Use clean vessels for mixing, and wash and rinse carefully after use to avoid contamination.

The developer can be mixed to make 1 quart at a time (for ten 8×10 inch prints); or ½ gallon at a time (for twenty 8×10 inch prints); or you may mix for individual 8×10 prints by following directions on the instruction sheet contained in each chemistry set.

The bleach can be mixed to make multiples of 1 quart at a time. See package directions.

The fixer can be mixed to make multiples of 1 quart at a time. See package directions.

Complete processing directions for both the drum and tray techniques follow.

STORAGE

All Cibachrome chemicals should be stored at room temperature in well sealed glass or polyethylene bottles.

The concentrated stock solution will keep for several months in the tightly sealed bottles. Part 1B of the developer may turn yellowish on extended storage, but this will not affect its strength nor stain prints.

Storage life of the working solutions at room temperature is as follows:

Developer:	4 weeks—full bottle, 2 weeks—partially full bottle
Bleach:	4 to 6 months
Fixer:	4 to 6 months

REQUIREMENTS FOR CIBACHROME COLOR PRINTING

ENLARGER

Your enlarger need not be elaborate, but should have:

A color-corrected projection lens of at least an $f/4.5$ maximum aperture.

Preferably a 150 or 100 watt lamp; however, a 75 watt lamp will be satisfactory if the enlarger has efficient utilization of light.

A color head, or a filter drawer or system to hold the filters, preferably between the light source and the slide to be projected.

A heat absorbing glass in the enlarger head.

Optionally, a voltage regulator for the enlarger, especially if your electrical supply is subject to voltage fluctuation of more than ± 10 volts.

ILFORD

The Compact Photo-Lab-Index

FILTERS

As with all color print processes, you will need an assortment of color-printing filters including

an ultra-violet absorbing filter

yellow:	.05	.10	.20	.30	.40	.50
magenta:	.05	.10	.20	.30	.40	.50
cyan:	.05	.10	.20	.30	.40	.50

It is recommended you use Cibachrome color printing filters available from your photo dealer.

Cibachrome filters are polyester film supplied in two size filter sets: 6×6 inch filters for large format enlargers and $3\frac{1}{2} \times 3\frac{1}{2}$ inch filters for most home darkroom enlargers.

The Cibachrome filter set contains yellow, magenta and cyan filters in densities of .05, .10, 20, .30, .40 and .50. A UV absorbing filter is also included in the filter set.

DRUM OR TRAYS

For drum processing, it is recommended you use the unique Cibachrome drum processor available from your photo dealer.

The Cibachrome processing drum is a new concept in design to make daylight processing of Cibachrome simple, enabling the user to change from and 8×10 inch drum to an 11×14 inch drum by changing the center tube portion.

In addition to the 8×10 inch drum to an 11×14 inch tube, Cibachrome drums are also available in 4×5 inch and 16×20 inch size.

For tray processing, hard rubber, plastic or type 316 stainless steel trays are ideal. If you use enamelled trays, be sure there are no chips in the enamel surface, or any rust spots.

For most efficient use of chemicals in tray processing, the bottom of the trays should be flat, with neither ridges nor depressions.

MISCELLANEOUS NECESSITIES:

You should also have available:

A photographic thermometer accurate to $\pm \frac{1}{2}°F$, such as the Cibachrome thermometer available at your photo dealer.

A darkroom timer or clock.

Clean bottles for Cibachrome chemistry, either glass or polyethylene. For ease in mixing, use wide-neck bottles of a least $\frac{1}{2}$ gallon capacity.

Rubber gloves for mixing chemicals, or anytime your hands may come in contact with the chemicals. **Gloves are essential for tray processing.**

Measuring cups for chemistry. Each Cibachrome chemistry kit provides three specially marked cups for your convenience.

Optional equipment:

The Cibachrome exposure monitor to provide simple and precise exposure determination when printing from color transparencies onto Cibachrome print material. Available in two different models.

The Cibachrome processing drum motor base which accepts drums from 8×10 to 16×20 inches in size and assures correct agitation of Cibachrome chemistry for consistent results.

GENERAL INFORMATION

The first and most important thing to remember in printing Cibachrome material is that it is a *direct positive* material. That means it reacts to exposure variations and changes in the same way as reversal color film, such as Kodak Ektachrome and Kodachrome or Agfachrome, which you use in making your slides.

As you know, these materials respond to changes in light just as you would expect; that is, more light gives you a lighter image, and less light a darker image. By the same token, if the light becomes more yellow, the direct positive color image becomes more red, etc. As a result, it is quite simple to estimate what changes to make and the extent of correction once a first test print has been made with Cibachrome print material.

The Compact Photo-Lab-Index

You will see your slide in natural color and will find it easy to adjust the magnification and cropping to obtain just the effect you want in the final print.

If you have experience in making black-and-white prints or color prints from *negative* films, you will have to remember to use just the opposite correction in Cibachrome printing. The difference in exposing Cibachrome and conventional negative-to-positive materials are summarized later for ready reference.

SELECTION OF STANDARD SLIDE

It is important that you first select a slide to be used as a standard, then print, process, and adjust the color balance until you get a color print to your satisfaction. Use that same filter pack as the starting point for later prints from other slides on the same type of film.

You will find that you need a different basic filter pack for each different type of color film you use (Kodachrome, Ektachrome, Agfachrome, Fujichrome, etc.).

In selecting a slide to be used as a standard, be sure that it incorporates the following characteristics:

Flesh tones or neutral grays, normal overall density (within ½ stop of normal exposure), good color balance, good range of colors.

The inclusion of flesh tones or neutral grays is vital because your color balance should be corrected to these tones in order to assure a satisfactory filter pack for succeeding prints.

IDENTIFICATION OF CIBACHROME EMULSION SIDE

The emulsion side of Cibachrome print material is smooth, but the back side is almost as smooth, and it may be difficult at first to determine the emulsion side in total darkness.

If you have difficulty in feeling the difference, try swishing your thumb across one side at a time while holding it close to your ear. You will hear a "whisper" from the **back** side, and no sound from the emulsion side.

As an added aid, remember that all Cibachrome-A print material is packed in a black inner envelope with the emulsion side **facing** the label glued onto the black inner envelope.

If you should make a mistake and try to expose through the back side, you will be able to tell during exposure. The emulsion side is dark gray, and the back side is white.

RECIPROCITY FAILURE

This effect refers to the loss in photographic efficiency at low light intensities. With dark slides, a weak light source in your enlarger, or great magnification, you may expect to encounter reciprocity failure and will have to make adjustments in exposure and filter balance. Your print will tend to become darker and more bluish-cyan in color balance. Correct by increasing exposure and adding some yellow and subtracting cyan filtration and increasing exposure as follows:

Initial Exposure Time	To Double Exposure Time Use
10 seconds	21 seconds
15 seconds	35 seconds
20 seconds	48 seconds
30 seconds	78 seconds
40 seconds	112 seconds
50 seconds	150 seconds
60 seconds	192 seconds

These times are approximate and can vary because of line voltage or the equipment used.

ILFORD

The Compact Photo-Lab-Index

DIFFERENCES IN EXPOSING CIBACHROME AND NEGATIVE-TO-POSITIVE MATERIALS

If you have ever made black-and-white prints or conventional color prints from color negatives such as Kodacolor, you have to remember that making Cibachrome prints will be different in these ways:

	Cibachrome	Negative-to-positive
to lighten a print	more light and/or more time	less light and/or less time
to darken a print	less light and/or less time	more light and/or more time
to make significant changes in the density of a print	increase or decrease exposure by 2 times	increase or decrease exposure by only 25%
to make significant changes in color balance	change appropriate filter(s) by at least .20 density	change appropriate filter(s) by .05 density
borders of print if if covered during exposure	will be black	will be white
dust particles, scratches	will appear as black spots or lines...so slides must be carefully cleaned	will appear as white spots or lines
color filter corrections	add color filters as visual appearance requires	will be opposite of Cibachrome corrections

DODGING

To "dodge", which is normally meant to lighten a specific area, you must *add more light* to that area of Cibachrome print. This is generally done by using your hands to block out all of the area not to be lightened, or by using "dodging" kits or *opaque* plastic or cardboard available from your photo dealer.

The amount of extra light to be given to the area depends upon the effect you desire and must be done by judgment or trial-and-error.

BURNING-IN

The technique of "burning-in" a print is just the reverse of "dodging". There will be occasions when you will want to darken an area of your print, and with Cibachrome, you must decrease the amount of light to that area.

If it is a large portion of the print, it can easily be done with your hands by blocking out the area to be "burned-in". If it is a small area, you can use a small piece of *opaque* plastic or cardboard attached to a long wire. Kits are available from your photo dealer.

ILFORD

The Compact Photo-Lab-Index

PROCEDURES

Use the filter pack recommended on the back label of the Cibachrome "A" print material package for the type of slide film you will use. (See Basic Filter Pack Information on previous page.)

INITIAL EXPOSURE PROCEDURE

Insert filter pack as suggested above, *plus* the UV absorbing filter, adjust the enlarger for the print size you desire. Focus sharply on the reverse side of a previously processed piece of Cibachrome or double-weight paper; set exposure as follows:

If you have a direct reading light meter, remove your slide and leave filters in place. Set the meter on the easel and adjust the f/stop to secure a reading of 0.5 foot candle. Replace slide and set exposure for 9-12 seconds. Of course, if your enlarger gives less light, the exposure time will have to be increased proportionally, e.g., at 0.25 ft/c use 18-24 seconds.

If no meter is available, use one sheet of Cibachrome, and with the exposure mask packed in the inner envelope of the print material, make 4 test exposures. Make test exposures at $f/4.5$, $f/5.6$, $f/8$ and $f/11$ uncovering one section of the print at a time. Exposure time depends upon the light source and enlarger, so use the following guide:

75 watt bulb—50 seconds, 150 watt bulb—35 seconds, 250 watt bulb—25 seconds.

These times are longer than those that may actually be needed, depending upon the efficiency of the enlarger lamp house.

In exposing Cibachrome, it is preferable to adjust the lens aperture and maintain constant exposure time, but if your enlarger does not deliver sufficient light, you will have to increase the time of exposure to obtain a well exposed print.

In TOTAL DARKNESS, insert Cibachrome material into easel or frame, emulsion side up, expose print, process print.

LATITUDE OF CIBACHROME

One of the many advantages of Cibachrome is the great latitude, both in exposure and in filtration.

As you will note in studying your test sheet, you must be bold in making your corrections for exposure, Often, to make a significant change in density, you must increase or decrease your exposure by changing the lens aperture by one to two full stops or by altering the exposure time by a factor of two to four.

Also in making corrections for color balance, a change of at least .20 density in your filters may be necessary.

LATENT IMAGE

The latent image of Cibachrome is very stable. You may process immediately after exposure, or if you wish, prints may be kept at room temperature unprocessed overnight or even over a weekend without noticeable change in overall density or color balance.

CAUTIONS

As in all printing systems, you must beware of:

Lamp aging: Tungsten light changes toward yellow-red bulb aging which will affect filtration. Filter aging: Gelatin or acetate filters can fade with continued use which will affect color balance. Dirt and fingerprints on your enlarger lens will affect the contrast and quality of your print. Large voltage fluctuations; more than ± 10 volts will affect your exposure and color balance.

One of the many advantages of Cibachrome print material is the ability for you to proof your slides directly . . . and at the same time, you can obtain basic information for making an 8 × 10 inch enlargement.

PROCEDURE

Put one slide in your enlarger and adjust the height to make an 8 × 10 inch print from the full frame of the 35mm format.

Remove the slide and insert your filter pack. Set your timer. (You should obtain your

ILFORD

time information when you make a test print with your enlarger, as described previously.)

In darkness, place a sheet of Cibachrome print material, emulsion side up, on your easel, and lay your slides on the print material as shown above.

Expose and process.

Be sure to keep complete data on the: distance of enlarger lens to easel, filter pack, aperture of the lens, time, batch number of the Cibachrome print material used.

The color balance and the density of your proofs will give a good indication of what you will obtain by using the very same exposure conditions in making full 8 × 10 inch enlargements.

By using this technique, you can produce proof prints of up to 20 slides on one 8 × 10 inch sheet and you will be able to quickly and easily determine the exposure and color balance corrections needed for 8 × 10 inch prints.

PROCESSING CIBACHROME PRINT MATERIAL

SUMMARY

1. Remove the exposed Cibachrome print material from the enlarger easel, and slip it into the Cibachrome drum with the emulsion side inward. Pop on drum lid. Then, work in normal room light.

2. Pour the premeasured developer solution into the drum. It will stay in the reservoir cap until the drum is turned on its side. Then the solution is released onto the print and development begins.

3. For the 2-minute development step, agitate the drum vigorously for the first few seconds, then continue rolling it uniformly and gently back and forth. You can also use a motor base for agitation if you wish.

4. At the end of development, turn the drum upright over a pail. Allow the developer to drain out while pouring in the bleach. Tip the drum and agitate for 4 minutes (see agitation directions).

5. At the end of the bleach cycle, drain the bleach into a pail. (Later it will be neutralized before disposal.) Pour in the fixer while the bleach is draining. Tip and agitate for 3 minutes.

6. The fixed Cibachrome print should be washed under running, room-temperature water for a full three minutes. It can then be air dried or dried with an electric fan or a blower-type hair dryer.

DRUM PROCESSING STEPS
TOTAL TIME: 12 MINUTES AT 75°F ± 3°F (24°C ± 2°C)

1. DEVELOP—2 MINUTES

In **Total Darkness**, place the exposed Cibachrome print in the drum (be sure the drum in clean and **Dry**). For one 8 × 10 inch print, pour in 3 ounces (90 ml) of developer and agitate rapidly for the first 15 seconds of development. Then agitate gently and evenly through remainder of the cycle. (See comments on agitation that follow.)

Start draining the developer 15 seconds prior to Step 2. Drain carefully for the full 15 seconds and then add bleach to the drum.

If there is evidence of an unpleasant odor, use a 10 to 15 second water rinse and drain after development on subsequent occasions. To do this, drain the developer as recommended, then quickly pour 3 ounces of 75°F water into the drum and drain for 10 to 15 seconds. Then add the bleach solution.

2. BLEACH—4 MINUTES

Pour in 3 ounces (90 ml) of bleach and agitate rapidly for first 15 seconds and then agitate gently and evenly throughout remainder of cycle.

Start draining the bleach 15 seconds prior to Step 3. Drain carefully for the full 15 seconds and then add fixer to the drum.

If there is evidence of an unpleasant ordor, use a 10 to 15 second water rinse and drain, as described in Step 1 on subsequent occasions. After rinsing, add the fixer solution.

Important: Neutralize used bleach as described on Bleach Neutralizer package and in package instructions included in every Cibachrome P-12 chemistry kit.

ILFORD

3. FIX—3 MINUTES

For each 8×10 inch print, use 3 ounces (90 ml) of fixer and agitate uniformly and gently throughout the entire cycle. Fix for the full 3 minutes, then drain for 5 to 10 seconds.

4. WASH—3 MINUTES

Wash for 3 minutes in rapidly running, clean water at 75 °F.

Total elapsed time: 12 minutes.

To dry, remove the print from the drum, and remove the surface liquid with a soft rubber squeegee or clean chamois cloth. Hang up, or lay flat on a blotter or drying rack (emulsion side up), or use a print dryer designed for resin coated papers.

Approximate drying times:

air drying 1½-2 hours

electric fan, 15-18 minutes

blower-type hair dryer, 6-8 minutes.

Note: A wet Cibachrome print will look somewhat more magenta than a dry print.

Note: The procedure outline above is recommended for 8×10 inch Cibachrome prints. For 11×14 prints, follow the same steps, but use 6 ounces of chemistry. For 16×20 prints, there are *slight changes in procedure.* Be sure to read the special instruction inside the print material package for exposing and processing 16×20 inch print material.

DRUM PROCESSING PROCEDURE

INSERTING THE MATERIAL

Total Darkness is required in inserting the exposed Cibachrome material into the processing drum.

Curve the exposed sheet to be processed into a cylindrical shape with the emulsion side facing in. Make sure the tube is perfectly dry so the print will easily slide all the way in, and will not be damaged when you replace end-cap onto the drum.

Once the cap is securely in place, the lights may be turned on for the remainder of the process.

MEASURING CHEMICALS

Chemicals should be carefully measured in graduated beakers as follows:

4×4 inch print: 1 ounce (30 ml)

8×10 inch print: 3 ounces (90 ml)

11×14 inch print: 6 ounces (180 ml)

16×20 inch print: 12 ounces (360 ml)

Care should be taken to use the same beaker for each component of chemistry every time so there will be no chance of contamination. Rinse well after each use.

Note: Some graduates you may already have in your darkroom may be marked in cc's (cubic centimeters). Cubic centimeters and milliliters (ml) are equivalent measures; therefore you would use 90 cc for an 8×10 inch print.

TEMPERATURE AND TIME

The standard temperature for processing Cibachrome print material is 75 °F.

However, if necessary, you can work with solution temperatures of from 65 °F to 85 °F if appropriate compensation is made in the time of processing (see table below).

	68 °F ± 3 °F (20 °C ± 1½ °C)	75 °F ± 3 °F (24 °C ± 1½ °C)	82 °F ± 3 °F (28 °C ± 1½ °C)
Developer	2½ min.*	**2 min.***	1½ min.*
Bleach	4½ min.*	**4 min.***	3½ min.*
Fix	3½ min.	**3 min.**	2½ min.
Wash	3½ min.	**3 min.**	2½ min.
Total Time:	14 min.	**12 min.**	10 min.

*Includes 15 second drain. See preceding summary of drum processing steps for detailed instructions.

ILFORD

It is important that in any given processing run the temperature of all solutions and of the wash water to be kept within 3° of each other.

An increase or decrease in image contrast equal to about one grade of paper can be achieved through variations in developing time up to ± ½ min. Shorter times will yield lower contrast at some sacrifice in speed, and vice versa.

Unless processing is done under extreme climatic conditions, the short duration of each step should enable you to stay within the prescibed temperature limits. Otherwise, it is recommended that you pre-heat or pre-cool the drum, depending on the temperature condition, and that you roll the drum in a water bath at the proper temperature.

AGITATION

During the development and bleaching steps, agitation during the first 15 seconds should be rapid, vigorous, and somewhat irregular so that no uniform patterns of solution flow are created within the drum that might cause staining. Thereafter agitation should be more gentle and even throughout the remainder of the cycle. If a Cibachrome, or similar, motorized base is used, the drum should be agitated rapidly by hand for the first 15 seconds of the developing and bleaching steps for the reason given above, and then placed on the motorized base for the remainder of the cycle.

CONSISTENT TECHNIQUE

As will all color processes, it is important that you develop a consistent technique and procedure, and that you use them each time you make color prints.

Consistency in work habits will lead to uniformity in color print qulaity.

CAUTION

Read and follow all caution information on packages and labels.

KEEP OUT OF REACH OF CHILDREN.

TRAY PROCESSING STEPS
TOTAL TIME: 12 MINUTES AT 75°F ± 3°F (24°C ± 2°C)

1. DEVELOP—2 MINUTES

Developing Cibachrome print material in trays must be done **in total darkness.**

For each 8 × 10 inch print, pour 3 ounces (90 ml) of developer into a flat-bottomed tray. Three ounces will barely cover the 8 × 10 inch print, and therefore agitation must be continuous and vigorous for the entire cycle.

Start draining the developer 15 seconds prior to Step 2, then rinse briefly in a tray filled with 75°F water, and drain 5 to 10 seconds before placing the print in the bleach tray.

2. BLEACH—4 MINUTES

The first 3 minutes of the bleaching step must be done **in total darkness.**

Use 3 ounces (90 ml) of bleach for each 8 × 10 inch print to be processed, and agitate continuously and vigorously for the entire cycle.

After 3 minutes in the bleach, you may turn on the lights; continue to agitate the solution.

Start draining the bleach 15 seconds before the end of this step, then rinse briefly in clean water, and drain 5 to 10 seconds before placing the print in the fixer tray.

Important: neutralize used bleach as described in package directions enclosed in every Cibachrome P-12 chemistry kit.

3. FIX—3 MINUTES

Use 3 ounces (90 ml) of fixer for each 8 × 10 inch print and agitate continuously and vigorously for the full 3 minutes, then drain for 5 to 10 seconds.

4. WASH—3 Minutes

Wash for 3 minutes in rapidly running, clean water at 75°F.

ILFORD

Total elapsed time: 12 minutes.

To dry, remove the surface liquid with a soft rubber squeegee or clean chamois cloth. Hang up, or lay flat on a blotter or drying rack (emulsion side up), or use a print dryer designed for resin coated papers.

Approximate drying times:

air drying 1½-2 hours

electric fan, 15-18 minutes

blower-type hair dryer, 6-8 minutes.

Note: A wet Cibachrome print will look somewhat more magenta than a dry print.

Note: These instruction are for the benefit of those who prefer tray processing to drum processing. Advantages of trays are the simplicity of equipment and the possibility of processing more than one print at a time. Disadvantages are working in total darkness for 5 minutes and the possibility of scratching prints.

CAUTION

In tray processing, use clean rubber gloves to avoid contact of the solutions with the skin.

TRAY PROCESSING PROCEDURE

TYPES OF TRAYS

Plastic, hard rubber or type 316 stainless steel trays are recommended, but enamelled trays may be used if they are not chipped or rusted.

For processing a single 8 × 10 inch print in just 3 ounces of solution, it is important that the bottom of the tray be flat, with no ridges or depressions.

PROCEDURE

Because step 1 and step 2 are **in total darkness,** you should prepare one tray with developer and one tray with bleach before the lights are turned off.

Although the beginner is well advised to start tray processing with one print at a time following the procedure outlined in the foregoing tray processing steps, the more experienced worker may prefer to process several prints at a time. This can be done successfully with Cibachrome print material provided only that adequate solution volumes are employed; that is, at least 3 ounces per 8 × 10 inch print, and that care is taken to avoid scratching or gouging the swollen and fairly delicate emulsion during interleafing of the sheets. It is essential also that each print of a batch receive the correct treatment time in each solution. This can be assured by immersing and removing the sheets in 10 second intervals, always maintaining the same order.

MEASURING CHEMICALS

Chemicals should be carefully measured in graduated beakers as follows:

4 × 4 inch print: 1 ounce (30 ml)

8 × 10 inch print: 3 ounces (90 ml)

11 × 14 inch print: 6 ounces (180 ml)

16 × 20 inch print: 12 ounces (360 ml)

Care should be taken to use the same beaker for each component of chemistry every time so there will be no chance of contamination. Rinse well after each use.

TEMPERATURE AND TIME

The standard temperature for processing Cibachrome print material is 75 °F.

However, if necessary, you can work with solution temperatures of from 65 °F to 85 °F if appropriate compensation is made in the time of processing (see following table).

It is important that in any given processing run the temperature of all solutions and of the wash water to be kept within 3 ° of each other.

ILFORD

The Compact Photo-Lab-Index

	68 °F ± 3 °F (20 °C ± 1½ °C)	75 °F ± 3 °F (24 °C ± 1½ °C)	82 °F ± 3 °F (28 °C ± 1½ °C)
Developer	2½ min.*	2 min.*	1½ min.*
Bleach	4½ min.*	4 min.*	3½ min.*
Fix	3½ min.	3 min.	2½ min.
Wash	3½ min.	3 min.	2½ min.
Total Time:	14 min.	12 min.	10 min.

*Includes 15 second drain and rinse. See previous detailed instructions.

An increase or decrease in image contrast equal to about one grade of paper can be achieved through variations in developing time up to ± ½ min. Shorter times will yield lower contrast at some sacrifice in speed, and vice versa.

Unless processing is done under extreme climatic conditions, the short duration of each step should enable you to stay within the prescibed temperature limits. Otherwise, it is recommended that you pre-heat or pre-cool the trays, depending on the temperature condition, and that you float the trays in a water bath at the proper temperature.

AGITATION

For a single print, constantly agitate by raising and lowering each of the four sides of the tray to make sure that the entire surface of the sheet is swept over by solution throughout each processing step.

For several prints, agitate by interleafing, continually taking the print from the bottom and placing it on top. Processing prints face down will help reduce scratching of the emulsion.

CONSISTENT TECHNIQUE

It is important that you develop a consistent technique and procedure, and that you use them each time you make color prints.

Consistency in work habits will lead to uniformity in color print quality.

CAUTION

Read and follow all caution information on packages and labels.

KEEP OUT OF REACH OF CHILDREN.

MAKING OVERALL DENSITY AND COLOR BALANCE CORRECTIONS

VIEWING CONDITIONS

After your Cibachrome print has properly dried, it is important to judge the quality under the same kind of illumination as will be used for the ultimate display of the print. Different light sources emit light of significantly different color quality which affects the color balance of the print image. For example, tungsten light is much redder in color quality than white flourescent or daylight, and color prints that look well-balanced under tungsten light will tend to look too cold under daylight conditions.

It is also important that any comparison of your color slide and the Cibachrome print made from it be done by the same illumination. A good method for comparison is to place a neutral white sheet next to the Cibachrome print and to view the transparency against the sheet by the light reflected from the white surface. By following this procedure, you will avoid making incorrect conclusions about the color balance and overall density of the print.

MAKING CORRECTIONS

Before you make color balance corrections, be sure to judge the overall density of the image; i.e., is too dark, too light, or just right. A beginner may misinterpret overall density errors as color balance problems.

ILFORD

If the print is too	add	or subtract
blue	yellow	blue (magenta and cyan)
yellow	blue (magenta and cyan)	yellow
green	magenta	green (yellow and cyan)
magenta	green (yellow and cyan)	magenta
cyan	red (yellow and magenta)	cyan
red	cyan	red (yellow and magenta)

Note: if you view a Cibachrome print while still wet, it will look somewhat more magenta than when completely dry.

In color printing, it is important to remember these 3 basic filter rules:

1. use as few filters as possible, therefore
2. if possible, subtract filters to make a correction rather than add unnecessary neutral density; that is,
3. never have yellow, magenta and cyan filters in the same filter pack as it merely reduced the light intensity.

Because of the great latitude in Cibachrome print material, you must be bold in making filter and exposure changes. Also, if the color and/or exposure are substantially incorrect, it is always advisable to make a test sheet and try several corrections at one time.

CHANGE IN EXPOSURE

With a change in the filter pack, a change in exposure may be necessary, particularly if there are changes in magenta or cyan. The following exposure correction shows the added exposure time you must give if additional filters are used (subtract exposure time if filters are removed):

filter density to be added (subtracted)	.05	.10	.20	.30	.40	.50
yellow	10%	10%	10%	10%	10%	10%
magenta	20%	30%	50%	70%	90%	110%
cyan	10%	20%	30%	40%	50%	60%

Note: normally a 10% change can be ignored because of the wide exposure latitude of Cibachrome print material.

EXPOSURE AND PROCESSING FAULTS
CAUSES AND REMEDIES

Following are a number of faults which may affect your final Cibachrome print if exposing and processing steps are not carefully followed:

Fault Observed	Cause	Remedy
Picture dark reddish in tone and image reversed	Partial or complete exposure through the back of the print material	Reprint the picture. Be careful to have emulsion side up. Use a black printing support (enlarging easel).
Blue spots	Due to static, mainly in dry atmosphere	Handle print material carefully when removing from the envelope.
Black picture, or no picture	No exposure, or omission of Part A or B in either developer, or bleach, or omission of bleaching step.	Reprint under correct conditions. Follow directions closely.

ILFORD

EXPOSURE AND PROCESSING FAULTS (Continued)

Fault Observed	Cause	Remedy
Fogged and dull print	Probably due to incorrectly mixed bleach solution (too diluted), or	Check if bleaching conditions were correct and mixing instructions carefully followed.
	insufficient bleaching due to low temperature or insufficient bleaching time, or	
	developer not drained before bleach was added, or	Reprint and follow correct processing procedures.
	traces or fixer in the developer (for example, drum not sufficiently rinsed before reuse), or	Reprint and follow correct processing procedures
	reversal of fixer and bleach steps	Reprint and follow correct processing procedures.
Formation of yellow stain and relatively short time	Insufficient final wash	Wash print to stop further degradation.
Dark and flat print	Developing time too short	Reprint and follow correct processing procedures.
Yellowish appearance of the print	Bleach not drained before fixer was added, or	Reprint and follow correct processing procedures.
	fixing omitted or fixing time too short	Repeat fixing step and final wash.
Light print with loss of maximum density	Developing time too long	Reprint and follow correct processing procedures.
Streaky and irregular appearance of the print	Insufficient agitation during processing, or insufficient volume of solutions	Reprint and follow correct processing procedures.

SOME COMMON FAULTS:
1. "Light-struck"
2. Exposure through back of material
3. Insufficient agitation
4. Overdeveloped: 4 minutes instead of 2 minutes
5. Underdeveloped: 1 minute instead of 2 minutes
6. Drum not properly washed after use

ILFORD

CREATIVE AND EXPERIMENTAL TECHNIQUES WITH CIBACHROME

COMBINING OR "SANDWICHING" SLIDES

Unlike conventional color negative systems, slides can easily be combined, or "sandwiched", and imaginative color prints may be made directly from the combinations.

This possibility of printing two superimposed slides gives you unusual creative opportunities.

Depending upon the overall density of the combination, you may have to increase exposure to achieve the desired effect in the print.

POSTERIZATION

Posterization, or color tone separation, can be done directly on slide film with conventional methods as described in such publications as *Creative Colour Photograph* by Gareis-Scheerer, or Petersen's *Guide to Creative Darkroom Techniques*.

Other techniques, involving use of reticulated film, texture screens or diazo foils are also readily adaptable to Cibachrome printing.

PHOTOGRAMS IN NATURAL COLOR

Natural color photograms can be easily made directly on Cibachrome print material. Simply place a flower, a leaf, butterflies, stained glass, or any translucent object on a sheet of Cibachrome and expose, using the standard filter pack for that batch of print material. You may have to increase exposure, depending upon the density of the object(s), more than needed for conventional printing from normal slides.

OTHER CREATIVE PROJECTS

Cibachrome print material can be used to make Christmas cards, birthday cards or posters. Lettering can be printed directly onto your print by using "transfer type" on clear acetate, and then printing through the acetate.

Another possible use is that of making lasting color prints of your children's creative artwork directly from the art. The paper your children use should be relatively light-weight bond or tissue, and felt-tipped pens give brilliant color.

Whereas the colors in the original artwork may fade in time, the colors of the Cibachrome print will be brilliant for many years.

Place the artwork directly on a sheet of Cibachrome, lay a piece of clean glass over it to keep it flat, and expose on the enlarger easel. Use the same filter pack you would normaly use for that batch or print material.

RETOUCHING AND MOUNTING CIBACHROME

PROCEDURE

RETOUCHING

The amount of retouching is to be done on your Cibachrome prints will depend largely upon the condition of your slide. **It is essential** to have your slide absolutely clean before enlarging, because as mentioned earlier, dust particles will be printed black. Clean your slide carefully, and after you have placed it in the negative carrier, it is a good idea to recheck it with a magnifying glass or small loupe to make sure all dust particles have been removed.

If the slide has been scratched, apply a small quantity of "no-scratch" solution or oil from you face to help reduce the effect of the scratch, as it may print as a black line.

Black spots on your final Cibachrome prints can best be covered with opaque colors, such as artists' acrylic paints in the proper shade.

Retouching white spots, or adding color to lighter areas, is easily accomplished with

ILFORD

Cibachrome transparent retouching colors. These colors contain the same dyes as are in the Cibachrome print image and have a high resistance to fading.

Cibachrome retouching colors are water soluble and may be applied with a brush or cotton swab. They can be used in any desired concentration, but it is recommended you start with dilute colors. If too much color has been applied, the density of the retouched area can be reduced by prolonged washing (about one half hour).

MOUNTING

Cibachrome prints can be easily mounted with many of the mounting materials available at your photo dealers. The various two-sided adhesive-type sheets and boards work very well, as well as aerosol adhesive sprays, and some brands of dry mounting tissues. Carefully follow the manufacturers' directions for use of their products with Cibachrome print material.

In mounting Cibachrome, extra care must be taken to thoroughly roll out all bubbles and air spaces so that the print is perfectly flat.

Because of the lasting qualities of Cibachrome, it is advisable to use heavy cardboard, or Masonite, as a permanent mount.

Cibachrome prints may be sprayed with Cibachrome lacquer print sprays to protect the finish from fingerprints, dust and scratches, or to change the surface characteristics. Available in glossy, velvet lustre and matte.

REMOVING FINGERPRINTS

Fingerprints on Cibachrome prints may be caused in several ways, among them, touching the image surface of the print with wet fingers before processing, especially if wet with a processing solution...and by touching the print image during processing with contaminated fingers; i.e., bleach or fixer on fingers while print is in developer. The image will be affected and there is no way to correct other than by retouching. If carelessly handled with wet or dirty fingers after processing and drying, finger prints may be removed by washing the print again; superficial dirt and finger grease may be easily removed with film cleaner and a soft cotton cloth or swab. Do not use facial tissues.

Kodachrome, Ektachrome and Kodacolor are trademarks of Eastman Kodak Co., Rochester, N.Y.

GAF is a trademark of GAF Corp., N.Y., N.Y.

Agfachrome is a trademark of Agfa-Gevaert AG, Leverkusen, West Germany

Fujichomre is a trademark of Fuji Photo Film Ltd., Tokyo, Japan

ILFORD

CIBACHROME MAGNIFICATION TABLE AND EXPOSURE GUIDE

When you make prints of different size from one of your slides, you will have to change your print exposure as you change from one magnification to another. In order to avoid problems with reciprocity failure, you should try to maintain similar exposure times and make the necessary compensations in total exposure by varying the lens aperture. The light intensity at the easel will be directly proportional to $(1 + m)^2$ where m is the magnification ratio. For example, if you project a $1 \times 1\frac{1}{2}$ inch (35mm) slide film image first to a 4×5 inch size, and then to an 8×10 inch size, the difference in the intensity of illumination at the easel will be:

$$\frac{(1+8)^2}{(1+4)^2} = \frac{81}{25} \text{ or } 3.2x$$

This means 8×10 inch print will require 3.2 times more exposure than the 4×5 inch print.

The following table will help in determining the necessary changes in exposures as you switch from size to size.

The Compact Photo-Lab-Index

from	to		
4 × 5 inch	**5 × 7 inch**	**8 × 10 inch**	**11 × 14 inch**
exposure factor:	1.4x	3.2x	5.8x
example: *f*/8, 10 seconds	*f*/8, 14 sec.	*f*/8, 32 sec., or preferably,	*f*/5.6, 29 sec, or preferably,
(This sample is for illustrative purposes only. Your actual print exposures may be quite different.)		*f*/5.6, 16 sec.	*f*/4.5, 21 sec.
8 × 10 inch	**4 × 5 inch**	**5 × 7 inch**	**11 × 14 inch**
exposure factor:	0.31x	0.44x	1.8x
example: *f*/5.6, 16 seconds	*f*/8, 10 sec.	*f*/14 sec.	*f*/5.6, 29 sec., or preferably,
(This sample is for illustrative purposes only. Your actual print exposures may be quite different.)			*f*/4.5, 21 sec.

ILFORD

POLAROID CORPORATION
Cambridge, Mass. 02139

POLAROID LAND PHOTOGRAPHIC SYSTEM

FILM FORMATS

There are three basic Polaroid black and white film formats: roll, pack, and single 4 x 5 packets. In addition, there is a line of 10 x 12 in. X-ray products.

40 SERIES ROLL FILMS

Introduced in 1948 with the first Polaroid Land camera, the eight-exposure roll films are processed inside the camera or film back in which they are used, because they cannot be exposed to light while being processed. Although manufacture of roll film cameras ended in 1963, these films are still widely used in film backs for a variety of applications. Manufacture of roll film backs ended in 1979.

40 SERIES ROLL FILM

Film size: 3¼ x 4¼ in. (8.3 x 10.8 cm). **Image size:** 2⅞ x 3¾ in. (7.3 x 9.5 cm). **Number of exposures:** Eight per roll. **Equipment compatibility:** For use: with 40 Series roll film backs (manufacture discontinued in 1979) on instrumentation and on Polaroid MP-3 and MP-4 Multi-purpose Land camera systems; in Polaroid 40 Series roll film cameras (manufacture discontinued in 1963).

50 SERIES 4 x 5 FILM PACKAGES

Introduced in 1958, this film format opened instant photography to photographers with 4 x 5 equipment. The single exposure packets were designed for use with the Model #500 Land film holder, since superseded by the Model #545. The holders can be used with most cameras that accept standard 4 x 5 sheet film holders. They are also used on many kinds of instruments. 50 Series film packets can be loaded and processed in daylight, and processing is completed outside the film holder.

50 SERIES 4 x 5 FILM PACKET

Film size: 4 x 5 in. (10.5 x 13 cm). **Image size:** 3½ x 4½ in. (9 x 11.5 cm). **Number of exposures:** One per packet; 20 packets per box. **Equipment compatibility:** For use: with Model #545 Land film holder on most cameras accepting standard 4 x 5 sheet film holders and on Polaroid MP-3 and MP-4 camera systems; on instrumentation incorporating or accepting 4 x 5 film holders. The Model #500 Land film holder (discontinued 1969) is not recommended for use with current 4 x 5 films.

80/100/600 SERIES PACK FILMS

The 100 Series pack films and folding pack cameras were first marketed in 1963. The flat, eight-exposure pack snaps quickly and firmly into the camera or film back. Processing is completed outside the camera. This permits rapid successive exposures. These films are used with many types of pack film cameras and film backs for a wide range of photographic purposes. 600 Series films are designated professional pack films.

The 100/600 Series films produce rectangular pictures. 80 Series films, introduced in 1971, produce square pictures.

80 SERIES PACK FILM

Film size: 3¼ x 3⅜ in. (8.3 x 8.6 cm). **Image size:** 2¾ x 2⅞ in. (7 x 7.3 cm) **Number of exposures:** Eight per pack. **Equipment compatibility:** For use: with Polaroid pack film cameras that make square format pictures; with Model CB80 square format pack film back used on instrumentation and other equipment.

POLAROID

100/600 SERIES (AND TYPE 084) PACK FILM

Film size: 3¼ x 4¼ in. (8.3 x 10.8 cm). **Image size:** 2⅞ x 3¾ in. (7.3 x 9.5 cm). **Number of exposures:** Eight per pack. **Equipment compatibility:** For use: with wide variety of general purpose and special purpose, automatic and nonautomatic Polaroid pack film cameras; with pack film backs on Polaroid MP-3 and MP-4 camera systems, on other special purpose camera systems, and on instrumentation; with Model #405 pack film holder for use with most 4 x 5 cameras.

THE FINISHED PHOTOGRAPHIC PRODUCT

In terms of the type of finished photograph provided, Polaroid black and white films are of four basic kinds.

All Polaroid black and white films are characterized as *peel-apart films*. The finished picture product, whether a print or a transparency, must be separated from the negative by peeling it off. Except for films designated *positive/negative* (*P/N*), the *negative* portion of the film unit cannot be used to make prints in the usual manner and should be discarded.

POSITIVE PRINT FILMS, COATER TYPE

Prints must be coated after processing to protect them. Coaters are supplied in each film box. These films come in roll, pack, and single packet format; in very high speed, fine grain, and special purpose types.

POSITIVE PRINT FILMS, COATERLESS TYPE

Prints do not require coating. Within a short time after processing they have a dry, hard, glossy finish. These films are available in pack film format.

POSITIVE/NEGATIVE FILMS

These films provide coater-type prints of high quality and fine grain negatives that, after a simple treatment that does not require a darkroom, can be used to make excellent enlargements and copies. They are available in pack and single packet format.

TRANSPARENCY FILMS

A high contrast line film and a fine grain, medium contrast continuous tone film are available in roll film format.

FILM CHARACTERISTICS

SPECTRAL SENSITIVITY

Unmodified grains of silver halide are sensitive only to energy from the ultraviolet and blue regions of the spectrum. To extend the range of sensitivity into the remaining area of the visible spectrum (green and red) so as to make the film *panchromatic*, spectral sensitizing dyes are added to the emulsion.

While the use of sensitizers allows for the creation of panchromatic films, the pattern of relative sensitivity across the spectrum in these films does not parallel the sensitivity of the human eye. Even if there were an equal output of all colors from a light source, a photographic emulsion would generally record much more of some colors than of others. Depending on the types and combination of sensitizers employed, these relative sensitivities can differ from film type to film type.

The *spectral sensitivity curves* provided for each Polaroid film type in the data sheets show the photographer how each film responds to, and thus records, the different portions of the spectrum. The horizontal axis of the graph represents the visible portion of the spectrum, which extends from about 400 to 700 nanometers (a nanometer, nm, is equivalent to one billlionth of a meter or 10 angstrom

POLAROID

units). Below 400 nm lies the ultraviolet region and above 700 nm, the infrared region. The visible colors of the spectrum are identified as ranges of wavelengths approximately as follows: blue from 400 to 500 nm, green from 500 to 600, and red from 600 to 700 nm.

Although data are not given for spectral sensitivity below 350 nm, since that sensitivity is not generally useful in photography, Polaroid films (like other black and white films) are highly sensitive to ultraviolet energy below 350 nm. This sensitivity is useful in some special applications.

The vertical axis of the graph represents the reciprocal of the exposure (in ergs/cm²) required to produce a print reflection density of 0.5 (10^7 ergs equal one watt second). Measurements are made at intervals across the spectrum, with the use of monochromatic exposures.

Simply stated, the curve indicates the relative sensitivity of the film to light of different colors (wavelengths). The higher the line the greater the sensitivity of the film to that particular color.

The monochromatic exposures required to produce densities other than 0.5 can be estimated from the spectral sensitivity and the characteristic curves.

To calculate the results of a polychromatic exposure, one must perform the following steps:

(1) Read off the appropriate points on the log (spectral sensitivity) plot at equally spaced points (every 10 nanometers).

(2) Take the antilog of the log sensitivity to obtain the linear sensitivity in units of ergs/cm².

(3) Determine the incident energy* in ergs/cm² in each 10 nm wavelength band. Multiply the sensitvity by the incident energy at each wavelength point. This gives the exposure in units of sec.⁻¹ occurring in each 10 nam band.

(4) Add together all the narrow band exposures obtained in step (3). The resulting number has units of sec.⁻¹ and gives the number of exposures to 0.5D which can be made in one second. The reciprocal of this number is thus the required exposure time in seconds.

*This must be the incident energy on the film as derived from the source brightness, lens aperture, lens spectral transmission, etc.

Spectral sensitivity of Type 52 film (panchromatic).

Spectral sensitivity of Type 51 film (blue-sensitive).

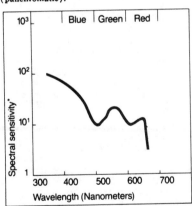

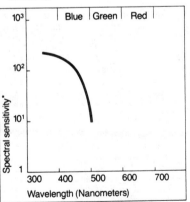

*Reciprocal of exposure (ergs/cm²) required to produce a 0.5 visual density.

*Reciprocal of exposure (ergs/cm²) required to produce a 0.5 visual density.

485

RESOLUTION

The ability of photographic film to record fine detail is generally expressed in terms of resolution. Polaroid determines the resolution of its black and white films according to ANSI Standard PH233-1969 (Method for Determining the Resolving Power of Photographic Materials). In this procedure, a film sample is exposed to a standard high contrast resolutin target. The target consists of groups of three black parallel bars on a clear background. The spaces between the bars are the same size as the bars themselves. Thse groups diminish in size to a maximum resolution of 323 line pairs per millimeter.

Exposures are made with a Xenon light source sensitometer. After exposure, film units are processed and the images are examined under a microscope. The assessment of a resolution value in lines per millimeter (lines/mm) or line pairs per millimeter (line pairs/mm) is achieved by determining the smallest group of bars in which one can still detect the original pattern of separate lines.

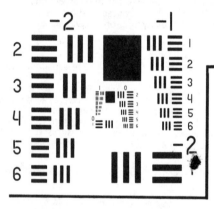

Standard resolution target (U.S.A.F. #XTRG 202.112). This target has a contrast of 1000:1 (high contrast), and a maximum resolution capacity of 323 line pairs per millimeter.

Speed differences in stops	Film speed ASA speed	DIN speed
0	50	18
1	100	21
2	200	24
3	400	27
4	800	30
5	1600	33
6	3200	36

FILM SPEED

The speed of a photographic film is a measure of its sensitivity to a specific exposure to light. For practical photographic purposes, the speed of a film is generally represented by a film speed number.

The accurate determination of film speeds is a major concern of the photographic industry. Today, a consortium of photographic companies supports the American National Standards Institute (ANSI), formerly the American Standards Association (ASA). Photographic speeds that are published by manufacturers of photographic films conform to the guidelines of the current ANSI standards, but, continuing the original ASA terminology, these speeds are always called *ASA speeds*.

ANSI standards for speed depend on an analysis of the H&D curve, subject to a known absolute value of exposure from the sensitometer, followed by well-controlled wet process development. ANSI standards have not yet been developed for instant films.

There is, however, an ANSI standard for exposure meters that implies an ASA speed for any film used with an ANSI calibrated exposure meter. Polaroid films are assigned *equivalent ASA speed values*, so that a meter set at the recommended speed will give a correct exposure.

ASA speeds progress in such a way that a doubling of the ASA number represents a doubling of sensitivity to light, or a difference of one stop in speed (see chart). Therefore, using equivalent ASA speed values, Polaroid film Type 52

POLAROID

speed 400) is three stops faster than Polaroid film Type 55 (speed 50), and the 3000 speed Polaroid films are almost three stops faster than Type 52.

The *DIN* (Deutsche Industrie Normen) film speed system is used in Europe. Changes of three units indicate a two-fold (one stop) change in sensitivity. The data sheets include DIN speeds for all of the Polaroid film types, based on a simple conversion from ASA to DIN units (see chart on previous page).

CONDITIONS CAUSING VARIATIONS IN SPEED

Polaroid's recommended ASA equivalent speeds are derived under these specific conditions:

 1—exposure to light with color temperature of 5500°K
 2—no filtration
 3—exposure duration of 1/125 sec.
 4—recommended processing time and temperature.

Variations from these conditions will change the response of the film and its effective film speed. A knowledge of the variables which affect film speed, and therefore exposure, will help the photographer achieve well exposed images with minimal film wastage.

VARIATION OF SPEED WITH CHANGES IN PROCESSING TIME AND TEMPERATURE

Each data sheet contains a chart devoted to the recommended adjustments in processing time for variations in processing temperature. See also The Effect of Temperature on Processing under Processing Techniques.

VARIATION OF SPEED WITH COLOR TEMPERATURE OF EXPOSING LIGHT

Each data sheet contains a chart which shows the exposure adjustment necessary to maintain speed performance when the color temperature of the exposing light varies from the standard 5500°K. See also Speed-/Color Temperature Variation under Exposure.

VARIATION OF SPEED WITH FILTERS

Each data sheet provides filter factors and aperture adjustment data for six commonly used Wratten filters. See also Filters under Exposure.

VARIATION OF SPEED WITH EXPOSURE TIME

Each data sheet provides a table and a graph indicating the exposure adjustment necessary when using very long and very short exposures. See also Reciprocity Effects under Exposure.

EXPOSURE

EXPOSING POSITIVE-TYPE FILM

Unlike negative films, which go through an additional print exposure step in the darkroom that provides opportunities for correcting errors committed in making the camera exposure, positive films must be exposed correctly in the camera to produce a successful image. For this reason, determining proper exposure is of critical importance when using any positive film type.

When using Polaroid print films, as with any positive film type, the familiar rule of thumb "expose for the shadows and develop for the highlights" does not hold true. Exposure should be based on the important highlight areas, in which textural detail is desired. The darker areas of the scene can be slightly manipulated through other means (see Controlling Image Values), but correct rendition of the highlight areas is controlled by exposure.

POLAROID

487

The Compact Photo-Lab-Index

Important: When using a positive/negative film type, the photographer may employ different exposure strategies depending on whether he is more interested in the print or the negative as a finished photographic product. Generally, a well-exposed positive print will indicate a negative of acceptable density, if important shadow detail is not required. However, where it is necessary to preserve essential shadow detail in the negative, positive/negative film should be exposed so that the positive appears somewhat overexposed. When the processing temperature is well below 70°F (21°C), it will become necessary to overexpose the positive in order to get an acceptable negative, because the speed of the negative is more affected by low temperature than is the speed of the positive. See also The Effect of Temperature Procssing under Processing Techniques.

USE OF AN EXPOSURE METER

Exposure meters are designed to produce the information for correct exposure settings by taking into account the following information:

1—the quantity of light available

2—the ASA speed (or equivalent) of the film (the photographer sets his meter to the appropriate number), and

3—the assumption that the scene being photographed is of average reflectance (18% reflectance).

Although a reflected light meter can take an accurate reading of the quantity of light available, under certain circumstances this is not sufficient to provide accurate exposure information. For example:

When the scene is not of average reflectance: When the scene has large bright or dark areas, the reflected light meter's assumption of average reflectance is wrong and the calculated exposure settings may be inaccurate. In this situation, spot metering can provide accurate exposure information for specific areas of the scene; taking a reflected reading from a standard 18% reflectance gray card, or using an incident light meter, will give a more accurate exposure calculation for the overall scene.

When the color temperature of the light being measured varies significantly from 5500°K: For example, when a film is exposed to tungsten light, the effective speed of the film is decreased. See the data sheets for exposure adjustment information based on the color temperature of the exposing light.

When the duration of the exposure is unusually short or long: This causes reciprocity failure, which is evidenced by a reduction in effective film speed. See the data sheets for exposure adjustment information based on duration of exposure.

When light entering the camera is modified at the lens by filtration: See the data sheets for exposure adjustment information for six commonly used Wratten filters.

EXPOSURE DETERMINATION

By taking one reading of the entire scene, then reading important parts of the scene, a photographer has a better idea of where to place his exposure. For the ultimate in metering control, the spot meter is capable of reading a very small part of the scene without being influenced by neighboring areas.

In addition, a photographer can benefit by becoming well-acquainted with the characteristics of his equipment, as there are inevitable variations in exposure meters and shutters.

Last but not least, Polaroid films are a well-known and invaluable tool in determining exposure because of the instant feedback they provide. Proper use of an exposure meter, combined with a test shot, will get the photographer very close to an optimum exposure, with a minimum of effort.

POLAROID

FILTERS

Many kinds of filters can be used to advantage with Polaroid Land films. They fall into the general categories of colored and neutral filters.

Colored filters allow light from only selected portions of the spectrum to reach the film; they can be used to enhance contrast, or to alter tonal relationships of colors in a subject or scene. These filters are commonly described in terms of filter absorption and transmittance curves, which indicate exactly how much of the spectrum is absorbed by the filter over a wide range of wavelengths.

Colored filters absorb some ultraviolet (UV) radiation; however, there are some very pale filters which block only UV radiation. These filters are sometimes called skylight or haze filters, and are designed to counteract the blue-bias of panchromatic films (most panchromatic films are sensitive to UV and record it as blue light.)

Neutral density filters which look gray, reduce the amount of light reaching the film across the spectrum and are used solely to control exposure. These filters are described in terms of the percentage of light they transmit and the exposure change they require. Their spectral absorption is "neutral" for the visible portion of the spectrum only.

Exposure determination: Although filters are sometimes placed at the source of illumination, they usually are placed over the camera lens. Because colored filters change both the quantity and the color quality of the exposing light, it is usually necessary to make an exposure adjustment to compensate for their effect. Therefore, suppliers of photographic filters provide an exposure multiplier, or *filter factor*, for each of their products. By multiplying the exposure time calculated for unfiltered light by this factor, the correct exposure can be determined.

Each film data sheet provides information for six commonly used Wratten filters. In addition to filter factors, the required exposure adjustment is given in terms of the correction in f/stops necessary to maintain correct exposure.

When extending exposure time to compensate for filtration, the photographer should be aware that reciprocity failure effects may create the need for a further adjustment of exposure. Consult the reciprocity table and graph on the data sheets for an indication of when and how much additional exposure is needed.

ADVANCED EXPOSURE TECHNIQUES

In addition to using an exposure meter, the photographer can improve his exposure technique by understanding how the film responds to light, as represented by the *characteristic curve*.

A characteristic curve (also called an H&D curve) is a graph of image densities plotted against the logarithm of the exposure. Thus, on the horizontal scale each 0.3 increment represents a doubling of exposure. The entire log exposure scale from-3 to 9 represents a brightness ratio of 1:1,000, or an exposure range of 10 stops. The density scale, which runs vertically, is also logarithmic, and is based on the percentage of light transmitted or reflected. Each 0.3 increment represents a halving of transmittance or reflectance. The entire density scale from 0 to 3 represents transmittance or reflectance from 100% to 0.1%.

The region of the curve between points A and B is called the *linear region*, where changes in image density are approximately proportional to changes in exposure. The dark areas of the scene (the "shadows") are recorded near A, on the *shoulder* of the curve; those that fall to the left of A will increasingly lose tonal separation until they are reproduced as uniform black. The bright areas of the scene (the "highlights") are recorded near B, on the *toe* of the curve; those that fall to the right of B will increasingly lose tonal separation until they are reproduced as uniform white.

POLAROID

489

The Compact Photo-Lab-Index

The steepness (or slope) of the middle portion of the curve indicates the *contrast* of a film. The steeper the curve (the higher the slope), the higher the contrast of Polaroid black and white Land print films is defined as:

1—Low contrast: slopes less than 1.10
2—Medium contrast: slopes from 1.10 to 1.70
3—High contrast: slopes greater than 2.50.

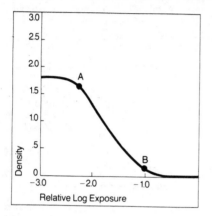

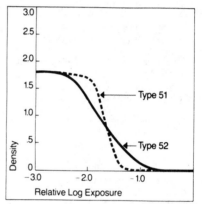

H&D curve of Type 52 film.

H&D curves of high contrast Type 51 film and medium contrast Type 52 film. High contrast film is characterized by a steep curve (high slope).

For both aesthetic and technical reasons, Polaroid's positive materials usually have a slope greater than 1.00, negative materials less than 1.00.
Type 55, positive material: slope=1.35
Type 55, negative material: slope=0.65.

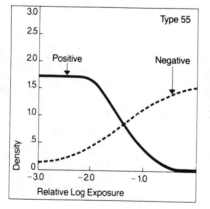

H&D curves of the positive and negative materials of Type 55 film. Positive materials usually have a slope higher than 1.00; negative materials usually have a slope less than 1.00.

POLAROID

490

The Compact Photo-Lab-Index

EXPOSURE RANGE

The useful exposure range of a film is the range of scene brightness which the film can record with detail in a single exposure.

For example, Type 52 film has an exposure range of approximately 1.65 units, or 1:48 in exposure (5½ stops). If the photographer determines by spot meter readings that the range of brightnesses in his scene does not exceed 1:48 (5½ stops), then the entire range can be recorded on Type 52 film with detail, provided that the scene is exposed accurately based on the speed data for the film. This does not take into account those dark shadows or bright highlights in a scene which may still be recorded by the film without texture or visible fine detail.

EXPOSURE LATITUDE

The exposure latitude of a film is the range of camera exposures (often expressed in stops), from the least exposure to the greatest, which will produce a "good exposure." Looking at the characteristic curve, exposure latitude represents the variations in camera exposures which will place the brightness range of a scene on the curve, within the exposure range of the film. Exposure latitude is a function of both the particular film emulsion and the scene brightness range.

The concept of exposure latitude is more significant when exposing negative material than when exposing positive material. To be judged "well exposed," a negative must contain all of the necessary detail in the shadow and highlight areas of a scene, and good tonal separation throughout the middle tones. Often, several different camera exposures can yield a usable negative of a given scene, depending on the scene brightness range. This "room for error" represents the exposure latitude of the film.

Positive films for pictorial use are characterized by more limited exposure latitude, because of their higher slope (see illustration). And, in addition to the technical requirements given above, a positive must be aesthetically pleasing. For these reasons, correct exposure of positive materials is critical.

POLAROID

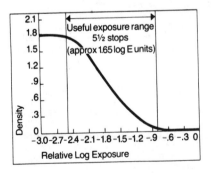

H&D curve of Type 52 film, showing the useful exposure range of the film. For this film type, the exposure range covers approximately 1.65 log E units, or 5½ stops.

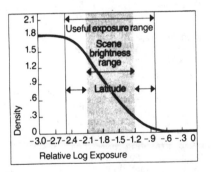

H&D curve of Type 52 film, showing "exposure latitude." The shaded area represents a scene with a limited brightness range; in this case, the scene could be over- or underexposed by a full stop and still exhibit detail in the shadows and highlights.

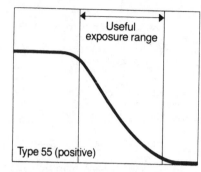
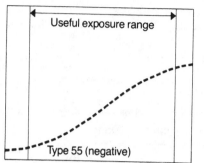

H&D curves of Type 55 positive and negative materials. Positive material is characterized by more limited exposure range, because of ts higher slope.

RELATING EXPOSURE TO THE H&D CURVE

When the scene brightness range corresponds to the useful exposure range of the film, there is limited exposure latitude, and the camera exposure must be accurate to obtain textural detail in both shadow and highlight areas.

When the brightness range of the scene is greater than the exposure range of the film, the film cannot record textural detail in both the highlight and shadow areas. The photographer must choose which part of the curve is most important to the photograph (or, he may lower the scene brightness range, if possible).

When the brightness range of the scene is less than the exposure range of the film, there is a certain degree of exposure latitude, and the photographer has some choice as to where to place his exposure on the curve, still retaining detail in both highlight and shadow areas.

CONTROLLING IMAGE VALUES

When using a positive film, the photographer should expose for best results in the critical highlight areas, and let the shadow areas fall more or less where they may. In some picture-taking situations it may be desirable to manipulate the shadow areas of a picture through other means. The techniques described briefly below alter image values by changing the normal imaging characteristics of the film.

PRE-EXPOSURE

In a scene that has a long brightness range and pictorially important shadow areas, it is difficult to expose for the highlights without sacrificing critical shadow detail. A possible solution would be to give the film a very slight *pre-exposure* to a flat surface of uniform luminance before the main exposure is made. This will have the effect of moving the shadow areas to the right on the characteristic curve, providing more tonal separation and textural detail in the darker areas of the picture. The additional exposure will have a negligible effect on the highlight areas and they will remain virtually unchanged in the picture.

PROCESSING DEVIATIONS

Polaroid black and white Land films are designed to provide maximum image quality and predictability under normal use conditions; that is, processing for the recommended time at the recommended temperature. However, with some Polaroid black and white materials it is possible to deviate from these normal conditions in order to produce specific pictorial effects.

By extending the process time, more silver is transferred to the positive sheet.

POLAROID

This has maximum impact on the darker areas of a picture, where there is more silver available to be transferred, resulting in greater density (deeper blacks) in the shadow areas. There is minimal impact on the highlight areas; thus, contrast is effectively increased.

Conversely, by processing for less time than recommended, less silver is transferred to the positive sheet, resulting in less density in the shadow areas. Again, the highlight areas are virtually unaffected, and contrast is effectively decreased.

This does not hold true for the reusable negative material of the positive/negative film types, which requires the full recommended processing time to produce a satisfactory negative, and does not increase in density or contrast with extended processing, Also, overextended processing must be avoided when using Type 52 film. The nature of the Type 52 negative material requires that recommended processing times be strictly adhered to.

SPEED/COLOR TEMPERATURE VARIATION

The spectral energy of an exposing light source is described by its color temperature in degrees Kelvin (°K). The color temperature (°K) of a continuous light source is the temperature (C° + 273) to which an "ideal black body radiator" would have to be heated to emit about the same spectral energy as that light source emits. Color temperature can be measured by a "color temperature meter." See the chart below for the color temperature of common light sources.

Color temperature of common light sources	
Source	**Color temperature (Degrees Kelvin)**
Candle	1900
75 watt tungsten bulb	2800
100 watt tungsten bulb	2900
200 watt tungsten bulb	3000
Professional quartz lamp	3200
Professional photolamp	3400
Clear flashbulb	3800-4200
Average daylight (mid ⅔ of day-sun, sky & clouds)	5500
Electronic flash	6000
Clear skylight (no direct sun)	12,000 +

Light sources with lower color temperatures emit more energy from the longer wavelength end of the visible spectrum, and are thus redder. Light sources with higher color temperatures emit more energy from the shorter wavelength end and are bluer. As discussed in Spectral Sensitivity, emulsion response varies in relation to the spectral energy of the exposing light; this can have practical consequences under certain circumstances, as described below.

Polaroid black and white film speeds are based on exposure to average daylight, which has a color temperature of 5500°K. Variation from 5500°K will cause changes in the speed of the film, generally as follows:

color temperatures higher than 5500°K tend to increase film speed
color temperatures lower than 5500°K tend to decrease film speed.

Each data sheet includes a chart which indicates speed variation in f/stops with variations in color temperature from 5500°K.

RECIPROCITY EFFECTS

Film speeds are calculated for moderate exposure times (in the case of Polaroid Land films, 1/125 sec.). If very long or very short exposures are required, film speed may change due to reciprocity failure effects.

The reciprocity law states that as long as the exposure (light intensity X time)

POLAROID

remains constant, the response of the emulsion (a specific image density following standard processing) remains constant. If the intensity of the exposing light is doubled and the exposing time halved, image density should remain the same.

But actually, the reciprocity law applies only under circumstances of moderate light intensity and moderate exposure times. When very low intensities of light are used over a very long exposure time, the exposure calculated may be insufficient to produce the calculated density. Similarly, when very short exposures are made with high intensity illumination (such as an automatic electronic flash unit), calculated exposure may prove to be insufficient.

A table is provided on the film data sheets to indicate the exposure increase that is required to compensate for the effect of reciprocity failure. In addition, a reciprooity curve is shown. The diagonal lines represent exposure time (t), the horizontal axis represents intensity (I), and the vertical axis represents the total exposure (I x t). From left to right, intensity increases and exposure time decreases. Therefore, low intensity (long exposure duration) reciprocity failure is illustrated by the upward curve of the graph at the left. The flatter the curve, the less is that particular emulsion affected by reciprocity failure. (If there were no reciprocity failure, the line would be hoizontal.)

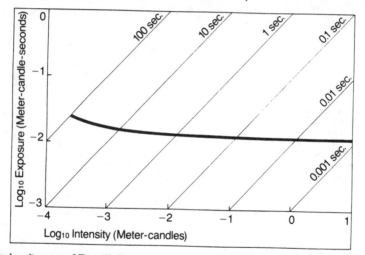

Reciprocity curve of Type 52 film.

PROCESSING TECHNIQUES

After a film has been exposed, it is processed by pulling the film unit through a pair of precisely dimensioned steel rollers. The film unit should be pulled from the camera or film holder with a steady, moderate speed.

Pulling a film unit too fast may result in incomplete reagent spread and/or white-speck defects (which are the product of trapped air bubbles). Too slow a pull, on the other hand, increases the chance that hesitation marks will appear. If, during a pull, there is a significant change in pull speed or a complete, momentary halt, there is a strong likelihood that the photograph will show bar-like marks running the width of the frame.

The recommended processing times for each Polaroid film type vary with ambient temperature. Except for Type 665, the recommended processing time should be held constant at temperatures above the recommended 70°/75°F

(21°/24°C). At lower temperatures, the processing reactions are slowed down, and processing times must be increased to maintain approximate speed and characteristic curve performance.

When processing positive/negative film at temperatures well below 70°F (21°C), the speed of the negative is reduced more than the speed of the positive, and a well-exposed positive may be accompanied by a negative that is too thin. To get the best negative at these temperatures, positive/negative film should be given more exposure, so that the positive appears somewhat overexposed.

Each film data sheet contains a table which details the relationship between processing time and ambient temperature. These processing time recommendations are approximate and are intended to provide the photographer with a starting point in calculating processing times when the temperature is well below 70°/75°F (21°/24°C). Polaroid black and white films are designed to produce optimum results under temperature conditions commonly found in most photographic studios, laboratories, and hospitals—60°F (16°C) to 90°F (32°C). Processing in ambient temperatures of less than 40°F (4°C) or higher than 100°F (38°C) is not recommended.

The photographer should keep in mind that the temperatures referred to in the processing table represent the temperature of the film unit at the time of processing. Under some circumstances the temperature of the camera or film holder, and consequently the temperature of the film unit, may vary significantly from ambient temperature. Processing times may need to be adjusted accordingly.

When using 50 Series 4 x 5 packets under extreme temperature conditions, the photographer may elect to make an exposure, but not to process the packet until a suitable environment can be found. Instructions printed on the Model #545 Land film holder explain how to remove an unprocessed packet from the holder. When subsequently processing an exposed packet, it is inserted into the holder as unexposed packets are, then processed in the normal manner.

PROCESSING AT LOW TEMPERATURES

In low temperature situations, pack and roll film cameras may be kept under a coat to keep both film and equipment warm until use. This insures that the processing reagent, emulsion, and image receiving sheet are as close as possible to processing temperatures within the recommnded range.

When using 4 x 5 film packets in cold conditions, the packet and the Model #545 Land film holder also may be stored under a coat until needed. If the photographer elects to process the photograph under low temperature conditions, the packet may be replaced under a coat after it has been pulled though the rollers.

Caution should be exercised when using coaterless print films at low temperatures. Under extreme conditions development time must be greatly extended and even then, results may exhibit objectionable tonal inconsistencies.

PROCESSING AT HIGH TEMPERATURES

In situations where ambient temperatures are over 90°F, Polaroid films should be kept below that temperature, if possible, or as cool as is practical. A plastic foam cooler, or similar container, can prove useful where cool, natural shade is unavailable or where ambient temperatures are above 90° even in the shade. Prolonged contact with direct sunlight can significantly raise the temperature of a film unit. For this reason, Polaroid Land films should be shielded from direct sunlight before exposure, and while they are developing.

Once an exposure has been made, the film should be processed at temperatures as close to "normal" as possible (70°/75°F, 21°/24°C). If no other options are open, the film unit should at least be shaded by the photographer's body. When using 4 x 5 film packets in extremely warm situations, the photographer may elect to expose a film but not to process it until that can be done in more favorable temperature conditions.

POLAROID

THE IMPORTANCE OF COATING

Because of the delicacy of the image layer, coater-type prints should be coated as soon after processing as is practical, in order to protect them from scratches and contamination. A delay in coating of more than two hours can result in a deterioration of image quality.

Print coaters are provided in each box of coater-type film in sufficient quantity to assure that all photographs produced from that pack, box or roll can be adequately coated. Use only the print coaters supplied with Polaroid films. Substitutes can seriously compromise the stability and quality of the image. Extra print coaters can be requested from Polaroid Corporation, if needed.

When coating prints, they should be placed, image layer up, on a disposable surface such as clean paper or cardboard. The entire surface of the print should be coated, including the white borders. The coater should be swept along the print, edge to edge, with moderate pressure. Excessive pressure may result in scratches. At least six overlapping strokes should be employed. The resulting coat should be thick, but even.

Keep freshly coated prints separate from each other until they have dried thoroughly. Drying time varies, depending on humidity and ventilation. Be careful not to touch the print surface while prints are drying.

Coated prints that have been handled carelessly may collect fingerprints, smudges, etc. These can be removed by carefully recoating the prints. Be sure that the coater provides a plentiful supply of liquid to form the new layer.

Print coaters should be handled carefully so as to avoid contact between print coater solution and furniture or clothing. If, by accident, coating solution gets on furniture or clothing, remove it before it dries. This can usually be accomplished by wiping or rinsing the affected area with water. If this proves unsatisfactory, add a little acetic acid (or vinegar) to the water Before wiping or rinsing with this solution, however, test it on a hidden surface. (Print coating solution will have different effects on different materials. In some instances, these effects cannot be reversed.)

PROCESSING OF POSITIVE/NEGATIVE (P/N) FILMS

Positive/negative films, which produce both a coater-type positive print and a negative suitable for making wet process copies and enlargements, are exposed and processed in a normal manner. When the positive image is separated from the negative, the print is coated in the usual way.

Further treatment of the negative is necessary if it is to be retained and used. Within three minutes, the negative should be immersed in a solution of sodium sulfite which removes residual layers of developer and anti-halation dyes. This solution should be prepared and ready for use before processing the film unit.

Polaroid Corporation recommends the use of an 18% solution of sodium sulfite for Type 55 negatives and a 12% concentration for Type 665 negatives. See the instruction sheet packaged in each box of film for a detailed description of how to prepare and use the solution. Negatives can be cleared in the sodium sulfite solution individually in trays or in sheet film tanks using clip-type film hangers, making sure the negatives do not touch each other. The solution should be stored in a brown, well-stoppered bottle or in a tank with a floating lid.

If you do not have immediate access to sodium sulfite, negatives can be safely stored in water for a short time. As soon as possible, however, the negatives should be treated in sodium sulfite solution in the normal way.

After treatment, negatives should be washed in running water for about five minutes. Great care should be taken during washing, and all other processing steps, not to scratch the emulsion. Solution and rinse temperatures should be kept closely aligned with one another to prevent reticulation of the emulsion.

After washing, the negative should be dipped in a very dilute solution of photographic wetting agent and hung up to dry in a dust-free environment.

POLAROID

PROCESSING OF TRANSPARENCY FILMS

There are two films which produce positive projection transparencies. After separation from the negative sheet each image must be hardened and stabilized. This is accomplished by immersion of the transparency in a solution, which is contained in a Polaroid Dippit tank, between 5 and 30 minutes after processing. Each self-contained Dippit tank holds enough solution to treat 48 pictures, or 6 rolls of film.

Complete instructions for the processing and treatment of Polaroid transparency images can be found packaged with each box of film and Polaroid Dippit.

STORAGE

STORAGE OF UNUSED FILM

Polaroid black and white Land films, like all sensitized photographic materials, are perishable and should be protected from adverse environmental conditions such as heat and high relative humidity. Store unexposed film in a cool, dry place. Do not break the foil wrap until just before the film is to be used. In the case of 4 x 5 film, place any unused packets in the polyethylene bag provided, fold over the top and secure it, to seal against moisture.

Film should be stored at or below 70°F (21°C) and refrigeration is recommended whenever possible. Polaroid black and white film may also be frozen, although there is no known advantage over mere refrigeration. In either case, shelf life is not extended beyond the expiration date stamped on the box. Film stored in the refrigerator should be sealed in its original foil wrapper or, in the case of partially used 4 x 5 film, carefully sealed in the polyethylene bag provided with the film. Remove film from the refrigerator in individual boxes at least two hours before use (24 hours, if the film was in the deep freeze), to allow the film to reach room temperature. To avoid condensation, do not break the seal until the warming up period has expired.

Once the foil wrap has been opened, protect the film from strong light and possible light leakage by keeping it in a closed container.

CARE AND STORAGE OF THE FINISHED PHOTOGRAPHIC PRODUCT

All black and white prints: Prints should not be stored in ordinary black paper photo albums, because most black papers contain impurities which could result in reduced image stability. For the same reason, do not secure prints with mounting corners, glue, paste, or tape. If prints are to be attached to documents, use staples or clips on the white borders only to avoid damaging the image area. In addition, do not write on the back of the image area.

Coater-type prints: Be sure the print is carefully coated (see The Importance of Coating under Processing Techniques). Keep freshly coated prints separate from each other until they are thoroughly dried, and do not touch the print while prints are drying. Coated prints are not easily scratched, but they can be damaged by rough handling or improper storage. They may be stored in the transparent sleeves or envelopes sold for negatives and color transparencies.

Coaterless prints: Prints which do not require coating can also be adversely affected by improper storage or handling. Allow them to dry thoroughly before storing. In low humidity, coaterless prints may curl. Do not attempt to straighten them by bending. Instead, place them in an area of higher relative humidity (about 45%) until they flatten. To protect image density during storage, insert prints in individual triacetate or PVC protective covers with low plasticizer content and keep in a cool area (below 75°F/24°C) with low relative humidity. Do not store coaterless prints face-to-face, or in contact with conventionally processed photographic materials or xerographic copies.

Negatives: After the appropriate post-development treatment (see Processing of Positive/Negative Films under Processing Techniques) these may be stored in

POLAROID

the same type of sleeves or envelopes used for wet-process negatives.

Transparencies: After treatment in the Dippit solution (see Processing of Transparency Films under Processing Techniques), transparencies may be projected immediately by mounting them full-frame in Polaroid snap-in plastic mounts (#633). Or, if properly planned, a portion of the image may be cut and mounted in 35mm or other small size mounts. The freshly treated emulsion is fragile and should be handled with care; however, after about twelve hours the transparencies are completely dry and set, and may be cleaned carefully with a damp cloth. At this point, they may be stored as above, or mounted for permanent storage between 3¼ x 4 in. lantern slide glass plates, using a suitable size standard mask.

A caution notice appears on every black and white film box, and in the instructions for both the films and the hardware which uses the films. The following is a typical example.

Caution

This process uses a caustic jelly which is safely packed inside sealed containers on each film unit. **If accidentally you should get some of this jelly on your skin, wipe it off immediately.** To avoid an alkali burn, wash the area with plenty of water as soon as possible. **It is particularly important to keep the jelly away from eyes and mouth.** Keep the discarded materials out of the reach of children and animals and out of contact with clothing and furniture, as discarded materials still contain some jelly.

The information supplied is accurate as of the date of publication. From time to time, however, film characteristics and/or specifications may change. Refer to the instruction sheet packaged in each box of film for the most up-to-date information.

AN EXPLANATION OF DATA CATEGORIES

DESCRIPTION

The description summarizes the imaging characteristics and major applications of each film type.

FORMAT

Polaroid Land films for industrial, scientific professional and general use are provided in several formats to permit maximum applications versatility.

The 50 series 4 x 5 Land film format is designed for use with: Polaroid Model #545 Land film holder on most cameras employing standard 4 x 5 film holders; instrumentation incorporating integral Polaroid 4 x 5 Land film holders. Image area measures 3½ x 4½ in. (9 x 11.5 cm.) Twenty single-exposure packets are provided per box.

The 100/600 series pack film format is designed for use with: Polaroid Land pack cameras making rectangular pictures; Polaroid pack film backs; instrumentation with integral Polaroid pack film holders. The image area measures 2⅞ x 3¾ in. (7.3 x 9.5 cm) on a 3¼ x 4¼ in. (8.3 x 10.8 cm) sheet. Eight exposures are provided per pack.

In addition, Polaroid Land films are also available in the following formats:

The 80 series pack film format is designed for use with: Polaroid Land cameras that make square format pictures; Polaroid 80 series film backs. Image area measures 2¾ x 2⅞ in. (7 x 7.3 cm) on a 3¼ x 3⅜ in. (8 x 8.6 cm) sheet. Eight exposures are provided per pack.

The 40 series roll film format is designed for use with: all Polaroid film cameras (except Model 80 series and the J-33); all 40 series roll film packs; instrumentation with integral 40 series roll film holders. Image area measures 2⅞ x 3¾ in. (7.3 x 9.5 cm) on a 3¼ x 4¼ in. (8.3 x 10.8 cm) sheet. Eight exposures are provided per roll.

POLAROID

CONTRAST

The terms used under this heading are meant to be generally helpful in aiding in the selection of a film compatible with the photographer's requirements. For more exact information on contrast properties, refer to the characteristic curve and the slope, which are provided for each film elsewhere on the data sheet.

SPEED

The speed value provided for Polaroid Land films represents a recommended setting for exposure meters calibrated in ASA or DIN speeds.

PROCESSING

Processing times for Polaroid Land films vary with ambient temperature. Information about processing-time/temperature relationships is provided for most situations which photographers are likely to encounter. Optimum results can be expected in time/temperature ranges in the unshaded portion of the table. Time/temperature recommendations within the shaded portion of the table are approximate.

The photographer should be cautioned that the temperatures referred to in the table *represent the temperature of the film unit* at the time of processing. Under some circumstances, the temperature of the film, the camera, or the film holding device may vary significantly from the ambient temperature and processing times may need to be adjusted accordingly.

Although this processing information is accurate as of the time of publication, it may change from time to time. Refer to the instruction sheet packaged with your film for the most up-to-date processing information for that box of film.

While Polaroid Corporation does manufacture some "coaterless" black and white print films, most Polaroid black and white prints must be coated. Unless otherwise stated on the film box and instruction sheet, coat each print using only the print coaters provided in boxes of Polaroid black and white film. Prints should be coated as soon as possible after processing.

FILTER FACTORS

When a filter is used between subject and film, an adjustment of exposure is usually required to insure optimum results. Information for six commonly used Wratten filters is provided on the data sheets in two forms:

Aperture adjustment—the amount of correction in f/stop units necessary to maintain correct exposure for each filter.

Exposure factor—by multiplying the exposure time calculated for unfiltered light by this factor, the photographer arrives at the correct exposure time.

When extending exposure time to compensate for filtration, the photographer should be aware that reciprocity failure may create the need for a further adjustment of exposure. Consult the reciprocity table and graph provided for each film type for an indication of when and how much additional exposure is needed.

SPEED/COLOR TEMPERATURE

Film speeds are calculated for a light source of specific color temperature. In the case of Polaroid black and white films this value is 5500°K (daylight). Light sources of other color temperatures may cause shifts in film speed. A chart outlining speed variation in f/stops relative to 5500°K is provided on each data sheet. Generally, at color temperatures lower than 5500°K speed decreases; at the higher color temperatures speed increases.

RESOLUTION

The resolution values provided on each data sheet indicate the ability of the film type to resolve detail.

POLAROID

SPECTRAL SENSITIVITY

The spectral sensitivity curve provides a graphic representation of the sensitivity of each of the film types to light between 350 nm and 690 nm. Unless otherwise indicated in the description and on the curve, all Polaroid black and white films are panchromatic.

CHARACTERISTIC CURVE

The characteristic curve (and the D-max, D-min and slope derived from it) is a valuable aid in determining the tonal and contrast properties of a film. The curve for paper print positives is generated with the print base as zero reference. (Average base density of Polaroid black and white prints is 0.08 relative to BaSO⁴.) In the case of transparency and negative materials, zero reference is air.

RECIPROCITY

Film speeds are determined for moderate exposure times (1/125th sec.). If very long or short exposures are required, the speed value of the film may change due to reciprocity failure. A table is provided to aid the photographer in maintaining correct camera exposure. In addition, a reciprocity curve is provided for use with instrumentation.

POLAROID BLACK-AND-WHITE LAND FILMS

Film type	Format	Result	Speed* ASA/DIN
Very high speed, print			
Type 667	professional pack	coaterless positive print	3000/36
Type 107C	pack	coaterless positive print	3000/36
Type 107	pack	positive print	3000/36
Type 084	professional pack	positive print	3000/36
Type 87	square-picture pack	coaterless positive print	3000/36
Type 57	4 x 5 film packet	positive print	3000/36
Type 47	roll	positive print	3000/36
Fine grain, print			
Type 52	4 x 5 film packet	positive print	400/27
Type 42	roll	positive print	200/24
Positive/negative			
Type 665	professional pack	positive print and negative	75/20
Type 55	4 x 5 film packet	positive print and negative	50/18
Special purpose			
Type 410	roll	positive print—for oscilloscope trace recording	10,000/41
Type 51	4 x 5 film packet	high contrast positive print	320/26
Type 146L	roll	high contrast positive transparency	200/24
Type 46L	roll	positive transparency	800/30
Type 611	professional pack	low contrast positive print— for video recording	

*Recommended meter setting

The Compact Photo-Lab-Index

TYPE 667

DESCRIPTION

This is a professional version of Type 107C selected for minimum sensitometric variation and maximum image quality. Does not require coating. Very high speed ideal for applications in bio-medical and diagnostic photography, especially CT (computed tomography), ultrasonography and nuclear medicine. Panchromatic.

FORMAT

100/600 series pack film (image area: 2⅞ x 3¾ in.—7.3 x 9.5 cm)

CONTRAST

Medium

SPEED

Approximately equivalent to ASA 3000 (36 DIN)

PROCESSING

°C	24+	20	18	16	10	
time in seconds		30	45	60	75	90
°F	75+	70	65	60	50	

For optimum results process at temperatures in unshaded portion of chart.

SPEED/COLOR TEMPERATURE

Speed variation relative to color temperature					
3200°K	4800°K	5500°K	6500°K	7500°K	10,000°K
−½ stop	–	3000°	–	–	+½ stop

•Effective ASA equivalent.

FILTER FACTORS

Light source at 3200°K – Tungsten

FILTER #	#6	#8	#15	#25	#47	#58
EXPOSURE ADJUSTMENT	½ Stop	⅔ Stop	1 Stop	1½ Stops	3⅓ Stops	3½ Stops
EXPOSURE MULTIPLIER	1.4X	1.6X	2X	2.8X	10X	11.2X

Light source at 5500°K – Daylight

FILTER #	#6	#8	#15	#25	#47	#58
EXPOSURE ADJUSTMENT	⅔ Stop	1 Stop	1⅓ Stops	2 Stops	2½ Stops	3⅓ Stops
EXPOSURE MULTIPLIER	1.6X	2X	2.5X	4X	5.6X	10X

RESOLUTION

16-20 line pairs/mm

CHARACTERISTIC CURVE

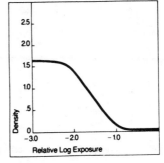

D-MAX: 1.60
D-MIN: .03
SLOPE: 1.45

POLAROID

SPECTRAL SENSITIVITY

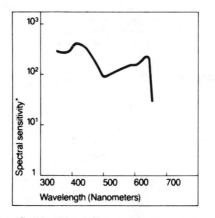

•Reciprocal of exposure (ergs/cm²) required to produce a 0.5 visual density.

RECIPROCITY

INDICATED EXPOSURE TIME	USE EITHER ADJUSTMENT		
	APERTURE	OR	EXPOSURE TIME
1/1000 sec.	None		None
1/100 sec.	None		None
1/10 sec.	+⅓ stop		None
1 sec.	+⅔ stop		+1 sec.
10 sec.	+1 stop		+10 sec.
100 sec.	+1⅔ stop		+220 sec.

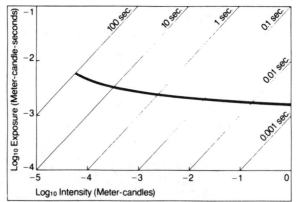

POLAROID

The Compact Photo-Lab-Index

TYPE 107

DESCRIPTION

For medium contrast paper print positives. Very high speed ideal for general purpose photography, for recording high speed events or for photographing subjects illuminated with low level ambient light. Panchromatic. Prints must be coated.

FORMAT

100/600 series pack film (image area: 2⅞ x 3¾ in.—7.3 x 9.5 cm)

CONTRAST

Medium

SPEED

Approximately equivalent to ASA 3000 (36 DIN)

PROCESSING

Under normal conditions (70°F 20°C and above) process for 15 seconds.

°C	20+	18	16	10	4
time in seconds	15	20	25	30-45	45-55
°F	70+	65	60	50	40

For optimum results process at temperatures in unshaded portion of chart.

SPEED/COLOR TEMPERATURE

Speed variation relative to color temperature					
3200°K	4800°K	5500°K	6500°K	7500°K	10,000°K
-½ stop	—	3000*	—	—	+½ stop

*Effective ASA equivalent.

FILTER FACTORS

Light source at 3200°K Tungsten

WRATTEN FILTER #	#6	#8	#15	#25	#47	#58
EXPOSURE ADJUSTMENT	⅓ Stop	½ Stop	⅔ Stop	1½ Stops	3½ Stops	3½ Stops
EXPOSURE MULTIPLIER	1.3X	1.4X	1.6X	2.8X	11.2X	11.2X

Light source at 5500°K Daylight

WRATTEN FILTER #	#6	#8	#15	#25	#47	#58
EXPOSURE ADJUSTMENT	⅔ Stop	1 Stop	1⅓ Stops	2½ Stops	2⅔ Stops	3⅓ Stops
EXPOSURE MULTIPLIER	1.6X	2X	2.5X	5.6X	6.3X	10X

RESOLUTION

16-22 line pairs/mm

CHARACTERISTIC CURVE

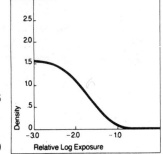

D-MAX: 1.55

D-MIN: .01

SLOPE: 1.40

POLAROID

The Compact Photo-Lab-Index

SPECTRAL SENSITIVITY

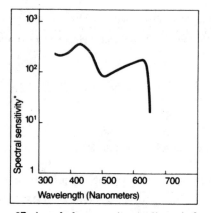

*Reciprocal of exposure (ergs/cm²) required
to produce a 0.5 visual density.

RECIPROCITY

INDICATED EXPOSURE TIME	USE EITHER ADJUSTMENT		
	APERTURE	OR	EXPOSURE TIME
1/1000 sec.	None		None
1/100 sec.	None		None
1/10 sec.	None		None
1 sec.	+½ stop		+½ sec.
10 sec.	+1 stop		+10 sec.
100 sec.	+1½ stops		+180 sec.

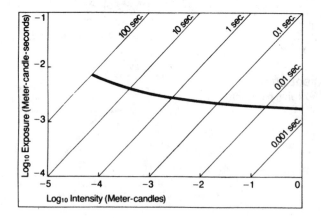

TYPE 87

DESCRIPTION

For medium contrast paper print positives. Does not require coating. Very high speed ideal for general purpose photography, for recording high speed events or for photographing subjects illuminated with low level ambient light. Panchromatic.

FORMAT

80 series pack film (image area: 2¾ x 2⅞ in.—7 x 7.3 cm)

CONTRAST

Medium

SPEED

Approximately equivalent to ASA 3000 (36 DIN)

PROCESSING

°C	24+	20	18	16	10
time in seconds	30	45	60	75	90
°F	75+	70	65	60	50

For optimum results process at temperatures in unshaded portion of chart.

SPEED/COLOR TEMPERATURE

Speed variation relative to color temperature					
3200°K	4800°K	5500°K	6500°K	7500°K	10,000°K
–½ stop	–	3000°	–	–	+½ stop

•Effective ASA equivalent.

FILTER FACTORS

Light source at 3200°K – Tungsten

FILTER #	#6	#8	#15	#25	#47	#58
EXPOSURE ADJUSTMENT	½ Stop	⅔ Stop	1 Stop	1½ Stops	3⅓ Stops	3½ Stops
EXPOSURE MULTIPLIER	1.4X	1.6X	2X	2.8X	10X	11.2X

Light source at 5500°K – Daylight

FILTER #	#6	#8	#15	#25	#47	#58
EXPOSURE ADJUSTMENT	⅔ Stop	1 Stop	1½ Stops	2 Stops	2½ Stops	3½ Stops
EXPOSURE MULTIPLIER	1.6X	2X	2.5X	4X	5.6X	10X

RESOLUTION

16-20 line pairs/mm

CHARACTERISTIC CURVE

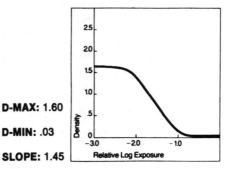

D-MAX: 1.60

D-MIN: .03

SLOPE: 1.45

POLAROID ·

505

SPECTRAL SENSITIVITY

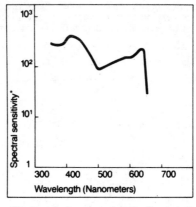

*Reciprocal of exposure (ergs/cm²) required to produce a 0.5 visual density.

RECIPROCITY

INDICATED EXPOSURE TIME	USE EITHER ADJUSTMENT		
	APERTURE	OR	EXPOSURE TIME
1/1000 sec.	None		None
1/100 sec.	None		None
1/10 sec.	+⅓ stop		None
1 sec.	+⅔ stop		+1 sec.
10 sec.	+1 stop		+10 sec.
100 sec.	+1⅔ stop		+220 sec.

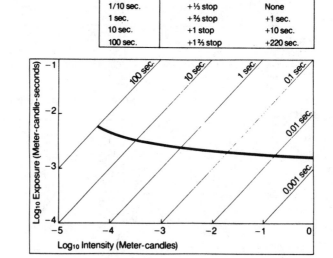

POLAROID

TYPE 57

DESCRIPTION

For medium contrast paper print positives. Very high speed ideal for general purpose photography, for recording high speed events or for photographing subjects illuminated with low level ambient light. Panchromatic. Prints must be coated.

FORMAT

4 x 5 film packet (image area: 3½ x 4½ in.—9 x 11.5 cm)

CONTRAST

Medium

SPEED

Approximately equivalent to ASA 3000 (36 DIN)

PROCESSING

Under normal conditions (70°F 20°C and above) process for 15 seconds.

°C	20+	18	16	10	4
time in seconds	15	20	25	30-45	45-55
°F	70+	65	60	50	40

For optimum results process at temperatures in unshaded portion of chart.

SPEED/COLOR TEMPERATURE

Speed variation relative to color temperature					
3200°K	4800°K	5500°K	6500°K	7500°K	10,000°K
-⅓ stop	–	3000*	–	–	+⅓ stop

*Effective ASA equivalent.

RESOLUTION

16-22 line pairs/mm

D-MAX: 1.55

D-MIN: .01

SLOPE: 1.40

FILTER FACTORS

Light source at 3200°K Tungsten

WRATTEN FILTER #	#6	#8	#15	#25	#47	#58
EXPOSURE ADJUSTMENT	⅓ Stop	½ Stop	⅔ Stop	1½ Stops	3½ Stops	3½ Stops
EXPOSURE MULTIPLIER	1.3X	1.4X	1.6X	2.8X	11.2X	11.2X

Light source at 5500°K Daylight

WRATTEN FILTER #	#6	#8	#15	#25	#47	#58
EXPOSURE ADJUSTMENT	⅔ Stop	1 Stop	1½ Stops	2½ Stops	2⅔ Stops	3⅓ Stops
EXPOSURE MULTIPLIER	1.6X	2X	2.5X	5.6X	6.3X	10X

CHARACTERISTIC CURVE

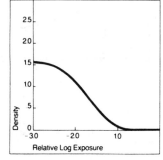

POLAROID

507

The Compact Photo-Lab-Index

SPECTRAL SENSITIVITY

*Reciprocal of exposure (ergs/cm²) required to produce a 0.5 visual density.

RECIPROCITY

INDICATED EXPOSURE TIME	USE EITHER ADJUSTMENT		
	APERTURE	OR	EXPOSURE TIME
1/1000 sec.	None		None
1/100 sec.	None		None
1/10 sec.	None		None
1 sec.	+½ stop		+½ sec.
10 sec.	+1 stop		+10 sec.
100 sec.	+1½ stops		+180 sec.

POLAROID

TYPE 47

DESCRIPTION

For medium contrast paper print positives. Very high speed ideal for general purpose photography, for recording high speed events or for photographing subjects illuminated with low level ambient light. Panchromatic. Prints must be coated.

FORMAT

40 series roll film (image area: 2⅞ x 3¾ in.—7.3 x 9.5 cm)

CONTRAST

Medium

SPEED

Approximately equivalent to ASA 3000 (36 DIN)

PROCESSING

Under normal conditions (70°F 20°C and above) process for 15 seconds.

°C	20+	18	16	10		4
time in seconds	15	20	25	30-45		45-55
°F	70+	65	60	50		40

For optimum results process at temperatures in unshaded portion of chart.

SPEED/COLOR TEMPERATURE

Speed variation relative to color temperature					
3200°K	4800°K	5500°K	6500°K	7500°K	10,000°K
–½ stop	–	3000*	–	–	+½ stop

*Effective ASA equivalent.

RESOLUTION

16-22 line pairs/mm

D-MAX: 1.55

D-MIN: .01

SLOPE: 1.40

FILTER FACTORS

Light source at 3200°K Tungsten

WRATTEN FILTER #	#6	#8	#15	#25	#47	#58
EXPOSURE ADJUSTMENT	⅓ Stop	½ Stop	⅔ Stop	1½ Stops	3½ Stops	3½ Stops
EXPOSURE MULTIPLIER	1.3X	1.4X	1.6X	2.8X	11.2X	11.2X

Light source at 5500°K Daylight

WRATTEN FILTER #	#6	#8	#15	#25	#47	#58
EXPOSURE ADJUSTMENT	⅔ Stop	1 Stop	1⅓ Stops	2½ Stops	2⅔ Stops	3⅓ Stops
EXPOSURE MULTIPLIER	1.6X	2X	2.5X	5.6X	6.3X	10X

CHARACTERISTIC CURVE

Density / Relative Log Exposure

POLAROID ·

The Compact Photo-Lab-Index

SPECTRAL SENSITIVITY

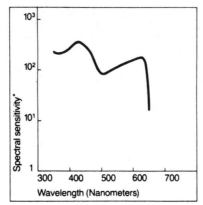

*Reciprocal of exposure (ergs/cm²) required to produce a 0.5 visual density.

RECIPROCITY

INDICATED EXPOSURE TIME	USE EITHER ADJUSTMENT	
	APERTURE OR	EXPOSURE TIME
1/1000 sec.	None	None
1/100 sec.	None	None
1/10 sec.	None	None
1 sec.	+½ stop	+½ sec.
10 sec.	+1 stop	+10 sec.
100 sec.	+1½ stops	+180 sec.

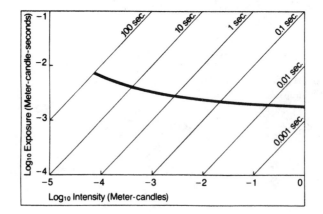

POLAROID

TYPE 52

DESCRIPTION

For medium contrast paper print positives. High speed, fine grain and excellent tonal rendition ideally suited for general purpose photography. Panchromatic. Prints must be coated.

FORMAT

4 x 5 film packet (image area: 3½ x 4½ in.—9 x 11.5 cm)

CONTRAST

Medium

SPEED

Approximately equivalent to ASA 400 (27 DIN)

PROCESSING

Under normal conditions (70°F 20°C and above) process for 15 seconds.

°C	20+	18	16	10	4
time in seconds	15	15	20	35-40	45-60
°F	70+	65	60	50	40

For optimum results process at temperatures in unshaded portion of chart.

SPEED/COLOR TEMPERATURE

Speed variation relative to color temperature					
3200°K	4800°K	5500°K	6500°K	7500°K	10,000°K
– ½ stop	–	400*	–	–	+ ½ stop

*Effective ASA equivalent.

RESOLUTION

20-25 line pairs/mm

FILTER FACTORS

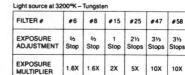

Light source at 3200°K – Tungsten

FILTER #	#6	#8	#15	#25	#47	#58
EXPOSURE ADJUSTMENT	⅔ Stop	⅔ Stop	1 Stop	2½ Stops	3⅓ Stops	3⅓ Stops
EXPOSURE MULTIPLIER	1.6X	1.6X	2X	5X	10X	10X

Light source at 5500°K – Daylight

FILTER #	#6	#8	#15	#25	#47	#58
EXPOSURE ADJUSTMENT	1 Stop	1⅓ Stops	1⅔ Stops	3⅓ Stops	2⅔ Stops	3½ Stops
EXPOSURE MULTIPLIER	2X	2.5X	3.2X	10X	6.3X	10X

CHARACTERISTIC CURVE

D-MAX. 1.80

D-MIN. .03

SLOPE: 1.35

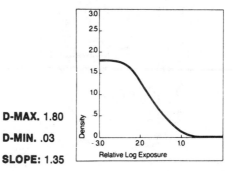

POLAROID

The Compact Photo-Lab-Index

SPECTRAL SENSITIVITY

*Reciprocal of exposure (ergs/cm²) required to produce a 0.5 visual density.

RECIPROCITY

INDICATED EXPOSURE TIME	USE EITHER ADJUSTMENT	
	APERTURE OR	EXPOSURE TIME
1/1000 sec.	None	None
1/100 sec.	None	None
1/10 sec.	None	None
1 sec.	None	None
10 sec.	+ ⅓ stop	+3 sec.
100 sec.	+1 stop	+100 sec.

POLAROID

The Compact Photo-Lab-Index

SPECTRAL SENSITIVITY

*Reciprocal of exposure (ergs/cm²) required to produce a 0.5 visual density.

RECIPROCITY

INDICATED EXPOSURE TIME	USE EITHER ADJUSTMENT	
	APERTURE OR	EXPOSURE TIME
1/1000 sec.	None	None
1/100 sec.	None	None
1/10 sec.	None	None
1 sec.	+ ½ stop	+ ½ sec.
10 sec.	+1 stop	+10 sec.
100 sec.	+1 ½ stops	+180 sec.

POLAROID

513

TYPE 42

DESCRIPTION

For medium contrast paper print positives. High speed, fine grain and excellent tonal rendition ideally suited for general purpose photography. Panchromatic. Prints must be coated.

FORMAT

40 series roll film (image area: 2⅞ x 3¾ in.—7.3 x 9.5 cm)

CONTRAST

Medium

SPEED

Approximately equivalent to ASA 200 (DIN))

PROCESSING

Under normal conditions (70°F 20°C and above) process for 15 seconds.

°C	20+	18	16	10	4
time in seconds	15	15	15-20	25-30	35-40
°F	70+	65	60	50	40

For optimum results process at temperatures in unshaded portion of chart.

SPEED/COLOR TEMPERATURE

Speed variation relative to color temperature					
3200°K	4800°K	5500°K	6500°K	7500°K	10,000°K
− ⅓ stop	−	200*	−	−	+ ½ stop

*Effective ASA equivalent.

RESOLUTION

25-28 line pairs/mm

D-MAX: 1.60

D-MIN: .01

SLOPE: 1.30

FILTER FACTORS

Light source at 3200°K – Tungsten

FILTER #	#6	#8	#15	#25	#47	#58
EXPOSURE ADJUSTMENT	⅓ Stop	⅔ Stop	⅔ Stop	2 Stops	3⅔ Stops	3⅓ Stops
EXPOSURE MULTIPLIER	1.3X	1.6X	1.6X	4X	12.6X	10X

Light source at 5500°K – Daylight

FILTER #	#6	#8	#15	#25	#47	#58
EXPOSURE ADJUSTMENT	⅔ Stop	1 Stop	1⅓ Stops	2⅔ Stops	3 Stops	3½ Stops
EXPOSURE MULTIPLIER	1.6X	2X	2.5X	6.3X	8X	11.2X

CHARACTERISTIC CURVE

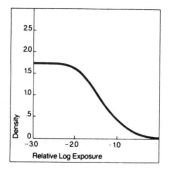

POLAROID

514

TYPE 665

DESCRIPTION
For photographic applications where a medium contrast instant print and a permanent negative are desired. Panchromatic. Prints must be coated.

FORMAT
100/600 series pack film (image area: 2⅞ x 3¾ in.—7.3 x 9.5 cm)

CONTRAST
Medium

SPEED
Approximately equivalent to ASA 75 (20 DIN)

PROCESSING
Under normal conditions (70°F 20°C and above) process for 15 seconds.

°C	20+	18	16	10	4
time in seconds	30	35	40	60	—
°F	70+	65	60	50	40

For optimum results process at temperatures in unshaded portion of chart.

SPEED/COLOR TEMPERATURE

Speed variation relative to color temperature					
3200°K	4800°K	5500°K	6500°K	7500°K	10,000°K
– ½ stop	–	75*	–	–	+ ½ stop

*Effective ASA equivalent.

To clear negative: Within 3 minutes from separation from positive, immerse negative with continuous agitation in 12% sodium sulfite solution.
Complete clearing instructions are packed in each film box.

12% Sulfite:

Warm water	1000 ml	112 oz.
Sodium sulfite (anhydrous)	136 gm.	16 oz.

FILTER FACTORS

Light source at 3200°K – Tungsten

FILTER #	#6	#8	#15	#25	#47	#58
EXPOSURE ADJUSTMENT	½ Stop	⅔ Stop	1 Stop	2½ Stops	3⅔ Stops	3 Stops
EXPOSURE MULTIPLIER	1.4X	1.6X	2.0X	5.6X	12.6X	8X

Light source at 5500°K – Daylight

FILTER #	#6	#8	#15	#25	#47	#58
EXPOSURE ADJUSTMENT	1 Stop	1⅓ Stops	1½ Stops	3½ Stops	3 Stops	3 Stops
EXPOSURE MULTIPLIER	2X	2.5X	2.8X	11.2X	8X	8X

RESOLUTION
14-20 line pairs/mm (print)
160-180 line pairs/mm (negative)

POLAROID

515

CHARACTERISTIC CURVE

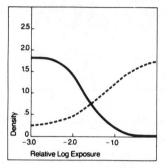

D-MAX: 1.75 (print/1.70 (negative)

D-MIN: .02 (print)/.27 (negative)

SLOPE: 1.50 (print)/.75 (negative)

SPECTRAL SENSITIVITY

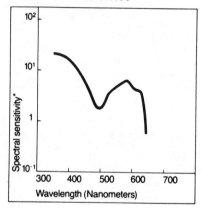

*Reciprocal of exposure (ergs/cm²) required to produce a 0.5 visual density.

RECIPROCITY

INDICATED EXPOSURE TIME	USE EITHER ADJUSTMENT		
	APERTURE	OR	EXPOSURE TIME
1/1000 sec.	None		None
1/100 sec.	None		None
1/10 sec.	None		None
1 sec.	None		None
10 sec.	+½ stop		+5 sec.
100 sec.	+1½ stops		+150 sec.

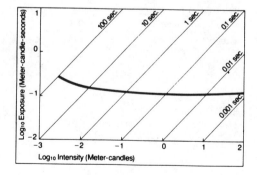

POLAROID

TYPE 55

DESCRIPTION
For photographic applications where a medium contrast instant print and a permanent negative are desired. Panchromatic. Prints must be coated.

FORMAT
4 x 5 film packet (image area: 3½ x 4½ in.—9 x 11.5 cm)

CONTRAST
Medium

SPEED
Approximately equivalent to ASA 50 (18 DIN)

PROCESSING
Under normal conditions (70°F 20°C and above) process for 20 seconds.

°C	20+	18	16	10	4
time in seconds	20	30-35	40	60	—
°F	70+	65	60	50	40

For optimum results process at temperatures in unshaded portion of chart.

SPEED/COLOR TEMPERATURE

Speed variation relative to color temperature					
3200°K	4800°K	5500°K	6500°K	7500°K	10,000°K
-⅓ stop	—	50*	—	—	+⅓ stop

*Effective ASA equivalent.

To clear negative: Within 3 minutes from separation from positive, immerse negative with continuous agitation in 18% sulfite solution.
Complete clearing instructions are packaged in each film box.

18% Sulfite:

Warm water	1000 ml	70 oz.
Sodium sulfite (anhydrous)	220 gm.	16 oz.

FILTER FACTORS

Light source at 3200°K – Tungsten

FILTER #	#6	#8	#15	#25	#47	#58
EXPOSURE ADJUSTMENT	⅓ Stop	⅔ Stop	1 Stop	2⅔ Stops	4 Stops	3 Stops
EXPOSURE MULTIPLIER	1.3X	1.6X	2X	6.3X	16X	8X

Light source at 5500°K – Daylight

FILTER #	#6	#8	#15	#25	#47	#58
EXPOSURE ADJUSTMENT	⅔ Stop	1 Stop	1⅓ Stops	3½ Stops	3 Stops	3 Stops
EXPOSURE MULTIPLIER	1.6X	2X	2.5X	11.2X	8X	8X

SPECTRAL SENSITIVITY

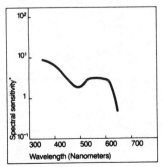

*Reciprocal of exposure (ergs/cm²) required to produce a 0.5 visual density.

POLAROID

517

The Compact Photo-Lab-Index

RESOLUTION
22-25 line pairs/mm (print)
150-160 line pairs/mm (negative)

CHARACTERISTIC CURVE

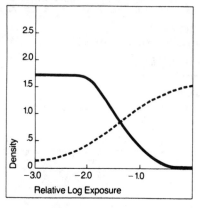

D-MAX: 1.65 (print)/1.55 (negative)

D-MIN: .01 (print)/.18 (negative)

SLOPE: 1.35 (print)/.65 (negative)

INDICATED EXPOSURE TIME	USE EITHER ADJUSTMENT		
	APERTURE	OR	EXPOSURE TIME
1/1000 sec.	None		None
1/100 sec.	None		None
1/10 sec.	None		None
1 sec.	None		None
10 sec.	+⅓ stop		+3 sec.
100 sec.	+1 stop		+100 sec.

RECIPROCITY

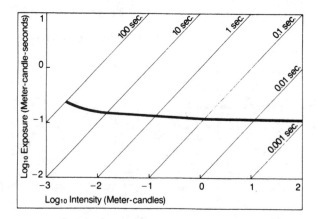

POLAROID

TYPE 51

DESCRIPTION

For high contrast paper print positives. Blue sensitive. Ideal for graphic arts and half-tone applications. Also useful for some applications in photomicrography, metallography and the laboratory sciences. Prints must be coated.

FORMAT

4 x 5 film packet (image area: 3½ x 4½ in.—9 x 11.5 cm)

CONTRAST

High

SPEED

Approximately equivalent to ASA 320 (26 DIN) Daylight
Approximately equivalent to ASA 125 (22 DIN) Tungsten—2800K

PROCESSING

°C	20+	18	16	10	4
time in seconds		15-20 (line) 10 (half-tone)	20-25 (line)		
°F	70+	65	60	50	40

For optimum results process at temperatures in unshaded portion of chart.

SPEED/COLOR TEMPERATURE

Speed variation relative to color temperature					
3200°K	4800°K	5500°K	6500°K	7500°K	10,000°K
−1 stop	−⅓ stop	320*	+⅓ stop	+½ stop	+⅔ stop

*Effective ASA equivalent.

CHARACTERISTIC CURVE

D-MAX: 1.75

D-MIN: .01

SLOPE: 3.30

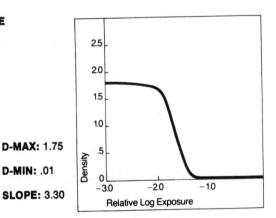

RESOLUTION

28-32 line pairs/mm

POLAROID

519

The Compact Photo-Lab-Index

SPECTRAL SENSITIVITY

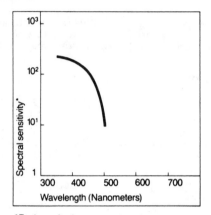

°Reciprocal of exposure (ergs/rm²) required
to produce a 0.5 visual density.

RECIPROCITY

INDICATED EXPOSURE TIME	USE EITHER ADJUSTMENT		
	APERTURE	OR	EXPOSURE TIME
1/1000 sec.	None		None
1/100 sec.	None		None
1/10 sec.	None		None
1 sec.	+⅓ stop		None
10 sec.	+⅔ stop		+6 sec.
100 sec.	+1⅓ stops		+150 sec.

POLAROID

ACUFINE INC.
ACUFINE FILM DEVELOPER

Acufine is a maximum acutance, ultra-fine-grain film developer, combining optimum quality, with the highest effective speeds currently available with single solution developers. It is a modern developer formulated for modern emulsions, and fully exploits the inherent capabilities of any film. Acufine's higher speed ratings permit the use of slower films, with superior resolving power and finer grain in situations that previously required high-speed films.

PREPARATION

Acufine Film Developer is packaged in single-mix dry powder form, readily soluble in water. (70° to 90°F.) Although the water in most areas is suitable, the use of distilled water is recommended wherever the mineral content or alkalinity is high. Acufine, either dry or in solution, may assume a slight coloration which will in no way affect its chemical properties.

STORAGE

Acufine Film Developer, in solution, will retain its full strength for approximately one year if normal precautions are taken against contamination and oxidation. All storage and processing equipment must be clean. If deposits of previously-used chemicals remain on any items of equipment, these should be soaked overnight in a solution of approximately one ounce of sodium sulfite per gallon of water, and then thoroughly rinsed. To minimize oxidation, Acufine Film Developer should be stored in full, tightly-capped, amber glass or polyethylene bottles. When stored in open tanks, floating lids should be used.

RECOMMENDED EXPOSURE INDICES

The high film speed ratings listed on the chart are in every sense the normal exposure indices for Acufine. It cannot be overemphasized that the recommended exposure development values are calculated for optimum quality negatives, and are not the result of "pushing." At the recommended speeds and developing times, Acufine works best. . . . To alter the speed rating and/or developing times will result in negatives of less than Acufine's optimum quality.

A single index is given for each film since the color sensitivity of most modern exposure meters eliminates the need of separate tungsten ratings.

DEVELOPING TIMES

The developing times will produce negatives of ideal contrast for printing in modern condenser enlargers. For cold-light and diffusion-type enlargers, development may be increased by 25%. Contrast may be increased or decreased to meet the individual's requirements by varying developing times ±25% from normal. Extreme variations from the chart recommendations will affect quality and film speed.

Whenever the conditions require higher than normal Acufine ratings, medium and high speed emulsions may be "pushed" in Acufine to produce the maximum possible speeds, but at some sacrifice in quality. The maximum gain of 2X to 3X the recommended indices is achieved at approximately double the developing time. With slow films, the speed gained by force development is negligible.

AGITATION

The developing times listed on the chart are based on **gentle** agitation for the first ten seconds after immersion, followed by **gentle** agitation for five seconds every minute. Excessive or vigorous agitation is to be avoided since it results in greatly increased contrast, with little or no speed gain. Less than recommended agitation promotes the possibility of irregular development, low contrast, and loss of speed. Constant agitation cannot be compensated for by decreasing development.

REPLENISHMENT

Acufine Replenisher is strongly recommended for maintaining consistency in quality and developing time. Replenisher should be added and thoroughly stirred into the developer at the end of each processing cycle. Average replenishment is at the rate of ½ fl. oz. per 80 square inches of film. (1 roll of 36 exposure 35mm, or 1 roll of 120/620, or four 4 x 5 sheets.) Replenishment may be continued until a volume equal to the original amount of developer has been added. Without replenishment, four rolls may be developed at normal times. Increase the developing time by 2% for each additional roll. Develop no more than 16 rolls per quart in this manner.

ONE TIME USE

If longer developing times are desired for more convenient control, Acufine Film Developer may be used as a diluted preparation with no change in either film speed or quality. The following chart gives the time factors for the recommended dilutions.

Recommended Dilution Ratio:	Development Increase
1 part Developer to 1 part water	2X
1 part Developer to 3 parts water	4X

Diluted developer must be used only once, immediately after preparation, and then discarded.

RECIPROCITY FAILURE

Reciprocity failure is the speed loss incurred by all photographic emulsions with exposures of extremely short or long duration. This effect is unnoticed with most popular electronic flash units, but if the flash duration is 1/2000th of a second or faster, development should be increased by 25%. Reciprocity failure also becomes noticeable with exposures of approximately 10 seconds and becomes more pronounced with increased times. The exposure compensation necessary for these conditions varies with each type of film, but for most practical applications, exposures of 2X to 4X the calculated time should be used.

ACUFINE FILM DEVELOPER

35mm FILMS	ASA	65F	68F	70F	75F	80F	85F
Kodak Tri-X	1200	6	5¼	4¾	3¾	3	2¼
Kodak Plus-X	320	5	4½	4	3¼	2½	2
Kodak Panatomic-X	100	2½	2¼	2	1¾	1¼	1
Kodak 2475 Recording	3200	8¾	7¾	7	5½	4½	1½
Infrared Tungsten	40	8¾	—	7	5½	4½	3½
Agfa Agfapan 1000	2400	10	—	8	6¼	5	4
Agfa Isopan U	500	5¾	—	4½	3½	2¾	2¼
Agfa Isopan SS	200	4¼	—	3½	2¾	2¼	1¾
Agfa Agfapan 100	320	8¾	7¾	7	5½	4½	3½

MISCELLANEOUS
MANUFACTURERS

ACUFINE FILM DEVELOPER (Continued)

35mm FILMS	ASA	65F	68F	70F	75F	80F	85F
Agfa Agfapan 400	800	8¾	7¾	7	5½	4½	3½
Agfa Isopan Record	1000	8¾	7¾	7	5½	4½	3½
Agfa Isopan F	125	3¾	3¼	3	2¼	1¾	1½
Agfa Isopan FF	64	2½	2¼	2	1¾	1¼	1
Ilford FP 4	200	5	4½	4	3¼	2½	2
Ilford HP 4	1600	10	8¾	8	6¼	5	4
Ilford Pan F	64	2½	2¼	2	1¾	1¼	1
Ansco Super Hypan	1000	8¾	7¾	7	5½	4½	3½
Ansco Versapan	250	4¾	4¼	3¾	3	2¼	1¾
Sakura Konipan SSS	1000	8¾	—	7	5½	4½	3½
Sakura Konipan SS	400	8¾	—	7	5½	4½	3½
Fuji Neopan SSS	1000	6	—	4¾	3¾	3	2¼
Fuji Neopan SS	400	7½	—	6	4¾	3¾	3

SHEET FILMS	ASA	65F	68F	70F	75F	80F	85F
Kodak Super Pan Portrait	320	12½	—	10	8	6½	5
Kodak Plus-X Pan	320	10	8¾	8	6¼	5	4
Kodak Super-XX	500	12½	11	10	8	6½	5
Kodak Tri-X	800	6¼	5½	5	4	3¼	2½
Kodak Panatomic-X	80	6¼	5½	5	4	3¼	2½
Kodak Tri-X Pack	800	10	8¾	8	6¼	5	4
Kodak Royal-X Pan	3000	15	13	12	9½	7½	6
Kodak Royal Pan	1000	10	8¾	8	6¼	5	4
Kodak Super Panchro Press B	320	10	8¾	8	6¼	5	4
Kodak LS Pan	100	5¾	5	4½	3½	2¾	2¼
Kodak RS Pan	800	17½	—	14	11	9	7
Dupont Cronar XF Pan	125	7½	—	6	4¾	3¾	3
Dupont Cronar High Speed Pan	400	10	—	8	6¼	5	4
Dupont Cronar Arrow Pan	400	15	—	12	9½	7½	6
Dupont Cronar Press	600	15	—	12	9½	7½	6
Gevapan 30	125	7½	—	6	4¾	3¾	3
Gevapan 33	320	10	—	8	6¼	5	4
Gevapan 36	600	15	—	12	9½	7½	6
Ilford Special Portrait 124	200	7½	—	6	4¾	3¾	3
Ilford FP 3	320	10	—	8	6¼	5	4
Ilford HP 3	800	10	—	8	6¼	5	4
Ilford HP 3 Matte	800	10	—	8	6¼	5	4
Ilford HP 4	1000	15¾	—	12½	10	8	6½
Agfa IP 21	200	14	—	11¼	9	7¼	5¾
Agfa IP 21 Matte	200	14	—	11¼	9	7¼	5¾
Agfa IP 24 Matte	400	8¾	—	7	5½	4½	3½
Ansco Finopan	200	10	—	8	6¼	5	4
Ansco Superpan	500	11	—	8¾	7	5¾	4½

MISCELLANEOUS MANUFACTURERS

ACUFINE FILM DEVELOPER (Continued)

120/620/127 FILMS	ASA	65F	68F	70F	75F	80F	85F
Kodak Tri-X Professional	800	7½	6½	6	4¾	3¾	3
Kodak Tri-X	1200	7½	6½	6	4¾	3¾	3
Kodak Plus-X	320	5	4½	4	3¼	2½	2
Kodak Verichrome Pan	250	5¾	5	4½	3½	2¾	2¼
Kodak Panatomic-X	100	5¾	5	4½	3½	2¾	2¼
Kodak Type 2475 Recording	3200	8¾	—	7	5½	4½	3½
Agfa Pro 100	320	12½	11	10	8	6½	5
Agfa Pro 400	800	12½	11	10	8	6½	5
Agfa Isopan Record	1000	8¾	7¾	7	5½	4½	3½
Agfa Isopan F	125	4¼	3¾	3½	2¾	2¼	1¾
Agfa Isopan FF	64	3¾	3¼	3	2¼	1¾	1½
Agfa Isopan SS	200	5¾	—	4½	3½	2¾	2¼
Agfa Isopan U	500	5¾	—	4½	3½	2¾	2¼
Ansco Super Hypan	1000	10	8¾	8	6¼	5	4
Ansco Versapan	250	7½	6½	6	4¾	3¾	3
Ilford FP 4	200	7½	6½	6	4¾	3¾	3
Ilford HP 4	1600	12½	11	10	8	6½	5

ACU-1 FILM DEVELOPER

ACU-1 is a maximum acutance, ultra-fine-grain film developer, combining optimum quality. with **great effective** speed It is a modern developer formulated for modern emulsions, and fully exploits the inherent capabilities of all films. ACU-1's higher speed ratings permit the use of slower films with superior resolving power and finer grain in situations that previously required high speed films. ACU-1 is a developer designed for those who prefer to work with a "one-time" use preparation with convenient dilution ratios.

PREPARATION

ACU-1 concentrate is packaged in single-mix dry powder form, readily soluble in water (70 to 90°F). Prepare the concentrated "stock solution" by dissolving completely the full contents of the can in 1 quart of water (946 ml). Although the water in most areas is suitable, we recommend the use of distilled water wherever the mineral content or alkalinity of the tap water is high. ACU-1 concentrate, either dry or in solution, may assume a slight coloration which in no way will affect its chemical properties.

STORAGE

ACU-1 "stock solution" will retain its full strength for approximately one year if normal precautions are taken against contamination and oxidation. All storage and processing equipment must be clean. All equipment suspected of contamination should be soaked for eight hours in a solution of approximately one ounce of sodium sulfite per gallon of warm water, and then thoroughly rinsed. To minimize oxidation, ACU-1 should be stored in full, tightly-capped amber glass or polyethylene bottles. For infrequent use, it is recommended that the concentrate be stored in several small bottles to assure longer life.

MISCELLANEOUS MANUFACTURERS

The Compact Photo-Lab-Index

RECOMMENDED EXPOSURE INDICES

The high speed ratings listed on the chart are the normal exposure indices for ACU-1. The recommended exposure/development values are calculated for optimum quality negatives, and are not the result of "pushing." Alteration of these values, variations of personal technique excepted, will result in negatives of less than ACU-1's best quality.

A single index is given for each film since the sensitivity of most modern exposure meters eliminates the need of separate tungsten ratings.

RECOMMENDED EXPOSURE INDICES AND DEVELOPING TIMES

Dilution Ratios: 1:5 Dilution/5⅓ oz. or 157ml developer Balance water to make 1 quart (946ml). 1:10 Dilution/3 oz. or 86ml developer. Balance water to make 1 quart (946ml).

	EXPOSURE INDEX	DILUTION developer: water	68°	70°	75°	80°	85°F
35mm Films							
Kodak Tri-X	1000	1:5	11	10	8	6½	5
Kodak Plus-X	250	1:10	10	9	7	5½	4½
Kodak Panatomic–X	64	1:10	6¼	5½	5	4	3¼
Ilford HP5	800	1:5	10	9	7	5½	4½
Ilford FP4	250	1:10	10	9	7	5½	4½
Ilford Pan-F	64	1:10	6¼	5½	5	4	3¼
Roll Films							
Kodak Tri-X Professional	650	1:5	10	9	7	5¾	4½
Kodak Tri-X	1000	1:5	15½	14	11	9	7
Kodak Plus-X Professional	250	1:10	6¼	5½	5	4	3¼
Kodak Panatomic-X	80	1:10	6¼	5½	5	4	3¼
Kodak Verichrome Pan	250	1:5	12½	11¼	9	7¼	5¾
Kodak Pan-X Professional	100	1:10	6¼	5½	5	4	3¼
Ilford HP4	800	1:5	12½	11	10	8	6½
Ilford FP4	250	1:10	12½	11¼	9	7¼	5¾
Ilford Pan-F	64	1:10	6¼	5½	5	4	3¼

MISCELLANEOUS MANUFACTURERS

IMPROVED DIAFINE

Diafine is usable over a wide temperature range with **one developing time for all films.** Fast, medium and slow films can be developed simultaneously without adjustment in developing time. All films with the exception of a few extremely slow emulsions are automatically developed to the most desirable contrast. Time and temperature have no practical effect if the minimum recommendations are observed.

Diafine film developer produces the greatest effective speed, ultra-fine grain, maximum acutance and highest resolution. It is a characteristic of Diafine film developer to permit wide latitude of exposure without the necessity of time-temperature compensation.

PREPARATION

Diafine is supplied in dry powder form to make two separate solutions (A & B). The two powders contained in a carton of Diafine are to be prepared and used separately.

Dissolve the contents of the smaller can (Solution A) in water (75 to 85°F) to make the volume specified on the carton. Dissolve the contents of the larger can to make an equal amount of Solution B. Label the storage containers clearly. For maximum consistency and stability, use distilled water. As with any photographic developer, all storage and processing equipment must be clean.

In use, the solutions will become discolored and a slight precipitate may form which in no way will affect the working properties of Diafine. The precipitate may be removed, if desired, by filtering.

TIME AND TEMPERATURE

Diafine may be used within a temperature range of 70 to 85°F with a minimum time of 3 minutes in each solution. Increased developing times will have no practical effect on the results. It is recommended that you do not exceed 5 minutes in either solution.

DEVELOPING PROCEDURE

Do not pre-soak films.
Any type of tank or tray may be used.
1. Immerse film in Solution A for at least 3 minutes, agitating very gently for the first 5 seconds and for 5 seconds at 1-minute intervals. **Avoid excessive agitation as this may cause some loss of shadow speed and excessive contrast.**
2. DRAIN, BUT DO NOT RINSE.
3. Immerse film in Solution B for at least 3 minutes, agitating gently for the first 5 seconds and for 5 seconds at 1-minute intervals. **Avoid excessive agitation.**
4. Drain and rinse in plain water for about 30 seconds. Use of an acid stop bath is not recommended.
5. Fix, wash and dry in the usual manner.

Optimum results are obtained if all solutions, including the wash, are maintained at the same temperature. Care must be exercised to prevent any amount of Solution B from entering Solution A.

REPLENISHMENT

Diafine does not require replenishment. It is an extremely stable formula and has an unusually long work life, if normal precautions are taken against contamination.

When necessary, the level of the solutions can be maintained by the addition of fresh Diafine. Add **equal amounts** of fresh A & B to their respective working solutions. Since the introduction of dry film into Solution A decreases the volume of A more rapidly than that of B, some of the B will have to be discarded before adding the fresh B solution.

MISCELLANEOUS MANUFACTURERS

The Compact Photo-Lab-Index

MINIATURE & ROLL FILMS	Exposure Index	SHEET FILMS	Exposure Index
Kodak Tri-X	1600	Kodak Royal-X Pan	3000
Kodak Tri-X Professional 120	1000	Kodak Royal Pan	2000
Kodak Plus-X	400	Kodak Tri-X	1200
Kodak Panatomic-X	160	Kodak Super XX	800
Kodak Verichrome Pan	400	Kodak Plus X	400
Kodak Royal-X Pan	2400	Kodak Panchro Press B	500
Ilford Pan F	125	Kodak Portrait Pan	400
Ilford FP4	320		
Ilford HP5	800		

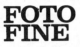

FOTO FINE

FOTOFINE is a developer for all types of B&W print emulsions. It is an extremely stable formula with great capacity, and because of its 1:7 dilution is considerably more economical than conventional preparations. One gallon of the ultra-concentrated "stock" FOTOFINE will prepare 8 gallons of "working" solution...a full 5 gallons more than the usual preparations. The 1 quart size will prepare 2 gallons of "working" developer.

FOTOFINE has exceptional middle tone capabilities and produces outstanding deep blacks. It is neutral in its tonal rendition.

Preparation: Thoroughly dissolve the entire contents of the container in the specified volume of water (70° to 90°F). Store in clean, suitable containers. Do not mix partial quantities.

Usage: For normal use, mix 1 part "stock" solution to 7 parts of water. Normal developing times will be about three minutes. Times may be varied from three to five minutes, depending upon the contrast desired. After development, stop, fix and wash in the usual manner. We strongly endorse the use of a hypo eliminator before washing.

MISCELLANEOUS MANUFACTURERS

The Compact Photo-Lab-Index

The accompanying table gives the relative printing speeds of some of the most popular print emulsions developed in FOTOFINE. All speeds are based on the "normal" grade of the respective emulsions. In the case of variable contrast papers, the relative speed has been computed without filters. When using filters, the appropriate factors for the filters must be applied.

Polycontrast (no filter)	3
Polycontrast Rapid (no filter)	1
Polycontrast Rapid RC (no filter)	1
Kodabromide	2
Kodabromide RC	1
Medalist	4
Panalure	2
Portrait Proof	8
Portralure	12
Kodabrome II RC	1
Ilfobrom	3
Ilfobrom Galerie	1.5
Ilfospeed	3
Ilfospeed Multigrade (no filter)	1
Brovira	3
Brovira-Speed	1.5
Portriga Rapid	2

MISCELLANEOUS MANUFACTURERS

COLOR BY BESELER E-6 PROCESSING KIT

The Color by Beseler E-6 Processing Kit contains the chemistry to produce richly detailed and color saturated transparencies from all Kodak E-6 and other E-6 type color reversal films. This chemistry gives greater creative control than can be obtained with commercial lab processing.

REQUIRED EQUIPMENT

1. Processing Tank and Reels

Either invertable or rotary types may be used. While stainless steel is preferred, plastic tanks and reels which are compatible with color processing chemicals may be safely used. Certain plastics may show some discoloration with repeated use.

2. Bottles

Seven 1 liter bottles will be required to store the chemicals. New brown plastic or glass bottles should be used and it is a good idea to acquire a set exclusively for use with this chemistry. This will eliminate the possibility of contamination from traces of chemicals which might remain in previously used bottles.

3. Thermometer

A thermometer accurate to within ½°F at 100°F will insure precise temperature control in the critical developing steps.

4. Temperature Control Tray

In addition, you will require a tray large enough to hold the processing tank and solutions in a water bath of the correct temperature. A darkroom timer provides a convenient means of timing each processing step.

MIXING THE SOLUTIONS

The kit is designed to make one liter (34 oz.) of working solutions. For optimum results the entire kit should be mixed at one time. If, however, it is desired to make smaller quantities this may be done by measuring out proportional amounts of the liquid concentrates. For example, to make a half liter (17 oz.) you would measure out half the quantity of each concentrate in the kit. Be careful, when dividing concentrates to measure as precisely as possible and to avoid contaminating one solution with another. Also, partially filled bottles of concentrate will oxidize more rapidly than full ones, resulting in decreased shelf life. Once you have mixed part of a kit, the remainder should be used within two to three months. If the developer concentrates turn a dark brown, they should be discarded. Once mixed, the solutions have a shelf life of four weeks when stored in full, tightly stoppered containers.

COLOR BY BESELER PROCESS E-6

To help you keep track of the mixed solutions self adhesive labels have been provided to be put on the outside of the storage bottles. Record the date mixed and the number of rolls processed on these labels. Solutions should not be mixed until they are to be used. Mixing with water at a temperature close to 100°F is a convenient method of getting the solutions to approximately processing temperature.

Important Note: To facilitate packaging, some of the bottles in this kit are only partially filled. However, all bottles contain the specified measure of liquid concentrate for making the proper amount of chemical solution.

MIXING INSTRUCTIONS FOR ONE LITER WORKING SOLUTIONS

No.	Solution	Start With This Much Water	Add Concentrates in These Amounts	Add Water to Make
1	First Developer	600 ml (20 oz)	1 bottle (200 ml)	1 Liter (34 oz)
2	Reversal Bath	600 ml (20 oz)	1 bottle (100 ml)	1 Liter (34 oz)
3	Color Developer	600 ml (20 oz)	1 bottle Part A (200 ml) 1 bottle Part B (50 ml)	1 Liter (34 oz)
4	Conditioner	600 ml (20 oz)	1 bottle (200 ml)	1 Liter (34 oz)
5	Bleach	400 ml (14 oz)	1 bottle Part A (400 ml) 1 bottle Part B (40 ml)	1 Liter (34 oz)
6	Fixer	600 ml (20 oz)	1 bottle (200 ml)	1 Liter (34 oz)
7	Stabilizer	600 ml (20 oz)	1 bottle (40 ml)	1 Liter (34 oz)

To mix ½ liter (17 oz) use ½ of the above listed quantities
To mix ¼ liter (8½ oz) use ¼ of the above listed quantities

PROCESSING

TIME

All processing times include the time it takes to drain the tank. Most tanks will drain completely in about 10 seconds.

After processing the equivalent of four rolls of film in each liter of developer, the processing time in the First Developer must be increased from 6½ minutes to 7 minutes. Processing time in the other steps remains the same. One roll of film is considered to be 80 square inches, which is equivalent to a 36 exposure roll of 35mm or a roll of 120. Other equivalents are given below. In every case the first development time should be increased after processing *half* the capacity per liter of solution.

When processing film which has been exposed at other than the normal ASA speed, the time in the First Developer must be adjusted as shown later (Processing for Different Film Speeds).

TEMPERATURE

When working with the E-6 process, it is important to have precise control of the temperature of the processing solutions. The First Developer must be held at 100°F±½°F, while the Color Developer should be held at 100°F±1°F. In order to maintain these temperatures in the developing steps, it is recommended that processing solutions be brought to proper temperature and placed in a temperature controlled water bath before beginning processing. During processing, the tank should also be placed in the temperature controlled water bath in between agitation cycles.

AGITATION

In order to realize optimum results with this processing kit, it is important that processing time and temperature be controlled as precisely as possible and that the correct agitation technique be used in each solution. Note that in the Reversal Bath and Conditioner the tank should be agitated for the first 15 seconds *only*.

MISCELLANEOUS MANUFACTURERS

The Compact Photo-Lab-Index

WASHING

The first wash must be performed with the film in total darkness. A convenient way to do this is to fill and drain the closed tank at least four times during the 2 minute wash period. An alternate method is to turn out all the lights and wash the film under running water, of the proper temperature, with the cover removed from the tank. The final wash should be under running water with the cap off the tank and the room lights on.

SOLUTION CAPACITIES

The table shows how many rolls of film may be processed in each liter of working solution. In every instance, the processing time in the First Developer must be increased to 7 minutes after that solution has been used to 'half its capacity (e.g., after four rolls of 135-36).

Film Size	Rolls Per Liter
110 (20 exp.)	36
126 (20 exp.), 127	16
135 (24 exp.)	12
135 (36 exp.), 120, 620	8
220	4

PROCESSING SCHEDULE

Processing must be performed in total darkness through the Reversal Bath step, after which the cover may be removed from the tank and the remaining steps performed in room light. The processed film will have an opalescent appearance until it dries, at which time it will assume its normal color and density.

COLOR BY BESELER PROCESS E-6

No.	Solution	Time in Minutes	Temperature	Agitation
1	First Developer	6½*	100°F±½°	Continuously for first 15 seconds, then for 5 seconds every 30 seconds
	First Wash	2	92°-102°F	Fill and drain 4 times; agitate continuously
2	Reversal Bath	2	92°-102°F	First 15 seconds only
3	Color Developer	6	100°F±1°F	Continuously for first 15 seconds, then for 5 seconds every 30 seconds
4	Conditioner	2	92°-102°F	First 15 seconds only
5	Bleach	6	92°-102°F	Continuously for first 15 seconds, then for 5 seconds every 30 seconds
6	Fixer	4	92°-102°F	Continuously for first 15 seconds, then for 5 seconds every 30 seconds
	Final Wash	4	92°-102°F	Running water
7	Stabilizer	½	68°-102°F	First 5 seconds only

Dry the film in a dust-free environment, removed from the processing reel, and at temperature not over 120°F.

*After processing the equivalent of 4 rolls of film in each liter of First Developer, increase the processing time to 7 minutes.

The Compact Photo-Lab-Index

PROCESSING FOR DIFFERENT FILM SPEEDS

While it is always desirable to expose reversal films at the recommended exposure index (ASA), the need may occasionally arise to deliberately underexpose or overexpose the film, or such may happen accidentally. Providing that some deficiencies in color balance and contrast can be tolerated, it is possible to compensate for such exposure variations, within limits, by varying the processing time in the First Developer. Where this technique is used to "push" the speed of the film, it is not recommended to exceed a one stop increase, unless it is of primary importance to record an image and the color balance is only of secondary importance.

To Compensate for This Exposure Variation	Make This Adjustment to the First Developer Processing Time
1 stop overexposed (½ normal ASA)	Decrease by 2 minutes
1 stop underexposed (2× normal ASA)	Increase by 2 minutes
2 stops underexposed (4× normal ASA)	Increase by 5 minutes

SUMMARY OF INGREDIENTS AND SAFETY PRECAUTIONS

FIRST DEVELOPER

Caution: May be fatal if swallowed—injurious to eyes—skin irritant—may cause allergic skin skin reaction. Contains: A Hydroquinone derivate, Potassium Carbonate, Sodium Bromide and Sodium Thiocyanate. Avoid contact with eyes and skin. In case of eye contact, flush with water for 15 minutes and call physician immediately. In case of skin contact, wash thoroughly. If swallowed, give 1 or 2 glasses of water and get immediate medical attention. Keep out of reach of children.

REVERSAL BATH

Caution: Harmful if swallowed. Contains, Tin-(2)-Chloride and Sodium Salts of Carbonic Acid. If swallowed, give 1 or 2 glasses of water and induce vomiting. Call physician immediately. Keep out of reach of children.

COLOR DEVELOPER—PART A

Caution: Injurious to eyes—skin irritant—harmful if swallowed. Contains: Sodium Hydroxide, Sodium Sulfite and Sodium Bromide. Avoid eye contact. In case of eye contact, flush with water for 15 minutes and call physician immediately. Keep out of reach of children.

COLOR DEVELOPER—PART B

Caution: May be fatal if swallowed—may cause allergic skin reaction. Contains: Sodium Sulfite and a Paraphenylene Diamine derivate. Do not get in eyes, on skin or clothing. In case of eye contact, flush thoroughly with water. For skin contact, wash thoroughly. If swallowed, give 1 or 2 glasses of water and get immediate medical attention. Keep out of reach of children.

CONDITIONER

Caution: Harmful if swallowed. Contains: Potassium Sulfite and Thioglycerin. If swallowed, give 1 or 2 glasses of water and induce vomiting. Call physician immediately. Keep out of reach of children.

BLEACH—PART A

Caution: Harmful if swallowed—eye irritant. Contains: Ammonium hydroxide, Ammonium and Ammonium Ferric Salts of Ethylenediamine Tetraacetic Acid and Mercapto-Triazol-Disulfide. In case of eye contact, flush thoroughly with water and call physician immediately. If swallowed, give 1 or 2 glasses of water and induce vomiting. Call physician immediately. Keep out of reach of children.

MISCELLANEOUS MANUFACTURERS

The Compact Photo-Lab-Index

BLEACH—PART B

Caution: Injurious to eyes—harmful if swallowed. Contains: Acetic Acid. Avoid eye contact. In case of eye contact, flush with water for 15 minutes and call physician immediately. If swallowed, give 1 or 2 glasses of water and induce vomiting. Call physician immediately. Keep out of reach of children.

FIXER

Caution: *Harmful if swallowed.* Contains: Ammonium Thiosulfate and Sodium Sulfite. In case of eye contact, flush thoroughly with water. If irritation persists, get medical attention. If swallowed, give 1 or 2 glasses of water and induce vomiting. Call physician immediately. Keep out of reach of children.

STABILIZER

Caution: Injurious to eyes—may cause allergic skin reaction. Contains: Formaldehyde. Avoid contact with eyes. In case of eye contact, flush with water for 15 minutes and call physician immediately. In case of skin contact, wash thoroughly. Keep out of reach of children.

TROUBLE SHOOTING GUIDE

Problem	Possible Answer
Slides too dark	Underexposure. Check camera and meter. Adjust film speed setting on meter to compensate for any systematic error. Insufficient time, temperature or agitation in First Developer. Exhausted or oxidized First Developer.
Slides too light	Overexposure. Check camera and meter. Adjust film speed setting on meter to compensate for any systematic error. Too much time, temperature too high, or too much agitation in First Developer.
Unnatural color balance, color fog	Contamination of one processing solution with another.
Blue-Magenta shadows	Temperature too low or insufficient time in Color Developer. Exhausted Color Developer.
Unevenness, streaks or blotches	Improper agitation. Be sure the correct technique is being used in each step.

COLOR BY BESELER 3 STEP CHEMISTRY

Beseler 3 step chemistry is used for processing prints from slides on Kodak Ektachrome 2203-RC and similar color papers. It has been specially formulated to provide the utmost in processing simplicity with only 3 chemical steps. A reversal agent incorporated in the color developer eliminates the need for a separate reversal bath or white light reversal exposure.

Color by Beseler 3 Step Chemistry processing kit gives greater creative control than you can obtain with commercial lab processing.

REQUIRED EQUIPMENT

1. Processing Drum

Plastic drums which allow the print to be processed in normal room lighting provide the ideal means for using this chemistry.

2. Bottles

Three bottles will be required to store the mixed chemicals. New brown plastic or glass bottles should be used and it is a good idea to acquire a set exclusively for use with this chemistry. This will eliminate the possibility of contamination from traces of chemicals which might remain in previously used bottles.

3. Graduates

Three graduates of a size appropriate to the processing drum you are using and a one liter (34 oz.) graduate will be required to mix and measure the solutions.

4. Thermometer

A reliable accurate thermometer, will insure consistently good results.

5. Wash Tray

A tray large enough to hold your prints should be used for the final wash. Various print washers are commercially available although an ordinary tray and a length of hose are perfectly adequate.

MIXING THE SOLUTIONS

The kit contains Step 1 (First Developer), Step 2 (Color Developer) and Step 3 (Bleach Fix) components. Each yields working solutions equal to the specified volume of the kit. For example, the 1 liter kit makes 34 oz. (1 liter) of each step. The 4 x 1 liter kit may be mixed to make either four individual liters of each step or a four liter batch. Mixing may be done over a range of temperatures, though the solutions should be allowed to adjust to room temperature when using the ambient temperature processing technique.

Both metric and U.S. customary units of measure are used in these instructions. Where doing so will have no adverse effect, conversions have been rounded off to provide convenient quantities of measure. As with all color processing chemicals, be particularly careful to avoid cross contamination of solutions when mixing or processing.

MISCELLANEOUS MANUFACTURERS

BESELER 3 STEP CHEMISTRY MIXING INSTRUCTIONS

| | One Liter Kit | Four |×| One Liter Kit | |
|---|---|---|---|
| **Step 1**
Wash All Utensils Before Mixing | To mix one
liter (34 oz) | To mix one
liter (34 oz) | To mix four
liters (128 oz) |
| 1 Start with water at
68°-100° (20-38°C) | 700 ml
(24 oz) | 700 ml
(24 oz) | 2800 ml
(96 oz) |
| 2 While stirring, add Step 1, Part A | entire bottle | 100 ml | entire bottle |
| 3 While stirring, add Step 1, Part B | entire bottle | 100 ml | entire bottle |
| 4 While stirring, add Step 1, Part C | entire bottle | 30 ml | entire bottle |
| 5 Add water to make . . . | 1 liter | 1 liter | 4 liters |
| **Step 2**
Wash All Utensils Before Mixing | | | |
| 1 Start with water at
68°-100° (20-38°C) | 700 ml
(24 oz) | 700 ml
(24 oz) | 2800 ml
(96 oz) |
| 2 While stirring, add Step 2, Part A | entire bottle | 30 ml | entire bottle |
| 3 While stirring, add Step 2, Part B | entire bottle | 20 ml | entire bottle |
| 4 While stirring, add Step 2, Part C | entire bottle | 30 ml | entire bottle |
| 5 While stirring, add Step 2, Part D | entire bottle | 100 ml | entire bottle |
| 6 Add water to make . . . | 1 liter | 1 liter | 4 liters |
| **Step 3**
Wash All Utensils Before Mixing | | | |
| 1 Start with water at
68°-100° (20-38°C) | 700 ml
(24 oz) | 700 ml
(24 oz) | 2800 ml
(96 oz) |
| 2 While stirring, add Step 3, Part A | one package | one package | four packages |
| 3 While stirring, add Step 3, Part B | one package | one package | four packages |
| 4 Add water to make . . . | 1 liter | 1 liter | 4 liters |

Mixed solutions will last approximately four weeks in full, tightly stoppered bottles.

EXPOSING THE PRINT

When exposing reversal materials, it is important to remember that they behave in a manner opposite to negative materials. To make a reversal print DARKER, one must DECREASE the exposure; to make it LIGHTER, one must INCREASE the exposure. Similarly, if a print shows an EXCESS of a certain color, then that color must be REMOVED from the filter pack, and vice versa. For example, if your first print is TOO MAGENTA, the filter pack should be corrected by SUBTRACTING MAGENTA FILTRATION, or alternatively ADDING GREEN (CYAN + YELLOW) filtration. If you are accustomed to printing negatives you will find that reversal materials require greater changes of filtration and exposure to produce the desired effect on the print. As a rule of thumb, you should *double* the filtration or exposure corrections that you would use for negative printing.

Suggested trial exposures are listed below. For more information on exposing the print, consult the instruction sheet packed with the paper.

TRIAL EXPOSURES FOR 8 x 10 PRINTS FROM 35mm TRANSPARENCIES

Type of Slide	Filtration	Exposure
Ektachrome	20C + 10M	5, 10 and 20 seconds at f/8
Kodachrome	10C + 5M	5, 10 and 20 seconds at f/8
Agfachrome	25C + 30M	5, 10 and 20 seconds at f/8
Fujichrome	30C + 35M	5, 10 and 20 seconds at f/8

PROCESSING

Beseler 3 step chemistry is suited for processing in plastic drums such as the Color by Beseler Processing Drum. The solutions may be used at room temperatures of 70°-75°F without any temperature control or a series of warm water presoaks may be used to elevate the processing temperature for rapid processing. On processors which provide a means of temperature control, the chemistry may be used at a constant temperature of 100°F.

The processing chart shows the correct volume of solution for Beseler 8 × 10, 11 × 14 and 16 × 20 drums. Drums of other manufacture may vary slightly in their requirements. Note that after Step 1, four (or six) sequential 30 second rinses are required. After Step 3 the print should be removed from the drum and washed in a tray of water. The print will have a cloudy appeaance until it is dried.

A convenient method of providing the warm water prewash and rinses is to fill a one or two liter graduate with 120°F water at the start of processing. If the temperature begins to drop, add a small amount of hot tap water to keep it at the correct temperature.

MISCELLANEOUS MANUFACTURERS

	Rapid Processing in Beseler Drums		Ambient Temperature Processing 70°-75°F (21°-24°C) in Beseler Drums	
	Temperature	Time	Temperature	Time
Water	120°F (49°C)	1 minute		
Step 1	70°-75°F (21°-24°C)	2 minutes	70°-75°F (21°-24°C)	4½ minutes
Water	120°F (49°C)	4 × 30 seconds (2 minutes)	70°-75°F (21°-24°C)	6 × 30 sec. (3 minutes)
Step 2	70°-75°F (21°-24°C)	2 minutes	70°-75°F (21°-24°C)	5½ minutes
Water	120°F (49°C)	30 seconds	70°-75°F (21°-24°C)	30 seconds
Step 3	70°-75°F (21°-24°C)	3 minutes	70°-75°F (21°-24°C)	5 minutes
Water	Running Water for 2 min at 100°F ± 10°F (38°C ± 4°C)		Running Water for 3 min at 75°F ± 10°F (24°C ± 3°C)	

The Compact Photo-Lab-Index

	VOLUME OF SOLUTION FOR BESELER DRUMS†		
	8″ × 10″	**11″ × 14″**	**16″ × 20″**
Water*	8 oz. (250 ml)	16 oz. (500 ml)	32 oz. (1000 ml)
Step 1	2½ oz. (75 ml)	5 oz. (150 ml)	8 oz. (250 ml)
Water	3 oz. (100 ml)	6 oz. (200 ml)	8 oz. (250 ml)
Step 2	2½ oz. (75 ml)	5 oz. (150 ml)	8 oz. (250 ml)
Water	3 oz. (100 ml)	6 oz. (200 ml)	8 oz. (250 ml)
Step 3	2½ oz. (75 ml)	5 oz. (150 ml)	8 oz. (250 ml)
Water	Running Water		

*Not necessary for ambient temperature processing.
†For non-Beseler equipment, solution volumes should be provided by the manufacturer.

CONSTANT 100°F (38°C) PROCESSING
For use only in processing equipment that will maintain a constant temperature†

100°F (38°C)	Time
Step 1	1½ minutes
Water	4 × 30 seconds (2 minutes)
Step 2	2½ minutes
Water	30 seconds
Step 3	2½ minutes
Water	2 minutes

SUMMARY OF INGREDIENTS AND SAFETY PRECAUTIONS
STEP 1

PART A—*Caution*: *Injurious to eyes—harmful if swallowed.* Contains Potassium Carbonate Potassium Sulfite, Potassium Thiocyanide. Avoid eye contact. In case of eye contact, flush with water for 15 minutes and call physician immediately. If swallowed, give 1 or 2 glasses of water and induce vomiting. Call physician immediately. Keep out of reach of children.

PART B—*Caution*: *Injurious to eyes—harmful if swallowed.* Contains Potassium Carbonate, Potassium Sulfite, Potassium Thiocyanide. Avoid eye contact. In case of eye contact, flush with water for 15 minutes and call physician immediately. If swallowed, give 1 or 2 glasses of water and induce vomiting. Call physician immediately. Keep out of reach of children.

PART C—*Caution*: *Harmful if swallowed.* Contains Hydroquinone and Diaethylenglycol. If swallowed give 1 or 2 glasses of water and induce vomiting. Call physician immediately.

STEP 2

PART A—*Caution*: *Injurious to eyes—harmful if swallowed.* Contains Benzyl Alcohol. Avoid eye contact. In case of eye contact, flush with water for 15 minutes and call physician immediately. If swallowed, give 1 or 2 glasses of water and induce vomiting. Call physician immediately. Keep out of reach of children.

PART B—*Caution*: *Harmful if swallowed.* Contains Hydroxylamine Sulfate. If swallowed, give 1 or 2 glasses of water and induce vomiting. Call physician immediately. Keep out of reach of children.

The Compact Photo-Lab-Index

PART C—*Caution: May be fatal if swallowed—may cause allergic skin reaction.* Contains Sodium Bisulfite and a Paraphenylenediamine Sulfate Derivate. Do not get in eyes, on skin or clothing. In case of eye contact, flush thoroughly with water. For skin contact, wash thoroughly. If swallowed, give 1 or 2 glasses of water and get immediate medical attention. Keep out of reach of children.

PART D—*Caution: Injurious to eyes—harmful if swallowed.* Contains Potassium Carbonate and Potassium Hydroxide. Avoid eye contact. In case of eye contact, flush with water for 15 minutes and call physician immediatelv. If swallowed, give 1 or 2 glasses of water and induce vomiting. Call physician immediately. Keep out of reach of children.

STEP 3
PART A—*Caution: Harmful if swallowed.* Contains Ammonium Iron salt of EDTA. In case of eye contact, flush thoroughly with water. If irritation persists, get medical attention. If swallowed, give 1 or 2 glasses of water and induce vomiting. Call physician immediately. Keep out of reach of children.

PART B—*Caution: Harmful if swallowed—eye irritant.* Contains Mercapto-Triazol-Disulfide and Ammonium Thiosulfate. In case of eye contact, flush thoroughlv with water and call phvsician. If swallowed, give 1 or 2 glasses of water and induce vomiting. Call physician immediately. Keep out of reach of children.

TROUBLE SHOOTING GUIDE

Problem	Possible Cause	Remedy
Image too dark	Underexposure	Increase exposure time or open lens aperture
Image too light	Overexposure	Decrease exposure time or close lens aperture
Greenish blacks, contrast too high	Excessive first development, temperature too high, developing time too long	Follow time/temperature recommendations. If necessary, shorten first development time.
Image too dark, insufficient contrast	Insufficient first development, temperature too low, developing time too short	Prolong first development time or raise temperature.
Weak shadows, blue/magenta color cast	Insufficient color developer. Temperature too low, developing time too short	Follow time/temperature recommendations. If necessary, prolong color developing time.
Gray looking colors, contrast too low, blue/gray shadows and borders	Color developer contaminated with first developer. Insufficient wash between first and color developers	Avoid cross-contamination of solutions when mixing or processing. Increase washing between first and color developers.

MISCELLANEOUS MANUFACTURERS

BESELER CN2 COLOR NEGATIVE CHEMISTRY
for Color Negative Films

Color by Beseler CN2 can be used for the following color negative films:
Kodacolor II
Vericolor II
Eastman Color Negative Type 5247
Fujicolor II.
It should not be used for the following:
Kodacolor-X
Ektacolor-S
Other C-22 type films.

CN2 process has been designed for home processing in inversion type developing tanks.

The CN2 chemistry in this processing kit can be used at your choice of either 85°F (30°C) or 75°F (24°C). Either temperature is considerably easier to achieve and maintain in your darkroom than the super-hot processing temperatures recommended for other brands of chemistries. The 75°F (24°C) processing temperature is very close, if not identical, to many household ambient (room) temperatures. If the temperature of the mixed CN2 chemistry is 75°F ± 1°F, no temperature control (heating or cooling) of any kind is required. Process your film according to the 75°F (24°C) recommendations on the TIME / TEMPERATURE CHART.

If you prefer, use the faster processing times in CN2 chemistry at 85°F (30°C). If the ambient (room) temperature is less than 85°F ± ½°F or 75°F ± 1°F, you must use some technique to heat and hold the processing tank, chemistry, and water wash at this higher temperature.

Recommended is the use of a water filled tray or dishpan large enough to hold the chemistry bottles and developing tank. Stainless steel developing tanks will do a superior job of transmitting heat from a water bath to the chemicals inside. Use a tray deep enough for water to just cover the top of the film tank. Just a few of the many ways to reach and consistently hold the required 75° or 85° processing temperature include: running water of the correct temperature, raising the ambient temperature to the required processing temperature, use of a temperature-adjustable food tray warmer under the tray of water, or an aquarium heater adjusted to produce the correct chemical temperature. Regardless of the method used, be sure to check the temperature frequently and try to hold it within the recommended tolerances.

PROCESSING

Bring all CN2 chemicals up to the desired processing temperature. In a changing bag or in total darkness load exposed color film onto a clean film reel and put it into the film tank. If one roll of film will be processed in a two roll film tank, insert an empty reel in the tank to prevent overagitation during development.

Use a wrist watch or an accurate timer for all processing times and agitation cycles. Start the timer and fill the processing tank with CN2 DEVELOPER of the correct temperature. Rap the bottom of the tank twice on a table top to dislodge any air bubbles on the film. GENTLY invert the tank twice and put it in the water bath (if one is being used.) Thereafter, GENTLY invert the tank once every 15 seconds for the remainder of the developing time. The tank should ALWAYS be returned to the water bath after each agitation to guarantee proper temperature control. About 15 to 30 seconds before the end of the processing time, begin draining the CN2 DEVELOPER from the tank into its storage bottle. Shake the tank to help it drain completely.

Start the timer and immediately begin filling the tank with CN2 BLEACH-FIX of the correct temperature. Invert the tank gently and continuously for the first 15 seconds. Thereafter, gently invert the tank once every 15 seconds for the remainder of the processing time. **In between** agitation cycles, return the tank to the water bath. At the end of the recommended processing time, drain the CN2 BLEACH-FIX into its storage bottle. Processing times in this step are not critical and can be extended without harm.

Remove the top of the processing tank and wash the film in 75°F to 100°F (24°C-40°C) running water for 4 minutes. If running water is not available, fill the tank with heated water from the water bath. Agitate continu-

MISCELLANEOUS MANUFACTURERS

ously for 30 seconds. Drain and repeat for a total of 4 minutes washing time in 8 changes of water. The washing time is not critical and can be extended without harm.

After the film washing is completed, immerse the film reel for 30 seconds in ambient temperature CN2 WET-TING AGENT. Hang the film to dry in a clean, dust free place.

Tightly recap all of the chemistry storage bottles. For future reference, mark the label of CN2 DEVELOPER with the film size and number of rolls of film just processed.

Other than the processing temperature and time listed for the Color by Beseler CN2 DEVELOPER, the temperature/time tolerances for CN2 BLEACH FIX, wash and CN2 WET-TING AGENT are much greater.

While excellent results can be obtained with these chemicals anywhere within the listed temperature ranges, it is a good practice to maintain them at the same temperature as the CN2 DE-VELOPER if possible.

EASTMAN COLOR NEGATIVE 5247

When processing Eastman Color Negative 5247 film, the black carbon jet backing should be removed during the water wash.

Carefully remove the film from the reel. Gently wipe the black backing from the film with running water and a damp photo-quality fine pore sponge. DO NOT TOUCH OR RUB THE FILM EMULSION. Continue to wash until all visible black particles of the backing have been removed from the film. Eastman Color Negative 5247

TIME/TEMPERATURE CHART
COLOR BY BESELER CN-2 PROCESSING KIT 75°F (24°C)

	Temperature	1st & 2nd rolls*	3rd & 4th rolls	5th & 6th rolls
CN2 Developer	75°F±1°F (24°C±.6°C)	16 min.	18 min.	20 min.
CN2 Bleach-Fix	75°F±5°F (24°C±3°C)	9 min.	9 min.	9 min.
Water Wash	75°F to 100°F (24°C to 38°C)	4 min.	4 min.	4 min.
CN2 Wetting Agent	68°F to 100°F (20°C to 38°C)	½ min.	½ min.	½ min.

*135-36 or 120

COLOR BY BESELER CN-2 PROCESSING KIT 85°F (30°C)

	Temperature	1st & 2nd rolls*	3rd & 4th rolls	5th & 6th rolls
CN2 Developer	85°F±½°F (30°C±.3°C)	8 min.	9 min.	10 min.
CN2 Bleach-Fix	85°F±10°F (30°C±6°C)	8 min.	8 min.	8 min.
Water Wash	75°F to 100°F (24°C to 38°C)	4 min.	4 min.	4 min.
CN2 Wetting Agent	68°F to 100°F (20°C to 38°C)	½ min.	½ min.	½ min.

*135-36 or 120

MISCELLANEOUS MANUFACTURERS

	Increase Development per roll processed	Capacity per kit
135-36 or 120	5%	Up to 6 rolls
135-20 or 126-20	3%	8 rolls
126-12	3%	10 rolls
110-12 or 110-20	2%	16 rolls
220	12%	3 rolls

film should not be processed in the same CN2 chemicals kit which is used for Kodacolor II, Vericolor II, etc. Mix a separate Color by Beseler CN2 processing kit only for the development of Eastman Color Negative 5247 film.

PROCESSING CAPABILITY

Color by Beseler CN2 color negative chemistry can be reused at the times shown on the 75°F and 85°F charts for up to 6 rolls of 135-36 or 120 film. To determine the proper extended development times in CN2 DEVELOPER for other roll film sizes, increase the first roll development time by the percentage shown for each roll processed.

MIXING INSTRUCTIONS

It is not normally necessary to use distilled water for the mixing of Color by Beseler CN2 chemistry. Use normal tap water unless you have experienced bad water problems in the past. If your local water supply contains large quantities of minerals, dissolved metals, or chemical impurities, superior results will be obtained by using a BESELER WATER FILTER.

Use new, clean brown glass bottles for the greatest possible chemistry storage life. Start with the mixing of the CN2 DEVELOPER. Mix each additional chemical in order of use. Carefully wash out and clean the mixing graduate, stirring rod, etc. after each chemical has been mixed.

Avoid skin contact with the working strength or concentrate solutions. Wear rubber gloves. Completely dissolve and mix each component into solution before adding the next part. For more detailed information, see the cautionary information elsewhere in these instructions.

CN2 DEVELOPER
(1) Start with 10 ounces (.3L) of water 75°F-85°F (24°C-30°C)
(2) While stirring, add "CN2 DEVELOPER PART 1." Mix completely.
(3) While stirring, add "CN2 DEVELOPER PART 2." Mix completely.
(4) While stirring, add "CN2 DEVELOPER PART 3."
(5) While stirring, add water to make 16 ounces (.5L).*

CN2 BLEACH-FIX
(1) Start with 10 oz. (.3L) of water 120°F-140°F (50°C-60°C)
(2) While stirring, add "CN2 BLEACH-FIX PART 1."
(3) While stirring, add "CN2 BLEACH-FIX PART 2."
(4) While stirring, add "CN2 BLEACH-FIX PART 3."
(5) While stirring, add water to make 16 ounces (.5L).*

CN2 WETTING AGENT
(1) Add contents of "CN2 WETTING AGENT to water 68°F to 100°F (20°C-38°C) to make 16 ounces (.5L).*
*Each chemical step in this kit can be mixed to make either 16 ounces or 17 ounces of working solution. Mix this kit to make the amount of solution (number of ounces) required by your processing tank. Processing times in all steps remain as shown with either 16 ounces or 17 ounces of solution.

Once mixed, the CN2 processing kit can be used immediately.

STORAGE LIFE
Store unopened, unmixed, CN2 chemistry in a dry place at normal room temperature. Do not refrigerate or freeze mixed or unmixed Color by Beseler CN2 chemistry. For the longest storage life, the mixed working strength chemistry should be kept in full, tightly capped brown glass bottles.

MISCELLANEOUS MANUFACTURERS

541

Working Solution	Keeping Properties
CN2 DEVELOPER (full bottle)	about 6 weeks
CN2 DEVELOPER (partly full bottle)	about 1-2 weeks
CN2 BLEACH-FIX	about 2 months
CN2 WETTING AGENT	about 2 months

The storage life of the CN2 DEVELOPER in partly full bottles can be extended to the times listed for full bottles by using Color by Beseler XDL spray. XDL spray is a heavier-than-air neutral gas that extends the storage life of all black-and-white and color developers.

COLOR FILM CARE

You can accumulate a number of rolls of color negative film for batch processing at one time. This is one way to guarantee you will use up the full capacity of the CN2 processing kit.

All color films respond best to proper pre- and post-exposure care. If possible, refrigerate all unexposed color film. After it has been exposed, if you won't be processing the film immediately, put it into a tightly capped can. Refrigerate the exposed film until you are ready to process it.

TROUBLESHOOTING

When using CN2 color negative chemistry you can avoid most problems by following the instructions carefully, maintaining temperature control within the tolerances recommended, agitating according to the directions, and using clean brown glass storage bottles and a clean reel and tank.

Some possible problems and their likely cause are listed below:

THIN NEGATIVES

Possible Cause	Solution
1) Low developer temperature	Follow temperature control instruction.
2) Developer oxidized or exhausted	Do not try to over-use the chemistry. Use brown glass bottles. Use XDL spray.
3) Film was underexposed	Expose film per factory recommendations.

STREAKS OF HIGHER DENSITY AT SPROCKET HOLES

Possible Cause	Solution
1) Over-agitation	Follow agitation instruction.
2) Processed one film in a 2 reel size tank.	Put empty film reel on top of full one.

STREAKS OR LOWER DENSITY AT TOP OF FILM

Possible Cause	Solution
1) Not enough solution in tank to cover film.	Mix this kit to make 16 oz. or 17 oz. solution as required by maker your film tank.

IRREGULAR BLACK SPECKS ON NEGATIVE

Possible Cause	Solution
1) ECN 5247 film not fully washed.	Remove all black backing from film during water wash.

MISCELLANEOUS MANUFACTURERS

The Compact Photo-Lab-Index

CAUTION
Keep Out of the Reach of Children
The CN2 kit contains chemicals which may be dangerous if misused. Harmful if taken internally. If swallowed, call a physician at once. Read the specific warnings listed below for each chemical.

All chemical concentrates and working solutions may cause skin irritation. Keep out of eyes, cuts, or open wounds. Wear rubber gloves when mixing and using this chemistry. Before removing the gloves, wash them in a 2% acetic acid solution and rinse with water. In case of eye or skin contact, immediately flush with plenty of water.

The CN2 DEVELOPER contains substances that may stain or discolor certain plastic processing tanks and reels. Avoid skin contact with this solution.

CN2 Developer Part 1—If swallowed, call a physician. Contains: Hydroxylamine sulphate.
CN2 Developer Part 2—If swallowed, call a physician. Contains: Sodium sulphite and p-phenylenediamine derivate.
CN2 Developer Part 3—If swallowed, call a physician. Contains: Potassium bromide and potassium carbonate.
CN2 Bleach-Fix Part 2—If swallowed, call a physician. Contains: Ammonium bromide.
CN2 Belach-Fix Part 2—If swallowed, call a physician. Contains: EDTA NaFe.
CN2 Bleach-Fix Part 3—If swallowed, call a physician. Contains: Ammonium thiosulphate.
CN2 Wetting Agent—If swallowed, call a physician. Contains: Stab. formalin.

Chemicals may cause stains on implements or clothing. Use and mix with adequate ventilation. Children should use CN2 chemistry only with adult supervision.

BESELER 2-STEP, COLOR PRINT CHEMISTRY
for Kodak and other type "A" color papers

This chemistry will produce quality color prints from Kodak Ektacolor RC and similar type "A" color papers of other manufacturers.

Color by Beseler chemistry may be used in plastic processing drums such as the Color by Beseler color print processors, in motorized processors such as the Kodak model II drum, or in open trays.

Processing is very simple and requires only two chemical steps, followed by a brief wash in ordinary tap water. While no pre-wetting of the paper, pre-heating of the drum or intermediate rinsing are required, any or all of these techniques may be utilized if desired.

AMBIENT TEMPERATURE PROCESSING

Ambient (room) temperature processing is the simplest and most repeatable method of processing a color print. Since both the chemistry and the processing instrument (drum or tray) are used at existing room temperature, absolutely no temperature control of any kind is required.

Simply find the processing times on the time/temperature chart and process for the indicated times in STEP #1 and STEP #2.

MISCELLANEOUS MANUFACTURERS

TIME/TEMPERATURE CHART F

Room Temp.	Processing Time (Min.) Step #1	Step #2
107°F	1 minute	1 minute
101°F	1½ minutes	1 minute
96°F	2 minutes	1 minute
92°F	2½ minutes	1 minute
89°F	3 minutes	1½ minutes
86°F	3½ minutes	1½ minutes
83°F	4 minutes	1½ minutes
81°F	4½ minutes	2 minutes
79°F	5 minutes	2 minutes
77°F	5½ minutes	2 minutes
75°F	6 minutes	2½ minutes
72°F	7 minutes	2½ minutes
70°F	8 minutes	2½ minutes
68°F	9 minutes	3 minutes
66°F	10 minutes	3 minutes

TIME/TEMPERATURE CHART C

Room Temp.	Processing Time (Min.) Step #1	Step #2
42°C	1 minute	1 minute
38°C	1½ mintues	1 minute
36°C	2 minutes	1 minute
33°C	2½ minutes	1 minute
32°C	3 minutes	1½ minutes
30°C	3½ minutes	1½ minutes
28°C	4 minutes	1½ minutes
27°C	4½ minutes	2 minutes
26°C	5 minutes	2 minutes
25°C	5½ minutes	2 minutes
24°C	6 minutes	2½ minutes
22°C	7 minutes	2½ minutes
21°C	8 minutes	2½ minutes
20°C	9 minutes	3 minutes
19°C	10 minutes	3 minutes

AMBIENT TEMPERATURE DRUM PROCESSING

Load the exposed paper into a clean Color by Beseler or other brand of processing drum and stand the drum on its feet on any reasonably level surface. Consult the TIME/TEMPERATURE chart and pour-in the required amount of STEP #1 chemistry at ambient temperature. IMMEDIATELY begin continuous and vigorous agitation by rolling the drum from side to side at the rate of one complete left to right cycle per second for the first 20 seconds and thereafter at the rate of 30 cycles per minute for the remainder of the processing time.

At the end of the recommended processing time, thoroughly drain the drum (shake it dry) and pour-in STEP #2. IMMEDIATELY begin continuous and vigorous agitation by rolling the drum from side to side at the rate of one complete left to right cycle per second for the first 20 seconds and thereafter, at the rate of 30 cycles per minute for the remainder of the processing time.

At the end of the recommended processing time, drain out STEP #2. Processing is now complete. The print should be washed and dried. Do not use a holding tray or batch washing.

OPTIONAL PRE-SOAK)
(for ambient temperature drum processing)

If you wish to pre-soak (and pre-condition) the paper and then to process at ambient temperature, simply stand the drum on its feet and fill it with 16 ounces (500 ml) of ambient temperature water. (32 ounces [1 liter] for 11 x 14 and 16 x 20 drums). Rotate the drum for one minute and then drain-out ALL of the pre-soak water so as not to dilute the STEP #1 chemistry. (Shake the drum absolutely dry.)

Stand the drum on its feet and pour-in the required quantity of ambient temperature STEP #1 chemistry. Process according to instructions.

OPTIONAL HEAT-SOAK
(for high-temperature drum processing)

If you wish to pre-soak the paper and to pre-heat the drum, just lay a straightedge from the ROOM TEMPERATURE column to the DESIRED PROCESSING TEMPERATURE. The point of intersection of the WATER TEMPERATURE Column indicates the correct temperature of the pre-soak water.

Stand the processing drum on its feet and fill it with 16 ounces (500 ml) of pre-soak water of the required temperature. (32 ounces [1 liter] for 11 x 14 and 16 x 20 drums). Rotate the drum for one full minute and then drain-out ALL of the pre-soak water. (Shake the drum absolutely dry, so as not to dilute the STEP #1 chemistry.)

Stand the drum on its feet and pour-in the required quantity of ambient temperature STEP #1 chemistry. Process according to instructions.

MISCELLANEOUS MANUFACTURERS

PRE-SOAK CHART

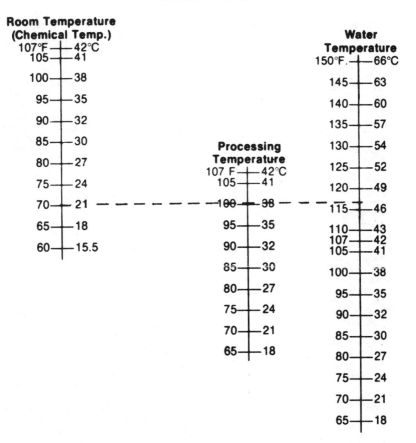

Example: If the room temperature is 70°F. and the desired processing temperature is 101°F, then the correct temperature for the pre-soak water is about 117°F. (Dotted line is example only. Make your own line for other temperature conditions.)

2 MINUTE COLOR PRINTS IN A DRUM

Load the exposed paper into a clean and dry processing drum and stand the drum on its feet on a level surface. Heat the Step #1 to 125°F (52°C) and pour it into an ambient temperature drum and IMMEDIATELY begin continuous and vigorous agitation by rolling the drum from side to side at the rate of one complete left to right cycle per second during the first 20 seconds and then at the rate of 20 left to right cycles during the remaining 40 seconds of processing time.

Thoroughly drain the drum (shake it dry) and pour-in STEP #2. IMMEDIATELY begin continuous and vigorous agitation by rolling the drum from side to side at the rate of one com-

MISCELLANEOUS MANUFACTURERS

545

8 x 10 Prints	Step #1	Step #2	Process Time
#1	3 oz.* (90ml)	3 oz.* (90ml)	Normal
#2	+½ oz. (15ml)	+½ oz. (15ml)	+10%
#3	+½ oz. (15ml)	+½ oz. (15ml)	+10%
#4	+½ oz. (15ml)	+½ oz. (15ml)	+10%

*In any brand 8 x 10 drum, use at least 3 oz. for the first print. Use 5 oz. (150ml) for 11 x 14 drums, and 8 oz. (240ml) for 16 x 20 drums.

plete left to right cycle per second during the first 20 seconds and then at the rate of 30 left to right cycles during the remaining 40 seconds of processing time. Pour-out STEP #2. You're all done processing.

RE-USABLE CHEMISTRY (DRUM PROCESSING)

Beseler TWO-STEP Chemistry is re-usable up to four times within a period of a few hours. This lowers the cost of processing a color print in a drum.

For each re-use (8 x 10 print or equivalent), add ½ oz. (15 ml) of fresh STEP #1 to the used STEP #1 and ½ oz. (15 ml) fresh STEP #2 to the used STEP #2 and increase processing times by 10% (STEP #1 and STEP #2). Discard the exhausted chemistry after it has been used four times. (For larger print sizes, add 1 oz. (30 ml) fresh chemistry per 11 x 14 and 2 oz. (60 ml) per 16 x 20 print. Always increase processing times 10% per re-use regardless of print size.)

TRAY PROCESSING AT AMBIENT TEMPERATURES

Only two trays are required. Pour one quart (1 liter) of ambient temperature STEP #1 into an 8 x 10 tray and one quart (1 liter) of ambient temperature STEP #2 into a second 8 x 10 tray. (Use ½ gallon (2 liters) for 11 x 14 trays and use one gallon (4 liters) for 16 x 20 trays.)

Consult the time/temperature chart for processing times in STEP #1 and STEP #2. Use plastic or stainless steel print tongs to totally immerse the exposed sheet of paper face down into tray #1 and agitate the print continuously for the recommended processing time.

Use a second set of print tongs to totally immerse the print and to agitate it continuously in tray #2 for the recommended processing time.

Use the tray #2 print tongs to lift the print out of the tray and allow it to drain back into tray #2 for 20 seconds. The print is now fully processed, and ready for washing.

RE-USING THE CHEMISTRY (TRAY PROCESSING)

After processing the first five 8 x 10 prints, add 5 oz. (150 ml) of fresh STEP #1 chemistry to tray #1 and 5 oz. (150 ml) of fresh STEP #2 chemistry to tray #2 and increase processing time by 10% (tray #1 and tray #2) for the next five prints. Continue to add 5 oz. (150 ml) of fresh chemistry to each tray and to increase processing time an additional 10% (both trays) for each additional five 8 x 10 prints which are processed. (Add 10 oz. (300 ml) of fresh chemistry for five 11 x 14 prints and 20 oz. (600 ml) for five 16 x 20 prints. Increase processing times 10% for each five prints, regardless of print size.)

Critical workers wishing to obtain the ultimate degree of uniformity may elect to add fresh chemistry and to adjust processing times after processing each individual print. (Add one oz. (30 ml) of fresh chemistry to each tray and increase processing times by 2% in STEP #1 and in STEP #2.)

Partially used chemistry which has not been used to exhaustion may be stored in a pair of clean, empty bottles for subsequent re-use. (The keeping properties vary with the degree of oxidation caused by exposure to air while in the trays, and with the number of prints which have been processed.)

DO NOT MIX PARTIALLY USED CHEMISTRY WITH FRESH CHEMISTRY, AS THE KEEPING PROP-

MISCELLANEOUS MANUFACTURERS

ERTIES OF THE FRESH CHEMISTRY WILL BE GREATLY REDUCED!

When used as directed, one gallon of chemistry will process up to 100 8 x 10 prints or their equivalent.

CHEMICAL CONTAMINATION

The resulting print quality and the useful life of the two processing chemicals depends upon the cleanliness of the equipment in which the chemicals are mixed, stored and used. The contamination of one chemical by the other is to be avoided, since it will seriously impair print quality. Take extreme care to avoid the contamination of STEP #1 by even the smallest quantity of STEP #2 during mixing, measuring or processing. Wash processing drum, thermometer, etc., in running water after each use in STEP #2.

Label all STEP #2 containers, graduates, and other implements. Use them only for STEP #2; never with STEP #1 unless they have been thoroughly washed in running water.

STREAKING OR STAINING

Large amounts of carry-over of STEP #1 into STEP #2 caused by incomplete draining of STEP #1, waiting too long before beginning agitation in STEP #2, or inadequate agitation' during the first 20 seconds in STEP #2 can result in blue streaks or stains.

Drain thoroughly after STEP #1 and begin agitation in STEP #2 immediately at the rate of one left-right cycle per second during the first 20 seconds and subsequently at the rate of 30-40 cycles per minute thereafter for the remainder of the processing time. If streaking or staining persists, add a brief cold water rinse in between STEPS #1 and #2. (3 oz. [90 ml] of 65-70° water; agitate for 5-10 seconds. Drain and repeat a second time.)

If you are experiencing localized streaking or staining problems when processing with trays, deep tanks, mechanical processors (like the Kodak Model II) or drums that drain incompletely, it is probably caused by insufficient (excessive carryover) of STEP #1 into STEP #2. In such cases, an intermediate rinse with room temperature 2% acetic acid for 10-15 seconds may be used as an alternative to the cold water rinse already suggested.

TROUBLE SHOOTING

Uneven Development:
1. Not enough solution (STEP #1).
2. Rolling (agitation) surface not level.
3. Waited too long before beginning agitation (STEP #1).
4. Agitation rate too slow during first 20 seconds (STEP #1).
5. Inconsistent agitation (STEP #1).

Localized Blue Streaks or Stains:
1. Waited too long before beginning agitation (STEP #2).
2. Agitation rate too slow during first 20 seconds (STEP #2).
3. Inconsistent agitation (STEP #2).
4. Insufficient drain (STEP #1): Drain thoroughly or add a cold water rinse after STEP #1.

Cyan Cast Over Entire Print (Cyan Borders):
1. Step #1 is contaminated: Wash all utensils in cold water and mix fresh STEP #1.
2. Print exposed to B & W safelight.
3. If STEP #1 is greatly contaminated you may see a reddish-purple cast over the print and in the borders.

Pinkish Cast Over Entire Print (Pink Borders):
1. Forgot to drain out STEP #1. Repeat exposure and use a fresh 3 oz. (90 ml) of STEP #1 and STEP #2 to process.
2. Step #2 is contaminated: Wash all utensils in cold water and mix fresh STEP #2.

Yellow or Reddish Areas:
1. Paper is light-fogged.

Blue Splotches on Face of Print:
1. Trace quantities of STEP #1 trapped between drum walls and back of paper: 1) Use a water pre-soak before STEP #1; 2) Use a cold water rinse after STEP #1.

Color Shift When Re-using Chemistry:
1. Forgot to add ½ oz. (15 ml) fresh STEP #1 and ½ oz. (15 ml) fresh STEP #2 for each re-use in a drum (8 x 10 prints).

MISCELLANEOUS MANUFACTURERS

2. Forgot to add 1 oz. (30 ml) fresh STEP #1 and 1 oz. (30 ml) fresh STEP #2 for each re-use in a tray (8 x 10 prints).

Density Shift (Lighter) When Re-using Chemistry:

1. Forgot to increase processing time 10% for each re-use in a drum.

2. Forgot to increase processing time 10% for each five prints processed in a tray.

WIDE TOLERANCE

All processing times quoted represent actual processing times with continuous agitation at the recommended rates. To these actual processing times you must add the "drain and fill" times in drum processing and the "drain" time in tray processing. (About 20 seconds with either method.)

Shorter processing times are not recommended but longer times (up to 25% longer in STEP #1 and up to 100% longer in STEP #2) will have virtually no adverse effect.

PRINT WASHING

Wash each print individually immediately after processing it, wash for 2½ minutes at approximately 85°F (30°C) or 5 minutes at 75°F (24°C) in a tray of rapidly changing water.

Do not wash prints substantially longer than the recommended times. It is not advisable to keep processed prints in a holding tray or batch washing several together. Wash and dry each processed print on an individual basis for optimum results.

DRYING

Dry prints in accordance with the recommendations of the paper manufacturer. No special drying procedure is required for prints processed in Color by Beseler TWO-STEP chemistry.

GOOD PRINT PERMANENCE

Color papers processing in Color by Beseler TWO-STEP Chemistry and washed according to directions have excellent fade-resistant properties. It

should be noted however, that all color dyes will fade in time, if exposed to intense or prolonged light. No claim or guarantee as to specific fade-resistance is made for COLOR BY BESELER, TWO-STEP chemistry.

LONG STORAGE LIFE

Unopened packages of Color by Beseler TWO-STEP color chemistry are guaranteed to be good for use for one full year from date of purchase. Store unopened chemistry in a dry place at normal room temperature. Do not refrigerate or freeze it.

Once mixed, the liquid chemistry has a useful life of 8-10 weeks when stored in well-filled, tightly capped brown glass bottles.

MIXING INSTRUCTIONS: ONE QUART (1 LITER) SIZE

Mix contents of STEP #1 Package as follows:

A. Shake bottle labeled "A" and empty contents into 3 quarts (3 liters) of water at 77°F (25°C). Stir very thoroughly.

B. Add part "B" and stir until dissolved.

C. Add part "C" and stir until dissolved.

D. Add part "D" and stir until dissolved.

E. Add sufficient additional water at 77°F (25°C) to make a total of one quart (32 oz.) (1 liter). Stir until uniform.

Mix contents of STEP #2 Package as follows:

A. Dissolve Part "A" in 24 oz. of (720 ml) of water at 77°F (25°C). Stir thoroughly.

B. Add part "B" and stir until dissolved.

C. Add sufficient additional water at 77°F (25°C) to make a total of one quart (1 liter). Stir until uniform.

NOTE: The quart of TWO-STEP chemistry is now ready for immediate use.

MISCELLANEOUS MANUFACTURERS

MIXING INSTRUCTIONS:
ONE GALLON (4 LITER) SIZE

Mix contents of STEP #1 Package as follows:

A. Shake bottle labeled "A" and empty contents into 3 quarts (3 liters) of water at 77°F (25°C). Stir very thoroughly.

B. Add part "B" and stir until dissolved.

C. Add part "C" and stir until dissolved.

D. Add part "D" and stir until dissolved.

E. Add sufficient additional water at 77°F (25°C) to make a total of one gallon (4 liters). Stir until uniform.

Mix contents of STEP #2 Package as follows:

A. Dissolve Part "A" into 3 quarts (720 ml) of water at 77°F (25°C). Stir thoroughly.

B. Add part "B" and stir until dissolved.

C. Add sufficient additional water at 77°F (25°C) to make a total of one gallon (4 liters). Stir until uniform.

NOTE: The gallon of TWO-STEP Chemistry is now ready for immediate use.

MIXING INSTRUCTIONS:
3½ GALLONS (13.2 LITERS)
2-STEP CHEMISTRY

Mix contents of STEP #1 Package as follows:

A. Empty contents of the bottle labeled PART "A" into 11 quarts (10 liters) of water at 77°F (25°C). Stir very thoroughly.

B. Add part "B" and stir until dissolved.

C. Add part "C" and stir until dissolved.

D. Add part "D" and stir until dissolved.

E. Add sufficient additional water at 77°F (25°C) to make a total of 3½ gallons (13.2 liters). Stir until uniform.

Mix contents of STEP #2 package as follows:

A. Dissolve part "A" into 11 quarts (10 liters) of water at 77°F (25°C). Stir thoroughly.

B. Add part "B" and stir until dissolved.

C. Add sufficient additional water at 77°F (25°C) to make a total of 3½ gallons (13.2 liters). Stir until uniform.

NOTE: The 3½ gallons (13.2 liters) of TWO-STEP Chemistry are now ready for immediate use.

SPECIAL NOTE: It is not necessary to use distilled water for mixing Beseler TWO-STEP color chemistry. Use normal tap water. However, if your local water supply contains large quantities of minerals, dissolved metals or chemical impurities, superior results will be obtained by using a BESELER WATER FILTER.

CAUTION

Harmful if taken internally. If accidentally swallowed, induce vomiting and call a physician at once. Keep out of eyes and cuts or open wounds (wear rubber gloves). Some people may be adversely affected as a result of contact. If skin irritation or inflammation occurs, rinse the affected area immediately with a solution of 2% acetic acid and water and follow by washing in running water.

(NOTE: Ordinary household vinegar may be substituted for the acetic acid). KEEP THIS AND ALL OTHER PHOTOGRAPHIC CHEMICALS OUT OF THE REACH OF CHILDREN.

STEP #1 Contains: Sodium hydroxide, benzyl alcohol hydroxylamine sulfate, p-phenylene diamine derivative, sodium sulfite, and potassium carbonate.

STEP #2 Contains: Ethylene diamine tetraacetic acid iron salt an ammonium thiosulfate.

MISCELLANEOUS MANUFACTURERS

549

The Compact Photo-Lab-Index

MISCELLANEOUS
MANUFACTURERS

EDWAL FILM CLASSIFICATION

35MM FILMS AND SMALLER

EFKE (Adox): KB-14 I, KB-17 III
EASTMAN KODAK: Panatomic X II, Infra-Red III, High Contrast Copy Film I, Plus-X II, Improved TRI-X III, 2475 V.
ILFORD: Pan-F I, FP4 III, HP5 III.
MINOX: 25 ASA I, 50ASA II, Plus-X II, Tri-X III.

ROLL FILMS AND PACKS

EFKE (Adox): See 35mm.
EASTMAN KODAK: Plus-X II, All others III.
ILFORD: Pan F I, FP4 III, HP4 IV.

SHEET FILMS

EASTMAN KODAK: Commercial IV, Infra Red IV, Super Panchro Press Type B VI, Super XX VI, Royal Pan V, Tri-X Ortho III, Tri-X III, Royal X VI, Plus-X III, Kodak Ektapan 4162 V.
ILFORD: FP4 III, HP4 IV, Commercial Ortho IV.

EDWAL FG7

WHAT FG7 IS AND DOES

GENERAL INFORMATION

Edwal FG7 is a compensating, general purpose developer for continuous-tone films, and tends to prevent blocking-up on contrasty subjects. It is softer working than the long-scale developers. Edwal Super 12 or Edwal Super 20, but not as soft-working as Edwal Minicol II. Edwal FG7 gives a rather full bodied negative with good resolution or "acutance."

Seven methods and dilutions are available:

Rapid development for sheet film: 1:1 dilution.

Rapid development for roll film: 1:2 dilution.

Professional, photo finishing, and deep tanks: 1:3 dilution.

Single-use development: 1:15 dilution.

Available light: 1:3 or 1:15 dilution (with sulphite).

FG7 Automatic (two bath): 1:1, 1:3, or 1:5 dilution.

Controlled Monobath: 1:15 dilution followed by Hi-Speed Liquid Fix Concentrate.

GRAIN

At 1:2 or 1:3 dilution, Edwal FG7 gives fine enough grain for many purposes, but is not an ultra-fine grain developer such as Edwal Super 20. For finest grain on medium and high speed films, the 1:15 dilution using a 9% sodium sulphite instead of water is recommended, producing fine enough grain for practically any use.

When diluted 1:15 with plain water, Edwal FG7 is a non-solvent type developer which gives very fine grain with fine grain films such as Panatomic-X and Adox-14, and reasonably fine grain on medium and high speed films.

PRACTICAL FILM SPEED AND EXPOSURE METHODS

Edwal FG7 is best used with a higher exposure index than the film manufacturers recommend.

MISCELLANEOUS MANUFACTURERS

The Compact Photo-Lab-Index

Some practical ratings for normal development are:

Royal-X	4800	Adox-14	50
Tri-X	2400	Adox-17	80
Hp-5	2400	Plus-X	500
FP-4	500	Pan-F	160
		Panatomic-X	125

for 1:3 or 1:5 dilutions on 35mm and roll films.
For 1:1, 1.2, or on sheet films, use 1 stop exposure.

These film speeds are for hand-held exposure meters, with a narrow acceptance angle, when pointed at the darkest shadow area in which it is desired to hold shadow detail (Zone III in the Zone System). These include the Weston, G.E., Honeywell Spot V, Minolta Auto Spot II, Sekonic L-228, Soligor Spot-Sensor, etc. If an averaging meter or a gray card is used, the speed numbers should be cut at least in half.

Users of spot or incident light meters should make a test strip to determine which practical film speed is best for their method. The best exposure system is one that gives a fairly thin negative, still with enough density to hold shadow detail. This gives the best grain and printing quality.

HOW TO USE EDWAL FG7

All the common films have been classified into seven groups in the Edwal film classification table given on the previous page. A time and temperature table is given for each dilution.

The various dilutions used with FG7 concentrate are:

1. *1:1 for sheet films* and roll films. Rapid tray development.

2. *1:2 dilution.* Usually used for roll films for tray development.

3. *1:3 dilution* for use in studio, custom finishing, deep tank, or processor (CTX or Versamat). Good acutance. Mediumly fine grain on medium and high speed films. Very fine grain on fine grain films such as Panatomic-X, Adox-14, or Pan-F. Excellent for commercial microfilming of x-rays.

4. *"Single Use" development,* diluted 1:15 with plain water. Gives fine grain with fine grain films, medium grain with high speed films. Commonly used only once for one roll, but each 16-oz. of the 1:15 diluted FG7 may be used to develop a second and third roll if done the same day. Developing time is increased 10% for each roll after the first.

"Single Use," Fine Grain, using 15 parts of a 9% sodium sulfite solution in place of ordinary water. Gives considerably finer grain on medium and high speed films than the 1:15 dilution with plain water, but is not recommended for use with fine grain films because of diminished acutance on these emulsions.

5. *Extended development (pushing).* With extended development using the 1:1, 1:2, and 1:3 with 9% sulfite dilutions, increasing the developing time about 50% will double the effective film speed. Doubling the standard developing time will produce about a fourfold increase in practical film speed, but on many films some shadow detail is lost. If the film is developed "to finality" (about 45 min. at 70°F) the maximum possible film speed is obtained, which may be 4 to 8 times the normal speed, depending on the film used.

MISCELLANEOUS MANUFACTURERS

6. *FG7 Automatic (Two-Bath System).* In this system the film is developed in a 1:1 dilution of FG7 concentrate for one minute and then transferred to FG7 Solution B concentrate which has been diluted 1:1. After 2 minutes in Solution B the film will be completely developed; then rinsed in plain water, and transferred to the fixer. Exposure indexes of 3200 for Tri-X and 800 for Plus-X are possible. Grain is satisfactory for most purposes. Details are given on the following pages.

7. *Controlled Monobath.* When a 35mm or 120 size film is developed in 16 oz. of FG7 diluted 1:15 in plain water, the developer in the tank may be converted into a monobath by adding, with thorough mixing, 1 oz. Edwal Hi-Speed Liquid Fix concentrate. The film is then agitated in the tank 4 to 6 min. The fixer stops developing action and fixes the film, which may then be washed as usual.

The best method of getting good mixing is to pour several ounces of the developer out of the tank when development is finished, then add the 1 oz. Hi-Speed and then immediately refill the tank by pouring the used developer back and agitating vigorously to get complete mixing. (See Edwal Controlled Monobath information on pages which follow).

9% SODIUM SULFITE

A 9% sodium sulfite solution can be easily made by dissolving a pound of anhydrous photo grade sodium sulfite in 5 qts. water, or 45 grams of sodium sulfite in 15 ozs. water. The developer is made by adding 1 oz. FG7 concentrate to the 15 ozs. water containing the sodium sulfite.

The 9% sodium sulfite solution will keep for months in a sealed glass bottle but will oxidize and lose effectiveness if exposed to air, much in the same way as a developer. It should not be stored for a long time in a plastic bottle. For photographers who want to use this method, Edwal sells plastic "speed cups" which hold 45 grams sulfite (1 fl. oz. liquid volume), sufficient for 16 oz. of 1:15 diluted FG7. Inquiries can be made by writing to Edwal Scientific Products Corp., 12120 So. Peoria St., Chicago, Ill.

CONTRAST CONTROL

If a film is known to have been given too much exposure, dense negatives can be avoided by reducing the developing time 20% to 30%. Sometimes this causes low contrast negatives which tend to give "muddy" prints on a #2 paper. A #3 paper is usually satisfactory.

Contrast may be increased or decreased by using lesser or greater amounts of FG7 concentrate to make the working solution. Thus a 1:19 or even a 1:31 dilution may be used to hold highlight detail without losing shadow area density. Exposure should be increased ½ F stop for 1:19, or a full F stop for 1:31 dilution. A 1:63 dilution can be used for making B/W negatives for projection from color slides. Just put the slide in the enlarger and enlarge on Panatomic-X or similar B/W film. This dilution may also be used for making normal contrast negatives on Kodak High Contrast Copy Film.

Contrast may be increased without changing the developing time by using higher concentrations, e.g., 1:11 or even 1:9 for the "single use" method (6 and 7 in the FG7 Instructions).

KEEPING CHARACTERISTICS

Edwal FG7 Concentrate normally has a pale lavender or tan color due to the developing agents used, and will retain that color as long as it is in good condition. It contains so much active ingredient that it keeps well even in a partly full bottle if tightly sealed. The 1:1, 1:2, and 1:3 dilutions will keep for months in tightly closed glass bottles. Polyethylene "squeeze-type" bottles are not recommended for long storage because air diffuses through the walls. The 1:15 dilutions should be made up just before using.

MISCELLANEOUS MANUFACTURERS

FG7 Concentrate will keep for a year or more at room temperature, but if stored for several months at 90°F or higher there may be some loss of film speed (about ½ stop to one full stop). If crystalization occurs due to low temperature, crystals will gradually redissolve if warmed to room temperature and shaken or stirred in a beaker. The solution containing crystals may first be shaken vigorously to get a uniform mixture, and then the necessary amount withdrawn to make the working solution. Crystals will dissolve quickly on dilution.

PRECAUTIONS

Edwal FG7 will not stain hands or clothing in ordinary use. However, if spilled or allowed to dry up completely, it may produce brownish stains, which will usually wash out with warm water and a detergent. FG7 contains no metol and can be safely used by many people who are allergic to developers. Occasionally on very long storage a small amount of sediment will form. This may be filtered out or allowed to remain in the bottom of the bottle, since it does no harm and there will be no change in the developing power of the clear liquid.
CAUTION: Contains sodium sulphite and hydroquinones. Harmful if taken internally. Keep out of reach of children.

FG7 "AUTOMATIC" DEVELOPMENT TWO-BATH METHOD

EDWAL "AUTOMATIC" (TWO-BATH) DEVELOPMENT AND ITS ADVANTAGES

Edwal "Automatic" Film Development is probably the simplest and easiest way of developing negatives yet devised. It gives automatic control of contrast at the most desirable value for making a good print, automatically produces maximum normal film speed, and does away with the need for exact time and temperature control. All films, fast or slow, are developed for the same length of time. Any temperature between 65° and 85°F is satisfactory. Experienced photographers can go up to 95°F.
 The procedure is simple and rapid. The film to be developed is dipped for 1 minute in Solution A, consisting of Edwal FG7 concentrate diluted 1:1, then for two minutes in Solution B which consists of Edwal FG7 Solution B concentrated diluted 1:1, then rinsed, fixed and washed as usual. In the first solution (A) the film becomes saturated with enough developing agent to create the image, but little development takes place until it is dipped into Solution B which causes development to be completed very rapidly.
 Cost per film is low. Solution A and Solution B can be used over and over until about 50 rolls are developed in a quart of each. Grain, while not quite as fine as with standard development in Edwal FG7, is surprisingly good—satisfactory for all ordinary purposes.

ADVANTAGES OF THE EDWAL "AUTOMATIC" DEVELOPMENT METHOD OVER PREVIOUS TWO-BATH SYSTEMS

Previous two-bath formulations have not given adequate control of contrast. Such solutions might give good contrast on fast films, but would give too strong contrast on fine-grain films, etc. With the Edwal "Automatic" method, contrast can be controlled over a reasonable range by varying the immersion time in Solution A between 30 seconds minimum and 2 or 3 minutes maximum. For still stronger contrast, Solution A is made from Edwal FG7 concentrate full strength instead of 1:1. For the lower contrast necessary for some of the slower films, Solution A is made by diluting Edwal FG7 concentrate 1:3, or for some films 1:5.

MISCELLANEOUS MANUFACTURERS

OPERATING DETAILS

1. Edwal FG7 concentrate and FG7 Solution B concentrate are each diluted 1:1 with water to make the two working solutions A and B. These solutions should be stored in full, tightly closed, *glass* bottles. Plastic bottles are not recommended for long storage because air diffuses through the plastic bottle walls, causing loss of strength.

2. Film can be developed in tanks or trays. The best tanks are those which can be completely filled and completely emptied in 15 seconds or less. Immersion times are usually measured from the time you *begin* to pour the developer into the tank to the time you *begin* to pour the developer out of the tank. Note: If development can be done in a darkroom that is really dark, Solution A and Solution B can be put in separate tanks and the film dipped 1 minute in Solution A and then transferred to the Solution B tank which is then covered, and processing finished in ordinary light as usual. DO NOT PRE-SOAK FILMS IN WATER.

3. Solution A immersion should be accurately timed, but time in Solution B need not be closely measured. Increasing or decreasing the immersion time in Solution A will increase or decrease contrast somewhat. Increasing or decreasing the immersion time in Solution B has no noticeable effect, except that the minimum immersion time should be at least 1 minute. The maximum should not be more than 4 or 5 minutes at room temperature. The time between immersion in Solution A and Solution B should be as short as possible.

4. Agitation in Solution A should be vigorous for the first five seconds, and gentle and continuous thereafter. Agitation should be gentle and continuous for the first 30 seconds in Solution B and about 10 seconds at 30 second intervals thereafter.

5. After the film has been removed from Solution B, it should be rinsed gently in plain water for 20 to 30 seconds. The water should then be poured off, fixer should be poured in, and the film fixed in a strongly hardening rapid fixer (Edwal Quick-Fix or Hi-Speed Liquid Fix with hardener) and then washed as usual. Use of Edwal Hypo Eliminator after fixing is recommended for shortest washing time.

6. All processing solutions (Solution A, Solution B, rinse water, and fixer) should be at the same temperature, especially when developing above 75°F, to avoid possible reticulation. Once the film has been thoroughly fixed in Edwal Quick-Fix with hardener, it may be washed in cool water if necessary, but should not be plunged directly into cold water from a warm fixing bath. The film may be transferred from the fixer to a bath of water at the same temperature, and then the cooler wash water slowly run in to provide a gradual temperature transition.

REPLENISHMENT AND RENEWAL

Neither the A nor the B solutions require replenishment in normal operation. A certain amount of solution A will be carried out by the film. This may be replaced by adding Edwal FG7 at the same dilution originally used for Solution A. If this is done, a corresponding amount of fresh Solution B working solution should be added to the original working Solution B bottle, discarding enough of the old solution to allow the addition of the new.

If immersion times longer than 1 minute in Solution A are used, there will be a gradual loss of activity, in which case FG7 *concentrate* rather than FG7 at 1:1 dilution may be used as the "make-up solution" to maintain volume. If "make-up solution" is not added to keep the level up, about 50 rolls of film usually can be processed in a quart of Solution A and corresponding quart of Solution B.

Some sediment gradually appears in both working solutions as more and more film is processed, and there is some darkening in color. These do not seem to seriously affect the developing power but it is just as well to discard the working solutions if they get too "dirty" looking.

The Compact Photo-Lab-Index

TEMPERATURE

While 70° to 75°F is best, "Automatic" (two-bath) development with FG7 Solutions A and B may be used at any temperature from 65° to 95°F. The immersion time in Solution A should be reduced to about 45 seconds above 75°F and to about 30 seconds above 85°. Immersion in Solution B should be kept down to 1 minute above 85°F.

The following films show a tendency to fog at temperatures from 85°F up: Tri-X, Agfa 1000, Royal X, Adox 14, 17, and 21. The high temperature fog can be prevented by dissolving 8 grams of potassium bromide in a quart of Solution A or using 80 ml of 10% potassium bromide solution as part of the dilution water when making up a quart of working Solution A from FG7 Concentrate.

CONTRAST CONTROL

With most films, the proper degree of contrast for best print-making is automatically produced using Solution A made by diluting FG7 concentrate 1:1 with water. To increase contrast, use full strength FG7 as Solution A, or allow the film to remain in the Solution A for 2 or 3 minutes rather than the recommended 1 minute time.

With the fine-grain films, Solution A made by diluting FG7 1:1 gives excessive contrast with the standard 1 minute immersion time. Contrast can be reduced somewhat by shortening the Solution A immersion time down to a minimum of 30 seconds. However, the best method is to use a higher dilution with a 1 minute immersion time. Suggested dilutions for several such films are:

1:3 Dilution	1:5 Dilution
Plus-X	Ilford Pan F
Panatomic-X	VTE
Adox 14	High Contrast Copy Film

FILM SPEEDS

The following film speeds for miniature and roll films are suggested, based on the commonly used methods of determining exposure by measuring reflected light. For sheet films, one stop more exposure will be desirable.

Adox-17	160
Adox-21	640
FP4	1200
HP4	2000
Tri-X	3200
Plus-X	1000 (1:1) 800 (1:3)
Panatomic-X	160 (1:1) 125 (1:3)
FP4	640 (1:1) 500 (1:5)
Adox-14	80 (1:3) 64 (1:5)
Pan-F	300 (1:3) 200 (1:5)

MISCELLANEOUS MANUFACTURERS

EDWAL CONTROLLED MONOBATH METHOD

The new Edwal "Controlled Monobath" method is a simple, convenient means of developing and fixing the film without having to save used developer or fixer. If it requires only two bottles of concentrates, plus water which can be obtained from almost anywhere. It has the chief advantage of a monobath (developing and fixing in the same solution) together with the advantage of conventional "single use" developing (fresh solution every time, plus control of density and contrast by increasing or decreasing developing time). It is excellent for travelers, vacationers, or home darkroom workers who make negatives only "now and then" and do not want to keep used solutions.

The only chemicals necessary are a bottle of FG7 and a bottle of Hi-Speed Liquid Fix Concentrate. With most films *these will develop and fix one roll of film for each ounce of concentrate.* It is much less expensive than conventional monobath solutions.

DIRECTIONS

1. Develop film for the usual time and in the usual way, using Edwal FG7 at 1:15 dilution. •

2. When development is finished, add 1 oz. Edwal Hi-Speed Liquid Fix Concentrate for each pint of working solution direct to the developer in the tank. Mix thoroughly and fix for 2 to 3 minutes for films in Edwal film classification 1 through IV. Do not use less than 1 oz. of Fixer concentrate, even though your tank holds less than 1 pint developer. Also, if 2 rolls are being processed together in the same tank, use 1 oz. of concentrate for each roll.

For films in Edwal classifications V, VI, VII, fix 5 to 6 minutes or use 2 oz. of Hi-Speed Liquid Fix Concentrate per roll for a 2 to 3 minute fixing time.

3. Discard the solution, wash and dry the film as usual.

Any kind of film can be developed and fixed by this method. With sheet film, use a tank with hangers or one that can be picked up and shaken is recommended because of the difficulty of getting good mixing and circulation with other types.

FG7 can be used at *any* dilution with this method, but the 1:15 dilution with plain water is recommended for economy. When using FG7 with the 1:2, 1:3, or 1:15 with 9% sulfite dilution methods, 2 oz. of Hi-Speed Liquid Fix Concentrate should be used per roll of film.

All Edwal film developers can be used with this method. It is especially recommended for use with Minicol II at 1:7 dilution for thin emulsion films, and with Edwal Super 12 at 1:9 dilution or Edwal Super 20 at 1:7. It is not recommended with full strength Super 12 or Super 20.

If hardening is desired, the film may be immersed in a hardening bath (½ oz. of Edwal Anti-Scratch Hardener in 16 oz. of water) for 1 to 3 minutes after pouring out the developer-fixer. It is then washed as usual.

Thin emulsion films should be washed 7 minutes. Medium and high speed films should be washed 10 minutes.

Quick-Fix Concentrate without hardener or IndustraFIX Concentrate without hardener can be used instead of H-Speed Liquid Fix, following exactly the same procedure.

PRECAUTIONS

It is necessary to get the fixer completely and rapidly mixed with the developer solution. Tanks that can be picked up and shaken are the best. With other small roll film tanks, it is recommended that several ounces of developer be poured out of the tank before adding the fixer concentrate, and then this developer poured back into the tank *after* the fixer has been added, to force the fixer out of the center of the tank into the main body of solution. Agitation should be vigorous during the first minute of fixation to get complete circulation of the fixer into the narrow passages between the film layers. Tanks which use an apron between the film layers are not recommended unless they can be picked up and shaken to get efficient mixing and circulation.

MISCELLANEOUS MANUFACTURERS

MINICOL II

Minicol II is a super-compensating, maximum acutance developer similar to the old original Edwal Minicol but especially adapted to single-use work. The Minicol II Concentrate keeps very well, even in a partly full bottle, and is much more economical to use than the small 1 oz. packs furnished with some developers intended for the same purpose.

Minicol II produces finer grain than most other developers, not because of silver-solvent action, but because the image is produced rather slowly, causing more gradual energy release and less disturbance as the silver particles are built up.

Minicol II at 1:7 dilution is primarily intended for use with thin emulsion, fine grain films such as Panatomic-X, Adox-14, Pan-F. It also gives excellent results with the medium speed films such as Plus-X, FP-4, and Adox-17. Minicol II may also be used at 1:7 dilution with 9% sulphite for single use, super-compensating, fine grain development of fast films such as Tri-X, HP-5, etc. When so used it requires one f-stop more exposure than Edwal FG7.

FILM SPEED

Typical recommended film speeds for low and medium speed 35mm and roll films to be developed in Minicol II diluted 1:7 with water are:

Adox-14	25	Pan-F	80
Adox-17	40	Panatomic-X	80
		Plus-X	320

These film speeds are intended for use with a G.E., Weston, or similar reflection type of light meter, held at camera position and pointed at the darkest part of the subject where detail is desired. If the meter reading is taken on the middle brightness value in the subject, these numbers should be cut in half. With other methods (e.g., incident light) the user should determine the best speed number using a test strip or two.

HOW TO USE MINICOL II

FOR SLOW AND MEDIUM SPEED FILMS

Minicol II Concentrate is diluted with 7 parts water to give 8 parts working solution. This is recommended for development of one roll of film in a small spiral reel tank of developer, but two rolls can be satisfactorily processed without increase in developing time if they can be loaded into the tank at the same time. If necessary, two films can be developed consecutively in 16 ounces of Minicol II working solution, provided the second film is developed within an hour or two after the first and if the developing time of the second film is increased 15%.

FOR HIGH SPEED FILMS

High speed films may be developed in Minicol II diluted with plain water. For finest grain on these films, however, it is recommended that Minicol II concentrate be diluted with a 9% sulphite solution and the developing times be reduced to one-half those given on the Minicol II label for Minicol II diluted with plain water. Minicol II produces a rather soft, highly compensated negative with the fast films. For most purposes Edwal FG7, which produces a snappier negative, will be more suitable on these films.

TEMPERATURE

Developing times from 65° to 75°F are given on the bottle label for Minicol II diluted with water. If it is desired to use Minicol II above 75°F, dilute the concentrate with a solution of 2 ounces anhydrous (chemically pure) sodium sulphate (not sulphite) in a quart of water, instead of plain water. The developing time at 80°F in such a solution would be the same as the developing time at 75°F without the sodium sulphate. For each increase of 5° above 80°F, reduce the developing time 20%. Some increase in contrast will occur at higher developing temperatures.

MISCELLANEOUS MANUFACTURERS

KEEPING CHARACTERISTICS

Minicol II normally has a very faint yellowish color and will retain that color as long as it is in good condition. It will keep for years in a tightly sealed glass bottle. The working solution should be made up just before use. If it is desired to make up working solution and keep it for several days before use, this can be done if the water is de-oxygenated by boiling for 10 minutes or by letting it stand several hours in a sealed bottle after dissolving about 10 grams of sodium sulphite in a quart.

If it is desired to keep Minicol II Concentrate for several months when the bottle is half full, the concentrate can be diluted with an equal part of water. After that, 2 ounces of the 1:1 Minicol II should be used in place of 1 ounce of full strength concentrate. This procedure can be repeated again after the bottle becomes half empty the second time. From that point on, 4 ounces of the partly diluted Minicol II would be used instead of 1 ounce of full strength Minicol II Concentrate.

PRECAUTIONS

Persons who are allergic to metol or similar developing agents should avoid direct contact with Minicol II since it may produce a skin rash. Minicol II will not stain hands or clothing under ordinary conditions. However, brown stains may result if it is allowed to oxidize severely. Such stains usually wash out with ordinary soap and water. WARNING—Minicol II contains sodium sulphite and hydroquinones. Harmful if taken internally. KEEP OUT OF REACH OF CHILDREN.

EDWAL SUPER 12

Edwal Super 12 is a non-compensating (high fidelity) developer which produces negative densities exactly proportional to the brightness values of the subject over a wider range than the "compensating" developers now in common use. This "high fidelity characteristic makes it desirable for the following uses:
1. For putting the appearance of "snap" into a flat scene.
2. For photography of subjects with limited brightness range, especially paintings.
3. For developing copy negatives in mural making where the enlargement must have the same tone range as th print being copied.
4. For portrait photography if high key subjects such as babies or blonde women where it is desired to show a maximum of hair texture (e.g. for a baby's eyebrows).

GRAIN

Edwal Super 12 produces "fine grain" negatives, giving 10-12 diameter enlargements on coarse grain films, more on medium and fine grain types. The best grain is obtained when exposure is properly adjusted to give a relatively thin negative, but with still enough density to hold shadow detail.

FILM SPEED

Edwal Super 12 gives maximum film speed (similar to Edwal FG7). It will give practical film speeds of 500 for Plus-X and 2400 for Tri-X when used with a hand held, narrow acceptance angle exposure meter, such as a Weston, G.E., Honeywell Spot V, Minolta Auto Spot II, Sekonic L-228, Soligor Spot-Sensor, etc., if the exposure is taken on the darkest part of the subject where it is desired to hold shadow detail (Zone III in the Zone System). If an averaging meter or a gray card is used, the speed numbers should be cut at least in half (800 for Tri-X and 250 for Plus-X) when using the times and temperatures given on the bottle label.

PUSHING

To get maximum practical film speed, the developing times from the table should be increased 50% which will double the film speed number. If these times from the table are increased 100% the practical film speed will be increased four times. Some additional speed can be obtained by developing about 45 minutes at 70°F (development to finality). Grain on a pushed negative is not as fine as that on one developed normally.

PRECAUTIONS

Super 12 contains sodium sulfite and paraphenylene diamine and is a strong sensitizer. Allergic persons should avoid direct contact.

Super 12 will produce purple or black stains if spilled and allowed to dry in the air. Stains can be prevented by using newspaper under developing tanks, etc. to catch spills or splashes. Spills on other surfaces or on hands should be washed off thoroughly with soap and water within 10 to 15 minutes to prevent oxidation which produces a stain. Stains can be removed with permanganate and muriatic acid (see information on Scum, Fog & Stains later in this section). KEEP OUT OF REACH OF CHILDREN.

HOW TO USE EDWAL SUPER 12

DEVELOPING TIMES

All the common films have been classified into seven groups in the Edwal film classification table given in the instruction folder attached to the developer bottle. The times and temperatures are given on the bottle label. If Super 12 is used without replenishment, the first batch of film (up to three rolls) should be developed 20% less than shown in the time and temperature table to "take the edge off" the fresh developer. Good agitation should be used, especially with fine grain films, to prevent dichroic fog on the surface of the emulsion. Agitate continuously for one minute at the start of development and about 10 seconds every minute thereafter.

TEMPERATURE

Super 12 may be used "as is" at any temperatures from 65° to 85°F. It may be used above 85°F if 45 grams anhydrous sodium sulfate (not sulfite) are dissolved in each quart of developer. Developing times at 85°F with sulfate are the same as for the same film at 80°F without sulfate. Developing times decrease about 20% for each 5°F rise in temperature up to about 100°F. For processing above 75°F, all solutions including stopbath and wash water, if possible, should be at about the same temperature. The stopbath should be made by using 10 ml (⅓ oz.) acetic acid per quart of water, and should contain 2 ounces (60 grams) anhydrous sodium sulfate per quart to prevent undue emulsion swelling.

REPLENISHMENT

For small tanks, Super 12 may be used without replenishment according to directions on the bottle label. It may also be used by the perpetual self-replenishing method given in the instruction folder.

For deep tanks the bath may be self-replenished by adding about 1 ounce fresh developer for each roll developed. This will keep the level up on the tank, with perhaps a small amount of overflow.

SINGLE-USE DEVELOPING WITH SUPER 12

Super 12 may be diluted with seven parts of water and the film developed at 70°F using a developing time that is twice that recommended for the same film in undiluted Super 12. Use the diluted developer only once. At this dilution Super 12 loses its "high fidelity" characteristic and becomes a mildly compensating developer.

SUPER 12 IN OUTDOOR PHOTOGRAPHY

Where, it is desired to use Super 12 on normal contrast scenes in outdoor work, the tendency to block up highlights may be reduced or eliminated by using a developing time that is 20% to 30% less than the recommended developing time in the time and temperature table. If this is done the exposure on the scene should be increased about one f stop to maintain sufficient overall density.

MISCELLANEOUS MANUFACTURERS

FINE GRAIN FILMS (PANATOMIC-X, PAN-F)
Super 12 should be diluted 1:1 with plain water for developing such films, using the regular developing times recommended on the bottle label. Replenish with 1 ounce undiluted Super 12 after each roll, until 17 rolls have been developed per quart.

KEEPING CHARACTERISTICS
Super 12 normally has the color of weak tea and will retain this color as long as it is in good condition. It will keep for years in a tightly sealed glass bottle (do not use plastic bottles which allow air to diffuse through the plastic walls and oxidize the developer). If the cap should come loose the solution will become dark brown or red and should be discarded.

EDWAL SUPER 20 FOR EXTREME FINE GRAIN

Edwal Super 20 is a true "super fine" grain developer, meaning that it will consistently produce negatives capable of 15 to 25 diameter enlargements from coarse grain films, 20 to 30 diameters or more from medium speed films, and highly magnified enlargements when used with fine grain films.

For comparison, its companion developer, Edwal FG7, is a "fine grain" (not super fine grain) developer, capable of 10 to 15 diameter enlargements from coarse grain, high speed films. (*Note:* The terms "super-fine" and "ultra-fine" have been so misused in advertising claims that they are not to be taken seriously unless supported by specific figures).

NEGATIVE QUALITY
Edwal Super 20 when used with Super 20 Replenisher is a long scale developer, producing a rather "snappy" negative. It gives densities which are exactly proportional to the brightnesses in the original subject over a longer range than do the compensating type developers. In photography of contrast subjects, developing times may be reduced 10% to 30% as experience indicates, to avoid blocking up of highlights.

FILM SPEED
Super 20 should be used with an exposure index half that recommended for use with Edwal FG7. Typical recommended Super 20 film speeds for 35mm and smaller films are: Improved Tri-X 800 and Improved Panatomic-X 60. Super 20 contains paraphenylene diamine, and because of this gives higher film speed than the "non-diamine" super fine grain developers.

HOW TO USE EDWAL SUPER 20
TEMPERATURE
Edwal Super 20 gives best results at 70°F, but the full strength solution can be used up to 85°F if all solutions, including wash water, are at the same temperature. Care should be taken to avoid excessively rapid drying or touching the emulsion of the film with any solid object until completely dry. For development at 85°F or above, dissolve 45 grams of anhydrous chemically pure sodium sulphate (not sulphite) in each quart of developer and 22½ grams in each 16 ounces of replenisher. Developing times for 85°F with sulphate are the same as at 80°F without sulphate. Times at 90°F with sulphate are the same as times at 85°F without sulphate, etc.

FOR MEDIUM SPEED FILMS AND TRI-X
Develop in full strength Super 20 with replenishment, using Super 20 Replenisher at the rate of 1-oz. replenisher per 80 sq. in. roll of film. Two 16-oz. bottles of replenisher may be used with one quart of Super 20 to develop thirty-three 36-exposure rolls of 35mm film or the equivalent in other sizes.

The Compact Photo-Lab-Index

For Minox or other subminiature tanks holding very small amounts of developer, full strength Super 20 can be used once and then discarded.

FOR FINE GRAIN FILMS

Use Super 20 diluted 1:1 with water as the working solution, and replenish with ½-oz. Super 20 Replenisher for each 80 sq. in. roll of film or equivalent. Use the same developing times which are given for full strength Super 20 in the table.

FOR "SINGLE USE" DEVELOPMENT OF FINE GRAIN FILMS

Dilute Super 20 1:7 (2-oz. Super 20 to make 16 ounces working solution) and use a developing time twice as long as that given in the developing time table. Do not use above 75°F. The 1:7 strength is softer working than full strength or 1:1 dilution.

RECOMMENDED FILMS FOR USE WITH SUPER 20

Super 20 gives good results under ordinary developing conditions with Tri-X and most medium speed and fine grain films. It should not be used with Royal-X, Super Hypan, or with the European high speed films except with continuous and efficient agitation, because these films tend to produce dichroic fog with developers of this type. Recently two medium speed U.S.A. films, Verichrome Pan and Professional Plus-X, have also begun to show dichroic fog with Super 20, so should have continuous efficient agitation if used.

REMOVAL OF DICHROIC FOG

If it is desired to use Super 20 to develop one of the above mentioned films which tend to give dichroic fog, or if this fog is accidentally obtained through poor agitation, it can be easily removed by soaking the film in water until thoroughly wet and then dipping or swabbing it for 2 to 4 seconds in ½ strength Farmer's Reducer and immediately immersing it in water. It should then be washed and dried as usual. Repeat if necessary.

FOR SUPER FINE GRAIN PHOTO FINISHING

Photo finishers who specialize in subminiature work use Super 20 in their deep tanks and replenish by adding Edwal Super 12 (instead of Super 20 Replenisher) from time to time as needed to keep the level up. Tank life is very long—often 6 months to a year—and negative quality is better than with the usual developers. Super 12 may also be used (1 oz. per roll developed) instead of Super 20 Replenisher in small tanks.

PRECAUTIONS

Super 20 is a "staining developer" in that it will produce deep purple or black stains if spilled and allowed to dry out or oxidize in the air. Stains can be prevented by using newspaper under developing tanks, etc. to catch stray splashes or spills. Spills on other surfaces should be washed up thoroughly within a few minutes, before oxidation has a chance to produce colors. Stains on the skin will be prevented by prompt and thorough washing with soap and water. If stains do appear, they can be removed with permanganate and muriatic acid (see pages in this section on Fog, Scum & Stains). CAUTION: Super 20 contains sodium sulfite and paraphenylene diamine. Harmful if swallowed. A strong sensitizer. Allergic persons should avoid direct contact. KEEP OUT OF REACH OF CHILDREN.

MISCELLANEOUS MANUFACTURERS

LITHO-F DEVELOPER

Edwal Litho-F is a single solution developer for litho film to be used for any type of line work. It can be used at 70° to 110°F (preferably at 75° to 85°F). It has the following characteristics:

Litho-F Developer lasts a week in an open tray (one inch depth or more). It can be used all day long in the tray and then can be poured back into a bottle for storage and later use. It can be used in a tray or processor without replenishment other than to replace the liquid carried out.

USES OF LITHO-F

Litho derivations, silhouettes, high contrast solarizations, black and white posterizations, and newspaper and non-critical line work.

DILUTION

Dilute one part of Litho-F concentrate with one part of water to make the working solution for all litho films. For litho coated papers, dilute one part of Litho-F concentrate with two parts of water.

FOR TRAY WORK ON FILMS

If development is done by inspection, there will be no visible image formation for about half of the developing time, whereupon the image will build up in a very few seconds. The developing times and temperatures for a density of 3.5 to 4.0 on Kodalith Ortho are:

F	70°	75°	80°	85°	90°	95°	100°	110°	120°
Sec	90	60	45	36	30	25	21	18	15

To avoid emulsion damage in the processing solutions, the wash water should be at the same temperature as the developer and fixer.

Litho Derivations are made by enlarging a continuous-tone negative onto litho film and developing in Litho-F to get a positive. This is contact printed on litho film and again developed in Litho-F to get a negative, which may be enlarged or printed on regular enlarging paper to give a print on which the middle tones are "dropped out." The litho film negative may also be contact printed again on litho film, developed in Litho-F and the process repeated to give stronger contrast; e.g. *silhouettes.* Solarizing a third generation litho derivation in fresh Litho-F can produce an image defined by extremely fine lines.

Black and White Posterizations require Graphic Arts registration pins and a standard office paper punch. The continuous tone negative is enlarged and exposed three different times: one stop under, normal and one stop over exposure. These three positives are then contact printed with three other sheets of Kodalith, given normal exposure, and processed in Litho F. These resulting negatives are then exposed in succession with varying amounts to produce two shades of gray and a black on normal printing paper. All the sensitized materials have to be punched the same and placed in registration the same way to achieve a proper posterization.

For further details, see The Litho-F Booklet sold by Edwal, or your dealer.

EDWAL QUICK-FIX

WHAT QUICK-FIX IS AND DOES

Edwal Quick-Fix, first marketed in 1940, was the first of the present day ammonium thiosulfate rapid fixers for general, professional, and amateur photography. There are now five other Edwal fast fixers, designed to give the best results in specific fields: Edwal Hi-Speed Liquid Fix, IndustraFIX, Processor Fix, Permanizer, and CR Fixer (for high speed processing of RC paper).

Quick-Fix can be used for: General film and paper fixing, x-ray and cine x-ray, motion picture film processing, microfilm processing, high speed RC paper processing, any photographic work where less-than-a-minute fixing and full hardening is required.

ODOR

Quick-Fix has no offensive odor, because it gives off practically no sulfur dioxide if properly mixed. Darkrooms should, however, be properly ventilated.

SPEED AND TEMPERATURE

Quick-Fix working solution can be used from 45°F (slow) up to 110°F (very fast). Film clearing times vary from 10 seconds to 50 seconds at 70°F, and 5 seconds to 25 seconds at 110°F for the 1:3 diluted working solution.

PRINT FADING CHARACTERISTICS

Prints can be left in Quick-Fix for longer than with most other fast fixers without fading of the image. It is superior to the old hypo type fixers in this respect, especially if used with little or no hardener.

HARDENING

Quick-Fix with the full amount of hardeners gives negatives that are fully and completely hardened as soon as they are fixed. A Quick-Fix negative, after drying, cannot be scratched with the fingernail. Controllable hardening for prints is obtained through regulation of the amount of hardener added when making the working bath.

HOW TO MIX AND USE QUICK-FIX

1. Quick-Fix concentrate is much heavier than water. Mix by pouring the concentrate into the water, not vice versa. Stir till the "striations" which first appear in the liquid are no longer visible, indicating that mixing is substantially complete.
2. Then add hardener and mix again till striations disappear. Quick-Fix may be used with only part of the hardener for paper or films that are to be retouched, and if so it is desirable to add 1 ounce of 28% acetic acid per gallon for each ounce of hardener that is left out of the formulation. This avoids hardener precipitation due to alkalinity of the mixing water and maintains full resistance to developer carry-over.
3. Quick-Fix with the full amount of hardener usually has a pH of around 4.2 to 4.4. The pH may be tested with hydrion paper (available under the name "Monitor Strip Paper" from Edwal). Dilute (not glacial) acetic acid may be added to get the pH between 4.2 to 4.4 in case alkaline water is used for mixing.

AGITATION IN THE FIXER

For film fixing use the same agitation method and frequency as is used for developing the film. For paper processing in trays, use as much movement of prints as possible. Do not let prints pile up. Keep them free-floating.

MISCELLANEOUS MANUFACTURERS

The Compact Photo-Lab-Index

DILUTION

1:3 dilution for X-ray, cine X-ray, motion picture film, microfilm, RC paper in phototypesetting, and "ultra speed" processing of all photographic films.

1:4 dilution for commercial deep tanks (a "5-gallon size" to make 6 working gallons or a "25-gallon size" to fill a 30 gallon tank).

1:5 dilution as described on the bottle label for fixing both film and paper in the same bath, for fixing stabilization processed prints, for fixing film in a "film machine," and manual tray processing of small prints (to 16 x 20 size).

1:7 to 1:9 for mural making or where processing a large number of prints in a tray makes good agitation unlikely. The usual fixing times are 3 to 5 minutes.

USE WITH AND WITHOUT A STOPBATH

For maximum life, Quick-Fix should be used with a standard strength acid shortstop such as Edwal Signal Shortstop. If a stop bath is not used, the pH of the fixing bath should be checked occasionally, and the acidity renewed whenever there has been enough developer carry-over to cause milkiness to appear or to cause the bath to feel "slippery." If either of these occurs, addition of 2 to 3 oz. of 28% acetic acid per gallon of working solution will cause the slipperiness to disappear and will allow any milkiness due to hardener to go back into solution.

TYPICAL FILM CLEARING TIMES IN QUICK-FIX AT 70°

	1:3	1:5	1:7
Panatomic-X	7 sec.	9 sec.	10 sec.
Pan-F	20 sec.	25 sec.	50 sec.
Plus-X	12 sec.	25 sec.	40 sec.
FP-4	15 sec.	25 sec.	35 sec.
Tri-X	30 sec.	35 sec.	50 sec.
HP-5	25 sec.	32 sec.	53 sec.
High Contrast Copy	3 sec.	4 sec.	5 sec.
Kodalith Ortho III	5 sec.	7 sec.	8 sec.
Dental X-ray	30 sec.	90 sec.	115 sec.

Actual clearing time depends on the age of the film. The clearing time may double with film over two years old.

QUICK-FIX CLEARING AND FIXING TIMES STAY SHORT TO THE END OF ITS LIFE

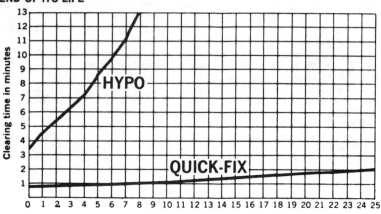

Thousands of square inches of film fixed in 1 gallon of Quick-Fix working solution.

TO TEST FOR EXHAUSTION

The clearing time of film in Quick-Fix stays short till the end of its useful life. When it reaches about 2 minutes at 70°F, the bath is pretty well exhausted and should be sent to the silver recovery unit. *Any fixer that is loaded with silver is toxic to plant life and should be run through a silver recovery unit before discarding.* Edwal Hypo-Chek tests for the amount of silver accumulated in the fixing bath, not for exhaustion due to developer carry-over or other causes. See "Testing the Fixing Bath," on one of the following pages.

STORAGE

Quick-Fix concentrate in gallon or larger plastic bottles will keep up to 2 years at 70° to 90°F. Storage above 90°F shortens its life. The quart bottle of concentrate should not be stored over 1 year. A partially empty bottle of concentrate should be used up within a couple of months because the air over the concentrate will cause oxidation which eventually will cause sulfurization.

Quick-Fix is not harmed by extreme cold. It will crystallize below 0°F, but will re-liquefy at room temperature.

PRECAUTIONS

Quick-Fix is harmless to most fabrics. It is washed out of clothing readily with cold water. Working solution which has been used long enough to contain a good deal of dissolved silver may cause stains on clothing if sent to the laundry or cleaners without first rinsing the fixer out with plain water. Such stains can be removed according to the directions given in later pages on Fog, Scum, and Stains.

CORROSION

Quick-Fix concentrate and working solution do not corrode stainless steel or other commonly used photographic materials of construction such as styrene, polyethylene, hard rubber, etc. *It should not be used in contact with copper, brass, iron, zinc, or other "base" metals.* It is especially corrosive to copper and its alloys. It should be kept away from copper drains or air conditioning units that might be corroded.

MISCELLANEOUS MANUFACTURERS

QUICK-FIX PACKAGING

The 1-gal. size consists of a quart plastic bottle of fixer concentrate and a 4-oz. bottle of hardener which makes 1 gallon for x-ray or for ultra rapid film fixing, or 1½ gallons for standard rapid fixing of both film and paper. It may be diluted to 2 gallons for paper.

Users of 3 gal. or 3½ gal. film tanks should split a 5 gal. size Quick-Fix (135 oz. concentrate) into two equal portions, using one half the concentrate (67½ oz.) and half the hardener to make the 3 gal. or 3½ gal.

The 5-gal. commercial size is a 135-oz. plastic bottles of concentrate with 20 oz. hardener to make 5 gal. for x-ray or ultra-speed fixing, 6 gal. for deep tank, or 7 to 7½ gal. for standard rapid fixing of film and paper. Packed both 1/cs and 4/cs.

The 25-gal. industrial size contains 5.27 gal. concentrate in a rigid cube, and a separate 80-oz. hardener to make 25 gal. fixer for x-ray, motion picture film processing, microfilm, high-speed photo film processing, 30 gal. for deep tank, 35 to 37 gal. for standard rapid fixing for film and paper.

HOW TO MIX QUICK-FIX THE WRONG WAY

Occasionally, because of local water conditions, or incorrect mixing, some unusual trouble may be encountered. The following procedures explain how to avoid any difficulties.

HOW TO MIX QUICK-FIX THE RIGHT WAY

(1) Mix the Quick-Fix concentrate with most of the dilution water and stir vigorously for two or three minutes with a spatula or paddle until the striations which first appear in the solution have disappeared. (2) Then add the hardener fairly slowly. It should be stirred with a paddle or spatula to get the hardener fully mixed with the main solution. (3) Then add the rest of the dilution water to get a uniform working solution.

HOW TO MIX QUICK-FIX THE WRONG WAY

Here are some of the undesirable results you can get if the above procedure is not followed:

1. If the fixer concentrate and the hardener concentrate are put in the mixing vessel together *before the dilution water is added,* you can get partial sulfurization which produces a yellowish precipitate, which will not re-dissolve.

2. If you put in the fixer concentrate and then the dilution water but *don't stir* it, the hardener can go right to the bottom of the vessel and react with the undiluted fixer concentrate, and the result would be the same as number 1.

3. If you have considerable alkali in your dilution water, it may precipitate part of the hardener because the alkali will have neutralized part of the acid that the fixer normally contains, so the pH will get above 4.8 to 5. Hardener will come down as a milkiness. It may not precipitate right away, but it may form a scum on the negatives or prints in the fixing solution. This hardener can be wiped off the negative or the print by means of a damp rag that has a little 2% or 3% sodium carbonate in it. Then wash with water for 3 to 5 minutes.

4. If you have very hard water with a high calcium content, it may cause precipitation of the hardener, and also some sulfurization, if the sulfite content is reduced too far. The remedy for this is to use a little Edwal Water Conditioner in the mixing water according to the instructions on the Water Conditioner label and information which appears on the following pages.

5. If the fixer is mixed with *only part of the hardener* the resulting pH may be high enough (about 4.6 or above) so that some of the hardener will precipitate. This can be prevented by putting in 28% acetic acid to keep the pH down. For instance, if you mix a quart of Quick-Fix to make two gallons of paper fixer and put in only one ounce of hardener, you should put in three ounces of 28% acetic acid to make up for the three ounces of hardener you left out.

MISCELLANEOUS MANUFACTURERS

TESTING THE FIXING BATH

The initial fixing speed and capacity of a fresh fixer or the degree of exhaustion after partial use can be judged by reliable practical tests which any darkroom operator can use, as follows:

TESTING FOR FIXING SPEED (CLEARING TIME)

Minimum fixing time is twice the length of time required for the film to become completely clear when immersed in the fixing bath. To determine clearing time, use undeveloped film as follows:

1. Use the same brand of film for the clearing time test as you will be using in regular production. Also have the fixing bath at the same temperature for the clearing time test as in your regular work.
2. Cut a strip of undeveloped film about three inches long, hold it at one end between thumb and finger, and immerse it about half-way in the fixing bath.
3. Move the film strip back and forth in the fixer so as to get about **the same degree of agitation** as you would in regular processing.
4. By means of a timer or stop watch, measure the shortest time required for the film to become completely clear so that newspaper type can be read through it easily. **This is the clearing time.** A recommended method is to put the sample of fixer for the clearing time test in a flat glass dish over a piece of newspaper, so that the clearing time can be accurately judged by noting the immersion time necessary for the newspaper type to become clearly readable through the film.

TESTING FOR SILVER TAKE-UP

Edwal Hypo-Chek is used to estimate the degree of fixer exaustion due to silver taken up from film or paper. To make the test, scoop a little of the fixing bath up in a clear glass vessel and drop one or two drops of Edwal Hypo-Chek into it. If the silver content is low, Hypo-Chek will produce no precipitate. With an ordinary hypo-type fixer (made from sodium thiosulfate), Hypo-Chek will first produce a precipitate when the fixer is near exhaustion due to silver take-up. Such a bath should be discarded, or used for silver recovery.

Edwal fast fixers, such as Quick-Fix, IndustraFIX, or Processor Fix will take up much more silver than the hypo-type, and the addition of Hypo-Chek will **begin** to show a precipitate after the fixer has taken up about half its maximum silver capacity. However, at that time the precipitate from Hypo-Chek will disappear if the fixer is stirred or agitated. When so much silver has been taken up that stirring or agitating no longer causes the Hypo-Chek precipitate to disappear, but the permanent cloudiness remains, the fixer is practically saturated with silver salts and should be discarded or used for silver recovery.

The clearing time test described above is also excellent for determining when the fixer should be replaced due to silver take-up. When the clearing time has risen to half the minimum fixing time which will be used in manual or automatic processing, the bath should be replaced.

TESTING FOR ACIDITY

The acid content of the fixer maintains the hardening action at its proper rate and also stops the action of the developer. If the acid content gets too low due to developer carry-over, the film will not harden properly and will have a "slippery" feel in the fixer. The appearance of this slippery feel is a good practical test for loss of acid reserve, which may cause film sticking and scum or streaking (due to precipitation of basic aluminum sulfite from the hardener) on the film in automatic processors. The film scum may also occur in manual processing where there is inadequate use of a shortstop.

Acidity of the working fixer is easily tested with Edwal Monitor Strip Paper. With an automatic processor, a drop of the fixer from the tank is obtained while the processor is running (so it will be representative of the main body of fixer in the tank) by means of a plastic Edwal Monitor Rod. This drop is then applied

MISCELLANEOUS MANUFACTURERS

to an Edwal Monitor Paper Strip and the resulting color matched against the color scale to get the pH of the working fixer. If the pH of the fixer bath has risen above 4.5, Edwal Processor Fix Rejuvenator should be added according to directions given in the Edwal Processor Fix instruction sheet. An Edwal Monitor Rod is included in every 5-gallon size Edwal Processor Fix.

For manual processing, a short strip of Edwal Monitor Paper can be torn off the dispenser, dipped in the fixing bath, and the color matched against the chart in the dispenser. Edwal Processor Fix Rejuvenator may be added from time to time to maintain fixing bath pH below 4.5, extending the life of the tray of fixer 200% to 300% in operations where no stop bath is used. Edwal IndustraFIX thus treated, will outlast any other fixer in graphic arts use.

TESTING FOR DEGREE OF HARDENING

The most practical method of testing the hardening action of a fixer is to actually fix and harden a strip of film which has previously been soaked in a developer for the same length of time as would be used in normal processing. After fixing for the normal length of time, the test strip of film is washed and dried in the usual fashion. After it has been thoroughly dried it is tested by scratching with a nail, knife point, or scribing tool, or by application of retouching, dye-wash, staging, or other preparations which it is desired to use. Information on the type of hardening and gelatin conditioning effect available with various Edwal fixers is available from your Edwal dealer or direct from Edwal on request.

TESTING FOR PRINT FADING PROPERTIES

Almost everyone has had the experience of forgetting a print in the fixer and having the image fade. All present day acid fixers will cause some amount of fading on a print that is left in them for a long time (some more than others). For the least fading tendency, use of Edwal Quick-Fix at 1:7 dilution without hardener is recommended. Quick-Fix used in this fashion allows immersion in the fixer up to two hours for a cold tone print or one hour for a warm tone print. This is a much lower fading tendency than with any other fixer tested, either rapid or ordinary hypo-type.

To compare different fixers for fading tendency, make a print in the usual way and leave it in the fixer, using the same amount of agitation from one fixer to the next. The print image will first take on a warm color and then will begin to fade. For an exact comparison, use prints made with the same image, exposed and developed in exactly the same way, and all fixed at the same time in parallel trays in the fresh fixer.

TESTING FOR PROBABLE LIFE

Many rapid fixers, at the dilutions customarily used, show clearing times fairly close to each other, but in actual use some will fix much more film per gallon than others. However, when the test is made at very high dilution (say 1:11) the rate of fixing is much more comparable to what it would be after most of the fixing power has been used up by silver bromide accumulation. A fixer of unknown strength can be quickly evaluated in comparison with a fixer of known fixing capacity as follows:
1. Dilute the fixer concentrate whose fixing capacity you know, with 11 parts of water and determine a clearing time on a strip of undeveloped film. At this degree of dilution, the clearing time will be 1½ to 3½ minutes.
2. Dilute the fixer concentrate of unknown fixing capacity with 11 parts of water and determine the clearing time on another strip of the same brand of film using **exactly the same rate of agitation and the same temperature.**

The relative strengths of the two fixer concentrates can be roughly judged by comparing the two clearing times. If an exact comparison is desired, the fixer concentrate showing the longest clearing time can be used to make up test solutions at 1:5, 1:7, and 1:9 dilutions and the clearing time of another strip of film determined in each to find which strength is most nearly equal to the 1:11 dilution of the stronger fixer. For instance, some rapid fixer concentrates now on the market when diluted with only 7 or 8 parts of water require as long a time to clear film as Edwal Quick-Fix or IndustraFIX at 1:11.

MISCELLANEOUS MANUFACTURERS

EDWAL WATER CONDITIONER

Impurities present as "hardness" in public water supplies have a considerable effect on the results obtained when such water is used or photographic solutions. With some types of water, the popular carbonate-type print developers can not be used. The common impurities are:

1. Iron salts, which cause developers to oxidize more rapidly than they should during use.
2. Copper salts, which cause fog with black-and-white developers, or incorrect color rendition with color developers.
3. Calcium salts, which cause precipitation of sulfite or carbonate, sometimes in sufficient quantities to shorten the life of the solution.

Some cities, industries, and private homes have "water softening" systems which remove the objectionable hardness but at the same time introduce enough alkalinity into the water to seriously affect the performance of film developers or reduce the acid reserve of fixing solutions.

HOW TO USE EDWAL PHOTOGRAPHIC WATER CONDITIONER

Edwal Water Conditioner forms complexes or chelate compounds with iron, copper, calcium and similar salts to render them photographically inactive, thus making most types of water which contain them usable for making photographic solutions. It is **not** a "softener" which precipitates calcium, etc., but leaves increased alkalinity.

Edwal Water Conditioner is added directly to the water to be used in diluting photo concentrates. With formulas mixed from powders, Edwal Water Conditioner is best added after the powders have been completely dissolved. If precipitates have formed due to the interaction of developer chemicals with water hardness, addition of Edwal Water Conditioner will usually cause them to re-dissolve so that no essential developer quality is lost. **Do not use in batteries or where distilled water is needed to leave no residue when evaporated. Do not store in iron, copper, or aluminum containers.**

Edwal Water Conditioner does not remove sulphides or other compounds which cause a sulphur (rotten egg) odor. Water containing such compounds can usually be made usable by boiling or aerating till the odor is gone.

The amount of Edwal Photographic Water Conditioner to be added can be determined in one of the following ways:

1. Add ⅓ oz. Edwal Water Conditioner to each gallon of working solution. This is sufficient for public water supply in most major U.S.A. cities, outside of Arizona, Indiana, Iowa, Nebraska, New Mexico, South Dakota and Utah.
2. Determine the hardness in grains per gal. from the water chemist in charge of your local water supply. Then add 1 ml of Water Conditioner per grain of hardness per gallon.

SOURCES OF HARDNESS IN WATER

Iron and calcium salts are usually found in water obtained from wells because such water usually percolates through beds of limestone or other rocks which contain such metals. Surface water from lakes and rivers generally contains much less iron or calcium hardness, but this will vary from one season to the next, depending on the amount of rain or snow and the amount of evaporation from lakes, reservoirs, etc.

Very few natural waters contain copper, but surface water which has come from a water-shed where there is considerable vegetation may have taken up nitrogen compounds during percolation through dead leaves, etc. These nitrogen compounds sometimes cause dissolving of copper from tubing or valves, etc. Copper can be considered to be present if the drip from a faucet leaves a green ring in a wash basin or a bathtub. Iron is indicated by formation of a reddish-brown ring.

MISCELLANEOUS MANUFACTURERS

EDWAL "FOUR AND ONE" SUPER HYPO ELIMINATOR

Edwal "Four and One" is a hypo eliminator that removes hypo, silver hypo complexes, polythionates, excess silver ions, and **gives protection to the silver image itself** during storage. It provides complete control of all the factors affecting permanence as specified in the American National Standards Institute, standards PH 4.32-1974 (image stability), PH 1.28-1973 (archival records), PH 1.43-1976 (safety film storage), and PH 1.41-1973 (archival records).

Edwal "Four and One" improves the permanence of photographic films, prints, and microfilms in the following ways:

1. It takes the waiting out of washing, speeding up the removal of silver thiosulfate complexes in the wash bath.

2. Reverses the formation of insoluble polythionates, converting them to thiosulfates which are easily washed out. Unremoved polythionates can break down under humid storage conditions to form silver sulfide stains in the emulsion.

3. Prevents the oxidizing effect of air and chlorine in the wash water from causing further polythionate formation. It also protects the image against changes in tone in case of treatment with a hydrogen peroxide bath.

4. Helps remove excess silver ions which can react with atmospheric pollutants to cause background stain.

5. Coats the silver image with a compound that protects the silver particles from attack by such pollutants as found in city atmospheres, giving protection exceeded only by expensive gold treatments.

STANDARD HYPO ELIMINATION PROCEDURE

Edwal "Four and One" eliminates hypo, polythionates, etc., producing prints suitable for dye-toning and normal commercial use.

FOR FILMS

Use Edwal "Four and One" at 1:31 dilution (4 oz. concentrate to make 1 gallon). After fixing, films should be rinsed in running water for 30 seconds to remove excess fixer. Treat the film for 2 minutes in the Edwal "Four and One" working solution. Use mild agitation. Wash the film for 5 minutes in running water and dry as usual. A final 20 second rinse in Edwal LFN is recommended to prevent spotting. Capacity: 7500 to 8000 square inch per working gallon.

FOR PAPERS

Use "Four and One" at 1:31 dilution (4 oz. concentrate to make 1 gallon). After fixing, rinse prints in running water for 30 seconds to remove excess fixer. Treat single weight papers for 2 minutes and double weight papers for 4 minutes in Edwal "Four and One" working solution. Wash for 15 minutes in an efficient print washer and dry on a clean dryer with a freshly washed blanket. Capacity: 40 to 50 d.w. or 75 to 100 s.w. prints per working gallon.

PROCEDURE FOR TRUE ARCHIVAL PERMANENCE

This accomplishes the maximum degree of permanence, and makes it unnecessary to use the customary hydrogen peroxide wash for prints for museum standards.

FOR FILMS AND MICROFILMS

1. Use Edwal "Four and One" at 1:15 dilution (8 oz. to make 1 gallon). After fixing, rinse the films or microfilms in running water for 30 seconds to remove excess fixer. Treat the films for 2 minutes in a fresh Edwal "Four and One" bath and wash for 5 minutes.

2. Treat again in a second fresh Edwal "Four and One" bath for 2 minutes and wash for another 5 minutes. The second bath insures that the film is treated with solution that is as fresh as possible. Dry as usual. For maximum protection, treat with Permafilm, which toughens the emulsion and removes all excess moisture usually held by the so-called "dry" emulsion.

FOR PAPERS

1. Use Edwal "Four and One" at 1:15 dilution. After fixing, rinse for 30 seconds to remove excess fixer. Soak single weight paper for 2 minutes, double weight paper for 4 minutes in Edwal "Four and One" working solution with mild agitation. Then wash in an efficient print washer with running water for 30 minutes.
2. Treat again in a fresh Edwal "Four and One" bath for the above time and wash for another 30 minutes.

For archival processing, the print dryer, drainboards, squeegee, clips, and tongs should be washed in Edwal "Four and One" (1:15), rinsed with water, and wiped with a clean cotton cloth before handling the paper. Dryer blankets should be washed well with lukewarm water, then soaked in the 1:15 Edwal "Four and One" for one hour and then laundered in warm water and a little Tide (not soap) and dried on the drum. Hard surfaces such as drums should be washed with straight Edwal "Four and One" and rinsed thoroughly with clean water.

It is best to test your own print wash system to determine the best washing time for that particular equipment. Edwal tests were made with a Kodak tray siphon to simulate average wash conditions. Test prints made by this method on double weight papers should have no detectable hypo content when tested by the American National Standards Institute silver nitrate test PH 4.8-1971.

MISCELLANEOUS USES

Edwal "Four and One" is excellent for removing dye toner stains from hands and clothing. Edwal "Four and One" at 1:15 dilution can be used as a neutralizer for developer tray cleaning solutions such as Edwal Single Solution Tank, Tray, and Rack Cleaner to insure complete elimination of the cleaning agents.

PRECAUTIONS

Working solution should be made up fresh just before use. Working solution will gradually oxidize if left in an open tray, but can be kept up to a month in a stock bottle or tank with floating lid. Contains sulfites and glycols. Harmful if taken internally. Keep out of reach of children.

MISCELLANEOUS MANUFACTURERS

TESTS FOR PRINT AND FILM PERMANENCE

TRUE ARCHIVAL QUALITY

To make a film or print "permanent" (archival quality) it must be resistant to staining, fading, or discoloration of the image or background during many years of use or storage. The degree of permanence can be predicted by a series of quick chemical tests which indicate the degree and kind of deterioration the print will undergo.

1. **Deterioration Due to Presence of Silver Ions** (non-complexed silver salts of bromide, iodide, etc.), caused by incomplete fixation. Such silver compounds will react with sulfur compounds in the air or gelatin during storage or use, to form brown silver sulfide, both in the background and image.

TEST FOR SILVER IONS WITH SODIUM SULFIDE

A. Make a stock solution of 2 g. sodium sulfide and 100 ml distilled water. Store in an amber or pyrex glass bottle with a clean bakelite or styrene cap.

B. Make the working solution just before use by diluting one part A with nine parts distilled water and place in a clean glass or plastic tray. Submerge a 4 x 5 print halfway under the surface. Hold it there for 2 minutes with slight agitation. Any brown silver sulfide that forms will show the approximate maximum brown color that will appear on prolonged storage in industrially polluted air. This test can be used on the white border of a print. If the print is not acceptable, it can be re-fixed with a fresh fixer, processed in "Four and One," and re-tested.

2. **Deterioration Due to Presence of Thiosulfate [Hypo].** Films (not prints) may be tested for freedom from thiosulfate by the Methylene Blue test described in the American National Standards Institute (ANSI) PH 4.8-1971. The procedure is rather complicated and **does not** test for polythionates.

3. **Deterioration Due to Presence of Hypo or Polythionates.** A film or print may be washed free of thiosulfate (hypo), but not have archival quality because the emulsion will still contain polythionates, which are caused by too long a time in the fixer or use of an overworked fixing bath. A chemical test for the presence of both hypo and polythionates is provided by use of an acetic acid—silver nitrate solution as follows: (See ANSI—PH 4.8-1971).

A. Make a stock solution by dissolving 30 ml glacial acetic acid and then 10 g. silver nitrate in 750 ml distilled water. Mix well and dilute with distilled water to make 1 liter. Store in a clean brown glass bottle with bakelite or styrene cap.
B. To make the test, use a little of the above solution full strength without dilution in a clean glass or plastic tray. Use an unexposed 4 x 5 sheet of film or paper that has been developed and fixed and washed in the same manner as the regular prints. Dry the test sheet and then submerge halfway into the acetic acid-silver nitrate solution for 4 minutes with gentle agitation. Avoid strong light. Any stain that appears will show approximately the maximum possible yellowing after long storage. If the test print shows any yellow, the other prints from this batch should be treated with Edwal "Four and One" according to the directions in the "Four and One" information on previous pages.

4. **Resistance to Oxidizing Agents [Ozone, Peroxides, etc.].** This test is unique to Edwal "Four and One" and is given mainly for those who are interested in the protective properties of "Four and One" against oxidizing agents in the air or aqueous solutions.

A. Use two exactly equal size pieces of film (approximately 1 x 1). Expose both to room light and develop, stop, and fix as usual. Treat one strip with Edwal "Four and One" and the other with the other brand of hypo eliminator that you wish to use as a comparison. Wash both strips as usual and dry.

B. Make the test solution by dissolving 10 ml of 28° ammonia solution in 700 ml distilled water, adding 250 ml of 3% hydrogen peroxide, and enough distilled water to make 1 liter. This solution should be made fresh just before the test. It cannot be stored. It should not be put in a bottle with a cap on it because the gas that may be evolved may break the container.

C. Put the solution in a tall beaker or measuring graduate. Mark the two strips and submerge them in the solution at the same time and force them to the bottom. The black silver on the strips will react with the peroxide, forming small gas bubbles on the surface of the film. The amount of time it takes for enough bubbles to form to float the two equal strips is a measure of the oxidation resistance of the strip. Edwal "Four and One" coats the image and protects it from oxidation. Strips treated with Edwal "Four and One" react very slowly and usually take ten to twenty times longer to float than the identically processed strip that has been treated with the other brand of hypo eliminator. There will be a greater comparative effect when using slow speed fine grain films for the test than will be the case with high speed coarse grain film. Fine grain films are more susceptible to oxidation than the course grained films.

"MUSEUM" QUALITY FILMS AND PRINTS

The directions given on previous pages, for using Edwal "Four and One," will give true "archival" quality prints and films meeting American National Standards specifications if the following precautions are observed.

1. **Cleanliness.** Trays, tongs, hangers, table tops, and every surface that the print is likely to come in contact with should be cleaned, including the photographer's hands. Fingers contaminated with grease or chemicals can leave spots that won't show up for years, but will eventually ruin the print. Avoid soap. Clean hands with detergents such as Tide, followed by water, and finally with a little "Four and One" full strength.

2. Use developer, stop, and fresh fixer for normal times. Don't force development or over-fix, or let prints pile up. Keep dryer temperatures below 150°F. Air drying is preferred. Use Edwal Super-Flat if necessary, but not Super-Flat B or glycerine or glycol flatteners.

3. **Mounting.** Prints should be mounted on acid-free board. Use of a pH pencil obtained from Micro Essential Laboratory, 4224 Avenue H, Brooklyn, NY 11210, is recommended. The pH should be greater than 6.5. Dry mounting a print that has been thoroughly dried ahead of time does not seem to cause cracking on storage. Coda Corp. makes a cold dry mounting adhesive for this purpose, but tests have been running for only eight years at this writing. Use a clean sheet of paper between the print and the mounting press to avoid contamination from the press surfaces.

EDWAL LFN WETTING AGENT
(THE LOW FOAM WETTING AGENT)

Edwal LFN is an improved, non-flammable, more concentrated and improved descendant of the well-known Edwal Klik-Wet, having more wetting power but less foaming action. LFN is used as follows:

Dilute *one drop per pint* in distilled water (or two drops per pint in tap water) for use as a film rinse to prevent water spots.

Dilute *one drop per pint* in developers to prevent air bubbles and floating dust particles from causing "pinholes."

Dilute *5 drops per pint* of tap water to make a final rinse for RC paper to promote even drying.

LFN is "non-ionic" which means that it will not react with the active ingredients of any photographic solution, and it can be safely used in toners or solutions containing dyes. It is non-corrosive, harmless to equipment, photo materials or personnel.

LFN exerts its wetting action with much less foam than other wetting agents, so there is less tendency to cause airbells on film during development, and less waiting for bubbles to break after agitation. LFN DOES NOT CAUSE A LOT OF BUBBLES TO DO ITS WETTING AGENT JOB.

PACKAGING

Edwal LFN is available in a ¾-oz. squeeze bottle which contains enough for 800 or more pints or 100 gallons working solution. It is also available in 4-oz. bottles which treat approximately 4266 pints or 533 gallons working solution. It is harmless to the user except when a large quantity might be accidentally swallowed. It does not contain an anti-foam compound, which might leave an oily residue.

HOW TO USE EDWAL LFN

IN A FILM RINSE BATH

After a film is developed, fixed, and washed in the usual small tanks, the film is given a final rinse in a bath containing one drop of LFN mixed into one pint distilled water (or two drops LFN in 1 pint tap water) to serve as a water spot preventive. The usual procedures are: after fixing and washing, leave the film in the tank reel, put the LFN rinse bath in the tank and slosh the film and reel up and down vigorously for 10 to 30 seconds to get the film completely wet with the LFN rinse solution, or: put the LFN rinse solution in a pint beaker or tray, take the film out of the spiral groove holder, and see-saw it up and down in the rinse bath for 10 to 30 seconds. Then hang it up to dry. The use of LFN in this way will allow the film to drain evenly and completely, with no adhering water droplets. There will be no water marks after drying.

IN A FILM DEVELOPER

Put one drop of LFN in a pint of the film developer working solution and stir vigorously for 10 to 20 seconds to be sure the mixture is complete. Then insert the film in the tank and pour in the developer and develop as usual. The use of LFN makes any dust particles float in the liquid rather than adhering to the film causing "pinholes." It also floats any air bubbles so they don't stick to the emulsion during development. This is important in small spiral groove tanks where liquid circulation is not very good.

IN A PAPER DEVELOPER

In developing mural size glossy prints, especially with emulsions that have been strongly hardened during manufacture, the addition of one drop of LFN per pint if working developer will tend to minimize the adherance of bubbles of air which interfere with even development.

When processing RC papers which are to be air dried by hanging, rinse the fixed and washed paper about one minute in a rinse solution of 5 drops LFN per pint of water, and then hang the prints up to dry. This treatment reduces the drying time of RC papers by about one half.

FOR COLOR PRINTS AND PAPERS

The following formula is suitable for use as a final stabilizing bath for all color films and papers:

> Distilled water 1-qt. (1 liter)
>
> LFN 5 drops
>
> Formulin (37% formaldehyde solution) ½ fl. oz. (15 ml)

IN TONERS AND RETOUCHING DYES

Since LFN is "non-ionic" it can be safely used in toners and retouching media without causing precipitation of the dyes. It is very useful when these are to be applied with a brush because it makes the dye solutions or retouching media spread easily, giving good control.

IN GLASS CLEANING

Any laboratory glass or other glass surface will drain completely without hanging droplets or water marks after drying, if rinsed in a bath containing about 5 drops LFN per pint. The glass should be washed and rinsed with ordinary water in the usual fashion and then dipped in the LFN rinse. Microscope slides and cover glasses can be handled in this fashion. If a large number of objects are to be rinsed in an LFN bath the LFN can be replenished as needed. Add only enough LFN so the rinse bath shows small, quickly broken foam bubbles when vigorously stirred with a glass or plastic rod.

Large windows or plastic or painted surfaces can be washed with detergents, then thoroughly rinsed down with plain water and then swabbed with a bottle cap full of LFN in a bucket of water, and can then be allowed to dry without wiping.

MISCELLANEOUS MANUFACTURERS

PRINT MAKING ON RC PAPER WITH EDWAL CHEMICALS

These instructions cover the use of Edwal chemicals on the four most common resin coated papers: Kodak, Ilfospeed, Luminos, and Unicolor.

DEVELOPERS

The three Edwal paper developers, Platinum, Super III, and T.S.T., perform well on resin coated papers. The dilutions are the same as for regular papers. Developing times and temperatures are:

Kodak, Ilford, and Unicolor

70°F	80°F	90°F	100°F
90 sec.	60 sec.	45 sec.	30 sec.

Luminos

70°F	80°F	90°F	100°F
120 sec.	90 sec.	75 sec.	60 sec.

If the developer is used above 80°F the other solutions, shortstop, fixer, and hypo eliminator, should be at approximately the same temperature. Temperatures below 70°F will require increased developing times and may not produce sufficient density. Recent tests on Ektabrome SC in T.S.T. *without Solution B* indicate full development at 70°F in approximately 30 sec. Use of Solution B produces poor density with this paper.

SHORTSTOP

A shortstop made by diluting 1-oz. Edwal Signal Shortstop in 1-gal. water will extend the life of the fixer by eliminating developer carry-over. This is especially desirable when a fixer without any hardener is used.

FIXING

Some resin coated papers have a pronounced tendency to curl. Use of a non-hardening fixer such as Edwal Hi-Speed Liquid Fix or Quick-Fix without Hardener at a dilution of 1:5 is recommended. The fixing time should be at least as long as the developing time, but fixing more than four minutes is not recommended because there will be a tendency toward fading of the image. If the print is left in the fixer for 8 minutes or more the drop-off in density becomes quite noticeable.

If the developing temperature is above 80°F, the use of Edwal Quick-Fix at 1:5 dilution *with Hardener* is recommended.

WASHING AND HYPO ELIMINATION

Edwal tests have shown that none of the resin coated papers wash completely clear of residual hypo and polythionate using plain water and the manufacturer's recommended wash times. Even with extended wash times, up to 30 min., tests still indicate the presence of these impurities in the emulsion. The use of Edwal "4 and 1" Hypo Eliminator will greatly aid in preventing brown spots from appearing during the predicted life time, especially if the print is exposed to industrial fumes. While the prints made on present RC papers cannot be termed "archival" in the same sense as prints made on standard papers, the tests in previous pages, "Tests for Print and Film Permanence" would be desirable.

TONING

Prints to be toned should be fixed in a non-hardening fixer which should be specially made from water which doesn't contain a lot of chlorine. If heavily chlorinated water is the only kind available, 1-oz. Edwal "4 and 1" Super Hypo Eliminator concentrate should be added to each gallon of working fixer to counteract the oxidizing action of the chlorine. The prints should be rinsed, treated with Hypo Eliminator, and washed according to the directions given in the Edwal "4 and 1" information on previous pages.

Kodak and Ilfospeed papers will tone satisfactorily with Edwal Blue Toner but are not recommended for the other Edwal Color Toners. With all four of the common resin coated papers the Blue Toner will give a good color in about 5 minutes at room temperature. A 5 minute wash in running water is usually sufficient after toning.

Edwal Brown Color Toner may be used with Luminos or Unicolor resin coated papers, but should not be used with Ilfospeed or Kodak RC. Tests on newly purchased Kodak Polycontrast RC paper indicate that all Edwal Color Toners will now produce satisfactory results on this paper if the expiration date is 12/78 or later. The degree of toning may be varied according to the desire of the user. A certain amount of brown color will be left in the "white" areas even with prolonged washing, but this is usually acceptable—especially if the borders of the print are trimmed off.

Yellow, Red, and Green Edwal Toners work well with Luminos and Unicolor papers. Approximately ten minutes toning at room temperature gives a good color. A 15 minute wash is usually sufficient. Unicolor paper tones very rapidly and should be closely watched to get the desired result. Over-toning can be avoided if you watch the areas with thinnest lines in the image.

Toning is best done at 70°F but temperatures may be increased up to 90°F which will give very rapid toning.

DRYING

Air drying is best. If you hang the prints up to dry, the drying time can be cut in half if the print is first immersed in a solution of five drops LFN (Low Foam, Non-Ionic) Wetting Agent diluted in 16-oz. water.

MISCELLANEOUS MANUFACTURERS

EDWAL T. S. T. (Twelve-Sixteen-Twenty) LIQUID PAPER DEVELOPER CONCENTRATE

Edwal T.S.T. (Twelve-Sixteen-Twenty) is an extremely versatile paper developer. Working solution costs less than other liquids, and works well with all papers, including RC. T.S.T. is a two-part developer consisting of an A solution and a small bottle of B solution to control tone and contrast. It can be made to give very warm tones or blue-black tones through proper paper selection. Its specific characteristics are:

1. One gallon concentrate gives 12 gallons workings solution for heavy duty, 16 gallons commercial strength, 20 gallons portrait strength, and 40 gallons for warm-tone papers.
2. Gives varying amounts of contrast by regulating the amount of Solution B.
3. Gives varying warmth of tone on a single paper through proper regulation of exposure, development, and B content.
4. Panthermic. Can be used from 55°F to 90°F.
5. One gallon of concentrate develops 4000 or more 8 x 10 prints at 1:11 dilution.
6. The lower dilutions (1:7, 1:11, and 1:15) will *last a week* in a big tray where the developer solution is two inches deep or more.

HOW TO USE EDWAL T. S. T.
MIXING FOR NORMAL CONTRAST

To make working developer with normal contrast always use 1 ounce Solution B with each 8 ounces Solution A, no matter what the final dilution of the working bath may be. Dilute Solution A first, mix briefly, add Solution B, bring up to the final volume and mix to get uniform solution. For very hard water use Edwal Water Conditioner. See the Edwal Water Conditioner information on earlier pages.

1. Dilute 1:7 for coldest tones and densest blacks.
2. Dilute 1:11 for *Industrial and Product* photography.
3. For *General Purpose* photography use a 1:15 dilution. Gives neutral image tones.
4. For most *Portrait* photography use a 1:19 dilution. Gives normal warm tones.
5. For *warm-tone soft portrait* photography use a 1:39 dilution. Gives warmest tones possible on warm-tone papers.

To make 1 gal. T.S.T. working developer for normal contrast:

At 1:7 dilution use 16 oz. Solution A plus 2 oz. Solution B

At 1:11 dilution use 12 oz. Solution A and 1½ oz. Solution B

At 1:15 dilution use 8 oz. Solution A and 1 oz. (30 ml) Solution B

At 1:19 dilution use 6½ oz. Solution A and 25 ml Solution B

At 1:39 dilution use 3¼ oz. Solution A and 12½ ml Solution B

Use the graduated measuring cup packed with the quart or gallon size to measure Solution B.

HOW TO VARY CONTRAST AND IMAGE TONE

Regulate the amount of Solution B (1) To get approximately *number 3 contrast on a number 2 paper* use no Solution B. Develop at 68°F to 75°F. Cut the brightness of the safe light to prevent fog. (2) To get approximately *number 1 contrast on a*

number 2 paper, double the amount of Solution B. The tone can be made progressively colder by increasing the developing time. Intermediate amounts of Solution B gives intermediate results. (3) T.S.T. will not give a brown image on a cold tone paper, but on a warm-tone paper the 1:19 and the 1:39 dilutions with extra Solution B will give the warmest tone possible.

For Spot Intensification during development, treat the desired area with cotton balls dipped in 1:7 TST with no Solution B. For spot reduction, apply 1:15 with twice the normal amount of Solution B.

DEVELOPING TIME

The best developing time for normal contrast is 2 to 2½ minutes at 70°F for a developer containing 1 oz. Solution B with each 8 oz. Solution A. When the activity is increased by cutting down the amount of Solution B, use less development, from 60 seconds to 2 minutes, depending on the activity of the developer. When the warm-tone working solutions are used, develop 2 minutes to 4 minutes or more, depending on the judgment of the operator.

AGITATION

For normal development, submerge the print as rapidly as possible, agitate continuously for the first 30 seconds, and then agitate gently by lifting a corner of the tray once at approximately 30 second intervals. When no Solution B is used, submerge the print as quickly as possible, agitate for the first 15 seconds. Thereafter lift the corner of the tray once at approximately 15 second intervals.

STORAGE

Store concentrate at room temperature, 65° to 85°F (not above 90°F). If crystallization occurs, shake the bottle well and then dilute as usual. Crystals will dissolve in dilution water. Do not store over two to three weeks in a partly filled container. T.S.T. in *glass* bottles (quart size) can be stored for two years. T.S.T. in plastic bottles should not be stored for more than 6 months because plastic bottle walls allow air to diffuse through. The 5-gal rigid cube may be used with an Edwal Rigid Cube Faucet, available from your dealer or direct from Edwal.

KEEPING DEVELOPER TRAYS CLEAN

When T.S.T. is left overnight in the tray, silver may form as a brown or black coating on the tray due to silver dissolved from the prints. This does no harm. If the developer is pushed hard the first day, some of the silver may be formed fast enough to cause an appearance of milkiness. The milkiness will settle out overnight. If needed, the tray can be cleaned with Edwal Single Solution Tray Cleaner. See the Edwal Single Solution Tank, Tray and Rack Cleaner information on later pages in this section.

PRECAUTIONS

T.S.T. concentrate contains metol. Persons who are allergic to photo chemicals should avoid direct contact with the solution. Irritation or rash may result. Edwal T.S.T. Paper Developer is "non-staining" in the usual sense. It will, however, produce brown stain if spilled and allowed to dry. Such stains can usually be washed out with warm water and a laundry type detergent. KEEP OUT OF REACH OF CHILDREN.

MISCELLANEOUS MANUFACTURERS

EDWAL SUPER III & EDWAL PLATINUM DEVELOPER

Edwal Super 111 is a high quality state of the art professional and pictorial paper developer, made with the best developing agents known. It gives neutral (not bluish) black image (image tone can be made warmer by adding bromide) and has the following characteristics:

1. Because of the unusual developing agents used, the solution is made extremely concentrated so that one gallon makes 10 gallons of working solution which will produce 1500 to 2000 8 x 10 prints under heavy duty conditions.

2. It is very clean working which allows it to be used for developing seismograph paper, and auto-positive and copy papers, as well as for the usual continuous tone picture making. Super 111 at 1:9 or Platinum at 1:7 are excellent developers for slides because they give practically no fog, and avoid the necessity of using Farmer's Reducer to "clean up" a slide.

3. Because it contains no hydroquinone, it is not susceptible to aerial fog, or to high-temperature fog when the developer is used above 75° to 80°F.

4. Super 111 gives excellent images on the chlorobromide papers such as Medalist, Ektalure, and Portriga, etc. With these papers it also produces an image which is exceptionally well suited for toning.

Edwal Platinum Developer is an amateur-type paper developer based on the same formula and giving the same results as Super 111, but somewhat less concentrated. It is sold in 4-oz. (to make 1 quart of working solution) and 16-oz. (to make 1 gal.). It is packed in *glass bottles* and is guaranteed for a shelf life of five years. Glass is the only container which keeps developer as well for prolonged periods.

HOW TO USE SUPER III AND EDWAL PLATINUM PAPER DEVELOPER

EXPOSURE

Exposure is best determined by means of test strips or a projection print scale. However, where these are lacking an initial estimate can be made on the basis that, when correctly exposed, the print will begin to show an image in 12 to 20 seconds at 70° to 75°F. For best results, exposure should be regulated so that the print can be developed at 70°F a full 45 seconds for contact paper, and 1½ to 2 minutes (maximum 3 minutes) for enlarging papers. Development is more rapid at higher temperatures.

CONTRAST

The usual dilution of 1:9 for Super 111 and 1:7 for Platinum concentrates produces standard contrast on cold-tone papers and a somewhat snappier-than-usual print on warm-tone papers. Softer results can be obtained by diluting with more water. Contrast can be increased if needed by diluting with less water. For developing copy papers or line reproduction papers, a 1:7 dilution is usually used with Super 111.

WORKING TEMPERATURE

Both Edwal Super 111 and Edwal Platinum Developer may be used at any temperature from 65° to 75°F with normal procedure, and up to 85°F if care is taken not to handle the emulsion side of the print while wet with developer. Above 85°F, 2 ounces of anhydrous sodium sulphate should be added to each quart of working solution to allow use up to 95°F without fogging or staining.

MISCELLANEOUS MANUFACTURERS

581

The Compact Photo-Lab-Index

DEVELOPMENT OF FILM

Super 111 and Edwal Platinum Developer can be used to develop film. For tray development dilute Super 111 with 10 parts of water, or Platinum with 8 parts and develop 3 to 7 minutes at 70°F. For tank development, dilute Super 111 with 25 parts of water, or Platinum with 20 parts, and develop common roll films 10 to 12 minutes at 70°F. Thin emulsion films are developed 5 to 6 minutes at 70°F. For specific films the Super 111 tank developing times and temperatures are the same as those for Edwal Super 12 (see Super 12 instructions). These are "long-scale" developers, giving rather snappy negatives. Shorter developing times will give less contrast.

KEEPING QUALITIES

Super 111 and Platinum are clear solutions with a slight tan or lavender color and will remain in this condition without loss of strength for years in a tightly closed glass bottle. Developers should not be stored in polyethylene plastic (squeeze type) bottle for long periods since they may lose strength due to oxygen and carbon dioxide which diffuse through the walls of such bottles. If Super 111 or Platinum become dark brown or black, it is a sign of serious oxidation and the developer should be discarded. Both concentrates keep well in partly full, *tightly closed* glass bottles because they contain so much active ingredient that the small amount of air in the bottle has practically no effect.

STORAGE TEMPERATURE

Because of the extremely high concentration of developing agents, some floating crystal-like particles are apt to form if the concentrate is stored or shipped at temperatures below 50°F. These crystals may not re-dissolve when the concentrate is warmed to room temperature. This does no harm. To use the concentrate merely shake to get a uniform mix when withdrawing concentrate to make working developer. The crystals dissolve easily in the dilution water. Another possibility is to dilute the concentrate and crystals with an equal volume of water and store with occasional shaking for a day or so in a larger glass bottle. Crystals will re-dissolve. To use: Take 2 oz. of the 1:1 solution in place of each oz. specified in the directions.

PRECAUTIONS

Edwal Super 111 and Platinum Developer contain metol. Persons who are allergic to this chemical should avoid direct contact with the solution. These developers are "non-staining" in the usual sense. They will form brown stains if spilled and allowed to dry, but the stains are usually removed by ordinary soap and water. (See information on Scum, Fog & Stains in later pages.)

"G" PREMIXED PRINT DEVELOPER

GENERAL

"G" is a premixed paper developer that can be used with any photographic paper be it RC or fiber-based. It is used full strength and never diluted. It does away with the need for dissolving powders, diluting concentrates and adjusting temperatures. Simply use as is, and when done pour the remainder back in the bottle for reuse.

CHARACTERISTICS

1. GREATER THROUGHPUT. When used over a short period of time for developing a lot of prints you can use "G" down to the last drop. One quart of "G" will develop upwards of 200 to 250 8 x 10 RC prints when you allow sufficient drain time over the developer tray.
2. HIGHER CONTRAST. "G" will provide about one grade increase in paper contrast on the low and medium contrast papers. This increase does not apply to the high contrast or ultra hard papers.
3. LONGER LIFE. "G" is extremely concentrated and long lasting. When used in an open tray at a depth over ½", "G" will last up to a week. "G" is used as is and never diluted. When you are done printing simply pour the remainder back in the bottle and save it to use again. With intermittent printing, "G" should last up to three months or longer if kept in a tightly closed glass bottle.

TIMES AND TEMPERATURES

When using "G" there is no need to adjust the temperature. However, all solutions should be at the same temperature. Typical temperatures and associated developing times are: 70°F: 90 seconds; 80°F: 60 seconds and 90°F: 45 seconds.

LARGER SIZES

"G" is available in 2½ and 5 gallon cubes through Graphic Arts Dealers.

EDWAL SUPER-FLAT FOR PRINT FLATTENING

Edwal Super-Flat* makes non-resin coated photo papers lie flat regardless of humidity, gives ferrotyped prints a deep rich gloss, and acts as a release agent to reduce tendency to stick on the dryer drum. It differs distinctly from those "print flattening" compositions containing glycerine, ethylene glycol, etc., which depend on holding moisture in the emulsion.

Super-Flat does its work by reacting chemically with the cellulose fibers in the paper, making them immune to humidity changes. With certain industrial papers, addition of a small amount of Super-Flat B, a humectant additive, to the Super-Flat bath is necessary. With resin coated or plastic base papers, Super-Flat B only (not Super-Flat) should be used.

Prints treated with Super-Flat retouch easily, taking air brush, flooding, wash, and brush work equally well. Application of Super-Flat is simple. The prints, after being washed free from hypo, are soaked in Super-Flat working bath for 1 to 10 minutes or more, depending on whatever is convenient to the operator, and dried as usual. No special equipment is needed.

*Covered by U.S. Patent 2,692,183 and re-issue Patents 23,866; 24,003; 24,011.

HOW TO MIX AND USE

Mix working bath by pouring Super-Flat concentrate into the dilution water (rather than the reverse) and mix vigorously for a full minute or more until uniform. Working bath may be at any convenient temperature from 55° to 90°F. Immersion times for prints should be longer if the bath is cold.

MISCELLANEOUS MANUFACTURERS

FOR BLACK AND WHITE PRINTS

For Use With Heated Dryers: Make the Super-Flat working bath by diluting 1 part Super-Flat concentrate with 25 parts water. Wash prints free of hypo after fixing, and then soak the prints in the Super-Flat bath 2 to 6 minutes for single weight, 4 to 10 minutes for double weight, and dry as usual. These soaking times may be lengthened if desired, with no bad effect.

For Hard To Flatten Papers: Best dryer temperature is 220° to 240°F, up to 260°F for industrial papers. Adjust drum speed so prints will "bake" at maximum drum temperature for several minutes after they are completely dry. This allows Super-Flat to react efficiently with paper fibers. Occasionally a few sheets out of a single box will curl more than others. These often can be flattened by re-soaking in Super-Flat and putting them through the dryer again. For papers which are very hard to flatten see Edwal Print Flattening Bulletin B.

For Cold Ferrotyping: Dilute Super-Flat concentrate 1:5 for the working bath. Soak prints 2 to 3 minutes, drain, squeegee onto ferrotype plates, and dry as usual. For blotter or blotter roll use 1:5 up to 1:15. Determine best dilution by trial.

For Machine Processing: If the processor allows a 1 minute dip in Super-Flat, the working bath may be at 1:25 dilution. For a 45 second dip, use 1:20, and for a 30 second dip, use 1:15 dilution in the working bath. For shorter immersion times the working bath dilution should be determined by practical test on the processor. The concentration must be such as to allow the paper to take up sufficient Super-Flat to give good penetration of the paper fibers while on the dryer. Best drum temperature is from 220° to 260°F. As prints come off the hot dryer drum, they will have a curl, which will disappear in a few minutes and prints will lie flat.

Replenishment: The Super-Flat working solution does not become exhausted but is gradually diluted by water carried in with the prints. Replenishment at the rate of 1½ ounce Super-Flat concentrate per 8000 to 10,000 sq. in. of paper will be satisfactory, assuming prints are reasonably well drained before being put into the Super-Flat bath. The bath can be used indefinitely until it becomes dirty.

For Glossing Only: Super-Flat makes an excellent gloss solution at 1:80 dilution (approximately 1½ ounce of concentrate per gallon). If there should be difficulty in getting even ferrotyping, this may be due to excessive hardening or prolonged fixing.

Prevention of Sticking: While Super-Flat contains a release agent which causes prints to come off the dryer readily, sticking can occur if there is enough buildup of chemical on the drum. Hence, the dryer drum or ferrotype plates should be washed occasionally with a pure, non-perfumed soap (such as Ivory). If it is necessary to use a detergent or chrome cleaner to remove tightly adhering dirt, this should be followed by the Ivory soap wash to properly condition the chrome surface.

FOR COLOR PRINTS

Super-Flat is especially recommended for color prints because it does not tend to hold excessive moisture in the emulsion which might cause color fading on storage. Use 8 to 12 ounces Super-Flat per gallon in the stabilizer (buffer) bath as determined by trial.

Storage: Super-Flat concentrate is guaranteed for a five-year shelf life. It will not spoil or deteriorate at any ordinary temperature if kept in the original closed container. It should not be diluted with water until ready to be used, since the presence of water will gradually cause a change in composition on long storage. Super-Flat concentrate will solidify at very cold temperatures but is not harmed in any way. It will re-liquify on warming to room temperature.

Fungus: Super-Flat concentrate contains a fungicidal ingredient, but in some locations certain varieties of fungus will grow in the Super-Flat working bath anyway. If such growth appears it can be strained out and usually prevented from recurring by addition of ½ ounce formaldehyde per gallon of working bath.

Containers: Super-Flat concentrate may be satisfactorily stored in polyethylene-plastic or glass bottles. It should not be kept in iron, tin, copper, galvanized, or other base metal containers. Super-Flat is entirely safe to use with stainless steel, chrome-plated, hard rubber, plastic, or other standard photographic equipment. *The concentrate will soften certain types of paint or lacquer. If spilled, wash off immediately.*

PRECAUTIONS

While Super-Flat working solution is non-toxic and non-irritating to normal skin, Super-Flat concentrate contains isopropyl alcohol and polyglycols and is harmful if taken internally. If swallowed, induce vomiting and call a physician. KEEP OUT OF REACH OF CHILDREN.

EDWAL SUPER FLAT B FOR PRINT FLATTENING

Super-Flat B is a flattening agent which acts as a humectant in the emulsion of photographic papers. Super-Flat B may be used alone for resin coated papers, or in conjunction with Edwal Super-Flat on regular (fiber base) papers. Edwal Super-Flat exerts its flattening action on the paper fibers of regular papers. Super-Flat B acts on the emulsion. Strongly hardened regular papers require both Super-Flat and Super-Flat B for effective flattening.

Super-Flat B is non-toxic. It contains no ethylene glycol or other toxic components that are frequently used in print flatteners. The use of Super-Flat B on many of the RC papers is not necessary to get flat prints, but with others where the gelatin hardening has been very thorough, Super-Flat B will produce the desired effect.

HOW TO USE SUPER-FLAT B WITH RC PAPERS

Most RC type papers can be hung up to dry after washing without the use of a flattening bath. If the prints are dipped in a rinse bath of Edwal LFN Wetting Agent (5 drops per pint of rinse bath), the draining process will be speeded up and the total drying time will be cut in half. If the paper seems to need a flattening agent to produce prints without curl, the rinse bath may be made by mixing 1 or 2 ounces Super-Flat B (in addition to the LFN) in the prints of rinse water. Allow the prints to soak about 2 minutes before hanging them up to dry.

HOW TO USE SUPER-FLAT B WITH PRINTS ON REGULAR (FIBER BASE) PAPERS

For prints that are to be dried on a heated rotary dryer, the usual concentration of Super-Flat A is 1 part concentrate per 25 parts water to make the working solution. If Super-Flat B is necessary, the usual quantity of Super-Flat B concentrate is 1 part Super-Flat B to each 25 parts Super-Flat working solution for atmospheric humidities above 30%. At lower humidities the amount of Super-Flat B may be increased, but not more than 2 parts Super-Flat B per 25 parts working solution are recommended except in extremely low humidities. The use of too much Super-Flat B is apt to produce a backward curl. Prints should be allowed to soak in the flattening bath 2 to 3 minutes before being put on the dryer drum.

The practice of hanging the prints up to dry with ordinary papers is not recommended. The heat of the dryer drum is necessary to get the Super-Flat to react with the paper fibers to produce the desired flattening effect. The best temperature range for the dryer drum is 220° to 240°F. Lower temperatures may require a more concentrated Super-Flat working bath. Higher temperature (above 250°F) tend to increase curl-tendency, and to cause static.

MISCELLANEOUS MANUFACTURERS

USE OF A NON-HARDENING FAST FIXER

With some papers such a Polycontrast and Azo, a flatter print is obtained if the papers are fixed in a non-hardening fixing bath and the immersion in the fixer is kept to a minimum. Fixing in Edwal Quick-Fix without Hardener at 1:5 dilution for 2 to 3 minutes or at 1:7 dilution for 3 to 5 minutes is best. With some industrial papers a certain amount of Hardener is necessary to keep the prints from sticking to the dryer drum. This is usually less in winter when the wash water runs cold than during the summer when the wash water runs warm.

REPLENISHMENT

When using Super-Flat B as an additive to normal 1:25 Super-Flat working at the rate of 1½ ounce per each 100 8 x 10 prints. As long as the atmospheric humidity remains constant, Super-Flat B concentrate should be added to the working solution with each replenishment of Super-Flat. The amounts of Super-Flat and Super-Flat B used for replenishment would be in the same ratio that were present in the original bath.

If, on a succeeding day, the atmospheric humidity rises, little or no Super-Flat B replenishment may be added. The amount should be determined by test, adding just enough to make the prints lie flat as they come off the dryer.

Flatness of prints should be judged 20 to 30 minutes after they have come off the dryer because the hot dryer drum will reduce the water content in the gelatin to practically zero and the print should be allowed to come to equilibrium with the atmosphere before judging its flatness.

Sizes: Super-Flat B is available in quart bottles (6/cs) and in gallon (1/cs) bottles.

ANTI-STAT CLEANING AND SCRATCH PREVENTION

STATIC ON FILM

In dry weather, static is generated on negatives, slides, and motion picture films just by picking them up and putting them down. It pulls the ever present dust out of the air, causing it to stick to the film. This results in "dust marks" in enlargements, unsightly dust on slides and motion picture films, and permanent disfiguration of films when dust becomes embedded or builds up in the projector, causing scratches.

ANTI-STAT TREATMENT AND CLEANING OF B/W AND COLOR FILMS

Permanent static resistance in negatives, slides, and movies can be obtained either by treatment with Edwal Anti-Static *Color & B/W Film Cleaner* or with Permafilm. A single application of either of these products will reduce the static tendency at least 50%. A second application will reduce it still further and a third will practically abolish it forever. The Anti-Static compound stays permanently in the emulsion and is reinforced any time either of these compounds is used as a cleaner later on.

Permafilm of course has other beneficial effects such as fungus prevention, scratch prevention, making the film remain pliable on long aging, reduction of color fading tendency, etc., but is more expensive than Edwal Color & B/W Film Cleaner. For maximum all-around film protection an initial thorough application of Permafilm is recommended, followed by one or two applications of Edwal Anti-Static Color Film Cleaner to give complete static protection.

The solvent both in Edwal Anti-Stat Color & B/W Film Cleaner and in Permafilm is much less dangerous than the older carbon-tetrachloride cleaners (20 times *less* toxic) and has been approved for use on submarines and in other confined work areas.

ANTI-STATIC CLEANING OF CHROME, PLASTIC, GLASS, AND B/W FILM

Edwal Anti-Static *Film, Glass & Chrome Cleaner* is a faster and more powerful cleaner than Edwal Color & B/W Film Cleaner but should not be used for color

MISCELLANEOUS MANUFACTURERS

film because it will dissolve dyes. With B/W films it is especially good for finishers because it not only prevents static caused by handling but it "uncurls" the negative so that it flattens out, thus facilitating printing. It is recommended for light tables, negative carriers, flash reflectors, plate glass counters and doors, and any chrome, glass, or plastic or film surface where fingerprints accumulate. It dissipates the static which is caused by rubbing but does not have a permanent anti-static effect, because all its ingredients will evaporate completely. It should not be used near open flame.

STATIC ON LENS TISSUE

Static is generated in the simple act of tearing individual cleaning tissues out of a lens tissue book. Here again static attracts dust onto the tissue and this dust acts like sandpaper when the dry tissue is used on a lens. The resulting scratches are easily visible on a coated lens viewed horizontally against the light, and will reduce the sharpness of the image in the camera due to light-diffraction.

SCRATCH-FREE LENS CLEANING

Edwal Protective Lens Cleaner has been specially designed to lubricate as well as clean the lens surface, thus preventing the scratching which would be caused by dust particles if the lens were cleaned with dry cloth or lens tissue. It contains no silicone or other materials to leave a permanent film on the lens. It is completely safe for coated lenses and for all optical glass such as spotting scopes, binoculars, microscope lenses, etc.

The Edwal Lens Cleaner bottle is specially designed with a one-drop applicator tip which prevents application of excessive fluid which might get between lens components if applied in a spray or stream. It can also be used on your eyeglasses for clearer vision.

CLEANING CLOTHS

Cotton cloth for use in applying Film, Glass & Chrome Cleaner, Color & B/W Film Cleaner, or Permafilm should be free of soap, laundry sizing, etc., which are often present in new cloths or cloths from a commercial laundry. The cleaner partially removes these substances from the cloth and deposits them as streaks on the film. Home laundering of such cloths, using a synthetic detergent such as Tide is recommended.

Edwal Film, Glass & Chrome Cleaner and Color & B/W Cleaner may be applied with cleaning machines such as those made by Ceco, but such mechanical applicators are not suitable for Permafilm because of rapid buildup of active ingredients on the cleaning pads.

SCRATCHES ON B/W NEGATIVES

Scratch-resistance in B/W films may be obtained through fixing in Edwal Quick-Fix with the full amount of hardener, which makes scratch problems disappear "almost like magic." For photographers who wish to use a separate hardening bath for film, such a bath can be made by mixing 1 ounce Edwal Anti-Scratch Hardener and 1 ounce of 28% acetic acid in water to make 1 quart. This bath will harden film in 2 to 3 minutes at 68° to 75°F. A quart will harden 15 to 20 rolls of 35mm or 120 size.

Most negatives which already have scratches on them will give scratch-free enlargements through use of Edwal No-Scratch, which is applied to the film just before projection and then wiped off afterwards. The No-Scratch causes the scratch to disappear, unless it is deep enough to have removed part of the image.

MISCELLANEOUS MANUFACTURERS

PERMAFILM

PERMAFILM MAKES FILMS LIVE LONGER

Permafilm is a liquid which, when applied with a cotton cloth or applicator to negatives, slides, and motion picture films, extends their useful life in the following ways: Makes negatives and movies practically scratch-proof; reduces tearing of sprocket holes. Makes film tough, but not brittle. Will restore pliability to an old brittle film. Cuts down fungus growth. (For extremely humid climates use Permafilm 129FTR). Greatly slows down rate of color fading due to prolonged projection of slides. Reduces static and makes fingerprints easy to wipe off.

HOW PERMAFILM WORKS

Permafilm replaces most of the moisture normally held by gelatin with a non-reactive permanent compound, which imparts the above characteristics. It is not a lacquer, which could be scratched itself, but it directly impregnates the gelatin, making it *able to protect itself* against scratches, fungus, and other deterioration. Permafilm makes the film "dimensionally stable," resisting the changes that occur in ordinary film as the humidity rises and falls.

WHO NOW USES PERMAFILM

Permafilm is used in large quantities by major film studios and others who process large amounts of motion picture films which get severe use.

FOR FUNGUS PREVENTION

Permafilm is wiped on the film strip so as to saturate the emulsion. After that, most types of fungus will not grow in the gelatin. No absolute guarantee against fungus growth can be given, because there are types of fungus which will grow under all sorts of conditions, but Permafilm has preserved films safely in many tropical and sub-tropical regions.

STATIC PREVENTION AND DUST

A single treatment with Permafilm will greatly reduce the static tendency of a film. Three treatments will make a film completely static-free. Thereafter there will be practically no tendency for the film to pick up dust. However, since the anti-stat in Permafilm is compatible with the one used in Edwal Anti-Stat Color and B/W Film Cleaner, the usual procedure is to apply Permafilm first, and then wipe on Edwal Anti-Stat Color & B/W Film Cleaner twice on the emulsion side to make the film completely static-free "forever." The Permafilm treatment is permanent, and is not removed by the film cleaner.

MOVIE FILM SCRATCHES AND TORN SPROCKET HOLES

Application of Permafilm makes the film strongly scratch-resistant, so that there is much less tendency for sprocket holes to tear out. Also, the film emulsion becomes resistant to fingerprints so that they are easier to wipe off with an ordinary film cleaner later on.

PERMAFILM ON COLOR SLIDES

Slides can be treated without removal from the cardboard redimount. The major benefit is from treatment on the emulsion side. On the film base side Permafilm is a cleaner and may have some slight lubricant action, but is otherwise not necessary. The Permafilm treatment will reduce the tendency to slide popping, and will prevent warping due to aging or prolonged projection. Permafilm will also increase by 100% to 300% the number of hours that a slide can be projected without color-fading.

MISCELLANEOUS MANUFACTURERS

HOW AND WHEN TO APPLY PERMAFILM

Permafilm should be applied as soon as possible after the film has been processed, washed, and completely dried. If sound track is to be applied, the Permafilm treatment should precede application of the sound track. Permafilm should be applied by saturating a clean, lint-free, home-laundered *cotton* cloth with the liquid and wiping it on the film in firm, even strokes. (Cloth should be home-laundered, using a detergent such as Tide, *not soap*. Commercially laundered cloth may contain starch or sizing which can cause streaks). Just enough liquid should be released to the film so that it shows on the surface. In the case of films which have a lacquer or wax coating, the first application of Permafilm will remove the coating (which is unnecessary on Permafilm treated film), and a second Permafilm application should be made to insure complete penetration. Use a gentle, rotary polishing motion to be sure lacquer is completely removed.

PRECAUTIONS

The solvent used for Permafilm is about 20 times less toxic than carbon tetrachloride, but should be used with good ventilation. It has been approved for use in submarines and in other confined work places. It will affect polyethylene and other plastic materials, so *plastic* reels should not be used as take-up reels when applying Permafilm to motion picture films. WITH SLIDES IN PLASTIC MOUNTS, THE FILM SHOULD BE REMOVED FROM THE MOUNT BEFORE APPLYING PERMAFILM. Magnetically striped film may be wiped gently *once only* with Permafilm. Heavy scrubbing will remove the stripe. Optical sound tracks need no special precautions.

FOG, SCUM AND STAINS

CHEMICAL FOG

Chemical fog is usually gray, sometimes yellow or brown, and consists of silver deposited in areas of the film or print which should normally be clear. It is usually caused by the use of out-dated film or paper, or by developing prints at too high a temperature, or by touching the emulsion surface during development. It can be prevented to a large extent by use of an anti-foggant, Edwal Orthazite, according to directions given in the Orthazite bottle bulletin. Use of Orthazite will often salvage out-dated paper. In commercial print-making, a developer can be made to process up to 20% more prints just by adding Orthazite as recommended.

DICHROIC FOG

Dichroic fog on the emulsion surface of a film usually is green or purple, but may show two or more colors depending on the angle at which it is viewed. It is caused by development of silver bromide which has been dissolved and diffused *outside* the film emulsion. The silver thus formed is deposited on the surface of the emulsion to form the fog. Causes and remedies are:

1. *Lack of Agitation.* If there is no circulation of the developer past the emulsion surface, dissolved silver bromide will be reduced to metallic silver by the developer right at the surface of the emulsion and deposited as dichroic fog. The new high speed films are especially subject to this difficulty. *Remedy:* Provide good circulation of the developer.

2. *Over-worked Developer.* Developer which has been used many times sometimes causes dichroic fog. If this is the cause, the trouble will disappear when a fresh batch of developer is used.

MISCELLANEOUS MANUFACTURERS

3. *Ineffective Stop Bath.* If the stop bath is exhausted or if the film is in it for too short a period to completely neutralize the developer, or if no shortstop at all is used, dichroic fog is often formed. *Remedy:* Leave the film in the shortstop bath for at least 30 seconds and be sure the shortstop bath is acid. Edwal Signal Shortstop will warn by a color change if the acidity is near exhaustion.

4. *Over-worked Fixer.* If the fixer contains a lot of dissolved silver bromide, or if it has lost its acidity due to a large amount of developer carry-over, there may be dichroic fog. *Remedy:* Avoid over-working the fixer.

5. *Removal of Dichroic Fog.* Dichroic fog can easily be removed by dipping the wet negative for a few seconds in Farmer's Reducer and then immediately immersing it in water. The idea is to allow the reducer to dissolve the silver from the surface of the film, but not to allow it to penetrate far enough to remove part of the image. Repeat if necessary. Frequently, dichroic fog is so even and so thin that it has no effect on the enlarging quality of the negative so that it need not be removed.

SCUM

Scum is usually a white deposit on a negative due to partial precipitation of the hardener when the acidity of the fixer is lowered by excessive developer carryover. The remedy is to use a shortstop such as Edwal Signal Shortstop. This type of scum can be removed by swabbing the negative in a 1% solution of sodium carbonate and then washing in running water for about 10 minutes.

DEVELOPER STAINS ON CLOTHING, ETC.

Most developer stains are removed by ordinary washing with soap and water. However, developers containing paraphenylene diamine or amidol will produce dark purple or black stains if allowed to dry or oxidize on the skin or other surface. Such stains can be prevented by immediate washing off of any spills or splashes with plenty of soap and water. Once formed, however, they can be removed by rubbing for a few minutes with a solution or damp crystals of potassium permanganate, rinsing with water, and then rinsing for about 30 seconds with muriatic acid made by diluting concentrated muriatic acid with 5 parts of water. Severe stains may require three or four repetitions. This treatment will remove any other dyes on cloth as well as the stain. Developer stains in trays or tanks can be removed with Edwal Single Solution Tray Cleaner.

FIXER STAINS

While fixers do not stain when fresh, a fixer which is loaded with silver may cause stains on clothing which will not appear until *after* the clothing is laundered or pressed. The heat of laundering or pressing decomposes the silver-hypo complex and causes a brown (silver sulphide) or black (metallic silver) stain.

Prevention: Wear a rubber apron or don't splash. However, if a garment is splashed with silver loaded fixer, stains can be prevented by thoroughly wringing out the affected part in a fresh fixer working solution and then *thorough* rinsing out with cold water before the garment is laundered.

For removing fixer stains from white cotton or linen, dampen the stain with water, apply tincture of iodine to each spot, let stand for three minutes, and then swab the area with *fresh fixer concentrate* (e.g. Quick-Fix, Hi-Speed Liquid Fix, or Industra-FIX) and then rinse thoroughly in cool water before laundering. Bad stains may require repetition of the treatment.

With colored material, silk, wool, etc., the iodine treatment should be applied first in an inconspicuous place to see whether there is any damage to color or to the material itself, before using on the rest of the garment.

EDWAL LIQUID ORTHAZITE

Edwal Liquid Orthazite is a ready-to-use anti-fog preparation containing benzo-triazole. It is useful for:
1. Restraining fog when paper developers are run above normal temperature, or when they are pushed to the limit.
2. Salvaging out-dated paper.
3. Obtaining true black or blue-black tones on certain papers which tend to give an image with a green cast.
4. Getting finer grain from Borax type semi-fine grain developers.
5. Getting satisfactory negatives at manufacturers' recommended film speeds with FG7 instead of the higher film speeds which this developer normally gives.

HOW TO USE ORTHAZITE

AS A FOG RESTRAINER FOR PAPER DEVELOPERS

Most properly formulated paper developers will give prints without fog or stain at 68° to 70°F with reasonably fresh paper and with the use of print tongs for handling paper in the developer However, gray or brown chemical fog will often appear along the edges of prints when developer temperature runs 75°F or over, or when prints are warmed in spots by contact with the operator's hands while saturated with developer. This tendency becomes greater with certain developers as more and more prints are pushed through the solution, leaving dissolved silver salts and developer oxidation products.

The addition of Edwal Liquid Orthazite direct to the developer will restrain the above types of fog, allowing the developer to be safely used at higher temperatures and for a larger number of prints. The amount of Orthazite needed differs from developer to developer and should be determined by experience, taking the minimum quantities that are suggested on the bottle label as a starting point. Just enough Orthazite should be added to cut out the fog or edge stain. If too large a quantity of Orthazite is used, it will hold back development sufficiently to require extra exposure and in some cases to give a warm-toned image.

TO SALVAGE OUT-DATED PAPER

Old photo printing paper has more tendency to give chemical fog and edge stains than new material. Addition of just enough Orthazite to prevent the fog will usually make out-dated papers give good prints. The recommended procedure is to start with the minimum quantity of Orthazite given on the bottle label and add more only if the fog or stains persist.

GETTING COOL TONES ON GREENISH-TONE PAPER

With some industrial papers (mostly contact types) which give greenish-tone print images with the usual developers, a more bluish black can be obtained just by adding Orthazite direct to the developer. A still better method is to mix your own developer formula, reducing the potassium bromide to 1/10th to 1/6th the usual amount and adding just enough Liquid Orthazite to prevent developer stain or fog. Some very rich black tones can be obtained with almost any cool-tone papers using this procedure.

FINER GRAIN WITH BORAX TYPE SEMI-FINE GRAIN DEVELOPERS

Addition of a very small amount of Liquid Orthazite to D-76 and similar developers will cause some improvement in graininess, though there will be some loss of film speed. 2 ml of Liquid Orthazite added per gallon of Borax developer causes a slight improvement of graininess with no apparent change in film speed. An additional 2 ml Orthazite per gallon of developer will cause some further improvement of grain, but will result in one f-stop speed loss. Addition of an extra 4 ml of Liquid Orthazite (total 8 ml) per gallon will result in a speed loss of 2 f-stops but also some grain improvement. Further addition of Orthazite causes more speed loss but no particular grain improvement.

GETTING SATISFACTORY DENSITY FROM MANUFACTURERS' FILM SPEED RATINGS WITH FG7

FG7 usually produces negatives which are denser and grainier with the manufacturers' recommended film speed than with the higher film speed recommended in the earlier FG7 information and instructions. For those who prefer to use the manufacturers' film speeds and want the fine grain and excellent negative quality which FG7 produces, Liquid Orthazite can be added to the developer. If 2 ml Orthazite are added to 16 oz. of FG7 either 1:3 dilution or 1:15 dilution, the effective film speed is reduced by about one f-stop. An additional lowering of speed by another f-stop can be achieved by adding another 2 ml of Liquid Orthazite (total of 4 ml) per pint of working developer.

EDWAL SINGLE SOLUTION TANK, TRAY, AND RACK CLEANER

This cleaner is intended for removing developer and activator stains or scale in photographic, medical and dental x-ray, photo mechanical transfer (PMT), and stabilization tanks, trays, and processors. It is not intended for removing deposits in fixer or stabilizer trays, tanks, etc., though in some cases it will loosen such deposits so as to aid in their removal by scraping or scrubbing.

Edwal Single Solution Tank, Tray, and Rack Cleaner is packed in 16-oz. and 1-qt. bottles of concentrate which may be diluted to make 4 to 20 times the original volume of concentrate, depending on the speed with which it is desired to clean the equipment. The working solution can be used over and over until the normal reddish color begins to turn green. This will usually occur after three or four cleanings at the 1:3 dilution, two cleanings at the 1:7 dilution, and a single cleaning at a dilution of one part to 15 to 20 parts of water.

DIRECTIONS

For cleaning photographic tanks, trays, hangers, etc., dilute the concentrate with 3 parts of water to make the working solution, and follow the directions given on the label. The diluted cleaner is used at room temperature (70° to 80°F) and will remove the developer stains very quickly. Incrustations on film hangers, etc., may require prolonged soaking. Wash well with water after cleaning.

Porcelain trays may be successfully cleaned with this solution at the 1:3 dilution, but cleaning time should be short and the trays should be immediately and thoroughly flushed with water, since the cleaner will gradually etch the porcelain surface. The cleaner is safe for hard rubber, stainless steel, polyethylene, or polystyrene articles. In case of splashes on cloth, wool, leather, or wood, it should be washed off immediately with plenty of water and neutralized with baking soda in water.

Office copy equipment and PMT processors. Clean only the developer tray and rolls. Pour the 1:3 diluted cleaner over the stained rollers and into the developer tray. Be sure to wash thoroughly afterwards until no color remains in the drippings after draining.

Stabilization processors: Use Edwal Single Solution Cleaner only on the activator tray, rolls, and circulating system (if any). Before filling with cleaner, flush the tray (and pump and reservoir cube, etc.) thoroughly with water and drain completely. Remove the filter if there is one. For a non-circulating unit, dilute 1 pint of Edwal Single Solution Cleaner concentrate with water to make ½ gallon and fill the activator tray full. Run the rolls till clean (usually about 5 minutes at 70° to 80°F), then wash with water.

For a larger activator tray (up to 1 gallon capacity) dilute the concentrate with more water. One pint concentrate diluted with water to make 1 gallon at 80° to 90°F will usually clean a 1 gal unit in 10 to 15 minutes if rolls are run continuously.

MISCELLANEOUS MANUFACTURERS

To clean a recirculating unit with 2½ gallon cube reservoirs, dilute *1 quart* of Edwal Single Solution Cleaner concentrate with enough water at 80° to 90°F to completely fill the activator tray, the cube, and all activator feed lines (up to a maximum of 5 gallons total). Then run the pump and rolls 20 to 30 minutes until clean. Discard the used cleaner. Then flush the entire unit including cube and feed lines with water. Then fill the entire system with *fresh water* and run the pump and rolls for 5 minutes. Drain all parts thoroughly and replace the filter before refilling with activator.

Medical and dental x-ray processors. Flush developer section with water to remove old developer, and remove filter (if any) before filling tank with Edwal cleaner. For small (1 gallon) units the developing tank and rollers may be cleaned using Edwal Single Solution Cleaner Concentrate at 1:7 (one pint to make one gallon). Larger units may be cleaned by using one pint diluted to make 2 to 2½ gallons at 80° to 90°F. 5-gal. units are best cleaned by using the quart size concentrate which will make up to 5 gallons maximum. Run film transport rolls, etc. continuously during cleaning.

After cleaning, the tanks, rollers, racks, and circulating system should be thoroughly flushed with water until no trace of orange or green color is left, and should then be filled completely with water and operated for a few minutes and drained thoroughly before more fresh developer is used.

WARNING

Contains dichromates and acid sulfates. Strong oxidizer. May cause rash. Avoid contact with eyes, skin, or clothing. In case of contact, immediately wash well with water for 10 to 15 minutes. For eyes, see a physician. KEEP OUT OF REACH OF CHILDREN.

EDWAL COLOR TONERS

WHAT THEY ARE

Edwal Color Toners are liquids for converting the silver image on black and white prints, slides, motion picture films, etc., into colored images. The print or slide or film is immersed in the appropriate color toner working solution with occasional agitation until the desired image color is obtained, whereupon the print, slide, or film is washed in running water 10 to 20 minutes to remove excess toner. Five colors—red, brown, yellow, green, and blue—are available. Intermediate colors can be obtained by toning first in one color toner and then in another.

Edwal Color Toners are available in 4-oz. bottles of concentrate which make 64-oz. of working solution, enough for about 120 4 x 5 prints. Also in 1 qt. bottles. The Toners themselves are single-solution type, with no offensive odor. They require no heating or other manipulation other than just inserting the print, slide, or film into the solution, agitating it occasionally, and putting it in the wash water when the desired tone has been obtained. Edwal Toners can be used at any temperature from 65° to 110°F. Toning is usually complete in 4 to 10 minutes, but the warmer the solution, the faster toning takes place.

The colored images produced by Edwal Toners are (except for the blue which is an iron type toner) dyes which are mordanted onto the silver image. The performance of the colors is about the same as that of the colors in present day color films. However, it should be remembered that most dyes can be made to fade by long exposure to an atmosphere containing industrial fumes, especially in the presence of high humidity and bright direct sunlight. Under ordinary storage conditions, Edwal color toned images can be expected to last through a normal life time.

HOW TO USE EDWAL COLOR TONERS
SELECTING THE SUBJECT AND COLOR

Pictures to be toned with a single color should generally have a single dominant subject (a mountain, a forest, a person or animal, etc.) which will set the mood and determine the appropriate color to use.

The Compact Photo-Lab-Index

The color selected should be one which is appropriate to the dominant subject in the picture. Thus people or animals are usually best in some shade of brown. 'Cold' subjects such as machinery, water scenes, snow scenes, moonlight pictures, etc., are best in blue. Forest, grassland, and foliage-type landscapes are best in green, sometimes with light toning in yellow to add a feeling of sunlight. Sunset and fire pictures are best toned in red, sometimes with after toning in yellow to get fire-orange. Still-life pictures for Christmas and novelty cards, etc., can be toned almost any color or combination of colors.

PREPARING THE PRINTS

While Edwal Color Toners will tone any kind of paper or film that has a silver image, the best effect on prints are obtained with warm tone papers such as Ektalure or Portriga Rapid, developed in Edwal Super 111 or Platinum Developers. Exposure should be kept low enough to allow full development of the paper but development should never be forced, since this tends to produce fog which will produce a color even though the fog itself may be invisible in the black and white print.

Prints should be fixed not more than 1 or 2 minutes in Edwal Hi-Speed Liquid Fix or Quick Fix without hardener, or IndustraFIX using a 1:5 dilution and should be washed completely free of hypo. The use of Edwal "4 and 1" Hypo Eliminator is strongly recommended between fixing and washing to insure removal of fixer and polythionates. Prints should not be ferrotyped before toning. Ferrotyping can be done after toning if desired.

TONING THE PRINT, SLIDE, OR FILM

The toning solution (prepared according to the direction sheet with the bottle) is placed in a plastic or glass or stainless steel or rubber tray and the print or slide or motion picture film is immersed in the toner, agitated occasionally, and examined from time to time to see how toning has progressed. The color will look somewhat brighter after the picture has been washed in water than while it is still in the toner, so it is best to tone and wash a sample print or slide first to test the time required for the correct final tone.

If a larger number of prints are to have exactly identical color tone, they should all be inserted in the same batch of toner at the same time and toned identically. The toner gradually loses its strength as prints are toned in it, so that simultaneous toning is the best way to get matching tones on a number of different prints.

The longer the toning proceeds, the brighter will become the color until all the silver of the image has been used up. Toning for long periods (15 to 20 minutes or more) will produce 'chalk-like' tones which have very little depth. This will be noticed first in the fine lines of the image.

TONING SLIDES

Slides are toned in the same fashion as prints and should be washed in running water until the background areas are clear before being dried and mounted. For making commercial title slides, use Edwal FOTOTINT colors as directed in the FOTOTINT and "Making Title Slides" information which follows in later pages.

TONING MOTION PICTURE FILM

Black and white motion picture films, especially titles, can be advantageously toned. The film frequently has to be left in the toner several times as long as a print because the extreme hardning and the coating sometimes applied to the film slow down diffusion of the toners. However, the image eventually will take the color. A two-color effect can be obtained by toning the image one color, washing, and then dyeing the clear areas with Edwal "FOTOTINT" Colors.

MISCELLANEOUS MANUFACTURERS

INTENSIFICATION OF NEGATIVES WITH COLOR TONES

Toning tends to intensify and increase the contrast of the image on film, so the color toners can be used in this fashion. The green toner is usually preferred. There is no effect on the grain structure. As a matter of fact, if a little background color is allowed to remain, it tends to hide graininess. Tone only until maximum density is obtained. Prolonged toning removes too much silver and flattens the image.

TONING AS A TEST FOR COMPLETENESS OF WASHING

In commercial print making operations, the effectiveness of a print washing system can be tested by toning a washed print in Edwal Brown Toner. If the print is completely washed, it will tone satisfactorily, giving true brown tones over the entire image. If small quanties of hypo are present, the darker areas of the print will tone brown but the lighter areas will tone a rather wild, bright orange. If still more hypo is present, the darker areas of the print will tone very litle, if at all. (Incidentally, very inteersting effects can be obtained this way on Christmas cards, etc.) If still more hypo is present, the highlight areas of the print will fade out and the image will be completely lost.

MAKING OF FULL COLOR PICTURES FROM BLACK AND WHITE PRINTS

Some commercial artists and others skilled with a brush use partial toning of different areas with Edwal Color Toners to make full color prints which are said to be less expensive than prints made by the usual color separation methods. The color toning method has the advantage that any desired hue can easily be obtained just by brushing on the apropriate color toner. Edwal LFN is added to the color toners for this type of work in order to get ease of flow. Edwal FOTO-TINT Colors can be used in the clear areas.

KEEPING CHARACTERISTICS

Edwal Color Toner concentrates are furnished with one ingredient in a small plastic cup on the 4-oz. bottles and in a separate bottle for the 1 quart size. The toners will keep indefinitely as long as this separate ingredient is not added to the concentrate. Once the separate ingredient has been dissolved in the concentrate, the toner concentrate can be kept satisfactorily for six to eight weeks for all colors except blue which can be kept for a year or more. Once the toning solution has been used, it should not be stored for future use if the same tone is desired. However, dilution and storage of the toner for days or weeks before use often produces rather exotic shades which may be quite interesting.

PERTINENT POINTS

Prolonged washing of a toned print, especially if the wash water is slightly alkaline, will gradually remove the image color. This is useful if a too strong color is to be 'washed out' somewhat, but should be otherwise avoided. The dyes themselves can be washed out of clothing with soap and water if stains should occur. Washing with water at room temperature (70° to 80°F) removes background color from the non-image areas more efficiently than washing with cold water.

Iron from chipped spots in processing trays or from water supply pipes will cause small blue or green spots on the surface of a print through reaction with the toner.

Clean highlights can be obtained in a toned print only if the highlights of the black and white prints are completely free of fog. Fog can be caused by using old or light-struck paper, forced development, insufficient restrainer in the developer, or use of an old fixing bath loaded with silver.

MISCELLANEOUS MANUFACTURERS

595

The Compact Photo-Lab-Index

The highlights of a GREEN toned print may be more quickly cleared of excess dye by a short bath in a 1% sodium bisulfite solution (or 1% sodium sulfite plus 1% acetic acid). A brief bath in a 1% sodium carbonate solution will help clear a BLUE toned print. Stronger solutions will remove part or all of the color from the image itself, if desired. In all cases, at least 5 minutes wash in water should follow clearing.

Toning speed and brightness of the image can both be increased by adding between ½-oz. and 1-oz. of 28% acetic acid to the 64-oz. toner obtained from a 4-oz. bottle of brown, red, yellow, or green toner. There is little effect with the blue.

TONING RESIN-COATED PAPERS

Do not use a hardening agent in the fixer. Good washing and hypo elimination are a must. Temperatures are not critical for any of the toners, although processing at higher temperatures, 80°F and above, will reduce the time required.

Blue Toner: Edwal Blue Toner works well with all of the resin-coated papers including Kodak RC and Ilfospeed. Tone for 5 minutes at 70° to 80°F then wash for 5 minutes.

Brown Toner: Edwal Brown Toner is not recommended for any of the resin-coated papers since with these materials it has a very poor wash-out characteristic, though extensive washing of Luminos and Unicolor papers will eventually produce some degree of wash-out.

Yellow, Red, and Green Toners: These Edwal Toners work well with both Luminos and Unicolor papers but not with Kodak RC and Ilfospeed. Variations in toning time from 30 seconds to 10 minutes at temperatures from 70° to 80°F will produce a wide range of color tones.

WARNING

In cleaning trays that have been used for Edwal Color Toners DO NOT USE Edwal Single Solution Tray Cleaner or any other oxidizing cleaner until the trays have been *thoroughly* washed with water. An oxidizing cleaner may cause evolution of poisonous cyanide fumes if mixed with the toner solution itself.

MISCELLANEOUS MANUFACTURERS

ETHOL UFG DEVELOPER

DESCRIPTION

U F G, as its name implies, is an "ultra-fine-grain" developer that retains the inherent grain structure of the film emulsion developed in it. This developer, when used as instructed, produces negatives of very high acutance, normal contrast, and extreme latitude with all types of films, ranging in size from the sub-miniature Minox film to the 8 x 10 sheet film. Due to the extreme latitude, it is ideally suited to the needs of the photojournalist, the professional custom lab and the working press, i.e., TRI-X 35mm exposed at ASA-50 to ASA-3200 on the same strip of film renders quality prints from each frame when developed in U F G (3 stops underexposed and 3 stops overexposed). As indicated, U F G adapts itself to contrast control of the negatives, according to the brightness range of the lighting and subject matter. For very contrasty subjects, increase exposure and decrease the development; for flatly-lighted subjects, decrease the exposure and increase the developing time. Additional compensation in negative development is obtained by diluting U F G and using as a "one-time" developer; a Replenisher is available for repeated or deep-tank use of the "stock" developer. Both U F G and the Replenisher, when fresh, reveal a characteristic pale, yellow-brown color, approximately that of weak tea; this is normal and is not an indication of oxidation. U F G and its Replenisher are supplied both in powder form and in liquid "ready-mix." U F G is panthermic and may be safely used at temperatures from 60 to 90 degrees Fahrenheit; preference is limited to the range of 65 to 80 degrees.

Water quality is important for quality U F G processing; it should be as pure as possible for longest "stock life." If your water supply is not free of minerals and foreign matter, the use of boiled or distilled water is recommended. If you feel that contamination is not your problem and you are having some difficulty with the life of your developer, the answer may be the water.

If possible, **do not pour** solutions in and out of the daylight load tanks; preferably fill the tank with developer first and, in the dark, drop the loaded reel into it. Following development, lift reel out, **into** the next solution instead of pouring in and out; this contributes to more accurate timing and more uniform developing of the negatives.

*Note: TRI-X PAN has been assigned the E.I. of 1200 and 650; developing times have been given for each rating. It is suggested the E.I. of 650 be used when the subject brightness is very contrasty or where the additional speed is not required; the negative quality at both E.I. 1200 and 650 is very comparable.

GOOD HOUSEKEEPING

Cleanliness is a must; U F G, as well as other film developers, can be contaminated by foreign matter—especially by fixer or other developers. This will cause rapid exhaustion. Tanks and reels should be cleaned periodically, particularly when changing from another developer to U F G. A solution of 2 ounces sodium sulfite and 3 ounces sodium carbonate per gallon of hot water is an excellent cleaner; allow the tanks and reels to remain in this solution overnight and then rinse thoroughly. Always dry tanks and reels IMMEDIATELY after use with a clean lint-free towel.

STORAGE

If U F G is stored properly in full or covered containers away from excessive heat, it will last well over a year. It is suggested, where possible, to store the developer in the cooling chamber of the refrigerator for maximum life; allow it to reach proper temeprature before use. Filled sheet film tanks should have floating lids or be tightly covered with Saran Wrap.

MISCELLANEOUS MANUFACTURERS

REPLENISHMENT

Although development may be carried out in U F G without replenishment, it is not generally recommended. If you are developing in this manner, then add 10% to the developing time after your 2nd roll and limit to 25 rolls per quart. Replenishment is definitely recommended if U F G is not used with the "dilution and discard" method. The average rate of replenishment is at the rate of ½ ounce per 80 square inches of developed film—this means 1 roll of 120 or 35mm, 36 ex., 4 sheets of 4 x 5 or 1 of 8 x 10. Add the replenisher to the "stock" after each batch of film and stir well. Replenisher may be added until the amount of replenisher added equals the amount of the original "stock" U F G. Properly replenished it will develop at least 60 rolls of film per quart. Replenishment is affected by types of emulsions, storage conditions, overexposures, contamination, etc., therefore we can only give you a guide.

DILUTION

Where longer developing times are desirable or greater contrast control is needed, then dilution is definitely recommended; discard immediately after one-time use. Dilution may be desirable for one or more of the following reasons: time control, finer grain, contrast control, higher acutance or increased effective film speeds. **Never** dilute U F G "stock" that has had replenisher added to it. **Constant Agitation** is used with diluted U F G to prevent the gradation from becoming too soft. (Remember that exposure controls density, development controls contrast.) As a guide for developing films by a dilution of 1:5, it is recommended normal times be multiplied by approximately 2½ times and constant agitation used. For those who wish to develop for longer times, but do not wish to dilute, then add 1 ounce of sodium bisulfite per gallon of developer and triple the development times shown in the chart. If you wish to replenish this solution, then add 2 ounces of sodium bisulfite per gallon of replenisher. Note: Using the sodium bisulfite makes U F G reusable and is not in the category of a one-time use developer as when dilution is used. The sodium bisulfite does not affect the quality, but care must be exercised where film speed is important, as the speed will be affected slightly.

AGITATION

For 35mm and 120 roll films, tanks are preferred that can be inverted during agitation. Immediately after immersing films, agitate for the first 15 seconds; thereafter, agitate 5 seconds at the end of each 30 seconds. Our method, is 3 gentle inversions while rotating counterclockwise during the 5 seconds every 30 seconds, followed by putting the tank down with a gentle tap at the end of each 5-second inversion period, to dislocate any air bubbles that may have formed. The idea is to get even development of the films and consistently reproducible results. If you are getting these, but the developing times in the table are too long or too short for your purposes, then don't change your agitation, but instead change the developing times accordingly. If a multiple-reel tank is used for the development of one roll, we recommend that you insert empty reels to prevent too violent agitation by the reel shooting the length of the tank with each inversion. Where very deep roll-film developing tanks are used, it is suggested reels be placed on a long wire and agitation carried out by a gentle lifting and turning of the reels during the agitation periods; **do not** lift out of the solution.

For agitation of sheet film in hangers, agitate during the first 15 seconds then follow with agitation 5 seconds each 30 seconds thereafter. Hangers should be placed in the tank as a group, tapping the hanger bars on the top of the tank to dislodge any air bells. After agitation period lift hangers clear of the

MISCELLANEOUS MANUFACTURERS

solution, drain 1 to 2 seconds from each corner and replace smoothly into the tank; repeat these cycles until development is complete. Developing in a tray or dish, with constant agitation, will reduce developing time by 20%.

SHORT-STOP

A short-stop **is not** recommended except in cases where the temperature exceeds 80 degrees. If temperatures over 80 degrees are used, a hardening stop bath is advised; use 1 teaspoon of sodium bisulfite and 1 teaspoon of potassium chrome alum per quart of water. Use once and discard. In lieu of the short-stop, a brief water rinse of 30 seconds to 1 minute should be used.

FIXING FILM

Use a rapid-hardening fixer. Fix for twice the clearing time. Thick emulsion or high-speed films will require about 1/3 longer to fix than the slower thin-emulsion films; do not overfix—delicate halftones will be destroyed. If your fixer is not fresh, fogged or stained films may be expected.

WASHING—DRYING

Follow the wash with a brief 30- to 60-second immersion in a good wetting agent; remove film from reel and hang up by the end. Soak a viscose photo sponge in the wetting solution, squeeze out, and wipe down film one side at a time. Allow film to dry in an area free from dust and at a temperature as close as possible to the processing temperature; use no heat or fan.

TEMPERATURE

The importance of accurate temperature uniformity throughout the developing process, cannot be over-emphasized. Keep an ACCURATE laboratory "standard" thermometer aside to **check your working thermometer** against frequently. Inaccuracies in thermometers are very common and can play havoc with the negative contrast. Keep developer, fix, wash and drying at the same temperature.

TIME AND TEMPERATURE TABLE

Since photography is not an exact science and variables are encountered with each photographer and his equipment, the following tables are furnished as a guide—a STARTING POINT—so that he may achieve the optimum negative quality.

There is NO SINGLE CORRECT DEVELOPING TIME to give optimum results UNDER ALL CONDITIONS. The ideal negative is a delicate balance of exposure and development of the film, taking into consideration the brightness range of the subject, the latitude of the film and the photographer's aesthetic objectives.

Under normal conditions and using a double-condenser enlarger, the E.I.'s given in the table, should give optimum print quality when the negatives are developed as instructed. Negatives that are to be enlarged with a diffusion type enlarger will require about 20% longer developing times, as they require a higher gamma.

Ideally, negatives should be developed for different times according to the lighting, film contrast, exposure, and the brightness range of the subject, but this can only be done in the case of sheet films. Admittedly, roll films with mixed subjects and lighting conditions must get a compromise development; for these we recommend the times given in the table as a starting point. To cope with this situation, it is suggested that a 36-exposure roll of film, of the type normally used, be exposed as follows: bracket a series of 6 exposures with sunlight, 6 on a dull overcast day, 6 with your electronic flash, 6 with the

flashbulbs most frequently used, 6 under photofloods, and 6 under contrasty available-light conditions; develop this 36-exposure test roll NORMALLY. After the film has dried, select the best negative in each classification, record the proper E.I. or guide number from each tested series. In this way, the best exposure may be used for future shooting, for this given film and given developing time. Needless to say, if you shoot the entire roll under the same conditions, then by all means change the development time to suit those conditions.

Note: The Recommended E.I. (Exposure Index) listed below, may be above or below that listed by the film manufacturer, but has been determined to give the best Exposure Index to arrive at the optimum negative with proper development in U F G.

Note: When diluted developer is used, ALWAYS USE CONSTANT AGITATION.

ETHOL UFG

EXPOSURE INDEX			NORMAL DEVELOPING TIME (Minutes)			
Daylight	Tungsten	35mm Films	65°	70°	75°	85°
——	4000	Kodak "2475" (gamma .70)	12½	10½	8¾	7½
——	6000	Kodak "2475" (gamma 1.00)	18½	16½	14½	13
——	3200	Kodak "2484" (gamma .70)	11¼	9¾	8½	7¼
——	5000	Kodak "2484" (gamma 1.00)	17¾	14½	11½	9¾
1200	1000	Kodak Tri-X	7	5¼	4	3
650	500	Kodak Tri-X	4	3½	3	2¾
400	400	Kodak Tri-X	3½	3	2¾	2¼
——	2000	**Kodak Tri-X	—	7½	—	—
——	4000	**Kodak Tri-X	—	9½	—	—
320	250	Kodak Plus-X	4	3¼	2¾	2¼
80	64	Kodak Panatomic-X	3¼	2	1¼	—
320	250	Ilford FP-4	4¼	3½	2¾	2½
1000	800	Ilford HP-4	6¼	5¼	4½	3¾
80	64	Ilford Pan-F	3	2¼	—	—
160	125	GAF Prof. Film Type 2681	3¾	3¼	2¾	2¼
1200	1000	GAF 500	5½	4¼	3¼	2½
250	200	GAF 125	4¾	4	3½	2¾
800	640	Fuji Neopan SSS	8½	7	6	5

**These are "push processing" indexes only.

MISCELLANEOUS MANUFACTURERS

ETHOL UFG

Daylight	Tungsten	120 Films	65°	70°	75°	85°
			NORMAL DEVELOPING			
EXPOSURE INDEX			TIME (Minutes)			
1200	1000	Kodak Tri-X	6½	5¼	4¼	3½
650	500	Kodak Tri-X	4¾	4	3½	2¾
400	400	Kodak Tri-X	4¼	3½	3	2½
800	650	Kodak Tri-X Pan Prof.	7	5	3½	2½
320	250	Kodak Plus-X Pan	3¼	2¾	2¼	1¾
160	125	Kodak Verichrome Pan	3	2½	2¼	1¾
80	64	Kodak Panatomic-X	6¼	4½	3¼	2½
——	1600	Kodak Royal-X Pan Impr.	11	8	5¾	4
200	160	Ilford FP-4	4½	3½	2¾	2
1600	1200	Ilford HP-4	5¾	4¾	2¾	2¼
1000	800	GAF 500	6½	5¼	4½	3½
250	200	GAF 125	4½	3½	2¾	2
320	250	GAF Prof. Film Type #2681	3	2½	2¼	2
160	125	Agfapan ISS	2½	2¼	2	1¾
1000	800	Fuji Neopan SSS (Optimum)	11¼	9	7¼	5¾
800	640	Fuji Neopan SSS	8¾	7	5½	4½
500	400	Fuji Neopan SSS	5¾	5	4¼	3¾

MISCELLANEOUS MANUFACTURERS

ETHOL UFG

EXPOSURE INDEX			NORMAL DEVELOPING TIME (Minutes)			
Daylight	Tungsten	SHEET FILM	65°	70°	75°	85°
500	400	Kodak Tri-X (Estar Base)	3¾	3¼	2½	2
200	160	Kodak Plus-X	4¼	3¼	2¾	2
200	160	Kodak Super-XX	9¼	7¼	5¾	4¾
100	80	Kodak Ektapan	7	5¾	4½	3¾
1280	1000	Kodak Royal-X Pan Impr. 4166	13	11	9¼	8
400	400	Kodak Royal Pan	5¼	4	3¼	2½
400	320	Kodak Panchro Press B	7	5¼	4¼	3¼
64	32	Kodak Commercial Ortho	4½	3¾	3	2½
160	80	Kodak Super Speed Ortho	5¾	5	4½	3¾
——	20	Kodak Prof. Copy 4125	—	4	—	—
125	100	GAF Versapan Gafstar #2831	8	7	6	5¼
500	500	GAF Prof. Film Type #2863	8¼	6½	5¼	4¼
160	125	GAF Superpan Gafstar #2881	4¼	3½	2¾	2¼
32	25	Agfapan 25	7¾	6¾	5¾	5
100	80	Agfapan 100	6¾	5½	4¾	3½
250	200	Agfapan 200	9¾	8½	7¼	6¼
400	320	Agfapan 400	9½	7¾	6½	5¼
160	125	Ilford FP-4	7¼	5½	4	3
400	320	Ilford HP-4	8¾	7	5½	4½

ELECTRONIC FLASH

Negatives exposed by electronic flash units having a duration shorter than 1/2000th second, will require from 25% to 50% increase in developing time. Most of the popular flash units **do not** fall in this category and developing times will remain unchanged.

The exposure index and developing times recommended in the above charts, are based upon tests conducted in our laboratories. A small tolerance must be allowed to compensate for the many variables involved; i.e., thermometers, water supply, exposure meters, agitation and shutter speeds.

If any questions or problems arise, please write the Technical Department, Ethol Chemicals, Inc.

MISCELLANEOUS MANUFACTURERS

ETHOL T E C COMPENSATING DEVELOPER

T E C is a compensating developer, offering maximum shadow detail, economy, developing control, and acutance. T E C is panthermic, and may safely be used at temperatures from 60 to 80 degrees F.

GENERAL INFORMATION

T E C is available as a liquid concentrate in a package of 3 1-ounce bottles and also in a 4-ounce bottle. For use it is diluted 1 part developer to 15 parts water; use once and discard. It is recommended that a temperature range of 70° to 75° F be used. T E C is also available in a 2-SOLUTION powder form. Dissolve can (A) in ½ gallon of water and Can (B) in ½ gallon of water. FOR USE: Take 1 part (A), 1 part (B) and 14 parts water, use once and discard. TWO BATH DEVELOPMENT may be used as an alternate method of processing with the 2-Solution T E C. To use this method, prepare "stock" (A) and (B) solutions in the usual way. Use two containers for developing; Kinderman, Nikor, or Plastic 2-quart juice containers with lids are excellent. Fill one with the (A) solution, the other with the (B) solution; adjust temperatures to 75° F. Place film reels into (A) and then into (B), for the recommended times, WITHOUT ANY RINSE BETWEEN. Follow with water rinse and rapid fixer.

NOTE: For economy and negative control: "A" is the developing agent, which will help control your density. "B" is the activator for controlling contrast. Times may be changed in "A" or "B" or both, in order to achieve the desired control. If you desire to develop by inspection, start your inspection as you are ready to remove the film from the "A" bath.

The recommended E.I. (Exposure Index) listed in the chart may be above or below that listed by the film manufacturer, but has been determined to be the best exposure index to arrive at the optimum negative with proper development in T E C.

WATER quality is important for quality processing. It should be as pure as possible. If your water supply is not free of minerals and foreign matter, the use of bottled or distilled water is recommended.

If possible, **do not pour** solutions in and out of daylight loading tanks. Preferably, fill the tank with developer, and, in the dark, drop the loaded reel into it. Following development, lift the reel out, into the next solution. This contributes to more accurate timing and more uniform development of the negatives.

T E C is **not** a fine grain developer for HIGH SPEED films. Although high speed films will achieve maximum definition when developed in T E C, they will have more grain than if developed in a fine grain developer. There is NO film speed loss to high speed films when developed in T E C; i.e., TRI-X 35mm exposed at ASA-50 to ASA-2400 on the same strip of film, renders printable negatives from each frame.

GOOD HOUSEKEEPING

Cleanliness is a must. T E C as well as other film developers can be contaminated by foreign matter. Tanks and reels should be cleaned periodically: a toothbrush makes an excellent tool for cleaning reels. Always dry tanks and reels IMMEDIATELY after use, with a clean, lint-free towel.

STORAGE

T E C will keep almost indefinitely in its original sealed container. After opening a bottle and using part, it is recommended the remainder be placed in small, full bottles, or used within a period of 3 weeks. For **maximum** life, opened bottles should be stored in the cooling chamber of the refrigerator. Tests indicate a life beyond 6 months when stored in this manner. DO NOT USE IF DEVELOPER HAS TURNED BROWN OR REDDISH BROWN.

MISCELLANEOUS MANUFACTURERS

Longer life can be expected from 2-SOLUTION T E C, because of the separation of chemicals.

AGITATION

For 35mm and 120 roll films, tanks that can be inverted during agitation are preferred. Immediately after immersing films, agitate for the first 15 sec.; then agitate 5 sec. at the end of each 30 sec. The method is 3 gentle inversions during the 5 sec., with a gentle rotation of the tank followed by putting the tank down with a gentle tap at the end of each interval to dislodge any air bubbles that may have formed. Where very deep roll film tanks are used, it is suggested reels be placed on a long wire and agitation carried out by a gentle lifting and turning of the reels during the agitation periods. **Do not** lift out of the solution.

For agitation of sheet film in hangers, agitate during the first 15 sec., then follow with agitation 5 sec. each 30 sec. thereafter. Hangers should be placed in the tank as a group, tapping the hanger bars on the top of the tank to dislodge any air bells. After the agitation period, lift hangers clear of the solution, drain 1 to 2 sec. from each of the lower corners, and replace smoothly in the tank. Repeat these cycles until development is complete. Developing in a tray or dish, with constant agitation, will reduce developing time by approximately 20%.

SHORT STOP

A short stop is NOT recommended except in cases where the temperature exceeds 75° F. If temperatures over 75° are encountered, a hardening stop bath is advised. Use 1 tsp. sodium bisulfite and 1 tsp. potassium chrome alum per qt. of water. Use once and discard. In lieu of the short stop, a brief water rinse of 20 to 30 sec. may be used, if desired.

FIXING THE FILM

Use a rapid hardening fixer. Fix for twice the clearing time. Thick emulsion or high speed films will require about ⅓ longer to fix than the slower, thin emulsion films. Do not over-fix ... delicate half-tones will be destroyed and grain clumping will result. If your fixer is not fresh, fogged or stained film may be expected.

WASHING—DRYING

Follow the wash with a brief 30 to 60 sec. immersion in a good wetting agent; use 3 or 4 drops to a quart of DISTILLED WATER. Tap water **is not** recommended. Remove film from reel and hang by the end. Soak a viscose sponge in the wetting solution, squeeze out, and wipe down film, one side at a time. Allow film to dry in a dust-free area, and at a temperature **not in excess** of 5° higher than the final bath. Use no heat or fan.

TEMPERATURE

The importance of accurate temperature uniformity throughout the developing procedure cannot be over-emphasized. Inaccuracies in thermometers are very common, and can play havoc with negative contrast. Check your thermometer often. Keep developer, fix, wash and drying at the same temperature. Avoid high-temperature processing of high-speed films; chemical fog may result.

TIME AND TEMPERATURE TABLE

Photography is not an exact science, and variables are encountered with each photographer and his equipment. The following tables are furnished as a guide; a STARTING POINT so that you may achieve the optimum negative quality. Using a double condenser enlarger, the E.I.'s given in the table should give optimum print quality when the negatives are developed as instructed. Negatives that are to be enlarged with a diffusion type of enlarger will require about 20% longer developing times, as they require a higher gamma. There is NO SINGLE CORRECT DEVELOPING TIME to give optimum results UNDER ALL CONDITIONS.

ETHOL TEC TIME AND TEMPERATURE TABLE

E.I. USED FOR DILUTION DISCARD METHOD		35mm Films	DEVELOPING TIME IN MINUTES FOR DILUTION DISCARD METHOD				E.I. USED FOR TWO-SOLUTION METHOD		TIME IN MINUTES FOR TWO-SOLUTION METHOD AT 75°	
Daylight	Tungsten		65°	70°	75°	80°	Day.	Tung.	"A"	"B"
500	400	GAF 500	24½	18	13½	10¼	640	500	5	4
200	160	GAF 125	8¼	7	6	5¼	200	160	2¾	4
1000	800	†Fuji Neopan SSS	32	26	21½	17½	*—	—	—	—
800	640	†Fuji Neopan SSS	26½	22	18¾	15¾	*—	—	—	—
		Sheet Films								
400	400	Kodak Tri-X Pan	11	9¾	8½	7½	320	320	2	2
200	160	Kodak Plus-X	9	8	7	6¼	200	160	3	2½
100	80	Kodak Ektapan	16¾	14¼	12	10¼	*—	—	—	—
400	320	GAF Prof. Type 2860	16	13	10¾	9	400	320	1	1½
160	125	GAF Prof. Type 2831	14½	12½	10½	9	160	125	1	2
400	400	GAF Prof. Type 2863	23	19	16	13¼	*—	—	—	—
500	400	Agfapan 400	27½	21½	16¾	13¼	*—	—	—	—
25	20	Agfapan 25	11¾	10	8¾	7½	*—	—	—	—

*(Data not available at this time.)

NOTE: • The liquid ready-mix TEC is diluted 1:15 for use.
 • The 2-SOLUTION TEC, as per instructions under GENERAL INFORMATION.
 • Shake "A" and "B" "stock" solution before use.
 • The above tables apply to ALL TEC packings.
 # Omit "B" solution unless you wish to obtain added contrast.
 † Different E.I. using different developing times.

MISCELLANEOUS MANUFACTURERS

MISCELLANEOUS MANUFACTURERS

ETHOL TEC TIME AND TEMPERATURE TABLE

E.I. USED FOR DILUTION DISCARD METHOD			DEVELOPING TIME IN MINUTES FOR DILUTION DISCARD METHOD				E.I. USED FOR TWO-SOLUTION METHOD		TIME IN MINUTES FOR TWO-SOLUTION METHOD AT 75°	
Daylight	Tungsten		65°	70°	75°	80°	Day.	Tung.	"A"	"B"
		35mm Films								
1000	800	Kodak Tri-X Pan	16	12	9½	7¼	1200	1000	4	3
320	250	Kodak Plus-X Pan	7	6¾	6¼	6	160	125	2	2
80	64	Kodak Panatomic-X	6¼	5½	4¾	4½	80	64	1½	1
8	6	Kodak High Contrast Copy (Diluted 1:30)	5¼	5	4¾	4½	8	6	3¾	#
1000	800	Ilford HP-4	16½	15	13¾	12½	*—	—	—	—
320	250	Ilford FP-4	11¼	10	8¾	7¾	*—	—	—	—
64	50	Ilford Pan-F	7½	6½	5½	4¾	100	80	2¼	2
500	400	GAF 500	16¼	14	12½	11	800	640	5	3¾
320	250	GAF Prof. Type 2681	8¾	8¼	7¾	7¼	*—	—	—	—
250	200	GAF 125	9¾	8¾	7¾	7	320	250	2	3
1000	800	Fuji Neopan SSS	24	21	18¼	16	*—	—	—	—
80	64	VTE Pan (diluted 1:30)	—	10	—	9	*—	—	—	—
		120 Roll Films								
800	800	Kodak Tri-X Pan	15	13	11	9½	640	640	4	3
400	320	Kodak Tri-X Pan Prof.	17	14½	11½	9½	400	320	2½	2
160	125	Kodak Plus-X Pan	10	7¾	6	4½	250	200	2	2
80	64	Kodak Panatomic-X	7¾	6	4¾	3¾	100	80	2¼	2¾
1000	800	Ilford HP-4	23	18½	14½	12¼	*—	—	—	—
250	200	Ilford FP-4	7½	6½	5¾	5	*—	—	—	—

"ETHOL BLUE—HIGH PERFORMANCE DEVELOPER"

DESCRIPTION

Ethol BLUE is a new concept in film development, highly concentrated for the dilution and one-time-use method of processing. It is panthermic and may be safely used at temperatures from 65 to 90 degrees F.; preference is limited to the range of 65 to 80 degrees F.

GENERAL INFORMATION

Ethol BLUE provdes high, effective film speeds, a maximum of shadow detail, high acutance, medium fine grain, processing control, ease of use and economy. It is ideally suited to the requirements of the photojournalists and the available light photographer.

BLUE is available in a (1) pint and 4 oz. liquid concentrate. It is normally diluted 1:30 for use, but for extended processing control or for special applications, it may be diluted upwards to 1:120.

The recommended E.I. (Exposure Index) listed in chart below may be con-considerably above that listed by the film manufacturer, but has been determined to be the best exposure index for a negative of optimum quality with proper development in Ethol BLUE.

Because Ethol BLUE has such great latitude, there are, in some cases, more than one index listed for certain films. Where this has been done, the asterisk (*) will indicate the optimum index for that film.

If possible, do not pour solutions in and out of daylight loading tanks. Preferably, fill the tank with developer and, in the dark, drop the loaded reel into it. Following development, lift the reel out, into the next solution. This contributes to more accurate timing and more uniform development of negatives.

DILUTION

Where longer developing times are desirable, or greater contrast control is needed, then extended dilution upwards to 1:120 is suggested; discard immediately after one-time-use. Do not be alarmed if any crystalization occurs in the "stock" developer. **Simply place bottle in hot water, shaking occasionally, until crystals dissolve.**

STORAGE

Ethol BLUE has extremely long shelf life in its "stock" solution form. Do not dilute "stock" until ready to use. Simply store bottle at room temperature. Do not refrigerate. Ethol BLUE will last well over one year if kept tightly stoppered in its original bottle. Occasionally the stock solution will darken to a brown or a black color. This is due to peculiarities in certain raw materials and does not indicate that the developer is exhausted. Continue to use as recommended.

The Compact Photo-Lab-Index

AGITATION

For 35mm and 120 roll films, tanks that can be inverted during agitation are preferred. Immediately after immersing the films, agitate for the first 15 sec.; then agitate 5 sec. at the end of each 30 sec. The method is 3 gentle inversions with a gentle rotation—during the 5 seconds every 30 seconds, followed by putting the tank down with a gentle tap at the end of each 5-second agitation period, to dislodge any air bubbles that may have formed. This method of agitation is advised for even development of the films and consistently reproducible results. If you are getting consistent negatives, but the developing times in the tables are too short for your purposes, then do not change your agitation, but instead change the developing times—based upon your dilution or the need of more or less contrast. Where deep roll film tanks are used, it is suggested reels be placed on a long wire and the agitation be carried out by a gentle lifting and turning of the reels during the agitation periods. Do not lift reels out of the solution.

SHORT STOP

An acid short stop is not recommended. Instead of an acid stop-bath, a brief rinse of 20-30 seconds in plain water may be used. If temperatures of over 75°F. are encountered, a hardening stop-bath of 1 tsp. sodium bisulfite and 1 tsp. of potassium chrome alum in a quart of water is recommended. Use once and discard.

FIXING THE FILM

Use a rapid hardening fixer and fix for twice the clearing time. DON'T over-fix—delicate half-tones will be lost and grain clumping will result. If fixer isn't fresh, it is possible film may be fogged or stained.

WASHING-DRYING

Wash films in a rapid washer, such as the Miller Hurricane film washer. Follow the wash with a brief 30- to 60-second immersion in a good wetting agent; remove film from reel and hang up by the end. Soak a photo viscose sponge in the wetting solution, squeeze out, and wipe gently down film, one side at a time. Allow film to dry in a dust-free area and at a temperature as close as possible to the processing temperature that was used; use no heat.

TEMPERATURE

The importance of accurate temperature uniformity throughout the developing procedure cannot be over-emphasized. Inaccuracies in thermometers are very common, and can play havoc with negative contrast. Check your thermometer often. Keep developer, fix, wash and drying at the same temperature. Avoid high temperature processing of high speed films, if possible; chemical fog may result.

TIME AND TEMPERATURE TABLE

Photography is not an exact science, and variables are encountered with each photographer and his equipment. The following tables are furnished as a guide; a STARTING POINT so that you may achieve the optimum negative quality. Using a double condenser enlarger, the E.I.'s given in the table should give optimum print quality when the negatives are developed as instructed. Negatives that are to be enlarged with a semi-diffusion or diffusion type of enlarger will require about 20% to 30% longer developing times respectively, as they require a negative to be developed to a higher contrast index for ease of printing. There is NO SINGLE CORRECT DEVELOPING TIME to give optimum results UNDER ALL CONDITIONS.

MISCELLANEOUS MANUFACTURERS

ETHOL BLUE

TIME AND TEMPERATURE CHART

EXPOSURE INDEX					NORMAL DEVELOPING TIME IN MINUTES			
Daylight	Tungsten	35mm Films	DILUTION	65°	70°	75°	80°	
2400	2000	Kodak 2475	1:30	12¾	10	8	6¼	
2400	2000	Kodak Tri-X	1:30	8¼	6¾	5½	4½	
2000	1600	*Kodak Tri-X	1:30	7¾	6	4¾	3¾	
1600	1280	Kodak Tri-X	1:30	7½	5¼	3¾	2¾	
400	400	Kodak Tri-X	1:60	6	5½	5	4¾	
500	400	Kodak Plus-X		4½	3½	2¾	2	
500	400	Kodak Plus-XX	1:60	7¼	6	5	4	
400	320	Kodak Plus-X	1:30	3½	2¾	2	1½	
125	100	Kodak Panatomic-X	1:60	7	5½	4¼	3¼	
64	50	*Kodak Panatomic-X	1:60	4½	3¾	3	2½	
80	64	Kodak Panatomic-X	1:120	8	7	6	5¼	
10	8	Kodak High Cont. Copy	1:120	—	6	—	—	
320	250	Ilford FP-4	1:30	3¾	3	2½	2	
320	250	Ilford FP-4	1:60	7	6	5	4¼	
1600	1200	Ilford HP-4	1:30	11	8	5½	4	
1200	1000	*Ilford HP-4	1:30	8¼	6½	5	3¾	
80	64	Ilford Pan-F	1:60	5¼	4½	3¾	3¼	
320	250	GAF 125	1:30	7	5½	4½	3½	
1000	800	GAF 500	1:30	8½	7	5¾	4¾	
1200	1000	*Fuji Neopan SSS	1:30	9½	7½	6	4¾	
640	500	Fuji Neopan SSS	1:30	6¼	5	4	3	
250	200	Lumipan	1:60	—	5¼	—	—	
800	640	Imperiale S Pan	1:30	—	5	—	—	
32	25	VTE Pan	1:90	6¼	5½	4¾	4¼	

*Different EI using different developing times.

MISCELLANEOUS
MANUFACTURERS

ETHOL BLUE

TIME AND TEMPERATURE CHART

EXPOSURE INDEX				NORMAL DEVELOPING TIME IN MINUTES			
Daylight	Tungsten	120 Films	DILUTION	65°	70°	75°	80°
1000	800	*Kodak Tri-X	1:30	5¾	4½	3¾	3
1600	1200	Kodak Tri-X	1:30	6¼	5	4	3¼
32	25	Kodak Panatomic-X	1:60	4¼	3¼	2¾	2
200	160	Kodak Verichrome Pan	1:60	6½	5	3¾	3
320	250	Kodak Plus-X	1:30	3½	2¾	2	1½
1200	1000	Kodak Royal-X Pan Imp.	1:30	9	7¼	5¾	4¾
800	640	Fuji Neopan SSS	1:30	9¼	6½	4¾	3½
160	125	Ilford FP-4	1:30	3	2½	2¼	1¾
1000	800	Ilford HP-4	1:30	7¼	6	5	4
800	640	*GAF 500	1:30	10¾	8	6	4½
1000	800	GAF 500	1:30	13½	10	7½	5½
250	200	GAF 125	1:30	6½	5¼	4¼	3¼

4 x 5 Sheet Film

500	400	Kodak Tri-X Pan Prof.	1:30	6¾	5½	4¼	3½
160	125	Kodak Plus-X Pan Prof.	1:60	7¾	7	6¼	5¾
2000	1600	Kodak Royal-X Pan Imp.	1:30	12	9¾	8	6½
640	500	Kodak Royal Pan	1:30	7¼	6	5	4¼
125	100	Kodak Ektapan	1:60	8½	6¾	5¼	4
200	160	Ilford FP-4	1:60	7¾	6¾	6	5
500	400	Ilford HP-4	1:30	7	6	5	4¼
800	640	GAF Prof. Type 2863		8½	7¼	6	5

*Different EI using different developing times.

MISCELLANEOUS MANUFACTURERS

ETHOL 90 DEVELOPER

DESCRIPTION

Ethol 90 is a fine-grain, normal contrast, long-scale, very rapid working developer. It is used in an extremely broad range of general and scientific photographic applications, including press, industrial and commercial photography, available light, macrophotography, electron microscopy, holography, x-ray, cineflure, cardiology, and in automatic processing of motion-picture negative and positive films.

GENERAL

No special equipment or procedures are required. Ethol 90 is available in both powder and liquid form. It also has its own replenisher, both powder and liquid. The liquid 90 is a ready-to-use working solution. Simply bring the liquid to the required temperature and process. The powder form is dissolved in ¾ths the final volume of water at 80°—100°F. Then add cold water to make up the balance.

USE

Normal development times for most films, exposed at double their ASA rating, is 90 seconds at 70°F. with CONSTANT GENTLE AGITATION. If development is extended to about 6 minutes the ASA rating for slow films may be increased to 3X, and for fast films up to 6X. If impractical to hold temperature at 70°F., follow the chart below. Times may be changed to meet individual contrast and density requirements.

Degrees, F.	60	65	70	75	80	85	90	95	100
Time, Seconds	180	120	90	60	50	40	30	25	20

If you prefer longer developing time, this is accomplished by diluting 1 part of Ethol 90 to 10 parts water, or 1 part to 20 parts water. This will give slightly increased film speed, as well as slightly finer grain. For slower, thin-emulsion films, the dilution method is recommended. Used in this manner, 90 becomes a one-time developer, and must be discarded after use. Do not use developer in which film has been processed, or to which replenisher has been added, for the dilution method.

REPLENISHER

For more stable life, and constant results, Ethol 90 replenisher is recommended, when using 90 stock developer. As a starting point, use ½ oz. Ethol 90 replenisher for each 80 sq. in. of film processed (1 roll 35mm, 36 exp., roll 120 films).

TIME AND TEMPERATURE TABLES

There is no EXACT DEVELOPING TIME to give optimum results UNDER ALL CONDITIONS and since Ethol 90 is so broad in scope, no attempt is made to give a table covering all films. Below are a few of the most popular films, which should give a starting point, a guide to cotninue with tests on films other than those indicated herein.

MISCELLANEOUS MANUFACTURERS

ETHOL 90

EXP. INDEX	FILM	DILUTION	AGITATION	TIME, MIN., 70°F.
400	Tri-X	Full Str.	Normal	1½
800	Tri-X	Full Str.	Constant	1½
1600	Tri-X	Full Str.	Normal	6
500	Tri-X	1:10	Normal	6
800	Tri-X	1:10	Constant	6
1000	Tri-X	1:10	Normal	6½
2000	Tri-X	1:10	Normal	9
50	Panatomic-X	1:20	Normal	5¼
80	Panatomic-X	1:20	Constant	5¼
250	Plus-X	1:20	Normal	5½
320	Plus-X	1:20	Constant	5½

64-80 HIGH-CONTRASTY COPY Full Str. Normal 4¼ (for line copy work)

Since Ethol 90 has a degree of compensating action, push processing will give but a minimum increase in grain, and will not block highlights while the developer continues to work in the shadow areas.

CINEFLURE FILM

In processing of cineflure films, Ethol will give **better contrast.** The film base is extremely clear, compared to films processed in other developers.

Radiation factors may be reduced by 50% or more. (Reduce KV by 10, or reduce milli-amperage by 50%). The 50% factor is conservative. If development is extended to about 6 min. at 70°F., the ASA rating of slow films may be increased by 3X and fast films to 8X. Normal x-ray fixers may be used. Aside from lower radiation levels, improved contrast, and a clearer film base, Ethol 90 gives a lower tube load and, therefore, longer life. Low-gain, borderline image tubes may still be usable and life extended; less radiation to the doctor and the patient, and fewer repeat examinations.

Below is a brief table which should give processors of Cineflure, and other films, an adequate starting point on which to base their individual tests.

FILM	MACHINE		DEV. TIME	TEMP.	
DOUBLE-X	Fisher-Processall	25′ per min.	48 sec.	85° F.	(1)
DOUBLE-X	Fisher-Processall	5½′ per min.		75° F.	
CINEFLURE	Fisher-Processall	4′ per min.	88-90 sec.	75° F.	
CINEFLURE	Fisher-Processall	4′ per min.	1½ min.	84° F.	
CINEFLURE	Picker-Smith (with Nitrogen-burst agitation)	2′ per min.	3 min.	68° F.	(2)
EK Fine Grain Positive	Houston Fearless (with circulating pump agitation)	3′ per min.	3 min.	75° F.	(2)

(1) Replenishment rate 63—72 ml per min.
(2) Dryer temperature at 120° F.

ELECTRON MICROSCOPY

In using Ethol 90 for processing of plates and films for electron microscopy, you will find that you obtain superior contrast along with much shorter developing time (2 min. to 6 min. at 70° F.) than that obtained with other developers. To get higher acutance and contrast, you may use constant agitation.

To retain normal contrast, use one-half oz. Ethol 90 Replenisher for each 80 sq. in. of film processed. If you desire more contrast in your negatives, you may use more replenisher, up to an amount which will maintain the original volume of developer.

As previously stated, Ethol 90 will not block highlights, and will give excellent shadow detail.

To obtain superior clarity, sharpest detail, and highest resolution for extreme enlargements, use Ethol 90 for negative processing and a point light source enlarger for printing.

ETHOL LPD DEVELOPER
For all Printing Papers, Lantern Slides, Press Negatives and Microfilms

DESCRIPTION

LPD is a simple, easy to use paper developer that offers long life, economy and tone control. It gives brilliant blacks, the pure sparkling whites, and has a capacity to maintain quality for many prints. It is non-staining and free from tendency to irritate skin.

LPD is a paper developer available either as a powder or liquid. It is a non-staining developer that gives brilliant prints with rich blacks and clean whites. It is a long scale, neutral tone, normal contrast developer with a good developing capacity that may be used in the usual dilute-discard method, or may be replenished.

LPD offers great print capacity, i.e., a tray of ½ gallon of working solution will process a minimum of 360 8x10 single weight prints, when properly replenished. Uniform quality and tone is maintained throughout the useful life of the developer. Replenishment according to directions will allow extended use of the developer making it unnecessary to discard if only a few prints have been made.

LPD may be used with all types of printing papers. Tones may be varied from cold to warm by selection of the paper, and by varying the dilution of the stock solution.

It can also be used for processing projector slides, press negatives and microfilms.

LPD does not stain and irritate the skin, as is characteristic of so many developers. Most developers contain Metol, which is a toxic developing agent. LPD contains no Metol. Instead, Phenidone® has been used. This developing agent is non-toxic and has made it possible for many photographers to return to the lab without fear of skin problems.

LPD contains Hydroquinone, which is a regenerating chemical that acts very rapidly on the Phenidone.® When LPD is used as directed, full strength of the solution is maintained until all the working and replenishment solution has been used.

LPD is versatile, and it may be used with all types of printing papers. Tones may be varied from the very cold to very warm just by selection of the paper and the dilution of the "stock" developer.

LPD developer may also be used for the processing of lantern slides, press negatives, and microfilms.

MIXING

LPD is a single-mix powder which dissolves easily in tap water at 80 to 100 degrees F. The contents of the can should be dissolved in ¾ the final volume of water, and then cold water added to bring the solution up to the indicated amount. This becomes the "STOCK" solution. When diluting the developer, be

MISCELLANEOUS MANUFACTURERS

sure to stir well to obtain a more uniform solution. LPD Liquid Concentrate in 1 qt. and 5 gallon sizes are also available and should be mixed as per directions on the container.

NORMAL USE

To make a working solution, dilute the stock solution 1:2 with water, and develop the prints for 1½ to 2 minutes at 70 degrees F. This dilution will produce a neutral tone.

TONE CONTROL

LPD offers the unique ability of print tone control. Where most developers change in contrast as they are diluted, LPD maintains a uniform contrast, but changes tone. i.e., a dilution of 1:4 produces warm tones; 1:2 neutral tones; and 1:1, or full strength, produces the colder tones.

Very wide tone latitude is obtained by the choice of paper, coupled with the appropriate dilution of the developer. Fast bromide papers will give a very blue-black tone, while the chloro-bromide papers would naturally produce warmer tones. Prints should be exposed sufficiently to give good blacks. LPD does not sacrifice emulsion speed, so the normal exposure should be correct.

SHORT STOP AND FIX

Even though LPD has a minimum tendency to stain, it is advisable to use a short stop. Any regular stop-bath may be used and any of the fixers; however, if a rapid-fix is used, care should be taken not to leave the prints in too long, or bleaching will result and tones will be sacrificed.

TO REPLENISH

After printing 15 8 x 10 prints in tray containing 1 quart of solution, replenish with 5 oz. of replenisher; after 30 prints in tray using ½ gallon of solution, replenish with 10 oz. of replenisher; after 60 prints in tray containing 1 gallon of solution, replenish with 20 oz. replenisher.

WHEN DONE WITH PRINT SESSION

1. Pour solution remaining in tray back into working solution bottle.
2. Replace depleted portion from replenisher bottle.
CONTINUE UNTIL ALL REPLENISHER HAS BEEN USED, THEN START PROCEDURE WITH FRESH SOLUTIONS.

NOTE

The above proportions apply to single weight paper, 8 x 10 size. For those who wish to use this system with double weight papers, you may compute that each 8 x 10 double weight paper uses approximately ½ ounce of developer.

Do not attempt to print 70 or 80 prints before replenishing. Replenish as indicated above. This will assure you that your solution is at full strength, for as explained previously, a Phenidone® developer regenerates quickly.

For those who prefer a more contrasty type of solution or for those who use continuous automatic machines, or for those who wish to hold working time to a minimum, make working solution by diluting stock solution 1:1. For this purpose, use straight stock solution as your replenisher.

FOR SOFTER PRINTS

Make solution on a 1 to 4 basis and replenish as follows. Make the original stock solution. Remove ⅕ of this into another bottle and fill with water to make your working solution. Now take the first bottle which still has ⅘ of the solution remaining and split into 2 bottles containing equal amounts of solution and fill these two bottles with water. You now have 2 bottles of replenisher from which you may replenish on the same basis as the above.

INFORMATION FOR THE NEW PLUS-X FILM AS APPLIED TO ETHOL UFG, TEC, 2 SOLUTION TEC & BLUE

DEVELOPER	DILUTION	FORMAT	E.I. DAY/TUNG	FILM	65°	70°	75°	80°
UFG	—	35mm	1200/1000	Kodak Tri-X	6½	5¼	4¼	3½
UFG	—	35mm	320/250	Kodak Plus-X	4¾	4	3½	3
UFG	—	120mm	320/250	Kodak Plus-X Pan	6¾	5	3¾	2¾
UFG	—	120mm	125/125	Kodak Plus-X Pan	2¾	2¼	2	1½
TEC	1:15	35mm	400/320	Kodak Plus-X	15	12	9¾	7¾
TEC	1:15	120mm	320/250	Kodak Plus-X Pan	11	9	7¼	6
TEC	1:45	35mm	25/20	VTE Ultra	23½	20	17	14½
TEC	1:45	120mm	50/50	VTE Pan	—	13	—	—
TEC	1:30	35mm	80/80	**Kodak Photomicrography Monochrome Film	—	7	—	—
2 SOL TEC	—	35mm	5000	Kodak 2475		7-A; 6-B @ 75°		
2 SOL TEC	—	35mm	500/400	Kodak Plus-X		3-A; 3-B @ 75°		
2 SOL TEC	—	120mm	400/320	Kodak Plus-X Pan		3-A; 3-B @ 75°		
2 SOL TEC	—	35mm	1200/1000	Ilford HP-4		5-A; 4-B @ 75°		
2 SOL TEC	—	120mm	1000/800	Ilford HP-4		5-A; 4-B @ 75°		
2 SOL TEC	—	35mm	320/250	Ilford FP-4		3½-A; 3-B @ 75°		
2 SOL TEC	—	120mm	400/320	Ilford FP-4		3-A; 3-B @ 75°		
BLUE	1:30	35mm	400/320	*Kodak Plus-X	3¾	3	2½	2¼
BLUE	1:60	35mm	400/320	Kodak Plus-X	6	5	4¼	3½
BLUE	1:30	120mm	320/250	*Kodak Plus-X Pan	4½	3½	2¾	2¼
BLUE	1:60	120mm	320/250	*Kodak Plus-X Pan	8¼	6½	5	4
BLUE	1:60	120mm	125/125	*Kodak Plus-X Pan	5	4	3¼	2¾

*Optimum index and/or dilution.

**For general photography (continuous tone).

MISCELLANEOUS MANUFACTURERS

615

The Compact Photo-Lab-Index

The following table is a guide for exposure and development under different brightness ranges.

	Brightness Range (approx.)	Exposure	Stops	Development Factor
Misty Landscapes	1:10	⅓X	Under 1½	2X or 100% Over
Distant Views	1:20	⅓X	Under 1½	1.5X or 50% Over
Street Scenes (diffuse Light)	1:40	½X	Under 1	1.2X or 20% Over
Summer Landscapes	1:100	Normal	Normal	Normal
Back Light (Natural)	1:250	2X	Over 1	.8X or 20% Decrease
Interiors	1:500	4X	Over 2	.7X or 30% Decrease
Exteriors (Sun)	1:1000	6X	Over 2½	.6X or 40% Decrease

Note: Increase or decrease in development factor applies to optimum development times as listed in Ethol film development charts.

MISCELLANEOUS MANUFACTURERS

PHOTOCOLOR II® COLOR PROCESSING

FILM (processing at 38°C/100°F)		PAPER (processing at 38°C/100°F)	
Developing	2¾ mins	Developing	2 mins
Rinse	30 secs	Rinse	10 secs
Bleach-Fix	3 mins	Bleach-Fix	1 min
Wash	5 mins	Wash	1½ mins

WARNING

The Color Developer is an alkaline solution and contains a color developing agent which is a compound of para-phenylenediamine. Chemicals of this type are skin-irritants to which some persons are unusually sensitive.

Avoid skin contact with the developer concentrate or working solution. In case of accidental contact with skin, eyes or clothing flush immediately with plenty of clean water. In the case of eyes rinse thoroughly with water and seek medical help.

The Developer Additive contains Benzyl Alcohol and Diethylene Glycol.

The Photocolor II process has been designed by Photo Technology Ltd to simplify the development and printing of color negative films. It eliminates many of the complexities of processing outfits previously available and makes possible the development of an occasional film without the necessity of buying a separate developing outfit.

The outfit consists entirely of liquid concentrates which have excellent keeping properties and allow any convenient volumes of solution to be quickly and easily prepared for the work in hand.

The process is simple and straightforward.

If black-and-white film processing and enlarging equipment is already available, the only additional items likely to be needed are a thermometer reading to at least 40°C (105°F), a safelight for color paper and, perhaps, a print processing drum. The enlarger must also have facilities for using color printing filters, i.e. a color head, a filter drawer and set of subtractive color printing filters or a filter holder and set of additive filters.

The outfit will process:

COLOR NEGATIVE FILMS

Kodacolor II, Kodak Vericolor II Types S & L, Fujicolor II Types S & L, Fujicolor II 400, Sakuracolor II, Sakuracolor II 400, Boots' Colourprint II — in all sizes from 110 to sheet film (where available). i.e. films designed for processing by the Kodak C41 (or equivalent) process.

COLOR PRINTING PAPERS

Kodak Ektacolor 37RC and 74RC, Sakuracolor, Agfacolor Type 4

THE PHOTOCOLOR II OUTFIT—CONTENTS, MIXING, STORAGE

The outfit consists of:

500 ml Color Developer Concentrate (making 1½ litres at dilution 1 + 2).

500 ml Bleach-Fix Concentrate (making 1 litre at dilution 1 + 1).

30 ml Print Developer Additive and a 10 ml measure.

The bottles are sealed to ensure that the solutions reach the user in good condition. Once the seal on the bottle of *developer* concentrate has been broken, it is very important to keep the bottle tightly stoppered. Squeeze the bottle to exclude as much air as possible and *reseal it with the special cap provided in the outfit*.

When fresh, the Developer Concentrate has a slight yellow tint, similar to that of white wine. The Bleach-Fix is deep orange-brown in color. The Print Developer Additive is used only when developing Ektacolor 37RC and 74RC and similar paper — it must **not** be used when developing films.

MIXING

Dilute the concentrates, as instructed, with clean tap water. Use clean glass or plastic measures. When measuring the Print Developer Additive use a glass measure or the special plastic measure provided. New, unchipped enamel and stainless steel measures may be used *but stainless steel will corrode if left in contact with Bleach-Fix for any length of time.*

Protect working surfaces with polythene sheet or similar. If the chemicals are left in con-

MISCELLANEOUS MANUFACTURERS

tact with plastic surfaces, paintwork, baths, linoleum, clothing, etc., stains will result; in case of spillage wash at once with plenty of water.

Keep the chemicals out of reach of children and pets.

STORAGE

As supplied the concentrates will keep in good condition for a year or more. Once opened the shelf-life of the developer will depend on the exposure to air of the contents. Squeeze the bottle to minimize the airspace before recapping and transfer small quantities of solution to smaller airtight bottles.

Working strength Developer should normally be prepared just before use, but will keep for about 6 weeks in a full airtight bottle. Partially used developer will keep 2-3 weeks stored similarly.

Bleach Fix solution differs from developer in that its action is actually improved by aeration. After use and/or fairly long storage, the solution should be regenerated by, for example, vigorous shaking with air in a partially filled bottle. If Bleach Fix is habitually stored in half-filled bottles and given a good shake occasionally, it will work more effectively and its useful life will be prolonged. Stored in this way, working strength Bleach Fix will keep for at least 8 weeks.

WATER RINSE OR STOP BATH AFTER DEVELOPMENT

As in black-and-white processing this is used to prevent carry-over of Developer into the Bleach-Fix and minimize the risk of staining. An acid stop bath has the advantage of arresting development immediately and, when available, its use is recommended, particularly when processing films. To prepare a suitable stop-bath dilute Johnson Indicol (or Glacial Acetic Acid) in the proportion of 10 ml to each litre of water.

FILM PROCESSING

It will have been noticed that the processing sequence for negative color films is very short (about 7 minutes apart from washing) but that the only processing temperature quoted is 38°C (100°F). This is because most films are primarily designed for machine processing at 38°C and will not develop properly at appreciably lower temperatures.

In practice this is not a serious problem. A large bath of warm water will keep the temperature steady for the few minutes required and small errors in the temperature (2°C or so either way) can be compensated using the time/temperature correction diagram.

For negatives of consistent quality, which will make color printing considerably easier, it is well worth while taking extra care to standardize processing times and temperatures.

If good darkroom facilities are available the simplest way is to process films in the dark. Pour the processing solutions into three tank bodies (or other suitable containers) and bring them to 38°C by standing them in a bath of water at about 41°C. Then load the film into a spiral (in complete darkness) and process it by transferring it from one container to the next, using an audible or luminous timer.

When using a developing tank in the normal way first load the film in the dark and replace the lid of the tank. Pour the processing solutions into suitable containers and bring them up to 38°C by standing them in a water bath. Next, pre-warm the tank by filling it with water at 40°C and, after 1 minute, drain the tank thoroughly and pour in the developer. Stand the tank in the water bath during processing.

FORCED DEVELOPMENT (PUSH PROCESSING)

For normal work the best results are obtained by exposing according to the film manufacturers speed ratings and developing for the standard time. However, by increasing the developing time to 4 mins. at 38°C the effective speed of films may be increased to at least double the normal rating. There will also be an increase in negative contrast, but with low or medium contrast subjects this technique will give printable negatives in circumstances where this would not otherwise be possible.

PROCESSING SOLUTIONS

For the best results use freshly made solutions. Dilute the Developer concentrate 1 + 2 and the Bleach-Fix concentrate 1 + 1. Use an acid stop bath if available, or, if not, have sufficient warm water ready to give 3 rinses.

The Compact Photo-Lab-Index

DEVELOPMENT

Agitate continuously for the first 20 seconds (taking the usual precautions to dislodge air bubbles) and thereafter agitate for 5 seconds (or give two inversions) four times per minute. Check the temperature after the first 20 seconds and develop according to the time/temperature diagram. **Time development carefully; the developing time includes the time for pouring out the developer, which is usually 10-15 seconds.** Pour the used developer into a clean measure and keep it for re-use.

Stop Bath/Water Rinse

Pour in the acid stop bath and agitate continuously for 30 seconds **or** give three 15 second rinses with fresh water at 35—40°C.

BLEACH FIXING

This is a more critical process than the fixing of black-and-white films. Fresh or almost fresh solution should be used and time and temperature control must be fairly accurate.

The use of stale or partially exhausted solution can adversely affect negative quality and if there is any doubt the bleach fix solution should be regenerated by vigorous shaking with air.

Agitate continuously for the first minute and then frequently (say, four times each minute) for the next two minutes. When the process is complete, the image (viewed from the back of the film) will appear deep blue against a purplish brick-red background. The film will have a milky appearance by reflected light but this will disappear when it is dry.

The Bleach-Fix time must be increased by about 10% for each film processed in 300 ml of solution (see Capacity below). If for any reason (e.g. insufficient agitation, fall in temperature, failure to increase the time in used soution) the film is seen to be insufficiently bleached, return it to the solution. Agitate continuously until bleaching is visually complete, and then for a further 15 seconds.

WASHING

For preference wash for at least five minutes at 30°–25°C in running water or using 30 second changes. If it is more convenient to wash at a lower temperature, gradually reduce the temperature with changes of water over a minute or two and then wash for 10 minutes at 25°C or 15 minutes at 20°C.

DRYING

After washing use a final rinse of water containing the recommended quantity of a good wetting agent. It is important to avoid water droplets drying on the film surface. Hang the film up in a warm dust-free place; it will usually dry in about 20 minutes. Drying may be hastened by the careful use of a warm-air fan dryer, but take care not to over-heat the emulsion locally or to blow dust on to its surface.

CAPACITY

This will depend on circumstances, i.e. whether further films are to be processed fairly soon or whether prints are to be made first. If only one or two films have been processed the solutions should, in either case be stored. They may be used again for film processing within a week or so but otherwise it is better to use them for printing and make up fresh solutions for the next film.

If the solutions are used only for films 300 ml of Color Developer (topped up as necessary) will process either 3-36 exp. 35mm films, 5-20 exp. 35mm films, 3 No. 120 roll films or an equivalent area. The developing time should be increased by 12% (to 3 minutes 5 seconds at 38°C) for the second film. For the third film the development time should be increased by 30% (to 3 minutes 35 seconds at 38°C). Used developer is usually colored by dyes dissolving from the films but this will not affect subsequent films or prints.

300 ml of Bleach-Fix will process a maximum of 5-36 exp. 35mm films, 5 No. 120 roll films or the equivalent. The Bleach-Fix time (3 minutes at 38°C) should be increased by about 10% after each film, i.e.

2nd film—3 min. 20 sec.	4th film—4 min. 15 sec.
3rd film—3 min. 45 sec.	5th film—4 min. 45 sec.

INSTRUCTIONS FOR TANK DEVELOPMENT

1. Load tank, in total darkness.

2. Developer – dilute 1 + 2
 Bleach Fix – dilute 1 + 1
 Stop Bath – 1% Indicol (or acetic acid)

3. Warm processing solutions to 38°C (100°F).

4. Fill developing tank with water at 40°C (105°F) to pre-heat. After 1 min. drain completely.

5. Pour in Developer. Agitate 20 secs., develop for 2¾ mins. at 38°C (100°F). Agitate 4 times/min.

6. Drain Developer into a beaker for re-use. Pour in Stop Bath, agitate 30 secs. and drain.

7. Pour in Bleach-Fix. Agitate 1 min. and then 4 times/min. for 3 mins. Pour out and keep for re-use.

8. Wash 5 mins. at 30°–35°C (86°–95°F) or reduce temperature gradually to about 20°C (68°F) and wash 15 mins.

9. Rinse in water with wetting agent and hang to dry in warm, dust-free place.

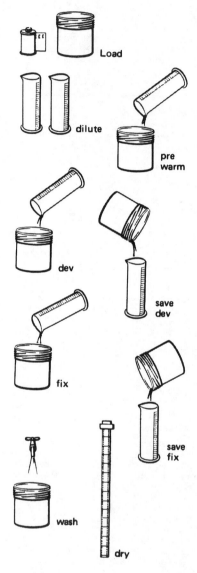

Load

dilute

pre warm

dev

save dev

fix

save fix

wash

dry

MISCELLANEOUS MANUFACTURERS

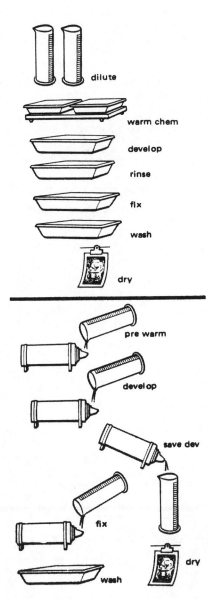

INSTRUCTIONS FOR TRAY DEVELOPMENT

1. Developer – dilute 1 + 2 and, for Ektacolor 37RC and 74RC, add the special Additive (2 ml per 100 ml). Bleach-Fix – dilute 1 + 1. (Chemicals used for film processing may be used.)

2. Warm solutions to chosen working temperature using tray warmer or water bath.

3. Develop 2 mins. at 38°C (100°F).

4. Stop Bath or water rinse.

5. Bleach Fix 1 min. at 38°C (100°F).

6. Wash 2 mins. at 34°–38°C (93°–100°F); or longer at lower temperatures.

7. Fan dry.

INSTRUCTIONS FOR DRUM PROCESSING

Steps 1 and 2 as above.

3. Load print processing drum.

4. Pre-heat drum with warm water.

5. Develop 2 mins. at 38°C (100°F). Drain drum, retaining solution for re-use.

6. Stop Bath or water rinse 10–20 secs.

7. Bleach-Fix 1 min. at 38°C (100°F). Retain solution for re-use.

8. Wash print in tray. Thoroughly wash and dry drum.

9. Fan dry.

MISCELLANEOUS MANUFACTURERS

621

The Compact Photo-Lab-Index

STAGE	TIME	TEMPERATURE	NOTES
Pre-heat tank	1 min	40°(104°F)	Pre-heat with water, if necessary.
Color Development	2¾ min	38°C(100°F)	Or as corrected from diagram. Times include draining. Continuous agitation for 20 sec. then 5 sec. rotation or 2 inversions four times per minute.
Stop Bath	30 sec	(95°–104°F)	
Bleach-Fixing	3 min	35°C–35°C (95°–104°F)	Continuous agitation (1 inversion every 5 sec.) for 1 min. Then 5 sec. rotation or 2 inversions four times per minute.
Washing	5 min	30°C–35°C (86°–95°F)	Minimum times with running water or frequent changes.
	10 min	25°C(77°F)	
	15 min	20°C(68°F)	

PHOTOCOLOR II FILM DEVELOPMENT TEMPERATURE CORRECTION DIAGRAM

NEGATIVE FAULTS AND PROBABLE EXPLANATIONS

NEGATIVE FAULTS	PROBABLE EXPLANATIONS
Negatives of low contrast, giving flat prints. Loss of shadow detail. Faint edge markings.	Underdevelopment. Incorrect time or temperature in processing. Use of exhausted or oxidized developer. Developer Concentrate incorrectly diluted.
Thin negatives lacking in shadow detail but normally developed edge markings.	Underexposure
Contrasty negatives, with strongly markings. Unexposed areas very dense.	Overdevelopment. Incorrect time or temperature in processing. Developer concentrate incorrectly diluted.

MISCELLANEOUS MANUFACTURERS

The Compact Photo-Lab-Index

NEGATIVE FAULTS	PROBABLE EXPLANATIONS
Excessively contrasty negatives. Unexposed areas very dense. Strongly developed edge markings.	As above - but errors more serious **or** Print Developer Additive in developer used to process films.
Negatives of fairly normal contrast, but degraded and heavy with dense brown unexposed areas.	Contamination of developer with Bleach-Fix.
Negatives dense by transmitted light and appear opaque by reflected light. From the back, by reflected light, heavier densities show up as lighter blue-gray areas.	Insufficient Bleach-Fixing. Incorrect time and/or temperature. Use of exhausted or weak Bleach-fix. Immerse film in fresh Bleach-Fix until film is completely bleached and then re-wash.
Irregular stained areas.	Insufficient rinsing after development and/or insufficient agitation in the early stages of bleach-fixing. May also be caused by cinch-marks, buckling of the film before processing and by coils of the film touching during processing.

PRINT PROCESSING

Photocolor II has been primarily designed to process Kodak Ektacolor 37RC and 74RC, Sakuracolor and similar resin coated papers. For this purpose *only* the Print Developer Additive must be added to the Color Developer.

Agfacolor Type 4 PE paper may also be processed, but in this case the Additive is *not* required and processing must be carried out at 32°–34°C. Many users have been very satisfied with this combination, although contrast and color saturation are somewhat lower than the paper is capable of giving.

MIXING THE PRINT DEVELOPER ADDITIVE

Make up a convenient quantity of Color Developer by diluting the concentrate 1 + 2 – or use developer in which films have been processed (see below).

Measure the additive carefully using the measure provided or an accurate glass measure. *Do not measure additive in transparent plastic (polystyrene) measures, since these are affected by the solvent which it contains.*

Use Additive in proportion of 2 ml to each 100 ml of working strength developer (preferably at processing temperature) and stir briskly with a glass or plastic rod for a minute or two, until all the oily globules have dissolved.

Developer in which films have been processed may be used to develop prints provided that not more than two 36 exp. 35 mm films *or* two No. 120 roll films *or* four 20 exp. 35 mm films have been processed in 300 ml. For Ektacolor 37RC and 74RC and similar papers add and dissolve the Print Additive as for fresh developer. Increase the recommended developing time by 10% for each 36 exp. 35 mm or No. 120 roll film developed in 300 ml, or by 5% for each 20 exp. 35 mm film.

HANDLING COLOR PRINTING PAPERS

Being panchromatic, these papers must be handled in complete darkness or, with care, using the makers' recommended safelights, e.g. Kodak No. 10 or No. 13 or Agfa Gevaert No. 08. *Amber, orange and red safelights used for black and white photography are NOT suitable.*

The emulsion surface is very sensitive to finger marks and should never be handled with fingers which are damp or contaminated with chemicals.

The Compact Photo-Lab-Index

TRAY PROCESSING

Many home photographers prefer to use developing drums, particularly when only limited darkroom facilities are available — but tray development has some advantages.

Ordinary developing trays may be used and prints of any size processed without having to preheat a drum and wash and dry it each time. The temperature can be maintained by means of a tray heater or by floating the trays in a water-bath. Temperature control of the stop bath and bleach fix is less critical than that of the developer.

An effective darkroom is, however, essential and the use of print tongs or rubber gloves is strongly recommended to avoid contact between the chemicals and the skin.

DRUM PROCESSING

In drum processing the paper has to be loaded into the drum in the dark but processing can be carried out in normal room light. For success, particular care must be taken to standardize the time and temperature of development, and to wash the drum thoroughly and dry it before re-use.

Each drum requires a certain minimum volume of solution to process a print and this is specified by the maker. Most drums for 10 × 8 inch prints require between 45 and 60 ml.

For the best and most consistent results this volume of Developer should be used for one print only, but greater economy can be obtained by using the replenishment system detailed later. The Bleach-Fix may be reused.

All drum makers supply instructions for maintaining the correct processing temperature by pre-heating the drum after the paper has been loaded. A quantity of water at a pre-determined temperature is poured into the drum, left for approximately 1 minute and then drained away before the developer is poured in.

It is usually recommended that the processing solutions should be poured into the drum at room temperature, the temperature of the pre-heated water being sufficiently high to bring both drum and developer to the processing temperature required. This works well at lower processing temperatures (32°–34°C) but at the higher processing temperatures (36°–38°) this would necessitate the use of pre-heated water at too high a temperature for the paper, resulting in staining. At processing temperatures of 36°–38°C it is therefore recommended that the solutions should be warmed to the chosen processing temperature, in addition to pre-heating the drum.

The pre-heated water temperature should not exceed 50°C.

Whichever method is used it is strongly recommended that a 'dummy run' should be made, without loading the tank and using water in place of developer. The temperature of the 'developer' when it leaves the drum should be no more than 1°–2°C lower than the target temperature. Alternatively the developing time should be adjusted to correspong with the developer temperature. Slight over-development is preferable to under-development.

As a guide the table gives approximate pre-heated water temperatures for an average 10 × 8 inch drum using 250 ml water for 1 minute.

DRUM PREHEATING

Pre-heat Temperatures (using 250 ml water in an 8 × 10 inch print drum)

Processing Temperature	Room Temperature			
	15°C (59°F)	20°C (68°F)	25°C (77°F)	30°C (86°F)
38°C (100°F)	—	49°C (120°F)	47°C (117°F)	44°C (111°F)
36°C (97°F)	50°C (122°F)	43°C (109°F)	41°C (106°F)	40°C (104°F)
34°C (93°F)	46°C (115°F)	40°C (104°F)	38°C (100°F)	37°C (99°F)
32°C (90°F)	42°C (108°F)	37°C (99°F)	35°C (95°F)	34°C (93°F)

MISCELLANEOUS MANUFACTURERS

PAPER PROCESSING TIMES

Kodak Ektacolor 37RC and 74RC, Sakuracolor, (with additive)

Pre-heat (if processing drum is used)	one minute			
Dev. Temperature	32°C	34°C	36°C	38°C
Color Develop	3¾ min	3 min	2½ min	2 min
Stop Bath	10 sec	10 sec	10 sec	10 sec
Bleach-Fix	1¼ min	1½ min	1¼ min	1 min
Wash	3 min	2 min	1¾ min	1½ min

Agfacolor Type 4 (without additive)

Pre-heat (if processing drum is used)	one minute	
Dev. Temperature	32°C	34°C
Color Develop	3¾ min	3 min
Stop Bath	10 sec	10 sec
Bleach-Fix	1¼ min	1½ min
Wash	3 min	2 min

PHOTOCOLOR II
WITH ADDITIVE:
'EKTACOLOR' 37RC/74RC
 SAKURACOLOR
WITHOUT ADDITIVE:
 AGFACOLOR TYPE 4

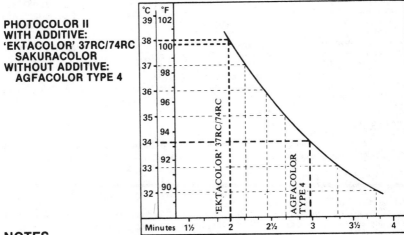

NOTES

PRE-HEATING.
Standardize the pre-heating procedure — temperature and time — as closely as possible, otherwise inconsistent results will be obtained. Drain the tank thoroughly before adding the developer.

MISCELLANEOUS
MANUFACTURERS

625

DEVELOPMENT.

After use the developer will usually become colored due to dyes dissolved from the emulsion of films and/or papers. This does not affect the performance of the developer.

Take every possible precaution not to contaminate the developer with other chemicals, particularly with Bleach-Fix. Even a few drops of Bleach-Fix will seriously affect color balance, and quality of the prints.

STOP BATH/WATER RINSE.

The advantage of an acid stop bath is that it arrests development immediately, reduces the risk of staining when the print is transferred to the Bleach-Fix (particularly if agitation is not efficient in the early stages) — and needs less frequent replacement. However, a water rinse is quite sufficient provided that the water is changed frequently.

DRYING.

After washing remove surface water (using a blade squeegee or synthetic sponge) from both sides of the print. Prints will dry very quickly if placed face upwards on a print dryer (without the cloth) or are dried using a fan heater or hair dryer. They will also dry quite quickly if left face upwards in a warm room. Do not attempt to ferrotype them.

ASSESSING COLOR BALANCE.

Prints on 'Ektacolor' 37RC and 74RC and similar papers change noticeably on drying, and the difference between viewing in artificial light and daylight can also be considerable. Whenever possible prints should be evaluated after drying and in daylight.

CAPACITY

Using tray processing at least 25 8 × 10 prints (equivalent to 36 whole plates, 65 half-plates or 100 enprints) can be developed in a litre of working strength developer without appreciable change in color balance and with only about 20% increase in the developing time. For example, when using 1 litre of solution and developing 8 × 10 inch prints at 38°C increase the developing time by 5 seconds after every 5 prints. By further prolonging the developing time as many as 40 8 × 10 inch prints have been developed in a litre of developer.

Using a processing drum on a one-shot basis the capacity will, of course, depend on the minimum quantity of developer required. For example, if 60 ml developer is needed for an 8 × 10 inch print, the capacity of 1 litre of solution will be 1000/60 or say 16 prints. However, this figure can be greatly increased using the following replenishment method, which depends on the addition to the developer after each print of a small quantity of solution at a somewhat higher concentration. This solution is made up as follows, or, of course, in any convenient quantity pro rata:

REPLENISHER SOLUTION

	'Ektacolor' 37RC and 74RC	Agfacolor Type 4
Color Developer Concentrate	100 ml	100 ml
Water	150 ml	150 ml
Print Developer Additive	6 ml	—

Develop the first print in normal print developer (as recommended for the paper in use) using the quantity recommended for the processor.

After development pour this developer back into measure and add to it a quantity of replenisher solution equal to 1/5 the volume of the original developer, e.g. if 60 ml developer was used for the first print add 60/5 = 12 ml replenisher.

Use this to develop the second print, increasing the original developing time by 25%. Pour this used solution back into a measure and add the same volume of replenisher (taking the example given this would be a further 12 ml) before developing the third print. Using this method the developing time for the third, and subsequent, prints will be the same as for the second.

The developer can usually be replenished in this way at least 5 times but the efficiency of

MISCELLANEOUS MANUFACTURERS

the process depends to some extent on the care taken to drain the pre-heat water. It is also most important to wash the drum thoroughly after use since any slight contamination will have a cumulative effect.

Bleach-Fix has a greater capacity than Developer and may be reused for more than one print. When using Developer on a "one-shot" basis use 60 ml of Bleach-Fix for *two* 8 × 10 inch prints.

When greater economy is required, measure out a convenient quantity of Bleach-Fix (greater than the minimum required by the drum) and calculate its capacity on the basis of 15 ml working strength solution per 8 × 10 inch print, e.g. 90 ml may be used for 90/15 = six 8 × 10 inch prints.

PRINTING FILTERS

Correctly exposed color negatives processed in Photocolor II can be printed by commercial laboratories and, of course, prints can be made from commercially processed negatives.

The basic principles for determining correct filtration and exposure are common to all color printing processes, whatever the film, paper or chemicals used. Details are regularly published in photographic magazines or can be obtained from one of the many popular books on color photography.

Most modern enlargers make provision for color printing — either in the form of filter drawers in which the sheet filters can be placed, or in the form of 'color heads' with built-in filters controlled by dials. It is important to note that the numbers designating the strengths of filters differ from manufacturer to manufacturer, so that it is difficult to discuss filtration except on the basis of one particular make of filters or color head.

Filtration wil also depend on the make of film and printing paper used, subject lighting, enarger illuminant, etc. — and is also affected by variations in negative and print processing. Photographers are strongly advised to keep to one make of film and paper, at least for the time being, and to do everything possible to standardize methods of processing. It is important to follow the instructions as carefully as possible, but even more important to work in exactly the same way each time. In this way it will be found possible to establish a filter pack which will give reasonably correct color balance with the majority of negtives. With a little practice, only one or two test strips will then be needed to obtain optimum results from individual negatives.

When printing Kodacolor II and similar negatives, fairly heavy yellow and magenta filtration is usually needed. Cyan filters are not normally used. An ultraviolet filter (e.g. Kodak CP2B) should always be included in the filter pack.

As a rough guide, printing on Ektacolor 37RC paper using an enlarger with a line voltage lamp and Kodak CP filters, it may be necessary to use a pack consisting of CP100Y and CP80M. Using an enlarger with a halogen lamp and dichroic filters the filtration will be approximately 95Y + 85M.

In view of these high filtrations it is usually convenient to keep a basic filter permanently in the filter drawer. This could consist of a CP40R (red) filter — or CP40Y + CP40M. Alternatively a piece of unexposed but processed film sandwiched together with the negative will have a similar effect. This will avoid the risk of running out of sheet filters or running off the scale when using dichroic filters.

Ektacolor 74RC paper, which will eventually replace 37RC gives excellent results in Photocolor II.

Compared with Ektacolor 37RC, this paper requires rather less filtration (by about 15Y) and only about half the exposure.

NEGATIVE FAULTS	PROBABLE EXPLANATIONS
Prints (including borders) have an overall pink stain.	Contamination of Color Developer with Bleach-Fix. Even slight contamination will produce a noticeable stain. More serious contamination can give heavy staining and also accentuates magenta and cyan, resulting in heavy degraded colors with a strong violet cast. The presence of Bleach-Fix in the Developer tends to change its color from the normal clear emerald green of used solution to a dirty yellowish green.
Prints normal but with areas of pink and/or green stain.	Insufficient rinsing after development. Rinse or stop bath may need replacement. May be insufficient agitation in the rinse and/or in the Bleach-Fix. In tray development if more than one print is processed at the same time, care must be taken to ensure sufficient agitation and keep prints separated.
Prints (including borders) have an overall green stain.	Failure to wash out print processor thoroughly. Contamination of pre-heat water with Bleach-Fix.
Prints (including borders) have an overall orange tint.	Fogging by stray light, light from luminous clocks, unsafe safe lights, etc. Too long exposure to a safe-light.
Prints (including borders) have an overall gray tint.	Insufficient bleach-fixing. Exhausted or over-diluted solution. Incorrect time or temperature. Inadequate agitation.
Prints of low contrast with yellow cast.	Under-development. Exhausted developer. Temperature too low, e.g. inadequate pre-heating of a drum processor.
Finger marks.	Paper handled with damp or contaminated fingers.
Red or yellow scratch marks on print surface.	Abrasion of wet emulsion by print tongs, finger-nails, etc.
Over-dense prints with magenta cast — probably with degraded highlights.	Over-development. Temperature too high, e.g. too much pre-heating of a drum processor.
Prints on Agfacolor Type 4 paper have an overall pink or orange stain.	Processing at temperature above 35°C or use of an intermediate water rinse at a temperature higher than that of the developer.

MISCELLANEOUS MANUFACTURERS

SPRINT DIRECT POSITIVE (REVERSAL) B&W FILM & PRINT PROCESSING

The Sprint Direct Positive Chemistry is designed as a reversal process for b&w films and papers. Positive b&w slides and prints can be made directly in the camera, or from transparencies. Some of the materials that can be processed in this way are:

B&W Direct Positive (DP) transparencies on:
Kodak Panatomic-X, Plus-X, Tri-X, Infrared, *Kodalith,* and *Verichrome Pan.*
Ilford HP5

B&W DP Prints on:
Kodak Panalure II and Superspeed DP *Panchromatic*

Copy Negatives on:
Kodak Fine Grain Positive Film

The following Sprint B&W concentrates and converters are used for the processing of above materials:

QUICKSILVER Print Developer	QUICKSILVER Reversing Converter 1
BLOCK Stop Bath	QUICKSILVER Exposing Converter 2
RECORD Speed Fixer	QUICKSILVER Accelerating Converter 3
RECORD Alum Hardening Converter	DIRECT POSITIVE Silver Bleach
ARCHIVE Fixer Remover	ARCHIVE Prefix Converter
END RUN Wetting Agent & Stabilizer	

EXPLANATION

The Sprint DP processes all operate in basically the same way. DP is a reversal of normal development which produces positive b&w slides instead of negatives on b&w film, and positive images on b&w printing paper from slides or camera exposure instead of from negatives. For example, DP processing of b&w film produces slides in the following way:

The **First Developer** reduces all silver bromide crystals exposed to light into metallic silver, developing the negative image through to the film base.

The **Silver Bleach** removes this developed metallic silver from the emulsion, leaving only the unexposed and undeveloped silver bromide crystals on the film.

The **Fixer Remover** washes out the bleach solution.

The **Redeveloper,** which contains an automatic exposing agent, develops the remaining silver bromide crystals into metallic silver, which is the direct positive image.

The **Prefix** neutralizes and stops redevelopment, prevents staining from reprecipitated silver, and prepares film for fixing.

The **Fixer** eliminates any silver crystals which did not chemically react in the process, and increases transparency.

USING LIQUIDS

All Sprint products are available in liquid form to permit uniform mixing in any desired volume. The HOW TO MIX directions for each process give examples for preparing approximately one-liter volumes of working solution. Any volume may be mixed using the indicated proportions and dilutions. Metric volumes are recommended for accuracy and convenience.

Some concentrates, such as BLOCK Stop Bath, DIRECT POSITIVE Silver Bleach, and ARCHIVE Fixer Remover, are to be mixed as a "1:9 working solution." To do this, dilute any one part of the concentrate with nine parts water. For example, to make one liter of 1:9 working solution:

MISCELLANEOUS MANUFACTURERS

$$
\begin{array}{r}
100 \text{ ml concentrate} \\
+ \quad 900 \text{ ml water} \\
\hline
1000 \text{ ml 1:9 working solution}
\end{array}
$$

Other B&W concentrates, such as RECORD Speed Fixer and END RUN Wetting Agent & Stabilizer, are to be mixed "as directed on container" the same as for conventional b&w processing.

VOLUME MEASUREMENT

For accuracy and best results, especially when measuring Converters, use a graduated beaker for volumes over 100 ml, a graduated cylinder for volumes 10-100 ml, and a measuring pipette and bulb (do not apply suction with mouth) for volumes under 10 ml. Read liquid volumes at the bottom of the meniscus. Sprint Developer Converters tolerate a ±2% error in measurement. Sprint Developer concentrates tolerate a ±5% error. Other Sprint B&W concentrates and Converters tolerate a ±10% error.

DEVELOPMENT & THE SPRINT CHART

Development directions for each DP process give Chart Letters (A, B, C...) instead of a time and temperature. Each letter is a code for *all* the combinations of time and temperature of development which will give one particular result. All equivalent time/temperature combinations are found in one line on the Sprint Development Chart, designated by the letter. A complete chart is provided below.

To use the chart: First determine the Chart Letter recommended for the process, and then choose any convenient time/temperature combination in that line on the chart. Each subsequent line (in alphabetical order) represents an increase in development of approximately 15%.

When developing sheets of film or prints in a tray, it is not necessary to maintain a constant temperature for consistent results. As the temperature varies, adjust the development *time* using the chart.

TEMPERATURE

Select temperature from within the range 18-25 °C (64.5-77 °F). Use all solutions in the process at the temperature selected for development. Use Pre-wet Water at exactly the same temperature as the first developer. Pre-wet and Developer controls are the most critical, and will tolerate ± ⅓ °C error. All other steps tolerate at least ± 1½ °C error, and do not require adjustment of timing to temperature.

For best results, use a thermometer calibrated to within ± ⅓ °C (.6 °F).

AGITATION

Agitate films and prints continuously for the first minute of each step. Follow with a cycle of agitation for 10-15 seconds of each minute thereafter.

In development steps, if times are shorter than 6 minutes, this cycle should be for 10-15 seconds of each *half*-minute. If time is shorter than 3 minutes, agitate continuously.

For films, use only enough solution to cover reels in tanks, leaving an air space for agitation with bubbles.

For sheet films and prints in trays, sheets should move 1-2 inches per second through solutions.

PREFIXING

The Prefixer solution gives DP slides and prints cleaner and more neutral tones. The Prefix Converter may be omitted for warmer tones. Use BLOCK Stop Bath 1:9 working solution instead.

MISCELLANEOUS MANUFACTURERS

The Compact Photo-Lab-Index

SPRINT'S DEVELOPMENT TIMING SYSTEM

Directions for use. Locate known Temperature/Time combination. Note chart letter. Use any Temperature/Time combination that is convenient.*

	18°C 64.5°F	19°C 66°F	20°C 68°F	21°C 70°F	22°C 71.5°F	23°C 73.5°F	24°C 75°F	25°C 77°F	26°C 79°F	27°C 80.5°F	28°C 82.5°F	29°C 84°F	30°C 86°F	31°C 88°F	32°C 89.5°F	33°C 91.5°F	34°C 93°F	35°C 95°F	36°C 97°F	37°C 98.5°F	38°C 100.5 F	39°C 102°F	40°C 104°F	
AAA	1:14	1:07	1:00	:54	:49	:46	:40	:36	:32	:29	:26	:23	:21	:19	:17	:16	:14	:12	:11	:10	:09	:08	:07	AAA
AA	1:26	1:18	1:10	1:03	:57	:51	:46	:42	:38	:34	:31	:28	:25	:22	:20	:18	:16	:15	:13	:12	:11	:10	:09	AA
A	1:44	1:34	1:25	1:17	1:09	1:02	:57	:51	:46	:41	:37	:34	:30	:27	:24	:22	:20	:18	:16	:14	:13	:12	:11	A
B	1:57	1:45	1:35	1:26	1:17	1:10	1:03	:57	:51	:46	:41	:37	:34	:30	:27	:25	:22	:20	:18	:16	:14	:13	:12	B
C	2:15	2:00	1:50	1:39	1:29	1:21	1:13	1:05	:59	:53	:48	:43	:39	:35	:32	:29	:26	:23	:21	:19	:17	:15	:14	C
D	2:35	2:20	2:05	1:53	1:42	1:32	1:23	1:14	1:07	1:00	:55	:49	:44	:40	:36	:32	:29	:26	:24	:22	:19	:17	:15	D
E	3:00	2:40	2:25	2:10	1:58	1:46	1:36	1:26	1:18	1:10	1:03	:57	:51	:46	:41	:37	:34	:31	:28	:25	:21	:19	:17	E
F	3:29	3:08	2:50	2:33	2:18	2:05	1:52	1:40	1:31	1:22	1:14	1:07	1:00	:56	:49	:44	:40	:36	:33	:29	:26	:23	:21	F
G	4:00	3:37	3:08	2:56	2:38	2:23	2:09	1:55	1:44	1:34	1:25	1:17	1:09	1:02	:56	:50	:46	:41	:37	:34	:30	:27	:24	G
H	4:45	4:15	3:45	3:23	3:05	2:45	2:29	2:15	2:01	1:49	1:38	1:28	1:20	1:12	1:05	:58	:52	:47	:43	:38	:35	:32	:28	H
I	5:15	4:45	4:15	3:50	3:27	3:05	2:48	2:30	2:17	2:03	1:51	1:40	1:30	1:22	1:13	1:06	1:00	:53	:49	:44	:39	:35	:32	I
J	6:15	5:30	5:00	4:30	4:00	3:40	3:18	2:58	2:41	2:25	2:11	1:57	1:46	1:36	1:26	1:18	1:10	1:03	:57	:51	:46	:42	:37	J
K	7:00	6:15	5:45	5:15	4:45	4:15	3:48	3:25	3:05	2:47	2:30	2:16	2:02	1:50	1:39	1:29	1:20	1:12	1:05	:59	:53	:48	:43	K
L	8:00	7:15	6:30	5:45	5:15	4:45	4:15	3:52	3:29	3:08	2:50	2:33	2:18	2:04	1:52	1:41	1:31	1:22	1:14	1:07	1:00	:54	:49	L
M	9:15	8:15	7:30	6:45	6:00	5:30	5:00	4:30	4:00	3:37	3:16	2:56	2:39	2:23	2:10	1:56	1:45	1:35	1:25	1:17	1:10	1:03	:57	M
N	10:30	9:30	8:30	7:45	7:00	6:15	5:30	5:00	4:30	4:00	3:38	3:16	2:57	2:40	2:24	2:10	1:57	1:45	1:32	1:25	1:17	1:09	1:03	N
O	12:30	11:00	10:00	9:00	8:00	7:15	6:30	5:45	5:30	4:45	4:15	3:56	3:32	3:12	2:52	2:36	2:20	2:06	1:54	1:42	1:32	1:23	1:15	O
P	14:00	13:00	11:30	10:30	9:15	8:30	7:30	6:45	6:00	5:30	5:00	4:30	4:00	3:42	3:15	3:00	2:45	2:30	2:11	1:59	1:46	1:32	1:26	P
Q	16:00	14:30	13:00	11:45	10:30	9:30	8:30	7:45	7:00	6:15	5:45	5:00	4:30	4:00	3:42	3:22	3:00	2:43	2:26	2:12	1:59	1:47	1:37	Q
R	18:30	17:00	15:00	13:30	12:30	11:00	10:00	9:00	8:00	7:15	6:30	5:45	5:15	4:45	4:15	3:53	3:30	3:10	2:51	2:34	2:19	2:05	1:53	R
S	21:00	19:00	17:00	16:00	14:00	13:00	11:15	10:00	9:00	8:00	7:15	6:45	6:00	5:30	5:00	4:30	3:50	3:34	3:13	2:54	2:37	2:22	2:08	S
T	25:00	23:00	20:00	18:30	16:00	14:30	13:00	11:30	10:00	9:00	8:00	7:15	7:00	6:15	5:45	5:15	4:45	4:15	3:48	3:25	3:05	2:47	2:31	T
U	28:00	25:00	23:00	21:00	18:30	17:00	15:00	13:30	12:00	11:00	10:00	9:00	8:00	7:15	6:30	6:00	5:30	5:00	4:30	3:56	3:32	3:05	2:52	U
V	31:00	28:00	25:00	22:30	20:30	18:30	16:30	15:00	13:30	12:00	11:00	10:00	9:00	8:30	7:45	7:00	6:30	5:15	5:00	4:15	3:51	3:28	3:08	V
W	37:00	33:00	30:00	27:00	24:00	22:00	20:00	18:00	16:00	14:30	13:00	11:45	10:30	9:30	8:30	7:45	7:00	6:15	5:45	5:00	4:30	4:15	3:45	W
X	43:00	39:00	36:00	33:00	30:00	27:00	24:00	21:00	19:00	17:00	15:00	13:30	12:30	11:00	10:00	9:00	8:15	7:30	6:45	6:00	5:30	5:00	4:30	X
Y	49:00	44:00	40:00	36:00	33:00	29:00	26:00	24:00	21:30	19:30	17:30	15:30	14:00	11:30	10:30	9:30	9:00	8:30	7:30	6:45	6:15	5:30	5:00	Y
Z	56:00	50:00	45:00	41:00	37:00	32:00	29:00	27:00	24:00	21:30	19:30	17:30	16:00	14:30	13:00	11:45	10:30	9:30	8:30	7:45	7:00	6:15	5:30	Z
ZZ	74:00	67:00	60:00	54:00	49:00	44:00	40:00	36:00	32:00	29:00	27:00	23:00	21:00	19:00	17:00	15:30	14:00	12:30	11:30	10:15	9:15	8:15	7:30	ZZ
ZZZ	86:00	78:00	70:00	63:00	57:00	51:00	46:00	42:00	38:00	34:00	30:00	27:00	25:00	22:30	20:00	18:00	16:30	15:00	13:30	12:00	10:45	9:45	8:45	ZZZ

*Most black & white films should remain below 25°C. Certain color films will not tolerate great temperature deviation.

© 1978 Sprint Systems of Photography, Inc.

MISCELLANEOUS MANUFACTURERS

The Compact Photo-Lab-Index

FIXING

In DP Slide processes, extending fixing times up to 10 minutes will maximize highlight transparency. This is especially useful when copying line drawings or charts.

WATER WASHES

There should be a complete exchange of water (empty and refill) three times per minute in all wash steps. Most automatic film washers exchange water only once every 6-10 minutes.

ARCHIVAL PERMANENCE

All DP Slide processes with Sprint are designed for archival permanence, when the final Water Wash step is a full 3 minutes.

SELENIUM TONING

DP Slides may be toned in selenium to increase shadow contrast; ARCHIVE Fixer Remover is an excellent vehicle for selenium toner.

TO TONE: Add up to 20 ml rapid selenium toner concentrate to each liter of ARCHIVE Fixer Remover 1:9 working solution. Agitate films in this solution for up to 1 minute, and follow with the final wash step. Toned slides will have a neutral color.

SAFETY PRECAUTION

DIRECT POSITIVE Silver Bleach contains sulfuric acid and potassium dichromate and may cause severe burns of skin, eyes, and clothing upon contact. Protection against contact with skin and eyes is IMPERATIVE with this solution. Store below eye level. In case of contact flood with water for 15 minutes; if swallowed dilute with milk or water; notify a physician immediately.

QUICKSILVER Exposing Converter 2 contains caustics and may cause burns of skin or eyes: In case of contact flood with water for 15 minutes and notify a physician.

All photographic chemicals are potentially dangerous. Use only as directed. Keep out of children's reach. Protect hands with tongs, rubber gloves, or plastic bags as mittens.

Avoid contamination of chemicals and working solutions in DP processes. Contamination of first developer working solutions in particular will impair results. Wash all utensils; do not interchange caps of containers; keep hands and work area clean. **DIRECT POSITIVE Silver Bleach** is corrosive: check caps periodically for deterioration.

CAPACITY

Working solutions have the following capacities per liter:

First Developer 5 rolls of film* OR 15 8 × 10 prints
Stop, Bleach, Bleach Remover,
 Redeveloper 15 rolls of film* OR 30 8 × 10 prints
Prefix, Fixer, Fixer Remover,
 Stabilizer 30 rolls of film* OR 60 8 × 10 prints
*35mm 36 exposure film or equivalent.

SHELF LIFE

Developer and **Redeveloper** working solutions have a shelf life of at least one day.

Prefixer working solution has a shelf life of at least one week, stored with up to 25% air in the container.

Silver Bleach working solution has a shelf life of at least 3 months, stored with up to 25% air in the container.

All other solutions and concentrates have shelf lives as indicated on their labels.

MISCELLANEOUS MANUFACTURERS

DIRECT POSITIVE B&W SLIDES FROM PANATOMIC-X FILMS

CHECKLIST

- ☐ QUICKSILVER Print Developer
- ☐ QUICKSILVER Reversing Converter 1
- ☐ QUICKSILVER Exposing Convert 2
- ☐ DIRECT POSITIVE Silver Bleach
- ☐ BLOCK Stop Bath
- ☐ RECORD Speed Fixer
- ☐ RECORD Alum Hardening Converter
- ☐ ARCHIVE Fixer Remover
- ☐ ARCHIVE Prefix Converter—(optional)
- ☐ END RUN Wetting Agent & Stabilizer

In DP processes, other manufacturer's chemistry is NOT compatible with, and may NOT be substituted for, Sprint products.

PROCEDURE

		Timing in Minutes	(Range)
Step 1.	Water Pre-wet	1	(1-3)
Step 2.	Develop	see EXPOSURE RECOMMENDATIONS	
Step 3.	Stop	1	(1-3)
Step 4.	Water Wash	1	(1-3)
Step 5.	Bleach	1	(1-3)
Step 6.	Water Wash	1	(1-3)
Step 7.	Remove Bleach	1	(1-3)
Step 8.	Water Wash	1	(1-3)
Step 9.	Redevelop	2	(2-3)
Step 10.	Prefix	1	(1-3)
Step 11.	Fix	1	(1-10)
Step 12.	Water Wash	1	(1-3)
Step 13.	Remove Fixer	1	(1-3)
Step 14.	Water Wash	2	(1-3)
Step 15.	Stabilize	1	(1-3)
Step 16.	Squeegee & Dry		

HOW TO MIX

Step 2. Dilute **QUICKSILVER Print Developer** concentrate 1:9 with water. To each liter of diluted Print Developer, add 15 ml* **QUICKSILVER Reversing Converter 1**. For example:

 100 ml **QUICKSILVER Print Developer** concentrate
 900 ml water
+ 15 ml **QUICKSILVER Reversing Converter 1***

 1015 ml **DP Developer** for *Panatomic-X* Film

 *For brighter slides with more transparent highlights, mix with *16-18* ml QUICKSILVER Reversing Converter 1 instead of 15 ml per liter.

Step 3. Mix **BLOCK Stop Bath** 1:9 working solution. Reuse Step 3 only.

Step 5. Mix **DIRECT POSITIVE Silver Bleach** 1:9 working solution.

WARNING: DIRECT POSITIVE Silver Bleach may cause burns on contact with skin or eyes. Protect hands and use with caution.

MISCELLANEOUS MANUFACTURERS

633

Step 7. Mix **ARCHIVE Fixer Remover** 1:9 working solution. Do NOT reuse this solution for Step 13.

Step 9. Dilute **QUICKSILVER Print Developer** concentrate 1:9 with water. To each liter of diluted Print Developer, add 30 ml **QUICKSILVER Exposing Converter 2.** For example:

> 100 ml **QUICKSILVER Print Developer** concentrate
> 900 ml water
> + 30 ml **QUICKSILVER Exposing Converter 2**
> _____
> 1030 ml **DP Redeveloper** for *Panatomic-X* film

Step 10. Dilute **BLOCK Stop Bath** concentrate 1:9 with water. To each liter of diluted Stop Bath, add 20 ml **ARCHIVE Prefix Converter.** Do NOT use Step 3 solution. For example:

> 100 ml **BLOCK Stop Bath** concentrate
> 900 ml water
> + 20 ml **ARCHIVE Prefix Converter**
> _____
> 1020 ml **Prefixer** working solution

For warmer-toned slides, omit Prefix Converter from this solution.

Step 11. Mix **RECORD Speed Fixer** 2:8 working solution for Films with **RECORD Alum Hardening Converter** as directed on container.

Step 13. Mix **ARCHIVE Fixer Remover** 1:9 working solution. Mix fresh and reuse for this step only of this process.

Step 15. Mix **END RUN Wetting Agent & Stabilizer** 1:99 working solution as directed on container.

EXPOSURE RECOMMENDATIONS

Expose Panatomic-X for desired contrast in DP slides.

Recommended ASA ratings for copying should be used with a placed reading from a white card plus 2 stops. For ordinary shooting, use incident meter readings at the ASA rating recommended below.

Low Contrast ASA 32 Chart Line **J**
For copying original photographs to
closely match the projected image with
the original.

Normal Contrast ASA 80 Chart Line **N**
For copying reproductions of photographs
and for general photography.

Use any time/temperature combination in the Chart Line for Step 2 Development. See GENERAL DIRECTIONS for explanation.

CONTRAST ADJUSTMENTS

The highlight and shadow density of the slides may be adjusted slightly in processing.

When mixing **Step 2 Developer**, increasing the **Converter 1** up to 18 ml per liter will brighten highlights. To brighten shadow detail, dilute the **Print Developer** concentrate 2:8 with water instead of 1:9, *OR* add 20-25 ml **QUICKSILVER Accelerating Converter 3** to the normal recommended solution to increase contrast.

For more neutral tones, especially in highlights, reduce the **Converter 2** in Step 9 **Redeveloper** to only 2-5 ml *and* extend processing time in th is step to Chart Line **N**.

MISCELLANEOUS MANUFACTURERS

DIRECT POSITIVE B&W SLIDES FROM PLUS-X, TRI-X, HP5, AND INFRARED FILMS

CHECKLIST

- ☐ QUICKSILVER Print Developer
- ☐ QUICKSILVER Reversing Converter 1
- ☐ QUICKSILVER Exposing Converter 2
- ☐ QUICKSILVER Accelerating Converter 3
- ☐ DIRECT POSITIVE Silver Bleach
- ☐ BLOCK Stop Bath
- ☐ RECORD Speed Fixer
- ☐ RECORD Alum Hardening Converter
- ☐ ARCHIVE Prefix Converter—(optional)
- ☐ ARCHIVE Fixer Remover
- ☐ END RUN Wetting Agent & Stabilizer

In DP processes, other manufacturer's chemistry is NOT compatible with, and may NOT be substituted for, Sprint products.

PROCEDURE STEPS TIMING IN MINUTES (Range)

Step		Timing	Range
Step 1.	Water Pre-wet	1	(1-3)
Step 2.	Develop	see EXPOSURE RECOMMENDATIONS	
Step 3.	Stop	1	(1-3)
Step 4.	Water Wash	1	(1-3)
Step 5.	Bleach	1	(1-3)
Step 6.	Water Wash	1	(1-3)
Step 7.	Remove Bleach	1	(1-3)
Step 8.	Water Wash	1	(1-3)
Step 9.	Redevelop	2	(2-3)
Step 10.	Prefix	1	(1-3)
Step 11.	Fix	see FIXING	(1-10)
Step 12.	Water Wash	1	(1-3)
Step 13.	Remove Fixer	1	(1-3)
Step 14.	Water Wash	2	(1-3)
Step 15.	Stabilize	1	(1-3)
Step 16.	Squeegee & Dry		

HOW TO MIX

Step 2. Dilute **QUICKSILVER Print Developer** concentrate 3:7 with water. To each liter of diluted Print Developer add 25 ml **QUICKSILVER Reversing Converter 1** and 20-25 ml **QUICKSILVER Accelerating Converter 3.*** For example:

> 300 ml **QUICKSILVER Print Developer** concentrate
> 700 ml water
> 25 ml **QUICKSILVER Reversing Converter 1**
> + 25 ml **QUICKSILVER Accelerating Converter 3***
> ———————————————————————————
> 1050 ml **DP Developer** for *Plus-X, Tri-X,* etc.

***Accelerating Converter 3** is too viscous to measure precisely. Any amount between 20-25 ml per liter is correct.

Step 3. Mix **BLOCK Stop Bath** 1:9 working solution. Do NOT reuse for Step 10.

Step 5. Mix **DIRECT POSITIVE Silver Bleach** 1:9 working solution.

MISCELLANEOUS MANUFACTURERS

WARNING: DIRECT POSITIVE Silver Bleach may cause burns on contact with skin or eyes. Protect hands and use with caution.

Step 7. Mix **ARCHIVE Fixer Remover** 1:9 working solution. Do NOT reuse this solution for Step 13.

Step 9. Dilute **QUICKSILVER Print Developer** concentrate 2:8 with water. To each liter of diluted Print Developer, add 30 ml **QUICKSILVER Exposing Converter 2.** For example:

> 200 ml **QUICKSILVER Print Developer** concentrate
> 800 ml water
> + 30 ml **QUICKSILVER Exposing Converter 2**
> _____
> 1030 ml **DP Redeveloper** for *Plus-X, Tri-X,* etc.

Step 10. Dilute **BLOCK Stop Bath** concentrate 1:9 with water. To each liter of diluted Stop Bath, add 20 ml **ARCHIVE Prefix Converter.** Do NOT use Step 3 solution. For example:

> 100 ml **BLOCK Stop Bath** concentrate
> 900 ml water
> + 20 ml **ARCHIVE Prefix Converter**
> _____
> 1020 ml **Prefixer** working solution

For warmer toned slides, omit Prefix Converter from this solution.

Step 11. Mix **RECORD Speed Fixer** 2:8 working solution for films with **RECORD Alum Hardening Converter** as directed on container.

Step 13. Mix **ARCHIVE Fixer Remover** 1:9 working solution.

Step 15. Mix **END RUN Wetting Agent & Stabilizer** 1:99 working solution as directed on container.

EXPOSURE RECOMMENDATIONS

The following exposure rating adjustments and development chart letters are recommended:

Kodak Plus-X	ASA	320	Chart Line **L**
Tri-X		500	Chart Line **O**
Infrared		600*	Chart Line **O**
Ilford HP5		1000	Chart Line **Q**

*May vary with meter's sensitivity to infrared light, and with filters.

Use any time/temperature combination in the Chart Line for Step 2 Development. See GENERAL DIRECTIONS for explanation.

MISCELLANEOUS MANUFACTURERS

UNICOLOR E-6 CHEMISTRY

This chemistry will process all reversal films designed for the E-6 process, including Ektacrome, Fujichrome, etc.

UNICOLOR E-6 CHEMISTRY MIXING INSTRUCTIONS

ALL SIZES

The table below shows how to mix 480ml (16 oz.) of working solutions. To make more or less than this amount multiply or divide by the appropriate factor. Mix the chemicals in the order given and put in labeled storage bottles.

ALL SIZES

To Make	Start with Water	Then Add & Mix This Concentrate	Then Add & Mix This Concentrate
First Developer	8 oz. (240ml)	4 oz. (120ml) 1st Developer Part A	4 oz. (120ml) 1st Developer Part B
Reversal Bath	15 oz. (450ml)	1 oz. (30ml) Reversal Bath	—
Color Developer	11 oz. (330ml)	4 oz. (120ml) Color Developer Part A	1 oz. (30ml) Color Developer Part B
Stop Bath	15 oz. (450ml)	1 oz. (30ml) Stop Bath	—
Bleach	12 oz. (360ml)	4 oz. (120ml) Bleach	—
Fixer	12 oz. (360ml)	4 oz. (120ml) Fixer	—
Stabilizer	15 oz. (450ml)	1 oz. (30ml) Stabilizer	—

MISCELLANEOUS MANUFACTURERS

UNICOLOR E-6 CHEMISTRY PROCESSING STEPS FOR CONVENTIONAL (Nikor, Etc.) FILM TANKS

Always use a *full* processing tank. Film must NOT be subjected to light until completion of Reversal Bath step. Consult text or mixing chart for first developer time additions in partly used solutions.

Step	Solution	Time†	Temperature	Technique	Effects of Time, Temperature, Agitation, etc. on Final Results*
1	First Developer	6½ min.	37.8°C (100°F)	Pour Developer in tank, agitate continuously for first 15 seconds. Agitate 2 seconds each 15 seconds thereafter. Include drain time in total time for this step.	↑ Time, ↑ Temp., ↑ Agitation → Density ↓
2	Water Rinse	2-3 min.	33-39°C (92-102°F)	FILL tank with water & drain. Repeat 5 times. NOTE: Total of 6 rinses is more important than absolute rinse time.	
3	Reversal Bath	2 min.	33-39°C (92-102°F)	Agitate initial 10 seconds & rap tank to dislodge air bubbles.	
				Film can be exposed to light at this point if desired	
4	Color Developer	6 min.	37.2-38.3°C (99-101°F)	Fill tank, agitate continuously for first 15 seconds. Agitate 2 seconds each 15 seconds thereafter.	↑ Time, ↑ Temp., ↑ Agitation → 0 ↓ Time ↓ Temp., ↓ Agitation → Density ↓
5	Stop Bath	1-2 min.	33-39°C (92-102°F)	Fill tank, agitate continuously for first 15 seconds. Agitate 2 seconds each 15 seconds thereafter.	

MISCELLANEOUS MANUFACTURERS

UNICOLOR E6 CHEMISTRY PROCESSING STEPS FOR CONVENTIONAL (Nikor, Etc.) FILM TANKS (Continued)

Step	Solution	Time†	Temperature	Technique	Effects of Time, Temperature, Agitation, etc. on Final Results*
6	Water Rinse	2-3 min.	33-39°C (92-102°F)	Fill and dump with water 6 times in 2-3 min. or use film washup.	Too Little Rinse → Magenta Stains
7	Bleach	3-4 min.	33-39°C (92-102°F)	Fill tank, agitate continuously for first 15 seconds. Agitate 2 seconds each 15 seconds thereafter.	
8	Fixer	2-3 min.	33-39°C (92-102°F)	Fill tank, agitate continuously for first 15 seconds. Agitate 2 seconds each 15 seconds thereafter.	
9	Water Rinse	2-3 min.	33-39°C (92-102°F)	Use water flow sufficient to change water in film tank at least 6 times. Time not critical.	
10	Stabilizer	½-1 min.	Room Temp.	Agitate gently initial 10-15 seconds only to prevent foaming.	Use distilled water to mix stabilizer if hard water spots are a problem.
11	Dry	—	Not over 60°C (140°F)	Hang film by clips or clothes-pins in dust free area.	

†Where a timing range is given, e.g., 2-3 minutes, flexibility is implied, meaning this variable is not critical so long as the minimum is given.

*Only critical variables are listed; their general effects are given as a guideline only. Example: ↑ Time, ↑ Temp., ↑ Agitation → 0 means increasing time, temperature or agitation has little or no effect on final results, within reason.

MISCELLANEOUS MANUFACTURERS

MISCELLANEOUS
MANUFACTURERS

UNICOLOR E-6 CHEMISTRY PROCESSING STEPS FOR UNICOLOR FILM DRUM

See following table for solution required for the size and number of rolls being processed. Times given are for initial films in a set of working solutions. Consult text or mixing chart for first developer time additions in partly used solutions.

Step	Solution	Time†	Temperature	Technique	Effects of Time, Temperature, etc., on Final Results*
1	Water Preheat	1 min.	40.6°C (105°F)	Fill film drum. Let stand 1 minute. Drain at end of step.	↑ Temp. → Density ↓ ↓ Temp. → Density ↑
2	First Developer	6½ min.	40.6°C (105°F)	Add required volume, agitate on Uniroller for required time & drain. Include drain time in total time for this step.	↑ Temp. or ↑ Time → ↓ Density ↓ Temp. or ↓ Time → ↑ Density
3	Water Rinse	2-3 min.	40.6°C (105°F)	Fill film drum with water & drain. Repeat 5 times. Total number of rinses more important than time.	
4	Reversal Bath	2 min.	40.6°C (105°F)	Add required volume, agitate on Uniroller and drain.	↓ Temp. → Density ↓ ↑ Temp. → 0
				Film can be exposed to light at this point if desired	
5	Color Developer	6 min.	40.6°C (105°F)	Add required volume, agitate on Uniroller and drain.	↑ Time or ↑ Temp. → 0 ↓ Time or ↓ Temp. → Density ↓
6	Stop Bath	1-2 min.	32-43°C (90-110°F)	Add required volume, agitate on Uniroller and drain.	

UNICOLOR E-6 CHEMISTRY PROCESSING STEPS FOR UNICOLOR FILM DRUM (Continued)

Step	Solution	Time†	Temperature	Technique	Effects of Time, Temperature etc., on Final Results
7	Water Rinse	2-3 min.	32-43°C (90-110°F)	Fill & dump film drum 6 times in 2-3 min. or use Film Drum Washer.	Too Little Rinse → Magenta Stains
8	Bleach	3-4 min.	32-43°C (90-110°F)	Add required volume, agitate on Uniroller and drain.	
9	Fixer	2-3 min.	32-43°C (90-110°F)	Add required volume, agitate on Uniroller and drain.	
10	Water Rinse	2-3 min.	32-43°C (90-110°F)	Fill & dump film drum 6 times in 2-3 min. or use Film Drum Washer.	
11	Stabilizer	½-1 min.	Room Temp.	Agitate gently initial 10-15 seconds only to prevent foaming.	Use distilled water to mix stabilizer if hard water spots are a problem.
12	Dry	—	Not over 60°C (140°F)	Hang film by clips or clothes-pins in dust free area.	

†Where a timing range is given, e.g., 2-3 minutes, flexibility is implied, meaning this variable is not critical so long as the minimum is given.

*Only critical variables are listed; their general effects are given as a guideline only. Example: ↑ Temp. → 0 means higher temperature has little or no effect on final results, within reason.

MISCELLANEOUS MANUFACTURERS

UNICOLOR E-6 CHEMISTRY PROCESSING STEPS FOR UNICOLOR FILM DRUM (Continued)

Step	Solution	Time†	Temperature	Technique	Effects of Time, Temperature etc., on Final Results
7	Water Rinse	2-3 min.	32-43°C (90-110°F)	Fill & dump film drum 6 times in 2-3 min. or use Film Drum Washer.	Too Little Rinse → Magenta Stains
8	Bleach	3-4 min.	32-43°C (90-110°F)	Add required volume, agitate on Uniroller and drain.	
9	Fixer	2-3 min.	32-43°C (90-110°F)	Add required volume, agitate on Uniroller and drain.	
10	Water Rinse	2-3 min.	32-43°C (90-110°F)	Fill & dump film drum 6 times in 2-3 min. or use Film Drum Washer.	
11	Stabilizer	½-1 min.	Room Temp.	Agitate gently initial 10-15 seconds only to prevent foaming.	Use distilled water to mix stabilizer if hard water spots are a problem.
12	Dry	—	Not over 60°C (140°F)	Hang film by clips or clothes-pins in dust free area.	

†Where a timing range is given, e.g., 2-3 minutes, flexibility is implied, meaning this variable is not critical so long as the minimum is given.

*Only critical variables are listed; their general effects are given as a guideline only. Example: ↑ Temp. → 0 means higher temperature has little or no effect on final results, within reason.

PUSH AND PULL PROCESSING

When Exposure Change is:	Use This ASA Speed:	And Change First Developer Time By:
2 stops under	4× normal	+4 minutes
1 stop under	2× normal	+2 minutes
1 stop over	½ × normal	−2 minutes

PROCESSING PROBLEMS, PROBABLE CAUSE(S) & REMEDY

Problem	Probable Cause(s)	Remedy
Image too light	Overexposure in Camera Too much First Development	Expose film correctly. Use proper time & temperature for all solutions.
Image too dense	Under exposure in Camera Too little First Development	Expose film correctly, Use proper time & temperature of all solutions.
	First Developer exhausted	Don't over extend solution capacity and/or solution storage life.
Milky appearance	Insufficient fixing	Refix in fresh fixer followed by remaining steps.
Brown cast, streaks or mottle	Insufficient bleaching	Rebleach in fresh bleach followed by remaining steps.
Scum or residue on slides after drying	Hard water residue	Mix stabilizer with distilled or deionized water.

Warning: Read and observe all cautionary information provided with this kit. This kit contains the following chemicals which may be dangerous if misused. **Children should use only with adult supervision.**

Concentrate	Contains
First Developer Part A	Hydroquinone
First Developer Part B	Sodium Carbonate
Color Developer Part A	Sodium Phosphate
Color Developer Part B	4-amino-N-ethyl-N-(B-methane sulfanamido-ethyl) m-toluidene sesquisulfate
Stop Bath	Acetic Acid
Bleach	Potassium Bromide & Potassium Ferricyanide
Fixer	Ammonium Thiosulfate
Stabilizer	Formaldehyde
Reversal Bath	Propionic Acid

All of the above concentrates may cause skin irritation. Flush skin thoroughly with water. Harmful if swallowed. Consult specific bottle whether or not to induce vomiting. **Call a physician at once.**
Keep out of reach of children. Use only in well ventilated area.

MISCELLANEOUS MANUFACTURERS

UNICOLOR CHEMISTRY K-2

This chemistry will process all color negative print films designated "process C-41."
This includes: **Kodacolor II, Vericolor II, Fujicolor FII (ASA 100 and 400), Kodacolor 400, Eastman 5247,** and other C-41 process films.
color 400, Eastman 5247, **Ilford XP-1, Agfa Variopan XL** and other C-41 process films.

MIXING CHEMICALS

Since Unicolor K-2 chemicals are liquid concentrates, any quantity of working solutions can be prepared. The table below shows how to make 480ml (16 oz.) of working solutions. To make more or less than 480ml, multiply by the appropriate factor given below.

QUART & GALLON KITS

To make	Start with Water	Then Add & Mix This Concentrate	Then Add & Mix This Concentrate	Then Add & Mix This Concentrate
Developer	300ml (10 oz)	120ml (4 oz) Developer, Part A	30ml (1 oz) Developer, Part B	30ml (1 oz) Developer, Part C
Blix	270ml (9 oz)	120ml (4 oz) Blix, Part A	30ml (1 oz) Blix, Part B	60ml (2 oz) Blix, Part C
Stabilizer	450ml (15 oz) (Use distilled or deionized water, if available to prevent water spots)	30ml (1 oz) Stabilizer	—	—

PINT KIT

To make	Start with Water	Then Add & Mix This Concentrate	Then Add & Mix This Concentrate	Then Add & Mix This Concentrate
Developer	240ml (8 oz)	120ml (4 oz) Developer, Pt. A	60ml (2 oz) Developer, Pt. B	60ml (2 oz) Developer, Pt. C
Blix	240ml (8 oz)	120ml (4 oz) Blix, Part A	60ml (2 oz) Blix, Part B	60ml (2 oz) Blix, Part C
Stabilizer	420ml (14 oz)*	60ml (2 oz) Stabilizer		

*Use distilled or deionized water, if available, to prevent water spots.

Examples:

To Make This Volume Of Working Solution	Multiply Quantities Above By This Factor
150ml (5 oz)	0.313
180ml (6 oz)	0.375
210ml (7 oz)	0.438
240ml (8 oz)	0.500

MISCELLANEOUS MANUFACTURERS

PROCESSING INSTRUCTIONS FOR UNICOLOR FILM DRUM

(For all films except those listed at end of table. See Film Drum instructions for solution volume required for the size and number of rolls being processed.)

Step	Solution	Time (in minutes)	Temperature	Remarks
1	Water Preheat	1	38°C (100°F)	Fill Film Drum with reels in place. Let stand 1 min. and drain at end of step.
2	Developer	3¼	38°C (100°F)	Add required volume, agitate on Uniroller for required time and drain. Include drain time in total time for this step.
3	Blix	6-7	35-41°C (95-105°F)	Add required volume, agitate on Uniroller and drain at end of step. Time not critical beyond minimum.

The Remaining Steps Can Be Done in Roomlight With Film Drum Lid Off

Step	Solution	Time (in minutes)	Temperature	Remarks
4	Water Wash	3-4	35-41°C (95-105°F)	Use water flow sufficient to change water in Film Drum at least 6 times. Time not critical beyond minimum.
5	Stabilizer	½-1	Ambient	Agitate initial 10-15 seconds only to prevent excess frothing.
6	Dry	—	Not over 60°C (140°F)	—

FOR:

Fuji FII (ASA 100)—use 3 min. development

Eastman Type 5247—use water preheat and developer temperature=40°C (104°F)

Type 5247 has a carbon jet backing—which must be removed during Step 4 (water wash). This is easily done by removing film from reel—hold under running water between thumb and forefinger backing side up—gently rub off with thumb. A photo sponge may be used if you desire. **Do not rub emulsion surface.** At the start your wash water will run black—this is normal. Continue washing until backing is completely removed. Make certain possible loose particles are washed free from emulsion surface. If necessary, extend wash time. Because of the backing material and the by products it liberates. **One shot processing is recommended. Do not process Type 5247 in same solution with other films.**

PROCESSING INSTRUCTIONS FOR CONVENTIONAL (Nikor, Etc.) FILM TANKS
(For all films except those listed at the end of table.) Always use a full processing tank.

Step	Solution	(in minutes) Time	Temperature	Remarks
1	Developer	3¼	38°C (100°F)	Pour developer in tank, agitate continuously for first 15 seconds. Agitate 2-3 seconds each 15 seconds thereafter. Include drain time in total time for this step.
2	Blix	6-7	35-41°C (95-105°F)	After filling tank, agitate continuously for initial 30 seconds. Agitate 5 seconds each 30 seconds thereafter. Time not critical beyond minimum.
	The Remaining Steps Can Be Done in Roomlight With Film Tank Lid Off			
3	Water Wash	3-4	35-41°C (95-105°F)	Use water flow sufficient to change water in film tank at least 6 times. Time not critical beyond minimum.
4	Stabilizer	½-1	Ambient	Agitate initial 10-15 seconds only to prevent excess frothing.
5	Dry	—	Not over 60°C (140°F)	—

FOR:
Fuji FII (ASA 100)—Use 3 minute development.
Eastman Type 5247—Use developer temperature=40°C (104°F).

**SOLUTION CAPACITIES—ADDITIONS TO DEVELOPER TIME
FOR REUSE OF SAME SET OF WORKING SOLUTIONS***

Film Size	No. Exp.	Rolls For Each 240ml 8 oz.) Working Solutions†	Additions to Developer Time for							
			2nd Roll	3rd Roll	4th Roll	5th Roll	6th Roll	7th Roll	8th Roll	9th Roll
			sec.	sec.	sec.	sec.	sec.	sec.	sec.	sec.
110	12	9	4	8	12	16	20	24	28	32
	20	7	5	10	15	20	25	30	—	—
126	12	5	8	16	24	32	—	—	—	—
	20	3	15	30	—	—	—	—	—	—
135	20	4	10	20	30	—	—	—	—	—
	36	3	15	30	—	—	—	—	—	—
120		3	15	30	—	—	—	—	—	—

*Times for other processing solutions do not change when reusing solutions.

†Number of rolls that can be processing in different working solution volumes can be calculated by multiplying by appropriate factor. **Example:** In 180 ml (6oz.) working solutions, you can process 180/240 x 4 = ¾ x 4 = 3 rolls, 135/20 exposure film.

MISCELLANEOUS MANUFACTURERS

YOU CAN MAKE INTERNEGATIVES—With both Kodacolor II and Eastman Type 5247. Use standard slide copying techniques in conjunction with the following data.

Film	Exposure Index	Light Source	Technique: Use Standard Processing Except . . .
Kodacolor II	100	Daylight or Strobe	Reduce development time by 15 seconds
Eastman 5247	100	#2 Photo-Flood	Increase development time by 15 seconds

YOU CAN CONTROL CONTRAST . . . Slightly . . . by modifying the development time. To increase contrast, increase development 15 seconds; to decrease contrast, decrease development 15 seconds.

Trial Filter Packs for Printing on Unicolor RB Paper—Use a trial exposure of 10 seconds at f5.6 for an 8 x 10 enlargement and include a UV filter.

Film	Dichroic Filters	Sheet Filters
Kodacolor II Fuji FII (ASA 100 & 400) Vericolor II	60Y + 60M	40Y + 40M
Kodacolor 400	70Y + 50M	50Y + 30M

PROCESSING PROBLEMS, PROBABLE CAUSE(S) AND REMEDY

Problems	Probable Cause(s)	Remedy
Thin negatives	Low developer temperature, under exposure in camera Developer exhausted	Reread and follow all instructions carefully on temperature control, solution capacity, etc.
Negatives appear more magenta than normal with higher density near sprocket holes	Developer too warm Overly-vigorous agitation in conventional tank	Maintain temperature control. use only agitation methods prescribed
Black dirt specks on negatives which print as white spots	Improperly washed 5247 film	Remove ALL carbon jet backing during final rinse
Negatives look OK but prints are a bit too flat	Too little development	Increase developer time
Negatives look OK but loss of highlight and shadow detail	Too much development	Decrease developer time

Warning: Read and observe all cautionary information provided with the kit

MISCELLANEOUS MANUFACTURERS

647

The Compact Photo-Lab-Index

The kit contains the following chemicals which may be dangerous if misused and **should only be used with adult supervision.**

Concentrate	Contains
Developer, Part A	Sodium carbonate
Developer, Part B	Hydroxylamine sulfate
Developer, Part C	4-amino-3-methyl-N-(B-hydroxyethyl)-aniline sulfate
Blix, Part A	Ammonium Thiosulfate
Blix, Part B	Acetic Acid
Blix, Part C	Ethylenediamine tetraacetic acid
Stabilizer	Formaldehyde and methyl alcohol

All of the above concentrates may cause skin irritation. Flush skin thoroughly with water. Harmful if swallowed. Consult specific bottle whether or not to induce vomiting. **Call a physician at once.**

MISCELLANEOUS
MANUFACTURERS

UNICOLOR TOTAL COLOR

FILM PROCESSING GENERAL INSTRUCTIONS

Total Color will process all color negative print films designated "process C-41." This includes: Kodacolor II, Vericolor II, Fujicolor II (ASA 100 and 400), Kodacolor 400 and Eastman 5247. Total Color will also process currently available resin coated color negative print papers (Unicolor RB, Unicolor Exhibition, Ektacolor 74RC, and Ektacolor 78RC.)

After using Total Color Chemistry to process a batch of film(s), it can be reused to process prints. See Print Processing instructions.

Total Color is **not** a kit. Instead it is packaged as two units: **Total Color (1) Developer** and **Total Color (2) Blix.** Both units are required to process either films or prints. You can obtain additional Developer or Blix separately, as needed. The concentrate for stabilizer (an optional processing step) is included in the Blix unit.

Capacity. Each 24 oz. (0.72 liter) of film chemistry is sufficient to process the equivalent of 12, 20 exposure, 35mm rolls. Each 48 oz. (1.44 liters) of print chemistry is sufficient to process 24, 8 x 10 prints when used in a Unidrum.

Chemical Storage and Shelf Life. If you store working solutions, use full, tightly capped bottles. Unused concentrates will last up to 24 months if bottles are tightly capped and excess air is squeezed out. Working solutions over 1 week old should not be used to process films.

Temperature Control. Process each film at the specified time and temperature. When processing in conventional film tanks (**not** the Unicolor Film Drum) keep the film tank in a water bath maintained **at the developer temperature.** When processing in the Unicolor Film Drum, the developer step is preceded by a 1 **minute preheat at the same temperature as the developer.** See Film Drum instructions for general details on preheat procedures.

Agitation for all solutions—conventional tanks—agitate continuously the first 30 seconds. Agitate 2-3 seconds each 15 seconds thereafter. **Film Drum**—agitate continuously on Uniroller.

Reuse of Chemistry. Total Color chemistry can be reused to process more films, or it can be modified to process prints. Chemistry used for prints cannot be used to process films.

The table below gives the developer time additions when reusing the chemistry to process more films. Extra time is not required in the other processing steps.

Film No. Size Exp.		Rolls For each 8 oz. Working Solution	2nd Roll	3rd Roll	4th Roll	5th Roll	6th Roll	7th Roll	8th Roll	9th Roll
110	12	9	4 sec	8 sec	12 sec	16 sec	20 sec	24 sec	28 sec	32 sec
	20	7	5	10	15	20	25	30		
126	12	5	8	16	24	32	—	—	—	—
	20	3	15	30						
135	20	4	10	20	30	—	—	—	—	—
	36	3	15	30						
120		3	15	30	—	—	—	—	—	—
220		1	—	—	—	—	—	—	—	—

MISCELLANEOUS MANUFACTURERS

649

TOTAL COLOR FILM PROCESSING (Mixing Working Solutions)

To Make 24 oz.* of	Start With Water	Then Add & Mix	Then Add & Mix	Then Add & Mix
Film Developer	12 oz. (360 ml)	8 oz. (240 ml) Developer Part A	2 oz. (60 ml) Developer Part B	2 oz. (60 ml) Developer Part C
Film Blix	11 oz. (330 ml)	8 oz. (240 ml) Blix Part A	1 oz. (30 ml) Blix Part B	4 oz. (120 ml) Blix Part C
Film Stabilizer (optional)	23½ oz. (705 ml)	⅓ oz. (15 ml)	—	—

To make less than 24 oz. of any working solution, divide quantities above by the appropriate factor.

TOTAL COLOR FILM PROCESSING TIMES
For all films except Fujicolor II (ASA 100), and Eastman Type 5247
*See below for Fujicolor F-II and Eastman Type 5247
Processing Times in Fresh Chemistry—See General Instructions on Reuse of Chemistry

Step	Solution	Time	Temperature
1.	Water preheat (Unicolor Film Drum only)	1 minute	*100°F (38°C)
2.	Developer (Time & Temperature in this step is critical)	3¼ minutes	100°F (38°C)
3.	Blix	6 minutes	95-105°(35-41°C)
4.	Running Water Rinse (Lights on OK)	3 minutes	95-105°(35-41°C)
5.	Stabilizer (optional)	30 seconds	Room Temperature

*Processing Fujicolor F-II: Same as above but development time (fresh chemistry) = 3 minutes.

*Processing Eastman Type 5247:
Water preheat and developer temperature=104°F (40°C)
Development time (fresh chemistry)—3¼ minutes
Times and temperatures for remainder of process are identical to those above.

Note on Water Rinse—Type 5247 film has a carbon rem-jet backing on the base side which must be removed during rinse step. Remove film from reel and thoroughly rub off backing with fingers or sponge.

MISCELLANEOUS MANUFACTURERS

The Compact Photo-Lab-Index

TOTAL FILM PROCESSING

Problems	Probable Cause(s)	Remedy
Thin negatives	Low developer temperature. Under exposure in camera. Developer exhausted.	Reread and follow all instructions carefully on temperature control, solution capacity, etc.
Negatives appear more magenta than normal with higher density near sprocket holes.	Developer too warm. Overly-vigorous agitation in conventional tank.	Maintain temperature control. Use only agitation methods prescribed.
Black "dirt" specks on negatives which print as white spots.	Improperly washed 5247	Remove ALL carbon jet backing during final rinse.
Negatives look OK but prints are a bit too flat.	Too little development.	Increase developer time.
Negatives look OK but loss of highlight and shadow detail.	Too much development.	Decrease developer time.

Warning: Read and observe all cautionary information provided with this kit.

The kit contains the following chemicals which may be dangerous if misused and **should only be used with adult supervision.**

Concentrate	Contains
Developer, Part A	Sodium carbonate
Developer, Part B	Hydroxylamine Sulfate
Developer, Part C	4-amino-3-methyl-N-(B-hydroxyethyl)-anilene sulfate
Blix, Part A	Ammonium Thiosulfate
Blix, Part B	Acetic Acid
Blix, Part C	Ethylenediamine Tetraacetic Acid
Print Developer Additive	Benzyl alcohol
Stabilizer	Formaldehyde

All of the above concentrates may cause skin irritation. Flush skin thorough with water. Harmful if swallowed. Consult specific bottle whether or not to indu vomiting. **Call a physician at once.**

TOTAL COLOR PRINT PROCESSING GENERAL INSTRUCTIONS

Total Color will process currently available resin-coated color negative pr papers (Unicolor RB, Unicolor Exhibition, Ektacolor 74RC, and Ektacolor 78RC).

After using Total Color Chemistry to process a batch of film(s), it can be reused to process prints. Chemistry used for prints **cannot** be reused to process films.

MISCELLANEOUS MANUFACTURERS

Total Color is **not** a kit. Instead it is packaged as two units: **Total Color (1) Developer** and **Total Color (2) Blix**. Both units are required to process either films or prints. You can obtain additional Developer or Blix separately, as needed. Stop Bath and stabilizer are optional processing steps. Concentrates for these solutions are included in the Blix unit.

Capacity. Each 24 oz. (0.72 liter) of film chemistry is sufficient to process the equivalent of 12, 20 exposure, 35mm rolls. Each 48 oz. (1.44 liters) of print chemistry, is sufficient for 24, 8 x 10 prints when processed in a Unidrum.

Chemical Storage and Shelf Life. If you store working solutions, use full, tightly capped bottles. Unused concentrates will last up to 24 months if bottles are tightly capped and excess air is squeezed out. Working solutions over 1 week old should not be used to process films.

Print Developer Additive. This solution is used **only** when processing prints.

Temperature Control (Unidrums). The processing time and temperature are controlled by (1) the temperature of the water preheat step and (2) the temperature of the developer. The nomograph gives the development time for each set of temperatures. General details on the water preheat procedure are given in the Unidrum instructions.

Printing Filter Packs. The data shown elsewhere are average trial filter packs for all films. Use a trial exposure of 10 seconds at f5.6 for an 8 x 10 print and include a UV filter in the pack.

How to Get Consistent Print Results. Nothing plagues the color printer more than inconsistent results; i.e., shifting color balance and density. To **get** consistent results, be consistent in all aspects of printing. Don't let any variable get out of control. These are particular things to watch out for.

Temperatures. Choose presoak and developer temperatures and stay with them. Different sets of temperatures yield different results.

CHEMISTRY CONDITIONS. Freshly mixed print chemistry may or may not give the same results as chemistry made from previously used film solutions; it all depends on how many rolls were processed and the age of the chemistry. Therefore, during a given processing session use chemistry of only one type, i.e., either all fresh from concentrates, all from film chemistry or a single blend of the two.

Paper	Dichroic Filters	Acetate Filters with Tungsten Bulb
Unicolor RB, Unicolor Exhibition	60Y + 60M	40Y + 40M
Kodak Ektacolor 74RC, 78RC	60Y + 60M	40Y + 40M

MISCELLANEOUS MANUFACTURERS

TOTAL COLOR PRINT PROCESSING

Mixing Working Solutions. You can make working solutions for print processing in two ways: (1) The most economical method for many workers is to reuse the film developer and Blix: (2) The second method is to mix all solutions directly from concentrates.

METHOD=1—Print Chemistry Mixed from Film Processing Working Solutions

To Make 48 oz. of	Start With Water	Then Add & Mix	Then Add & Mix
Print Developer	22½ oz. (675 ml)	24 oz. (720 ml) Film Developer (Working Solution)	1½ oz. (45 ml) Print Developer Additive
Print Stop Bath (Optional)	45 oz. (1350 ml)	3 oz. (90 ml) Blix, Part B Concentrate	—
Print Blix	24 oz. (720 ml)	24 oz. (720 ml) Film Blix (Working Solution)	—
Print Stabilizer (Optional)	47 oz. 1410 ml)	1 oz. (30 ml) Stabilizer Concentrate	—

This table lists the quantities required for 48 oz. of print working solutions. To make less, divide by the appropriate factor.

METHOD=2—Print Chemistry Mixed Directly from Concentrate

To Make 48 oz. of	Start with Water	Then Add & Mix	Then Add & Mix	Then Add & Mix	Then Add & Mix
Print Developer	34½ oz. (1035 ml)	8 oz. (240 ml) Developer Part A	2 oz. (60 ml) Developer Part B	2 oz. 60 ml) Developer Part C	1½ oz. 45(ml) Print Dev. Additive
Print Stop Bath (Optional)	45 oz. (1350 ml)	3 oz. (90 ml) Blix, Part B	—	—	—
Print Blix	35 oz. (1050 ml)	8 oz. (240 ml) Blix, Part A	1 oz. (30 ml) Blix, Part B	4 oz. (120 ml) Blix, Part C	—
Print Stabilizer (Optional)	47 oz. (1410 ml)	1 oz. (30 ml) stabilizer	—	—	—

To make less than 48 oz. of all working solutions, divide by the appropriate factor.

MISCELLANEOUS MANUFACTURERS

PRINT PROCESSING TIMES IN UNIDRUMS

Development Time: Consult nomograph.

Blix and Water Rinses: Use times below if solutions are between 70-100°F (21-38°C). Above 100°F (38°C)—you can use 1 minute each for Blix and water rinse.

Step	Solution	Time
1.	Water Presoak	1 minute
2.	Developer	See nomograph
3.	Stop Bath (or water rinse)	15-30 seconds
4.	Blix	2 minutes
5.	Water rinse	2 minutes
6.	Stabilizer (optional)	½-1 minute

If stabilizer is omitted, double rinse time above (Step 5). Stabilize in tray only.

HOW TO USE THE NOMOGRAPH

1. Measure temperatures of presoak Water and Developer.

2. Lay a straightedge across the nomograph to intersect the two temperatures on either the (F°) or (°C) scales.

3. Read the Development Time on the center line at the point where the straightedge intersects it.

Example A (see dotted line on nomograph).
 Presoak Temperature=110°F (43.5°C)
 Developer Temperature=100°F (38°C)
 Development Time=2 minutes.

Example B (see dotted line on nomograph):
 Presoak Temperature=100°F (38°C)
 Developer Temperature=80°F (27°C)
 Development Time=minutes.

Note: To get consistent results (color balance and density) you must use the **same** development time at the **same** set of temperatures.

MISCELLANEOUS MANUFACTURERS

The Compact Photo-Lab-Index

PRINT PROCESSING TIME/TEMPERATURE NOMOGRAPH FOR TOTAL COLOR

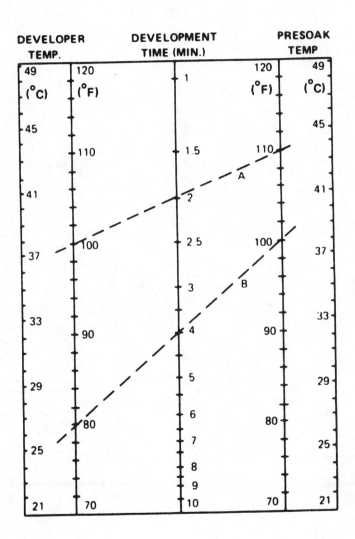

MISCELLANEOUS
MANUFACTURERS

The Compact Photo-Lab-Index

TOTAL COLOR PROCESSING IN TRAYS

No water presoak is required.

Use nomograph for development time as follows:

1. Measure developer temperature.
2. Read straight across on the nomograph to get the development time.

Example: Developer temperature=90°F. Development time=4 minutes.

Times for other steps—same as for Unidrums.

Problem	Probable Cause(s)	Remedy
Fingerprints or smudges, generally reddish inco lor.	Emulsion surface touched before processing. Water or chemistry on fingers.	Handle RC paper only by edges and/or back with clean hands, or wear dry rubber or plastic gloves.
Stained prints borders may extend into body of print, generally bluish-magenta in color.	Paper not presoaked in UNIDRUM® Insufficient stop between developer and Blix. Too little chemistry used or rolling surface not level.	Read and Follow instructions per Table I. Use twice as much chemistry and reuse once. Use more water and/or Stop Bath volume or time.
Cyan-Blue cast over entire print.	Paper exposed to black and white safelight.	Use only Wratten #10 or #13 Safelight with no more than 15 watt bulb—or no safelight.
Magenta or Cyan-Blue cast overe ntire print.	Developer contaminated with Blix.	Mix new developer.
Yellowish-brown cast, generally localized and darker towards an edge.	Stray light reflected off nearby object during exposure (such as enlarger post). Light leak in paper box (or bag).	Eliminate reflections. Secure closure on paper container when not in use.
On dry print—magenta-blue "opalescence" not correctable by filtration.	Underdevelopment or developer weak or old.	Follow prescribed techniques of time, temperature, etc. Mix chemistry per instructions and do not overextend capacity of shelf life.
"Muddiness," generally grayish-purple, over entire print.	Insufficient Blixing.	Same as above.

MISCELLANEOUS MANUFACTURERS

UNICOLOR 2-STEP CHEMISTRY

FOR COLOR PRINTS FROM COLOR NEGATIVES

CAT. 174—1 LITER KIT (33.8 oz.) CAT. 175—4 LITER KIT (1.05 gallons)

SYNOPSIS OF THE UNICOLOR 2-STEP PROCESS

The Unicolor 2-Step process is suitable for Unicolor RB, Ektacolor 74 and 78, and most other current color negative print papers. It consists of two chemical steps and one water rinse. A water pre-heat step is required in drums to bring the mechanical parts of the system up to operating temperature. The process can be completed in roughly 5 minutes at the highest allowed temperatures. Processing time increases with decreasing temperatures.

The chemical steps and their functions are listed below:

DEVELOPER

Exposure produces a so-called *latent* (invisible) image on the print. Developer converts this latent image into a composite visible image made up of silver metal and three dyes (cyan, magenta and yellow); the latter will correspond to the final image.

BLIX

Blix, Unicolor's acronym for Bleach-Fix, has a more burdensome role than is usually appreciated since it must do three things in concert.

First, in any two-step chemistry, it must quickly stop the development reaction by changing the paper's environment from alkaline to mildly acid. Unlike a conventional and flexible acetic acid stopbath, however, Blix cannot be too acid or print highlights will go cyan. Nor can the acidity be so low that it verges on alkalinity; otherwise the prints may suffer cyan, blue or magenta stains. The narrowness of the acidity (pH) window is such that it is often the cause of print stains in some other 2-step chemistries, especially when the user is either a bit careless in completely draining developer from a drum or not fast enough in commencing vigorously agitation in the bleach-fix. Although Unicolor 2-Step Chemistry has been designed to have superior stain-suppression qualities, normal diligence must still be given to draining the developer and agitating the Blix to allow the chemistry to do the excellent job it is capable of.

Bleaching and fixing are the remaining roles played by Blix. The bleach component converts the silver metal part of the image into an intermediate form which can be dissolved by fixer, while the fixer component removes this intermediate plus any silver salts not developed as part of the image. The subsequent water rinse removes any Blix remaining in the paper.

VOLUME REQUIREMENTS IN DRUM PROCESSORS

The chemical volumes required in Unidrum (or similar) processors can be stated quite simply:

1. When processing one large print, use the minimum volume which will cover the print in a particular size and brand of drum; and as a general rule, use the chemistry only once.

2. When processing multiple small prints in a drum, it is often better to use *two times* the minimum volume to insure complete coverage and reuse it once to get maximum chemistry capacity.

657

The solution requirements for Unidrum processors are summarized below. For more details, see the Unidrum instructions.

Unidrum size	Minimum chemistry volume required for:		Minimum wash volume (per rinse) for Fill & Dump Rinse method
	Single large print	Several small prints	
8 x 10	60 ml (2 oz.)	120 ml (4 oz.)	180 ml (6 oz.)
11 x 14	120 ml (4 oz.)	240 ml (8 oz.)	360 ml (12 oz.)
16 x 20	240 ml (8 oz.)	480 ml (16 oz.)	720 ml (24 oz.)

SOLUTION CAPACITIES

It is no easy matter to give an airtight definitive capacity rule for any color negative print chemistry (in terms of prints per liter, per gallon, etc.) because one important condition is attached. Simply stated, this condition asks: what is *your* acceptance level of both quality and repeatability of results?

If you desire the best possible of all worlds—maximum capacity, repeatability, and consistent quality—there is no question that using the chemistry one-shot in a Unidrum is the preferred method. Under these conditions you can expect to obtain at least 16, 8x10 prints per liter of working solutions based on a chemistry usage of 60 ml (2 oz.) per 8x10 print.

If, on the other hand, you would like to obtain more capacity from the chemistry for whatever reasons, you can reuse the chemistry in a Unidrum until the results are no longer to your satisfaction.

A 60 ml volume of color negative print chemistry doesn't simply process one 8 x 10 print and instantly exhaust itself. Indeed, enough activity remains to process *at least* another 8x10 and perhaps more. But with the developer activity reduced, you can expect to see increasing signs of underdevelopment with each use, namely lower print density, less color saturation and a color balance shift to blue or blue/magenta. Unfortunately these shifts are not 100% predictable so it is difficult to provide a guaranteed corrective action (filtration and exposure change). Overdevelopment by 50% on reuse is probably the simplest expedient to lessen the shifts.

Obviously, the above should *not* be taken as recommendations, but instead as things you can test if if you are curious or are trying to save money.

Tray processing is, in plain terms, very wasteful of color negative print chemistry because (1) a large volume is left open and exposed to air where it oxidizes faster and (2) the activity of the entire volume depletes with each use just as it does when chemistry is reused in a Unidrum, although to a lesser degree.

STORAGE LIFE OF CONCENTRATES AND WORKING SOLUTIONS

The liquid concentrates supplied in Unicolor 2-Step chemistry should last in good condition up to 3 years or more. A slight degree of aging does take place, of course, but it is generally so insignificant that you'll never be aware of it because color negative print processing tends to be self-compensating. Of all the components supplied in 2-step chemistry, the first one which will eventually deteriorate to the stage where processing results are compromised is Developer Part A. This point is rarely realized in practice unless the chemistry is exceptionally ancient and/or has been stored under adverse conditions before purchase. If you open a *new* kit of Unicolor 2-Step chemistry and find that Developer Part A is extremely dark or *black and opaque,* it may be unusable. Under these circumstances, you may return this *FULL, UNUSED BOTTLE* to Unicolor, *postpaid,* and they will send a fresh bottle back to you. Please include the dealer's name where you purchased the chemistry.

MISCELLANEOUS MANUFACTURERS

The Compact Photo-Lab-Index

Working solutions do not last as long as concentrates. For best results, solutions should be used within the timespans listed below. But even if you have stored working solutions for times longer than those suggested, it's worthwhile to make one or more small test prints to determine if the chemistry will still give good results. The suggestion is then: don't throw solutions away until you've tested them, regardless of age. When testing old solutions, it's a good idea to standardize on a development time 50% longer than normal to minimize the effects of depleted developer activity. If the test results are good, proceed with processing (using 50% overdevelopment).

Working Solution	Used Solution	Unused Solution
Developer*	2 weeks	6 weeks
Blix †	4 weeks	8 weeks

*Developer should be stored in full, tightly closed bottles.

†Note that Blix benefits from exposure to air. It can be stored in partially filled bottles.

TROUBLE SHOOTING

The Unicolor 2-Step process has been designed to be as troublefree as possible. Those few occurrences of unsatisfactory results can usually be attributed to contamination in one form or another. The following chart should be consulted for diagnosing a particular symptom and remedying the problem.

Problem	Probable Cause(s)	Remedy
Fingerprints, smudges (generally reddish)	Emulsion touched before processing. Water or chemistry on fingers.	Handle paper only by edges with clean, dry hand.
Stained borders (blue or blue/magenta), usually mottled or streaked.	Developer not drained completely. Blix agitation insufficient.	Complete draining of developer and vigorous Blix agitation are *very* important in 2-step chemistry. Can also use *stop bath* if this is a continuing problem (see below).
Magenta or Cyan/Blue cast over entire print.	Developer contaminated with Blix (if so developer may smell like ammonia).	Mix new developer.
Yellowish/brown cast, usually localized and darker toward an edge.	Paper light fogged by timer, or stray light; light leak in paper bag or box.	Locate and correct source.
Yellow to yellow/gray on borders, usually streaked.	Insufficient chemistry coverage.	Use proper volumes. Level drum
Blue to magenta/blue color balance not correctable by filtration.	Underdevelopment by too little time, low temperature. Developer old or weak.	Use correct time/temperature. Overdevelop by 50% as a possible cure.

STOP BATH

The most common cause of print stains with any 2-step chemistry is interaction of Blix with residual developer. If this occurs and thorough draining of developer and vigorous Blix agitation do not cure it, stop bath should be tried. This can be mixed from concentrated acetic acid as follows:

NOTE: Always add acid to water, not vice versa.

Acetic Acid Concentration	Volume of Acid	Volume of Water
28%	60 ml	900 ml
99% (glacial)	17 ml	950 ml

To use stop bath follow this processing sequence:
1. Presoak normally if using a Unidrum.
2. Develop normally.
3. Add required volume of stop bath for your drum. Agitate 30 seconds and drain.
4. Complete process normally.

UNICOLOR 2-STEP PRINT CHEMISTRY

MIXING CHEMICALS

This table shows how to mix 1 liter (34 oz.) of working solutions. To make more or less than this amount, multiply or divide by the appropriate factor. Mix the chemicals in the order given and put in labeled storage bottles.

To Make	Start with Water	Then Add & Mix This Concentrate	Then Add & Mix This Concentrate	Then Add & Mix This Concentrate
Developer	640 ml (22 oz.)	60 ml (2 oz.) Developer Part A	240 ml (8 oz.) Developer Part B	60 ml (2 oz.) Developer Part C
Blix	580 ml (20 oz.)	240 ml (8 oz.) Blix Part A	60 ml (2 oz.) Blix Part B	120 ml (4 oz.) Blix Part C

TRIAL FILTER PACKS AND EXPOSURES

If you have already made color negative prints with another chemistry, you should start with your *previous* filtration and exposure.

If you have never made color negative prints, the procedure outlined in the Unicolor Duocube instructions is the best and fastest way to obtain the proper filtration and exposure.

In lieu of this recommended procedure, you should make the following trial exposures, one of which should be fairly close to correct depending on your equipment, film, etc.

TRIAL EXPOSURES FOR 8 x 10 PRINT

Film Size	Trial #1	Trial #2
35mm	Exposure: 10 seconds @ f/5.6 Filtration: 10Y + 20M + UV	Exposure: 15 seconds @ f5.6 Filtration: 50Y + 50M + UV
120	Exposure: 10 seconds @ f8 Filtration: 10Y + 20M + UV	Exposure: 15 seconds @ f/8 Filtration: 50Y + 50M + UV

MISCELLANEOUS MANUFACTURERS

UNICOLOR 2-STEP CHEMISTRY
PROCESSING STEPS FOR UNIDRUMS

Note: Development time is determined by the presoak temperature and the developer temperature. See Nomograph for details.

Chemical Step	Solution	Time (in minutes)	Technique
	Water Preheat	1	See text or details on three alternate preheat techniques.
#1	Developer	(See Nomograph)	Add required volume for your drum, agitate continuously on Uniroller or by hand, and drain *thoroughly* at end of step.
#2	Blix	1 (27- 49°C) (80-120°F) 1½(21- 26°C) (70- 79°F)	Add required volume for your drum; agitate continuously on Uniroller or by hand. Drain at end of step.
	Water Wash	1-4	Use running water in a tray or use at least four fill-and-dump rinses. Additional washing beyond the minimum increases print stability.
	Dry	As Required	Either air dry or use a hand-held hair-dryer. Color balance cannot be evaluated until dry.

SOLUTION REQUIREMENTS

Unidrum size	Chemistry) (single print)	Chemistry* (several small prints)	Water Preheat†	Min. Wash Volume (per rinse)
8x10	60 ml	120 ml	600 ml	180 ml
11x14	120 ml	240 ml	1 liter	360 ml
16x20	240 ml	480 ml	2 liters	720 ml

*Reuse chemistry one time. See text for details.
†Use this colume when preheating by partially filling Unidrum and agitating on Uniroller.
Note: To get consistent results (color balance and density) you must use the *same* development time at the *same* set of temperatures.

MISCELLANEOUS MANUFACTURERS

The Compact Photo-Lab-Index

UNIDRUM PRINT PROCESSING TIME/TEMPERATURE NOMOGRAPH

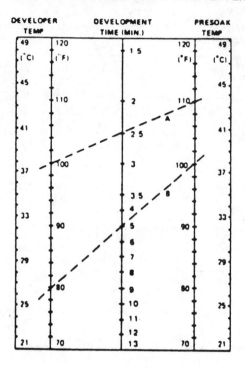

HOW TO USE NOMOGRAPH

1. Measure temperature of presoak Water and Developer.

2. Lay a straightedge across the nomograph to intersect the two temperatures on either the (F) or (C) scales.

3. Read the Development Time on the center line at the point where the straightedge intersects it.

Example A (see dotted line on Nomograph):
Presoak Temperature=
 110°F (43.5°C)
Developer Temperature=
 100°F (38°C)
Development Time=
 2.5 minutes

Example B (see dotted line on Nomograph):
Presoak Temperature=
 100°F (38°C)
Developer Temperature=
 80°F (27°C)
Development Time=5 minutes

MISCELLANEOUS MANUFACTURERS

662

PROCESSING STEPS FOR TRAYS, TANKS, AND BASKET PROCESSORS

DEVELOPER TIME See Nomograph that follows.

LIGHTING

Process must be done in *complete darkness* or using a Wratten #13 safelight through step 2 (Blix). Lights may be turned on after step 2.

Chemical Step	Solution	Time (in minutes)	Technique
#1	Developer	(See Nomograph)	Agitate continuously and drain at least 20 seconds before transferring print to Blix tray.
#2	Blix	1 (27- 49°C) (80-120°F) 1½ (21- 26°C) (70- 79°F)	Agitate vigorously and continuously to prevent stains. Multiple prints should be separated to give even solution coverage.
	Water Wash	1-4	Use running water to give at least four changes of water. Additional washing beyond the minimum increases print stability.
	Dry	As required	Either air dry or use a hand-held hairdryer. Color balance cannot be evaluated until dry.

TRAY AND TANK PROCESSOR TIME/TEMPERATURE NOMOGRAPH

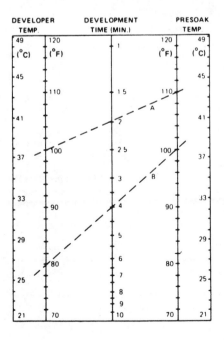

DEVELOPER TEMP.　**DEVELOPMENT TIME (MIN.)**　**PRESOAK TEMP**

HOW TO USE NOMOGRAPH

1. Measure developer temperature.

2. Lay a straightedge across the nomograph to intersect the two temperatures on either the (F) or (C) scales.

3. Read the Development Time on the center line at the point where the straightedge intersects it.

Example A (see dotted line on nomograph):
Developer Temperature= 82°F (27.8°C)
Development Time= 5¼ minutes

Example B (see dotted line on nomograph):
Developer Temperature= 105°F (40.5°C
Development Time=2 minutes
Note: Development times less than 2 minutes are not recommended when using basket processors.

MISCELLANEOUS MANUFACTURERS

663

UNICOLOR R-2 CHEMISTRY

This chemistry is designed to process Unicolor RB, Unicolor Exhibition and Kodak 74RC/78RC color print papers in Unidrums, trays and deep tanks. Unicolor R2 chemistry kits are available in 1 qt., 1 gal. and 4 gal. sizes. The 4 gal. kit makes working solutions and/or replenisher solutions.

CHEMISTRY STORAGE LIFE

Unused concentrates have a shelf life up to 24 months if bottles are kept full by squeezing out excess air. Working developer (unreplenished) lasts 2-4 weeks in full glass bottles. Other working solutions (unreplenished) last up to 12 weeks and need *not* be kept in full air-tight containers. *Blix,* for example, actually *benefits* from exposure to air.

Do not store concentrations or working solutions under refrigeration.

The working life of all working solutions can be extended indefinitely in deep tanks if used and replenished regularly. Keep a floating lid on the developer when not in use.

MIXING CHEMICALS

Liquid concentrates permit mixing any volume of working strength solutions. The table below gives the mix ratios for one quart (32 oz.) of working solutions. To make more or less than one quart, multiply or divide by the appropriate factor.

UNIDRUM PROCESSING

Mix small volumes of working strength chemistry sufficient for one printing session and use the chemistry "one-shot." Replenishment of small working solutions volumes (less than 1 gallon) is not recommended.

DEEP TANK (BASKET) AND TRAY PROCESSING

Mix sufficient working strength chemistry to charge the processor. Use the 4 gal. R2 chemistry kit to replenish solutions, if desired.

1 QUART KIT

Mixing Instructions—Unicolor R2 Chemistry. Bottles are usually overfilled. Measure all quantities carefully including water.

To Make	Start with Water	Then Add & Mix This Concentrate	Then Add & Mix This Concentrate	Then Add & Mix This Concentrate
Developer	20 oz. (600 ml)	2 oz. (60 ml) Developer Part A	8 oz. (240 ml) Developer Part B	2 oz. (60 ml) Developer Part B
Stop Bath	30 oz. (900 ml)	2 oz. (60 ml) Stop Bath	—	—
Blix	24 oz. (720 ml)	8 oz. (240 ml) Blix	—	—
Stabilizer	30 oz. (900 ml)	2 oz. (60 ml) Stabilizer	—	—

MISCELLANEOUS MANUFACTURERS

The Compact Photo-Lab-Index

1 GALLON KIT

Mixing Instructions—Unicolor R2 Chemistry. Bottles are usually overfilled. Measure all quantities carefully including water.

To Make	Start with Water	Then Add & Mix This Concentrate	Then Add & Mix This Concentrate	Then Add & Mix This Concentrate
Developer	21 oz. (630 ml)	2 oz. (60 ml) Developer Part A	8 oz. (240 ml) Developer Part B	1 oz. (30 ml) Developer Part C
Stop Bath	30 oz. (900 ml)	2 oz. (60 ml) Stop Bath	—	—
Blix	24 oz. (720 ml)	8 oz. (240 ml) Blix	—	—
Stabilizer	31 oz. (930 ml)	1 oz. (30 ml) Stabilizer	—	

4 GALLON REPLENISHER KIT

Mixing Instructions—Unicolor R2 Chemistry. Bottles are usually overfilled. Measure all quantities carefully including water.

To Make	Start with Water	Then Add & Mix This Concentrate	Then Add & Mix This Concentrate	Then Add & Mix This Concentrate
Developer Replenisher*	21 oz. (630 ml)	2 oz. (60 ml) Developer Part A	8 oz. (240 ml) Developer Part B	1 oz. (30 ml) Developer Part C
Stop Bath Replenisher	30 oz. (900 ml)	2 oz. (60 ml) Stop Bath	—	—
Blix Replenisher	24 oz. (720 ml)	8 oz. (240 ml) Blix	—	—
Stabilizer Replenisher	31 oz. (930 ml)	1 oz. (30 ml) Stabilizer	—	—

To make working strength developer—Add 15 ml **Developer Starter** per gallon developer replenisher. Working strength developer is required for Unidrums and trays and for the initial charge in deep tank processors.

Other working solution—Stop Bath, Blix and Stabilizer working solutions are identical to the replenisher solutions.

PROCESSING INSTRUCTIONS

Unicolor R2 Chemistry may be used at any temperature between 70-120°F (21-49°). A water Presoak is required before the developer when processing in Unidrums. (See Unidrum instructions for details on presoak procedure). *No* water presoak is used in trays or tank processors. Use the nomographs below to determine the developer time.

The Compact Photo-Lab-Index

PROCESSING DATA FOR UNIDRUMS

DEVELOPER TIME See nomograph A.

BLIX AND WATER RINSE TIMES

Use times below if solutions are between 70-90°F (21-32°C). Use 1½ minutes each for these steps if solutions are above 90°F (32°C).

Step	Solution	Time
1.	Water presoak	1 minute
2.	Developer	See Nomograph
3.	Stop Bath	15-30 seconds
4.	Blix	2 minutes
5.	Water Rinse	2 minutes
6.	Stabilizer	1 minute

UNIDRUM PRINT PROCESSING—R2 CHEMISTRY

Time/Temperature Nomograph A

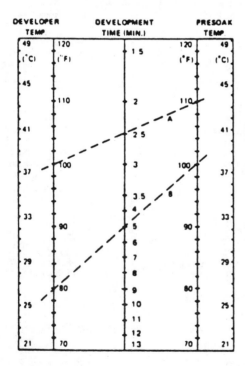

Note:

To get consistent results (color balance and density) you must use the *same* development time at the *same* set of temperatures.

HOW TO USE NOMOGRAPH A

1. Measure temperatures or pre-Water and Developer.

2. Lay a straightedge across the nomograph to intersect the two temperature on either the (°F) or (°C) scales.

3. Read the Development Time on the center line at the point where the straightedge intersects it.

Example A (see dotted line on nomograph):
Presoak Temperature=
 110°F (43.5°C)
Developer Temperature=
 100°F (38°C)
Development Time=
 2.5 minutes

Example B (see dotted line on nomograph):
Presoak Temperature=
 100°F (38°C)
Developer Temperature=
 80°F (27°C)
Development Time=5 minutes.

MISCELLANEOUS MANUFACTURERS

The Compact Photo-Lab-Index

PROCESSING DATA FOR TRAYS AND TANK PROCESSORS
DEVELOPER TIME See Nomograph B.

BLIX AND WATER RINSE TIMES
Use times below if solutions are between 70-90°F (21-32°C). Use 1½ minutes each for these steps if solutions are above 90°F (32°C). Process must be done in complete darkness or using a Wratten #10 or #13 safelight through Step 2. Lights may be turned on after Step 2.

Step	Solution	Time*
1.	Developer	See Nomograph
2.	Stop Bath	1 minute
3.	Blix	2 minutes
4.	Water Rinse	2 minutes
5.	Stabilizer	1 minute

*Include at least a 20 second drain time in each process step to prevent excess carry over from one solution to the next.

TRAY AND TANK PROCESSOR TIME/TEMPERATURE NOMOGRAPH B

HOW TO USE NOMOGRAPH B

1. Measure developer temperature.

2. Lay a straightedge across the nomograph to intersect the two temperature on either the (°F) or (°C) scales.

3. Read the Development Time on the center line at the point where the straightedge intersects it.

Example A (see dotted line on nomograph):
Developer Temperature= 82°F (27.8°C)
Development Time= 5¾ minutes.

Example B (see dotted line on nomograph):
Developer Temperature= 105°F (40.5°C)
Development Time=2 minutes.

Note: Development times less than 2 minutes are not recommended when using basket processors.

MISCELLANEOUS MANUFACTURERS

R2 CHEMISTRY REPLENISHMENT

To extend chemistry life and maintain consistency when processing in deep tanks, replenish *all* solutions at the nominal rate of 30 ml (1 fl. oz.) per 80 sq. in. of paper. Standard prints or sensitometric strips can be processed and evaluated regularly to monitor the state of the processing solutions. Signs of underreplenishment are loss of print density and contrast and blue color balance shift. Over-replenishment gives greater density and contrast and yellow color balance shift. Change the replenishment rate by 10% increments to correct either of these situations.

The recommended replenishment method for the deep tanks is to *remove* 30 ml of each working solution for each 80 sq. in. of paper processed and to *replace* it with 30 ml of replenisher solution. Replenish after each batch of prints.

Paper Size	Sq. In.	Nominal Replenishment Rate per Sheet (ml)
4 x 5	20	7.5 ml
5 x 7	35	13
8 x 10	80	30
11 x 14	154	58
16 x 20	320	120

PROCESSING PROBLEMS, CAUSES AND REMEDIES

Problem	Probable Cause(s)	Remedy
Fingerprints or smudges, generally reddish in color.	Emulsion surface touched before processing. Water or chemistry on fingers.	Handle RC paper only by edges and/or back with clean hands or wear dry rubber or plastic gloves.
Stained prints borders— may extend into body of print, generally bluish-magenta in color.	Paper not presoaked in UNIDRUM® Insufficient stop between developer and Blix. Too little chemistry used or rolling surface not level.	Read and Follow instructions per Table 1. Use twice as much chemistry and reuse once. Use more water and/or Stop Bath volume or time.
Cyan-Blue cast over entire print.	Paper exposed to black and white safelight.	Use only Wratten #10 or #13 Safelight with not more than 15 watt bulb or no safelight.
Magenta or Cyan Blue cast over entire print.	Developer contaminated with Blix.	Mix new developer.
Yellowish-brown cast— generally localized and darker towards an edge.	Stray light reflected off nearby object during exposure (such as enlarger post). Light leak in paper box (or bag).	Eliminate reflections. Secure closure on paper container when not in use.
On dry print—magenta-blue "opalescence" not correctable by filtration.	Underdevelopment or developer weak or old.	Follow prescribed techniques of time, temperature, etc. Mix chemistry per instructions and do not over-extend capacity of shelflife.
"Muddiness," generally grayish-purple, over entire print.	Insufficient Blixing.	Same as above.

MISCELLANEOUS MANUFACTURERS

The Compact Photo-Lab-Index

This kit contains the following chemicals which may be dangerous if misused. **Children should use only with adult supervision.**

Concentrate	Contains
Developer Part A	Benzyl alcohol and 4-amino-N-ethyl-N-(methane sulfanamido-ethyl)-m-toluidene sesquisulfate
Developer Part B	Sodium Carbonate
Developer Part C	Hydroxylamine Sulfate
Developer Starter	Acetic Acid
Stop Bath	Acetic Acid
Blix	Ammonium Thiosulfate
Stabilizer	Formaldehyde

All of the above concentrates may cause skin irritation. Flush skin thoroughly with water. Harmful if swallowed. Consult specific bottle whether or not to induce vomiting. **Call a physician at once.**

MISCELLANEOUS MANUFACTURERS

UNICOLOR CHEMISTRY Aʳ

QUART, GALLON, AND 4 GALLON KITS

This chemistry is designed to process **Kodak Ektacolor 74 RC and 78 RC Color Print Paper.**

MIXING CHEMICALS

Since Unicolor Aʳ chemicals are liquid concentrates, any quantity of working solutions can be prepared. The table below shows how to make 480 ml (16 oz.) of all working solutions. To make more or less than 480 ml, multiply by the appropriate factor given below.

To Make	Start With Water	Then Add & Mix This Concentrate	Then Add & Mix This Concentrate
Developer	390 ml (13 oz.)	30 ml (1 oz.) Developer Activator	60 ml (2 oz.) Basic Developer
Stop Bath	420 ml (14 oz.)	60 ml (2 oz.) Stop Bath	—
Blix	360 ml (12 oz.)	120 ml (4 oz.)	—
Stabilizer	465 ml (15½ oz.)	15 ml (½ oz.) Stabilizer	Gallon & 4 Gallon
Stabilizer	420 ml (14 oz.)	60 ml (2 oz.)	Quart Kit

Examples:

To Make This Volume of Working Solution	Multiply Quantities Above By This Factor
150 ml (5 oz.)	0.313
180 ml (6 oz.)	0.375
210 ml (7 oz.)	0.438
240 ml (8 oz.)	0.500

Unused concentrates have a shelf life up to 24 months if bottles are kept full by squeezing out air. Used developer lasts up to 4 weeks in **full glass** bottles. Used Stop Bath, Blix and Stabilizer last up to 12 weeks and need not be kept in full, air-tight containers. Blix, for example, actually **benefits** from exposure to air.

PROCESSING INSTRUCTIONS

Unicolor Aʳ Chemistry may be used at any temperature between 70-120°F (21-49°C). A water presoak is required before the developer when processing in Unidrums. (See Unidrum instructions for details on chemistry volumes required and presoak procedure). *No* water presoak is used in trays or deep tank processors. Use the nomographs below to determine the developer time.

MISCELLANEOUS MANUFACTURERS

The Compact Photo-Lab-Index

PROCESSING DATA FOR UNIDRUMS
DEVELOPER TIME
See nomograph A.

BLIX AND WATER RINSE TIMES
Use times below if solutions are between 70-90°F (21-32°C). Use 1½ minutes each for these steps if solutions are above 90°F (32°C).

Step	Solution	Time
1.	Water Presoak	1 minute
2.	Developer	See Nomograph
3.	Stop Bath	15-30 seconds
4.	Blix	2 minutes
5.	Water Rinse	2 minutes
6.	Stabilizer (optional—see notes)	1 minute

UNIDRUM PRINT PROCESSING TIME/TEMPERATURE NOMOGRAPH A

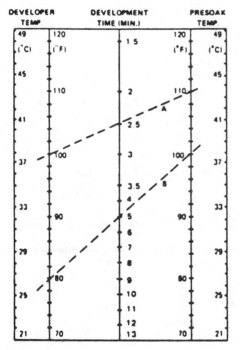

HOW TO USE NOMOGRAPH A

1. Measure temperatures of presoak Water and Developer.

2. Lay a straightedge across the nomograph to intersect the two temperatures on either the (°F) or (°C) scales.

3. Read the Development Time on the center line at the point where the straightedge intersects it.

Example A (see dotted line on nomograph):
Presoak Temperature= 110°F (43.5°C)
Developer Temperature= 100°F (38°C)
Developer Time=2 minutes

Example B (see dotted line on nomograph):
Presoak Temperature= 100°F (38°C)
Developer Temperature= 80°F (27°C)
Development Time=4 minutes

MISCELLANEOUS MANUFACTURERS

The Compact Photo-Lab-Index

PROCESSING DATA FOR TRAYS AND DEEP TANK PROCESSORS
DEVELOPER TIME
See nomograph B.

BLIX AND WATER RINSE TIMES
Use times below if solutions are between 70-90°F (21-32°C). Use 1½ minutes each for these steps if solutions are above 90°F (32°C). Process must be done in complete darkness or using a Wratten #10 or #13 safelight thru Step 2. Lights may be turned on after Step 2.

Step	Solution	Time*
1.	Developer	See Nomograph
2.	Stop Bath	1 minute
3.	Blix	2 minutes
4.	Water Rinse	2 minutes
5.	Stabilizer (optional—see notes)	1 minute

*Include at least a 20 second drain time in each process step to prevent excess carry over from one solution to the next.

TRAY AND TANK PROCESSOR TIME/TEMPERATURE NOMOGRAPH B

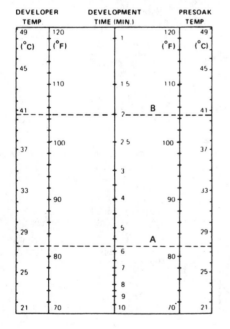

HOW TO USE NOMOGRAPH B

1. Measure developer temperature.

2. Lay a straightedge across the nomograph to intersect the temperature on either the (°F) or C°) scales.

3. Read the Development Time on the centerline at the point where the straightedge intersects it.

Example A (see dotted line on nomograph):

Developer Temperature= 82°F (27.8°C)
Development Time=5¾ minutes

Example B (see dotted line on nomograph):

Developer Temperature= 105°F (40.5°C)
Development Time=2 minutes

MISCELLANEOUS MANUFACTURERS

NOTE: Development time less than 2 minutes is not recommended when using basket processor.

Problem	Probable Cause(s)	Remedy
Fingerprints or smudges, generally reddish in color.	Emulsion surface touched before processing. Water or chemistry on fingers.	Handle RC paper only by edges and/or back with clean hands, or wear dry rubber or plastic gloves.
Stained prints borders— may extend into body of print, generally bluish-magenta in color.	Paper not presoaked in UNIDRUM® Insufficient stop between developer and Blix. Too little chemistry used or rolling surface not level.	Reread and follow all instructions per Table 1. Use twice as much chemistry and reuse once. Use more water and/or Stop Bath volume ro time.
Cyan-Blue cast over entire print.	Paper exposed to black and white safelight.	Use only Wratten #10 or #13 Safelight with not more than 15 watt bulb, or no safelight.
Magenta or Cyan-Blue cast over entire print.	Developer contaminated with Blix.	Mix new developer.
Yellowish-brown cast— generally localized and darker towards an edge.	Stray light reflected off nearby object during exposure (such as enlarger post). Light leak in paper box (or bag).	Eliminate reflections. Secure closure on paper container when not in use.
On dry print—magenta-blue "opalescence" not correctable by filtration.	Underdevelopment or developer weak or old.	Follow prescribed techniques of time, temperature, etc. Mix chemistry per instructions and do not overextend capacity of shelf life.
"Muddiness," generally grayish-purple, over entire print.	Insufficient Blixing.	Same as above.

The kit contains the following chemicals which may be dangerous if misused and **should be used only with adult supervision.**

Concentrate	Contains
Basic Developer	Sodium Metaborate
Developer Activator	Benzyl alcohol and 4-amino-N-ethyl-N-(methane sulfanamido-ethyl)-m-toluidene sesquisulfate
Stop Bath	Acetic Acid
Blix	Ammonium Thiosulfate
Stabilizer	Formaldehyde

All of the above concentrates may cause skin irritation. Flush skin thoroughly with water. Harmful if swallowed. Consult specific bottle whether or not to irduce vomiting. **Call a physician at once.**

NOTES ON THE Aʳ CHEMISTRY PROCESS STEPS

WATER PRESOAK

The water presoak in Unidrum processing does two things: (1) warms the drum to allow faster processing, and (2) wets the paper's surface to promote even coverage by the tiny volume of chemistry. Presoaking can be done in two ways (1) load the paper in a *completely dry* Unidrum, then fill the drum with water and allow to stand 1 minute or (2) fill the drum with presoak water while exposing the print. Load the print in the completely filled drum, put on the drum cap and drain. A 1 minute wait is *not* required since the drum is already warm and the paper wets instantly. Method 2 is preferred when making successive prints since it saves time and prevents water spots on the prints.

DEVELOPER

The developer reacts with the exposed paper to form the three color dyes that make up the final image and simultaneously produces a silver metal image.

STOP BATH

Neutralizes the alkaline developer and leaves the paper in an acid state which (1) unequivocally prevents stains caused by the potential interaction of Developer and Blix, (2) improves print whites, (3) accelerates Blix action. The omission of— or incorrect use of—Stop Bath is the source of 99% of all print processing stains, spots, "glitches," etc.!

BLIX

Blix is Unicolor's acronym for Bleach Fix. As such, it (1) bleaches silver metal image to a soluble silver complex and (2) fixes the unused (non-image) silver salts to the same soluble complex.

WATER RINSE

Removes residual processing chemicals and silver complexes from the paper.

STABILIZER

Helps retard image fading and yellowing of print highlights. The latest evidence suggests great improvements in dye stability against light-induced fading. But dye fading and yellowing can also occur in the dark! Stabilizer appears to be an effective way to retard these dark reactions which occur slowly and inexorably over many years. Until all evidence is complete on stabilizers it would seem prudent to use it unless you are making test prints or others that have no lasting value.

Aʳ CHEMISTRY REPLENISHMENT

When processing in trays, deep tanks or baskets with Aʳ chemistry you can replenish with the regular starter chemistry at a nominal rate of 1 fl oz. (30 ml) per 80 sq. in of paper. All solutions are replenished at the same rate. Standard prints or sensitometric strips can be processed and evaluated regularly to monitor the state of the processing solutions.

Signs of underreplenishment are loss of print density and contrast and blue color balance shift. Increase replenishment rate by 10% increments to correct for this situation. (**Note:** It is impossible to overreplenish the solutions.)

Paper Size	Area	Nominal Replenishment Rate per sheet
8 x 10	80	1 fl. oz. (30 ml)
11 x 14	154	1.9 fl. oz. (58 ml)
16 x 20	320	4 fl. oz. (120 ml)

MISCELLANEOUS MANUFACTURERS

UNICOLOR RP-1000 CHEMISTRY

Unicolor RP-1000 chemistry is a 3-chemical step process designed to make direct prints from slides on Unicolor Unichrome, Kodak Ektachrome Type 2203 RC and 14 RC Papers. The 3-chemical step process drastically reduces the amount of chemicals and time needed to process this paper. The incorporation of a reversing agent in the color developer eliminates the need for a separate reversal bath or light reversing step. **Note:** Kodak Ektachrome 14 RC paper is not available in the U.S.A.

MIXING CHEMICALS

Because RP-1000 chemicals are liquid concentrates, any quantity of working solutions can be mixed. The table below shows how to make 480 ml (16 oz.) of working solutions. To make more or less than 480 ml (16 oz.), use the factors at the end of the table.

MIXING INSTRUCTIONS—RP-1000 Chemistry

Bottles are usually overfilled—measure all quantities carefully including water

To make 480 ml (16 oz.) working solution of:	Start with water at 21-27°F (70-80°F)	Then Add & Mix This Concentrate	Then Add & Mix This Concentrate	Then Add & Mix This Concentrate
First Developer	360 ml (12 oz.)	120 ml (4 oz.) First Developer	—	—
Color Developer	360 ml (12 oz.)	30 ml (1 oz.) Color Dev. Part A	60 ml (2 oz.) Color Dev. Part B	30 ml (1 oz.) Color Dev. Part C
Blix	210 ml (7 oz.)	120 ml (4 oz.) Blix Part A	120 ml (4 oz.) Blix Part B	30 ml (1 oz.) Blix Part C

Examples:

To make this volume of working solutions:	Multiply quantities above by this factor:
150 ml (5 oz.)	0.313
180 ml (6 oz.)	0.375
210 ml (7 oz.)	0.438
240 ml (8 oz.)	0.500
960 ml (32 oz.)	2.000

MISCELLANEOUS MANUFACTURERS

675

UNICOLOR RP-1000 CHEMISTRY AND REPLENISHER

This sheet is a supplement to the general RP-1000 instructions. With this kit you can make replenisher solutions and/or working strength solutions for processing in Unidrums, trays or tanks. Mixing instructions and recommended replenishment procedures are given below.

UNIDURUM PROCESSING

Mix small volume of working strength solutions sufficient for one printing session and use the chemistry "one-shot." Replenishment of small working solutions volumes (less than one gallon) is not recommended.

DEEP TANK (BASKET) PROCESSING

Mix sufficient working strength solutions to charge the processor and use the remaining concentrates for replenisher solutions.

The tables below show how to make one quart (.95 l.) of solutions. To make more or less than this amount, multiply or divide by the appropriate factor.

MIXING INSTRUCTIONS—Replenisher Solutions

To Make	Start With Water	Then Add & Mix This Concentrate	Then Add & Mix This Concentrate	Then Add & Mix This Concentrate	Then Add & Mix This Concentrate
First Developer Replenisher	720 ml (24 oz.)	240 ml (8 oz.) First Developer	—	—	—
Color Developer Replenisher	705 ml (23.5 oz.)	60 ml (2 oz.) Color Developer Part A	120 ml (4 oz.) Color Developer Part B	60 ml (2 oz.) Color Developer Part C	15 ml (0.5 oz.) Color Developer Starter
Blix	420 ml (14 oz.)	240 ml (8 oz.) Blix, Part A	240 ml (8 oz.) Blix, Part B	60 ml (2 oz.) Blix, Part C	—

MIXING INSTRUCTIONS—Working Solutions

To Make	Start With Water	Then Add & Mix This Concentrate	Then Add & Mix This Concentrate	Then Add & Mix This Concentrate
First Developer	720 ml (24 oz.)	240 ml (8 oz.) First Developer	7.5 ml (¼ oz.) First Developer Starter	—
Color Developer	720 ml (24 oz.)	60 ml (2 oz.) Color Developer Part A	120 ml (4 oz.) Color Developer Part B	60 ml (2 oz.) Color Developer Part C
Blix	420 ml (14 oz.)	240 ml (8 oz.) Blix, Part A	240 ml (8 oz.) Blix, Part B	60 ml (2 oz.) Blix, Part C

MISCELLANEOUS MANUFACTURERS

The Compact Photo-Lab-Index

REPLENISHMENT TECHNIQUE

To extend chemistry life and maintain consistency when processing in deep tanks, replenish all solutions at the nominal rate of 90 ml per square foot of paper. Standard prints or sensitometric strips can be processed and evaluated regularly to monitor the state of the processing solutions. Signs of underreplenishment are a magenta cast on the prints and weaker color saturation. Over-replenishment may lead to lighter prints. Change the repenishment rate by 10% increments to correct either of these situations.

The recommended replenishment method is to *remove* 90 ml of each working solution for each square foot of paper processed and to replace it with 90 ml of replenisher solution. Replenish after each batch of prints.

Paper Size	Square Inches	Nominal Replenishment Rate Per Sheet (ml)
4 x 5	20	12.5 ml
5 x 7	35	22 ml
8 x 10	80	50 ml
11 x 14	154	96 ml
16 x 20	320	200 ml
1 Square Foot	144	90 ml

CHEMISTRY STORAGE LIFE

For best results storing working solutions is not recommended, but if you must, do not store them longer than the following times. *Mix only what you need!*

Solution	Storage Conditions	Time
Unopened chemistry	Original Bottles	Up to 2 years
Opened concentrates	Original bottles kept full by squeezing out air	Up to 12 months
Working strength solutions	Full glass bottles	Up to 2 weeks

PRINTING INFORMATION FOR ENLARGERS

Unicolor Unichrome and Ektachrome 2203 Papers have wide exposure latitude and the following trial filter packs should produce acceptable prints. Of course, different emulsions of paper may require different exposure conditions. Consult the data sheet supplied with the paper for further information.

Enlarger	Filters	8 x 10 Exposure
Condensers with sheet filters	Unichrome Paper 10C + 10Y + UV	10 seconds $f/5.6$ to $f/8$
	2203 Paper 20C + 20Y + UV	10 seconds $f/5.6$ to $f/8$
Dichroic Color Filters	Unichrome Paper 10C + 10Y	10 seconds $f/5.6$ to $f/8$
	2203 Paper 20C + 20Y	10 seconds $f/5.6$ to $f/8$

MISCELLANEOUS MANUFACTURERS

ADJUSTING PRINT DENSITY

To lighten a print—increase exposure time or "open up" lens aperture.
To darken a print—decrease exposure time or "stop down" lens aperture.

ADJUSTING COLOR BALANCE

If the Print is	Subtract These Filters	or	Add These Filters
Cyan	Cyan		Red (M & Y)
Magenta	Magenta		Green (C & Y)
Yellow	Yellow		Blue (C & M)
Red	Red (M & Y)		Cyan
Green	Green (C & Y)		Magenta
Blue	Blue (C & M)		Yellow

If the desired color change is small—add or subtract 5-10 units of filtration.
If the desired color change is large—add or subtract 20-40 units of filtration.

UNIDRUM PROCESSING INSTRUCTIONS*

Step	Solution	Presoak, Washes at 105°F (41°C) Chemical Solution Temp.		
		75°F (24°C)	90°F (32°C)	105°F (41°C)
	Presoak	See notes	See notes	See notes
1	First Developer	2½ min.	2 min.	1½ min.
	Wash #1	2 min.	2 min.	2 min.
2	Color Developer	5 min.	4 min.	3 min.
	Wash #2	½ min.	½ min.	½ min.
3	Blix	2½ min.	2½ min.	2 min.
	Wash #3	1½ min.	1½ min.	1½ min.
	Total Time	14 min.	12½ min.	10½ min.

Print may be exposed to light after completion of the color developer.
Other manufacturer's drums may also be used.
All presoaks, washes at 105°F (41°C).

NOTES ON UNIDRUM PROCESSING

Water Presoak—Either: (1) fill drum with water before exposure and load paper (Note: drum warms to presoak temperature during print exposure), (2) load exposed paper in thoroughly dry drum, then fill with water and let stand 1 minute to warm drum, or (3) put 16 oz. of water in a thoroughly dry and loaded 8 x 10 (32 oz. in larger drums) and agitate on uniroller for 1 minute. Use 105°F (41°C) for water presoak.

MISCELLANEOUS MANUFACTURERS

The Compact Photo-Lab-Index

Developers—Pour developers into drum and agitate for correct time. Drain drum thoroughly at *end of step*.

Water Washes—Pour at least 16 oz. (480 ml) water into 8 x 10 drum (32 oz. in larger drums). Agitate 15-20 seconds and dump so as to obtain one complete rinse every 30 seconds. Continue fill-and-dump technique until end of rinse step (e.g., 4 rinses in 2 minutes). Use 105°F (41°C) for water washes.

Required Chemical Quantities—These are dictated by the size and brand of your processing drum. See drum instructions.

TRAY PROCESSING INSTRUCTIONS

Unicolor RP-1000 Chemistry can be used to process Ektachrome 2203 and 14 RC Papers as a 3-step tray process. Ideal tray processing can be accomplished with the Unicolor Temperature Control Processing Trays. These trays can maintain the solution temperatures at the required range.

Tray	Solution	Time at 100°F (38°C)
1	First Developer	1½ minutes
	Wash #1	1½ minutes
2	Color Developer	2½ minutes
	Wash #2	½ minute
3	Blix	2 minutes
	Wash #	1½ minutes
	Total Time	9½ minutes

Print may be exposed to light after print is placed into color developer.

NOTES ON TRAY PROCESSING

Agitation—Prints should be agitated slightly. Use print tongs to swirl print around in solution. Leave print face down in tray to avoid scratching print surface. *Do not* splash solutions into other trays. Contamination may result.

Wash #1—Must be done in complete darkness. Remove print from first developer and place in tray or sink and wash with running water for required time. Can be washed up to 3 minutes if desired. Lights can be turned on when print is placed into color developer.

Wash #2, 3—Place in running water for required time. May be done in room light.

TROUBLE SHOOTING CHART

Problem	Probable Cause	Remedy
Print dark with Magenta highlights	Too little first development from low temperature, too short time, weak or old developer.	Print not recoverable. Follow time/temp. chart or mix new First Developer.
Print dark with grayish highlights	Underblixing from low temperature, too short time, weak or old solution.	Print recoverable. Reblix in fresh blix or increase time/temp.
Print light, lacking color saturation or abnormal colors	Too little color development from low temperature, too short time, weak or old solution. Contaminated First Developer.	Print not recoverable. Mix fresh Color Developer and follow time/temp. chart. Mix fresh First Developer.
Print streaked	Too little solutions used. Drum rolling surface not level.	Print not recoverable. Use proper solution volumes. Level rolling surface.
Blue spots on prints	Iron contamination of solutions.	Print not recoverable. Use Unicolor Water Filter to make solutions and for all washes.
Minus density spots or mottle	Moisture condensation on cold paper.	Print not recoverable. Follow data sheet packaged with paper concerning cold storage and warm-up time before opening paper.
No maximum density. (Borders not black) or print too "washed out."	Too much First Development. Solution too warm or too much time given.	Print not recoverable. Follow time/temp. chart. Wash more thoroughly in Wash #1.

Warning: Read and observe all cautionary information provided with this kit.
This kit contains the following chemicals which may be dangerous if misused. **Children should use only with adult supervision.**

Concentrate	Contains
First Developer	Hydroquinone
Color Developer Part A	4-amino-N-ethyl-N-(8-methane sulfanamido-ethyl) M-toluidene sesquisulfate
Color Developer Part B	Sodium Carbonate
Color Developer Part C	Hydroxylamine Sulfate
Blix Part A	Ammonium Thiosulfate
Blix Part B	Ethylenediamine Tetraacetic Acid
Blix Part C	Sodium Sulfite

Keep out of reach of children. Use only in well ventilated area.

UNICOLOR BLACK & WHITE FILM DEVELOPER

CAT. 156—16 oz. bottle

Unicolor Black and White Film Developer is a liquid concentrate that is used to process black and white negative films. The chemistry can be used in two manners.

MIXING INSTRUCTIONS

(1) Dilute 1 part of liquid concentrate with 19 parts of water to make working solution. Each liter of 1:19 solution will process 4 rolls 135-36 film (or equivalent).

(2) Dilute 1 part concentrate with 39 parts water to make working solution. Use the 1:39 working solution as a one-shot developer. Use of the 1:39 dilution allows more control of negative development and produces finer grain.

Film Processing at 68°F (20°C)

1.	Film Developer	see Development Table following
2.	Stop Bath	15 to 30 seconds
3.	Fixer (Fix 2)	2 to 4 minutes
4.	Wash*	20 to 30 minutes in running water

*Wash time can be shortened with use of washing aid such as Kodak Hypo-Clearing Agent.

Films processed in inversion tanks should be agitated continuously the first 15 seconds, then 5 seconds every 30 seconds thereafter.

FILM DEVELOPMENT TABLE

Film	Film Drum 1:19	Film Drum 1:39	Inversion Tank 1:19	Inversion Tank 1:39
Panatomic-X	4¼ min.	6 min.	5 min.	7 min.
Plus-X	4¼ min.	6 min.	5 min.	7 min.
Tri-X	6½ min.	9 min.	7½ min.	10½ min.
Ilford Pan F	4 min.	5½ min.	4½ min.	6¼ min.
Ilford FP4	4½ min.	6 min.	5 min.	7 min.
Ilford HP5	6½ min.	9 min.	7½ min.	10½ min.

Times can be modified up to ±25% to suit individual needs. To increase film contrast, increase development time. To decrease contrast, decrease devlopment time.

To process other B&W films not listed in the able above, use the following guide:

ASA	Development Time 1:19	Development Time 1:139
32-50	4½ to 5 min.	6¼ to 7 min.
80-200	4½ to 6 min.	6¼ to 9 min.
200-400	6½ to 8 min.	9½ to 11 min.

MISCELLANEOUS MANUFACTURERS

UNICOLOR BLACK & WHITE INDICATING STOP BATH

CAT. 158—16 oz. bottle—makes 4 gallons

Unicolor B&W Indicating Stop Bath is used to stop the developing action on all B&W paper and films.

MIXING INSTRUCTIONS

Indicating Stop Bath is a liquid concentrate that is diluted 1 part concentrate to 31 parts water to make a working solution.

PROCESSING INSTRUCTIONS

After development, immerse films or prints 15-30 seconds and drain before placing in fixer. Fresh Stop Bath is yellow in color. Discard exhausted Indicating Stop Bath when the color changes to blue/purple.

UNICOLOR FIX-2 FOR B & W FILMS

CAT. 154—16 oz. bottle—makes 2 quarts (½ gallon)

Unicolor B&W Film Fixer Fix-2 used to "fix" black and white negative films. Fixer removes the unexposed silver halide crystals which would later darken the film if not removed.

MIXING INSTRUCTIONS

Dilute 1 part liquid concentrate to 3 parts water to make a working solution. Each gallon of fixer has a capacity of 100 rolls 135-36 film (or equivalent).

PROCESSING INSTRUCTIONS

Fix films 2-4 minutes at 20°C (68°F). Wash films thoroughly after fixing and dry films normally.

UNICOLOR BLACK & WHITE FIX BATHS FIX-1 FOR B & W PAPERS

CAT 152—16 oz. bottle—makes 1 gallon
CAT. 142—½ gal. bottle—makes 4 gallons (to be announced)

Unicolor B&W Paper Fixer Fix-1 is used to "fix" black & white prints. Fix-1 is a rapid-type fixer in a convenient liquid concentrate available in quantities to make 1 or 4 gallons.

MIXING INSTRUCTIONS

For RC papers: dilute 1 part of concentrate with 3 parts water to make a working solution. For NON-RC (baryta) papers: dilute 1 part concentrate with 7 parts water to make a working solution.

PROCESSING INSTRUCTIONS

B&W resin coated (RC) prints are completely fixed in 30-45 seconds at 20°C (68°F). DO NOT fix longer than 2 minutes. Baryta (NON-RC) prints should be fixed 1½-2 minutes. After fixing, wash RC prints 2-4 minutes and Baryta prints 20 minutes.

MISCELLANEOUS MANUFACTURERS

UNICOLOR BLACK & WHITE PAPER DEVELOPER

CAT. 150—16 oz. bottle—makes 1.25 gallons
CAT. 140—½ gallon bottle—makes 5 gallons

Unicolor B&W Paper Developer is available in quantities to make either 1.25 or 5 gallons of working solution paper developer. It is a liquid concentrate that can be used to process any black and white paper.

MIXING INSTRUCTIONS

Dilute 1 part concentrate to 9 parts water to make a working solution.

PROCESSING INSTRUCTIONS

B&W prints can be developed in trays or in a UNIDRUM (8 x 10 drum—2 oz., 11 x 14 drum—4 oz., 16 x 20 drum—8 oz.). Recommended developing time is 1½-1 minutes at 20°C (68°F). Time can be changed by up to +50% to modify print contrast.

RECOMMENDED PRINT PROCESSING SEQUENCE AT 68°F (20°C)

1. Developer	1½-2 minutes
2. Stop Bath	30 seconds
3. Fixer (Fix-1)	45-90 seconds (RC papers) 2 minutes (baryta papers)
4. Wash	2-4 minutes (RC papers) 1 hour* (baryta papers)

*To achieve maximum hypo elimination. Or use guidelines supplied by manufacturers of washing aids (such as Kodak Hypo Clearing Agent).

UNICOLOR B & W COLD TONE PAPER DEVELOPER

CAT. 151—16 oz. bottle—makes 1.25 gallons

Unicolor B&W Cold Tone Developer (CTD) is designed to produce neutral to cold-black image tones on most B&W enlarging papers. The most dramatic change in tone is observed on warm image tone paper. The image tone can be controlled by using CTD at different dilutions.

Unicolor CTD is an all-liquid concentrate developer which is diluted 1 part developer concentrate to 9 parts water to make a working solution. To produce a colder tone, dilute 1 part developer concentrate to 4 parts water. You will find that you can produce the desired tone on many papers by controlling the dilution ratio anywhere from 1:4 to 1:39.

Recommended developing time is 1½ minutes at 20°C (68°F) for the 1:9 dilution. Shorter development times (30-45 seconds) can be used when using the 1:4 dilution.

Development time can be changed up to ±50% to modify print contrast. Increasing development time will slightly decrease print contrast.

MISCELLANEOUS MANUFACTURERS

683

UNICOLOR BLACK & WHITE ENLARGING PAPERS

Unicolor Resin Coated Black & White Paper is a premium quality RC enlarging paper with excellent tonal range and image depth. There is no gray "veiling" as with many other RC papers. The emulsion is coated on a brilliant white base containing optical brighteners for extra highlight snap, and has a neutral to warm black image tone. Unicolor RC B&W paper comes in four contrast grades and six surfaces:

Fine Grain (J)—retains brilliance and tonal range without annoying reflections; popular among illustrators and commercial photographers.

Glossy (F)—suitable for a wide variety of commercial subjects where maximum brilliance and detail are needed without surface reflections.

Lustre (E)—lightly textured paper surface; excellent for subjects where maximum brilliance and detail are needed without surface reflections.

Matte (N)—non-reflecting surface for use in exhibition prints or portraiture.

Pearl (P)—a lightly textured paper with a pearl-like sheen excellent for portraiture.

UNICOLOR PAPER (BARYTA) BASE B & W PAPER

Exhibition Baryta Soft-Gloss (SG)—a double weight paper with a slight sheen, for the photographer who displays his finest photographs.

Exhibition Baryta Lustre Matte (LM)—a double weight flat non-reflecting surface with greater tonal depth than conventional matte papers.

UNICOLOR RESIN-COATED (RC) BLACK & WHITE ENLARGING PAPER

	GLOSSY				MATTE		FINE GRAIN		PEARL		LUSTRE	
	F1	F2	F3	F6	N2	N3	J2	J3	P2	P3	E2	E3
5x7 100 sheets		•	•				•	•				
8x10 25 sheets	•	•	•	•	•	•	•	•	•	•	•	•
8x10 100 sheets	•	•	•	•	•	•	•	•	•	•	•	•
11x14 10 sheets	•	•	•	•	•	•	•	•	•	•	•	•
16x20 10 sheets		•	•				•	•				

UNICOLOR BARYTA (PAPER) BASE BLACK & WHITE ENLARGING PAPER

Exhibition Soft Gloss	Double Weight	SG-2 SG-3
Exhibition Lustre Matte	Double Weight	LM-3 LM-2

All Baryta base papers are available in the following sizes:
 8 x 10—25 sheets 8 x 10—100 sheets 11 x 14—10 sheets

MISCELLANEOUS MANUFACTURERS

UNICOLOR RB COLOR PRINT PAPER

UNICOLOR RB COLOR PRINT PAPER
A professional, resin-coated paper designed for processing speed and ease. RB paper can be processed with Unicolor Total Color Chemistry or R2 Chemistry, using two, three, or four chemical steps. Additional characteristics are increased highlighting brightness. Type RB color paper comes in three popular surfaces:

GLOSSY
Suitable for a wide variety of commercial subjects or where maximum detail and brilliance are necessary.

MATTE
A flat finish with a slight amount of sparkle to add life to salon or display prints where reflections or high surface gloss are undesirable.

LUSTRE
A sparkle finish with a slight amount of texture that adds brilliance to prints where minimum reflection is required.

SAFELIGHT
Use Kodak Wratten #13 or #10 Safelight filters in a safelight lamp with 7½ watt bulb no closer than four (4) feet from paper. Excess exposure to safelight should be avoided since it may produce undesirable changes in the paper.

STORAGE AND HANDLING
Unexposed paper should be stored under cool, dry conditions to minimize changes in color balance. Paper stored under cold (0°C, 32°F) conditions should be warmed to room temperature before use. The emulsion is sensitive to finger prints. Handle the paper by the edges only. It may be advisable to wear cotton or plastic gloves if paper handling is unavoidable. Store RP paper in *both* the plastic moisture-proof bag and protective outer package. Both packages are necessary for complete protection from light fog and physical damage.

EXPOSURE
Unicolor RB Paper may be exposed on enlargers using standard tungsten enlarger bulbs (#211, 111, 212) or quartz-halogen color heads. An ultraviolet filter (Unicolor UV, or Kodak 2B) should always be placed in the color filter drawer.

STARTING FILTER PACKS FOR UNICOLOR RB PAPER

Film	Color Head Enlargers	Standard CP Filter Enlargers
Kodacolor II	70Y + 60M	40Y + 40M
Vericolor II	90Y + 70M	60Y + 50M
Fuji F-II (100 & 400)	90Y + 80M	60Y + 60M
Ektacolor	20Y + 50M	05Y + 10M
Kodacolor X	20C + 20M	20Y + 50M

Use these filter packs as guides only. The Unicolor Duo-cube should be used to determine filter changes necessary for balancing a color print.

MISCELLANEOUS MANUFACTURERS

685

UNICHROME REVERSAL COLOR PRINT PAPER

Unichrome Reversal Color Print Paper is a resin-coated paper for making color prints directly from color slides (transparencies). Unichrome Paper can be processed in the following chemistries: UNICOLOR RP-1000, Kodak Ektaprint R-1000 or other compatible chemistries.

NOTICE

This paper will be replaced if defective in manufacture, labeling, or packaging. Except for such replacement, the sale or any subsequent handling of this paper is without warranty or liability even though defect, damage, or loss is caused by negligence or other fault. Since color dyes may in time change, prints on this material will not be replaced for, or otherwise warranted against, any change in color. Direct all warranty claims to Unicolor Customer Service Department.

STORAGE AND HANDLING

Performance of Unichrome Paper is affected by high temperature and/or high humidity. Store unexposed paper at a temperature of 50°F (10°C) or below and 50% relative humidity or below. Allow paper to warm up to room temperature before opening package. Refrigeration or freezing of Unichrome Paper extends storage life.

WARM-UP TIMES FOR UNICHROME REVERSAL COLOR PAPER

Paper Size	From 0° to 70°F (−18° to 21°C)	From 35° to 70°F (1.5° to 21°C)	From 50° to 70°F (10° to 21°C)
8 x 10 (15 sheets)	3 hours	2 hours	1 hour
8 x 10 (60 sheets)	4 hours	3 hours	2 hours

Do NOT warm up paper by placing on a heated surface to bring it to room temperature.

Outer cardboard packaging is not lighttight. Keep paper in inner, plastic bag to avoid accidental light fogging.

Paper should be processed within 8 hours of exposure to minimize latent-image fading. If it is necessary to delay processing 24 hours or longer, store paper at 0°F (−18°C).

PRINTING INFORMATION FOR ENLARGERS

Unichrome Paper has wide exposure latitude and the following *trial* filter packs should produce acceptable prints. Different Unichrome emulsions may require different exposure conditions.

Enlarger	Filters	Exposure Time	f/stop for print size: 4 x 5	5 x 7	8 x 10	11 x 14
Condenser with sheet filters	See Package + UV filter	10 seconds	f/16	f/11	f/8	f/5.6
Dichroic Color	See Package	10 seconds	f/16	f/11	f/8	f/5.6

The actual filter pack used will depend on the type of enlarger and the paper emulsion. Therefore, use the values listed only as guides to calibrate your system.

MISCELLANEOUS MANUFACTURERS

The Compact Photo-Lab-Index

ADJUSTING PRINT DENSITY

To lighten a print—increase exposure time or "open up" lens aperture.
To darken a print—decrease exposure time or "stop down" lens aperture.

ADJUSTING COLOR BALANCE

If the print is	Subtract these Filters	or	Add these Filters
Cyan	Cyan		Red (M & Y)
Magenta	Magenta		Green (C & Y)
Yellow	Yellow		Blue (C & M)
Red	Red (M & Y)		Cyan
Green	Green (C & Y)		Magenta
Blue	Blue (C & M)		Yellow

If the desired color change is small—add or subtract 5-10 units of filtration.
If the desired color change is large—add or subtract 20-40 units of filtration.

Color balance evaluation is easily obtained by viewing an area in the print that should be reproduced as a neutral (gray). To determine what filter addition will correct the print, examine the print through a filter that is complementary to the overall hue (e.g., if the print is red, view through a cyan filter, etc.).

Always remove filters from the enlarger whenever possible. For example, if the print is green—subtract cyan and yellow rather than adding magenta.

If all three colors (C, M, Y) are present in the enlarger, neutral density is formed. This lengthens exposure time without accomplishing color correction. To remove neutral density, remove *equal* amounts of all three colors.

EXPOSURE ADJUSTMENT FOR FILTER CHANGES

Allowances should be made for exposure times whenever filter changes are made. Consult the instruction sheet with your color filter set to determine the filter factors for your printing filters. If you are using a dichroic enlarger, consult the instruction booklet for your enlarger. Typically, dichroic filters have small filter factors and moderate changes in filtration do not require exposure adjustments.

CHANGING PAPER EMULSIONS

The color correction number (c.c. #) stamped on the outer package of Unichrome Paper reflects the starting recommended filter pack. If the color correction number changes from one package to another, determine the difference between the packages and apply this difference to *your* normal printing conditions.

Example: Your successful filter pack has been 10C + 15Y with package #1 that had C.C. # of 10C + 10Y. A new package of paper has a C.C. # of 15C + 20Y. The new package requires 5C and 10Y more than package #1. Therefore, add this difference to *your* previous filter pack (10C + 15Y plus 5C + 10Y = 15C + 25Y). Your filter pack for the new paper is therefore approximately 15C + 25Y. Because many conditions affect the color balance, these color correction numbers can only be used as a guide in obtaining approximate emulsion corrections.

The Compact Photo-Lab-Index

(The following chapter is reprinted from *The Morgan and Morgan Darkroom Book,* by Algis Balsys and Lilian DeCock-Morgan.)

Fine Tuning the Chemicals

The following listing of chemical formulations is comprised of various general and special purpose developing compounds, fixers, toners and the like. Some of these are currently being used with contemporary photographic emulsions, while others are old formulas, and it ought to be emphasized; *they may or may not produce desirable results when used with current materials.* Those formulas considered obsolete are indicated with an * next to the formula heading. They are included because many photographers are interested in old compounds and processes.

Pre-packaged, commercially available formulas offer many advantages not the least of which is convenience: Also, all other factors being equal, the end result is consistent and dependable. However, to the photographer inclined toward a better understanding of the photographic process or—experimentation—concocting one's own formulary can be a rewarding experience.

A word of caution: If you alter the amount of *any one* compound in a formula, do it in *very* moderate steps and keep accurate records, so results can be duplicated and mistakes avoided next time.

Lastly, never—never—run a roll of, possibly irreplaceable, negatives through an untested film developer.

MIXING CHEMICALS

It has been said throughout this text, but it bears repeating: Always mix chemicals in the order given (this includes water—it is, after all, a chemical compound).

- *Never* pour water on an acid—always add acid to water, to avoid splattering.
- If the instructions say "stir rapidly" or, "stir vigorously", then do so—otherwise, precipitates may form (some of these can be put back into solution by restirring, others cannot—avoid the risk by stirring vigorously the first time).
- Pay strict attention to temperature, where indicated, not only in processing, but in mixing the chemicals as well.
- If the formula includes strong alkalines or acids, wear rubber gloves. A rubber apron would not be a bad idea either.
- *Never* mix chemicals in your kitchen.
- Do not lean over the container you are mixing in. None of the fumes or airborne particles of photographic chemicals is particularly pleasant, and some are dangerous. If you don't hover over the containers, you will run less of a risk of inhaling harmful substances.
- Always mix in a well ventilated area.
- Measure chemical amounts carefully. For solid substances use a laboratory scale only. Your kitchen scale won't do, for two reasons: First, because of the potential health hazard this poses, and second, because the average kitchen scale is neither sensitive nor accurate enough.
- Clean all beakers, graduates, containers and so on scrupulously, as soon after using as possible —and wash them again before each use just to be sure.

689

- To avoid difficulty in mixing, make sure containers and measuring surfaces are dry before measuring out powders or crystals onto them.

- Pay attention to the chemical names. For example, do not confuse sulf*a*te with sulf*i*te, or chlor*a*te with chlor*i*de. The very least that will happen if you are careless is that your formula will not do what you want it to. At worst, you might inadvertently cause a dangerous chemical reaction.

- If there are young children around, be sure to take *extra* precautions. A solution stored in a *familiar*, brown apple juice bottle, for example, can only invite disasters. Store out of reach of children.

Metric. In this chapter, metric measurements are given, *only*. Accurate measuring aids — scales and graduates — are necessary if you mix your own formulas; laboratory quality is required (i.e., a kitchen or diet scale won't do). Most, if not all, of these measuring aids are now all metric or give metric as well as avoirdupois measurements.

If you need to convert a formula, conversion tables, and conversion calculation factors, can be found at the end of this chapter.

PERCENTAGE SOLUTIONS

Certain chemicals used in the compounding of photographic formulas are best kept in *percentage solution*. Percentage solutions are made by dissolving amounts of the substance (in the percentage indicated) in water or, in some cases, alcohol. Percentage solutions make the measuring out of extremely small amounts of a chemical far easier — you can drive yourself to distraction trying to measure out 1/8 gram of a crystalline chemical, for example.

To prepare a percentage solution of a liquid chemical, take the *same number of ml* of the substance as the percentage number indicated in the formula, and dilute it into about 50 ml of water. Then add enough water to bring the total volume to 100 ml. For solid chemicals, dissolve as many grams as the percentage figure given in the formula. For example, if a 5% solution of a liquid is asked for, dissolve 5 ml of the liquid into 50 ml of water, then add 45 ml of water (5+50+45=100) to bring the total volume to 100 ml. If the chemical is solid, dissolve 5 grams of it into 50 ml water, then add enough water to bring total volume to 100 ml.

Figuring Dilutions. To achieve a desired dilution, use the following criss-cross method based on the accompanying diagram.

At *A* place the percentage of the solution that is to be diluted to some lesser concentration. (Example, in diluting 99% acetic acid, place 99% at A.)

At *B* place the percentage of the solution you will use to make the dilution; usually this is water, which has a percentage strength of 0.

At *W* place the percentage strength that you want in the final solution.

Subtract *W* from *A;* place the result at *Y*.
Subtract *B* from *W;* place the result at *X*.
Mix *X* parts of *A* with *Y* parts of *B;* the result is a solution of *W* strength.

For example, using 99% Acetic Acid (*A*), to dilute it with water (0, *B*) to 28% (*W*), take 28 parts of 99% acid and 71 parts water.

DEVELOPERS

In order to put the developer formulas contained in this chapter to their most productive use, it is useful to understand the nature of photographic developers, and the role that each of their component chemicals plays. It makes little sense to change or adjust existing formulations haphazardly; whereas a general knowledge of the job of each part of a developer compound will help you to make sensible decisions should you decide to formulate your own developer, or modify the ones you are presently using.

Developer ingredients fall into 6 categories. These are: developing agents; activators; preservatives; restrainers; solvents; and miscellaneous additives.

FORMULAS

Developing Agents. The developing agent in a developer formula is that chemical which changes exposed silver salts of the emulsion into metallic silver, while leaving the unexposed ones relatively unaffected.

The two most commonly used developing agents are metol (also known as Elon) and hydroquinone. Metol produces softer contrast while hydroquinone, a more vigorous developer, produces higher contrast. Either agent can be used by itself or in combination of varying concentrations to produce any contrast desired.

Other developing agents are: Pyro, amidol, catechol, and glycin.

Activators. Developing solutions need to be alkaline to work properly. Since almost all developing agents are not sufficiently alkaline by themselves, some sort of alkaline substance must be added to the formula in order to produce the right environment for proper development to take place. The alkalis used in developer formulas are, from the most to the least alkaline: Sodium hydroxide; sodium carbonate; Kodalk (a proprietary alkaline compound made by Eastman Kodak); and borax.

Preservatives. Photographic developers and the dissolved developing agents in them have a tendency to react with oxygen in the air, producing products that color and cloud the solution. If this is allowed to happen to any great degree, the developer becomes useless. Therefore, most developer formulas call for the addition of sodium sulfite, which combines with the oxidation product in such a way that the solution stays clear longer. Sodium sulfite also reduces the rate of oxidation, giving the developer longer life.

Restrainers. Restrainers, such as potassium bromide, are added to further reduce the possibility of unexposed silver halides becoming affected by the developing agents in the formula. The more effectively this is done, the less "chemical fog" will appear on the clear portions of the emulsion. (Strictly speaking, such formulations as benzotriazole and *Kodak* Anti-Fog #1 are also restrainers — see the paragraph on miscellaneous additives.)

Solvents. A solvent is that which places a chemical formula into solution. Being photographically neutral, water is the ideal solvent for photographic formulas; though some very concentrated liquid formulas call for additional solvent compounds, most commonly diethyleneglycol.

In addition to its role as the medium for developer solutions, water also plays a second, equally important role — it swells the gelatin of photographic emulsions, so that the developer can more easily go to work.

Try at all times to use distilled water when mixing chemicals. If you can't find any, boil your tap water and use that — but distilled water is infinitely preferable.

Miscellaneous Additives. There are a number of other chemicals which, when judiciously added to a developer formula, can adjust it for use under special conditions. For example, if you find yourself needing to process photographic emulsions at extremely high temperatures, you will probably look up the formula for a "tropical" developer, and you will notice that it contains an ingredient not found in a more conventional developing compound. This ingredient is sodium sulfate (not to be confused with the preservative sodium sulfite). Sodium sulfate retards swelling of the gelatin in photographic emulsions, thereby allowing films and papers to safely endure processing at higher than normal temperatures.

Sodium thiocyanate is another additive that is put into certain developers, for the purpose of dissolving some of the silver halide crystals during development. The effect of this is to make the grain structure of the emulsion less noticeable. Most "extra-fine grain" developers contain small amounts of sodium thiocyanate, or similar compounds.

Benzotriazole and *Kodak* Anti-Fog are chemical additives used to boost the restraining action of potassium bromide. They extend the life of outdated photographic papers and films to a degree.

One more additive worth a mention is water softener, such as *Kodak* Anti-Calcium. This additive is used when distilled water is not available, and when the tap water is especially hard. Hard water tends to cause sludging in developers, and water softening agents will, when added, effectively neutralize the sludge-causing calcium in hard water.

FORMULAS

691

FILM DEVELOPERS

Normal Contrast Glycin Developer — Agfa #8

Warm water 52°C	750	ml
Sodium Sulfite, desiccated	12.5	grams
Glycin	2.0	grams
Potassium Carbonate	25.0	grams
Add cold water to make	1.0	liter

Development time for ASA 100-125 films is 10-12 min. at 20°C.

Fine Grain, Soft Working, Metol/Sulfite — Agfa #14

Warm water 52°C	750	ml
Metol (Elon)	4.5	grams
Sodium Sulfite, desiccated	85.0	grams
Sodium Carbonate, monohydrated	1.2	grams
Potassium Bromide	0.5	gram
Add cold water to make	1.0	liter

Development time, at 20°C is best determined by testing—but will range between 10 and 20 minutes. The longer the development time, the more contrast.

For High Contrast Results with Sheet Film and Plates — Agfa #40

Warm water 52°C	750	ml
Metol (Elon)	1.5	grams
Sodium Sulfite, desiccated	18.0	grams
Hydroquinone	2.5	grams
Potassium Carbonate	18.0	grams
Add cold water to make	1.0	liter

Develop for 4-5 minutes at 20°C.

Agfa #12*

Fine grain film developer with a long life (intended primarily for tank use).

Warm water 52°C	1.0	liter
Sodium Sulfite (anhydrous)	8	grams
Sodium Carbonate (monohydrated)	5.75	grams
Potassium Bromide	2.5	grams

Use undiluted, at 18°C for 8-12 minutes.

Agfa #16

A film developer that substitutes Borax for Sodium Carbonate in order to produce a slow, soft-working and fine grained development.

Warm water 52°C	1.0	liter
Metol (Elon)	1.5	grams
Sodium Sulfite (anhydrous)	80	grams
Hydroquinone	3	grams
Borax	3	grams
Potassium Bromide	0.5	gram

Use undiluted, at 18°C, for 10-15 minutes.

M-H Tank Developer — Agfa #42*

A long lasting efficient tank developer yielding negatives of high contrast.

Water	1.0	liter
Metol	0.8	grams
Sodium Sulphite (anhydrous)	45	grams
Hydroquinone	1.2	grams
Sodium Carbonate (monohydrated)	8.0	grams
Potassium Metabisulphite	4.0	grams
Potassium Bromide	1.5	grams

Do not dilute for use. Develop 15 to 20 minutes at 18°C.

Metol-Pyro Developer — Agfa #46*

A developer which gives brilliant printing quality to the negative.

Solution A:

Water	1.0	liter
Sodium Bisulphite	7.5	grams
Metol	7.5	grams
Pyro	30	grams
Potassium Bromide	4.2	grams

Solution B:

Water	1.0	liter
Sodium Sulphite (anhydrous)	150	grams

Solution C:

Water	1.0	liter
Sodium Carbonate (monohydrated)	80	grams

Tank development: take one part each of solutions A, B, and C, and 13 parts of water. Develop 8 to 10 minutes at 18°C.

Tray development: take one part each of solutions A, B, C, and 8 parts of water. Develop 5 to 7 minutes at 18°C.

Agfa #72*

This is a soft working developer built around glycin (rather than the currently more common Metol). It produces gently graded results in either tank or tray.

Water 52°C	1.0	liter
Sodium Sulfite (anhydrous)	125	grams
Glycin	50	grams
Potassium Carbonate	250	grams

For tank development, dilute the above stock solution 1 part to 10 parts water, and develop at 18°C for 15-20 minutes.

For tray development, dilute 1:4 and develop at 18°C for 5-7 minutes.

FORMULAS

Fine-Grain Tank Developer GAF-12

An excellent tank developer; keeps well.

Water 52°C	750.0	ml
Metol	8.0	grams
Sodium Sulfite (anhydrous)	125.0	grams
Sodium Carbonate (anhydrous)	5.75	grams
Potassium Bromide	2.5	grams
Cold water to make	1.0	liter

Do not dilute; develop 9-16 minutes at 20°C.

Fine-Grain Borax Tank Developer GAF-17

Recommended for all 35mm films.

Water 52°C	750.0	ml
Metol	1.5	grams
Sodium Sulfite (desiccated	80.0	grams
Hydroquinone	3.0	grams
Borax (granular)	3.0	grams
Potassium Bromide	0.5	gram
Cold water to make	1.0	liter

Do not dilute; develop fine-grain films 10-15 minutes at 20°C.

Replenisher for GAF-17 GAF-17a

Water 52°C	750.0	ml
Metol	2.2	grams
Sodium Sulfite (desiccated)	80.0	grams
Hydroquinone	4.5	grams
Borax (granular)	18.0	grams
Cold water to make	1.0	liter

Add 15-20 ml replenisher for each 36-exposure roll developed. Maintain original volume of developer by discarding some used developer, if necessary, to add full amount of replenisher. No increase in developing time for subsequent rolls is required.

Fine-Grain Metaborate Tank Developer GAF-17M

Similar to GAF-17, but permitting shorter developing times by varying the amount of metaborate.

Water 52°C	750.0	ml
Metol	1.5	grams
Sodium Sulfite (desiccated)	80.0	grams
Hydroquinone	3.0	grams
Sodium Metaborate	2.0	grams
Potassium Bromide	0.5	gram
Cold water to make	1.0	liter

Do not dilute; develop fine-grain films 10-15 minutes at 20°C. To reduce developing times, increase the amount of metaborate; up to 10 grams metaborate may be used, with a developing time of 5 minutes. Slightly coarser grain will result.

Replenisher for GAF-17M GAF-17M-a

Water 52°C	750.0	ml
Metol	2.2	grams
Sodium Sulfite (desiccated)	80.0	grams
Hydroquinone	4.5	grams
Sodium Metaborate	8.0	grams
Cold water to make	1.0	liter

Note: If an increased amount of metaborate is used, the replenisher should obtain four times the amount used in the developer.

Add 15-20 ml replenisher for each 36-exposure roll developed. Maintain original volume of developer by discarding some used developer, if necessary, to add full amount of replenisher. No increase in developing time for subsequent rolls is required.

Gevaert GD-17*

(Non-staining Formula)

Make up two solutions according to the following formulas:

Solution A:

Sodium Sulfite	200.0	grams
Potassium Metabisulfite	50.0	grams
Pyro	50.0	grams
Water to make	3.0	liters

Solution B:

Sodium Carbonate	225.0	grams
Water to make	3.0	liters

Mix A, 1 part; B, 1 part; water, 2 parts.

In making the "A" solution the sulfite and metabisulfite should be mixed together into hot water. When they are dissolved, the solution should preferably be brought to a boil and boiled for about a minute. After the solution has cooled, the pyro is added. The boiling greatly improves the keeping qualities of the solution.

This developer will produce negatives free from pyro stain, and 4 to 6 minutes development at normal temperature with full exposure will yield negatives which are well suited to enlarging. The advantages of the developer are its cleanliness and the extraordinary keeping qualities of the "A" solution, which must be made up as directed above.

FORMULAS

Gevaert GD-36

Metol	1.9 grams
Sodium Sulfite	35.0 grams
Adurol	1.4 grams
Hydroquinone	6.2 grams
Potassium Carbonate	27.0 grams
Potassium Bromide	1.7 grams
Water to make	1.0 liter

For tray use, take one part of stock solution and two parts of water. Develop 3-4 minutes.

For tank development, use one part to eight parts of water. Develop 12-14 minutes.

Gevaert GD-202*

Metol	1.0 gram
Sodium Sulfite	32.0 grams
Glycin	.5 gram
Hydroquinone	.5 gram
Sodium Carbonate	28.0 grams
Potassium Bromide	1.5 grams
Citric Acid	1.0 gram
Water to make	1.0 liter

If exposure has been correct, the film will be properly developed in 10-12 minutes.

Three-Solution Pyro Developer Kodak D-1*

This developer is intended for general tank or tray use.

Stock Solution A:

Sodium Bisulfite (anhydrous)	9.8 grams
Pyro (pyrogallol)	60.0 grams
Potassium Bromide (anhydrous)	1.1 grams
Water to make	1.0 liter

Stock Solution B:

Water	1.0 liter
Sodium Sulfite (anhydrous)	105.0 grams

Stock Solution C:

Water	1.0 liter
Sodium Carbonate	90.0 grams

For tank use, take 1 part of Stock Solution A, 1 part of Stock Solution B, 1 part of Stock Solution C, and 11 parts of water. Develop for approximately 12 minutes at 18°C.

For tray use, take 1 part of Stock Solution A, 1 part of Stock Solution B, 1 part of Stock Solution C, and 7 parts of water. Develop for approximately 6 minutes at 18°C.

Prepare fresh developer for each batch of film.

Kodak-D8

An extremely active developer, producing very high contrast results. It is primarily designed for use with line-copy materials.

Water 32°C	750 ml
Sodium Sulfite (anhydrous)	90.0 grams
Hydroquinone	45.0 grams
Sodium Hydroxide (granular)	37.5 grams
Potassium Bromide	30.0 grams
Add cold water to make	1.0 liter

To use, mix 2 parts stock solution to 1 part water, and develop at 20°C for about 2 minutes. Developer must be used immediately after diluting, since it has a very short tray life.

Kodak D-11

An active, high contrast developer with better keeping qualities than D-8. Can be used with most films, if very high contrast results are needed, although its primary use is for development of photographic records of line drawings and the like.

Water 50°C	500 ml
Elon (Metol)	1.0 gram
Sodium Sulfite	75.0 grams
Hydroquinone	9.0 grams
Sodium Carbonate (monohydrated)	30.0 grams
Potassium Bromide (anhydrous)	5.0 grams
Add cold water to make	1.0 liter

For line subjects, use undiluted; continuous tone subjects require a 1:1 dilution with water. Develop for 5 minutes in a tank or about 4 minutes in a tray at 20°C.

Kodak D-19

Less contrasty than D-8 or D-11, this developer produces brilliant higher than normal contrast negatives of continuous tone subjects. The solution keeps well and is clean working.

Water 50°C	500 ml
Elon (Metol)	2.0 grams
Sodium Sulfite (anhydrous)	90 grams
Hydroquinone	8.0 grams
Sodium Carbonate (monohydrated)	52.5 grams
Potassium Bromide (anhydrous)	5.0 grams
Add cold water to make	1.0 liter

Tank development is for 6 minutes, tray development 5 minutes at 20°C undiluted.

FORMULAS

Kodak DK-20

A fine-grain developer, using sodium thiocyanate which acts as a silver halide solvent (it breaks down the silver salt crystals somewhat, giving the negatives a less prominent grain pattern).

Water 50°C	750	ml
Elon (Metol)	5.0	grams
Sodium Sulfite (anhydrous)	100.0	grams
Kodalk Balanced Alkali	2.0	grams
Sodium Thiocyanate (liquid)	1.5	ml
Potassium Bromide (anhydrous)	0.5	gram
Cold water to make	1.0	liter

Average tank development time at 20°C is 15 minutes.

Glycin Negative Developer Kodak D-78*

Water	750	ml
Sodium Sulfite (anhydrous)	3.0	grams
Glycin	3.0	grams
Sodium Carbonate (monohydrated)	7.2	grams
Water to make	1.0	liter

The average development time is 15 to 25 minutes at 18°C.

Pyro Tank Developer Kodak D-79*

Water	750	ml
Sodium Sulfite (anhydrous)	25.0	grams
Pyrogallol	2.5	grams
Sodium Carbonate (monohydrated)	6.0	grams
Potassium Bromide (anhydrous)	0.5	gram
Water to make	1.0	liter

The average development time is 9 to 12 minutes at 18°C. The solution oxidized rapidly; use it within one hour after mixing.

Maximum Energy Developer Kodak D-82*

This developer is intended for use with badly underexposed films.

Water 50°C	750	ml
Methyl Alcohol	48	ml
Elon	14.0	grams
Sodium Sulfite (anhydrous)	52.5	grams
Hydroquinone	14.0	grams
Sodium Hydroxide (granular)	8.8	grams
Potassium Bromide (anhydrous)	8.8	grams
Cold water to make	1.0	liter

Use without dilution. Develop for 4 to 5 minutes in a tray at 18°C. The prepared developer does not keep for more than a few days. If methyl alcohol is not added, and the developer is diluted, the solution is not as active as in the concentrated form.

Tropical Developer Kodak DK-15*

This developer is intended for film and plate developing under tropical conditions.

Water 50°C	750	ml
Elon	5.7	grams
Sodium Sulfite (anhydrous)	90.0	grams
Kodalk Balanced Alkali	22.5	grams
Potassium Bromide (anhydrous)	1.9	grams
*Sodium Sulfate (anhydrous)	45.0	grams
Cold water to make	1.0	liter

*If crystalline sodium sulfate is preferred to the anhydrous form, use 105.0 grams instead of 45.0 grams listed.

The average time for tank development is about 10 minutes at 20°C and 2 to 3 minutes at 32°C. These times apply when the developer is fresh. Vary the time to produce the desired contrast.

When you are working at temperatures below 24°C, you may omit the sodium sulfate in order to obtain a more rapidly acting developer. The developer time *without* the sodium sulfate is approximately 6 minutes at 20°C.

When you are developing film in trays, shorten the developing times given above by about 29 percent.

When development is completed, rinse the film or plate for just 1 or 2 seconds, and then immerse it in *Kodak* Hardening Bath SB-4 for 3 minutes. Omit the rinse if you find that the film tends to soften. Fix the film for at least 10 minutes in an acid hardening fixing bath, such as *Kodak* Fixing Bath F-5, and wash for 10 to 15 minutes in water not over 35°C.

PAPER DEVELOPERS

Artura Developer Defender
Stock Solution

Water 52°C	500	ml
Metol	1.5	grams
Sodium Sulfite	22.5	grams
Hydroquinone	6.3	grams
Sodium Carbonate (desiccated)	15.0	grams
Cold water to make	1.0	liter

Working Solution. Dissolve each chemical thoroughly before another is added. Keep working solution at 18°C because the formula works best at this temperature.

For use, use equal parts of developer and water. Add 0.7 gram of Potassium Bromide to each liter of working solution.

FORMULAS

Artura Variable Contrast Paper Developer
Stock Solution

Solution No. 1:

Water 52°C	500	ml
Metol	3.0	grams
Sodium Sulfite	22.5	grams
Hydroquinone	3.0	grams
Sodium Carbonate (desiccated)*	15.0	grams
Potassium Bromide	0.7	gram
Cold water to make	1.0	liter

Solution No. 2:

Water 52°C	500	ml
Sodium Sulfite	22.5	grams
Hydroquinone	9.3	grams
Sodium Carbonate (desiccated)*	15.0	grams
Potassium Bromide	0.7	gram
Cold water to make	1.0	liter

*If monohydrated carbonate is used, the quantity must be increased to 17.5 grams in each solution.

Working Solution

(Temperature 18°C)

For **Normal** results:

Solution No. 1	1 part
Solution No. 2	1 part
Water	2 parts

For **Soft** results:

Solution No. 1	3 parts
Solution No. 2	1 part
Water	4 parts

For **Contrasty** results:

Solution No. 1	1 part
Solution No. 2	3 parts
Water	4 parts

Soft-Working Paper Developer GAF-120
Stock Solution:

Water 52°C	750.0	ml
Metol	12.3	grams
Sodium Sulfite (desiccated)	36.0	grams
Sodium Carbonate (monohydrated)	36.0	grams
Potassium Bromide	1.8	grams
Cold water to make	1.0	liter

Dilute 1:2 with water; develop 1-1/2 to 3 minutes at 20°C.

Note: GAF-120 is an excellent developer for two-tray print development, which permits control over print gradation that cannot be obtained by usual variations of exposure and developing time.

The two-tray procedure uses two separate developing solutions: a soft-working developer such as GAF-120, and a brilliant-working developer such as GAF-130. Development is begun in one solution and completed in the other; the first developer used has the greater effect. This procedure is particularly helpful in producing full-scale prints which exhibit well modulated gradation in both highlights and shadows.

Metol-Hydroquinone Developer GAF-125

Recommended for development of standard papers. May also be used to develop films.

Stock Solution:

Water 52°C	750.0	ml
Metol	3.0	grams
Sodium Sulfite (desiccated)	44.0	grams
Hydroquinone	12.0	grams
Sodium Carbonate (monohydrated)	65.0	grams
Potassium Bromide	2.0	grams
Cold water to make	1.0	liter

Paper development: dilute 1:2 with water, develop 1-2 minutes at 20°C. For softer, slower development, dilute 1:4 with water, develop 1-1/2 to 3 minutes at 20°C. For greater brilliance, shorten exposure and lengthen development time; for greater softness, lengthen exposure and shorten development time.

Film development: dilute 1:1 with water, develop 3-5 minutes at 20°C. For softer results, dilute 1:3 with water, develop 3-5 minutes at 20°C.

Universal Paper Developer GAF-130

For all projection and contact papers. Gives rich black tones with excellent brilliance and detail; provides unusual latitude in development, and is clean-working even with long developing times.

Stock Solution:

Water 52°C	750.0	ml
Metol	2.2	grams
Sodium Sulfite (desiccated)	50.0	grams
Hydroquinone	11.0	grams
Sodium Carbonate (monohydrated)	78.0	grams
Potassium Bromide	5.5	grams
Cold water to make	1.0	liter

Note: The prepared stock solution is clear but slightly colored. This coloration does not indicate that the developer has deteriorated or is unfit for use.

Dilute 1:1 with water, develop most papers 1-1/2 to 3 minutes at 20°C. For greater contrast, use stock solution full strength. For softer results, dilute 1:2 with water. See formula for GAF-120 for use in two-tray development.

FORMULAS

The Compact Photo-Lab-Index

Warm Tone Paper Developer **GAF-135**

For rich warm-black tones with chloride and bromide papers.

Stock Solution:

Water 52°C	750.0 ml
Metol	1.6 grams
Sodium Sulfite (desiccated)	24.0 grams
Hydroquinone	6.6 grams
Sodium Carbonate (monohydrated)	24.0 grams
Potassium Bromide	2.8 grams
Cold water to make	1.0 liter

Dilute 1:1 with water. A properly exposed print will be fully developed in 1-1/2 to 2 minutes at 20°C. For greater softness, dilute up to a maximum of 1:3 with water. For increased warmth of tones, increase the amount of bromide, up to a maximum of 5.6 grams.

For Vigorous Effects with Bromide
Papers **Gevaert GD-4**

Metol	.7 gram
Sodium Sulfite	10.7 grams
Hydroquinone	2.3 grams
Sodium Carbonate	14.2 grams
Potassium Bromide	.7 gram
Water to make	1.0 liter

For Softer Effects with Bromide
Papers **Gevaert GD-5**

Metol	3.3 grams
Sodium Sulfite	17.8 grams
Hydroquinone	1.0 gram
Potassium Carbonate	12.0 grams
Potassium Bromide	.7 gram
Water to make	500.0 ml

Print of any desired degree of contrast may be made by mixing GD-4 and GD-5 in suitable proportions. For a normal developer, use equal parts of GD-4 and GD-5.

Gevaert GD-31

Metol	.7 gram
Sodium Sulfite	23.0 grams
Hydroquinone	3.0 grams
Sodium Carbonate	17.0 grams
Water to make	1.0 liter

Add enough potassium bromide to keep whites clean.

Developer for Production of Very Soft
Prints or High Key Effects **Gevaert GD-67**

Metol	2.0 grams
Sodium Sulfite	28.5 grams
Sodium Carbonate	42.5 grams
Potassium Bromide	.3 gram
Water to make	500.0 ml

For use, dilute with four parts of water.

Metol-Hydroquinone Developer
For Bromide Papers **Ilford ID-20**

Stock Solution:

Water 52°C	750.0 ml
Metol	1.5 grams
Sodium Sulfite (desiccated)	25.0 grams
Hydroquinone	6.0 grams
Sodium Carbonate (monohydrated)	35.0 grams
Potassium Bromide	2.0 grams
Cold water to make	1.0 liter

Dilute: 1:1 with water; develop 1-1/2 to 2 minutes at 20°C.

Metol-Hydroquinone Developer
For Papers and Films **Ilford ID-36**

Stock Solution:

Water 52°C	750.0 ml
Metol	1.5 grams
Sodium Sulfite (desiccated)	25.0 grams
Hydroquinone	6.3 grams
Sodium Carbonate (monohydrated)	40.5 grams
Potassium Bromide	0.4 grams
Water to make	1.0 liter

For contact papers: do not dilute; develop 45-60 seconds at 20°C.

For enlarging papers: dilute 1:1 with water; develop 1-1/2 to 2 minutes at 20°C.

For films: dilute: 1:3 with water, develop 6-10 minutes at 20°C.

Amidol Developers for Bromide
Papers **Kodak D-51**

Stock Solution:

Water 50°C	750.0 ml
Sodium Sulfite (anhydrous)	120.0 grams
Di-Aminophenol Hydrochloride (Acrol; Amidol)	37.5 grams
Cold water to make	1.0 liter

Take 180 ml stock solution, 3 ml 10% potassium bromide solution, and 750 ml water. Mix only enough for immediate use, as this developer oxidizes rapidly when exposed to air.

Note: This developer is well-suited to re-development of negatives following the use of stain remover such as *Kodak* S-6. This method will usually also remove marks caused by water drops drying on the negative, as well as stains, unless the water marks are of long standing.

Kodak D-52

For warm tone papers; equivalent to *Kodak* Selectol developer.

Stock Solution:

Water 50°C	500.0 ml
Metol	1.5 grams
Sodium Sulfite (anhydrous)	22.5 grams
Hydroquinone	6.0 grams
Sodium Carbonate (monohydrated)	17.0 grams
Potassium Bromide	1.5 grams
Cold water to make	1.0 liter

Dilute 1 part stock solution with 1 part water; develop about 2 minutes at 20°C. For warmer tones, increase the amount of potassium bromide.

Kodak D-72

Universal paper developer; equivalent to *Kodak* Dektol developer.

Stock Solution:

Water 50°C	500.0 ml
Metol	3.0 grams
Sodium Sulfite (anhydrous)	45.0 grams
Hydroquinone	12.0 grams
Sodium Carbonate (monohydrated)	80.0 grams
Potassium Bromide	2.0 grams
Cold water to make	1.0 liter

Dilute 1 part stock solution with 2 parts water; develop 1 minute at 20°C. For warmer tones on Kodabromide paper, dilute 1:3 or 1:4 with water, add 8 ml of 10% potassium bromide solution for each 1.0 liter of working developer solution, and develop 1-1/2 minutes.

Kodak DK-93

P-Aminophenol Hydroquinone developer, recommended as a substitute for Metol-Hydroquinone developers for those subject to skin irritation due to *Kodak* Elon (Metol).

Water 52°C	500.0 ml
P-Aminophenol Hydrocholoride	5.0 grams
Sodium Sulfite (anhydrous)	30.0 grams
Hydroquinone	2.5 grams
Kodalk Balanced Alkali (or Sodium Metaborate)	20.0 grams
Potassium Bromide	0.5 gram
Cold water to make	1.0 liter

For warm tones, do not dilute; develop 2 minutes at 20°C. For colder tones, double the amount of *Kodalk*; develop 1-2 minutes. In either case, this developer gives slightly warmer tones than those normally given by D-52 and D-72.

STOPBATHS AND FIXERS

Tropical Hardener Bath Kodak SB-4

Recommended for use in conjunction with *Kodak* DK-15 Tropical Developer when working above 24°C.

Water	1.0 liter
Potassium Chrome Alum (crystals; dodecahydrated)	30.0 grams
Sodium Sulfite (anhydrous)	60.0 grams
or	
Sodium Sulfate (crystals)	140.0 grams

After development immerse films directly in SB-4; agitate 30-45 seconds immediately; leave in bath 3 minutes. If temperature is *below* 29°C, rinse films 1-2 seconds in plain water before using SB-4. This bath is violet-blue when fresh; it turns yellow-green and must be replaced when the hardening properties are lost. An unused bath will keep indefinitely, but the hardening properties of a partially-used bath fall off rapidly on standing for a few days.

Non-Swelling Acid Rinse Bath Kodak SB-5

Water	500.0 ml
Acetic Acid, 28%	32.0 ml
Sodium Sulfate (anhydrous)	45.0 grams
or	
Sodium Sulfate (crystals)	105.0 grams
Water to make	1.0 liter

Immerse films directly after development; agitate immediately; leave in bath about 3 minutes. This bath is satisfactory for use at temperatures up to 27°C. Capacity is approximately 100 rolls per 4 liters. *Do not revive used bath with acid.* At temperatures *below* 24°C, life of bath may be extended by rinsing films for a few seconds in plain water before immersion.

Acid Hardening Fixing Bath Kodak F-5
DuPont 1-F

For films and papers.

Water 50°C	600.0 ml
Sodium Thiosulfate (Hypo)	240.0 grams
Sodium Sulfite (desiccated)	15.0 grams
Acetic Acid, 28%	45.0 ml
Boric Acid (crystals)	7.5 grams
Potassium Alum (fine granular)	15.0 grams
Cold water to make	1.0 liter

Do not use powdered boric acid; it dissolves only with great difficulty. Do not dilute for use. Films are fixed in a fresh bath in 10 minutes. F-5 remains clear and hardens well throughout its useful

FORMULAS

life. Capacity is approximately 20-24 rolls per liter; discard before that time if fixing time reaches 20 minutes.

Acid Hardening Stock Solution — Kodak F-5a DuPont 1-FH

Water 50°C	600.0 ml
Sodium Sulfite (anhydrous)	75.0 grams
Acetic Acid, 28%	235.0 ml
Boric Acid (crystals)	37.5 grams
Potassium Alum (fine granular)	75.0 grams
Cold water to make	1.0 liter

For use, slowly add one part of cool stock hardener solution to four parts of cool 30% hypo .solution, while stirring hypo rapidly.

30% Sodium Thiosulfate (Hypo) Solution

Water 52°C	750.0 ml
Sodium Thiosulfate (Hypo)	300.0 grams
Cold water to make	1.0 liter

Odorless Acid Hardening Fixing Bath — Kodak F-6

For film and papers. This bath eliminates the odor of sulfur dioxide common to freshly mixed F-5 by substituting *Kodalk* Balanced Alkali (sodium metaborate) for the boric acid.

Water 50°C	600.0 ml
Sodium Thiosulfate (Hypo)	240.0 grams
Sodium Sulfite (anhydrous)	15.0 grams
Acetic Acid, 28%	48.0 ml
Kodalk Balanced Alkali	
(or Sodium Metaborate)	15.0 grams
Potassium Alum (fine granular)	15.0 grams
Cold water to make	1.0 liter

The ingredients other than hypo may be compounded as a stock hardener solution to be added to a 30% hypo solution; see *Kodak* Formula F-6a.

Acid Hardener Stock Solution — Kodak F-6a

Water 50%C	600.0 ml
Sodium Sulfite (anhydrous)	75.0 grams
Acetic Acid, 28%	235.0 ml
Kodalk Balanced Alkali	
(or Sodium Metaborate)	75.0 grams
Potassium Alum	75.0 grams
Cold water to make	1.0 grams

For use, slowly add one part of cool stock hardener solution to four parts of cool 30% hypo solution, while stirring hypo rapidly. The combined solution is *Kodak* F-6 Fixing Bath.

Rapid Fixing Bath — Kodak F-7

For negative films. This bath can be used with papers but has no advantage over other formulas which do not contain ammonium chloride. If used with papers, it must be used in conjunction with an acid stop bath; otherwise dichroic fog may result.

This formula clears most films in less time and has approximately 50% longer life than *Kodak* F-5.

Water 50°C	600.0 ml
Sodium Thiosulfate (Hypo)	360.0 grams
Ammonium Chloride	50.0 grams
Sodium Sulfite (anhydrous)	15.0 grams
Acetic Acid, 28%	47.0 ml
Boric Acid (crystals)	7.5 grams
Potassium Alum (fine granular)	15.0 grams
Cold water to make	1.0 liter

It is essential to add the ammonium chloride after the hypo, but before the other ingredients to avoid possible sludge formation. It is also possible to make up the hypo-plus-chloride solution as a stock solution and add stock hardeners solution *Kodak* F-5a (1 part hardener to 4 parts hypo-plus-chloride) for use.

Do not prolong fixing times for fine-grain films or for any paper prints — especially warm-tone papers. The image may have a tendency to bleach; the effect is great above 20%C.

Rapid Fixing Bath — Kodak F-9

If corrosion of metal tanks is encountered when using *Kodak* F-7, it can be minimized by substituting 60 grams of Ammonium Sulfate for the 50 grams of Ammonium Chloride for in F-7. This change is known as *Kodak* Rapid Fixing Bath F-9.

Non-Hardening Acid Fixing Bath — Kodak F-24

For films or paper when no hardening is desired.

Water 50°C	500.0 ml
Sodium Thiosulfate (Hypo)	240.0 grams
Sodium Sulfite (anhydrous)	10.0 grams
Sodium Bisulfite (anhydrous)	25.0 grams
Cold water to make	1.0 liter

Use only when temperature of developer, rinse bath, fixer and wash water is not higher than 20°C, and when ample drying time can be allowed so that relatively cool drying air can be used.

FORMULAS

699

Acid Hardening GAF 201
Fixing Bath DuPont 2-F

For use with either film or paper. May be stored indefinitely and used repeatedly until exhausted. If bath froths, turns cloudy, or takes longer than 10 minutes to fix completely, it must be replaced by a fresh solution.

Solution 1:

Water 52°C	500.0 ml
Sodium Thiosulfte (Hypo)	240.0 grams

Solution 2:

Water 52°C	150.0 ml
Sodium Sulfite (desiccated)	15.0 grams
Acetic Acid, 28%	45.0 ml
Potassium Alum	15.0 grams

Mix solutions separately; stir rapidly while adding 2 into 1; add water to make total volume of 1 liter. Do not dilute for use. Normal fixing time is 5-10 minutes at 20°C.

Chrome Alum GAF 202
Fixing Bath DuPont 3-F

A hardening fixing bath for use with films in hot weather, it must be used fresh, as it does not retain its hardening action.

Solution 1:

Water 52°C	2.5 liters
Sodium Thiosulfate (Hypo)	960.0 grams
Sodium Sulfite (desiccated)	60.0 grams
Cold water to make	3.0 liters

Solution 2:

Water (not more than 65°C)	1.0 liter
Potassium Chrome Alum	60.0 grams
Sulfuric Acid, C.P.	8.0 ml

Mix solutions separately; stir rapidly while slowly pouring 2 into 1. Rinse films thoroughly before fixing. Normal fixing time is 5-10 minutes at 20°C.

Non-Hardening Metabisulfite
Fixing Bath GAF 203

Recommended for use when hardening is not desired.

Stock Solution:

Water, 52°C	740.0 ml
Sodium Thiosulfate (Hypo)	475.0 grams
Dissolve thoroughly; when solution cools, add:	
Potassium Metabisulfite	67.5 grams
Cold water to make	1.0 liter

Dilute 1 part stock solution with 1 part water for use. Normal fixing time is 5-10 minutes at 20°C. Do not use above 21°C, or in conjunction with solutions containing hydrogen peroxide, such as *Kodak* Hypo Eliminator HE-1.

Acid Hardening Fixing Bath GAF 204

For use with either films or papers; may be stored indefinitely and used repeatedly until exhausted.

Water 52°C	750.0 ml
Sodium Thiosulfate (Hypo)	240.0 grams
Sodium Sulfite	15.0 grams
Acetic Acid, 28%	75.0 ml
Borax	15.0 grams
Potassium Alum	15.0 grams
Cold water to make	1.0 liter

Do not dilute for use. Normal fixing time is 5-10 minutes at 20°C.

INTENSIFIERS

Negatives can be intensified by adding silver (or another metal) to the silver in the image, or by making the existing image less transparent to actinic light. In either case, the density increase in each area of the image is in *direct* proportion to the amount of developed silver present. Highlights will therefore be intensified more than shadow areas, resulting in an overall contrast increase.

Chemical intensifiers won't add much density to faint images; they correct underdevelopment, but not underexposure. Almost all intensifiers increase graininess. For permanent intensification, use a chromium or silver intensifier.

Caution: The metallic compounds used in intensifier formulas are poisonous. Mercuric chloride and mercuric iodide are deadly.

Negatives must be completely fixed and washed before treatment. They must be wet and free of scum and stains (soak dry negatives for 20-30 minutes in water). Treat films in a formalin hardening bath before intensification (see *Kodak* SH-1 under hardeners).

Mercuric Iodide Intensifier DuPont 2-1

Water	1.0 liter
Mercuric Iodide	20.0 grams
Potassium Iodide	20.0 grams
Sodium Thiosulfate (Hypo)	20.0 grams
Water to make	2.0 liter

Use undiluted. Intensification is proportional to the time of treatment; it may be observed visually.

FORMULAS

Maximum effective treatment time is 15-20 minutes. After treatment, wash for 20 minutes in running water. The image is not permanent unless redeveloped in an ordinary non-staining developer (e.g., DuPont 53-D or its equivalent, *Kodak* D-76), or unless bathed in a 1% sodium sulfide solution *before* washing.

Mercury Intensifier GAF 330

Recommended for increasing the printing density of thin, flat negatives.

Water	750.0 ml
Potassium Bromide	10.0 grams
Mercuric Chloride	10.0 grams
Cold water to make	1.0 liter

Use undiluted. Immerse *thoroughly washed* negatives; when image is completely bleached, wash in water containing a few drops of hydrochloric acid. Redevelop in a 5% sodium sulfite solution or a standard non-staining developer (e.g., *Kodak* D-76). Scum formed on solution during storage does not affect working properties, but should be removed before treating negatives.

Chromium Intensifier GAF 332

Convenient to use, gives permanent results. Intensification can be controlled to some extent by varying time of redevelopment.

Cold water	1.0 liter
Potassium Bichromate	9.0 grams
Hydrochloric Acid, C.P.	6.0 ml

Bleach negatives thoroughly in this solution, wash for 5 minutes in running water, redevelop in bright, diffused light (use standard developer: GAF 47 or *Kodak* D-72). Wash for 15 minutes. Repeat treatment for increased effect, if desired.

If film base has any blue coloration after treatment, remove it by washing film briefly in (1) water with a few drops of ammonia, or (2) a 5% solution of potassium metabisulfite, or (3) a 5% solution of sodium sulfite. Follow with a thorough wash in water.

Mercuric Chloride Intensifier Ilford I.In-1

Water 52°C	750.0 ml
Mercuric Chloride	25.0 grams
Ammonium Chloride	25.0 grams
Cold water to make	1.0 liter

Bleach *thoroughly washed* negative in this solution, then redevelop in one of the following:

(1) 1 part ammonia (sp.gr. 0.800) in 100 parts water. This gives maximum intensification, but image is not permanent.

(2) Any standard developer (e.g., Iford ID-36, *Kodak* D-52). This gives less intensification than (1), but may be repeated if more density is required.

(3) A 20% sodium sulfite solution.
Wash thoroughly after redevelopment.

Silver Intensifier Kodak In-5
 DuPont 3-1

Intensifiers for both negative and positive black-and-white film images without change in coloration. Provides proportional intensification which may be controlled by varying treatment time.

Stock Solution 1 (store in brown bottle):

Silver Nitrate (crystals)	60.0 grams
Distilled water to make	1.0 liter

Stock Solution 2:

Sodium Sulfite (anhydrous)	60.0 grams
Distilled water to make	1.0 liter

Stock Solution 3:

Sodium Thiosulfate (Hypo)	105.0 grams
Water to make	1.0 liter

Stock Solution 4:

Sodium Sulfite (anhydrous)	15.0 grams
Metol	26.0 grams
Water to make	3.0 liters

Prepare intensifer as follows:

(a) Slowly add 1 part solution 2 to 1 part solution 1, stirring constantly to mix thoroughly. A white precipitate will form.

(b) Stir in 1 part solution 3. The precipitate will dissolve. Let solution stand until clear.

(c) Stir in 3 parts solution 4.

Use intensifier immediately; the mixed solution is stable for approximately 30 minutes at 20°C. Treatment should not exceed 25 minutes; observe progress visually. After treatment, immerse film in a 30% plain hypo solution and agitate constantly for 2 minutes, then wash thoroughly.

Quinone-Thiosulfate Intensifier Kodak In-6

For use with very weak negatives. Produces the greatest degree of intensification of any single-solution formula when used with high speed negative materials. Image is brownish, and is not indefinitely permanent. The intensification is destroyed by acid hypo; under no circumstances should the intensified negatives be placed in a fixing bath or in wash water contaminated with fixing bath.

FORMULAS

It is essential to mix the formula with water which has no greater than 15 parts chloride per million (about 25 parts sodium chloride per million). *Distilled water is recommended.*

Solution A:

Water 21°C	750.0 ml
Sulfuric Acid (concentrate)	30.0 ml
Potassium Dichromate (anhydrous)	22.5 grams
Water to make	1.0 liter

Solution B:

Water 21°C	750.0 ml
Sodium Bisulfite (anhydrous)	3.8 grams
Hydroquinone	15.0 grams
Photo-Flo 200	3.8 ml
Water to make	1.0 liter

Solution C:

Water 21°C	750.0 ml
Sodium Thiosulfate (Hypo)	22.5 grams
Water to make	1.0 liter

Prepare intensifier as follows. Stir 2 parts B into 1 part A. Then stir in 2 parts C. Finally stir in 1 part A. The order of mixing is important. Mix freshly before use; the solution is stable for 2-3 hours without use. Discard after one use. Stock solutions will keep for several months in stoppered bottles.

Do not touch film emulsion with fingers before or during treatment, or surface markings will be produced. Wash and harden negatives (in *Kodak* SH-1) before treatment. Agitate frequently during treatment; maximum effect is obtained in about 10 minutes at 20°C. Wash 10-20 minutes after intensification.

TONERS

Prints to be toned must be thoroughly fixed and washed. Use a hypo neutralizing bath first. Any traces of fixer or other processing chemicals in the paper may cause uneven toning stains.

Prints to be toned may need increased exposure, (10-15% more) and/or increased development (up to 50% more). Some recommendations are given with various formulas, but make a series of tests for the best results. Tests should also be made to determine whether your printing paper accepts proper toning by a particular formula—some paper-toner combinations produce unpleasant changes in tone.

Use nonmetallic (e.g., plastic or hard rubber) tanks and trays. *Do not* mix solution with metallic stirrers.

Redevelopment Sepia Tone **DuPont 4a-T**

Bleaching Solution:

Water not over 27°C	750.0 ml
Potassium Ferricyanide	25.0 grams
Potassium Bromide	27.4 grams
Ammonium Hydroxide (28%)	2.0 ml
Water to make	1.0 liter

Use undiluted. Bleach thoroughly fixed and washed prints until image is only faintly visible—about 1 minute. Wash thoroughly until no trace of yellow stain remains. Redevelop in following solution until desired tone is obtained.

Redeveloping Stock Solution:

Sodium Sulfide	50.0 grams
Water	1.0 liter

Dilute 1 part stock with 8 parts water. After redevelopment, wash prints thoroughly and dry as usual.

Sepia Toner **GAF 221**

Solution 1 (Bleach):

Water 52°C	750.0 ml
Potassium Ferricyanide	50.0 grams
Potassium Bromide	10.0 grams
Sodium Carbonate (monohydrated)	20.0 grams
Cold water to make	1.0 liter

Use undiluted to bleach thoroughly fixed and washed prints until image is very light brown, about 1 minute. Wash prints 10-15 minutes, then redevelop in Solution 2.

Solution 2 (Redeveloper):

Sodium Sulfide (desiccated)	45.0 grams
Water	500.0 ml

Dilute 1 part solution 2 with 8 parts water. Redevelopment should be complete in about 1 minute. Wash about 30 minutes after redevelopment; dry as usual. If toner leaves sediment which causes streaks or finger marks on paper, immerse print for a few seconds in a 3% acetic acid solution, then wash for 10 minutes.

Hypo Alum Toner **GAF 222**

For reddish-brown tones.

Solution 1:

Water	2350.0 ml
Sodium Thiosulfate (Hypo)	450.0 grams

Solution 2:

Water	30.0 ml
Silver Nitrate	1.3 grams

Solution 3:

Water	30.0 ml
Potassium Iodide	2.7 grams

FORMULAS

Stir solution 2 into solution 1 and mix thoroughly. Then stir in solution 3. Then dissolve 105 grams of potassium alum into the mixed solutions. Heat the entire bath to the boiling point or until sulfurization takes place (indicated by milky appearance of the solution). Tone prints 20-60 minutes at 43-52°C. Agitate prints occasionally until toning is complete. Be sure that black print tones are fully converted before removing prints from bath, otherwise double tones may result.

Gold Toner GAF 231

Produces red tones on prints that have previously been sepia toned. Produces deep blue tones in prints that have not been previously toned. Produces mixed tones of blue-black shadows and soft reddish highlights in prints that have been partially toned in a hypo alum toner.

Water 52°C	750.0 ml
Ammonium Thiocyanate	105.0 grams
(or Sodium Thiocyanate)	(110.0 grams)
(or Potassium Thiocyanate)	(135.0 grams)
Gold Chloride (1% solution)	60.0 ml
Water to make	1.0 ml

Red tones: Tone prints in sepia-sulfide redevelopment toner (GAF 221). Wash. Tone in above solution 15-45 minutes. For redder tones, use half the amount of thiocyanate.

Deep blue tones: Place well-washed black-and-white prints directly in above solution.

Mixed tones: Give prints incomplete toning in a hypo alum toner (GAF 222) and wash well before treating in above solution.

Iron Blue Toner GAF 241

Produces brilliant blue tones.

Distilled water, 53°C	500.0 ml
Ferric Ammonium Citrate	8.0 grams
Potassium Ferricyanide	8.0 grams
Acetic Acid, 28%	265.0 ml
Distilled water to make	1.0 liter

Use undiluted. Fix prints in plain, non-hardening hypo bath. Keep fixer at 20°C or less to avoid undue swelling. Prints fully toned in above solution will be greenish, but will wash out to a clear blue in running water. The depth of toning depends somewhat on original print depth; light-toned black-and-white prints produce light blue tones. Some intensification of the print usually occurs in toning, so prints should be slightly lighter than desired density of final toned print.

Wash water should be acidified slightly with acetic acid; alkaline water will weaken the blue tones. Tone variations can be obtained by bathing washed prints in a 0.5% solution (5 grams per liter) of borax; this produces softer, blue-gray tones which vary according to length of treatment.

Green Toner GAF 251

Produces rich green tones by combining the effects of iron blue toning and sulfide sepia toning. It must be employed carefully, with special attention to the directions below and to clean handling of the prints. Not all papers will tone well in this formula.

Solution 1:

Potassium Ferricyanide	40.0 grams
Water	1.0 liter
Ammonia (0.91 S.G.; 25% in weight)	15.0 ml

Solution 2:

Ferric Ammonium Citrate	17.0 grams
Water	1.0 liter
Hydrochloric Acid (concentrated)	40.0 ml

Solution 3:

Sodium Sulfide	2.0 grams
Water	1.0 liter
Hydrochloric Acid (concentrated)	10.0 ml

Add acid only immediately before use.

Prepare all solutions within 24 hours of use. Avoid contaminating solution 2 with solution 1; even *slight traces* of 1 carried on hands or prints into 2 can cause blue stains. Use solution 3 in a well-ventilated room, preferably near an open window or with an exhaust fan to lessen the chance of inhaling hydrogen sulfide formed in the solution.

Black-and-white prints to be toned should be darker and softer than a normal print. Use approximately 25% overexposure on the next softer grade of paper. Develop carefully, avoiding over- or underdevelopment. Fix, wash thoroughly, and dry before toning.

Soak prints in cold water until limp, then place in solution 1 until bleached. Transfer immediately to running water and wash thoroughly—at least 30 minutes.

Place bleached prints in solution 2 for 45 seconds to 1 minute, until the deepest shadows are completely toned. Then wash prints briefly (4-6 minutes). Avoid over-washing or alkaline water; either will weaken the blue tones. Acidify wash water with a small amount of acetic acid if necessary.

FORMULAS

Immerse blue-toned prints in solution 3 until green tone is sufficiently strong (usually about 30 seconds). Wash 20-30 minutes in neutral or acidified water. Dry *without* heat.

Sulfide Toner Ilford IT-1
For sepia tones.

Stock Ferricyanide Solution:

Water 52°C	750.0 ml
Potassium Ferricyanide	100.0 grams
Potassium Bromide	100.0 grams
Cold water to make	1.0 liter

Dilute 1 part solution with 9 parts water for use. Immerse fixed and thoroughly washed prints until completely bleached. Wash for about 10 minutes, then redevelop in following sulfide solution. For warmer tones, use only 25 grams of potassium bromide in above formula.

Stock Sulfide Solution:

Sodium Sulfide	50.0 grams
Water to make	1.0 liter

Dilute 1 part solution with 9 parts water for use. Redevelop bleached prints to desired sepia tonality. Wash thoroughly and dry as usual.

Hypo Alum Toner Ilford IT-2

Hot water	1.0 liter
Sodium Thiosulfate (Hypo)	150.0 grams
Dissolve hypo completely then add:	
Potassium Alum	25.0 grams

Until ripened, this bath has a reducing action on prints. To ripen, immerse some spoiled prints in the solution, or add 0.12 grams of silver nitrate prepared by dissolving a small amount in water and adding, drop by drop, sufficient strong ammonia to form and redissolve the precipitate. The toner lasts for years, and improves with keeping. It should be kept up to level by adding fresh solution as necessary. For warmer tones add 1 gram of potassium bromide to each liter of toner.

Develop prints a bit more than for usual black-and-white purposes, fix and wash thoroughly. Tone in above solution at 50°C for about 10 minutes. Lower temperatures unduly prolong toning; warmer temperatures produce colder tones. Wash prints thoroughly and swab off excess moisture before drying.

Selenium Toner Ilford IT-3
For purple to reddish-brown tones.

Stock Bleaching Solution:

Potassium Ferricyanide	100.0 grams
Potassium Bromide	100.0 grams
Water to make	1.0 liter

For use, dilute 1 part solution with 9 parts water. Bleach fixed and thoroughly washed print in this solution, then redevelop in selenium-sulfide solution.

Selenium-Sulfide Stock Solution:

Water 52°C	750.0 ml
Sodium Sulfide	104.0 grams
Dissolve sulfide completely, warm the solution, and add:	
Selenium Powder	6.8 grams
Continue warming solution until selenium is completely dissolved, then add:	
Water to make	1.0 liter

For use, dilute 1 part stock solution with 10 parts water. Tone bleached prints 2-3 minutes with continuous agitation. Wash thoroughly before drying.

Gold Toner Ilford IT-4
For red tones.

Water 52°C	750.0 ml
Ammonium Thiocyanate	20.0 grams
Gold Chloride	1.0 gram
Water to make	1.0 gram

First tone prints in a sulfide (Ilford IT-1) or hypo alum (Ilford IT-2) toner. Then immerse washed prints in above solution. Tones will change to reddish-brown, then to red; about 10 minutes is required for a red tone. After toning, refix prints in a 10% solution of plain hypo (sodium thiosulfate) for 5-10 minutes, then wash thoroughly and dry as usual.

Ferricyanide-Iron Toner Ilford IT-6
For blue tones on bromide papers.

Solution A:

Water 52°C	750.0 ml
Potassium Ferricyanide	2.0 grams
Sulfuric Acid (concentrated)	4.0 ml
Cold water to make	1.0 liter

Solution B:

Water 52°C	750.0 ml
Ferric Ammonium Citrate	2.0 grams
Sulfuric Acid (concentrated)	4.0 ml
Cold water to make	1.0 liter

Note: Add acid to water, while stirring, in both solutions. *Do not* add water to acid.

For use, mix 1 part A with 1 part B just before use. Prints for toning should be slightly lighter than normal, and thoroughly washed. Immerse print in toning solution until desired tone is reached. Wash until the yellow stain is removed from the whites. Alkaline wash water may bleach the image; acidi-

fy wash water with a few drops of sulfuric or acetic acid.

Hypo Alum Sepia Toner *Kodak* T-1a

For sepia tones on warm tone papers.

Cold water	2.8 liters
Sodium Thiosulfate (Hypo)	480.0 grams
Dissolve hypo completely, then add the following solution:	
Water 70°C	640.0 ml
Potassium Alum	120.0 grams
Then slowly add the following solution* (including its precipitate) while stirring rapidly:	
Cold water	64.0 ml
Silver Nitrate (crystals)*	4.0 grams
Sodium Chloride	4.0 grams
Then add:	
Water to make	4.0 liters

*Note: Silver nitrate should be dissolved completely before adding sodium chloride; immediately afterward add this milky white solution to the hypo-alum solution. The formation of a black precipitate in no way impairs the toning action of the bath if prints are then rinsed clean.

For use, pour toner into a tray in a water bath and heat to 49°C. Prints will tone in 12-14 minutes at this temperature; do not prolong time beyond 20 minutes. Do not use higher temperatures, or blisters and stains may result.

Prints for toning should be exposed to be slightly darker than normal when normally developed. They must be thoroughly fixed and washed. Soak dry prints in plain water to soften them before washing.

After toning, wipe prints clean of any sediment, then wash 1 hour in running water.

Sulfide Sepia Toner *Kodak* T-7a

For cold tone papers.

Stock Bleaching Solution A:

Water	1.5 liters
Potassium Ferricyanide (anhydrous)	75.0 grams
Potassium Bromide (anhydrous)	75.0 grams
Potassium Oxalate	195.0 grams
Acetic Acid, 28%	40.0 ml
Water to make	2.0 liters

For use, dilute 1 part A with 1 part water. Bleach thoroughly washed print until only a faint yellowish image remains—about 1 minute. Then tone in diluted solution B.

Stock Toning Solution B:

Sodium Sulfide (anhydrous)	45.0 grams
Water	500.0 ml

For use, dilute 124 ml of B with 1.0 liter water. After bleaching, rinse print *thoroughly* in running water—at least 2 minutes. Treat print in diluted solution B until original detail returns—about 30 seconds. Immediately rinse print thoroughly, then treat 2-5 minutes in a solution of 2 parts *Kodak* Hardener F-5a stock solution (see Fixer formulas) and 16 parts water. After hardening, wash print at least 30 minutes in running water before drying.

Polysulfide Toner *Kodak* T-8

For darker sepia tones than redevelopment-sulfide toners produce.

Water	750.0 ml
Sulfurated Potassium (Liver of Sulfur)	7.5 grams
Sodium Carbonate (monohydrated)	2.5 grams
Water to make	1.0 liter

Use undiluted. Immerse thoroughly washed print for 15-20 minutes at 20°C (or 3-4 minutes at 38°C), with continuous agitation.

After toning, rinse print briefly in running water, then place about 1 minute in a fresh solution of *Kodak* Hypo Clearing Agent kept only for this purpose, or in a solution of 30 grams of sodium bisulfite in 1 liter of water. Then treat print 2-5 minutes in a solution of 2 parts *Kodak* Hardener F-5a stock solution (see Fixer formulas) and 16 parts water. Wipe any sediment from print, then wash at least 30 minutes before drying.

Nelson Gold Toner *Kodak* T-21
 GAF 223

For warm black to neutral brown tones on warm-tone papers; has little effect on cold-tone papers. Tones both highlights and shadows of a print at a uniform rate.

Stock Solution A:

Water 50°C	4.0 liters
Sodium Thiosulfate (Hypo)	960.0 grams
Potassium Persulfate	120.0 grams

Dissolve the hypo completely before adding the persulfate, while stirring vigorously. If the solution does not turn milky, increase the temperature until it does so.

Cool the solution to about 27°C and add the solution below, including the precipitate, slowly and with constant stirring. *These two solutions must be cool when added together.*

Cold water	64.0 ml
Silver Nitrate (crystals)	5.0 grams
Sodium Chloride	5.0 grams

FORMULAS

Dissolve the silver nitrate completely before adding the sodium chloride.

Stock Solution B:

Water	250.0 ml
Gold Chloride	1.0 grams

Note: Gold Chloride will liquefy rapidly in a normal room atmosphere. Store the chemical in a tightly stoppered bottle in a dry atmosphere.

For use, pour 125 ml of B slowly into the entire volume of A while stirring rapidly. Let the combined solution stand about 8 hours, until a yellow precipitate has formed and settled to the bottom of the container. Then carefully pour off the clear solution for use and discard the precipitate.

Pour the solution into a tray in a water bath and heat to 43°C; maintain this temperature during toning. Wash prints fixed before placing them in the toner. Soak dry prints thoroughly in water before toning.

Keep an untoned black-and-white print on hand for comparison during toning. If sediment forms in the toning tray, it will not affect the results, but may form a scum on the print surface. If so, wipe the print clean with a soft sponge immediatley after toning.

Tone 5-20 minutes, until desired tone is obtained, then remove print and rinse in cold water. More than one print at a time may be toned; if they are kept separated. After toning, wash prints thoroughly and dry.

Revive the bath at intervals by adding Stock Solution B. The quantity to be added will depend upon the number of prints toned and the time of toning. For example, when toning to a warm brown, add 4 ml of B after each 50 20 × 25cm prints, or equivalent, have been toned.

Red Toner Gevaert-15

Solution A:

Potassium Citrate	100.0 grams
Water to make	500.0 ml

Solution B:

Copper Sulfate	7.5 grams
Water to make	250.0 ml

Solution C:

Potassium Ferricyanide	6.5 grams
Water to make	250.0 ml

Mix solution B into solution A, then slowly add solution C, stirring well. Remove prints from toning bath when desired tone is obtained and wash thoroughly.

Green Toner Gevaert-16

Solution A:

Oxalic Acid	7.8 grams
Ferric Chloride	1.0 gram
Ferric Oxalate	1.0 gram
Water to make	285.0 ml

Solution B:

Potassium Ferricyanide	2.0 grams
Water to make	285.0 ml

Solution C:

Hydrochloric Acid	28.4 ml
Vanadium Chloride	2.0 grams
Water to make	285.0 ml

In solution C the acid is first added to the water; the solution is then heated almost to the boiling point before the vanadium is added.

Mix solution B into A, then introduce solution C, stirring well.

Tone in the mixed solution until the prints are deep blue. Remove and place in wash until tone changes to green.

If there is any yellowish stain in the whites it may be removed by immersion in the following solution:

Ammonium Sulfocyanide	1.6 grams
Water to make	285.0 ml

STAIN REMOVERS AND CLEANERS

Tray Cleaner *Kodak* TC-1
DuPont 1-TC

To remove developer oxidation stains, and some silver and dye stains.

Water	1.0 liter
Potassium Dichromate (anhydrous)	90.0 grams
Sulfuric Acid	96.0 ml

Add acid to solution, while stirring. Never add solution to acid.

Pour a small amount of TC-1 into vessel to be cleaned, rinse around so that it has access to all parts, then pour it out and wash the vessel 6 or 8 times with water until all traces of the cleaning solution disappear. *Do not* use TC-1 to clean the hands; use *Kodak* TC-3.

Tray Cleaner *Kodak* TC-3

To remove stains due to silver, silver sulfide, and many dyes.

Solution A:

Water	1.0 liter
Potassium Permanganate	2.0 grams
Sulfuric Acid (concentrated)	4.0 ml

Add acid to solution, while stirring. Never add solution to acid. Store solution A in a stoppered glass bottle, away from the light.

Solution B:

Water	1.0 liter
Sodium Bisulfite (anhydrous)	30.0 grams
Sodium Sulfite (anhydrous)	30.0 grams

To use, pour a small quantity of A into the vessel being cleaned and leave it for a few minutes. Pour out A, rinse the vessel well, then pour in an equivalent amount of B. Agitate until the brown stain is completely cleared, then wash the vessel thoroughly. Several vessels can be cleaned consecutively without making up new solutions. However, do not store used solutions for repeated use.

May be used as described to clean hands; remove all jewelry. Wash thoroughly after use.

Stain Remover Kodak S-6

To remove developer or oxidation stains from film.

Stock Solution A:

Potassium Permanganate	5.0 grams
Water to make	1.0 liter

Be sure that all particles of permanganate dissolve completely.

Stock Solution B:

Cold water	500.0 ml
Sodium Chloride	75.0 grams
Sulfuric Acid (concentrated)	16.0 ml
Water to make	1.0 liter

Add acid to solution, while stirring. Never add solution to acid.

Harden film to be treated 2-3 minutes in *Kodak* SH-1, and wash 5 minutes. Mix equal parts of A and B *immediately* before use; keep them at 20°C. Immerse film in this solution 3-4 minutes; a brown stain of manganese dioxide will form on the film. To remove the stain, immerse film in a 1% sodium bisulfite solution (10 grams bisulfite in 1 liter water). Remove, rinse well, and develop in strong light (preferably sunlight) in a non-staining developer such as *Kodak* Dektol or D-72. *Do not* use slow-working developers such as *Kodak* D-76, Microdol-X, or DK-20; they tend to dissolve the bleached image before the developing agents are able to act on it.

Stain Remover for Hands DuPont 1-SR

To remove almost all developer and ink stains.

Solution A:

Water	1.0 liter
Potassium Permanganate	15.0 grams

Sulfuric Acid (concentrated)	5.0 ml

Add acid to solution, while stirring. Never add solution to acid.

Solution B:

Water	1.0 liter
Sodium Bisulfite	50.0 grams

Bathe hands in A, rinse in water, and bathe in B. If one treatment is not sufficient, wash hands with soap and water before repeating. Wash hands thoroughly when finished.

Developer Stain Remover for Films Ilford

Water 52°C	750.0 ml
Potassium Permanganate	6.0 grams
Sodium Chloride	13.0 grams
Acetic Acid (99% Glacial)	50.0 ml
Cold water to make	1.0 liter

Add acid to solution, while stirring. Never add solution to acid.

Harden negative 3-5 minutes in a 1% potassium chrome alum solution (10 grams alum in 1 liter water) and rinse before treatment. Immerse negative in stain remover about 10 minutes with constant agitation. Then remove brown stain by immersing negative in a 5% potassium metabisulfite solution (50 grams bisulfite in 1 liter water). Redevelop in any ordinary developer, such as Ilford ID-36, and wash thoroughly.

Developer Stain Remover for Prints Ilford

To remove stains from bromide paper prints.

Potassium Alum (saturated solution)	250.0 ml
Hydrochloric Acid (concentrated)	6.0 ml

Pour the acid slowly into the alum solution while stirring constantly.

Wash prints thoroughly after treatment.

Tank and Reel Cleaner

Sodium Sulfite	60.0 grams
Sodium Carbonate	90.0 grams
Hot water	4.0 liters

Soak equipment overnight in this solution, rinse thoroughly, dry immediately.

FORMULAS

CONVERSION CHARTS

Compound Conversions. When converting a formula given in metric terms to the U.S. system, or vice versa, it is essential to remember that formulas represent a proportion of x amount of each chemical in y volume of total solution. You cannot accurately convert only the amount of chemical, you must convert the volume of solution as well. For example, in terms of weight, 1 ounce equals 28.35 grams; but in terms of solution strength, 1 *ounce per quart* equals 30.0 *grams per liter*.

The factors and tables below will make formula conversion relatively painless.

Mass (Weight) Factors

Grains per quart × 0.068 = grams per liter
Ounces per quart × 29.96 = grams per liter
Pounds per quart × 479.3 = grams per liter

Grams per liter × 14.60 = grains per quart
Grams per liter × 0.033 = ounces per quart
Grams per liter × 0.002 = pounds per quart

Grains per quart		Grams per liter	Grams per liter		Grains per quart
5	=	0.3	0.5	=	7.3
10	=	0.7	1.0	=	14.6
15	=	1.0	1.5	=	21.9
20	=	1.4	2.0	=	29.2
25	=	1.7	2.5	=	36.5
30	=	2.1	3.0	=	43.8
40	=	2.7	3.5	=	51.1
50	=	3.4	4.0	=	58.4
60	=	4.1	4.5	=	65.7
70	=	4.8	5.0	=	73.0
80	=	5.5	6.0	=	87.6
90	=	6.2	7.0	=	102.2
100	=	6.8	8.0	=	116.8
150	=	10.3	9.0	=	131.4
200	=	13.7	10.0	=	146.0
300	=	20.5	20.0	=	292.0
400	=	27.4	25.0	=	365.0
500	=	34.2	30.0	=	438.0
600	=	41.1	40.0	=	584.0
700	=	47.9	50.0	=	730.0

Ounces per quart		Grams per liter	Grams per liter		Ounces per quart
0.1	=	3	1.0	=	.03
0.2	=	6	5.0	=	.17
0.3	=	9	10.0	=	.33
0.4	=	12	20.0	=	.67
0.5	=	15	25.0	=	.83
0.6	=	18	30.0	=	1.00
0.7	=	21	35.0	=	1.17
0.8	=	24	40.0	=	1.34
0.9	=	27	45.0	=	1.50
1.0	=	30	50.0	=	1.67
2.0	=	60	60.0	=	2.00
3.0	=	90	70.0	=	2.34
4.0	=	120	80.0	=	2.67
5.0	=	150	90.0	=	3.00
6.0	=	180	100.0	=	3.34
7.0	=	210	150.0	=	5.00
8.0	=	240	200.0	=	6.68
9.0	=	270	250.0	=	8.34
10.0	=	300	300.0	=	10.00

Liquid Factors

Fluid oz. per quart × 31.25 = ml per liter
Milliliters per liter × 0.032 = fl. oz. per quart

Fluid oz. per quart		Milliliters per liter	Milliliters per liter		Fluid oz. per quart
1/8 (1 fl dr)	=	3.9	1.0	=	.032 (0.25 fl dr)
1/4 (2 fl dr)	=	7.8	5.0	=	.160 (1.25 fl dr)
3/8 (3 fl dr)	=	11.7	10.0	=	.320 (2.50 fl dr)
1/2 (4 fl dr)	=	15.6	15.0	=	.480 (3.80 fl dr)
5/8 (5 fl dr)	=	19.5	20.0	=	.640 (5.10 fl dr)
3/4 (6 fl dr)	=	23.4	25.0	=	.800 (6.40 fl dr)
7/8 (7 fl dr)	=	27.3	30.0	=	.960 (7.70 fl dr)

Fluid oz. per quart		Milliliters per liter	Milliliters per liter		Fluid oz. per quart
1 (8 fl dr)	=	31.2	40.0	=	1.280
2	=	62.5	50.0	=	1.600
3	=	93.8	100.0	=	3.200
4	=	125.0	110.0	=	3.520
5	=	156.3	120.0	=	3.840
6	=	187.5	130.0	=	4.160
7	=	218.8	140.0	=	4.480
8	=	250.0	150.0	=	4.800
9	=	281.3	200.0	=	6.400
10	=	312.5	300.0	=	9.600
12	=	375.0	400.0	=	12.800
16	=	500.0	500.0	=	16.000

FORMULAS

The Compact Photo-Lab-Index

$$°C = \frac{(°F - 32) \times 5}{9}$$

$$°F = \frac{°C \times 9}{5} + 32$$

°C	°F	°C	°F	°C	°F	°C	°F	°F	°C	°F	°C	°F	°C	°F	°C
0=32															
1=33.8		16=60.8		31= 87.8		46=114.8		31=-0.6		51=10.6		71=21.7		91= 32.8	
2=35.6		17=62.6		32= 89.6		47=116.6		32= 0.0		52=11.1		72=22.2		92= 33.3	
3=37.4		18=64.4		33= 91.4		48=118.4		33= 0.6		53=11.7		73=22.8		93= 33.9	
4=39.2		19=66.2		34= 93.2		49=120.2		34= 1.1		54=12.2		74=23.2		94= 34.4	
5=41.0		20=68.0		34= 95.0		50=122.0		35= 1.7		55=12.8		75=23.9		95= 35.0	
6=42.8		21=69.8		36= 96.8		60=140.0		36= 2.2		56=13.3		76=24.4		96= 35.6	
7=44.6		22=71.6		37= 98.6		70=158.0		37= 2.8		57=13.9		77=25.0		97= 36.1	
8=46.4		23=73.4		38=100.4		80=176.0		38= 3.3		58=14.4		78=25.6		98= 36.7	
9=48.2		24=75.2		39=102.2		90=194.0		39= 3.9		59=15.0		79=26.1		99= 37.2	
10=50.0		25=77.0		40=104.0		100=212.0		40= 4.4		60=15.6		80=26.7		100= 37.8	
11=51.8		26=78.8		41=105.8				41= 5.0		61=16.1		81=27.2		110= 43.3	
12=53.6		27=80.6		42=107.6				42= 5.6		62=16.7		82=27.8		115= 46.1	
13=55.4		28=82.4		43=109.4				43= 6.1		63=17.2		83=28.3		120= 48.9	
14=57.2		29=84.2		44=111.2				44= 6.7		64=17.8		84=28.9		125= 51.7	
15=59.0		30=86.0		45=113.0				45= 7.2		65=18.3		85=29.4		130= 54.4	
								46= 7.8		66=18.9		86=30.0		140= 60.0	
								47= 8.3		67=19.4		87=30.6		150= 65.6	
								48= 8.9		68=20.0		88=31.1		175= 79.4	
								49= 9.4		69=20.6		89=31.7		200= 93.3	
								50=10.0		70=21.1		90=32.2		212=100.0	

Liquid Conversion

ml (milliliters)
× 0.0338 = ounces
× 0.0021 = pints
× 0.0010 = quarts
× 0.0010 = liters

l (liters)
× 33.814 = ounces
× 2.1133 = pints
× 1.0566 = quarts
× 0.2642 = gallons
× 1000.0 = milliliters

oz (ounces)
× 0.0625 = pints
× 0.0312 = quarts
× 0.0078 = gallons
× 29.573 = milliliters
× 0.0296 = liters

pt (pints)
× 16 = ounces
× 0.5 = quarts
× 0.125 = gallons
× 473.17 = milliliters
× 0.4731 = liters

qt (quarts)
× 32 = ounces
× 2 = pints
× 0.25 = gallons
× 946.34 = milliliters
× 0.9463 = liters

gal (gallons)
× 128 = ounces
× 8 = pints
× 4 = quarts
× 3785.4 = milliliters
× 3.7854 = liters

U.S.		U.S.	Metric
1 dram	=	1/8 ounce	= 3.7 milliliters
1/2 pint	=	8 ounces	= 237 milliliters
1 pint	=	16 ounces	= 0.473 liter
1 quart	=	32 ounces	= 0.946 liter
1/2 gallon	=	64 ounces	= 1.9 liters
1 gallon	=	128 ounces	= 3.79 liters

FORMULAS

The Compact Photo-Lab-Index

Liquid Capacity Measure

Milliliters		Ounces	Ounces		Milliliters	Milliliters		Ounces	Ounces		Milliliters
15	=	0.5	1/2	=	15	500	=	16.91	10	=	296
22	=	0.75	3/4	=	22	600	=	20.29	11	=	325
30	=	1	1	=	30	700	=	23.67	12	=	355
50	=	1.69	2	=	59	800	=	27.05	13	=	384
75	=	2.54	3	=	89	900	=	30.43	14	=	414
100	=	3.38	4	=	118	1000	=	33.80	15	=	444
150	=	5.07	5	=	148	1100	=	37.18	16	=	473
175	=	5.92	6	=	177	1200	=	40.56	24	=	710
200	=	6.76	7	=	207	1300	=	43.94	32	=	946
300	=	10.14	8	=	237	1400	=	47.32	64	=	1892
400	=	13.52	9	=	266	1500	=	50.70	128	=	3785

Mass (Weight) Measure

Grams		Grains	Grains		Grams	Grams		Ounces	Ounces		Grams
1	=	15.4	1	=	0.065	5	=	0.18	1/4	=	7.0
2	=	30.9	2	=	0.130	10	=	0.35	1/2	=	14.1
3	=	46.3	3	=	0.194	15	=	0.53	3/4	=	21.2
4	=	61.7	4	=	0.249	20	=	0.71	1	=	28.3
5	=	77.1	5	=	0.324	25	=	0.88	2	=	56.7
6	=	92.8	6	=	0.389	35	=	1.23	3	=	85.0
7	=	108.1	7	=	0.453	50	=	1.76	4	=	113.4
8	=	123.5	8	=	0.518	100	=	3.53	5	=	141.7
9	=	138.9	9	=	0.583	150	=	5.29	6	=	170.1
10	=	154.3	10	=	0.648	200	=	7.05	7	=	198.4
20	=	308.6	20	=	1.296	250	=	8.81	8	=	226.8
30	=	463.0	30	=	1.944	300	=	10.58	9	=	255.1
40	=	617.3	40	=	2.592	350	=	12.34	10	=	283.5
50	=	771.5	50	=	3.240	400	=	14.10	11	=	311.8
60	=	925.6	60	=	3.888	450	=	15.87	12	=	340.2
70	=	1080.0	70	=	4.536	500	=	17.63	13	=	368.5
80	=	1235.0	80	=	5.184	600	=	21.16	14	=	396.9
90	=	1390.0	90	=	5.832	800	=	28.21	15	=	425.2
100	=	1543.0	100	=	6.480	1000	=	35.27	16	=	453.6

Mass (Weight) Conversion

g (grams)
- × 15.432 = grains
- × 0.564 = drams
- × 0.035 = ounces
- × 0.002 = pounds
- × 1000 = milligrams
- × 0.001 = kilograms

kg (kilograms)
- × 15432.4 = grains
- × 564.383 = drams
- × 35.274 = ounces
- × 2.2046 = pounds
- × 1000 = grams

gr (grains)
- × 0.365 = drams
- × 0.0023 = ounces
- × 0.00014 = pounds
- × 64.799 = milligrams
- × 0.0648 = grams
- × 0.00006 = kilograms

oz (ounces)
- × 437.5 = grains
- × 16 = drams
- × 0.0625 = pounds
- × 28.349 = grams
- × 0.02834 = kilograms

lb (pounds)
- × 7000 = grains
- × 256 = drams
- × 16 = ounces
- × 453.59 = grams
- × 0.4536 = kilograms

FORMULAS

Glossary

(The following glossery is reprinted from *The Morgan and Morgan Darkroom Book,* by Algis Balsys and Liliane DeCock-Morgan.)

Aberration—a lens defect which causes a deviation of rays, resulting in imperfect image focus.

Accelerator—a component of a developer, usually an alkali, that increases the rate of development. Examples are sodium carbonate and borax.

Acetic Acid—a comparatively weak acid, usually supplied in 28% strength, which is one of the main ingredients of a stop bath.

Acid—a substance which neutralizes alkalis and which, in water solution, produces a pH below 7. Stop baths and fixers are usually acid solutions.

Actinic Light—light that has a chemical effect on photosensitive substances. The photographic effect varies according to the wavelength of the light, and the sensitivity characteristic of the emulsion.

Acutance—an objective measure of edge sharpness in a photographic image.

Agitate, Agitation—the systematic, repetitive movement of a photographic emulsion through processing solutions. Agitation is necessary to bring new areas of solution in contact with the emulsion.

Alkali, Alkaline—any substance with a pH value over 7. Most developers are alkaline solutions. (See **pH**.)

Ammonium Thiosulfate—the main ingredient of rapid-acting fixers. More gentle working fixing agents usually employ sodium thiosulfate instead.

Anhydrous—word used by chemists to indicate a substance containing no water, similar to "dessicated."

ANSI—(American National Standards Institute) an organization which establishes methods of procedure and measurement in a variety of fields, including photographic testing. (You will find ANSI speed rating numbers listed on printing paper boxes.) Formerly known as American Standards Association (ASA); the speed numbers of film are still preceded by the initials ASA.

Antifoggant—any of a number of chemicals used in emulsions or developers to reduce the rate of development of unexposed (as compared with that of exposed) portions. Examples are potassium bromide and benzotriazole. Also called restrainers.

Antihalation Layer —on a piece of photographic film, the layer that absorbs light once it has gone through the emulsion. This prevents stray light from bouncing back onto the emulsion and degrading the image.

Aperture—the opening of a lens through which light reaches the film. Generally known as an "f-stop", even though this term more accurately describes the way an aperture is measured, rather than the aperture itself. The word aperture, literally translated from the French, means "opening".

ASA—see **ANSI**.

Available Light—a common term used by photographers to describe low-light situations.

Avoirdupois—a system of weights commonly used in the United States, in which grams, ounces and pounds are units.

Autofocus—applied to projection printers which contain a cam or other mechanical device that adjusts the position of the lens to maintain a sharp image as the positions of other parts of the systems are altered.

Baryta—the barium sulfate layer applied to the paper base before the light sensitive emulsion is coated.

Base—the part of the photographic paper, film, or plate onto which the light-sensitive emulsion is attached.

Base Tint—the hue of photographic paper bases. This color, depending on the type of paper, falls within a range from pure white to a yellowish, creamy tone.

Bas-relief—a special raised effect obtained by making a contact positive transparency from a negative, binding the two together, slightly out of register, and printing from the combination.

Benzotriazole—see **Antifoggant**.

Bleach—in photography, the common term for potassium ferricyanide, which is used to selectively lighten areas of a photographic print.

Blocked Up—overexposed or overdeveloped highlights on film. Blocked up highlights cannot be printed properly.

Brightness—subjective term applied to the degree of light intensity given off by an object. Brightness is perceived, rather than measured (see **Luminance**).

Brilliance, Brillant—otherwise known as "lively" or "snappy", this term applies to a negative, transparency, or print that has a crisp look due to a large range of tones and bright highlight areas, usually with strong gradation.

Bromide Paper—high speed photographic paper for projection printing. The main light-sensitive ingredient in the emulsion is silver bromide.

Burning In—the procedure of allowing more light than the initial exposure to affect selective areas of a print.

Centigrade, Celsius—system of temperature measurement widely used throughout the world. Compatible with the metric system, since it uses 100° as its boiling point and 0° as freezing, it is somewhat less precise a system of measurement than the Fahrenheit system, because there are fewer steps between the two extremes of freezing and boiling.

Chloride Paper—photographic paper using silver chloride as its sensitive medium. Most contact papers are made this way. Though very slow, chloride papers produce an excellent tonal scale.

Chlorobromide (Bromochloride) Paper—photographic paper the emulsion of which is made up of both silver chloride and silver bromide. A medium speed paper for enlarging.

Clump, Clumping—the tendency of silver salt particles in photographic emulsions to "migrate" toward one another and form groups of grains is commonly referred to as clumping, also known as agglomeration, this tendency is most likely to occur during vigorous or overdevelopment.

Code Notches—on sheet films, indentations along one edge which can be felt in the dark to identify the type of film and locate the emulsion side.

Collimated Light—light passing through an optical system which causes the rays to be parallel.

Cold Tone—term used for photographic paper that has intense, bluish blacks and clean, pure whites.

Condenser—in enlarger heads, the lens or lenses *above* the negative carrier. The condenser gathers rays of light coming from the enlarging lamp, concentrates them to evenly illuminate the negative, then passes them through the negative and the enlarging lens onto the paper.

Contact Print, Printer—a photographic print by bringing the film and photographic paper into emulsion-to-emulsion contact, flattening them out with a piece of clean, scratch-free glass, and exposing to light; a machine used for this purpose, usually consisting of a light box with a hinged lid which, when closed, assures firm contact of negative and paper.

Contaminate—to introduce an impurity. A developing solution could be contaminated, for example, by allowing drops of fixing solution to fall into it.

Contrast—the term used to describe the range, from dark to light, that a photographic emulsion can record, and how this ability manifests itself with regard to the scene being recorded. Print contrast usually refers to how many distinct tonal steps are possible between the lightest and darkest tones the paper can produce. A high contrast paper compresses the tonal scale into few but distinct steps of gray from white to black; a low contrast paper will produce more gray tones between black and white, and will record a number of discrete steps of tonal range, producing subtle changes in gray. Contrasty negatives usually print best on low contrast paper, and low contrast negatives will generally give more pleasant results on paper of high contrast.

Densitometer—an instrument used to determine the degree of light that will pass through (transmission densitometer) or reflect from (reflectance densitometer) an exposed photographic emulsion.

Density—the degree of transparency/opacity of a negative.

Desiccated—applied to chemicals from which all or almost all water has been removed.

Developer—a formulated chemical solution that causes the latent image of an exposed photographic emulsion to become visible.

Developing Agent—a chemical (e.g. metol, hydroquinone) that reduces exposed silver halides to metallic silver in a shorter time than unexposed silver halide, normally used in a water solution together with other ingredients.

Development—the process of converting a latent image into a visible one.

Diaphragm, Iris Diaphragm—the part of a lens that controls the amount of light passing through the lens.

Diffusion Enlarger—a projection printer that uses diffuse light, not collimated light.

Dilution—adding water to a stock or other solution for use. The volume ratio of stock solution to water is expressed, for example as 1:2.

DIN—Deutsche Industrie Norm. A standard established by the German counterpart of ANSI which see.

Dodging—the technique of blocking light from portions of a print during exposure.

Double Weight—the base thickness of photographic paper is expressed in terms of "weight". Double weight is the thickest available and is preferred by many printers because of its resistance to creasing and other physical damage. Single weight papers are made as well. The terms double and single weight apply to fiber-based papers; resin coated papers are usually somewhere between these in thickness and are referred to as being "medium weight".

Easel—a device used to center and hold a piece of photographic paper flat during exposure.

Elon—Kodak's trade name for the developing agent also known by its proprietary name, metol.

Emulsion—a dispersion of silver halide crystals in gelatin or other suitable material; the part of photographic paper or film that is sensitive to light.

Emulsion Side—the side of a photographic film or paper on which the emulsion is coated. In film typically the dull side and concave as the film curls.

Enlarger—an optical device containing a light source used to project an image onto sensitized material. Also called a projection printer.

Enlarger Head—the part of a projection printer comprising the light source, the negative carrier, and the lens.

Enlarging Lens—a lens designed for use on a projection printer. The lens is mounted in a barrel without a shutter; the diaphram is equipped with click stops.

Enlarging Meter—a light meter designed to be used as an aid in determining the correct contrast grade and exposure settings for projection printing.

Exposure Index (E.I.)—a self-imposed film speed setting determined by making tests of one's equipment, film, and developing technique. Sometimes this rating agrees with the normal rating established by the film manufacturer. Variable factors in equipment or technique may require deviations from the manufacturer's rating.

Exposure Meter—a device used to measure light and to determine the shutter speed/aperture combination necessary to produce a good negative. Some exposure meters are designed to measure the light falling on an object (*incident light* meters); others measure the light reflecting from an object

(*luminance* or *reflected light* meters). All in-camera meters are reflected light meters.

F-stop—the aperture setting of a photographic lens.

Fahrenheit—until recently, the standard system of temperature measurement in the U.S. and England. Based on a table that indicates freezing temperature of water at sea level to be 32° and boiling point to be 212°. Now largely replaced by the Celsius, or Centigrade system.

Farmer's Reducer—a solution of potassium ferricyanide and hypo, used to reduce the density of silver images.

Film Speed—the relative sensitivity of film to light. Generally expressed by manufacturers as an ASA (American Standards Association) number. The higher the number, the "faster", or more sensitive to light, the film.

Fixer (Hypo)—a chemical solution used to remove all unexposed silver salts from a developed photographic emulsion so that the image will be rendered permanent. Usually contains sodium thiosulfate.

Fog—unwanted density on photographic emulsions, caused by inadvertent exposure to stray light, by contaminated chemicals, or by the use of outdated film or paper.

Gelatin—the substance used to bind silver halide crystals to film and paper bases.

Gradation, Tonal—the degree and relationship of tones in photographic emulsions.

Grade, Graded Paper—photographic paper manufacturers express the relative degree of contrast in their various papers in terms of contrast *grades*. Low contrast papers are assigned low numbers, and contrasty ones are given higher numbers. These numbers range from 0 to 6, but there is no real standardization, so that one manufacturer's Grade 3 paper may be the equivalent of another's Grade 2 or 4. Papers that have no one grade but are capable of producing prints of various grades with the aid of specially colored filters, are known as *Variable Contrast* papers.

Grain—the noticeable pattern, or texture, or a developed piece of photographic film. One piece of visible grain is actually made up of thousands of grains of developed silver salt grains that have clumped together. (See **Clumping**.)

Gray Card—a neutral-color cardboard, typically having 18% reflectance, used as a standard artificial medium tone for luminance readings. In the Zone System, an 18% reflectance gray card corresponds to Zone V.

Gray Scale—a series of neutral tones arranged in sequence from dark to light, ideally with equal density difference between steps.

H and D—Hurter and Driffield, the originators of photographic sensitometry.

H and D Curve—a graph obtained by plotting the logarithms of a series of exposures received by a photographic material and the corresponding resulting densities.

Hardener—an additive used with fixer to make the soft, wet emulsion less physically delicate. Some hardeners contain alum and dilute sulfuric acid.

High-Contrast—applied to developer, film, or photographic paper, used to increase differentation of tones, either to achieve a desired contrasty effect or to compensate for a low-contrast influence elsewhere in the process.

High Key—a photographic print in which most of the tones are light.

Highlight—a term loosely applied to any light-tone area on a positive image, or a corresponding dense area on a negative.

Hydroquinone—a highly active developing agent, used alone in high-contrast developers and in combination with metol for general-purpose developers.

Hypo—common name for sodium thiosulfate. Also called fixer.

Hypo-Clearing Agent—product used to neutralize the effects of hypo on emulsion once the process has gone to completion. Hypo must be removed, or it will attack developed silver in the image over a prolonged period of time.

Hypo Eliminator—a formula which chemically removes residual hypo from photographic emulsions.

Incident Light—light falling on an object.

Incident Light Meter—see **Exposure Meter**.

Intensification—a method of increasing image density by chemical means.

Intensifiers—chemical substances used to increase the density of a developed image. Intensifiers cannot place detail onto a negative where no detail is present; all they can do is make the exposed and developed part of the negative more opaque, thereby raising overall contrast. Grain increases with most intensifiers.

Latent Image—the invisible image that occurs on photogaphic emulsions when exposed to light, before development.

Latitude—the "margin of error" of photographic film is usually expressed in terms of latitude or the amount of over- or underexposure permissible without significant effect on image quality.

Luminance—the *measurable* degree of brightness, or light intensity, reflected from an object. Often, the word brightness (which is unmeasurable) is used incorrectly to mean luminance.

Luminance Meter—reflection type of light meter.

Metol—a gentle, slow-working developing agent, usually used together with the much more vigorous hydroquinone for general-purpose development.

Negative—a photographic image in which light subject tones are reproduced as dark (dense) and dark tones as light (thin).

Newton's Rings—faintly colored fringes caused by interference of light between two closely spaced reflecting surfaces; as when a negative is placed in a glass carrier for projection printing. The remedy is to use slightly roughened glass in the carrier, or to use a glassless carrier.

Normal Contrast—an acceptable degree of contrast which records tones in a "pleasing" way. A "normal" negative would be one which has enough tones between black and white to yield a pleasing print on Grade 2 paper.

Opaque—in retouching, to cover unwanted areas of a negative (background, defects) with pigment so that they will not appear in the print.

Orthochromatic—not sensitive to red, but sensitive to blue, green, and ultraviolet light. Many photographic papers and some special purpose films are orthochromatic.

Overdevelopment—developing for longer than recommended, increases contrast and graininess in films.

Overexposure—excessive exposure. When coupled with appropriate underdevelopment of films, will produce slightly less contrasty than normal negatives with increased shadow detail. Will reduce contrast slightly in prints, if development is shortened.

Panchromatic—sensitive to all colors of the visible spectrum and ultraviolet light. Most films and some papers are panchromatic.

714

pH—symbol of a measurement system used to gauge the relative alkalinity or acidity of substances. Water, which is used as a neutral standard, has a pH of 7. Acids have pH numbers lower than 7. Those of bases, or alkalis, are higher than 7. pH affects the activity of developing agents, most of which require pH values greater than 7 in order to function.

Photogram—a photographic image made by placing objects onto a piece of photographic paper, then exposing, so as to cause patterns where the light has been blocked.

Photography—broadly, the science, engineering, craft, and art of producing relatively permanent images by the action of light on sensitive materials.

Positive—a photographic image in which the tones are in approximately the same relationship as in the original; light tones are reproduced as light, and dark tones as dark (as opposed to negative, in which the original tones are reversed).

Postvisualization—an approach to photographic printing, especially of combination photographs and montages, in which the main decisions are made in the darkroom during the printing process.

Potassium Ferricyanide—see **Bleach.**

Preservative—a chemical, usually sodium sulfite, in developers added to retard oxidation.

Previsualization—in photography, a term connected with the Zone System; the mental process of the photographer by which the path to the desired print is controlled by exposure and development of the negative.

Rapid Fixer—fast acting hypo. See **Ammonium Thiosulfate.**

RC, Resin Coated—a term designating those photographic papers that have been coated with a water resistant resin or plastic, allowing very short processing, washing, and drying times.

Reducer—a chemical bath which is used to remove silver from a processed negative, or positive, to lower its density.

Resolution—the measurable ability of a film to record minute detail. Usually, the slower the film, the higher its resolving power. The same term applies both to lenses and to film.

Resolving Power—see **Resolution.**

Restrainers—see **Antifoggant.**

Sabattier Effect—partial image reversal associated with the following sequence: Primary exposure, partial development, fogging exposure, continued development, followed by completion of processing.

Safelight—a low wattage light that is fitted with a color filter to which photographic emulsions are not overly sensitive. Used in darkrooms during processing (of paper).

Spotting—a retouching method of removing unwanted white or light areas on a print surface, usually with special dyes and a fine-pointed brush.

Stop Bath—a solution of acetic acid, water and sometimes an exhaustion indicating dye, used to halt the effect of developer on paper and to neutralize the alkalinity of developing solutions.

Test Print, Strip—a print made by exposing sections of the paper to light for different lengths of time, in order to determine best exposure for the full image.

Underdevelopment—less development than normally required; sometimes quite useful. See **Overexposure.** Massive underdevelopment results in faint, unevenly recorded images that will not print properly, if at all. Underdeveloped prints look weak and washed out.

Underexposure—less exposure than normally required. Can be compensated for to some degree by subsequent overdevelopment, but only if the underexposure was slight. Image quality will generally suffer.

Variable Contrast Paper—see **Graded Paper.**

Other Morgan and Morgan titles...

THE NEW ZONE SYSTEM MANUAL

By Minor White, Richard D. Zakia, and Peter Lorenz

Following in the footsteps of Ansel Adams and Fred Archer, who first attempted to codify the way experienced photographers use their materials, Minor White created the original Zone System Manual in 1961. This up-to-date revision of White's 1961 classic exposition of the Zone System is comprehensive yet remarkably concise, covering visualization methods; calibration and contrast-control; graphs of sensitometry. 196 photographs, diagrams, and charts.

"The most extensive single book on the Zone System to date and the best explanation of contrast-control so far."
—RANGEFINDER

8 x 8, 256 pages, 0-87100-100-4
Order No. 2100 (paper) **$8.95**

ZONE SYSTEMIZER

By John J. Dowdell, III and Richard D. Zakia

This ingenious, easy-to-use, calibrated dial helps the photographer compute Zone System exposure and development in visual terms. No math is needed. The accompanying 64-page paperbound workbook presents all instructions, plus practical tips and pointers in using the Zone System.

"This is a most useful tool.... Certainly it is one of the most important developments to be given photography since the Zone System itself."—RANGEFINDER

Order No. 2040, 9 x 8½, 0-87100-040-7 **$10.95**

PHOTOGRAPHIC TONE CONTROL

By Norman Sanders

One of the most common problems in photography is failure in tone control: the ability to correlate the light source, its reflections off objects in the scene, and gradations of light-recording capability in both negative and photographic paper.

"Excellent book, clearly written ... [this is a] tone-control system that really works."—PETERSEN'S PHOTOGRAPHIC

8 x 8, 144 pages, 0-87100-117-9
Order No. 2117 (paper) **$8.95**

PHOTOGRAPHIC SENSITOMETRY

By Hollis N. Todd and Richard D. Zakia

A sensible approach to the subject, which emphasizes practical methods of process control. Especially lucid and helpful are the author's treatments of test methods, light and light sources, analysis of data, and the tone reproduction cycle in printing.

5 x 8½, 312 pages, 0-87100-000-8
Order No. 2000 (paper) **$10.95**

Other Morgan and Morgan titles...

THE KEEPERS OF LIGHT
A History & Working Guide to
Early Photographic Processes

By William Crawford

The Keepers of Light is two books in one: a splendid history of the development of photography plus a wonderfully lucid explanation of how to master the processes used by the great pioneers of photography.

"...a new kind of photographic history book. I found it hard to put down. In addition to the anecdote filled history there are how-to chapters that explain in detail how you can create prints as they did in the past, do color separations, and conserve and restore old prints."—ASSOCIATED PRESS

Now in its second printing!

Popular Photography Book Club Main Selection

8 x 9½, 324 pages, 0-87100-158-6
Order No. 2158 (paper) **$16.95**

ALTERNATIVE PHOTOGRAPHIC
PROCESSES: A Resource Manual for
the Artist, Photographer, Craftsperson

By Kent Wade

Ceramics, metals, fabrics, glass, wood, linoleum and plastics—all these materials and surfaces are a unique alternate to conventional photographic paper.

The step-by-step chapters cover Photo-Etching Techniques on Metal; Photo-Presentation Techniques on Glass; Photo-Ceramic Processes; Photographic Images on Fabrics; Traditional Non-Silver Printing Processes; Photo-Silkscreen Techniques; Color Separation Techniques; Advanced Photo Technology in the Graphic Communications Field.

"This is a must reference volume for anyone seriously interested in creative expression with photography...A truly ambitious work that is unusually extensive and complete in the variety of photographic processes described."
—PETERSEN'S PHOTOGRAPHIC

Popular Photography Book Club Selection

8 x 9½, 192 pages, 0-87100-136-5
Order No. 2136 (paper) **$11.95**

Other Morgan and Morgan titles...

THE MORGAN & MORGAN DARKROOM BOOK

Edited by Algis Balsys and Liliane De Cock-Morgan

"...a well-organized, lucid guide to developing film and making prints. It deals methodically—step by step—with the complex chemistry, technology and artistry of darkroom procedures."—PUBLISHERS WEEKLY

The first four chapters lead the photographer through the basics of the photographic process: Materials; Basic Film Developing; Basic Printing and Common Problems. The next six chapters are more advanced: Fine Tuning the Negative—and The Print; Processing for Permanence; Mounting and Presentation; Special Techniques; and—The Tailor-Made Darkroom.

"Final image quality is exemplified by superb reproduction of finished prints."—PUBLISHERS WEEKLY

The large-size paperbound format insures ease of handling and reference.

Popular Photography Book Club Main Selection

8 x 9½, 232 pages, 0-87100-120-9
Order No. 2120 **(paper) $10.95**

DICTIONARY OF CONTEMPORARY PHOTOGRAPHY

By Leslie Stroebel and Hollis N. Todd

From A (for ampere) to Zoom, here are definitions of thousands of photographic words, names, terms, and concepts. Jumbo-size (10 by 10 inch) pages, large-size type, hundreds of illustrations and diagrams.

10 x 10, 224 pages
Order No. 2065 0-87100-065-2 **(cloth) $20.00**
Order No. 2103 0-87100-103-9 **(paper) $9.95**

PHOTOGRAPHIC CHEMISTRY

(Revised Edition)

By George T. Eaton

You need no formal training in chemistry or physics to follow this lucid and logical book. Contents include: photographic emulsions; reaction of emulsions to light; solutions and chemicals in processing; developers; control and measurement of development; fixing baths; color processes; washing processed materials.

8¼ x 5½, 124 pages, 0-87100-067-0
Order No. 2067 **(paper) $6.95**